The Modern West

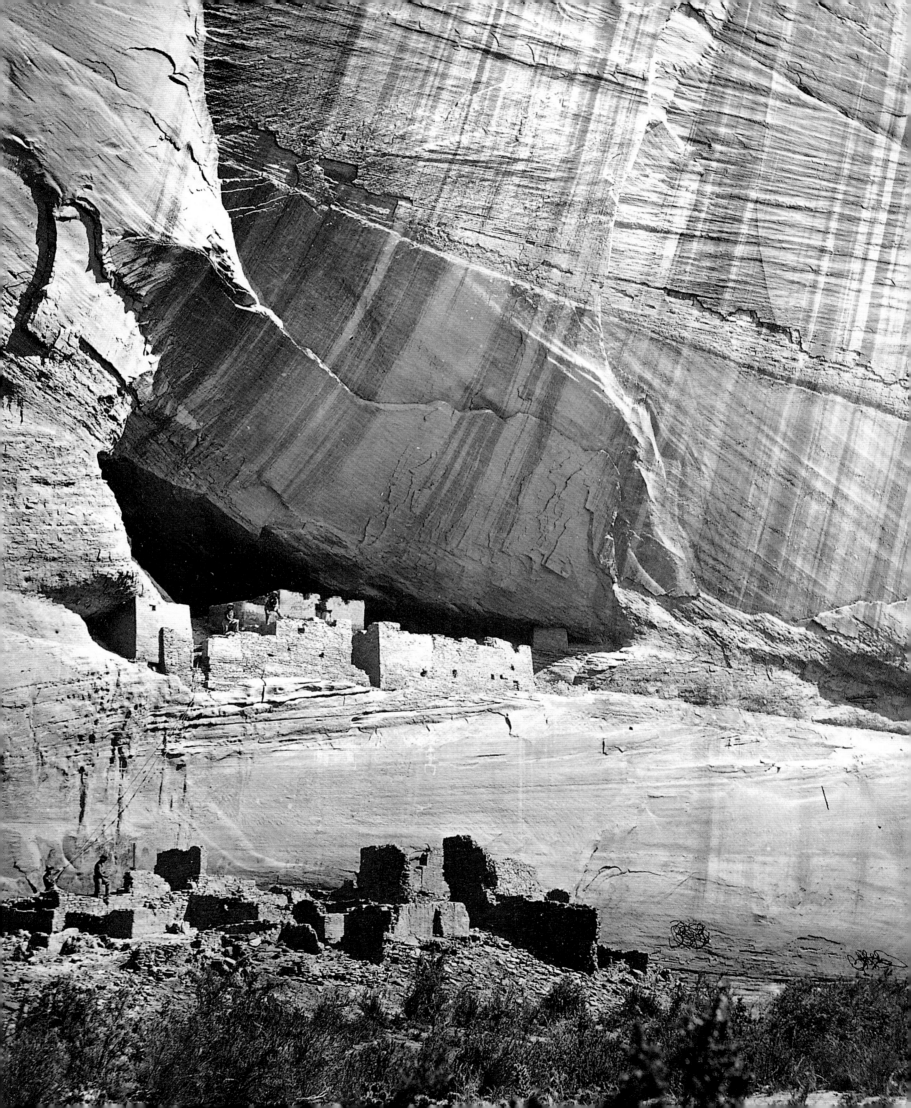

The Modern West
AMERICAN LANDSCAPES
1890–1950

EMILY BALLEW NEFF
WITH AN ESSAY BY BARRY LOPEZ

Yale University Press, New Haven and London
in association with
The Museum of Fine Arts, Houston

Exhibition Itinerary

The Museum of Fine Arts, Houston
October 29, 2006–January 28, 2007

Los Angeles County Museum of Art
March 4–June 3, 2007

The Modern West: American Landscapes, 1890–1950
was organized by the Museum of Fine Arts, Houston.
Generous funding was provided by the National Endow-
ment for the Humanities, the Stark Foundation, the
Hamill Foundation, the National Endowment for
the Arts, and Mr. Frank Hevrdejs. Additional funding was
provided by Wells Fargo, Mr. and Mrs. Robert L. Clarke,
Mr. and Mrs. Peter R. Coneway, Mr. John R. Eckel, Jr., Linn,
Thurber, Arnold & Skrabanek, Lisa and Will Mathis,
and Carla Knobloch. The catalogue for this exhibition
received support from Palm Beach! America's Interna-
tional Fine Art & Antique Fair.

Designed by Daphne Geismar, www.daphnegeismar.com
Set in Clarendon, Celeste, and The Sans by Amy Storm
Printed in Italy by Mondadori

Library of Congress Cataloging-in-Publication Data
Neff, Emily Ballew, 1963–
The modern West : American landscapes, 1890–1950 /
Emily Ballew Neff ; with an essay by Barry Lopez.
 p. cm.
Catalog of an exhibition at the Museum of Fine Arts,
Houston, Oct. 29, 2006–Jan. 28, 2007 and the Los
Angeles County Museum of Art, Mar. 4–June 3, 2007.
Includes bibliographical references and index.
ISBN-13: 978-0-300-11448-5 (hardcover : alk. paper)
ISBN-10: 0-300-11448-6 (hardcover : alk. paper)
ISBN-13: 978-0-89090-145-8 (pbk. : alk. paper)
ISBN-10: 0-89090-145-7 (pbk. : alk. paper)
1. West (U.S.)—In art—Exhibitions. 2. Art, American—
19th century—Exhibitions. 3. Art, American—20th
century—Exhibitions. 4. Modernism (Art)—United
States—Exhibitions. I. Museum of Fine Arts, Houston.
II. Los Angeles County Museum of Art. III. Title.
N8214.5.U6N44 2006
758'.178097307476415112222
2006015121

10 9 8 7 6 5 4 3 2 1

Cover illustrations: *(front)* Raymond Jonson, *Cliff
Dwellings, No. 3,* 1927 (detail of fig. 106); *(back)* Ansel
Adams, *Vernal Fall through Tree, Yosemite Valley,
California,* 1920 (detail of fig. 86)
Frontispiece: Timothy O'Sullivan, *Ancient Ruins in the
Cañon de Chelle, N.M.,* 1873 (detail of fig. 21)

Contents

On Modern Ground
EMILY BALLEW NEFF

The Many Wests: Modern Regions

Lenders to the Exhibition

Michael and Jeanne Adams

Robert Aichele

Albright-Knox Art Gallery, Buffalo, New York

Amon Carter Museum, Fort Worth, Texas

Andrew Smith Gallery, Santa Fe

The Art Institute of Chicago

Brigham Young University Museum of Art

Alan G. Burch

Amon Burton and Christopher M. Harte

Canadian Centre for Architecture, Montréal

The Center for American History, The University of Texas
at Austin

Sterling and Francine Clark Art Institute, Williamstown,
Massachusetts

The Cleveland Museum of Art

Mr. and Mrs. Peter Coneway

Denver Public Library, Western History Department

Lee and Judy Dirks

The Fine Arts Museums of San Francisco

George Eastman House, Rochester, New York

Georgia O'Keeffe Museum, Santa Fe

The J. Paul Getty Museum, Los Angeles

Gilcrease Museum, Tulsa, Oklahoma

Neil S. Goldblatt

Grey Art Gallery, New York University Art Collection

Harry Ransom Humanities Research Center,
The University of Texas at Austin

Hirshhorn Museum and Sculpture Garden, Smithsonian
Institution, Washington, D.C.

Jonson Gallery, University Art Museum, University of New Mexico, Albuquerque

Joslyn Art Museum, Omaha, Nebraska

Kirkland Museum of Fine & Decorative Arts, Denver

Robert G. Lewis

The Library of Congress, Prints and Photographs Division

Los Angeles County Museum of Art

Massachusetts Historical Society

The McNay Art Museum, San Antonio

Memorial Art Gallery of the University of Rochester

The Metropolitan Museum of Art

Morehouse Gallery, Brookline, Massachusetts

Munson-Williams-Proctor Arts Institute, Museum of Art, Utica, New York

Museum of the American West, Autry National Center, Los Angeles

Museum of Fine Arts, Boston

The Museum of Fine Arts, Houston

Museum of Fine Arts, Museum of New Mexico

The Museum of Modern Art, New York

National Gallery of Art, Washington, D.C.

National Museum of the American Indian, Smithsonian Institution, Washington, D.C.

Norton Museum of Art, West Palm Beach, Florida

Oakland Museum of California

Orange County Museum of Art, Newport Beach, California

Philadelphia Museum of Art

Philbrook Museum of Art, Tulsa, Oklahoma

The Phillips Collection, Washington, D.C.

Portland Art Museum, Oregon

Dennis Reed Collection

Reynolda House Museum of American Art, Winston-Salem, North Carolina

San Francisco Museum of Modern Art

Collection of Mr. Theodore P. Shen

Alice C. Simkins

Andrew Smith and Claire Lozier, Santa Fe

Andrew Smith, Claire Lozier, and John Boland, Santa Fe

Smithsonian American Art Museum, Washington, D.C.

Snite Museum of Art, University of Notre Dame

Frederick and Frances Sommer Foundation

Spanierman Gallery LLC, New York

Taft Museum of Art, Cincinnati

University of California, Berkeley Art Museum

University of Louisville Photographic Archives, Louisville, Kentucky

University of New Mexico Art Museum, Albuquerque

Various private collections

Wadsworth Atheneum Museum of Art, Hartford, Connecticut

Frederick R. Weisman Art Museum at the University of Minnesota, Minneapolis

Margaret M. Weston and the Weston Gallery, Carmel, California

Whitney Museum of American Art, New York

Williams College Library, Williamstown, Massachusetts

Wilson Centre for Photography, London

Wallace and Isabel Wilson

Yale University Art Gallery, New Haven

Foreword

The evolution of modern art in America was powered by new ideas, new subjects, and new views of the physical world. The western frontier—a place of "exotic" environments and cultures—contributed significantly to this modern aesthetic. This exhibition and book focus on those artists who used their western experiences to create paintings and photographs that defined the many faces of Modernism in the first fifty years of the twentieth century.

Indian pictographs, towering mountain ranges, endless desert horizons, and big skies could not be recorded by means of traditional Anglo-European artistic formulas and thus demanded new approaches to art. This challenging physical environment tested a person's stamina and will and required a rugged individual who—contradictory as it may sound—functioned as part of a team or worked within a community in order to survive.

The strange new world of the American West was discovered by artists at a time of aesthetic revolt in Europe. Led by the French Impressionists and other innovators, many artists were looking beyond the official art schools, academies, and studios to capture changing and fleeting subjects such as light, weather, and emotions. The act of painting itself became a legitimate subject, as brushstrokes and ink lines confirmed the hand of the artist and "represented" the visible world. From the mid-1870s through the 1940s, Paris was a primary incubator of these modern styles. However, in America, artists looked not only to the East for inspiration but also to the open regions of the West, a land devoid of European artistic traditions.

Both the avant-garde world of Paris and the new art emerging in the American West were right in step with the revolutions in science and the rise of psychology at the end of the nineteenth century, which showed that innumerable forces, invisible to the naked eye, provided the underpinnings of everything one could see or hear or that prompted one to speak or act. For many artistic visionaries, the realm of the invisible became their new territory.

Emily Ballew Neff's *The Modern West: American Landscapes, 1890–1950* offers a fresh look at the field of modern art in America. Dr. Neff's exhibition, which opens at the Museum of Fine Arts, Houston, in October 2006, marks the two-hundredth anniversary of the forty-month-long expedition of Meriwether Lewis and William Clark from St. Louis to the Pacific Ocean. Lewis and Clark returned to St. Louis in late September 1806, and the scientific, geographic, historical, and cultural information they had gathered became the basic guide for the ambitious U.S. Geological and Geographic surveys from 1867 to 1879. Photographs taken during these surveys documented the incredible land and its people. In 1873 one of the survey photographers, Timothy O'Sullivan, produced the stunning image *Historic Spanish Record of the Conquest, South Side of Inscription Rock, New Mexico*, which is included in Dr. Neff's exhibition. This photograph reveals the numerous cultures and historical events that left their marks on the American West for thousands of years.

The year 2006 also marks the fiftieth anniversary of the death of Jackson Pollock, a westerner who became the leading Abstract Expressionist painter, and whose work symbolized the new art and shifted the center of the art world from Paris to New York. Born in Cody, Wyoming, and reared in various western states, Pollock was inspired by American Indian art and religion throughout his life. Many of Pollock's works, such as *Night Mist*, 1945, recall the rich layering of American Indian compositions that he saw in his childhood.

Only seventy-two years separate the photograph by Timothy O'Sullivan from the radical painting by Jackson Pollock. What is their relationship? This is one of the many fundamental questions that Dr. Neff's exhibition tackles and that this book addresses. The answers are both subtle and complex, and some of the questions are too difficult to resolve conclusively. But this is the key: *The Modern West: American Landscapes, 1890–1950* argues for a rigorous effort to comprehend the major role that the American West played in the evolution of American Modernism. This exhibition and book constitute the first critical steps.

Peter C. Marzio
Director
The Museum of Fine Arts, Houston

Preface

Several years ago I attended an art-history conference in New Mexico on the subject of American Modernism. In the opening remarks, one of the participants noted the irony of discussing this topic in the American West. The comment took me by surprise because it exposed so clearly the widely held perception that concepts of American Modernism are limited to New York City in the decades following the turn of the twentieth century. During that time towering skyscrapers and clanking machinery, immigrants arriving on America's shores in successive waves, and avant-garde exhibitions at Alfred Stieglitz's elite gallery at 291 Fifth Avenue defined a new age focused on the big, the bustling, the powerful, and the bohemian, all set off by the glowing lights of Coney Island. In this context the sagebrush-dotted hills of New Mexico and its ancient adobe villages would indeed seem remote.

Although the urban East looms large in the imagination, it is the emphasis on a mythic West — reiterated in tourist magazines, western novels, and Hollywood movies despite an extensive record of revisionist western history — that long hindered many historians and the public from recognizing the related concepts of a modern East and a modern West. Since Henry Nash Smith's majestic *Virgin Land: The American West as Symbol and Myth* (1959), a landmark publication that describes the development of national symbols associated with the West during the period of westward expansion, the West's mythical aspects have been expanded upon with compelling force and promoted in engaging formats in subsequent books and exhibitions. However, as much as the West is known through myth, it is also a place where the groundbreaking effects of Modernism

took hold. The entrenched belief that "modern West" is an oxymoron, then, planted the seed for this exhibition, which examines the relationship of the American West to Modernism through landscape painting and photography from 1890 to 1950. In the process, the West is integrated into Modernism's larger story.

Modernism is, simply put, a cultural response to modernization and industrialization. In traditional accounts of art history, the concept of Modernism in art developed in the mid-nineteenth century with Charles Baudelaire's call for artists to paint modern life and to focus on themes of contemporary relevance that are rooted in the intellectual, political, and economic climate of their time. More narrowly, Modernism has also come to refer to works of art that exhibit specific characteristics, such as a flattened picture plane, and convey expressive relationships between color, line, and form, that is, a form of self-containment of its component parts. In American art, scholars generally place Modernism's point of origin (if there can even be one) in the first two decades of the twentieth century. The Armory Show of 1913 in New York introduced bold European modes of art-making to the American public and displayed the imaginative possibilities inherent in thwarting artistic traditions and academic convention. Other pioneer exhibitions of avant-garde European, American, and African art organized by photographer and art impresario Stieglitz, whose impact is felt in any accounting of American art, also set this story line in motion.

Modernism, more broadly, embraces the dramatically changed perceptions of time and space that played out with particular force in the nineteenth and twentieth centuries.

Sociological phenomena, such as urbanism and the move from an agricultural to an industrial economy, marked a powerful force of change. Technological inventions, such as the railroad and the factory, reoriented notions of time by linking land to time through the train schedule and laborers to time through the clock. In the context of speed and change, it is difficult to imagine a more modern place than the American West. President Thomas Jefferson, who acquired from France nearly one million square miles of western lands for the United States, stated in 1806 that it would take one hundred generations to settle the continent to the Pacific Ocean, but it took only five generations, moving forward exponentially during the westward expansion that characterized the Jacksonian Era. Looking back, we note that the heyday of fur trappers lasted only about fifteen years, from the mid-1820s to 1840; the government policy of Indian Removal, which moved the Chickasaw, Cherokee, Choctaw, Creek, Seminole, and other tribes from their homelands to a new region west of the Mississippi River, was initiated in 1830 and completed in little over a decade; the mass migration of California immigrants, the largest in U.S. history, occurred during a twenty-year period, in the 1840s and 1850s; the two major railroads, the Central Pacific and the Union Pacific, linked the continent in 1869 after only seven years of construction; and the buffalo herds on the plains, which once numbered in the millions, dwindled to the thousands by about 1880. The northern plains herd was virtually destroyed by 1883. By the end of the nineteenth century, the country's western ground was entirely remade. This enormous space that many had believed was essentially empty, a space that was still

becoming known and measured through the United States government surveys, threw into sharp relief the extraordinary speed of change taking place upon it. While surveys reduced the West to scientific notations worked out on paper, the railroad distorted it by reducing the time required to traverse its vast expanses. This compression of space and time, arising from empirical knowledge and technological advancement, informs the push-pull character of modernity in the West.

The national interest in this "new" nature was accompanied by a reengaged fascination with its "new" peoples: the First Americans. A form of cultural primitivism, the belief that American Indian cultures represented a preindustrial ideal of all that was then lost to America, is another aspect of Modernism that played out with special force in the desert Southwest in the early decades of the twentieth century. To Euro-Americans, the indigenous peoples of the West evoked a sense of lost time that stood out as starkly as the western landscape, revealing in the process the tensions between past and present, nostalgia and progress, and timelessness and marked time that characterize the modern West.

Painters and photographers of the late nineteenth and early twentieth centuries engaged with these themes of technology, scientific knowledge, and nostalgia for a lost past, and found them intensely expressed in the new ground of the West. Artists who traveled to the West are often described as anti-Modernists whose journeys represent an escape from the pressures of modern life. But these artists were also seeking to locate and define what was widely perceived to be possible at the time: an authentic and modern American art. The ubiquitous question of what was American—along with

the critical call for an "American art"—became a national debate, rising in urgency in the early decades of the twentieth century. For many artists, the skyscraper and the machines of mass production symbolized the contributions of the United States to urban life, and they became emblems of national identity and modernity. Other artists, who feared that machine-age technology would erode the human spirit, chose to reinvestigate the American landscape on their own terms and discovered that the Modernism of the West was expressed in the aesthetic qualities of the land itself: broad expanses of "empty" space, angular mesas, vivid and bold colors, and intense light that flattens forms.

Thus, from my perspective at the conference in New Mexico, geography and subject, American West and Modernism, were perfectly matched. Consequently, identifying, locating, and spending time in the places of the West—in an effort to imagine a geohistory of art—became an important part of this project, derived from the conviction, voiced by art historian Thomas DaCosta Kaufmann, that "if art has a history, it also at least implicitly had, and has, a geography; for if the history of art conceives of art as being made in a particular time, it obviously also puts it in a place."[1] To ignore the relationship of Modernism to the American West would be tantamount to rubbing out the other side of the Modernist coin. This exhibition and book were conceived as an opportunity to explore the interrelation of the West, modernity, and national identity by using the following road map. Six roughly chronological sections trace how artists, as part of early survey expeditions, made the expansive landscapes and vistas of the American West accessible and legible to the American public

at large; how subsequent artists found ways to interpret the West through their own artistic lenses; how the concept of a monolithic West broke apart and developed new regional contours at the turn of the twentieth century, most productively in the Southwest; and how, following the disasters wrought by nature and humankind during the Dust Bowl era, the western landscape ultimately was subsumed by artists and articulated in new and groundbreaking ways. Rather than offering an exhaustive survey, this exhibition and book highlight the various groups and artists who played integral roles in shaping visions of specific regions and how they pursued related issues of modernity and concepts of national distinctiveness that were relevant at this time. For these artists, the West provided a "new" environment—a "new" nature and the people who inhabited it—for constructing a "new" American art on thoroughly modern ground.

Emily Ballew Neff
Curator of American Painting and Sculpture
The Museum of Fine Arts, Houston

Note
1 Kaufmann 2004, 13 and 7.

Acknowledgments

During the course of organizing and researching this exhibition and catalogue, I have been helped and supported by a number of remarkable and generous people. Peter C. Marzio, director of the Museum of Fine Arts, Houston, offered encouragement and wisdom at every stage of this project; to him, to Isabel Brown Wilson, chairman of the Board of Trustees, and to all of the museum's trustees, I am especially grateful. Museum trustees Pete and Lynn Coneway remained dedicated to the project from beginning to end and offered gracious hospitality. Support from the National Endowment for the Humanities (NEH), which honored the museum with both a planning and an implementation grant, enabled the project to bloom. We thank Bruce Cole, chair of the NEH, and Clay Lewis, program officer, for their encouragement. NEH consultants Wanda M. Corn, the Robert and Ruth Halperin Professor in Art History at Stanford University, and W. Jackson Rushing III, then-professor of art history at the University of Houston, offered sound advice, wisdom, and expertise in their fields as the exhibition began to take shape. NEH consultant Richard Francaviglia, center director and professor of history/geography at the Center for Greater Southwestern Studies and the History of Cartography, The University of Texas at Arlington, helped refine the geographical contours of the exhibition and provided a thoughtful essay for the museum's Web site, created especially for the exhibition. NEH consultant Char Miller, professor and chair of the History Department of Trinity University in San Antonio, shared his expertise and edited the exhibition's time line, a component of the exhibition's Web site, coauthored by intern Jennifer Chuong. NEH consultants who also offered guidance include

Kathleen A. Brosnan, professor of history at the University of Houston, and the late Walter Hopps, then-curator of The Menil Collection, Houston. Of this NEH consultant group, I would like to single out two: writer Barry Lopez, who graced this project with his unfailing support, keen understanding, and generosity, imparting many life lessons and gems of wisdom along the way; and Janet Catherine Berlo, professor of art history and visual and cultural studies, and codirector of the Visual and Cultural Studies Graduate Program at the University of Rochester. These extraordinary people have taught me far more than the following pages reveal.

The National Endowment for the Arts awarded an Access to Artistic Excellence Grant, and we are grateful to Dana Goia, chair, and to David Bancroft, museums specialist, for their support. The Stark Foundation awarded a substantial grant to fund the publication of the book; Walter Reidel and David Hunt deserve special recognition for their help. Other generous funders include The Hamill Foundation and Mr. Frank Hevrdejs, with additional support provided by Wells Fargo, Mr. and Mrs. Robert L. Clarke, Mr. and Mrs. Peter R. Coneway, Mr. John R. Eckel, Jr., Linn, Thurber, Arnold & Skrabanek, Lisa and Will Mathis, and Carla Knobloch. The book also received support from Palm Beach! America's International Fine Art & Antique Fair. Research for the exhibition was greatly aided by two important fellowships. The Research and Academic Programs of the Sterling and Francine Clark Art Institute in Williamstown, Massachusetts, awarded a summer fellowship; Michael Ann Holley, Mark Ledbury, and Gail Parker provided for an intellectually satisfying research stint,

and much else. I am also grateful to the Georgia O'Keeffe Museum Research Center, which awarded a scholarship in residence and supported it with the efficient assistance of Barbara Buhler Lynes, Eumie Imm-Stroukoff, and Heather Hole.

For the generous loan of their works of art, and for their patience in answering numerous requests during the preparation of the catalogue, I wish to thank Michael and Jeanne Adams; Robert Aichele; Rick Stewart, Jane Myers, Paula Stewart, and, especially, John Rohrbach at the Amon Carter Museum, Fort Worth; James Cuno, David Travis, and Judith A. Barter at The Art Institute of Chicago; John L. Gray and Amy Scott at the Autry National Center, The Museum of the American West, Los Angeles; Campbell Gray and Dawn Phesey at the Museum of Art, Brigham Young University, Provo, Utah; Alan G. Burch; Amon Burton and Christopher M. Harte; Phyllis Lambert, Dirk De Meyer, and Louise Désy at the Canadian Centre for Architecture, Montréal; Don E. Carleton and Linda Peterson at The Center for American History, The University of Texas at Austin; Michael Conforti, Richard Rand, and Marc Simpson at the Sterling and Francine Clark Art Institute; Timothy Rub and Tom Hinson at the Cleveland Museum of Art; Mr. and Mrs. Peter Coneway; Rick J. Ashton, Jim Kroll, and Trina Purcell at the Denver Public Library, Western History Department; Lee and Judy Dirks; Harry S. Parker III and Timothy Anglin Burgard at the Fine Arts Museums of San Francisco; Dr. Anthony Bannon and Alison Devine Nordström at the George Eastman House, Rochester, New York; George G. King and Barbara Buhler Lynes at the Georgia O'Keeffe Museum, Santa Fe; Michael

Brand, Weston Naef, Gordon Baldwin, Anne Lyden, and Mary Morton at the J. Paul Getty Museum, Los Angeles; Joseph B. Schenk and Gary Hood at the Gilcrease Museum, Tulsa; Neil S. Goldblatt; Lynn Gumpert and Michèle Wong at the Grey Art Gallery, New York University Art Collection; Thomas F. Staley and Roy Flukinger at the Harry Ransom Humanities Research Center, The University of Texas at Austin; Ned Rifkin and Valerie Fletcher at the Hirshhorn Museum and Sculpture Garden, Smithsonian Institution, Washington, D.C.; Linda Bahm and Chip Ware at the Jonson Gallery, University Art Museum, University of New Mexico, Albuquerque; J. Brooks Joyner and Marsha V. Gallagher at the Joslyn Art Museum, Omaha; Hugh A. Grant at the Kirkland Museum of Fine & Decorative Arts, Denver; Robert G. Lewis; James H. Billington and Beverly Brannan at the Library of Congress, Prints and Photographs Division, Washington, D.C.; Dennis A. Fiori, Peter Drummey, and Anne Bentley at the Massachusetts Historical Society, Boston; William I. Chiego and Lyle Williams at the McNay Art Museum, San Antonio; Grant Holcomb III and Marjorie Searl at the Memorial Art Gallery of the University of Rochester, New York; Philippe de Montebello, Gary Tinterow, Malcolm Daniel, Lisa Mintz Messinger, and Ida Balboul at the Metropolitan Museum of Art, New York; Richard Morehouse Gallery; Paul D. Schweizer and Mary Murray at the Munson-Williams-Proctor Arts Institute, Museum of Art, Utica, New York; Malcolm Rogers, Clifford S. Ackley, and Karen Haas at the Museum of Fine Arts, Boston; Marsha C. Bol, Steven A. Yates, and Joseph Traugott at the Museum of Fine Arts, Museum of New Mexico, Santa Fe; Glenn Lowry and Peter Galassi at the Museum

of Modern Art, New York; Earl A. Powell III and Judith Brodie at the National Gallery of Art, Washington, D.C.; Richard West, Mary Jane Lenz, and Erik Satrum at the National Museum of the American Indian, Smithsonian Institution, Washington, D.C.; Christina Orr-Cahall and Jonathan Stuhlman at the Norton Museum of Art, West Palm Beach, Florida; Dennis M. Power, Philip Linhares, Harvey Jones, and Drew Johnson at the Oakland Museum of California; Dennis Szakacs and Elizabeth Armstrong at the Orange County Museum of Art, Newport Beach, California; Anne d'Harnoncourt and Michael Taylor at the Philadelphia Museum of Art; Brian Ferriso and James Peck at the Philbrook Museum of Art, Tulsa; Jay Gates and Eliza Rathbone at the Phillips Collection, Washington, D.C.; John E. Buchanan, Jr., and Bruce Guenther at the Portland Art Museum, Oregon; Dennis Reed; Tom Denenberg at Reynolda House Museum of American Art, Winston-Salem, North Carolina; Neal Benezra, Sandra Phillips, and Janet Bishop at the San Francisco Museum of Modern Art; Theodore P. Shen; Alice C. Simkins; Andrew Smith, Claire Lozier, and John Boland, Santa Fe; Elizabeth Broun and Eleanor Jones Harvey at the Smithsonian American Art Museum, Washington, D.C.; Charles R. Loving and Dean Porter at the Snite Museum of Art, University of Notre Dame, Indiana; Naomi Lyons and Jeremy Cox at the Frederick and Frances Sommer Foundation, Arizona; Ira Spanierman and Lisa Peters at Spanierman Gallery, LLC, New York; Phillip C. Long and Lynne Ambrosini at the Taft Museum of Art, Cincinnati; Kevin E. Cosney, Lucinda Barnes, and Lisa Calden at the University of California, Berkeley Art Museum; James C. Anderson and Amy Purcell at the University of Louisville Photographic Archives, Ekstrom Library, Kentucky; Linda Bahm and Michele Penhall at the University of New Mexico Art Museum, Albuquerque; Willard Holmes and Elizabeth Mankin Kornhauser at the Wadsworth Atheneum Museum of Art, Hartford, Connecticut; Lyndel King at the Frederick R. Weisman Art Museum at the University of Minnesota, Minneapolis; Margaret M. Weston and the Weston Gallery, Carmel, California; Adam Weinberg and Barbara Haskell at the Whitney Museum of American Art, New York; Sylvia Kennick Brown at Williams College Library, Williamstown, Massachusetts; Michael G. Wilson, Jane Wilson, and Violet Hamilton at the Wilson Centre for Photography; Wallace and Isabel Wilson; and Jock Reynolds and Jennifer Gross at the Yale University Art Gallery, New Haven. I also thank the private collectors who wish to remain anonymous as lenders.

I have benefited enormously from the following curators, professors, collectors, librarians, archivists, dealers, National Park Service staff members, and individuals: Mary Alinder, Liz Argentieri, Chuck Bancroft, Keith Basso, Nancy Boas, Ani Boyajian, Betty Bustos, Bill Camfield, Christopher Cardozo, Elizabeth Chew, Earl Davis, Michael Dawson, David Dethier, Charles Eldredge, David Fross, Steve Good, Denise Gosé, James Goss, Michael Grauer, John Hagood, Kathleen Haldeman, Peter Hassrick, Lyn Hopkins, Toby Jurovics, Patricia Junker, KeeChee, Robin Kelsey, Susan Larkin, Janet Lehr, Jason McCoy and Stephen Cadwalader, Maureen McKenna, Cary McStay, Chris Magoc, Malcolm Margolin, Tom Mayes, Anthony Montoya, James Moore, Christine Morgan, Gregory Most, Ruben Naranja, Francis Naumann,

Eric Paddock, Martha Parrish and James Reinish, Tom Petrie, Caroline K. Quenemoen, Carole Reynolds, Paula Rivera, Susan Seyl, George T. M. Shackelford, Scott Shields, Will South, Kaye Spilker, Robert Steavey, Mark Sublette, Myron Vallier, Andrew Walker, Douglas Walla, Lee H. Whittlesey, Eric Widing, Bryan Williams, Clint Willour, Reinhard Wobus, Daniel Wolf and Charles Isaacs, Timothy Wride, Paul Zaenger, and Kate Ziegler.

At the Museum of Fine Arts, Houston, several colleagues helped shape the exhibition and assisted with loans in significant ways. Anne Wilkes Tucker, The Gus and Lyndall Wortham Curator of Photography, and Alison de Lima Greene, curator of contemporary art and special projects, went far beyond the call of duty as colleagues, friends, and advisers. At various stages of the project I was expertly assisted by Kaylin H. Weber, Irene Trevor, and Melina Kervandjian, as well as by G. Clifford Edwards, who compiled the catalogue's bibliography. Special thanks go to then-associate director of development Margaret C. Skidmore, who faithfully supported the exhibition from its inception. I would also like to thank Gwendolyn H. Goffe, Paul Johnson, Beth B. Schneider, Margaret Mims, Victoria Ramirez, Andrew Huang, Michael K. Brown, Frances Carter Stephens, Marian Luntz, Katherine Howe, Christine Starkman, Cindi Strauss, Amy Purvis, Tammy Largent, Kathy Kelley, Marisa Sánchez, and Christine Gervais. A special salute goes to my colleagues in conservation: Wynne Phelan, Andrea di Bagno, Toshiaki Koseki, Maite Leal, Bert Samples, and Tina Tan. Del Zogg offered expertise and assistance in the Print Room, and Brooke Barclay managed framing. For their help with handling registraral and

administrative affairs, I thank Karen B. Vetter, Julie Bakke, Kathleen Crain, Michael Kennaugh, Richard Hinson, and the superb preparations staff. Designers Jack Eby and Bill Cochrane are responsible for the exhibition's design, and Phenon Finley-Smiley created its graphics. In the Hirsch Library, Margaret Culbertson, Jon Evans, and Margaret Ford were especially responsive. Past interns and researchers who made significant contributions include Kate Ballou, Melina Kervandjian, Rowena Houghton Dasch, Lynn Wexler, Andreea Mihalache, Amy Sullivan, Linh Dan Do, Miri Kim, and Elisabeth Papadopoulos.

We also salute our friends and colleagues at the Los Angeles County Museum of Art, the second venue of the exhibition and an important lender. Then-director Andrea Rich enthusiastically agreed to present the exhibition and incoming director Michael Govan graciously extended LACMA's continuing support. Bruce Robertson, chief curator of American art; Austen Bailly, assistant curator; Ilene Susan Fort, curator; and Irene Martín, assistant director, exhibition programs, were model colleagues.

This book would not have happened without the expertise and high level of professionalism in the MFAH publications department. Publications Director Diane Lovejoy deserves special mention for her skillful editing and sensitivity as she shepherded the manuscript through its various drafts with goodwill and humor. Heather Brand, Kem Schultz, Linda Wells, and Marcia K. Stein also made significant contributions to the book through editing and proofreading the manuscript, securing copyright and reproduction rights, gathering images, and developing content for the exhibition microsite on mfah.org. At Yale University Press, I would like to thank Patricia Fidler, publisher, art and architecture; John Long, assistant production coordinator; Mary Mayer, production manager; and Kate Zanzucchi, senior production editor, art books, as well as freelance copyeditor Janet Wilson, proofreader June Cuffner, indexer Catherine Dorsey, and designer Daphne Geismar.

As always, I should provide the caveat that any misstatements or errors of research or judgment are my own and do not reflect the extraordinary kindness of all the people listed above.

As has been the case in my previous books, this one is dedicated to my immediate and extended family, especially my husband, Richard, and my mother, Iris, who often shared the journey, and my late father, Bill Ballew. I'd like to single out for special acknowledgment, with love, pride and, above all, gratitude, my sons Dickie and Will. At a young age, they are already intrepid and observant place-makers, whether in the White Mountains of New Hampshire, the Sangre de Cristo Mountains of northern New Mexico, or the prairie grasslands of Burleson County, Texas.

Out West
BARRY LOPEZ

THE MASSACRES

In the early 1970s I began to take an interest in the Nez Perce retreat, an effort by this Oregon band of Sahaptin people to reach political asylum in Canada in the summer of 1877. Before they were cornered at an abbreviated range of low hills in north-central Montana, north of the Bears Paw Mountains, an emotionally exhausted and spiritually devastated group of families—they'd left their ancestral lands in the Wallowa Mountains three months before—the Nez Perce had fought off a pursuing U.S. Cavalry force in several skirmishes. As frequently occurs when I begin researching such a subject, I developed a keen interest in visiting some of those sites. Even the most meticulous history of such events, I had found, tends to be deskbound; the why and wherefore of what occurred often become more obvious (and less confabulated) when the real ground, the actual location, becomes a part of what one knows.

Accordingly, on June 17, 1973, I began at White Bird Canyon in western Idaho, the site of the first lethal encounter of the retreat. (Despite the Nez Perce's intent to leave the United States peacefully, historians routinely refer to what happened as the Nez Perce War.) My plan was to camp at this and subsequent sites—at Camas Prairie and Clearwater in Idaho and at Big Hole, Montana—during the same hours of the solar year in which the killings had taken place. I would begin at White Bird Canyon, visit the others in the coming years as I could, then travel to the Bears Paw in 1977, planning to arrive on October 4, the centennial eve of the last killings and the Nez Perce surrender.

Readers of nineteenth-century American Indian history would rightly regard this as a quick sketch presented from the Nez Perce, or Nimiipuu, point of view, and know I was passing over contradictions and complexities. My interest here, though, is not history so much as it is those who write the histories upon which we so often stake our political and spiritual lives. (Irritating to many historians today is the charge that when it comes to defining such encounters, Native American versions are routinely dismissed by scholars as "unorthodox.") My further interest—and what would compel other visits to fatal-encounter sites in the United States in the years after this—is the role the land itself played in these histories. I don't mean solely issues of tactics, weather conditions, or the position and angle of the sun on a particular day, but what might be learned from a people forced to unravel from their homeland, to abandon an integration with place that would strike many of us in the United States in the twenty-first century as bizarre, were we not so concerned with being respectful.

One further thing was always on my mind during the days I made my visits: the intractable problem of what one remembers. Who now recalls what happened during those years of warfare? And how does forgetfulness work in the service of illusions of national destiny?

I was recently in Germany. In Berlin I visited three times in one week a new work by Peter Eisenman, his Memorial to the Murdered Jews of Europe—an entire city block turned into something approaching a Dantean ring of Hell, an architecture that simultaneously evokes the Warsaw Ghetto, a morgue, and George Orwell's *1984*. Like many compelling

three-dimensional works, the monument is simple to the point of being reductive, but it draws very strongly on the fourth dimension, on time, the multifaceted antecedents that we call history; it cannot be entirely fathomed, in fact, without the aid of memory. What one has read, whatever one might have seen around the world of the iconography and tools of genocide, whatever images of madness and cruelty one has encountered in a museum—Francisco de Goya, Käthe Kollwitz, Leon Golub—come into play. Because it is a work of genius, however, at least in my mind, memory merely intensifies, to an almost unbearable degree, what such a monument already conveys with its lines, its volumes, its textures, its absence of color.

I thought about Eisenman's work for weeks afterward, what it is doing for the German people by way of catharsis. There is, of course, no such public work to memorialize what happened to Indians in the United States. We have built a Holocaust museum in Washington, D.C., but no monument to acknowledge responsibility for actions many American citizens today might be distressed, or even outraged, to hear called an American genocide.

For the majority of citizens in the United States, the Indian has vanished. Or, to use a euphemism of the twentieth century, the Indian has been assimilated, an idea that would raise a few eyebrows in 2006 at Oraibi, at Huslia, Tsaile, and Onondaga. The nation, firm in the conviction that Indian people have disappeared, that this is all in the past and requires no review, remains steadfastly focused on "moving forward."

I grew up steeped in works of fine art set out for the edification and appreciation of visitors to the Metropolitan Museum of Art, MoMA, the Frick, the Cloisters, and New York's other museums. Sanctuaries, temples of meaning, portals of history—I've not known a diminishment of the adolescent enthusiasm I first brought to those places, and with which, each time, I walked away. It's simply a more refined reverence now, I hope. (In all the countries I've been able to travel to it's been my custom not only to try to visit that culture's museums, the obscure along with the touted, but to carry with me afterward postcard reproductions of the work on display—images of what others have preserved as beautiful or inspiring.) Over the years, of course, the display of art and the popularity of styles in America have changed. Under the influence of Modernism's and then post-Modernism's protocols (to use probably more word than is called for), some

things I had come to trust in art—the concept of place, for example, that inapprehensible and profound sensation of being present at one spot only—were marginalized. Though I had read, and for a brief time even studied, enough quantum mechanics to be wary of absolutes, of categorical assertions, I also rued the diminished importance of empiricism in modern art. Post-Modernism, as I understood the school, preferred the imagination to the senses and took Modernism's mistrust of the past, its argument with Western tradition, a step further, finally coming to trust only the tradition of the self.

My personal misgivings about Modernism's evaluations and its influence count, certainly, for very little. I've no elaborated theory, no reevaluated social history with which to pose an argument with Modernism. I have, for my purposes here, however, two relevant thoughts. What kind of governance is apt to arise among us as a people if specificity of place is unimportant, and if empirical witness is no more to be trusted than a flight of imagination?

In the decades after that October night I spent asleep on the Nez Perce encounter ground north of the Bears Paw in Montana, I visited, whenever the opportunity arose, many of the western battle and massacre sites of the American Indian wars (injustices that, like the Punic Wars, for instance, came to be named for a menace "rightfully" defeated). The battle sites—Beecher Island (1868), Lava Beds (1873), Little Big Horn (1876)—were fewer than the massacre sites—Bear River (1863), Sand Creek (1864), Washita (1868), Tule Canyon (1874), Wounded Knee (1890). At Tule Canyon, Texas, having burned the homes, winter food stores, and clothing of hundreds of Southern Cheyenne, Kiowa, and Comanche people wintering at nearby Palo Duro Canyon, Col. Randal Mackenzie ordered his troopers to shoot eleven hundred Indian horses and mules he had captured and cordoned off in a box canyon. Some of the tightly bunched animals took days to die. For sixty-two years they lay where they fell that September morning. At Sand Creek, Colorado, a Methodist minister, Col. John Chivington, led a similar raid at dawn against another group of unsuspecting people, mostly Southern Cheyenne, who, in addition to having raised a thirty-five-star American flag, were camped under a white flag of truce. What happened at Bear River, Idaho, on January 29, 1863, is the least publicized and, for the number of human beings killed, the greatest of the western massacres. A freelancing group of California

Volunteers, thwarted in their attempt to join in the Civil War, attacked a winter village of Northern Shoshone and without cause killed more than three hundred people. Their leader, Col. Edward Connor, wrote in his official report of the essential need generally to "chastise" Indian people for their way of life.

Where is the art to help us deal with these actions and with the long silence that persists? Is what has been offered so far, mostly by Native American artists, so offensive to the nation's sense of self, so inconsequential when put up against the mythology of a chosen people, that it can't be accommodated? The Mexican novelist Carlos Fuentes once wrote that it was impossible for his country and the United States to have a productive conversation. Mexico, he said, is so burdened by its past it cannot easily imagine a future. The United States, he said, is so intent on imagining its future it isn't troubled by rewriting its past to serve that future.

What of the present? What is there in contemporary art for those who, offered Destiny's Eden, cannot relax their suspicions about its foundations?

Standing or walking the slaughter grounds I traveled to—astonishing, really, how infrequently I encountered another human being at these places—I could not quite make the leap to a resolution from the horror of what had happened. All my life, to be free of dejection and pessimism about the imperfections of my own culture, I've read poets of the past and of my own generation, listened to Bach's B Minor Mass and his cello suites, and recalled Vermeers in the Frick Collection, but the distance from Tule Canyon and Bear River to Bach's Leipzig or Zagajewski's Paris is very great.

As a longtime resident of the rural West, I can easily imagine that a concern about the killing of Indian people, let alone a disturbance of this old and suppurating wound, might be viewed as a regional, even an unseemly, affliction. But in this celebratory year (2006) of the Corps of Discovery's journey west and back, one is compelled to come face-to-face with the violent ghost history of Manifest Destiny, the kind of nineteenth-century assertions of rightful ownership and of racial and cultural superiority that would lead an unrepentant Edward Connor to take pride in his chastisements. The haunting figure in that 1803–6 expedition, because the memory of him will not completely quit the national conscience, no matter how often he is written off—a drunk, a manic-depressive, a man done in by the burden of responsibility—is Meriwether

Lewis. Expedition enthusiasts who seek to explain his violent death usually choose one of two competing theories. When he died in his room at an isolated inn on the Natchez Trace, fifty-some miles from Nashville, Tennessee, on October 11, 1809, he was the victim of either murder or suicide. Murdered, one theory goes, because he was traveling to Washington with papers that would have compromised people in the federal government jockeying to profit personally from 828,000 square miles of western real estate, the windfall of the Louisiana Purchase; or a suicide because he could not drink himself sufficiently into oblivion over the contradictions in Mr. Jefferson's dreams of democracy. (Lewis, who had served Jefferson as his chief of staff for eighteen months, was in thrall to his interpretation of Enlightenment ideals.)

In support of the latter argument, one might imagine the blow Lewis sustained when he came to realize that the peoples he had encountered, as different in their epistemologies as the landscapes in which he found them, were not to be included in Mr. Jefferson's democracy, that the Mandan, the Assiniboine, the Nez Perce, the Cayuse, and the Chinook were to be swept away, like the Yamasee, the Mahican, the Nanticoke, and the Powhatan before them. As governor of the Louisiana Territory, meeting daily with his constituents in St. Louis, he was familiar with the nature of the first wave of citizens who wished to take over for the Lakota in the Black Hills, for the Pawnee on the Platte. They were a class of men most American historians, until recently, have worked tirelessly to clean up but who have come down to us looking as feverish and ruthless after wealth as the conquistadores, men largely unmodulated by family life and lawless where the law was an inconvenience.

It is easy to imagine that in the three years between his return from the Pacific and that October night at Grinder's Inn, Lewis lost faith with the ideals of the Republic, and that Jefferson, by then, couldn't afford, or didn't want, to hear his complaint.

One day late in the spring of 2005 I walked the Cheyenne massacre site on the Washita River in western Oklahoma. On the morning of November 27, 1868, Lt. Col. George Armstrong Custer led four cavalry battalions in a surprise attack on a small encampment of Southern Cheyenne overwintering in the Washita bottoms (from *owa*, big, and *chito*, hunt, two Choctaw words, also anglicized as Ouachita). The isolated

village of about fifty lodges was the farthest west outlier of a gathering of some four to six thousand Cheyenne, Arapahoe, Kiowa, Comanche, and Plains Apache settled farther downstream. Custer's men killed the Cheyenne chief Black Kettle that morning (it was from a lodge pole of this man's tepee that the white flag had flown four years before at Sand Creek), also twelve other men, sixteen women, and nine children. In a hurry to depart with his force of eight hundred soldiers before the downstream camps were alerted, Custer still took time to savage the Cheyenne horses and mules in accordance with a military objective of the time, to deprive Indians of mobility. His troopers shot and cut the throats of about 875 animals and fled.

As I walked that afternoon—a child could pitch a stone to the far bank of the river, a man wade across without wetting his waist—I imagined no scene of redress, did not even think of blame. I was overcome by the immediacy of the place, the cemetery peace. Even though I would later come to feel that an understanding of the particulars of incidents like this was crucial to the nation's sense of identity, early on even I, curious and earnest as I was, knew little of Washita, even its whereabouts.

Walking the bottom lands, I came upon badger holes and coyote scat, stopped to gaze at bright yellow patches of prairie coneflower and clusters of white blooms on plains yucca stalks rocking and nodding in a light wind. Overhead, two Mississippi kites courted. Away on the hills to the north black Angus grazed. A few fair-weather clouds drifted in a milk-blue sky. The calls of male bobwhites pierced the warm air lying over the wooded flats.

If someone were to paint this place as it stands today, or to paint the history of that morning in this place, were to translate the acuity of his own senses, the emotional currents these sensations released in conversation with these very coneflowers, the discovered fate of Black Kettle, the silt-burdened Washita, the stray chips of horse bone still lying dull in the sunlight, would we turn our backs because it struck us as too representational, too sentimental, too western?

THE COUNTRY IN WINTER

When I was in my twenties and thirties, I regularly drove thousands of miles across the western United States. I slept in my truck or, if the weather was good, on the ground. I believed if I could actually see a location such as Teapot Dome,

Wyoming, or drive the east-west intergrade between short-grass prairie and tallgrass prairie in Kansas, I would be a better reader of the literature of the West, not to say its history. (Teapot Dome, thirty miles north of Casper, was the site of an oil field leased without competitive bidding by Warren Harding's corrupt secretary of the interior, Albert Fall, to an equally corrupt oil operator, Harry Sinclair, in 1922.) Among the books I was thinking about were Ole Rølvaag's *Giants in the Earth*, Frank Waters's *The Man Who Killed the Deer*, Wallace Stegner's *Angle of Repose*, Willa Cather's *My Ántonia*, and Ken Kesey's *Sometimes a Great Notion*. I carried them with me like another set of road maps, reading them in the evening along with works of history and anthropology.

In 1979 John Unruh published a landmark work of revisionist western history, *The Plains Across: The Overland Emigrants and the Trans-Mississippi West, 1840–60*, carefully dismantling the foundations for an entrenched American belief in God-blessed pioneers besieged by rapacious Indians during the westward movement, a folklore imposed on the West later by Hollywood and by many writers of pulp westerns. Unruh's work opened the door for writers as diverse as Annette Kolodny (*The Lay of the Land*) and Cormac McCarthy (*Blood Meridian*) to elucidate western history from perspectives less romantic, less racist, less colonial. I felt as if I were living through a period of revolt in those years, one almost unheralded, a time when geography was making its way back into history, and when the genocidal origins of the nation might be brought up in conversation without apprehension. And when corporate attempts to gain control over the West's natural resources—timber, water, grazing land, and minerals—might actually be addressed on ethical as well as economic grounds. The novelist and historian Wallace Stegner, mentor at Stanford to a remarkable group of writers—Wendell Berry, Larry McMurtry, Robert Stone, Tillie Olsen, Ken Kesey—was a major force in this revisionist movement, a broad-based effort by writers, artists, and humanists to throw off definitions long imposed on it by outsiders and to propose in their stead another set of definitions, ones truer to the actual place. (In the only area of the visual arts with which I have more than a passing acquaintance—photography—I saw the sensibility emerge early in the work of Robert Adams [*To Make It Home*] and continue through people like Richard Misrach [*Bravo 20: The Bombing of the American West*] and Mary Peck [*Away Out Over Everything*].)

When I learned that *The Modern West: American Landscapes, 1890–1950* was being organized at the Museum of Fine Arts, Houston, and received a letter from the exhibition's curator, Emily Ballew Neff, asking for some thoughts about the show, I was eager right away to look at what she was bringing together. Also somewhat nonplussed. I'd no credentials as a western historian (let alone an art historian), no expertise, as I saw it, to offer. I had enthusiasm, respect. Wonder. A longtime interest in the work of such people as Laura Gilpin, Maynard Dixon, Ansel Adams, and Alexandre Hogue, partly because their kinds of realism had gotten such a cold reception from critics who thought that western realism was too illustrative, in general, to be considered fine art. (In that way, Dixon and Hogue seemed to share the fate of Rockwell Kent.)

I knew very little, really, about what Ms. Neff was trying to say with the show, or about the West that was her West, but when I saw the paintings and photographs she had assembled, I recognized in the groupings many of my own concerns about western art, particularly the struggle in the nineteenth century to impose lines on volumes of space unfamiliar to the European imagination, the conceptual and technical effort it took to bring together the very far away and the intimate nearby when they were not connected by conventional human culture, by farming and roads. I saw the weird shimmer, too, of *toujours une étrangère*, the artist-observer's deepening awareness that he or she was not a resident of what he or she depicted. The geography of a place initiates these misgivings about belonging, and they are intensified by a growing awareness that the mythos most of us were born to, the early gyroscopes of our cultural psyche, does not fit here, and, further, that those myths that do fit have nearly been eradicated by cultural and religious zealotry. I also recognized in Ms. Neff's selections the ruptured bosom of the western earth—in Alexandre Hogue and Thomas Hart Benton, in Dorothea Lange and Arthur Rothstein—all of them forcing the irritating question that those politicians compulsively traveling on a folklore of unique American genius and rectitude would rather not see raised: Is this what we want? Is there something deeper in Lange's and Hogue's images than failed husbandry?

The culminating images in the show brought a new perception into focus for me. It was one thing to find in western painting and photography from this period a reading of the West's contours, a rendering of its geography that suggested an alternative to urban blight and haste, a refuge from wheedling advertising and commerce, a dream world of Rousseauian ideals. It was another to see in these images a lament, the kind of lament that lies within the foundation of Rainer Maria Rilke's *Duino Elegies*, that we are still so far from where we wish to be as a people. The approach taken to our dilemma in this show, it seemed to me, made the following assumption. In order to serve Progress, it has been necessary for us actively to refute the assertion of indigenous North American cultures that the land is sentient. The artists' recognition in *The Modern West*, then, of a spiritual dimension to western space leads us to consider that this refutation might be perilous. If place is stripped of geography, and if geography is stripped of spirit, any destructive scheme for profit will fly. The ghost towns, tailings piles, clear-cuts, emptied lakes, bomb craters, and devastated working lives of the West tell us this is so.

When I stepped away from the first sight of Ms. Neff's images, my thoughts were far more vaporous than this observation suggests. The ideas foremost in my mind then were about the West's all but incomprehensible spaciousness, and the suggestions in some of the paintings of places I thought I recognized. The paintings and photographs made me want to return to the road, to travel again as I had years before, to drive across the West and refamiliarize myself with it. With little more thought than that, I decided to go. I wrote a few particulars into my plan: I wanted to see Georgia O'Keeffe's White Place and her Black Place; El Morro National Monument (the site of Timothy O'Sullivan's Inscription Rock photograph, the most literal image in the show); Carson Sink in Nevada; and the convergence of the Comanche, Rita Blanca, and Kiowa national grasslands in panhandle Texas, southeastern Colorado, panhandle Oklahoma, and northeastern New Mexico. I'd never seen these places. And I wanted to return to some geographies that had long been touchstones—Jackson Hole, Wyoming; Taos, New Mexico; Canyon de Chelly ("canyon of the canyon"—*chelly* is a French corruption of the Navajo for canyon, *tsegi*).

I got out some books to refresh my mind: Stephen Pyne's *How the Canyon Became Grand*, his story of how that Colorado River canyon got its adjective, and Gary Witherspoon's *Language and Art in the Navajo Universe*. Witherspoon says that the aim of all Navajo art is the creation,

maintenance, and restoration of *hózhó*, which he translates as "beauty," and that for the Navajo, beauty is not about perception, is not in the eye of the beholder, but is the outcome of the artist's relationship to the world. The creation of beauty is simultaneously intellectual (the creation, maintenance, and restoration of order), emotional (of happiness), moral (of good), aesthetic (of balance and harmony), and biological (of health). Art is integral to life, and *hózhó*, distinctly different from Aristotle's "beauty," is the goal of art—and life. Witherspoon's long effort has been to comprehend "the frame of meaning in which other people move." Another anthropologist who has done this brilliantly among the Western Apache is Keith Basso, whose *Wisdom Sits in Places*, a cultural and spiritual geography, I had long wanted an opportunity to read.

As important to me as any of this remembering and self-tutoring was choosing to make the journey in winter. I wanted to see the land obscured by weather, see it covered over with snow, its colors muted, its edges rounded, its plants quiescent. Watching someone you love asleep is what I thought.

I drove for several weeks, speaking to no one but strangers. I had laid out a general route that I knew winter storms would force me to change. What I wanted more than meaning was experience. I wanted to sense the magic within the real in the untenanted West, where on a day's drive one might easily see from the public roads a hundred times as many wild animals as people—jackrabbits, coyotes, golden eagles rising in thermals, herds of pronghorn antelope, flocks of juncos and other small birds fleeing the roadside, wild horses grazing bunchgrasses, porcupines ambling.

I made notes daily, not toward any particular goal but because, like others, I forget the details of experience. I retain only a general impression, which contributes to a general sense of placelessness, which itself seems to have become part of the nature of reality for us. I remember, then, noting more than a hundred pieces of abandoned farm machinery; walking the still unmarked massacre site at Sand Creek listening to killdeer and coyotes; and walking away from FM (farm to market) 296 in Dallam County, Texas, a mile across the shortgrass prairie, the wind whistling and booming against the sheaves of it, a sound like tin roofing lifting and dropping. And in southeastern Nevada using the map dividers to determine that a two-lane highway stretching away from me to a spot where it pinched out in a climbing turn at the foot of a

mountain, a road straight as laborers could make it, was 15.2 miles long, the end of it no wider than the pencil point I was holding up.

Winter subdued every landscape. Near Deer Lodge, Montana, and later east of Quemado, New Mexico, I could barely hold the road in snowstorms I had to give up fighting; the weather, for that season, was mostly fine though. The bitterness of the wind on my bare ears at some points—at O'Keeffe's White Place, at Sand Creek—sharpened the melancholy. Traffic, in a geography thick with tourists in summer, was largely absent. The land was still and bloomless, skeletal but not dead. Not empty.

I found O'Keeffe's (and Eliot Porter's) Black Place along a stretch of US 550 east of Counselor, New Mexico. I don't know what I expected—preservation of some sort. An honoring. But like her White Place a few miles from Ghost Ranch, it, too, is an abused place, crowded with a consumptive culture's jetsam: empty beer cans, plastic ice bags, cigarette filters, tire rind, candy wrappers, fast-food cartons, torn medicine packets, broken electronic gadgets, spent matches, empty water bottles. (Around her White Place, not so hard by a paved road, visitors have left various large and small targets demolished by gunfire, the derelict carcasses of house furniture set on fire, drained whiskey bottles, and scraps of clothing.)

Though I was able to locate it, I could not *see* the place Porter photographed in 1945 and that O'Keeffe had painted the year before. It is half a fool's errand trying to match even highly representational art to a particular place; art's purpose in the cultural West has been to create *symbols* of emotion and thought. You cannot, in this narrow sense, lament the demise of the model. And, after all, many of the paintings in *The Modern West* are composites—Frederic Remington's *Fight for the Water Hole*, N. C. Wyeth's *Moving Camp*, and a dozen others. But somewhere in the filaments that bind place to art it is disturbing to note the passing of an empirical authority—the actual thing—that, once the artist became intimate with it (or afterward with the memory of it), compelled the work of art.

Before leaving on my orientation trip, I'd written down some notes about coal-fired power plants in the West. In seeking out the atmosphere, literally, that might have engendered some of the images in the show, I knew I no longer had available to me the same "open curtains," the same transparency.

Grand Canyon is periodically shrouded in Los Angeles's pallid air; the Four Corners country is blighted by exhaust from a coal-fired energy complex nearby. In the winter of 2004–5, new coal-fired power plants, thirty-two of them, were on the drawing boards in nine of the eleven western states. (Oregon and Washington had none. If you included the tier of states adjacent to the east, from North Dakota to Texas, the total number of plants was forty-eight.)

I tried to break my travels each day by hiking away from the truck, down into the draws, up the arroyos, into the foothills, across the playas, into the gallery forests of Frémont cottonwoods along the creeks, the bird-sheltering bosques. I would bring my binoculars, find a place out of the wind, and pick over the land, acre by acre, watching for movement. The creation of a painting or museum-quality photographic print requires an analogous kind of concentration, unusual in our lives now. To consider this is to see how subsumed the longer rhythms of human life have become in the cultural West, and to renew a perception of how art, itself a record of human concentration, can restore an awareness of those rhythms. We've become, it seems to me, a chronically distracted people, yearning to be relieved of the misgivings and anxiety we feel, thinking we no longer have time to go deep. We doubt the relief claimed for the manufactured products we're told will help. In some basic way, we've come to doubt our culture.

When I caught movement through my binoculars, animation suddenly mixed into the pastels of a sage flat or across the chiaroscuro of a snow patch-and-basalt scree, I responded with a quickening of the blood, like any animal. Concentration eventually reveals what at first was not apparent. It is as though the act of concentration itself draws out something latent, or, if time becomes a dimension like width, something that was there all along.

The country in winter, like a painting hung on a wall in a museum's quietest room, invites participation in the artist's concentration, which can take you as deep as you feel safe to go into a "frame of meaning" in which another person moves, someone with whom you share a heritage and the pursuit of a cultural identity.

On leaving some of the isolated landscapes I tried so hard to observe, I often sharply sensed that I remained a stranger there, and that I would always. Still, I'd leave with the stranger's ardent wish after experiencing such numinous events, the traveler's insistent plea: Don't forget me.

THE MUSEUM ROOM, HOUSTON, TEXAS

I did not want the trip to be over, so on what I knew to be my last day I drove north from Nevada into Oregon through a front of snow squalls moving away to the southeast, crossed the Malheur Basin, came around the north flank of the Sheepshead Mountains and through the town of Burns, and a few miles farther west turned north on the road to the Bureau of Land Management's wild-horse corrals.

The storm was distant in the south by then; the snow-less skies here were decked gray and grayer with cumulo-nimbus, like sheets of construction paper torn across the grain. It was mid-morning, a January Sunday. Two cowboys were haying and graining horses from the back of a pickup moving through a warren of abutted corrals, the horses separated according to sex. They were feral and never-ridden beings of every color and genetic background, the majority of them sorrels, browns, grays, roans, and claybanks. A few showed the characteristics of Spanish mustangs; other bloodlines included saddle horses, thoroughbreds, and draft horses. Two feet of snow on the ground, the ground hard, the snow packed hard in the corrals. They had recently been brought in off open ranges in eastern Oregon, from some of the BLM's federal Horse Management Areas: Paisley Desert, Stinkingwater, Palomino Buttes, Murders Creek. When I climbed the fence boards to get a better look across the checkerboard of corrals and let my head clear the last of the close-set rails, the horses, their nostrils flaring, spooked, bolted, and halted. We were a long ways here from *haute école*.

I watched the bewildered hundred and fifty of them, mestizo creatures, their lower lips newly tattooed with purple numbers, their future no longer their own, their meaning no longer theirs to define, until I was too cold to sit the fences and the cowboys were ready to be gone.

The last leg of the journey, crossing the high desert for the Cascade Mountains and home, I thought how, between those beachhead days at Plymouth Rock and Jamestown and now, we'd lost a sense of geographical vastness, of the unique and inaccessible, the too far. What was once vast we have now reduced to patterns of swift movement so ingrained, so routine, that much of the land's guiding specificity has fallen away. We move quickly now, through a country very different from the one that William Henry Jackson saw, that Marsden Hartley painted,

that D. H. Lawrence wrote about, and one as different from the country known to Bear's Heart, Pylen Hanaweaka, Julian Martinez, and Riley Sunrise as the Carolinas are from the Dakotas.

Alexandre Hogue (1898–1994) is perhaps best known for his *Erosion* series of paintings, one of which, *Erosions No. 2, Mother Earth Laid Bare*, is included in this exhibition. According to Lea Rosson DeLong in her biography of the artist, *Nature's Forms/Nature's Forces: The Art of Alexandre Hogue*, he "has wrongfully been identified with the Midwestern Regionalists who idealized the agrarian life and values and viewed rural America as the repository of the best American values." Something powerful, it had long seemed to me, even bridging, was at work in some of Hogue's images. He painted like a man at once intimately familiar with the literalness of machinery—employing a draftsman's eye—and like someone driven by second sight. The spiritual dimensions of landscape clearly were evident to him.

Curious about the history of *Erosions No. 2, Mother Earth Laid Bare*, I went one day to the Philbrook Museum in Tulsa, Oklahoma, to look at the charcoal and pencil sketches he'd made in 1926, 1928, and 1932, leading up to the oil painting of 1938. The sketches show a progression. From a spectral presence in 1926, the woman in the painting becomes increasingly more apparent, a bolder, starker being. The sketches recall two statements DeLong makes in her biography. Hogue, she writes, was imbued from childhood with the sense of "a great female figure under the ground everywhere." And "Hogue believed the understanding of nature and the understanding of art go hand in hand."

When set against the reveries of some twentieth-century western landscapes, Hogue's paintings, like those of Wood and Benton, bring us up short with their visions of forsaken machines and consuming and corrosive technologies. In *Pulliam Bluffs, Chisos Mountains* (1984), however, a painting from his *Big Bend* series (not in the show), Hogue uses fractal scaling to integrate reeling geographic space; he also creates a resonant middle ground, absent in many western landscape paintings. All his earlier work is here a palimpsest. It's a painting eerie in its parallels with the landscape painting of traditional Native Americans, trained later in life to a Western style, people coming at geography from another direction. In all this work the land is alive, unclaimed.

Hogue walked off the abused Texas landscape of his youth into some other, wholly different country, the habitat of his adult years.

The first time I saw a set of color-Xerox reproductions of the artwork assembled for this exhibition was in a windowless room in the Museum of Fine Arts, Houston. The images were pinned to two opposing walls, grouped according to the six sections Emily Ballew Neff had devised to structure the show. As I walked around the room, I noticed how many of the images were informed by crosses, from the ones on Lange's western churches to those in Ansel Adams's *Moonrise over Hernandez, New Mexico* cemetery, from William Henry Jackson's *Mountain of the Holy Cross, Colorado* to Morris Graves's *Memorial Day Wild Flower Bouquet in the Cemetery of an Abandoned Western Mining Town*. It could not have escaped the imagination of Indians coerced into one or another of the Christian religions that it was this very symbol of the church's authority (bearing, in this instance, copper wires) that was bringing to their universe the lightning-fast communications that were to stymie their last attempts to stay free of confinement, and that would later bring power to the industries that would desecrate the space upon which they had founded their own guiding and sustaining mythologies.

I marked, in that room that day, the terrifying communication between earth and sky I saw in Edward Weston's *White Sands, New Mexico*, the clouds racing, the sand abiding. Also the dead end in Maynard Dixon's *No Place to Go*. And how placeness disappears in Abstract Expressionism. How pervasive, deep, and unconscious, I thought that day, looking at all those images, is a cultural understanding of place, of geography. And how strikingly, how almost necessarily, is western space broken by a vertical line—the strange pole in Paul Strand's *The Dark Mountain, New Mexico*, the poles in Henry F. Farny's *The Song of the Talking Wire*, the woman in Laura Gilpin's *The Prairie*.

The last of these thoughts lingered for weeks, unfinished. Where it finally took me as I drove day after day across the West was to a realization of how deeply Europe's sense of identity was affected by the development of cathedral architecture, how profoundly this architecture had shifted a European understanding of interior space. Here in the West, I had now come to believe, was a long-running experiment in how to depict exterior space, to render a vast geography

that, since the survey photographers first went west in the 1860s, had not been so much plumbed as skirted. A new geography, made apparent in modern landscape art by incorporating duration of time, would mean a new American politics, at the least.

The work Emily Ballew Neff selected for the show seemed, during those first hours of my exposure, taken in the aggregate, like a chrysalis. What might we gain as a people if we were to reimagine what was, at one point, too vast either to imagine or render? It was with that thought that I turned out the lights in the windowless room and pulled the door shut behind me.

On Modern Ground

EMILY BALLEW NEFF

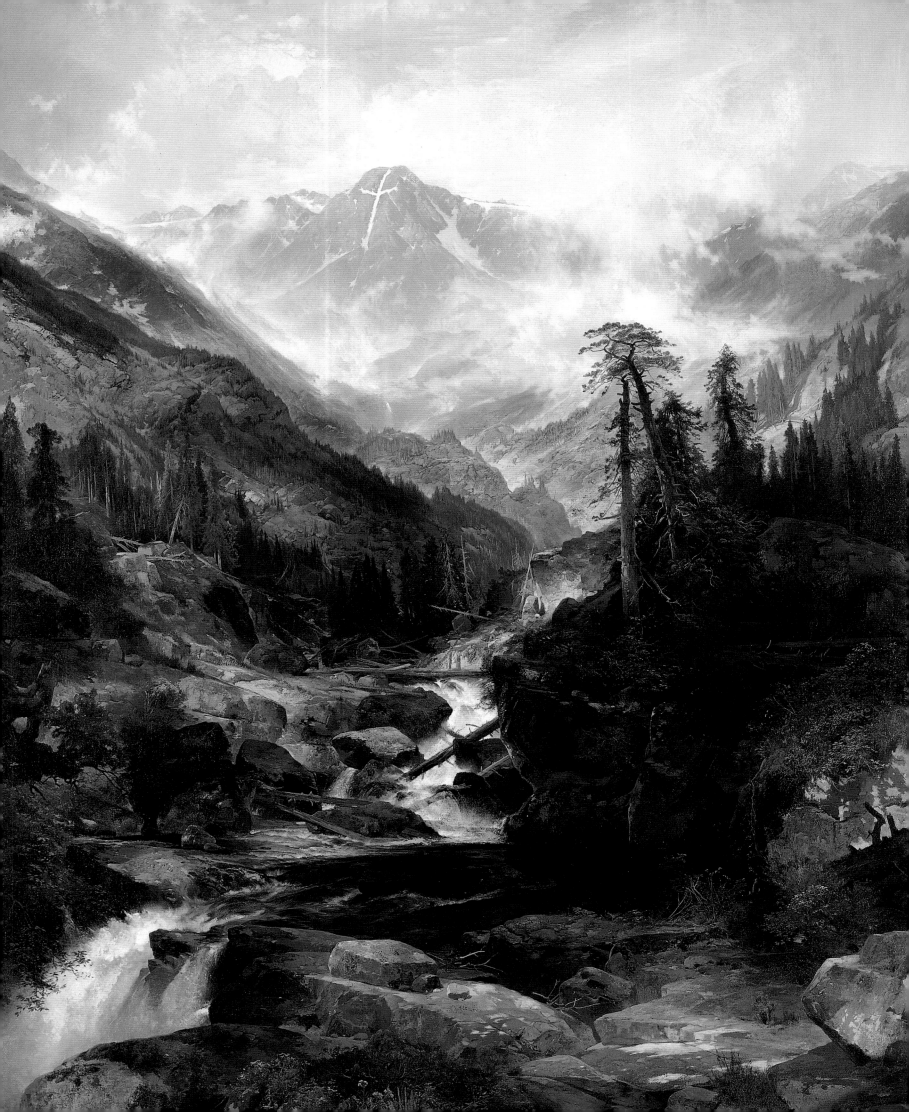

Prologue: Landmarking the West

HOW SPACES BECOME PLACES

"Until it has had a poet, a place is not a place," writer Wallace Stegner once claimed.[1] If true, then the Mountain of the Holy Cross, hidden in the Rocky Mountains, was not a place until it had as a poet Henry Wadsworth Longfellow. In 1879 Longfellow penned "The Cross of Snow," finding in this Colorado mountain—with its cross-patterned snow in its "sun-defying" crevasses—an apt metaphor for the eternal love he felt for his late wife. Never having set foot in the American West, much less seen the Mountain of the Holy Cross, Longfellow typified the nineteenth-century armchair traveler who, nourished by reports and images of distant, exotic climes, used them to make a metaphorical place in the mind and in the heart.

Western places have often served that poetic role, and still do. Rather than deny them their mythical power, we may seek to better understand their potency in American culture by examining the idea of place itself—"place" loosely defined as a space laden with meanings, or "centers of felt value," in the words of geographer Yi-Fu Tuan.[2] After all, the Mountain of the Holy Cross *is* a place, and before it had a poet, the mountain had a painter, and before that a photographer. All of these artistic endeavors—paintings, photographs, and poems—carve from inchoate space a concrete place. Tuan further explains the distinction between these concepts of space and place: "Open space has no trodden paths and signposts. It has no fixed pattern of established human meaning; it is like a blank sheet on which meaning may be imposed. Enclosed and humanized space is place. Compared to space, place is a calm center of established values. Human

beings require both space and place."[3] Or, as he writes, "Place is security, space is freedom: we are attached to one and long for the other."[4]

All landscape artists, it could be argued, make abstract, undifferentiated spaces into places endowed with a certain character and, in doing so, close the distance between the two concepts that Tuan describes. The story of the fabled Mountain of the Holy Cross—and the paintings and photographs that made it into a place—begins this particular journey of exploring the relationship of the American West to Modernism in the United States. Furthermore, the mountain serves as a landmark in two ways: it demonstrates how art, nature, and people define and transform places and, over time, re-create them anew, and it provides a point of departure for traveling across the West to memorable places made modern in artists' hands.

Landmark in all its meanings—signifying ownership, plotting and measuring to orient one's place in the world, and setting aside and preserving something culturally important—resonates throughout much of nineteenth-century American landscape painting and photography, particularly of the West. And no other nineteenth-century American painting suggests the richness of the word more than *Mountain of the Holy Cross* (1875), by the English-born American painter Thomas Moran (1837–1926; fig. 1).[5] For this is a painting about new territorial boundaries—those in the American West—and the country's willful destiny to command them; it is about a new, post–Civil War orientation, a national map carefully plotted to show both a personal and a national journey to western lands; and, finally, like other landmarks,

Fig. 1
THOMAS MORAN
Mountain of the Holy Cross, 1875
Oil on canvas, 82 1/8 x 64 1/4 in.
Museum of the American West Collection, Autry National Center, Los Angeles,
Donated by Mr. and Mrs. Gene Autry

Mountain of the Holy Cross was designated significant—the site itself and this painted image of it once embraced nationalism, science, religion, and art in a tangled mix not unlike the deadfall that abounds in the foreground of the painting.

About one hundred miles west of Denver and nestled within the rugged Sawatch Mountains, the site—a fourteen-thousand-foot-high peak with an eastern face displaying the pattern of a Latin cross in its snow-filled ravines—Santa Cruz, as it was reportedly known to earlier Spanish missionaries, eluded nineteenth-century Euro-American explorers of the Colorado Territory such as Zebulon Pike (in 1806), Stephen Long (in 1820), and John C. Frémont (in 1842). Even during the Colorado gold rush of 1859, the mysterious mountain peak remained a rumor.

The mountain was first documented in writing ten years later, in 1869, when journalist Samuel Bowles published *The Switzerland of America*, which, as its title suggests, employed booster language to promote western wonderlands as a counterbalance to then-prevalent perceptions of American cultural inferiority. In Bowles's mind, the Mountain of the Holy Cross was yet another example of how Americans, faced with vistas lacking the layers of human patina suggested by the castles and ruins of European antiquity, could derive continuity and a sense of security from the West's majestic, sublime wilderness and its perceived timelessness. American national identity had long been rooted in its landscape, which was promoted as a New Eden. Following a tradition of penetrating the untouched places of the American continent (one that disregarded the claims of the First Americans), Euro-Americans perceived the West as the last bastion of cherished hopes and dreams of a peaceful and bountiful land. Western lands were willed into sanctity and made sacred.

Writing about the Mountain of the Holy Cross, Bowles could make this concept literal. He identified the snowy cross from Gray's Peak, about forty miles away, and then set a nationalistic tone for its already legendary status: "It is as if God has set His sign, His seal, His promise there—a beacon upon the very center and height of the Continent to all its people and all its generations."[6] Mountain of the Holy Cross, in short, made visible Manifest Destiny, a phrase coined by New York journalist John O'Sullivan in 1845 (based on his earlier essays) to describe the mission of the United States to expand across the continent. Had there been any doubt that the country's purpose was territorial expansion, the religious nature of Victorian America—combined with a keen sense of national destiny—helped to dispel it. Mountain of the Holy Cross, Bowles claimed, was a visible guarantee that the country's right to expand was divine. Bowles claimed Euro-American ownership of the site and set the boundaries for how it would be understood and promoted for years to come, raising the stakes for the site's symbolic status. He was the first, at least in print, to capture the site and to affirm its significance.

For the Ute who had inhabited this mountain region for centuries, Mountain of the Holy Cross held no such marked importance. To be sure, the mountain's status was sacred inasmuch as it was part of a larger range, the source of the Ute origin story that places these mountains at the center of their universe and at the generative source of their very being. For the Ute, the Euro-American concept of "wilderness" had no place here. As historian James A. Goss has observed, "These mountains, from their point of view, weren't wilderness; this was their home. This view is that wilderness is natural landscape without people. This hasn't been a natural landscape without people for ten, fifteen, twenty thousand years. There were always people here. They were part of the environment, part of the natural history, if you will, part of the landscape."[7] In fact, the same year Samuel Bowles made his revelation, the Ute, in response to the demand of the United States, ceded the land in which the Mountain of the Holy Cross sits.[8] By the time the U.S. Geological and Geographical Survey team, in effect, laid claim to the area five years later, it had become a natural landscape—without people.

The purpose of the Great Surveys, the four government-sponsored geological and geographical surveys from 1867 to 1879, was not to discover the West for its audiences in the eastern United States, but literally to measure it.[9] In doing so, the surveys would help demystify and determine the utility of the West by extensively quantifying it through measurement. However, the sheer magnitude of the reports, written from time to time with western romance in mind, added additional luster to the West's already mythic and exotic stature. The four often overlapping and competitive surveys also assessed the value of the West for permanent settlement, military operations, economic opportunity, and scientific purposes. Converting western rumor and anecdote into science, the surveys checked accounts of earlier Spanish explorers and missionaries, fur trappers, Euro-American explorers, the military, prospectors, and adventurous sportsmen. The

surveyors took copious notes that detailed the topography, geology, biology, weather conditions, and American Indian customs of the West and compiled their findings in extensive government documents that were accompanied by illustrations by survey draftsmen, painters, and photographers.

The survey led by Lt. Ferdinand Hayden, to explore and document regions encompassing Yellowstone, the Tetons, and the Rocky Mountains, included the task of finding the Mountain of the Holy Cross, a quasi-religious pilgrimage that Hayden survey photographer William Henry Jackson (1843–1942) envisioned as a quest. In late August 1873 Jackson and part of the survey team approached the Valley of Roches Moutonnées (now generally referred to as Cross Creek Canyon) and then began their ascent of Notch Mountain (fig. 2). The climb was so treacherous that Jackson, a Civil War veteran and intrepid traveler accustomed to enduring adverse conditions for his art, abandoned his mules, forcing him and his assistants to carry the cumbersome photographic equipment themselves. After a two-day climb, Jackson reached the top of Notch Mountain, which allowed him a full view of the cross, and exposed eight glass-plate negatives (fig. 3). Jackson's photographs entered the public domain and, in providing visual confirmation of the mysterious cross — however exaggerated and manipulated by the photographic process — created a sensation.[10]

One artist who recognized the broad appeal of a wondrous and mystifying subject was Thomas Moran. In 1871 he had accompanied the Hayden survey to Yellowstone, creating magnificent watercolors of its shooting geysers and boiling hot springs, artworks so vivid and widely promoted that in

Fig. 2
WILLIAM HENRY JACKSON
Roches Moutonnées, Near the Mountain of the Holy Cross, 1873
Albumen silver photograph, 16 x 20 in.
Denver Public Library, Western History Department, Z-2602

1872 they prompted Congress to designate Yellowstone the country's first national park. Then, in 1874, Moran laid claim to another western marvel, Holy Cross, even before he saw it, creating a wood engraving of the mountainous scene for *Picturesque America*. He based his engraving on Jackson's photograph of Holy Cross and amplified it with a waterfall in the foreground (fig. 4). Later, in 1874, Moran traveled with part of the Hayden survey team to make his own quest of the mountain (fig. 5). In a letter to his wife, the artist recorded in detail the arduous journey through and across bog, swamp, deadfall, and steep rocks, much of it in the rain: "Camp Vexation," as Moran recorded it in his August 12, 1874, sketch of the trip.

As he climbed Notch Mountain, Moran conceived his 1875 painting, noting in a letter to his wife, "In the Valley [Roches Moutonnées] is one of the most picturesque waterfalls that I have ever seen. I shall use it in the foreground of the picture."[11] Moran had already included a waterfall in his earlier engraving. One could ask why he needed to make the journey, given the compositional similarities of the two images and the fact that he had produced his first image without actually seeing the site. But intrepid traveling and fieldwork were held in high esteem by the nineteenth-century American landscape artist, and Moran was a great champion of the importance of becoming accustomed to a place and observing the richness and nuances of its details. As one might expect from an artist who had come to know the site firsthand, the finished oil is full of the kind of observed detail—lichen on rocks, tufts of grass and flowers, and towering pines—that helped Moran proclaim definitively that he had been there.

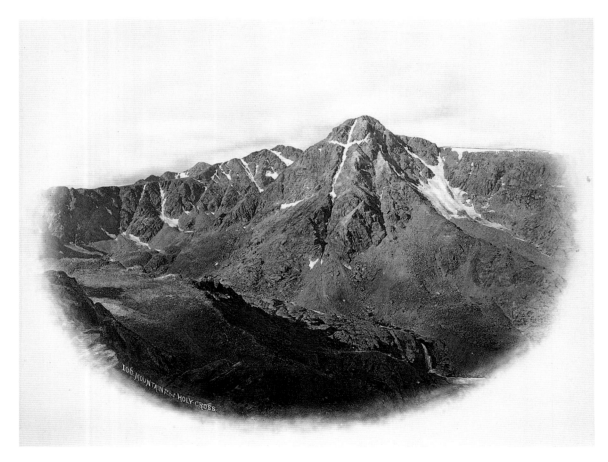

Fig. 3
WILLIAM HENRY JACKSON
Mountain of the Holy Cross, Colorado (retouched version with stream), **1873**
Albumen photograph, 8 x 10 in.
Collection of Neil S. Goldblatt

Moran also emphasized other aspects of the site that he had experienced. The seven-by-five-foot painting with its steep vertical thrust mimics the path of ascent. The fallen timbers and waterfall in the foreground, loosely based on Jackson's photographs and on Moran's sketches of Roches Moutonnées Valley, suggest the perils of the journey. Starting at lower left, the waterfall spills out of the viewer's space in a bravura display of loose brushwork. The gushing water contrasts with the crisply rendered interlocking pieces of landscape—jagged rocks, fallen timber, and steep creek bed—that Moran stacks vertically for the viewer to climb. The scene is both lush (the sounds of the rippling creek are nearly audible) and treacherous, the rough edges of rock and limb suggesting the severity of the ascent. The peak with its cross, painted in celestial tones of white, pale blue, and pink,

is encircled by a halo of gentle clouds and looms in the distance like an apparition, a holy grail proclaiming that nature is God's earthly church. In keeping with a spiritual theme, Moran made the central path glow, expertly using paint to create the effect of white foam emanating from the rushing creek in the foreground and, in the distance, sun-drenched rocks. With sunlight, timber, and water in abundance, this wilderness sanctuary guaranteed nature's bounty, its immense scale and grandeur promising rich reward for those who made, as Moran scholars have phrased it, a pilgrim's progress. *Mountain of the Holy Cross*, then, perfectly sums up what may be called a Christianized and nationalized sublime, in which the concept of awe-inspiring nature increasingly embodied nationalist, religious, and moral beliefs over the course of the nineteenth century.[12]

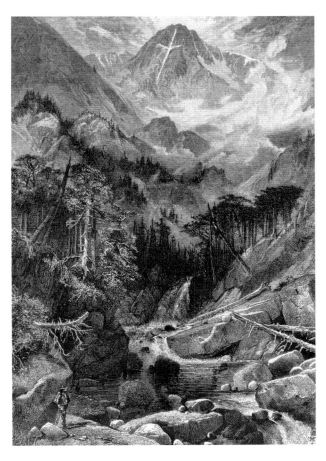

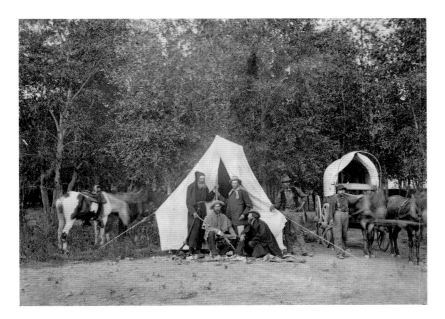

Fig. 5
On Trip to the Mount of the Holy Cross, 1874 expedition to Mountain of the Holy Cross, showing, standing, Col. L. W. Woods and James Stevenson; sitting, J. S. Delano and Thomas Moran, with unidentified African-American cook and teamster. Denver Public Library, Western History Collection, William Henry Jackson, WHJ-10141

Fig. 4
THOMAS MORAN
Mountain of the Holy Cross, **1874**
Wood engraving, published in *Picturesque America*, ed. William Cullen Bryant (New York: D. Appleton & Co., 1874), 501

The fact that this is a composite view compounds Moran's pedagogical intentions. The view of the Holy Cross that the artist offers does not exist. Instead, Moran combined different moments in his journey, the arduous creek bed and waterfall in the foreground juxtaposed with the view of the distant cross, which, in fact, comes into view only at the end of the ascent of Notch Mountain. Moran, like other landscape artists of the period, often distanced himself from the science of topography, which accounts for the specific "lay of the land" through slope and elevation. Thwarting the usual accusations of artists' infidelity to the specifics of place, Moran could and did argue "that a place, as a place, has no value itself for the artist only so far as it furnishes the material from which to construct a picture. Topography in art is valueless."[13] Thus, to set himself apart from topographers, Moran at first denies the primacy of place. Yet he dissembled and then proceeded to refute his own argument; his entire career demonstrates his dedication to knowing and capturing specific places, however creatively interpreted. In making careful choices about his subjects and his approaches to them, he turned places into paintings and, in turn, made places out of paintings. In the process, he greatly shaped his audience's expectations of what they would see in reality, a point not lost on such survey leaders as John Wesley Powell and Hayden, who recognized Moran's ability to popularize their fieldwork to dramatic effect. In the grand tradition of landscape painting, which appropriated the moral warnings and values usually associated with the higher and loftier category of history painting and then transposed them to a natural landscape, Moran merged metaphor with topography. He made the peak itself a mark of warning and of promise to his nineteenth-century viewers.

In choosing spiritual ascent as his overarching theme, Moran, a well-educated artist, would have been aware of Renaissance-era devotional images that employed a "mountain of virtue" that pilgrims ascended to reach God. As art historian Linda C. Hults has pointed out, this ascent is visualized perfectly in the frontispiece of the 1844 American edition of John Bunyan's *The Pilgrim's Progress*, an engraving after a picture by Joseph Mallard William Turner, the English landscape artist whom Moran greatly admired.[14] In addition to *Cross in the Mountains* by Dresden School painter Caspar David Friedrich and the more recent cross paintings by Thomas Cole and Frederic Church, Bunyan likely served as a

Fig. 6
PIETRO AQUILA, after Annibale Carracci
Hercules at the Crossroads, c. 1675
Illustration of engraving from a book in the library of the Fitzwilliam Museum, University of Cambridge

more direct source for Moran. More generally, Moran was undoubtedly aware of the initial source for the concept of virtue in Greco-Roman mythology, elaborated in Renaissance and Baroque-era images of the story of Hercules choosing between Vice and Virtue. In these images the figure of a languid Vice appears indolent, and a stern Virtue points the way toward a steep mountain climb (fig. 6). Hercules at the crossroads chose a life of virtue and made the climb. In composing his painting of Holy Cross, Moran distilled centuries of iconography and conferred meaning on his subject, consequently offering his viewers no choice between vice and virtue. Instead, he confronted his viewers and provoked them to ponder, as they symbolically climbed, the larger issues that the painting invoked.

Although Moran first exhibited his painting in Newark, New York, and Boston in 1875, he ultimately intended *Mountain of the Holy Cross*—along with two earlier monumental western paintings purchased by the federal government and displayed in the U.S. Capitol, *Grand Canyon of the Yellowstone* (1872) and *Chasm of the Colorado* (1873–74)—to form a national triptych to be displayed at the 1876 Centennial Exposition in Philadelphia (figs. 7 and 8). This triptych was never displayed in Moran's lifetime because Congress would not relinquish the other two paintings for the show. Moran's message of America's greatness based on its western wonders was nonetheless delivered with *Mountain of the Holy Cross*. The painting, still in Moran's possession at the time,

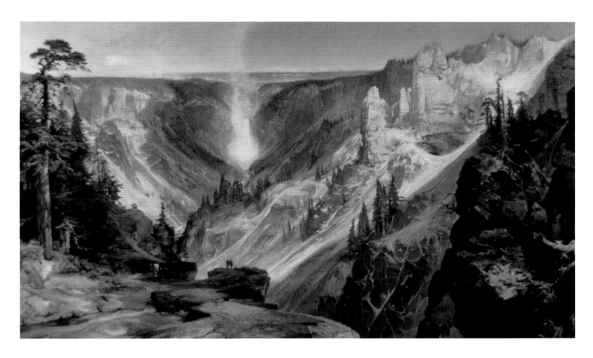

Fig. 7
THOMAS MORAN
Grand Canyon of the Yellowstone, 1872
Oil on canvas, 84 x 144 in.
U.S. Department of the Interior Museum, Washington, D.C.

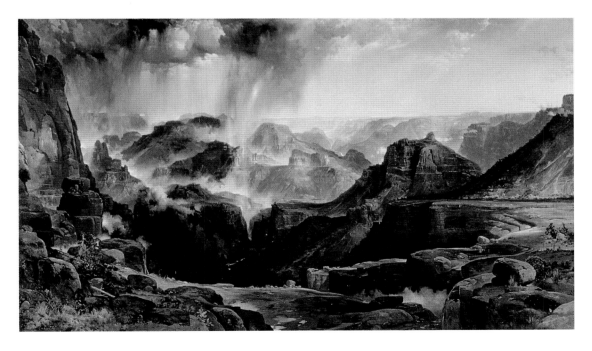

Fig. 8
THOMAS MORAN
Chasm of the Colorado, 1873–74
Oil on canvas, 84 x 144 in.
U.S. Department of the Interior Museum, Washington, D.C.

was exhibited in the Memorial Hall's American Art Gallery at the Centennial Exposition. When it was displayed, *Mountain of the Holy Cross*, so richly resonant on many levels, was seemingly equipped to resolve post–Civil War tensions, to proclaim the new American science of geology, and to call forth debates about the country's natural resources, all topical issues in American culture and especially relevant to expanding western borders.

As Moran scholars have shown, the painting, appearing as it did during the anxious period of Reconstruction and in the climate of national reflection promoted during the first centennial, could not help but urge Americans to take an upward path of virtue and to renew their sacred covenant. If the Civil War had been a dramatic expression of God's vengeance on his people, then virtue would light the way toward national redemption. Implicit in Moran's conception was that the journey was a western one. In the wake of the enormous rift caused by the Civil War, an age in which the center could not hold, Americans would understand the Mountain of the Holy Cross as marking a new center, literally the center of the United States along the Continental Divide, the watershed boundary for the entire continent, and the link between the Pacific and Atlantic oceans.

Moving from east to west, the Rocky Mountains, the country's backbone, were considered in earlier nineteenth-century culture as both a physical and a mental barricade, an obstacle to overcome before falling, just beyond the Sierra Nevada mountain range, into the gentle, golden lands of California. As New York journalist Fitz Hugh Ludlow observed in 1864, referring to the Rocky Mountains in *The Heart of the Continent* (published in 1870): "So long as it remains a formidable undertaking to pass between New York and San Francisco, so long there will develop an independence of interest and feeling which, however gradual and imperceptible, cannot fail to result into two distinct nations."[15] The issue of relationship of parts to the whole, of the periphery and the center, and of how to ensure national unanimity with such a far-flung and expanding empire was hardly new in American political thought or in American art, either.[16] But in the wake of the golden spike, hammered into the iron rail in Promontory, Utah, on May 10, 1869, linking the Union Pacific and the Central Pacific Railroads into one transcontinental mode of transport, a once vast continent now seemed just a bit smaller. To the viewing public of 1876, Moran's

hopeful image of the snowy cross offered a dramatic recentering and may have bestowed a blessing, anointing as promise what had once been thought of as barrier.

The thematic elasticity of *Mountain of the Holy Cross* allows for additional interpretations that go beyond the intersection of Christian religion and American nationalism, the two themes that together create the mythic space of the painting, in which the mountain itself is a place-marker. The documentary qualities of the painting—those detailed elements that remind us of Moran's function in the survey party to promote the West to nonwestern viewers—broaden the picture's possible meanings. As art historian Rebecca Bedell has noted, geologically minded viewers and critics teased out the geological lessons of *Mountain of the Holy Cross* and the role of the American landscape in defining and proclaiming a new physical science.[17] On one hand, with its carefully carved and highlighted path, which emphasizes the fissures and tensions that break alongside its course, Moran's mountain journey is a geophysical one. His journey shows how glaciers once flowed down mountain summits and sculpted the landscapes below, suggested by the ravaged deadfall. Contemporary critics, informed by nineteenth-century uniformitarian theories of geology that claimed that the Earth's surface was in a state of constant change and shift through erosion, deposition, and uplift (as opposed to cataclysm), could argue that Moran's painting was a "geological chart, showing mountain formation and traces of glacial action."[18] If places such as Mountain of the Holy Cross, Yellowstone Park, and the Grand Canyon were agriculturally irrelevant, their scenic splendor and textbook geological lessons held increasingly greater value over the course of the century. In fact, because of places like these, which provoked the subsequent development of the science of geomorphology, an American school of geology developed around them and dramatically expanded the history of the Earth—its dynamic evolution through volcanic activities, its fluvialism, and its erosion.[19] America, then, was a New Eden not only in conceptual but in geological terms, revealing to the world that the West bore witness to Creation. In the nineteenth century, to "discover" western wonders was to relive, as art historian Barbara Novak has suggested, "Genesis through the landscape" and to supplement spirituality with science.[20]

While Moran proudly proclaimed the modern, American science of geology, he also drew attention to the site's

buoyant—even holy—waters, recalling debates about natural resources and especially the importance of water in large sections of the arid West.[21] Surveyors Hayden and Powell differed in their theories about overcoming the aridity of the West: Hayden, who had surveyed Holy Cross, suggested that settlement—farming, forestation, and even technological activities along the railroad and telegraph lines—would encourage precipitation. His rival John Wesley Powell, with whom Moran had traveled on the survey to Yellowstone, argued otherwise. On lands west of the 100th meridian, the one hundred sixty acres allowed by the 1862 Homestead Act bore no relevance, he asserted; they were simply too dry and required irrigation. *Mountain of the Holy Cross*, with its prominent waterfall, could be understood to have satisfied either survey leader's concern, appearing as a source of irrigation for Powell or, for Hayden, a fortuitous result of settlement east of mountain peaks, where farms could use the water from melted runoff.

Curiously, water appears to be the symbolic source of the talismanic qualities that the artwork acquired less than a decade after it was painted. *Mountain of the Holy Cross* was bought in 1880 by Englishman Dr. William Bell, one of the owners of the Denver and Rio Grande Railroad, which traveled a southerly route from Denver to Mexico City, stopping at such sites as Colorado Springs and Manitou. These places were becoming well known for their therapeutic mineral waters, and the region was being newly marketed as a "Saratoga of the West." Bell promptly put his new acquisition to work, using the painting for promotional purposes, featuring it in railroad advertisements, and hanging the work prominently in his Manitou home. Visitors were invited to make twice-weekly pilgrimages to the painting-cum-shrine. A clever commercial promoter (armed with the legitimacy of a degree in medicine), Bell encouraged his visitors to make a visual link between the "holy" water of the painting and the hoped-for cure that they were seeking in the area's mineral springs, less than a hundred miles from the mountain peak. Thus Moran's *Mountain of the Holy Cross* gave definition not only to a site but to a community of turn-of-the-century invalids and health-seekers who looked to the West for physical and spiritual salvation.

In this exhibition and book, *Mountain of the Holy Cross* marks a moment when spiritual, national, and empirical values seamlessly intertwined and were thoroughly embedded in the American landscape. These values eroded, contributing to the skeptical realism of the twentieth century, when art and science severed their ties and when the operatic visions promoted by myth-makers were often exposed as false. This transition plays out in the site itself, which, based on its physical presence and repeated visual imagery, clearly held significant meaning for many Americans in the twentieth century. In 1929 President Herbert Hoover named the Mountain of the Holy Cross and the 1,392 acres surrounding it a national monument. Ironically, only a short time later, the right arm of the cross disintegrated and eventually collapsed. Difficulty of access and a short viewing season did little to encourage further tourism. Mountain of the Holy Cross no longer represented new empirical knowledge and imperial desire; in the twentieth century the topicality of westward expansion, in which the cross was so heavily invested, had passed. Indeed, in 1950 the Mountain of the Holy Cross lost its status as a national monument. Its work as a national symbol had been done, and, as if to dramatize that fact, the cross fell apart.

The sacred qualities of the West that the painting summons, however, remain. In 1973 the area was entered into the National Registry of Natural Landmarks for its geologic interest. In 1980, to accommodate both the need for natural resources and the importance of preservation, Congress unsuccessfully proposed that this land be designated the Holy Cross Wilderness Area, with allowances made for tunnels and dams to divert the land's precious supply of water. Today, in an effort to stave off attempts at water diversion, preservationists lobby for Cross Creek to be designated a wild and scenic river. In this sense, the Mountain of the Holy Cross—part of land set aside in 1891 as the White River Timber Plateau (or White River National Forest)—and its history of being made into a place summarize national attitudes and debates about the development and protection of the West's wilderness as a holy place.

HOW MAKING A PLACE CHANGES SPACE

When Moran publicly displayed *Mountain of the Holy Cross*, critics loudly applauded, the *New York Times* proclaiming that it was "one of the finest examples of American landscape art that has yet been produced."[22] Boston critics were more reserved; one, after praising the painting, faulted it for its "lack of space."[23] He wrote that "the picture seems

to lack atmosphere. The objects in the middle and extreme distance are quite as strongly defined as those in the foreground, and even the faraway mountain, with its cross of snow embedded in the fissure of the rocks, shows every marking on its surface. It has been said, in excuse of this apparent fault, that the atmosphere in this region is so clear and pure, that distant objects are seen in all their minuteness of detail." Another Boston critic, who found the "aerial perspective" weak and the cross "not far enough away," likewise had trouble with similar spatial issues.

Moran's artistic sensibility and effort to exploit the symbolic power of landscape may have demanded the spatial compression to which the Boston critics referred and that was needed to emphasize the cross. Setting this caveat aside for a moment, the Boston observations are representative of a more general problem in nineteenth-century criticism of the art of the West. Critics often felt at a loss or, at the very least, uncomfortable with interpreting a western space they understood only anecdotally and were asked to make allowances for because of the peculiarity of western optics that had not yet been codified aesthetically. In the dry, crystalline air of many western places, distance is deceiving and spatial perceptions uncertain, so that space itself is collapsed: the "near and…far," as Frederic Remington phrased it in 1901, and the "Faraway Nearby," to quote Georgia O'Keeffe in 1937.[24]

At the time, spatial distortion in painting was a relatively new subject that went beyond issues of geographic anomaly. Just two years after Thomas Moran painted *Mountain of the Holy Cross*, the aesthetic concept of space and the value of abstraction in art were under attack far away in an English court of law. In 1877 influential art critic and social reformer John Ruskin published a letter accusing the American expatriate artist James McNeill Whistler of "fling-

Fig. 9
JAMES ABBOTT MCNEILL WHISTLER
Sketches on the Coast Survey Plate, 1854–55
Etching, 5 1/2 x 9 11/16 in.
Freer Gallery of Art, Smithsonian Institution, Washington, D.C., Gift of
Charles Lang Freer, F1897.17

ing a pot of paint in the public's face," a metaphor for his aversion to Whistler's approach to making art in general and, more specifically, to Whistler's painting *Nocturne in Black and Gold: The Falling Rocket* (1875), which evokes an impression of nocturnal fireworks in London through broad patches of dark paint and specks of gold. Whistler sued Ruskin for libel, won a Pyrrhic victory of one farthing, and, in the process, put nineteenth-century notions and expectations of art on the stand.

Whistler, who began his artistic career with the U.S. Geological and Geodetic Survey, denied that paintings should accurately portray nature. Instead, he advocated "art for art's sake," or aestheticism, in which an artwork was concerned with art itself, with colors arranged in harmonious patterns for expressive ends. He recognized this sensibility, in part, through serial painting. Put another way, Whistler took a simple motif that he had learned while studying naval cartogra-

phy at the U.S. Military Academy at West Point and repeated it throughout his career in various incarnations.[25] In an 1854–55 etching, he produced a classic elevation of a coastal scene (fig. 9). This topographical device shows a narrow strip of land that divides empty expanses of sky and sea into two parts. This would prove to be a consistent motif in Whistler's nocturnes and landscapes, in which broad bands of sky or sea are intersected by a long, horizontal stretch of land that, over time and after many repetitions, appears increasingly opaque and mysterious (fig. 10). Thus his landscapes and nocturnes, in which space is inchoate, evoke moods and states of mind rather than traditional narratives.[26]

Whistler's *Coast Survey Plate* and his later series of nocturnes encapsulate a significant transition in European and American art. In them we move from the plotting of space in one-point perspective, as understood since the Renaissance, to principles that promote attention to the process of painting

Fig. 10
JAMES ABBOTT MCNEILL WHISTLER
Nocturne: Grey and Silver, 1873–75
Oil on canvas, 12 1/4 x 20 1/4 in.
Philadelphia Museum of Art, The John G. Johnson Collection

itself and, consequently, to an increasing flatness of the picture plane and the inconsequence of perspective. Moran's *Mountain of the Holy Cross*, wholly different but painted in the same year as Whistler's infamous *Nocturne in Black and Gold*, is implicit in this new matrix and foreshadows the transition from a culture of surveying and measuring to a more personal one in which evocation, sensation, and expression take center stage in the unfolding drama of Modernism.

In Moran's art, western land plays an integral role in formulating this new change in space. Land, as novelist Willa Cather later described it, was "the great fact," an overwhelming aspect of the western experience that artists had to confront, negotiate, and surmount.[27] Whether because of its soaring mountain ranges, angular mesas, steep canyons, interior woodlands, rolling prairies, or arid desert, the West's sheer enormity, variety, and geographic peculiarities presented as many challenges to visitors, developers, investors, explorers, and settlers as they did to artists. In 1855, when New York artist Asher B. Durand, who never ventured west, blithely encouraged younger landscape artists to seek out and paint the West's "ocean prairies," few of the country's major artists responded to his call, and of those who did, only Worthington Whittredge, in his series of quiet Platte River landscapes, seemed comfortable with his subject.[28] Sanford Robinson Gifford, for example, spent a summer with the Hayden survey party exploring Wyoming in the company of William Henry Jackson, one of the most gifted of survey photographers, but his production was meager. Gifford, like so many before and after him, was stymied in his efforts to paint western spaces, many of which were so peculiar and unique to the United States that there was little to no existing aesthetic convention to draw upon to portray them.

In general, artists applied already familiar artistic ideals to the western landscape, no different from any other Euro-American artist taking on new (for them) subject matter, whether in Europe, the Mediterranean, or the Holy Land. Albert Bierstadt adopted the traditions of Alpine scenery of his native Germany for his Rocky Mountain paintings but added a greater lateral expanse played out on an epic scale. The Rockies might be difficult to paint (John Frederick Kensett complained that the Rockies rose up "in ragged brawny masses without the apology of color for their nakedness"), but artistic precedence had been set.[29] When Moran painted

canyons like those at Yellowstone and the Grand Canyon, they came without an artistic road map (figs. 7 and 8).

In his epic paintings of Yellowstone and the Grand Canyon, Moran made the unconventional landscape conform to landscape traditions that had dominated American painting in the first three quarters of the nineteenth century. In both paintings, Moran takes as his subject dramatic declivity—no soaring mountains here but steep, dynamic canyons that had no parallel in Europe or Britain, a relevant point because the artistic traditions of that continent and country, including subject matter, had migrated to the United States. Moran's painting of Yellowstone combines his respect for the geological implications of the site with his sense of capturing the essence of the place rather than the specifics (fig. 7). For the painting, Moran created numerous sketches of the canyon and studied several photographs of it. Then he sifted and sorted these works so as to adopt several points of view into one panoramic canvas. To stabilize the resulting image and to provide scale, he included in the foreground a rocky platform dotted with tiny figures. In doing so, Moran renders manageable a site that is, in fact, difficult to comprehend. Viewed from nearly any angle, the canyon at Yellowstone is unsettling because of the ambiguity of its spatial depths and the absence of any kind of viewing platform to intersect the canyon like the one Moran invented. Several years later, in *Chasm of the Colorado*, the artist was bolder in conveying the site's utter spatial dislocation; here, indeed, depth perception constantly shifts and unnerves visitors to a far greater degree (fig. 8). He eliminated human figures, perhaps to add to the primordial qualities he wished to evoke in the painting, but also to contribute to the unsettling problems of scale that mark any direct experience of the canyon. Again, Moran added a rocky outcropping to stabilize the scene and to ground the viewer. The canyon experience itself, the expanses of which can seem either a few miles or a hundred miles away, is not so generous.

The West, in other words, distorted conventional notions of how forms in space should be depicted by an artist. The peculiarities of western spaces naturally were not addressed in the Anglo-European aesthetic traditions that Euro-Americans had long struggled to learn. The dramatic light of the West flattened forms and exploited color, and space itself offered multiple challenges. At the same time that American artists such as Moran were trying to negotiate and over-

come the West's distortions of space, artists in Europe and
the United States—driven by different, more subjective con-
cerns—likewise were experimenting with spatial issues. It
may be argued that the western artistic experience has been
overlooked as a catalyst of artistic change, specifically the
emergence of Modernism in the United States. The western
landscape, after all, was a concrete example of Modernist
tendencies. In Moran's painting trilogy, we see that he, per-
haps unconsciously, provided a geophysical example of new
artistic ideas.

Yet Moran remained committed to making places out
of spaces and, above all, out of the landscape itself. *Mountain
of the Holy Cross* shows how the spaces in the West that he
depicted were perceived by Euro-Americans, relatively speak-
ing, as a "blank sheet" or a canvas upon which rich, inextrica-
bly linked spiritual, geological, and nationalist meanings
could be imposed and strengthened by their mutually rein-
forcing effects. At the very moment the vast continent was
mapped, charted, and carefully measured, Moran could move
seamlessly between two points—mythic space (more than
one million square miles that had captured imaginations for
centuries) and specific place (the newly surveyed Mountain
of the Holy Cross, looming in a relatively compressed space
and tilting ever upward). The Latin cross manifest at the
peak conveyed, for most nineteenth-century Euro-American
audiences, biblical content and Christianized nationalism.
Looked at another way, however, and making allowances for
the fact that the design is not equilateral, to contemporary
eyes the peak's cross also recalls a Cartesian plane.[30] The
painting thus offers a diagram of space itself.

It is unknown if Moran made the pictorial connection
between biblical cross and grid, but it is a possibility given
that he was often in the company of surveyors, mapmakers,
scientists, and engineers who, as we see in an earlier image of
surveying methods, made lines in the landscape (fig. 11).
Regardless of his intentions, Moran created a shape that is
meaningful to us today, recalling as it does a coordinate sys-
tem with four quadrants created at an intersection, allowing
points to be plotted and distances to be measured (fig. 12).
The Cartesian plane, at its most basic level, allowed three-
dimensional modern navigation and mapmaking and,
provocatively, provided an analogue for the process of repre-
sentational painting itself: the transformation of three-
dimensional space onto a two-dimensional surface, using,

Fig. 11
FRANKLIN R. GRIST
Station East End of the Base Line, 1849
Toned lithograph, 4 1/2 x 7 3/4 in.
Denver Public Library, Western History Department

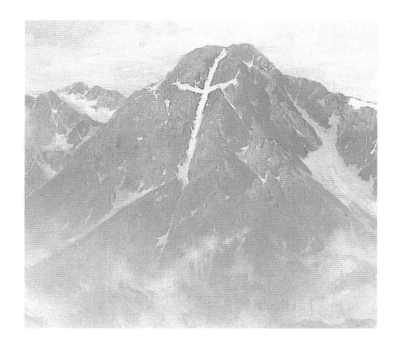

Fig. 12
Detail of cross on mountain from fig. 1

from the surveyor's point of view, triangulation, and, from the artist's point of view, one-point perspective. If we think of the cross as grid, Moran's painting draws attention to mapping spaces and the process that brought the artist to the West initially under the auspices of the U.S. Geological Survey. With the benefit of hindsight, we see that Moran's painting recalls the subject of the survey itself, the diagramming of space, the grid system imposed on the West as it developed over the past several centuries, and the reduction of nature to a series of calculations on paper. As surveyors, mapmakers, developers, and settlers continued to chart the West, artists disentangled themselves from the exacting process of mapping and measuring as an absolute means of knowing everything there was to know about a place. Instead, they forged ahead in another direction, moving tangible landmarks to the background and foregrounding new aesthetic and cultural concerns. These were still rooted in the landscape, but they were identified more closely with a search for an American art that increasingly could be called "modern."

SURVEY VISION AND NINETEENTH-CENTURY PHOTOGRAPHY

In 1937 photographer Ansel Adams (1902–1984) sent to Beaumont Newhall, curator of photography at the Museum of Modern Art in New York, a letter and original prints of images from an album by the virtually unknown photographer Timothy O'Sullivan (1840–1882). Plucking O'Sullivan out of obscurity and, in the process, putting himself at the contemporary end of a trajectory that would soon include other "rediscovered" nineteenth-century survey photographers of the American West, Adams remarked that O'Sullivan's work suggested "the vision of a [Paul] Strand or a [Edward] Weston —a vision not expected in a pioneer-explorer in the rugged West of the 1870s."[31] Along with Strand and Weston, Adams might have mentioned himself; in O'Sullivan, Adams had found a kindred spirit.

This photographic rediscovery was an artistic revelation. Newhall added O'Sullivan's photograph of Canyon de Chelly to the Museum of Modern Art's first photography exhibition, in 1937 and, subsequently, Adams made a gift of the O'Sullivan album to the museum (fig. 21). With the acquisition of O'Sullivan's photographs, the Museum of Modern Art thus crowned survey photography a forerunner of Modernism. These photographs were perceived to display proto-

Modernist tendencies in their dramatic contrasts of light and dark, their directness and simplicity, their crystalline clarity, their stark geometry, and their spatial eccentricity, qualities valued in the burgeoning field of American art history. This broader art-historical effort reached back to America's artistic roots—the simplified lines of folk art, for example, and the planar qualities of early genre paintings such as those by William Sydney Mount—to construct a pedigree for comprehending trends in Modernism, specifically abstraction, that were still confounding much of the American public. By drawing attention to the country's artistic traditions and heritage, art historians devised a formalist chronology in keeping with then-topical artistic values.

Cultural context, however, plays an important role in determining the appearance of nineteenth-century western photographs. For example, art historian Robin Kelsey has offered a compelling argument for understanding the often planar and flat surface qualities of an O'Sullivan photograph, which can be explained by the graphic qualities demanded by survey culture, in which diagrams, maps, atlases, cross sections, and tables provided a template for a graphic survey style, made manifest in photography.[32] Survey needs, he argues, determined survey vision. In order to appeal to different constituencies, these types of photographs needed to be easily legible. Survey photographs in the nineteenth century were used by the government and the military for documentary information, by scientists who gleaned geological and anthropological information from them, and by people who aimed to settle and develop the land or whose sense of adventure was piqued by seeing them in expositions and gallery exhibitions, or who purchased them as framed views or as a collection of stereographs in a parlor game. Thus maximum clarity and the abstraction of essential form and content represent the goal of survey vision. In a world of Victorian clutter, survey vision was remarkably pared down.[33]

Surveyor Ferdinand Hayden once commented that photographs comprised the "nearest approach to a truthful delineation of nature."[34] His statement helps show how nineteenth-century audiences were well equipped to recognize the mediated quality of photographs and to understand that they were not transparent reflections of reality. Photographs, Hayden asserted, offered not the truth but a near-truth, and such statements have helped photohistorians reassess nineteenth-century values placed on the images. Indeed, in

survey culture the photographer was but one of several members of a survey team consisting of engineers, mapmakers, surveyors, and scientists, each of whom made his own approximation of "the truth" with the intended goal that the sum of the survey would be greater than its parts. Like Thomas Moran and other painters, photographers also were able to manipulate their medium for effect. They combined negatives to make a composite photograph or squeezed stereograph lenses wider apart or closer together to achieve pictorial goals. Moran's paintings and the photographers' negatives were but two, among many, versions of the truth, and their roles were understood as such in survey culture. In a dynamic cross-fertilization, in which photographer and painter, engineer and geologist, examined the West, team members involved in nineteenth-century survey culture learned from one another and harnessed their research to suit their respective needs and to further their objectives.

If the survey parties included team members who occupied a sliding scale of truth value, ranging from strictly quantitative data (such as a cross section) to embellished art (Moran's paintings), photography occupied a space in between. Photographs could be read as documentary specimens, not unlike the fossils, minerals, and American Indian tools tagged for inspection. In addition, in their "near"-truthfulness, photographs also could be (and were) informed by and understood in the artistic tradition of meta-landscape, which colleagues such as Moran had developed to superb effect.

Timothy O'Sullivan's *Sand Dunes, Carson Desert, Nevada*, taken in 1867 during the survey of the Fortieth Parallel led by the Yale-trained geologist and civilian Clarence King, best expresses this nineteenth-century liminal space between specimen and symbolic landscape (fig. 13).[35] Once an apprentice to photographer Mathew Brady in New York and an associate of Civil War photographer Alexander Gardner in the Army of the Potomac, O'Sullivan photographed nearly every major Civil War battlefield. This experience suited him well to the rigors of the Fortieth Parallel environment, which consisted of the Great Basin, the Great Salt Lake, and parts of the Rockies.[36] This area appears otherworldly and desolate, a place of foul-smelling alkali flats, saline springs, and severe aridity. Although the "Great American Desert," as explorer Stephen Long phrased it during his expedition in 1819–20, generally referred to the vast region west of the Mississippi River, by the mid- to late nineteenth century the

term narrowed to embrace this region, a place to pass through, to survive rather than enjoy, a perception brought vividly to life in traveler J. G. Bruff's 1849 view of the forty-mile desert crossing, not far from the site at which O'Sullivan took his photograph of Carson Desert (fig. 14).[37]

In aesthetic theory, desolate spaces have long been cast in terms of the sublime, with emphasis on the feeling of vast loneliness they can provoke.[38] But eighteenth-century theorists of art had never actually experienced them, and in the context of the nineteenth-century West, the spaces were culturally loaded as negative. Westering Euro-Americans had to suffer through them to get to the fertile valleys of California. Still, when Clarence King's survey team passed through, the desert bustled not only with rattlesnakes, rabbits, and coyotes but also with Paiute, miners, and Mormons who saw in the desert spaces not a wasteland but a home, a source of mineral wealth, and a new Holy Land, respectively. O'Sullivan was especially equipped to appreciate the desert's distinctive qualities, asserting their strangeness on his negatives. He separated the physical characteristics of the place from the actual experience of being there, which was at the very least arduous and uncomfortable.[39]

O'Sullivan's canonical image of the Great Basin likely depicts a site south of Carson Sink that is now known as Sand Mountain Recreation Area.[40] In *Sand Dunes, Carson Desert, Nevada*, O'Sullivan focuses on the fine bleached mounds of sand. Their crests push toward the sky and are clipped in place by the dark background hills that flank their sloping sides. In the foreground, four mules pull O'Sullivan's wagon, which stored his heavy equipment and served as his darkroom for processing negatives. The tracks of the wagon wheels and the photographer's footprints, left as he dashed from the wagon to set up his camera, are visible impressions in the sand, but they are fleeting; the delicately articulated wind-carved ripples at lower left suggest the challenge of permanence in this ephemeral desert locale. O'Sullivan's positioning of the off-center mule train, his self-referential attention to the process of making the photograph, and the severity and spareness of the pictorial elements that he has arranged are all readily apparent to an eye now accustomed to considering these sensibilities as modern. To be sure, some of these effects may be attributed to the photographic medium itself.

Introduced to the public in 1839, the technology of photography was rapidly evolving at the time O'Sullivan made

his journey. Gradually supplanting daguerreotypy as a new photographic method, the wet-plate or collodion technology dominated photography in the 1860s and 1870s. In this process a photographer coated sheets of glass with light-sensitive chemicals, loaded a camera, and exposed and then developed glass negatives, all before the light-sensitive surface dried. As awkward as the process was, it yielded vivid images of exquisite detail. As a result of the long exposure required in the wet-plate process, skies become flat; white expanses and rolling waters appear still. Photographers could retouch their photographs with paint or manipulate their prints by adding a second negative of clouds, but usually they left the sky a void. Against the colorless sky, the landscape becomes an even greater presence.

In English photographer Francis Frith's images of the Egyptian desert (fig. 15), for example, the sky void that sets off the carefully detailed pyramids of Dashoor closely parallels O'Sullivan's desert view. Despite the seemingly insurmountable challenge of working in the desert heat with highly combustible materials, Frith produced more than five hundred elegant photographs on three different expeditions for his enormously successful publications on the Holy Land and Egypt.[41] He gave to his Victorian audiences a virtual tour of these "Oriental" places—armchair travel romanticism that was both critically and popularly received. Here Frith's desert scene achieves its expansiveness through the ghostlike pyramid that rises mysteriously in the distance, the adamant structure that dominates the middle ground, and the seated figures in the foreground that provide scale. Footprints making their way into the foreground announce the photographer's presence, but they simultaneously lead the eye back into the distance, to the pyramid, whose contours, construction,

Fig. 13
TIMOTHY O'SULLIVAN
Sand Dunes, Carson Desert, Nevada, **1867**
Albumen photograph, 10 3/4 x 7 3/4 in.
Cleveland Museum of Art, John L. Severance Fund, 2002.45

and solidity are carefully articulated. Marked by a stark simplicity, a carryover in part from the desert subject, the photograph is enhanced by Frith's framing and the technological capabilities of the medium itself. All of these elements conspire to show just what an event these mysterious pyramids are in the sparsely adorned landscape.

O'Sullivan, who traveled widely and was likely familiar with the images of his predecessor, worked a decade later than Frith. Despite some pictorial similarities to the Frith work, O'Sullivan's photograph exaggerates the slope of the dune so that it may be read as a planar surface that bears the imprint of windblown ripples. O'Sullivan turns the dune into a specimen that describes the behavior of the bleached

Fig. 14
JOSEPH GOLDSBOROUGH BRUFF
The Rabbit-Hole Springs (Wells in a Desert), September 20, 1849
Pencil on paper, 8 1/2 x 17 1/8 in.
The Huntington Library, San Marino, California

Fig. 15
FRANCIS FRITH
The Pyramids of Dashoor from the Southwest, 1858
Mammoth-plate albumen photograph, 16 x 20 in.
Wilson Centre for Photography, London

sand, made of fine quartz particles, and its delicate qualities.[42] By closing in on the sand dune, O'Sullivan gives the viewer little purchase on the foreground or even a sense of where foreground ends and the background peak begins. Because of the bleached whiteness of the sand dune, distant mountains, glimpsed only at the far edges, appear darker than the foreground, where one would intuitively, as in the Frith photograph, expect them to be lighter. Whereas Frith provides clearly articulated footprints that gently lead the viewer back into space (not unlike the visual paths provided in picturesque landscapes or even Moran's steep ascending path to the Holy Cross), O'Sullivan confounds the viewer's journey: a wagon makes its way across a dune, only to turn around and go back to where it came from. The desert environment O'Sullivan depicts defies expectations; it is turned upside down and inside out, and into an image of haunting strangeness that perfectly expresses nineteenth-century historian Francis Parkman's description of what it felt like to travel in the American West: "Here society is reduced to its original elements, the whole fabric of art and conventionality is struck rudely to pieces."[43] Shifting in time within this unusual environment, the sand particles and their movements form the core of O'Sullivan's scientific interests and the departure point for his desert ruminations.

If *Sand Dunes, Carson Desert, Nevada* distances the viewer from a comfortable relationship with the desert landscape, then Carleton E. Watkins's (1829–1916) *Cape Horn, near Celilo*, a photograph of Oregon's interior taken in 1867, gently lures viewers into the picture and allows them imaginative play within its lightly defined, expanding spaces (fig. 16). Watkins bisects this scene of railroad tracks with a sheer basalt cliff as well as a distant telegraph pole that provides vertical stability. Described by art historian Russ Anderson as perhaps "the single most beautiful photograph of the nineteenth century," the picture has a serene balance and quiet grace that promote a utopian image of American progress managed by careful stewards of the land.[44] Thirty-two years earlier in the expansionist Jacksonian Era, prominent landscape painter Thomas Cole, in his 1835 "Essay on American Scenery," and in his series of paintings titled *The Course of Empire*, warned of the "ravages of the axe," or the dangers of progress, in which a civilization that runs rampant could destroy Eden's natural bounty created by God in the "new world" of America. But in this tranquil view of developing Ore-

gon, Cole's dire warning has no place. Instead, Watkins asserts a pastoral vision of perfect harmony between humans and the land, one in which man steps lightly and efficiently on nature's bounty. The photograph affirms that if ever there was a land radiating peace and the gentle intrusion of the hand of man, this is it. The photograph's vision, however, belies the market forces at play in Oregon's developing economy.

In *Cape Horn, near Celilo*, the parallel lines of railroad track disappear into the distance and form two of many lines that emanate from the lower center right of the photograph: fine contoured edges of brush, sand, river, and foothills, the suppressed details of which allow line and shaded form to radiate slowly and serenely from the center. By placing his camera on the railway low to the ground, Watkins equates train and viewer so that, by implication, we rush forward into what looks like the peaceful lands of Oregon's interior.[45] A highly structured photograph, *Cape Horn, near Celilo*, and others like it by Watkins serve as an "allegory of American space" in which open land simply awaits settlement.[46] In addition, train travel, as Watkins's skillful composition suggests, eclipses time and distance in one roaring rush. Indeed, the theme of temporality hovers just beneath the surface in these and other nineteenth-century western photographs, through the surveys that measured the land and its distances and as the railroad began to link land to time through coordinated train lines and schedules. It was the railroad that introduced standard time, which synchronized clocks across the United States in 1883. *Cape Horn, near Celilo* asserts this optimistic side of modern industrial power and its consequences in an image of exquisite and mesmerizing beauty.

The photograph shows a portage railway (for transporting supplies and cargo between two waterways) owned by the Oregon Steam Navigation Company, which likely sponsored Watkins's trip to the Columbia River Gorge. Originally from Oneonta, New York, Watkins moved to San Francisco in 1850 following the Gold Rush. He trained with a local daguerreotypist and opened his own studio after 1858. Over the course of a long career, Watkins served as photographer for government-sponsored geological surveys as well as for railroad and mining industries throughout the West. In 1861, using a mammoth-plate camera, he photographed Yosemite in central eastern California. These photographs earned him national prominence and, in 1867, an international reputation after he won a bronze medal at the Paris Exposition.

Fig. 16
CARLETON E. WATKINS
Cape Horn, near Celilo, **1867**
Albumen photograph, 15 ¾ x 20 ⅝ in.
The Metropolitan Museum of Art, Gilman Collection, Purchase, The Horace W.
Goldsmith Foundation Gift, 2005 (2005.100.109)

Unlike O'Sullivan, who worked exclusively for survey leaders, Watkins was an ambitious artist and businessman who used and reused his photographs for government surveys, in public exhibitions, and as items for sale to patrons and customers who frequented his studio.

During the summer of 1867 Watkins undertook a wet and rainy four-month trip, traveling from Portland to Oregon's interior following the route of the Oregon Steam Navigation Company.[47] *Cape Horn, near Celilo* shows the Columbia River basin about ten miles east of The Dalles.[48] Watkins composed this view from the Oregon side of the Columbia River looking east. In the distance far beyond Cape Horn would be Celilo Falls, powerful chute falls that served as an important salmon-fishing ground for several American Indian tribes for thousands of years. Watkins's photograph of this prominent basalt cliff marks the approach to the Celilo Falls landmark, a giant commercial hub for American Indians throughout the North and West, observed by the earlier explorers Lewis and Clark. A photograph that Watkins took from the opposite direction (fig. 17), from the east facing west, maintains the sculptural solidity of the distant basalt cliff as seen in his other photograph, but this image is prosaic in comparison with the other, offering a great deal more geographical and technological information. In it we see the Columbia River, the raised portage railway, a steam locomotive with four cars and a gleaming new engine, and mounds of mercurial sand dunes.[49]

Watkins's expedition came on the heels of the Indian Wars, which had ended only nine years before, when the Klickitat and Yakama Indians were removed from their home-

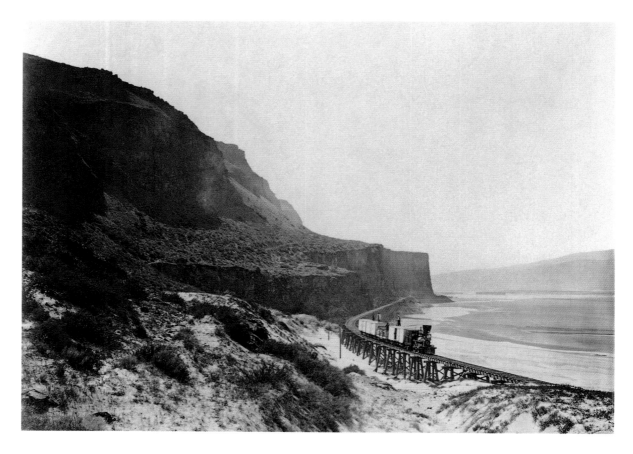

Fig. 17
CARLETON E. WATKINS
Cape Horn near Celilo, Columbia River, 1867, Portage Railroad, Oregon Steam Navigation Company, engine DF Bradford above The Dalles, Watkins photo no. 457
Mammoth-plate albumen photograph
Oregon Historical Society, Portland, OrHi 21585

lands. By 1858 the northwestern territory's fertile inland was open for settlement, and transportation became a key feature of the region's subsequent development. Portage railways to link the Columbia River, which was not continuous, became a booming business for the Oregon Steam Navigation Company. In 1863, after great difficulty (drifting sand constantly threatened progress), the company opened a new line from The Dalles to Celilo, the portage railway that Watkins displays in both photographs and skillfully trumpets in the view facing west.

In 1867, when Watkins journeyed to Oregon, the Central Pacific and Union Pacific transcontinental railroad was under construction and posed a threat to the Oregon Steam Navigation Company's ability to sustain its transport control of the area.[50] With the ever-increasing Anglo settlement and development of the interior, the combination of rail and steamship simply could not be sustained. The overland railroad took control of the area with its expanded routes, and in the 1870s the Oregon Steam Navigation Company sold a three-quarters interest to the Northern Pacific Railroad. Although speculative, it seems logical to conclude that at the time Watkins made the photographs, they stood as testimony that the Oregon Steam Navigation Company had made a substantial capital investment in its portage railway and was a flourishing concern in the region. It is not known how these two photographs may have been used by the company, but in them Watkins offered two approaches to the image of American industry in an age of territorial expansion: one that emphasized technological prowess and industrial success, the other, through its reductive, abstract spaces, a rhetorical view of American progress that preserves the notion that humankind and nature hang in equal balance. In the end, however, the serene site that Watkins pictures no longer exists.[51]

Watkins's legacy is one of imposing clarity on western spaces and carefully controlling the spatial chaos that the West could engender. His example of majestic poise helps define the distinct and often disconcerting pictorial choices of Eadweard Muybridge (1830–1904) in Yosemite.[52] Had it not been for a stagecoach accident on the Butterfield Overland Mail Company Stage in Texas, Muybridge might never have become a photographer—one of the greatest in this era of eminent photographers. Born in Kingston-on-Thames, England, Edward Muggeridge, as he was then named, moved to the United States, eventually settling in San Francisco in

1856 and styling himself E. J. Muygridge, bookseller. After the coach crash, he went back to England and recuperated from the accident, then wandered for years before returning to San Francisco in 1867. At this point he became a photographer and restyled himself Eadweard Muybridge, simultaneously using the alias Helios as his artistic name (*helios* is the Greek word for sun, referring here to light as a governing principle of photography). His only likely professional association was with the daguerreotypist and gallery owner Silas Selleck, through whom he sold photographs at Selleck's Cosmopolitan Gallery. Muybridge later exhibited and sold his photographs at various commercial establishments and also worked on government commissions along the Pacific Coast, in Alaska and Central America.[53] Before long, he would become known (and notorious) for his photographic cloud studies, for his experiments in motion photography that are considered the precursor to the modern motion picture, and for murdering his wife's lover (he pleaded guilty but was acquitted).

Muybridge began photographing the Yosemite Valley in 1867, following in the footsteps of Charles L. Weed (1859), Carleton Watkins (who made the first of his nine visits beginning in 1861), and W. Harris (1866).[54] Formed by glacial erosion many thousands of years ago, Yosemite is a seven-mile-long U-shaped valley about one mile across at its widest point and is characterized by sheer valley walls, dramatic waterfalls, and giant sequoias.[55] Few Euro-Americans knew of Yosemite until the mid-nineteenth century. In the wake of the 1849 California Gold Rush, U.S. troops forcibly removed the Miwok and Paiute Indians from Yosemite, making it available for the surrounding mining camps and, soon after, for the tourist industry. Even then known for its natural beauty and scenic wonders, Yosemite was protected and set aside in 1864 by the U.S. government (the first natural landscape protected by law, it became a national park in 1890). Although Muybridge produced accomplished photographs from his 1867 trip, his most elaborate images date from his second trip to Yosemite, from June through November 1872, when numerous photographers were already working in the area, and stock vantage points were becoming visual clichés.

Astute in matters concerning publicity, Muybridge returned from Yosemite and declared that his 1872 trip yielded "the most perfect photographs ever offered for public inspection," and, indeed, the softer light in the 1872 series and the technological skill displayed in coaxing out astonishing

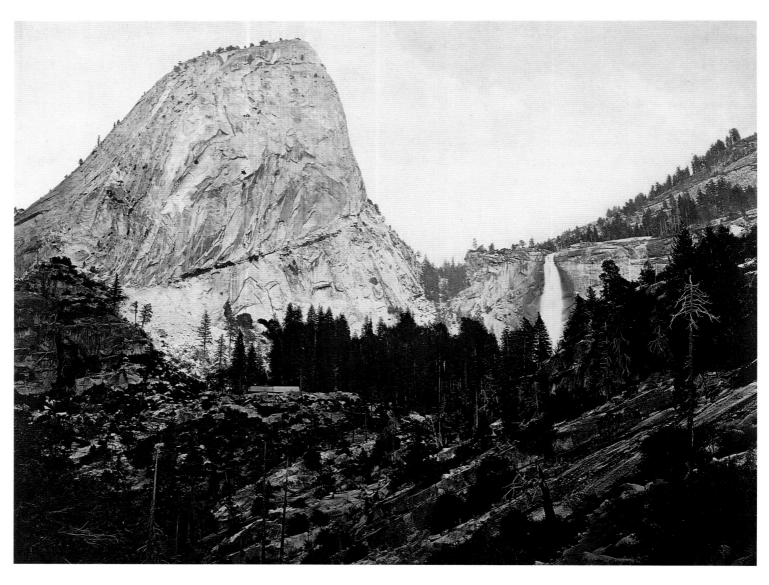

Fig. 18
EADWEARD MUYBRIDGE
Cap of the Liberty-Valley of the Yosemite, 1872
Albumen silver photograph, 16 9/16 x 21 in.
The Museum of Fine Arts, Houston, Museum purchase with funds provided by the
Brown Foundation Accessions Endowment Fund, The Manfred Heiting Collection

detail, convincing light effects, and greater qualities of depth account for his enormous success and lasting reputation as a landscape photographer.[56] The prospectus he had prepared even before he departed forecast his success, noting the improvements in "photographic manipulation," his own carefully chosen points of view, and his plan to produce images that strive for "the highest artistic achievement" in providing "a more complete realization than has hitherto been accomplished" of Yosemite's "vast grandeur and pictorial beauty."[57] Endorsed by distinguished subscribers, including his friend the painter Albert Bierstadt, Muybridge essentially threw down the gauntlet at Watkins, whose mammoth-plate series on Yosemite had set the photographic standard in 1861. Traveling to unknown picturesque sites within Yosemite and making images that emphasized its astonishing variety, Muybridge

provided a richer, multivalent picture of this quickly developing tourist mecca.

Like other photographers, including Watkins, Muybridge also photographed what were quickly becoming recognizable celebrated sites of Yosemite, such as *Cap of the Liberty-Valley of the Yosemite* (fig. 18). This photograph shows two prominent landmarks at Yosemite, Liberty Cap and Nevada Fall, taken from above Vernal Falls not far from the general area now called Silver Apron and Emerald Pool. Watkins's 1861 version of the same view, mistitled *Mt. Broderick, Nevada Fall, 700 ft. Yosemite* (Mt. Broderick is immediately west of Liberty Cap), demonstrates how identical sites produced dramatically different artistic interpretations (fig. 19). Watkins framed the view so that Liberty Cap and Nevada Fall rise abruptly out of the horizontal band of spruce

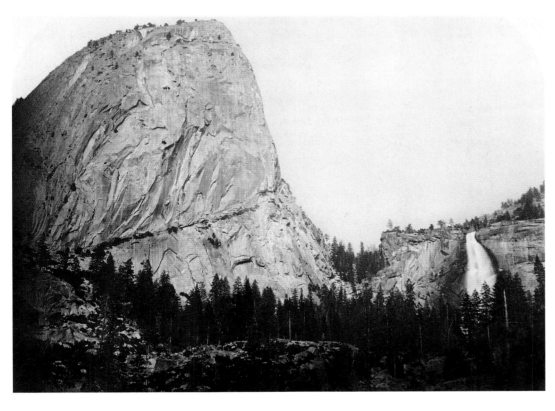

Fig. 19
CARLETON E. WATKINS
Mt. Broderick [sic], Nevada Fall, 700 ft. Yosemite, 1861
Mammoth-plate albumen photograph, 16 x 20 3/4 in.
San Francisco Museum of Modern Art, Purchased through a gift of Judy and John Webb, Sande Schlumberger, Pat and Bill Wilson, Susan and Robert Green, the Miriam and Peter Haas Fund, Members Accession Fund, and Mr. and Mrs. Max Herzstein and Mrs. Myrtle Lowenstern in honor of Mr. and Mrs. Stanley Herzstein's Fiftieth Wedding Anniversary, 95.98

and rock that provides foreground. Flat, planar, and stable, Watkins's photographs have been described by critics as either embodying a proto-Modernist sensibility for geometricizing space or reflecting an intrinsic self-detachment (given the artist's mild-mannered personality), or simply confronting the challenges of stereo vision, which promotes jumps of perspective into space, where middle ground simply does not exist.[58] Whereas Watkins provides a stable tableau that enables the viewer to take in Yosemite's geological and cascading features, Muybridge both enhances and obscures them by making them unapproachable. Muybridge rarely allows Watkins's degree of comfort in his understanding of nature. By stepping back (and up), Muybridge produced three successive bands of space that, although flattened as a result of the technological process, read as fore, middle, and background. A sinuous contour line traces the sharp slopes of Liberty Cap, plunging toward the waterfall and gently rising again. Etched in great detail with skeletal outlines sharply lit, a screen of spruce at mid-ground suddenly breaks apart and slides down a slope to an indeterminate area. The insistent diagonals, littered with rocks and deadfall with highlight effects dramatizing their appearance, make an otherwise sublime view of nature both chaotic and disorienting, the path into the scene blocked and uninviting.

Here Muybridge concentrates on the contrast between the ephemeral moment of a cascading waterfall and the seeming timelessness of the monolithic form, the rock debris of which litters the sloped floor below and thus contradicts Liberty Cap's quality of permanence. Muybridge consistently weaves between themes of stasis and change, summoning and then challenging the idea of durability. By including the lower band of talus in the photograph, he captures the violence of geological change that is so aggressively exposed in Yosemite's strange forms and scarred granite faces. Muybridge, thoroughly informed by the survey culture of which he was a part, found in the West a place to explore the nineteenth-century preoccupation with temporality. During an era in which the telegraph, the railroad, and other modern advances involving speed eclipsed perceptions of time and distance, this interest is hardly surprising to see in the West, where geological time was exposed so dramatically and where trains rushed across a landscape. It follows, then, that Muybridge, who had addressed the idea of change in time through landscape photography, spent the remainder of his career studying motion photography, which split and dissected time and threw into sharp relief the nature of speed.

As concepts of space, time, and distance shifted in the late nineteenth century, the concept of *lost* time also grew in importance and was explored visually, most comprehensively by artists who focused on the archaeological sites and desert spaces of the Southwest. Nineteenth-century photographers of the American West can be understood as part of a larger culture fascinated with evidence of the past, such as Francis Frith's views of pyramids in the ancient Near East. In photographing ancient American Indian architecture and art, survey photographers began to promote the concept of an American antiquity that supplemented the theme of geological antiquity. This theme quickly developed in the early decades of the twentieth century, as the fields of archaeology and anthropology burgeoned and artists and photographers flocked to the West.

Images of hidden cliff dwellings and villages built atop mesas in the desert Southwest galvanized romantic notions of a primordial past, one that, it should be noted, was often perceived to be unrelated to an American Indian present. In many of these pictures, including John Hillers's (1843–1925) *Hopi Pueblo of Walpi, First Mesa, Arizona* (1876) and O'Sullivan's *Ancient Ruins in the Cañon de Chelle, N.M.* (1873), contemporary American Indian life is nowhere to be seen (figs. 20 and 21).[59] In Hillers's photograph of Walpi, even the sheep pens are empty, evoking the ruins of Pompeii rather than an enduring civilization. Survey leader George Wheeler's caption for O'Sullivan's photograph claims the pictured dwellings of Canyon de Chelly are "characteristic of an ancient people and civilization of which the present tribes know nothing, not even in tradition." The caption denies the authorship and high culture of the Ancestral Puebloans (Anasazi), the ancestors of the Hopi and Zuni. The nineteenth-century message is clear: the antiquity of these sophisticated dwellings is either non-native (theories abounded that they were built by the Aztecs) or emptied of human inhabitants, leaving non-threatening, picturesque remnants of a colorful past.[60] The visual articulation of these theories and strategies absolved Euro-Americans from any guilt emanating from the seizure of Native American land and the forced relocation of its indigenous peoples.

Hillers, who emigrated from Germany in 1851, worked as a New York policeman and a Union soldier before joining

Powell's survey as boatman on the team's second trip to the Grand Canyon.[61] Hillers's burgeoning interest in photography, learned on the job, eventually led to his role as survey photographer from 1872 to 1878. He stayed close to Powell throughout his career, and his photographic subjects mirror Powell's activities, as he moved from surveying and mapping western areas to concentrating on the American Indian tribes who lived there. Whether working under Powell for the U.S. Geological Survey or the Bureau of American Ethnology at the Smithsonian Institution, Hillers provided photographs for government publications and international expositions (one of his versions of Walpi appeared in the American Indian exhibition at the 1876 Centennial Exposition in Philadelphia, the same venue in which Thomas Moran, his friend from the Powell survey, exhibited *Mountain of the Holy Cross*). But unlike such entrepreneurs as Watkins and Muybridge, Hillers was a steadfast bureaucrat, and his photographs have a workmanlike quality, devoid of Watkins's imposing serenity or Muybridge's eccentricities.

In the nineteenth century, it was a commonplace to describe and even name the western landscape in biblical, apocryphal, or literary terms—a way of making the unfamiliar familiar, and sometimes holy or supernatural, too. Thus towering slender rocks were Cathedral Spires, and other features of the natural landscape were given such names as Bridal Veil Falls, Tower of Babel, and the Devils Tower. Summoning travel literature, one contemporary likened this Hopi village atop a mesa to "an old German castle."[62] Yet, for this photograph, Hillers focused on his scientific goal, choosing an unusual vantage point from which to maximize pertinent information about the anthropology and geology of the area: the Pueblo architecture, in which rock blends seamlessly with architecture and ties together Hopi life and the land, both metaphorically and inextricably; the rock fences that allude to sheep farming; and the sweep and pitch of the mesa itself. Hillers's vantage point emphasizes several key and interrelated aspects of the site: the arid stretch of desert, in which landmarks of any kind would be easily unhidden from friend or foe; the tactical and practical use of the mesa as a site for a hilltop village from which to survey activity below; and the organic architecture that appears built into the landscape, where only a second glance or a closer look reveals that what appears to be a rock formation is actually an adobe village. At the same time, by juxtaposing foreground information with the endless expanse of desert, Hillers could tap into the quality of intense loneliness implicit and pervasive in nineteenth-century desert aesthetics in literature and art, also recalled in O'Sullivan's view of the Carson Sink. The romantic and dramatic effects of a desert sublime, complete with an imagined antiquity, were a misleading by-product of Hillers's scientific priorities. Although the village of Walpi appears to be desolate in the photograph, it was and remains a vibrant town. In fact, although the sheep pens are no longer extant, the home next to the ledge from which Hillers took his photograph still belongs to descendants of the same family.[63]

O'Sullivan's *Ancient Ruins in the Cañon de Chelle, N.M.*, taken on the Wheeler survey in 1873, likewise pictorially ignores any Native American presence.[64] The image depicts the White House ruins in the south rim area of Canyon de Chelly. The site is near Chinle in northeastern Arizona and lies in the center of the Navajo reservation in an area often described as Four Corners, which now borders the states of Arizona, Utah, Colorado, and New Mexico. Built by prehistoric Pueblo cultures, and including Ancestral Puebloan rock art, these dwellings date from 1100 to 1300, after which the Ancestral Puebloans mysteriously abandoned the site where they had lived for about a thousand years. The antiquity of the architecture is enhanced by the fantastic striated walls that illustrate geological time. An authoritative present, indicated by the three surveyors who appear in the photograph and provide scale, serves as a foil to antiquity.[65]

The name Canyon de Chelly suggests the confusion of cultures that have imprinted themselves there. *Chelly* is a Spanish and perhaps French version of the Navajo word for rock canyon (*Tséyi'* or *Tségi*), so Canyon de Chelly is a euphonious tautology: canyon of canyon. Like many canyons, the unusual landscape of Canyon de Chelly "suddenly is," that is to say, little warns visitors that they are about to approach an abrupt thirty-five-mile declivity, a steep gorge of pink-colored sandstone of Permian age, carved into its current labyrinthine shape by the erosional forces of a wandering stream.[66]

When the surveyors arrived at Canyon de Chelly, they entered what had been a legendary Navajo stronghold. The canyon was once a source of agricultural prosperity, as well as a staging ground for violent conflicts among the Spanish, Anglos, Mexicans, and Ute Indians. In 1864 Col. Christopher (Kit) Carson led a final, leveling assault against the Navajo, destroying the abundant peach orchards and

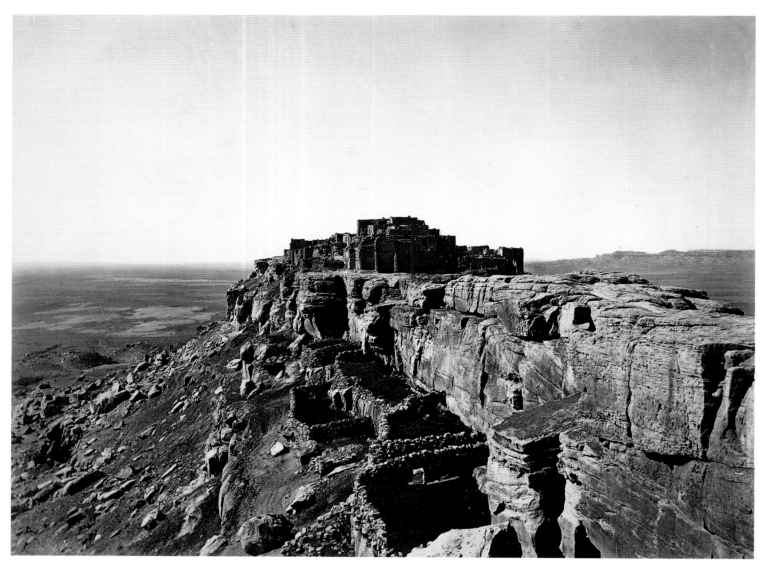

Fig. 20
JOHN K. HILLERS
Hopi Pueblo of Walpi, First Mesa, Arizona, 1876
Albumen photograph, 9 ³/₄ x 12 ¹³/₁₆ in.
Collection Centre Canadien d'Architecture / Canadian Centre for Architecture, Montréal

Fig. 21
TIMOTHY O'SULLIVAN
Ancient Ruins in the Cañon de Chelle, N.M., 1873
Albumen photograph, 8 x 10 in.
The Museum of Fine Arts, Houston, Gift of Mr. and Mrs. Robert L. Clarke

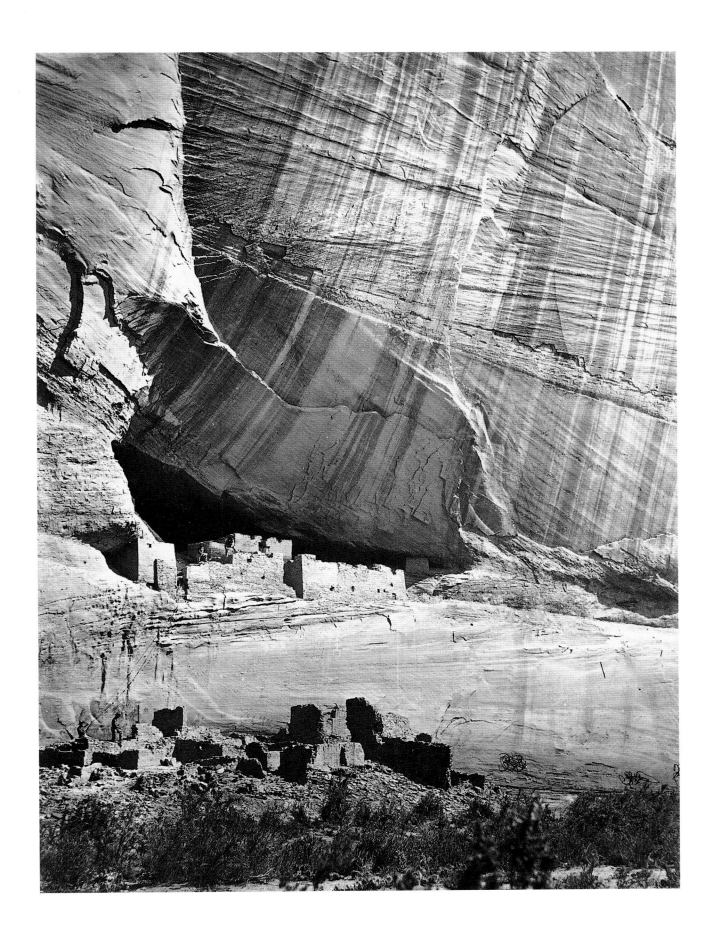

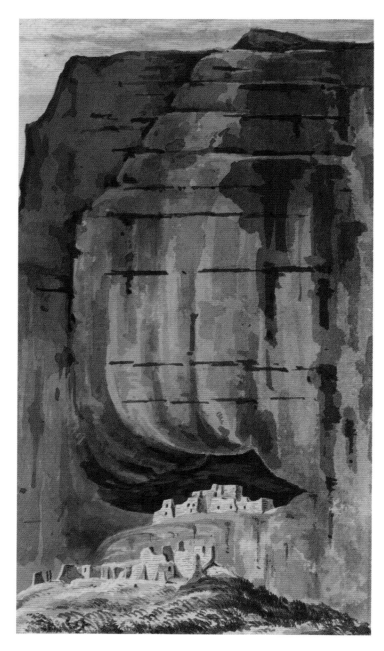

Fig. 22
R. H. KERN
***Ruins of an old pueblo in the Cañon of Chelly**, September 8, 1849*
Black-and-white wash on paper, 7½ × 4⅓ in.
Academy of Natural Sciences of Philadelphia, Ewell Sale Stewart Library,
Collection 146, Kern Drawings of the American Southwest

corn that provided their agricultural lifeline. During the forced march, or "Long Walk," some eight thousand Navajo walked more than three hundred miles to Fort Sumner (Bosque Redondo) along the Pecos River east of their homeland. After disease, starvation, and strained relations with the Mescalero Apache—coprisoners with the Navajo—caused national scandal, the U.S. government relented. In 1868, five years before the Wheeler survey approached the canyon, the Navajo negotiated a treaty that released them from Fort Sumner and provided a new reservation that encompassed the canyon.

In the photograph's caption, Wheeler reports that the Navajo knew nothing about the ancient cave dwellings seen in the photograph, thereby stressing his perception that the structures bore no relation to an American Indian present.[67] O'Sullivan, instead, focused on the scientific and specifically geological imperatives of the Wheeler survey, which the canyon walls displayed to stunning effect. By eliminating any reference to the horizon line where cliff meets sky, O'Sullivan dramatizes the canyon formation, exploiting its otherworldly qualities. The photograph, flattened like the abstract pictographs that may be seen throughout the canyon, provides a diagram of current geological theory and creates a tabula rasa on which is inscribed the history of time. It is no surprise that its aesthetic quality of emphatic flatness would later appeal to early-twentieth-century viewers who valued Modernism's new appreciation for planar surfaces.

O'Sullivan's photograph is a classic testimonial to the nineteenth-century uniformitarian theory of geology. Part of the Defiance Uplift of the Colorado Plateau, the area of Canyon de Chelly was, millions of years ago, an island surrounded by seas. Later, Middle Permian redbeds and de Chelly sandstone were deposited directly on top of the Precambrian basement rocks. The de Chelly sands were once part of a dunefield, evidence of which is clearly articulated in O'Sullivan's photograph showing fossilized sand dunes deposited in a combination of steep-bedded and eolian cross-beddings (the slight shift in horizontal patterning is probably a result of a change in prevailing wind direction). During the late Triassic period (the age of dinosaurs), rivers washing down from nearby uplifted mountains buried the de Chelly sands and formed a hard resistant cap on them, called the Shinarump Conglomerate, which essentially put a lid on advancing erosion.

Although the specifics of this geological description were still coming into view in the nineteenth century, O'Sullivan nonetheless captures its general outlines in the photograph's sharp lyrical detail. He displays the effects of deposition and the formation of the cliffs themselves. These cliffs resulted from river erosion and are maintained by the brittle and fragile canyon walls, which produce vertical fractures and break off in enormous slabs of sharply edged fragments. O'Sullivan also illustrates the phenomenon of desert varnish, a surface coating of manganese and iron oxides concentrated by bacteria. The varnish patterns displayed here intersect and highlight the sandstone cross-bedding. Compared with Richard H. Kern's 1849 watercolor of Canyon de Chelly —the first Euro-American rendering of the White House Ruins, produced during Lt. James H. Simpson's Corps of Engineers Survey of 1849 (fig. 22)—O'Sullivan's photograph suggests an astonishing amount of geological and archaeological information that could be used by scientists and those promoting the American school of geology and the growing field of anthropology. Indeed, the modern technology of photography, in the hands of a skillful artist like O'Sullivan, brilliantly served the survey's needs to diagram space and time, recording the cliffs in nearly infinite detail in the relatively brief period required to make an exposure.

If O'Sullivan's photograph of Canyon de Chelly is a page out of a textbook on geological theory, then *Historic Spanish Record of the Conquest, South Side of Inscription Rock, New Mexico* (fig. 23), also taken on the Wheeler survey in 1873, writes a schematic textbook of the history of the American West. The textbook includes the American Indian, Spanish, Mexican, and Euro-American cultures that left marks of their histories at Inscription Rock. The site, now called El Morro National Monument (*El Morro* means "bluff" in Spanish), is a two-hundred-foot sandstone promontory that stands prominently along the ancient Zuni-Acoma trail in southwestern New Mexico. Called *A'ts'ina*, or "place of writings on rock," by the Zuni (the descendants of the Ancestral Puebloans), Inscription Rock contains more than two thousand inscriptions, petroglyphs, and Ancient Puebloan ruins—a "stone-autograph book," as Charles Lummis, a champion of southwestern life and lore, phrased it in 1892. Its attraction is not difficult to understand: the bluff is lonely amid the flat highlands of the area, and it offered protective covering and a dependable source of water for the ancient

inhabitants and travelers who used the bluff as a campsite for many centuries.

In 1605, two years before English colonialists landed in Jamestown, Virginia, and fifteen years before the Pilgrims settled Plymouth Colony in Massachusetts, Juan de Oñate, a Zacatecan explorer and the first governor of New Mexico, carved the first European inscription into the soft sandstone at El Morro, marking over a previous American Indian petroglyph.[68] Since then, Spanish governors and soldiers, ecclesiastics, immigrants, explorers, and even O'Sullivan himself, who inscribed his name "TH O'Sullivan 1873" behind a now thriving juniper, felt compelled to add their witness to the place, creating, in effect, a community testimonial to the historic and often violent events that occurred in the area.

The first official Euro-American renderings of the site were conducted by Simpson and Kern, artist-topographers who also surveyed Canyon de Chelly. The inscription included in O'Sullivan's photograph was carefully detailed and translated in their 1849 report: "There passed by here the Lieutenant Don Joseph de Payba Basconzelos the year that he brought the council of the realm [the Cabildo of Santa Fe], at his expense, on the 18th of February of the year 1726." Abbé Domenech, a French friar who passed through the area in 1850, published in 1860 an engraving that frames the site within the Euro-American cliché of the awed spectator: a picturesque American Indian gestures toward the cliff to a Euro-American observer, as if to convey its larger meanings to his companion (fig. 24). Thirteen years later, the medium of photography could make a more accurate accounting. Then and now, however, the photograph's abstract legibility makes it vulnerable to potential misunderstanding. Today's viewers, as photographer Rick Dingus has observed, may appreciate the wry humor of O'Sullivan's photograph: the ironic juxtaposition of a three-foot ruler measuring something so historically enormous as the Spanish Conquest of the New World.[69] O'Sullivan and Wheeler, we now know, had something else in mind.

In two different versions of the identical site, O'Sullivan placed his camera close to the ground and focused tightly on the inscription, in the process editing out neighboring texts (figs. 25 and 23). As if to symbolize the purpose of the survey itself, but more practically to measure the actual inscription and to provide scale, O'Sullivan propped a ruler in the corner of the curved surface and

used a rounded root or stick to anchor the opposite end. Either Wheeler or O'Sullivan was dissatisfied with the result of the first photograph (most likely fig. 25). Perhaps the odd bulbous form of the root distracted from the inscription or the placement of the ruler did not appear straight. Symmetry governs O'Sullivan's framing in the second photograph (fig. 23), and in it he makes the inscription far more legible by moving the ruler to the left, raising it as if to underscore the inscription and minimizing the distracting presence of the ruler's anchor. The result is a far more visually satisfying statement.

O'Sullivan took a variety of photographs of various inscriptions at the site, yet he was at pains to make an exemplary photograph of this one. He likely added lampblack to accentuate the inscription and possibly cut back the yucca to expose the caption more fully. Despite the fact that Simpson and Kern had provided an accurate account of this inscription, Wheeler believed he was viewing an inscription dated "1526" (and with good reason, given the flamboyant eighteenth-century "7" of the original) and reported it as such to Simpson in a letter of 1874: "Should it prove that 1526 is the year the subject, from a historical point of view becomes a most interesting one."[70] In the competitive spirit of the survey culture that he helped define, Wheeler believed he had made an astonishing discovery, setting back Spanish government in the area by decades. Subsequent to the 1874 correspondence, he evidently dropped the matter, having been proven incorrect somewhere along the way.[71] This misguided effort

Fig. 23
TIMOTHY O'SULLIVAN
Historic Spanish Record of the Conquest, South Side of Inscription Rock, New Mexico, **1873**
Albumen silver photograph, 8 x 10 in.
Robert G. Lewis Collection

Fig. 24

"Inscription Rock, 1860" woodcut by A. Joliet, published in Abbé Emmanuel Domenech's
Seven Years' Residence in the Great Deserts of North America, vol. 1 (London: Longman,
Green, Longman, and Roberts, 1860), following p. 208

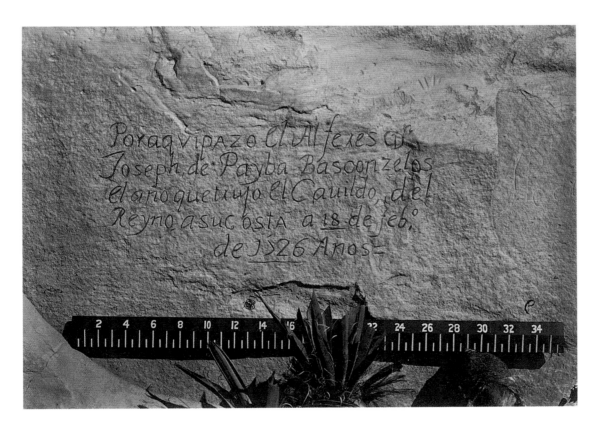

Fig. 25
TIMOTHY O'SULLIVAN
Historic Spanish Record of the Conquest, South Side of Inscription Rock,
New Mexico, No. 3 (Wheeler Survey), **1873**
Albumen photograph on paper mounted on paperboard, 8 x 10 7/8 in.
Smithsonian American Art Museum, Museum purchase from the Charles Isaacs
Collection made possible in part by the Luisita L. and Franz H. Denghausen
Endowment, 1994.91.137

to correct history helps explain O'Sullivan's attention to the photograph's legibility.

In its dedication to using photography for scientific and historical ends, O'Sullivan's work is remarkably similar to an image by Francis Frith, which shows the Sinaitic rock inscriptions at Wádee El-Mukattab, Sinai, in about 1857 (fig. 26). In the eighteenth century and well into the nineteenth, many scholars and ecclesiastics believed the inscriptions were those of the Israelites of the Exodus, and thus demonstrated proof of the Bible. Frith's position in the debate is unknown, but his photograph undoubtedly added to it, giving visual evidence of what turned out to be Nebataean versions of Aramaic script, inscribed on rocks by shepherds who left their names and messages of peace and goodwill. Historic graffiti, as Frith and O'Sullivan show us, contained so much promise

and hope in their mysterious calligraphic lines. And it is a great paradox of nineteenth-century photography that *Historic Spanish Record*, one of the most famous images of the American West, is a photograph *manqué*, so graphically emphatic in its intentions to rewrite history and yet fundamentally wide of the mark. *Historic Spanish Record* represents high hopes dashed in a place mythically constructed to be a land of great promise but, in the end, a place in which "felt values" depended on the viewpoints of individuals of many cultures—individuals whose voices are still being unearthed.

CHANGING SPACES

In 1875, the same year in which Thomas Moran painted *Mountain of the Holy Cross* and in the same decade survey

Fig. 26
FRANCIS FRITH
Sinaitic Inscriptions in Wádee El-Mukattab, Sinai, c. 1857
Albumen photograph, 6 3/8 x 9 1/16 in.
San Francisco Museum of Modern Art, Gift of Michael Wilson / The Wilson Centre for Photography

photography reached its peak, such Plains Indian artists as Cheyenne Bear's Heart (1851–1882) and Little Chief, or Koweonarre (1854–1923), took account of the spatial dislocations that forever altered their native histories. They produced a powerful body of work called ledger drawings.[72] These drawings demonstrate a dramatic alternative to the Euro-American concept of landmarking—and the sense of ownership, of mapping, and of making the land useful that the word implies—by their implications that the land is inseparable from life. Plains Indian drawings (and Amerindian art in general) do not reflect the concept of landmarks because these native cultures traditionally internalized the landscape and viewed themselves as inseparable from it. Landscape, in other words, is not an American Indian art tradition. We see this brought to life in nineteenth-century ledger drawings

that represent disruption, when forced removal from the land dealt the most devastating blow to Indian cultures by depriving them of a centuries-old sense of place.

Using ledger or account books, sketchbooks, muslin, colored pencils, watercolors, and ink, often provided by the military or settlers, Plains Indians recounted their histories and lifeways in an abstract pictographic style that derives from an older native tradition of hide painting. Bear's Heart and Little Chief were among the more than seventy warriors and chiefs incarcerated at Fort Marion in St. Augustine, Florida, in 1875 (fig. 27). These warrior-artists were encouraged by the prison's officer-in-charge, Captain Richard H. Pratt, to use sketchbooks for recording their old customs and their new experiences in a "before-and-after" format that draws attention to the ways in which American Indians responded

Fig. 27
Capt. R. H. Pratt with Indian prisoners at Fort Marion, Florida, c. 1876.
Little Chief (Koweonarre) appears in the front row, far left.
Bear's Heart is in the third row, far left.
The Fort Sill National Historic Landmark, Fort Sill, Oklahoma

to an acculturation process. Pratt encouraged the St. Augustine community and tourists to purchase the drawings, which he believed would foster positive interaction of the prisoners and local population and thus facilitate the prisoners' assimilation and Americanization.

These spare but potent drawings share with survey photography an abstract legibility that derives, in part, from a common need to make new spaces comprehensible, either those of the photographer, who interpreted the vast western landscape, or those of the Plains Indians, who tried to make sense of reservations and the new landscapes they were forced to inhabit. Because most tribes conceived of history in terms of space and place rather than time, their names and everything they symbolized formed the organizing principle of their lives. As anthropologist Keith Basso explains, "For Indian men and women, the past lies embedded in features of the earth—in canyons and lakes, mountains and arroyos, rocks and vacant fields—which together endow their lands with multiple forms of significance that reach into their lives and shape the ways they think. Knowledge of places is therefore closely linked to knowledge of the self, to grasping one's position in the larger scheme of things, including one's own community, and to securing a confident sense of who one is as a person."[73] To remove Indians from their homelands, to take away their sense of place, was to obliterate their identity and turn their worldview upside down, a development embodied in such drawings as *Troops Amassed against a Cheyenne Village* by Bear's Heart (fig. 28).

Once owned by historian and Bostonian Francis Parkman, *Troops Amassed against a Cheyenne Village* appears in a drawing book containing works by a number of artists. Bear's Heart takes advantage of the book's spine to create two separate spaces, that of the American soldiers, at left, and of the Cheyenne warriors, at right. The picture of the Cheyenne world deviates from pre-reservation artistic practice that leaves the page, or "background," blank. Here Bear's Heart uses western artistic traditions to indicate environment by including trees, clouds, and green grass as a background for the tepees and the warriors on foot or horseback. At left, three rows of soldiers appear in a space emptied of environment, which underscores their physical presence. According to contemporary artist Edgar Heap of Birds, the soldiers form "an endless line, a continuous, never-ending onslaught," that represents in general "the linearity of the white aggressor."[74]

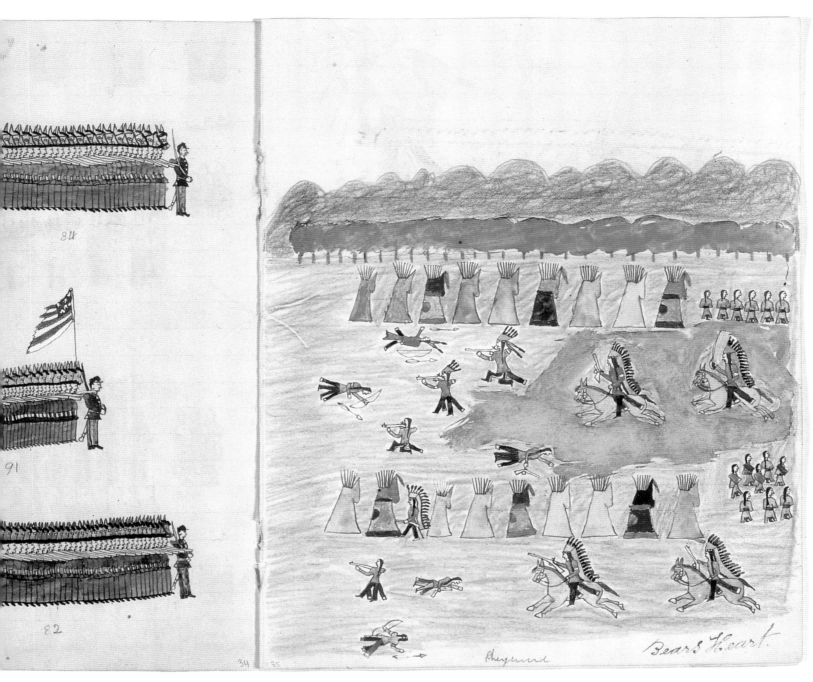

Fig. 28
BEAR'S HEART
Troops Amassed against a Cheyenne Village (part of a ledger book created by Fort Marion Indians), 1876–77
Pencil and ink on paper, 8 x 12⁷/₈ in.
Massachusetts Historical Society Manuscript Collection

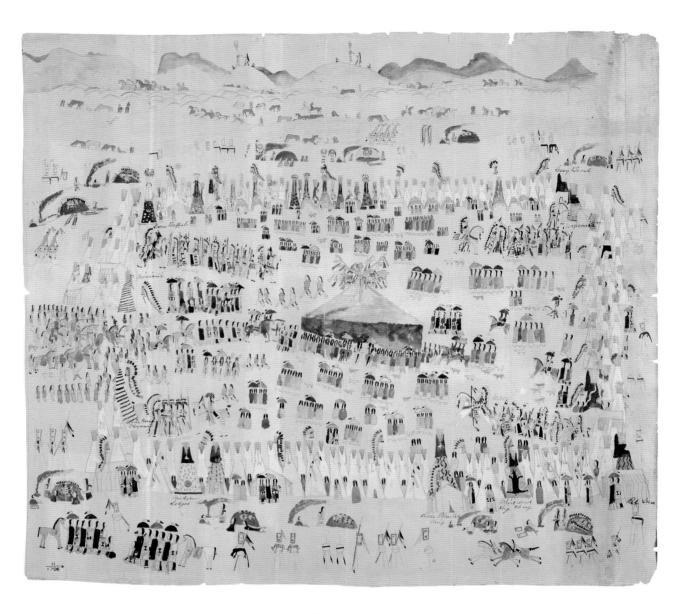

Fig. 29
ATTRIBUTED TO KOWEONARRE (LITTLE CHIEF)
Cheyenne Medicine Lodge, c. 1870
Ink, pencil, and watercolor on paper, 23 ½ x 26 in.
National Museum of the American Indian, Smithsonian Institution,
Washington, D.C. (11.1706)

This linearity is opposed to the cyclical and circular worldview implied by the more random spatial arrangement, at right, and more generally affirmed in another masterwork by Little Chief and possibly Bear's Heart, *Cheyenne Medicine Lodge* (fig. 29). In this work, which art historian Janet Berlo describes as a diagram of the orderly Cheyenne world, more than eight hundred figures and objects are organized into a sacred circle in an enactment of the summer Sun Dance.[75]

In *Troops Amassed against a Cheyenne Village*, the U.S. military's strict deportment and uniform discipline are rendered by abstract design, like a woven textile with patterns reiterated until the end of a row is reached. Indeed, the pattern of the soldiers that runs off the page and implies an infinite line inhibits individual portraits and instead suggests the soldiers through strong, recurring horizontal and vertical lines. Zigzag markings make their way across the page to suggest the ears of the cavalry horses. This interaction of traditional western styles (the western schematic indication of background to portray the Cheyenne world) and native traditions (American Indian abstract design to convey the white world) gives this drawing its force and verve as Bear's Heart moves between two idioms to suggest a way of life under siege and in transition.

The complexity of space and place expressed in American Indian drawings testifies to the West's new status as modern ground. Bear's Heart and other artists like him carefully delineated the flux and disruption associated with changing spaces. As disruption, violence, and transition characterized the realities of the newly remade West, its representation in paintings and photographs would begin to assume the look of being unmoored, vague, mysterious, placeless, and aestheticized. To be sure, aesthetic shifts in American art account, in part, for this change in appearance. But when artists combined the subject of western physical space with aesthetic changes in art, they turned the West into a psychological space that in its emphasis on mood and feeling somehow made the West easier to comprehend and negotiate because, in fact, it had been set adrift. Once the concept of landmarking as a means of knowing moved to the background, turn-of-the-nineteenth-century artists re-created the West by personalizing and transforming it into a site for introspection, nostalgia, loss, psychological release, and exhilaration.

The End of the Frontier: Making the West Artistic

In his study of the power of maps, geographer and writer Denis Wood tells us that maps "link the territory with what comes with it."[1] This observation is helpful when we apply it to nineteenth-century American maps. While sixteenth- and seventeenth-century maps presented North America as densely inhabited, with colonial and American Indian villages side by side or in close proximity to one another, nineteenth-century American maps altered this view of settled lands.[2] The West was presented as either uninhabited space or dotted with an occasional American Indian. For example, children in the 1820s who studied Emma Willard's widely circulated textbook, *History of the United States, or Republic of America*, and its accompanying atlas saw empty land awaiting settlement west of the Mississippi and Missouri Rivers (fig. 30)—disregarding the American Indian nations that had lived there for centuries or the Spanish who had taken control of the Southwest shortly before English colonialists had settled Jamestown in 1605. In these maps the West looks surprisingly uncomplicated.

Popular prints, such as Fanny Palmer's *Across the Continent: Westward the Course of Empire Takes Its Way* (1868; fig. 31), show how the vacant spaces of maps correlated with widely circulated images of the "empty" West in the nineteenth century. In the public's mind, such maps, prints, and other images of the West—along with written commentaries that focused on the "American Desert"—helped reinforce the ideology of Manifest Destiny and heroic ideals of westward expansion. In the foreground of Palmer's print, civilization has been carved out of the raw prairie and is symbolized by a bustling village with its public school proudly displayed. In

the empty spaces of the background, viewers could imagine the many towns, just like the one pictured here, stretching infinitely into the future. Conestoga wagons, at left, making their slow journey out of the village are preceded by a trail of similar ones glimpsed in the distance. Next come the telegraph and railroad, with parallel lines of tracks stretching toward the horizon, paving the way for the process of filling in with the elements of Civilization. In fact, Palmer's image asserts a fundamental perception about Manifest Destiny in American culture that would continue well into the twentieth century: the optimism of expansion evoked by busy pioneers and playful children, at left. We see the cost of that perceived progress, at right: the compromised First Americans who are placed on the other side of the railroad tracks and who will soon disappear in a trail of steam.

This visual construct of the West as an empty space awaiting settlement would soon receive a powerful makeover. In 1890 the U.S. Bureau of the Census had declared that the frontier line was no longer extant. The declaration defined a frontier as having no more than two people per square mile. Based on this metric, westward expansion was thus concluded. Three years after the Census Bureau published its findings, a thirty-two-year-old professor from the University of Wisconsin, Frederick Jackson Turner, reflected on the statistics and the bureau's ruling. Presenting a paper titled "The Significance of the Frontier in American History" at the American History Conference held during the World's Columbian Exposition in Chicago in 1893, Turner was little heralded at the time. In contrast, not far from his podium thousands applauded the gunslingers and Indian warriors enacting battles in Buffalo

Fig. 30
Eighth map in the bound series of maps that accompanies Emma Willard's
History of the United States, or Republic of America...(New York, 1828)
Case folio G1201 S1 W5 1828
The Newberry Library, Chicago

Fig. 31
FRANCES F. PALMER
Across the Continent: Westward the Course of Empire Takes Its Way
Colored lithograph by Currier & Ives, 1868
Museum of the City of New York, Harry T. Peters Collection

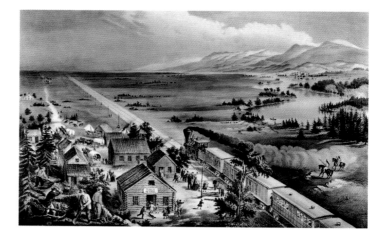

Bill Cody's Wild West Show. With bold rhetorical flourishes, Turner argued, "The existence of an area of free land, its continuous recession, and the advance of American settlement westward, explain American development."[3] Borrowing a model of social growth and change from Charles Darwin's theory of evolutionary biology, Turner claimed that pioneers became Americans by westering: "The frontier is the line of most rapid and effective Americanization." Also a geographically determinist argument, Turner's "frontier thesis" asserted that the American character, admired for its perceived traits of individualism, inventiveness, optimism, and self-respect, and for its honed reverence for freedom and democracy, was shaped by the westering experience. Turner initiated a new understanding of national identity at the turn of the last century and carved out a new academic discipline, western history.

The Turner thesis represented a paradigm shift in American history, one contemporary historian calling it "the single most influential piece of writing in the history of American history."[4] Turner's Anglo-triumphalist argument was taken up most notably and advanced by Presidents Theodore Roosevelt and Woodrow Wilson. Typical of powerful theories, this one has inherent flaws, but contemporary historians have put Turner's thesis in context and stress that it encapsulated the concerns and worries of the modern age.[5] Propelling Turner was his belief that if the frontier were closed and the process of westering therefore coming to an end, Americans would face undue challenges to ensure democracy and to maintain the heroic American character fostered by frontier life. He thus declared the end of the "first period," as he phrased it, in American history. By doing so, he preserved in amber a certain image of the West. Turner gave full license to turn the West into a region defined by memory and nostalgia, making it a symbol of what was irretrievably lost.[6]

Turner's thesis had profound aesthetic implications. Nostalgia and progress form two sides of the coin of Modernism, or, as Svetlana Boym describes it, "like Jekyll and Hyde: alter egos."[7] Like a coin, the faces are different but meaningless without the other side to help give them value. In this model of mutual definition, the rush to the future was accompanied by an intense longing for the past. In the process, in the last decades of the nineteenth century, perceptions of nature fundamentally changed. Although nineteenth-century landscape painting traditions, as represented by Thomas

Moran, emphasized the artist's direct contact with nature and the importance of that relationship, toward the end of the century, fieldwork no longer held its supreme value. Nature, of course, did not vanish, but American artists personalized their interactions with nature and made American landscapes aesthetic. Nature dissolved into a matter of light and air, as in Impressionism—a vague term in the context of late-nineteenth-century American art that generally applies to paintings that display a brightened palette, abruptly fragmented or cropped spaces, and skittering brushwork. Or nature stood for states of emotion, as in the roughly concurrent artistic trend of Tonalism, in which muted colors and gentle brushwork produced subtle, diaphanous, and ethereal paintings of mood. Related to the latter, Pictorialism refers to a trend in photography in the late nineteenth and early twentieth centuries. Pictorialists sought to have photography recognized as an art form. They adopted the painterly effects and minimal color harmonies of Tonalist works, producing soft-focus photographs in varying shades of gray.

By externalizing their very personal reactions to the western landscape, essentially claiming it as their own, turn-of-the-century American artists effectively made the West artistic by aestheticizing western nature. Intertwining such trends as Impressionism, Tonalism, and Pictorialism, they helped reify Turner's thesis, making the West look like a timeless, sepia-toned or strangely colored dreamworld that was closed off, distinct, and isolated from the "outside world," or from time itself. In effect, these artists shaped the West into an escape from modern urban life. Thus, the "end" or the *purpose* of the frontier was to make the West variously a refuge, a stage for nationalist heroics, or a place in which to reach a higher plane of spirituality. This concept recalls concurrent trends in France that saw artists escaping from Paris to remote places perceived to be in closer touch with a preindustrial past: Paul Gauguin in Tahiti is a prime example of a kind of artistic colonialism. The development in the art of the American West at the turn of the twentieth century may be understood, if only briefly here, in terms of this larger tendency.

THE CONSTRUCT OF VACANCY AND ITS RELATIONSHIP TO THE VANISHING

Expansive, relatively empty spaces were not new to late-nineteenth-century American painting. Artists often called

Luminists, such as Martin Johnson Heade, Sanford Robinson Gifford, and Worthington Whittredge, used long rectangular canvases to emphasize sparsely defined panoramic landscapes infused with light. Empty space assumed added meanings and inflections when it represented the American West. Not only were the endless spaces of the West's deserts and prairies a geographic reality, they were associated with expansion, imagined as a stage on which American values would be shaped, and conceptualized as a symbol of what was lost. Recalling Turner and his frontier-closure thesis, artist Frederic Remington (1861–1909) used the metaphor of the theater to

note in 1907 that the West "took up its blankets and marched off the board; the curtain came down and a new act was in progress."[8] In the cultural atmosphere of nostalgia for the "Old" West that Remington's description evokes, a model of cultural salvage took root and informed the careers of some of the country's major painters and photographers.

In 1905, from his studio outside New York City, Remington reminisced about frontier days in the West: "I knew the wild riders and the vacant land were about to vanish forever….I began to try to record some facts around me, and the more I looked, the more the panorama unfolded."[9] Recounting

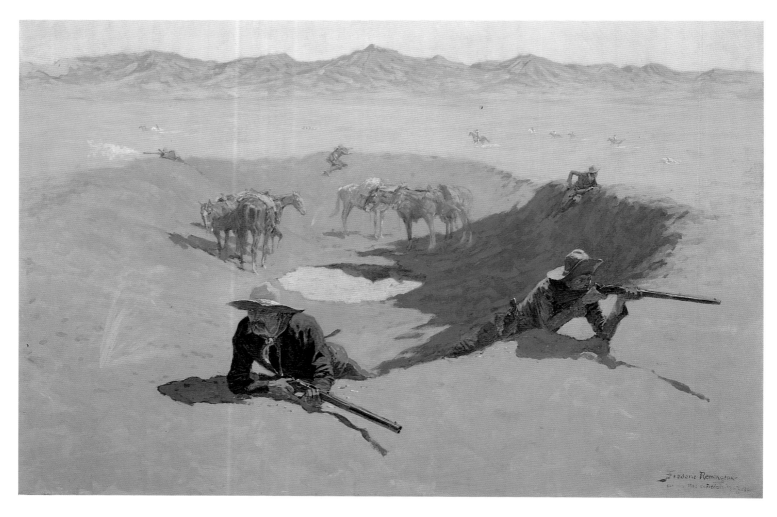

Fig. 32
FREDERIC REMINGTON
Fight for the Water Hole
(An Arizona Water Hole)
(A Water-Hole in the Arizona Desert), 1903
Oil on canvas, 27 1/8 x 40 1/8 in.
The Museum of Fine Arts, Houston, the Hogg Brothers Collection, gift of Miss Ima Hogg

the course of his career (from Kansas sheep farmer and saloon owner to magazine illustrator and New York painter), Remington seized on the persistent western metaphors of "vacant" and "vanishing" to explain his contributions to American art. His sense of his own artistic legacy, an artist who produced an image of the West as a heroic battleground for westward expansion, was reinforced at the White House by President Theodore Roosevelt. In 1907 Roosevelt wrote authoritatively about Remington: "I regard Frederic Remington as one of the Americans who has done real work for this country....He is, of course, one of the most typical American artists we have ever had, and he portrayed a most characteristic and yet *vanishing* type of American life. The soldier, the cowboy and rancher, the Indian, the horses and cattle of the plains, will live in his pictures and bronzes, I verily believe, for all time....It is no small thing for the nation that such an artist and man of letters should arise to make a *permanent record* of certain of the most interesting features of our national life" [emphasis added].[10]

Roosevelt's tribute to the artist makes it clear that he thought of Remington in terms of preservation, perhaps even viewing his art as a sociological and ethnological adjunct to the president's own efforts at land and wildlife preservation. These initiatives had an enormous effect on the West and served as a hallmark of his presidency.[11] Roosevelt championed Remington because his art celebrated American individualism, self-reliance, and stamina—qualities that Roosevelt and other privileged men valued highly and considered endangered. It is no accident that Remington's *Fight for the Water Hole* (1903; fig. 32), a painting that celebrates the heroism and bravery of a last-stand fight for survival, appeared as a frontispiece in the fourth volume (1904 edition) of Roosevelt's sweeping saga, *Winning of the West* (1889–96).

Remington's knowledge of the West developed from his frequent trips there to make sketches, take photographs, and buy artifacts of Native American and frontier life (fig. 33). Back in his New York studio, he created paintings and produced sculptures that chronicled the vanquished American Indian cultures and popularized the cowboy as a national folk hero. Remington distilled his subjects from a number of sources. *Fight for the Water Hole*, for example, draws on numerous paintings he produced on the subject of the circle of death, a motif that derives from a common military strategy; on a photograph he took of a water hole at the Sierra

Bonita Ranch in Arizona; and on stories and images of the Buffalo Wallow Fight in the Texas Panhandle during the Indian Wars. Remington certainly viewed one of John Henry Twachtman's paintings from his series on the Emerald Pool at Yellowstone (c. 1895) at Twachtman's estate exhibition in 1903 (see figs. 46–48).[12] Remington specifically admired the work of this artist and undoubtedly took note of the depiction of a deep crevasse on a two-dimensional surface as he began work on *Fight for the Water Hole* later that year (fig. 34).

Remington's water hole, however, could not be more different from Twachtman's paintings of Yellowstone's Emerald Pool. Remington used the water hole not for its mesmerizing effects but for its possibilities for heroic drama. This desperately inadequate water hole is a source of survival and protection. Simultaneously it underscores the fight for survival among cultures and in an environment defined by its aridity. Dividing the painting into broad bands of color, Remington places the viewer slightly above the action, a bird's-eye view close enough to catch the alert gaze and beady eyes of the gunman at left. Then the artist takes the viewer up and across a scorching desert plain, over which purple mountains rise in the distance. This sweeping movement intensifies the vast lateral expanse Remington skillfully implies as endless terrain. By composing the drama in a circle radiating outward, Remington could convey a land without end. This strategy renders the water hole itself a monumental event within the landscape, a metonymic reference to the narrative unfolding on center stage. Against this broad background, Remington positions five gunmen and their horses in an enormous hole. A long shadow on the right side of the hole, which signifies the close of day, ominously foretells the idea of passing: specifically, the ever-present threat of death in the West during the Indian Wars and, generally, the end of the "Old" West itself. In his rendering of a confrontation between peoples and against nature, Remington reinforced cultural constructs of loss and nostalgia by turning them into visual equivalents of vacancy and vanishing.

In *The Scout: Friends or Foes?* (1902–5; fig. 35), Remington paints an even starker landscape than that in *Fight for the Water Hole*. A large field of blue-white snow is divided diagonally in two and is capped by a stretch of twilight sky dotted with evening stars. The trope of expansiveness was noted by a 1905 critic, who observed how the horse and rider "contrasted with the broad, empty spaces, giving a

Fig. 33
Remington painting in the Badlands
Courtesy Frederic Remington Art Museum, Ogdensburg, New York

Fig. 34
FREDERIC REMINGTON
Study for *An Arizona Water Hole*, c. 1903
Oil on board, 12 x 17 7/8 in.
Buffalo Bill Historical Center, Cody, Wyoming, Gift of the Coe Foundation, 57.67

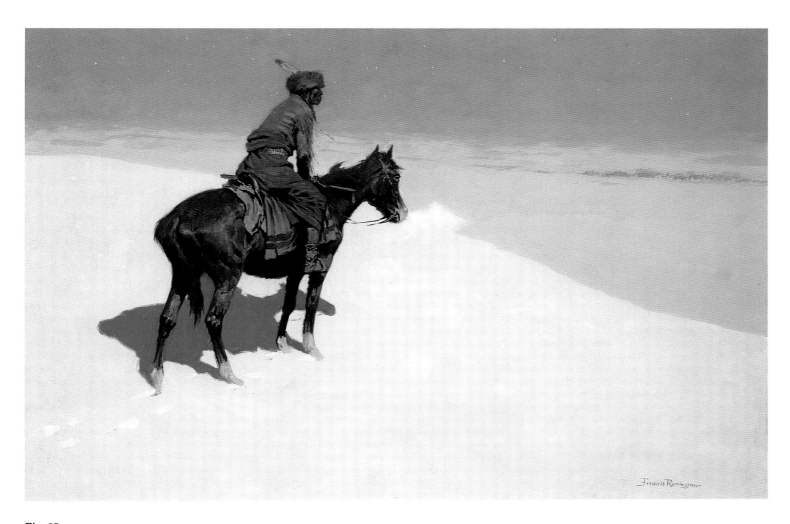

Fig. 35
FREDERIC REMINGTON
The Scout: Friends or Foes?
(The Scout: Friends or Enemies?), 1902–5
Oil on canvas, 27 x 40 in.
Sterling and Francine Clark Art Institute, Williamstown, Massachusetts

sense of the endless plains."[13] Here snowy plains in twilight are marked only by a Blackfoot scout who surveys the encampment below. Remington positions him heroically against a sweeping landscape, but at the same time metaphorically pictures the isolated scout standing on the edge of a precipice as the last of his race.

Throughout his career Remington reused earlier commissions for magazine illustrations. He had been sent to the Blackfoot reservation south of Bow River on the border between Alberta and northwestern Montana and would use those sketches later to produce increasingly simplified and ambiguous paintings. As he noted in 1903, "Big art is a process of elimination…cut down and out—do your hardest work outside the picture, and let your audience take away something to imagine.…What you want to do is to just create the thought—materialize the spirit of a thing…then your audience discovers the thing you held back, and that's skill."[14] Deliberately making the narrative ambiguous—it is unclear for whom the Blackfoot Indian is scouting or what kind of encampment, military or Indian, he sees in the distance— Remington reduces the image to a stretch of empty plains and a carefully depicted scout in a posture of tense alertness, cast in shadow and leaving evanescent tracks in the snow. The poses of both the Indian and the horse, which tucks its tail between its legs, suggest alarm, as if sensing danger. The snowy ether in which the Blackfoot is left to float—even the horse's hooves begin to disappear—heightens the tension and creates a mood of suspense. In nocturnes, or paintings of night or twilight such as this one, which Remington began painting in 1901, their evocative mood and supernatural qualities made the West look like a timeless dreamworld.[15] The visual motif of vacancy helps suspend the Blackfoot man in time and space. Further, the motif creates an inchoate netherworld that the scout will survey before, as Remington implies, he disappears into nothingness.

Although Remington's paintings concentrate primarily on human drama, landscape plays an important role in the telling of his tales. His stark, barren backgrounds help define the western landscape as a place of struggle among peoples and against a forbidding nature. Before Remington, only a few artist-explorers recognized or exploited the artistic possibilities of the western plains and deserts. Remington seized upon the abstract qualities of these terrains, creating a powerful and expressive role for the landscape. Although his back-

grounds are commonly referred to as generic, vague, or empty, these qualities serve to reinforce the idea of an empty space to be filled, of a vast place where heroic dramas could be enacted, or from where indigenous cultures might vanish into thin air.

American photographers Edward Sheriff Curtis (1868– 1952) and Erwin E. Smith (1884–1947) likewise depended on the trope of the vanishing West to sustain their careers at the turn of the twentieth century. While Curtis focused on American Indians, Smith photographed ranch life on the plains. Their cultural salvage projects were based on a fallacy, however, as neither American Indian cultures nor cowboys were or are extinct. To the contrary, Census Bureau statistics put the Native American population at 250,000 in the 1890s (compared with 2.5 million today), and on numerous ranches and farms throughout the West and in countless county rodeos, cowboy lifeways demonstrate a tale of endurance and survival.[16]

Curtis dedicated his entire life, losing his wife and his fortune in the process, to documenting American Indian culture, which he portrayed as being inextricably bound to the landscape (fig. 36). The result was a mammoth project, *The North American Indian*, which consists of twenty volumes of text (published between 1907 and 1930), accompanied by fifteen hundred photogravure prints and wax-cylinder sound recordings that document about eighty Indian tribes in western North America. The *New York Herald* called this project "the most gigantic undertaking in the making of books since the King James edition of the Bible."[17] It was enormously expensive, totaling about $1.2 million, of which $400,000 was largely funded by New York financier J. Pierpont Morgan.

Endorsed by President Theodore Roosevelt, who supported Curtis's preservation efforts and wrote the foreword to the first volume, and edited by Frederick Hodge of the Smithsonian Institution's Bureau of American Ethnography, *The North American Indian* touted a historic and scientific authority not fully supported by the stunning sepia-toned photographs in the books. Curtis himself noted in the introduction that he did not seek to record American Indian life "in microscopic detail" but rather to convey a "broad and luminous picture" of it. Seizing on the tenets of Pictorialism, Curtis created soft-focus images of a highly constructed preindustrial Native past that have retained their hold on the present. Both vilified and celebrated, Curtis's photographs

remain at the center of heated debates among American Indians and Euro-Americans alike. The cultivation of Curtis's sense of aesthetic beauty, a cultural norm of the time, lies at the heart of the debates. Some see the perpetuation of Euro-American stereotypes of the "noble savage" in Curtis's photographs, which emphasize delicate tones of light and shade and rely on props and poses that Curtis selected to sustain his nostalgic vision. Others agree with the statement of one writer who asserts, "Never before [Curtis] have we seen the Indians of North America so close to the origins of their humanity, their sense of themselves in the world, their innate dignity and self-possession."[18]

Born and reared in Wisconsin, Curtis moved to the Pacific Northwest as a young man. Virtually self-taught, he began his career as a survey photographer, participating in one of the last of the nineteenth-century surveys. Traveling to Alaska in 1899 to record Arctic geology and Native cultures, he began to undertake his life's work following a job photographing Montana's Blackfoot tribe the next year. In conceiving his ambitious project on the North American Indian, Curtis drew on an older tradition in American art. In the 1820s the commissioner of Indian affairs, Thomas McKenney, hired Charles Bird King and other artists to paint portraits of American Indians from tribes who were visiting Washington, D.C., to attend treaty negotiations. In the 1830s George Catlin carved a niche for himself by documenting all of the North American tribes, taking McKenney's project one step further by painting American Indian tribes in their native surroundings. These projects shared the goal of making a permanent record of vanishing peoples. This concept of "vanishing" had a long history drawn from literature, specifically in Jean-Jacques Rousseau's and François-Auguste-René Chateaubriand's romantic definition of the "noble savage" in the late eighteenth and nineteenth centuries. In this concept the American Indian is cast as uncorrupted, serene, and doomed to extinction because of his incompatibility with modern commercial society. It is astonishing to reflect that, in the more than one hundred years that transpired between the time of Rousseau, and that of McKenney and Curtis, a belief persisted that the American Indian could not survive the encroachment of the white man, as if this belief were a self-fulfilling prophecy.

In the framing of his monumental narrative, Curtis was clear that he was presenting to his audiences a world that no longer existed, and his photographs are filled with a sense of melancholy that permeates the entire project. Starting on a note of high drama, the first plate of volume one is titled "The Vanishing Race—Navaho," and Curtis notes in the text that he wished to convey the idea "that the Indians as a race… are passing into the darkness of an unknown future" (fig. 37). As an example of the push-pull effect of turn-of the-century American modernity, the Pictorialist aesthetic helped reinforce the vision of the West as a dreamworld that will vanish in the time it takes one simply to awaken. Curtis is persistent in never allowing his audiences to entertain alternative notions of an American Indian present. He used a nineteenth-century invention—the camera—to blur then-contemporary figures and details so as to distance his scenes from modern life in the first decade of the twentieth century.

In his canonical photograph *Canyon de Chelly* (1904; fig. 38), for example, Curtis captures a group of Navajo astride their horses making their way across the canyon floor.

Fig. 36
Untitled (Edward S. Curtis with Indians), **undated**
Hand-colored gelatin silver photograph
From the collection of Christopher Cardozo

Towering rock columns with conchoidal bases, their cliff walls pitted by fracturing, provide an eerie backdrop for these anonymous figures. The Navajo procession follows the emphatic horizontal lines of the canyon floor that represent distant washes in the moist beds that stretch on end. As the Navajo move across the space of the photograph, mere shades set within the banded space of a sun-drenched canyon floor, they and their slow journey appear timeless, the moon-like surface of the landscape emphasizing the strange effect of their environment. In what may be an unposed photograph, Curtis obscures what must have been, in fact, a prosaic event: horses and riders move eastward toward Wild Cherry Canyon on their way back from, presumably, a day of trading at nearby Chinle. As an image suspended in place and time, this photograph is spellbinding. Curtis's recovery project was predicated on the false concept that the American Indian had vanished. Yet the mesmerizing effects of this work and of his other photographs obscure this fact, thus creating a paradox.[19]

At about the same time that Curtis embarked on his lifelong project, Erwin E. Smith began photographing ranches in Texas, New Mexico, and Arizona, finding his calling in making a record of cowboys, ranches, and a way of life he mistakenly believed was disappearing. True, the invention of barbed wire and the close of the open range, new kinds of domesticated cattle, and new railroad lines that made long cattle drives a relic of the past were only a few of the developments that altered the course of ranch life at the turn of the last century.[20] But certainly Smith's chief supporter and champion, the journalist Harry Peton Steger, was incorrect when he claimed in 1908 that "cowboy life and ranches of more than a thousand acres would disappear within ten years."[21]

Smith was born in Bonham, Texas, and was reared on his uncle's ranch in the Texas Panhandle, as well as on popular western literature and on the art of Frederic Remington and other painters and photographers of the West.[22] Photography was not Smith's initial medium of choice. Demonstrating

Fig. 37
EDWARD S. CURTIS
The Vanishing Race, c. 1905
Orotone photograph
The Museum of Fine Arts, Houston, Gift of Peter R. Coneway in honor of Robert Devlin and Jon P. Newton at "One Great Night in November, 1999"

Fig. 38
EDWARD S. CURTIS
Canyon de Chelly, 1904
Toned gelatin silver print, 7⁷/₈ x 9⁷/₈ in.
Amon Carter Museum, Fort Worth, Texas, P1979.54.3

Fig. 39
ERWIN E. SMITH
The Dust of the Drags, Three Block Range, near Richardson, New Mexico, 1908–9
Gelatin silver photograph, 10 x 14 in.
The Center for American History, The University of Texas at Austin

Fig. 40
FREDERIC REMINGTON
The Last Cavalier, 1895
Oil on board, 23 x 35 in.
Published as a halftone illustration in *Harper's Monthly* (September 1895): 605

artistic talent and skill at a young age, he attended the Art Institute of Chicago, where he studied sculpture from 1905 to 1907. His schoolmate was another artist from the prairie, Wisconsin-born Georgia O'Keeffe. She, like Smith, would find in the open plains new, alluring, and powerful artistic ground. Smith then attended the School of the Museum of Fine Arts, Boston, from 1907 to 1910, continuing his study of sculpture. He found that his photographs, which he used as an aide-mémoire, were becoming increasingly important unto themselves. Smith was not associated with then-prevalent camera clubs; rather, he served as a commercial photographer for publications in the same way Remington had worked for commercial magazines before creating art for public exhibitions and gallery shows. Like Remington, Smith carved out a niche of his own by concentrating on ranch life, and he approached his subject with the same zeal he held for preservation.

As in any cultural salvage project, authenticity was key. Having worked summers during his youth as a cowhand on his uncle's ranch, Smith had an insider's knowledge of cowboy life. Steger promoted "the authenticity of Smith's photographs compared to the most picturesque aberrations of cowboy life found in popular art, literature, and theater."[23]

Yet, like Curtis, Smith posed his sitters, jotting down in his notebook compositions inspired by paintings and prints by Remington and other western artists and then arranging for scenes to be reenacted before his camera.[24] It is difficult to imagine that Smith could have made his photographs without knowledge of Remington's art. *The Dust of the Drags, Three Block Range, near Richardson, New Mexico* (1908–9; fig. 39) reveals a dry, flat landscape scene of cowboys, hazily seen through a cloud of dust that has been stirred up by stray cattle during a roundup. Smith chose legendary ranches as the subjects of his images, and in this photograph we see the Block Ranch, also known as El Capitan Land and Cattle Company, located west of Roswell and owned and managed by the Richardson family, who had moved from Ohio in the late 1800s to establish enormous ranches in Lincoln and Otero Counties of New Mexico. Although Smith captures a roundup scene, in composing the photograph he undoubtedly was aware of a series of five Remington illustrations accompanying Owen Wister's "The Evolution of the Cow-Puncher," the first celebrated statement of cowboy mythology, which was

published in *Harper's Monthly* in September 1895. Remington had encouraged Wister to write an article on the evolution of the cowboy, "the passing as it were," Remington wrote in 1894.[25] Although he had informed Wister that the cowboy represented a cultural hybrid, Wister transformed the figure into a latter-day Saxon lord from England, a modern medieval knight. Remington illustrated this "new cowboy" vividly in the accompanying illustration, *The Last Cavalier* (1895; fig. 40), which sets the western cowboy against a ghostly backdrop of his mounted ancestors. By implication and underscored by the final illustration in the story, *The Fall of the Cow-boy* (1895, Amon Carter Museum, Fort Worth), the cowboy will follow his ancestors and fade into history. Remington would continue the theme of the vanishing cowboy in later years. *Ghosts of the Past* (c. 1908, Buffalo Bill Historical Center, Cody, Wyoming), painted at roughly the same time that Smith composed *The Dust of the Drags*, similarly portrays cowboys disappearing into a twilight landscape. Smith, in delivering his scene of vanishing life in the same pictorial language as Remington, played on audience expectations of loss and nostalgia. By using a camera, Smith claimed a higher level of authority because he was undoubtedly there; the dust on the negative comes through on the printed photograph.

Just as Remington became associated with images of cowboys, Henry F. Farny (1847–1916) became known as an Indian painter and likewise earned support from his friend Theodore Roosevelt, who viewed Farny's lyrical paintings of Plains Indians as a veritable preservation project. In Farny's obituary, Roosevelt is quoted as saying, "The nation owes him a debt because he has preserved one of the most interesting phases of American life."[26] Farny's contact with various American Indian tribes came at a young age, and in time the artist would be adopted by both the Zuni and the Sioux. Alsatian-born, Farny moved with his family in 1853 to western Pennsylvania, where he became acquainted with members of the Seneca nation. He worked briefly as an illustrator for *Harper's Weekly* in New York before pursuing further artistic training in Rome and Düsseldorf, Germany, a center for aspiring American artists. In Düsseldorf Farny met Albert Bierstadt, who encouraged him to visit and paint the American West. A stint designing for McGuffey's Readers gave him the resources to make his first trip to the West. On this and three other trips, Farny, like Remington, gathered the stories

Fig. 41
HENRY F. FARNY
Morning of a New Day, 1906
Oil on canvas, 18 ⅝ x 28 ⅝ in.
Private collection, Wyoming

and images that he would use repeatedly and imaginatively throughout his career.

In 1881 Farny visited Standing Rock Agency (Fort Yates), in Dakota Territory west of the Missouri River on the border between what is now North and South Dakota. He had hoped to find the Lakota chief Sitting Bull, who, after five years of exile in Canada following the Battle of the Little Bighorn in 1876, had surrendered to U.S. authorities. Sitting Bull, however, had already been transferred downriver to Fort Randall, where he would be imprisoned for two more years. Farny remained nonetheless at Standing Rock, transfixed by his surroundings. The *Cincinnati Commercial* reported: "He draws Indians, he paints Indians, he sleeps with an Indian tomahawk near him, he lays greatest store by his Indian necklaces and Indian pipe, he talks Indian and he dreams Indian warfare."[27] In his enthusiasm, Farny noted, "The plains, the buttes, the whole country and its people are fuller of material for the artist than any country in Europe."[28] The trip evidently validated his career choice to paint the West and

its indigenous cultures, for shortly thereafter he created drawings based on the photographs that John Hillers had taken for ethnologist Frank Hamilton Cushing's 1882–83 account of his life among the Zuni Indians; the account was serialized in *Century Magazine.* In his mature, painterly style Farny created moody scenes of American Indian life that are a result, as one critic wrote, of a "lifetime of absorbed contemplation and interest."[29] Indeed, Farny, like Remington, could be genuinely moved by and often sympathetic to the plight of American Indian nations. These emotions were in part related to a larger culture that endowed Indians with national meaning at precisely the moment when they were conquered and contained.[30] American Indians, like the buffalo, became a symbol of a lost West, portrayed with melancholic nostalgia for the freedom and wildness such peoples represented to Euro-Americans.

For Farny, the expression of melancholy could be achieved by juxtaposing nostalgia, represented by out-of-time Indians, with emblems of modern progress. In *Morning of a New Day* (1906; fig. 41), for example, an empty snow-covered canyon creates the metaphorical divide between a group of Plains Indians in shadow, at right, and a train speeding westward, at left, on the side of a mountain blasted with sunlight announcing the dawn of a technological "new day." Farny's title makes it clear that these native peoples, grouped on the edge of a precipice, represent days gone by in contrast to the future of steam, speed, and new technology represented by the locomotive. Evoking the concept of mutuality implied by two faces of a coin, "morning" comes at the cost of "mourning" in Farny's modern vision of the West.

The Song of the Talking Wire (1904; fig. 42) is among Farny's most haunting paintings and best demonstrates his

Fig. 42
HENRY F. FARNY
The Song of the Talking Wire, 1904
Oil on canvas, 22 1/8 x 40 in.
The Taft Museum of Art, Cincinnati, Ohio, Bequest of Charles Phelps and
Anna Sinton Taft

clarity of vision. Using muted tones to convey a chilly winter scene at the end of day, he divides his canvas into three bands of color intersected by telegraph poles that recede into the distance, so that the spatial implications are both lateral and longitudinal. A Lakota man (inaccurately portrayed in a painted robe with geometric decorations associated with women's wear) leans against a pole, gun in hand, a look of concentration, confusion, or even consternation on his face. In the sparse background, two horses, at right, one carrying a dead deer, provide local narrative: a Lakota stops on his way back from the hunt to listen to the humming of a telegraph pole. Anchoring the scene, at left, is a buffalo skull, which, as Farny knew, was a sacred symbol in Plains culture and often used in religious rituals. In this context, however, the skull—ubiquitously employed by Euro-American artists— refers to death and symbolizes the American West and its passing. Here, as the chin of the skull points in the direction of the man, Indian and buffalo are metaphorically linked in a cliché that underscores how firmly the concept of vanishing had taken hold and was accepted without irony in the popular mind.

As Farny remarked later, his idea for the painting originated at Standing Rock Agency and was based on a recollection more than twenty years old. "The Indians," he said in an interview, "were very superstitious, and regarded the humming of the telegraph wire as the voice of Manitou, the Great Spirit."[31] Farny also noted that he had become acquainted with Long Day (or Long Dog), an aspiring religious man, and had encouraged him to pose before the pole (an oil sketch at the Taft Museum of Art, Cincinnati, records what may be an initial sketch). Farny, who spoke and understood several Indian languages, later noted that Long Day boasted that he had heard "spirit voices" over the wires, which he conveyed to his colleagues to reinforce his claim to become a spiritual leader. The anecdote illustrates the cultural divide between modern Euro-American and Plains Indian. As art historian Denny Carter writes, "The Indian has met something he does not understand, something more powerful than he and, as a result, life as he knows it will vanish."[32]

Through the literal device of communication, Farny relays his message of a vanishing culture. Like the relentless lines of soldiers in Bear's Heart's *Troops Amassed against a Cheyenne Village* (see fig. 28) or the railroad tracks of Carleton Watkins's *Cape Horn, near Celilo* (see fig. 16), the telegraph

poles in Farny's painting implicitly transmit modern values of measurement, order, and progress. Telegraph communication, by eliminating distance, brings people closer together, yet in this painting nothing could be more alienating. The telegraph makes irrelevant the expansive space that is implied laterally and longitudinally. Thus the very concept of vacancy and empty space that Farny sustains begins to vanish. The painting dramatizes the true meaning of crossed wires—a lack of communication among cultures—and points to the inevitable: the Lakota will become as meaningless as the vast spaces that have begun to be overtaken by telegraph wires.

In the summer of 1881, the same year that Farny visited Standing Rock, Pine Ridge Agency—located in southwestern South Dakota and another Sioux reservation—celebrated what was then described as the "last" Sun Dance.[33] Many American Indian tribes performed the Sun Dance, a lengthy ceremony that forms the center of communal and religious life among Plains Indian nations and also celebrates the rebirth and renewal of individuals, communities, and the Earth itself. Popular illustrator and painter Newell Convers (N. C.) Wyeth (1882–1945) had never traveled to the Dakota Territory, but he would paint the Sun Dance in 1908, more than twenty-five years after the so-called last enactment of this ritual.

A student of illustrator Howard Pyle in Wilmington, Delaware, and a member of the circle of illustrators centered in Brandywine, Wyeth determined early on that he would specialize in western subject matter. Raised on Remington's illustrations in popular magazines (he also attended exhibitions of Remington's paintings in New York in the early 1900s), Wyeth decided that he needed to have an authentic western experience to achieve his goals as a legitimate chronicler of the American West. As he would later reminisce, "The West appealed to me as it would to a boy." Although his earlier "ardor for the West" had diminished, his experiences there as a twenty-two-year-old were genuinely felt and enthusiastically expressed in letters. These experiences eventually shaped paintings like *Moving Camp* (1908; fig. 43), which Wyeth described as "one of the *best* Indian pictures I have ever done."[34]

In 1904 Wyeth worked on the legendary Hashknife Ranch near Holbrook in northern Arizona, where he participated in cattle roundups and ranch life in order to gain insight into the West and to generate ideas for picturing

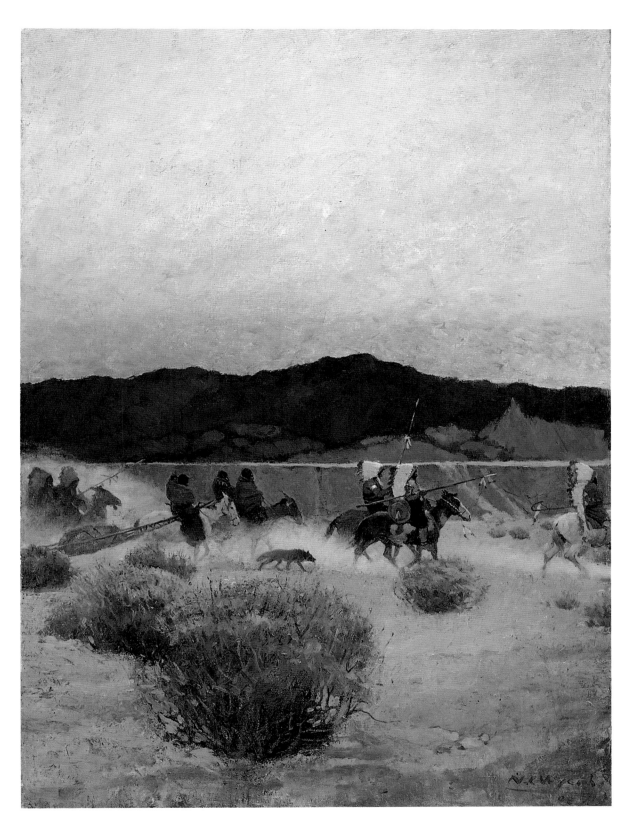

Fig. 43
N. C. (NEWELL CONVERS) WYETH
Moving Camp, 1908
Oil on canvas, 36¼ x 26⅛ in.
The Museum of Fine Arts, Houston, Gift of Mr. and Mrs. Ralph Mullin

authoritative western ranching experiences (fig. 44). This insistence on authenticity was newly charged. Only one year before, Remington had accused Charles Schreyvogel of historical inaccuracies in his award-winning *Custer's Demand*, exhibited at the 1903 National Academy of Design in New York. Schreyvogel's painting was judged accurate by no less than Custer's widow, and Remington was foiled in his attempts to disclaim the efforts of an emerging artist encroaching on his "western territory."[35] The highly publicized battle between these artists harmed Remington's career, a lesson that Wyeth would have understood and heeded.

Ultimately, Wyeth got more than he bargained for, but he seemed generally prepared for the adventure. After several weeks of working as a cowpuncher, followed by unsuccessful attempts to track down thieves who had stolen his

money from a safe in a government post in New Mexico, Wyeth found a job carrying mail between Two Grey Hills, New Mexico, and Fort Defiance, Arizona. Feeling the romance of his adventures, he wrote to his mother, "How I hated to leave those Indians and how I shall miss the many long silent evenings spent with them in their 'hogans,' seated around a flaming pile of crackling piñon listening to the low, plaintive moan of the wind as it swirled down the canyon. The life is wonderful, strange—the fascination of it clutches me like some unseen animal—it seems to whisper, 'Come back, you belong here, this is your real home.'"[36] The West and its indigenous cultures had cast their spell, this time on a young man from Needham, Massachusetts.

The impact of Wyeth's private emotions should not be diminished. The artist's observations form a classic statement of two related phenomena that characterized American modern culture. Wyeth suggests an elemental longing for "home," here expressed as a romantic attachment to Indian culture and its seemingly simpler way of life. He summons nostalgia for a preindustrial past characterized by primitivism. Based on the notion of racial difference and white hegemony, primitivism is an expressive form of nostalgia and, like it, coeval with modernity.[37] A reactionary response to the demands of modern life, primitivism glosses over historical reality. Although nostalgia in its sixteenth-century usage was considered a disease, primitivism was now offered as a cure. As historian Leah Dilworth has noted, "For its practitioners, primitivism is a source of authority, a gesture that demonstrates the essential nature or the primacy of their notions, because the primitive is imagined at a state somehow previous to modernity and therefore more real, more authentic."[38] Like nostalgia, which eclipses space and time and renders history mute, primitivism envisions the past as a better, more harmonious, and somehow higher state of being. Wyeth's western adventure enabled him to tap into and vividly express this primitivist yearning, which ultimately proved to be short-lived.

In 1906 Wyeth returned to the West for the last time, visiting Colorado on a trip sponsored by the magazine *Outing*. In 1907 he moved to Chadds Ford, Pennsylvania, one year before painting *Moving Camp*. As he wrote, "I have enthused over Colorado's mountains and Arizona's deserts. I have been profoundly impressed by the great canyons with their torrents and falls and I have watched hair-raising struggles

Fig. 45
Group Preparing for Sun Dance, 1883
Gelatin silver photograph
Nebraska State Historical Society Photograph Collections

between men and horses midst wonderfully picturesque sur-
roundings, but never have I felt the real story of nature as I
have this summer.…This is a country full of 'restraints.' Every-
thing lies in its subtleties."[39] Compared with Wyeth's earlier
western travels, taken to inspire his illustrations of roundups
and sheepherding, this new phase led him to find a different
kind of beauty in the unaffected landscape of Chadds Ford. As
if this change in geography also prompted a change in
method, Wyeth succumbed to the mood and quietism he
admired in Tonalist paintings by George Inness, Henry Ward
Ranger, and J. Francis Murphy and began painting in a more
lyrical key. Wyeth found melancholy and poetry in the land-
scape and coaxed misty, crepuscular atmospheres from thick
layers of paint.

In this new spirit, Wyeth painted *Moving Camp,* one
in a series of illustrations of the Plains Indian Sun Dance
intended to be published in Edgar Beecher Bronson's "The Last

Great Sun Dance" for *McClure's Magazine.* Despite the praise
of the magazine's editors and the plan to publish Wyeth's
paintings in the December 1908 issue, the series remained
unpublished, perhaps due to financial constraints. Instead,
two of the paintings (but not *Moving Camp*) were published
in Bronson's *Cowboy Life on the Western Plains: The Reminis-
cences of a Ranchman* in 1910.[40] *Moving Camp,* however,
clearly refers to a specific passage in Bronson's account,
although Wyeth alters the setting and the mood significantly.

Bronson recounts his witness to the "last" Sun Dance in
1881, in which twelve thousand Sioux gathered at Pine Ridge
Agency for the ceremony (fig. 45). Employing language com-
mon at the time, Bronson recalled: "The scene the next morn-
ing was like a savage Derby day. For hours, indeed throughout
the live-long day, a broad stream of primitive humanity swept
past the Agency buildings, filling the valley from rim to rim,
en route to Sun Dance Flat—as since it has been known—a

stream that ebbed and flowed a bit but never stopped till the entire tribe, with all their wealth of lodges, weapons, implements, and domestic chattels, freighted on travois or on the backs of ponies, had reached the designated camping site; a stream gay of temper as in its colours, all keen for the feasts and agog for the excitement of the coming ceremony."[41]

Like the Navajo making their way toward Wild Cherry Canyon in Edward S. Curtis's *Canyon de Chelly* (fig. 38), Wyeth's Plains Indians enact a seemingly timeless march in the pink and yellow mystical light of morning and the distant mountains.[42] Nestled within a band bordered by a stretch of dusty ground below and the clear-cut line of an alluvial slope above, the Plains Indians—portrayed with such details as feather bonnets, travois, and a crouching dog—appear tranquil, calm, and subdued in color, not at all the festive parade described by Bronson. Further, the specifics of geography seem to matter little as Wyeth borrows southwestern topography—its alluvial slope and *chamisa*—to transform the relatively flat spaces of Pine Ridge and to create a closer visual relationship between landscape and Plains Indian. For Wyeth, achieving some sense of western sensibility was more important than the specifics of place, which take the form of a landscape in which dramas of loss and nostalgia are enacted. In this painting of travel and migration, Wyeth seems to recall his own western travels, in the process summoning the observations of Hamilton Wright Mabie, a writer whom Wyeth admired: "Travel becomes…not so much an exploration as a revival of recollection, a stirring of the memory."[43]

REFINING THE WEST

Not all of the artists who imaged the American West about this time were involved in cultural salvage projects. Nor did they necessarily share with Frederick Jackson Turner an underlying intellectual or conceptual structure based on nostalgia, loss, American identity, or nationalism. Although the artists examined below also engaged with western spaces and express in their works a sense of rootlessness, they broke new ground in departing from nostalgic depictions and heroic revisions of the West. Still, a similar suspension of time and a weightlessness, characterizing a broader quest for intense, authentic personal experience, can be felt in their works. In the context of art that came before—paintings and photographs defined by landmarking—and art that came after, when regional cultural movements took hold and artists began

to reinvigorate the specific physical and cultural characteristics associated with the West, these artists share with their contemporaries the unreality of a vague, ethereal West, an almost placelessness in which the West functions as a potent psychological symbol.[44]

For the American Impressionist painter John Henry Twachtman (1853–1902), the West, at least initially, did not hold any particular appeal, yet he would come to find a specific, unique terrain that expressed the intensity of emotions he had experienced there. In Twachtman's art, western geography merges with a refined aesthetic philosophy, and the resulting works are among the most provocative paintings of the American West at the time (figs. 46–48).

Cincinnati-born and trained in his hometown, and in art schools in Munich and Paris, Twachtman changed his artistic style several times throughout his career as he honed and perfected his modern vision of simplicity. After Twachtman's death, his friend artist Thomas Wilmer Dewing noted that he was "too modern, probably, to be recognized or appreciated," and artist Charles C. Curran described him as "a modern of the moderns."[45] Twachtman is perhaps the first modern artist whose canvases were hung upside down; their perspectives and orientations were sufficiently vague to invite confusion about how best to hang them.[46] Most of his contemporaneous observers located his modernity in the evanescent qualities of his paintings—their delicate surfaces and unevenly textured canvases—and in his "intimate love for nature," which manifested itself as the "art of suggestion, that is, expression by the least amount of work and the least amount of paint."[47] Twachtman painted with a reductiveness and spareness that could yield works of the most exquisite fullness through the counterintuitive power of subtlety.

Given the well-understood delicacy of his art, at first it seems odd that the only commission Twachtman ever received was to paint the country's first national park, Yellowstone. After all, here was an artist associated with the gentle landscapes of Cos Cob, Connecticut, not the virile, grand, and potent American West imagined by Thomas Moran. His contemporaries, such as painter Eliot Clark, later commented that Twachtman's Yellowstone series had little to no "*scenic or illustrative* [emphasis added] value," as the artist was "unimpressed by the grandeur and sublimity of nature or perhaps thought it outside the limitations of pictorial representation."[48] In a positive review of one of Twachtman's Yellowstone pool

Fig. 46
JOHN HENRY TWACHTMAN
Emerald Pool, Yellowstone, c. 1895
Oil on canvas, 24 ¼ x 30 ¼ in.
Wadsworth Atheneum Museum of Art, Hartford, Connecticut, Bequest of George A. Gay,
by exchange, and the Ellen Gallup Sumner and Mary Catlin Sumner Fund

paintings, a Philadelphia critic in 1896 lamented that the artist's subtleties would be little understood, writing that "visitors will see nothing."[49]

Achieving scenic or illustrative values held little interest for Twachtman, making him the first major artist to produce paintings of the West that offer a new pictorial interpretation of it, one motivated less by landmark, less by conflict among cultures, and more by color and mood. To be sure, in his paintings of Yellowstone's cataracts and canyon, Twachtman adapted his Impressionist technique to more classically sublime subjects, and the results are arresting, if at times uneven. In his paintings of the park's thermal pools, however, he found his stride. Although Twachtman probably was not deliberately seeking the unhackneyed subject matter of Yellowstone's quiescent pools, he seems to have discovered himself in them and, in doing so, charted new artistic territory.

It is tempting to conclude that because of Twachtman's sensitive nature (his colleagues frequently commented on his fragility) he had been sent to the West to benefit from its curative and restorative attributes. A year before his September 1895 trip to Yellowstone, he had suffered from malarial fever, and about six months later his beloved daughter Elsie died of scarlet fever. Shortly before he died, his friends mentioned his abruptly changing moods, his drinking problems, and that "something [was] gnawing at the soul of the man."[50] If the West had been offered as a cure for some sort of mental anxiety or exhaustion, he would have followed the path of other artists, such as Thomas Eakins.[51] In fact, this mental exhaustion had a clinical name, "neurasthenia," defined by New York neurologist George M. Beard, who, in his 1881 book, *American Nervousness*, described it as the body's reaction to the assault of modernization. By the 1890s psychologist and

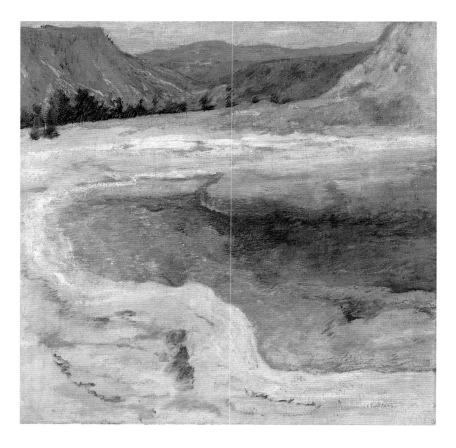

Fig. 47
JOHN HENRY TWACHTMAN
Emerald Pool, c. 1895
Oil on canvas, 25 x 25 in.
The Phillips Collection, Washington, D.C.

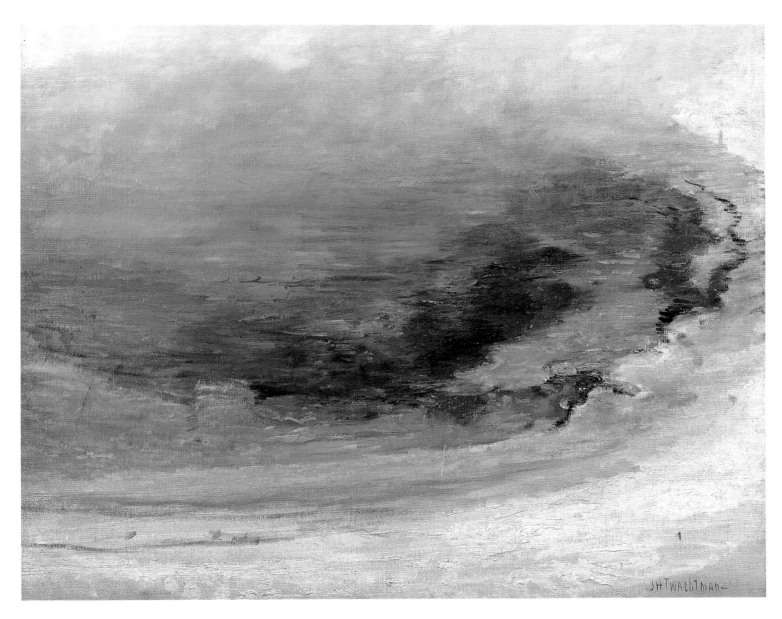

Fig. 48

JOHN HENRY TWACHTMAN

Edge of the Emerald Pool, Yellowstone, c. 1895

Oil on canvas, 25 x 30 in.

Courtesy of Spanierman Gallery LLC, New York

philosopher William James at Harvard University addressed the pervasive problem of neurasthenia by working on a mind cure.[52] In fact, Twachtman's friends, fellow painters J. Alden Weir and Theodore Robinson, had consulted with a mind curist.[53]

Although Twachtman, according to art historian Kathleen Pyne, sought a therapeutic relationship in his encounters with nature and was intent on providing in his paintings and pastels both comfort and a meditative experience for the viewer, there is no evidence to suggest that he was commissioned to paint Yellowstone for personal curative or medical reasons. The circumstances surrounding the commission appear to be straightforward, and the lure seems to have been that Twachtman would be paid handsomely for the commission from Maj. William A. Wadsworth (called "Austin") of Geneseo, New York.[54] A mutual friend wrote to Wadsworth on September 6, 1895: "I think from the tone of Twachtman's that he [basks] in the situation financially. Collins says he has started gleefully leaving his family (some obstreperous boys) with considerable equanimity."[55] Twachtman's expanding family, which at the time numbered four but would increase to seven, and his need for a stable income prompted the trip; indeed, 1895 would prove to be one of his best years financially.[56]

In hindsight, Twachtman and Yellowstone were a perfect match precisely because of the artist's eye for finding beauty in the unconventional and his technical ability to express so much with so little. Unlike Yosemite and Niagara Falls, which are defined by their sublime soaring mountains and overflowing cataracts, Yellowstone, formed by massive volcanism, was the real "Wild West" show, as historian John Sears describes it.[57] Yellowstone was either a hellish place "fearful in its vast unrelieved malignant weirdness," as one 1884 observer commented, or an amusing "Barnum's Museum of the natural world." Certainly its large lake—the largest mountain lake in North America—and its twenty-five-mile-long and one-thousand-foot-deep canyon with its upper and lower falls suggest something of the West's grandeur, but even then its colors were described as "lurid" and its outcroppings as "grotesque." More than for its scenic grandeur, Yellowstone was characterized as a freak show in which colorful mud pots, geysers, fumaroles, boiling springs, mud-spouting volcanoes, and a cracked and creviced earth emitting hisses, vaporous mists, and rank sulfurous smells constituted the main event. No wonder in 1872 that Yellowstone was first called "Wonderland," inspired by Lewis Carroll's 1865 *Alice's Adventures in Wonderland*, which characterizes a topsy-turvy world that is disturbingly erratic. In this eruptive, constantly performing space, Twachtman found quiet, contemplative places in Yellowstone's thermal pools, and he was the first major American artist to see their value and to paint them.

Twachtman wrote to his patron on September 22, 1895: "I am overwhelmed with things to do that a year would be a short stay. Your reply to my telegram came and I thank you for your liberality. This trip is like the outing of a city boy to the country for the first time. I was too long in one place. This scenery too is fine enough to schock [*sic*] any mind."[58] The landscape stimulated Twachtman, prompting a new alertness that he found both personally and artistically revitalizing. He continued, "We have had several snow storms and the ground is white—the cañon looks more beautiful than ever. The pools are more refined in color but there is much romance in the falls and the cañon. I never felt so fine in my life and am busy from morning til night. One can work so much more in this place never tiring....There are many things one wants to do in this place. Believe me."

In his letter Twachtman hints at his subject matter, the falls and canyons that he equates with "romance" and Yellowstone's thermal pools of refined color. One of these mesmerizing pools prompted an 1883 tourist to note "its indigo depths [where] there would form a phantom—a faint white cloud—growing whiter and more defined as it floated up to the surface and discharged itself in ebullition"; another visitor likened the Emerald Pool to "liquefied Chinese fire or the unknown, unnamable tones seen under the influence of an anesthetic or during delirium."[59] Twachtman was no less fascinated with the act of looking far down at the Earth's more bizarre geological events. Of the fourteen canvases he conceived during his month-long trip, five take the thermal pools as their subject. Twachtman specifically named his paintings *Geyser Pool* (unidentified site; c. 1895, private collection); *Morning Glory Pool, Yellowstone* (in the Upper Geyser Basin not far from Old Faithful; c. 1895, private collection); *Emerald Pool, Yellowstone* (c. 1895, Wadsworth Atheneum, Hartford; fig. 46); *Emerald Pool* (c. 1895, The Phillips Collection, Washington, D.C.; fig. 47); and *Edge of the Emerald Pool, Yellowstone* (c. 1895, Spanierman Gallery, New York; fig. 48).

At the time of Twachtman's visit, several pools were called "Emerald" in reference to their striking color, generally the result of yellow bacteria combining with blue water. Twachtman titled the Phillips Collection painting *Emerald Pool*, although the background landscape, dramatically compressed within a square format, clearly identifies the site: at left, Mount Everts; at right, Bunsen Peak; and, in between, the Washburn Range. This emerald pool was one of many that, over time, come and go on the Main Terrace at Mammoth Hot Springs in the northwest corner of the park, and thus not one of the named emerald pools or springs in other parts of the park. With only minimal landscape details provided by Twachtman, the site of *Emerald Pool, Yellowstone* (fig. 46) could be any pool at any basin. Nonetheless, it is likely that Twachtman painted the famous Emerald Pool at the Black Sand Basin.[60] Further, it is likely that he met and perhaps sought out Yellowstone National Park's official photographer, F. Jay Haynes, who officially titled the pool at Black Sand Basin

(fig. 49). Although Twachtman assigns somewhat descriptive titles, landmarking specific sites was not a priority for him as it had been for survey photographers, for example. What mattered were the colors, emotions, sensuous pleasures, and moods that these surreal boiling springs elicited.

Not unlike his Connecticut landscapes, in which Twachtman focused repeatedly on a specific motif in nature, such as a trickling stream or falls, in *Emerald Pool, Yellowstone*, the artist eliminates other landscape features more radically, in this instance a nearby tree stand and background hills, filling the nearly square canvas with an upward tilted pool. (*Edge of the Emerald Pool, Yellowstone*, is even more dramatically cropped and reduced in its pictorial elements.) The viewer looks down and across an ever-expanding space suggested both by several runoff channels in the foreground, at left, and by the extreme upper edge of the painting, which serves to anchor the pool in the composition. In highly contrasted summary brushstrokes, thick alternated with thin,

Fig. 49
F. JAY HAYNES
Emerald Pool, Yellowstone National Park, **1895**
Gelatin silver photograph
Haynes Foundation Collection, Montana Historical Society

short alternated with long, Twachtman creates a strange organic, almost amoebalike form, the vaporous mists of which virtually abolish any hint of a horizon line. Consequently, the painting reads as a flat planar surface, mesmerizing in its coloristic effects and sinuous contours.

Part of Twachtman's mode of distilling forms and cropping edges evolved from his appreciation of the art of James McNeill Whistler and of Japanese aesthetics, both of which depend on a dynamic interplay of shapes and patterns. Although Twachtman crops the subject at left, playing up the asymmetry of the pool and its odd shapes, he achieves a delicate balance in his painting. All painterly elements are in suspension. The painting perfectly expresses the integrative philosophy that was fundamental to Twachtman's fellow artists and contemporaneous intellectuals who held a therapeutic worldview. They sought to create, as Pyne has argued, a "higher life" based on "nature and the human-made world of culture."[61] This highly refined and holistic union served as a respite from the enervating demands imposed by a modern America.

In *Emerald Pool, Yellowstone*, Twachtman integrates opposing tendencies. The pool is a tourist spectacle, a freak of nature that is rendered with an almost tender intimacy. Its quiet, still surface contrasts with both the transient mists, above, and the roiling heated waters thirty-five feet below. This is a painting, in short, about energy seemingly at rest. In this sense, Duncan Phillips, a collector and champion of Twachtman's art and one of his most articulate interpreters, noted that Twachtman adopted a sensibility common in Asian art, a sensibility that "worshipped Nature by means of art."[62] Nature, in other words, provided a point of departure, and in the quiescent pools of Yellowstone, Twachtman found an analogue for a strange, yet perfect, state of grace.

About a decade later, Edward Steichen (1879–1973) likewise would use the western landscape as inspiration for photographic images that exude a mysterious and poetic power. Just as Twachtman's paintings of Yellowstone's thermal pools create disorienting effects, Steichen's *The Black Canyon* takes advantage of canyon geography to produce a similar strangeness (c. 1906; fig. 50). Whereas Twachtman's cultivation of the eerie relates to the effort to create meditative landscapes that offered viewers relief from the increasing strains of modern life, Steichen's motivation stems in part from something different—a desire to demonstrate how manipulated photographs can approximate paintings and, thus, high art. His efforts, even his tendency at this time to engage in both painting and photography, affirm his dedication to erasing the conceptual and perceived boundaries between the two. Although today photography is recognized as a vital art form, the acceptance of photography was initiated by artists such as Steichen, who made it his life's work to crusade for an art medium that was then little more than a half-century old.

Steichen, who over the course of his career would work as a painter, photographer, designer, and curator, painted nocturnes in the manner of Whistler and made photographs that look like them. His nocturnal scenes of nature's moods perfectly define Pictorialism, a term for describing photographs that make individual viewpoint, subjective emotion, or simply mood and atmosphere their primary focus. Pictorialism was a self-conscious effort to elevate photography to high art; the medium had long been associated with the scientific, documentary functions of the survey or with amateur photographers who had flocked to buy the Kodak handheld camera, invented in 1888. Pictorialist photographers combined or manipulated negatives by hand in labor-intensive processes in order to render more painterly images, applying pigmented solutions to photographic surfaces. *The Black Canyon* is a telling example of the effect of contrasting broad tones and minimal detail.

Steichen's self-taught examples of photography came to the attention of the two most important photographers in the country at the time, Clarence White and Alfred Stieglitz. White and Stieglitz encouraged Steichen, who was born in Luxembourg but reared in Milwaukee, to travel abroad to study. After participating in several group shows, Steichen was elected to the Linked Ring, a leading society of British Pictorial photographers, in 1901. Returning to New York, he became a charter member in 1902 of Stieglitz's new photographic society, the Photo-Secessionists, a group of Pictorialist photographers who essentially drew lines of demarcation between their high-art efforts and the work produced by amateurs and local camera-club hobbyists. Skilled in design, Steichen produced the cover of Stieglitz's elegant and substantive magazine, *Camera Work*, and in 1905 he helped Stieglitz establish the Little Galleries of the Photo-Secession, later called 291 in reference to the gallery's address on Fifth Avenue. In seven months, Steichen designed and curated seven shows, introducing the public to stimulating exhibitions that brought together

Fig. 50
EDWARD STEICHEN
The Black Canyon, c. 1906
Gum-bichromate photograph, 19 x 15 ⅟₁₆ in.
Andrew Smith, Claire Lozier, and John Boland, Santa Fe, New Mexico

traditionally discrete art forms; works on paper, photographs, and paintings held equal value.[63]

Steichen, restless and always eager for the next challenge, left New York in 1906—not because he failed but because he succeeded so brilliantly at such a young age. His portrait photography studio, the most fashionable in New York, was financially lucrative but artistically unsatisfying. As he said later, he needed a "kick in the pants."[64] He decided to move his family to Paris, to return to painting, to organize exhibitions of European art to send back to 291, and to champion American photography abroad. Before leaving the United States, he took his wife and daughter back to his home in Wisconsin and then headed west for a brief, but revelatory, vacation.

According to his biographer, Steichen encouraged Stieglitz to join him. Stieglitz refused, as he would continue to do years later when he was married to the artist Georgia O'Keeffe, who spent part of every year painting in New Mexico before eventually moving there. Evidently Steichen's friends and colleagues chided him for wanting to see the West, particularly the Colorado Rockies, before going to Paris. The response of his colleagues indicates perhaps a level of elitism (or, conversely, provincialism) on the part of New York's avant-garde artistic circles. They firmly linked the West with retardataire notions of exploration and discovery, western booster-ism, and, most likely, mass popular culture, from which this particular group of artists distinctly separated themselves.

Steichen was determined to go, and he reportedly benefited from the trip. As he wrote to Stieglitz, "[O]ne of the greatest things I have experienced—not so much from a pictorial standpoint [as from] the bigger standpoint of life.... I don't know which impressed me most—the prairie or the mountains—one bigger than the other—together forming a boundless whole....Somehow since I have been west I almost regret going to Paris—or Europe. I tell you one builds up a big wholesome respect and appreciation of those early settlers—My God what men & women they must have been."[65]

Like Twachtman, whose western sojourn was short and proved to be an anomaly in his career, Steichen traveled to Colorado, New Mexico, and Nebraska for only three weeks, and his artistic production was much sparser than Twachtman's. Only two large-format photographs are known to exist, and one of them, *The Black Canyon*, may be unique. The trip was apparently an especially collegial one, with members of the Colorado Camera Club serving as Steichen's guides as he explored the mountains on horseback and by car (for "free," as he mentioned to Stieglitz). One of his colleagues, Harry C. Rubincam, a fellow Photo-Secessionist who had moved west from New York in an effort to control his tuberculosis, took several photographs of Steichen during his journey, one a nocturne of Steichen taking pictures from a horse (fig. 51).

The Black Canyon is a view of what is now the Black Canyon of the Gunnison National Park, a fifty-mile-long canyon with a tiny opening, vertical walls, and two-thousand-foot depths plunging toward the Gunnison River on the western edge of the Rockies. The canyon is called "black" because little sunlight penetrates the walls. An artist such as Steichen, who favored nocturnes, did not need to photograph the canyon at night to awaken its moods. The canyon possesses nocturnal qualities both day and night, and its precipitous cliffs and jagged forms make for menacing effects. Unlike many artists who were stymied by the monumental, often eerie forms of the West, Steichen resolved the forms by reducing them and focusing on their unusual features, without sacrificing the element of strangeness. In *The Black Canyon*, cliff and mountain forms, rushing water, and clouds interlock like puzzle pieces on a planar surface. The cliff, at right, merges imperceptibly with a storm cloud that reaches its arm across the narrows, where it fuses again with rock. Like an inverted V, a shape Steichen favored, the foreground river guides viewers into the scene, only to close them off at midground before releasing them in a tiny skylit opening. Steichen unleashes a disquieting power through careful photographic manipulations that neutralize and soften the metamorphic rock of the Black Canyon's walls and allow them to be carefully balanced with river and clouds. Not unlike Twachtman's still pools, here western geography, reduced to its fundamental elements, holds together in dynamic suspension.

Steichen traveled to the West five years before Arthur Wesley Dow (1857–1922) made the trip. A father figure to a number of artists and craftsmen whom he taught and inspired (his student Georgia O'Keeffe fondly called him "Pa Dow"), he encouraged painters, printmakers, and photographers to follow certain compositional precepts that merged Asian aesthetics with moral force. Dow's artistic journey began in 1891 at a time when he was looking for something—what, he was not sure. Born in Ipswich, Massachusetts, to an estab-

lished New England family, Dow received his art training, like so many others of his generation, at the Académie Julian in Paris. He spent summers in Pont Aven in Brittany, where Paul Gauguin, Paul Sérusier, and Émile Bernard would develop their radical ideas of color, synthesis, and abstraction in painting.[66] Although Dow disapproved of the work of these Post-Impressionists, he empathized with them for taking bold steps, expressing a general feeling of dissatisfaction that he also felt about his own academic training. As Dow noted in his book *Composition* (1899), among the most influential treatises on American art, he found that five years of French academy training, based on rote imitation, stultified the imagination, limited the creative autonomy of students, and, by extension, stunted their intellect and character.

Dow set as his goal nothing less than to radically rethink artistic training. He perceived art as a means of promoting a new moral force in society, and he believed in the artist as a utopian visionary. To that end, he encouraged his students to "look within," as he had in 1891 when he began studying the art of all nations, searching for something that would revitalize American art.[67] At the Boston Public Library, Dow studied Egyptian, Oceanic, and Aztec art, but his encounter with Japanese art, specifically the woodblock prints of Hokusai, caught his attention: "One evening with Hokusai," he wrote, "gave me more light on composition and decorative effect than years of studies of pictures. I surely ought to compose in an entirely different manner and paint better."[68] Shortly thereafter, he met Ernest Fenollosa, the philosopher, tastemaker, and curator of Japanese art at the Museum of Fine Arts, Boston, who encouraged Dow's artistic pursuits. Two years later, Fenollosa hired Dow to work for him as a curator. The meeting changed his life.

Unlike other contemporaneous American artists who were also fascinated with Asian art, Dow had the advantage not only of Fenollosa's mentorship but also of behind-the-scenes access to great collections of art from this continent. Dow's appreciation of Asian art enabled him to move beyond superficially adopting its precepts of composition, as seen in the Japanese ukiyo-e woodblock prints that he and others admired, and to advance to the realm of the spiritual and the moral. Under Fenollosa's guidance, Dow developed a concept of making art that emphasized filling space harmoniously. By focusing on three elements that he called a "trinity of peace"—line, color, and *notan* (a Japanese word that refers to

Fig. 51
HARRY COGSWELL RUBINCAM
Steichen on Horseback, 1906
Gelatin silver photograph, 3 11/16 x 2 1/16 in.
The Metropolitan Museum of Art, Alfred Stieglitz Collection, 1949 (49.55.233)

patterns of dark and light)—artists would establish relationships among the component parts of an artwork through, to borrow musical principles, opposition, transition, repetition, symmetry, and so forth. In fact, both Dow and Fenollosa espoused the idea that the kind of "space art" that they promoted was a form of "visual music, in which lines, masses, and colors [can] be wrought into musical forms and endlessly varied."[69] Instead of an art of description, which Dow had first learned to create in his imitative exercises at the French academy, he advocated a union or synthesis of subject with pictorial form. As he wrote, "The art lies in the fine choices, not in the truth, likeness to nature, meaning, story-telling or finish....The artist does not teach us to see facts: he teaches us to feel harmonies and to recognize supreme quality."[70] These elements, when developed with keen discipline, would enable art to achieve a transcendental beauty and be supra-nature, but also inspired by nature.[71] Like Twachtman, who wanted art to provide a therapeutic visual experience for viewers wrestling with the demands of modern life, Dow harbored a deep aspiration, but he sought a much broader moral thrust and systematic outreach.[72] Art could change the world by making its citizens more visually attuned to it.

Fig. 52
ARTHUR WESLEY DOW
The Grand Canyon, c. 1911–12
Oil on canvas, 26 x 36 in.
Courtesy of Spanierman Gallery LLC, New York

As set forth in his book *Composition* as well as in the classes he taught at Pratt Institute, Teachers College at Columbia University, the Art Students League, and at the summer school he convened in Ipswich, Dow demonstrated his appreciation for a variety of media. Like Steichen, he dissolved hierarchical distinctions between craft and fine art (he himself made paintings, prints, and photographs). Dow showed his panculturalism, deriving inspiration not only from Japanese prints but also from Persian rugs and textiles, French landscape painting, American Indian pottery, and Peruvian tapestries, among other global sources. His interest in preindustrial roots links him firmly to the cultural primitivism of the period, yet he took a far more vigorous and well-researched approach than other artists. By placing a Zen-like emphasis on artistic choice and on carefully meditated gesture and arrangement, Dow emphasized process itself. He paid the highest respect to the idea of appreciation, by which he meant reciprocity and the acts of artistic giving and receiving; he revered the forces that inspired the spirit and the imagination.[73] His ecumenical cultural philosophy, coupled with a sincere respect for all art media, was a driving force in the founding of the American Arts and Crafts movement, which in turn energized American Modernism more broadly.

Dow painted *The Grand Canyon* around 1911–12 on the first of several trips he made to the West (fig. 52). The painting embodies his synthetic attempt to reinvigorate American art, to make it matter and become an integral part of the increasingly global modern world. Dow's friend Frank Hamilton Cushing, a Smithsonian Institution ethnologist who had lived with the Zuni for five years and had served as another model and mentor of cultural ecumenism for Dow, had encouraged the artist to travel to the West. It would take years and the pleas of some of Dow's former students then in California to have their effect.[74] Taking a sabbatical from Columbia University, he left in the fall of 1911, passed through the Grand Canyon, and returned to Arizona in the winter with his former student, photographer Alvin Langdon Coburn (fig. 53). Feeling the need for fresh inspiration, Dow revealed his long-held intention to "paint some of the *big things* of the world."[75] He chose the Grand Canyon, which Theodore Roosevelt had noted, in 1903, that "every American should see."[76] Three years before Dow's trip, Roosevelt had declared the Grand Canyon a national monument. The trip would profoundly affect both Dow and Coburn and resulted in sev-

Fig. 53
Arthur Wesley Dow at the Grand Canyon
Arthur Wesley Dow papers, 1858–1978, Archives of American Art, Smithsonian Institution

eral solo exhibitions featuring their new work. For Dow, his experience of the Grand Canyon and the way in which he painted it marked a decisive turn away from the subtlety and quietude of his earlier work.[77] In fact, other western subjects that Dow now essayed, such as his spare, colorful prints of Enchanted Mesa, are more in tune with his previously honed aesthetics of filling space with pictorial harmonies. By taking on the Grand Canyon, known for its swiftly changing and abrupt perspectives, fluid atmospheric effects, vast and monumental landforms, and shifting colors, Dow confronted the challenge of a space that was already abundantly filled and, by any aesthetic standard, one that overwhelmed the senses. "The Canyon," he wrote, "is not like any other subject in color, lighting or scale of distances. It forces the artist to seek new ways of painting—its own ways."[78]

Nearly forty years after Thomas Moran's epic canvas, *Chasm of the Colorado*, the canyon remained an unhackneyed subject, in part because of the problem of gaining access to it (see fig. 8). Just one year before Dow's trip, Moran had joined a group of American painters, including Elliot Daingerfield and Edward Potthast, who were sponsored by the Atchison, Topeka, and Santa Fe Railroad to promote images of western sites served by their new railroad lines. Stunned by their experience, they founded the Society of Men Who Paint

the Far West to foster their interest in painting American themes. While Daingerfield made the Grand Canyon into a hallucinatory Xanadu (with allegorical nudes nestled within canyon walls, the features of which begin to assume the contours of ancient architecture), Dow remained committed to abstracting the canyon's elements, focusing on its essential features, aided by the stunning photographs he took on his journey (fig. 54). He noted: "It was this line and color that interested me, hence I did not make any vague sketches. I wanted to seize the Grand Canyon's harmonies, and those only."[79]

The Grand Canyon depicts a view on the South Rim, likely from Mather Point or possibly farther west at Yavapai Point. At far left is Cape Royal on the North Rim, Wotan's Throne, and Vishnu Temple (its characteristic knoblike top

Fig. 54
ARTHUR WESLEY DOW
The Grand Canyon, c. 1911
Gelatin silver photograph
Herbert F. Johnson Museum of Art, Cornell University, Gift of Edgar O. Smith

smoothed over), and, at far right, is Yaki Point. At lower center mid-ground is the distinctive form of O'Neil Butte, with the crisp line of Cedar Ridge leading up to Yaki, visible as the second tier of sweeping incline seen in Dow's photograph. To make this view, Dow compresses the vast space of the canyon and simplifies its forms, having no interest in displaying the specific features of certain landscape elements but intent on softening them into reduced contours. The Inner Gorge appears hazy and smoky, defined by a lavender mist that falls into the suggested chasm below. The foreground is flattened by staccato brushwork so that the focus of the composition is Cedar Ridge's sharp edge cutting across the canvas diagonally and the landforms that float mysteriously in the distance.

The composition, which in fact conforms fairly closely to canyon topography, appears strikingly similar to that in one of Hokusai's famous views of Mount Fuji that Dow undoubtedly knew (fig. 55). Cedar Ridge serves as a divider between the background of Wotan's Throne just as the sweeping landform in Hokusai's print causes Mount Fuji to float in the distance. It is possible that the compression of space that Dow recognized at the Grand Canyon reminded him of Asian aesthetics, in which space is overlaid, one element on top of another, within the same plane, to indicate perspective. In fact, the Japanese written character for perspective (*enkinho*) combines the characters of "near" and "far," a concept that Dow appreciated and that would be further developed in the art of his student O'Keeffe.

When Dow exhibited his paintings in 1913 at the Montross Gallery in New York and at the Moore Galleries in Washington, D.C., and in the following year at the Montclair Art Museum in New Jersey, critics seeking obvious references to his well-known affinity for Asian art were disappointed. Dow supplied little reference to Asian art in his gallery exhibition essay, writing only that the Grand Canyon is "not unlike the classic subject of the Zen paintings of China and Japan."[80] The reference to Asian art appears more subtle because of Dow's emphasis on color, a phenomenon to which the *New York Times* must have alluded when its writer lauded the series for being "magnificent in effect."[81] In his Montross Gallery catalogue notes, Dow refers to myriad sources of inspiration, including the Bible (the Grand Canyon is a "geologic Babylon"); William Blake (the canyon's colors are "burning bright"); Paul Besnard's nineteenth-century murals in Paris of geological ages; flaming temples (a direct reference to the

many canyon formations that bear names alluding to Hindu temples and gods but also to Dow's willingness to see the canyon as holy sanctuary); and John Van Dyke's *The Desert* (1901), the first major book to codify desert aesthetics.[82] Dow clearly aimed to synthesize disparate cultural ideals, keeping alive a number of aesthetic, literary, spiritual, and mythological concepts as he broke new ground merging the Far East with the Far West.

Alvin Langdon Coburn (1882–1966) traveled to the Grand Canyon on his own and, in the winter of 1912, with Dow, who was his former teacher and mentor. Coburn's engagement with western nature and his collegial exchange with Dow prompted Coburn to work, as he put it, in an "entirely new note."[83] As scholars have noted, his wide-eyed experience of the West made him receptive to aesthetic changes that would result in his strikingly abstract aerial photographs of New York City the year after he left the West and shortly before he moved to England permanently. Born in Boston, Coburn studied photography with his distant cousin F. Holland Day in London and with Steichen in Paris. A studio assistant of Pictorialist photographer Gertrude Käsebier, Coburn began taking summer classes at Dow's summer school in Ipswich. Like all students there, he experimented with a variety of media—photography, ceramics, printmaking—seeking to reach ever more potent forms of expression through an almost relentless process of abstraction and simplification. Strikingly accomplished at a young age, Coburn was elected to several prestigious photographic societies, including the

Fig. 55
KATSUSHIKA HOKUSAI
Inume Pass in Kai Province (Kôshû Inume-tôge), **from the series**
Thirty-six Views of Mount Fuji (Fugaku sanjûrokkei), **Edo period, c. 1830–31**
Woodblock print; ink and color on paper
Museum of Fine Arts, Boston, William S. and John T. Spaulding Collection

Fig. 56
ALVIN LANGDON COBURN
The Temple of Ohm, Grand Canyon, 1911
Gelatin silver photograph, 16 x 12 ¾ in.
George Eastman House, Gift of Alvin Langdon Coburn

Fig. 57
ALVIN LANGDON COBURN
Grand Canyon III, 1911–12
Platinum photograph, 9 x 11 3/8 in.
Courtesy, Janet Lehr Inc., New York

Photo-Secession and the Linked Ring. He quickly became renowned for his photographic portraits of literary figures, such as George Bernard Shaw, Mark Twain, and Henry James, and of political figures, such as Theodore Roosevelt. But, as he himself said, his celebrity portraiture should not eclipse his work in landscape photography. For Coburn, the purpose of landscape photography, as his champion Shaw explained, "is always to convey a mood and not to impart local information." "A great challenge," Coburn responded, "because if left to its own devices [the camera] will simply impart local information to the exclusion of everything else."[84]

By choosing to photograph the Grand Canyon, Coburn set an especially difficult formal challenge for himself, precisely because "local information" looms so large. In a black-and-white photograph, the canyon's stratigraphy can appear like a model cross section in a geological textbook. As art historian Mike Weaver explains, Coburn surmounted the problem by using telephoto lenses to help achieve the Japanese spacing he had learned from Dow.[85] Telephoto lenses flatten perspective so that spatial shifts move abruptly from foreground to background; the middle ground is either entirely eliminated or layered in between the two. Put another way, Coburn created an image based on spatial stacking.

The Temple of Ohm, Grand Canyon (1911; fig. 56), one in a series of images that Coburn took of the Grand Canyon, is a more closely focused version of a scene he took titled *Grand Canyon III* (1911–12; fig. 57). Coburn wrote of the Grand Canyon: "No words can describe its grandeur. The camera can give us hints, but only hints, and even with the reality before us it is hardly possible to believe one's eyes."[86] He described the challenges of photographing the canyon, noting its "fast-moving clouds racing before the sun, and casting shadows, alternately concealing and revealing. In a moment all would be changed." Coburn elegantly captures the drama of shadow and light in *The Temple of Ohm*, in which the photographer upends any sense of space between forms. Leaving the background formations mysteriously undefined, he juxtaposes crisp chiseled rock with sweeping shadow. Printing his negatives on platinum paper and then coating them with pigmented gum, Coburn could achieve rich, luminous surfaces that impart an ethereal glow. Critics observed in his western photographs "the soulful delineation of his work."[87]

Critic W. Howe Downes, who wrote the catalogue notes for Coburn's 1913 exhibition of Yosemite and Grand Canyon photographs at Goupil's in London, declared that "Coburn with his camera has been the first to give us any idea of the grandeur and mystery and sublimity of the Grand Canyon."[88]

Coburn mistitled *The Temple of Ohm*, which actually represents Marsh Butte, west of Hermit's Rest from the South Rim. (The Temple of Ohm is invisible from this perspective at Hermit's Rest.) It is unclear if Coburn intentionally assigned an inaccurate title to his photograph as a means of conveying a more spiritual, non-Western mood. Perhaps he simply meant to refer to the general area as the Temple of Ohm. "Ohm," a seed word of Buddhism, is a mantra for prayer and embodies a number of ideas, including enlightenment, emptiness, and purity. A vehicle for uniting the individual with the universe, "Ohm" as a place-name likely appealed to the aesthetic sensibilities that Coburn had nurtured under Dow's tutelage. Further, in homage to the Tao and Zen union of opposites that Dow and his students had learned from Fenollosa and his protégé, Okakura Kakuzo, Coburn aspired to reconcile the geological solidity and topographical permanence of the Grand Canyon with the fluidity, ephemeral movement, and rhythm that he observed and felt there. By harmoniously merging solid stone with passing shadow, the photographer achieved a combination of "delicacy of expression and robustness," as art critic Charles Caffin wrote of his work.[89] In doing so, Coburn, like his mentor Dow, used the Grand Canyon to embrace evanescence and spirit, not over matter but in conjunction with it. One might say that Coburn, in his photograph, visualized yin-yang.

Augustus Vincent Tack (1870–1949) likewise upended the massiveness of western landforms, transforming hard matter into an example of ethereal abstraction that was more dramatic than Coburn's precedent. In the process, Tack eliminated the union of opposites that Coburn had carefully crafted. Following Coburn's work by eight years, Tack is perceived as an eccentric, still little-known artist whose mystical abstractions were admired by his most loyal patron, Duncan Phillips. Born in western Pennsylvania, Tack spent his mature life in New York City and Deerfield in western Massachusetts. Early on he trained with John Henry Twachtman and muralist H. Siddons Mowbray; traveled, like all serious American artists, to France; and was inspired by the work of James McNeill Whistler and John La Farge, whose development

of Asian aesthetics and discussion of musical analogies to painting helped Tack to cultivate his own aesthetic. Recalling Symbolist tendencies in art, Tack argued that "these [abstractions] deal with the idea of things rather than things themselves. They suggest subconscious moods, memories of experience, half-forgotten dreams, fragments of the mind....One looks not physically, but mentally, spiritually, emotionally. Perhaps this might be called the far side of painting."[90]

Tack's journey to the "far side" accelerated as a result of several trips to the American West. In the summer of 1920 he visited the Rocky Mountains, an experience that would change his art permanently. Recalling his visit, he wrote, "We took a horseback ride of sixteen miles over a trail which led to a wonderful valley....The valley was walled in by an amphitheater of mountains as colossal as to seem an adequate setting for The Last Judgement. Glacial lakes lay like jewels on the breast of the world....Battlements and pinnacles of rock rose to the clouds and on the mountain slopes great white glaciers seemed motionless and slumbering, but terrible in their potentialities."[91] Tack did not paint on-site but relied on his recollections to dematerialize mountain forms, the snowy peaks of which also recall the crashing waves seen in Ando Hiroshige's woodblock prints. In *Storm* (c. 1922–23; fig. 58), Tack arranges fragmented forms across the canvas, reinvigorating them by rubbing back the paint and using a roller brush to scumble the surface, which he generally works and manipulates to create a filigreed, hazy effect. The result is a far cry from the rocky pinnacles that initially had overwhelmed his senses. Tack's affinity for Asian aesthetics and philosophies, his reductive abstractions, and his innovative manipulated surfaces all suggest modern ideals he shared with members of the Stieglitz group of artists—sympathies Duncan Phillips undoubtedly recognized when he exhibited *Storm* with works by the Stieglitz circle, including O'Keeffe and Arthur Dove, in 1926.

Photographer Louise Deshong Woodbridge (1848–1925) traveled to the West on several occasions (figs. 59 and 60). At the same time that Dow and Coburn hiked, camped, and made observations about the Grand Canyon, Woodbridge traveled to Yellowstone, producing some of the smallest yet the most potent images of Yellowstone of the period. Woodbridge resolves the complexities of canyon geography in a different manner from her peers. Little is known about Woodbridge, a distinguished Camera Club photographer from Chester,

Fig. 58
AUGUSTUS VINCENT TACK

Storm, c. 1922–23

Oil on canvas mounted on wallboard, 36 $\frac{7}{8}$ x 48 $\frac{1}{16}$ in.

The Phillips Collection, Washington, D.C.

Pennsylvania.[92] She was the daughter of the prominent Deshong family, whose homes and collections are now an integral part of Widener University in Pennsylvania. Her marriage to Jonathan Edwards Woodbridge, a descendant of the famous colonial Congregationalist minister Jonathan Edwards, offered a comfortable, privileged life in which she met the usual charity demands of a woman of her age and class. All the while, she sustained her passion for photography and natural science. At her home near Philadelphia, a city renowned for its commitment to natural history, Woodbridge for many years hosted a program called "Afternoons with Science," and

she photographed landscapes in Pennsylvania, New England, and the Adirondacks. The sophistication of her work is a cut above that of the usual hobbyist; indeed, her work was exhibited at the 1893 World's Columbian Exposition in Chicago, and in her series of Yellowstone photographs, she hit her stride.

Yellowstone "Grand View," from about 1912, is a tiny platinum print that confounds the viewer with its near illegibility. By eliminating the horizon line that serves as a visual anchor for the viewer, Woodbridge instead presents a flattened space of rugged landforms, alluvial washes, spo-

Fig. 59
LOUISE DESHONG WOODBRIDGE
Yellowstone "Grand View," c. 1912
Platinum photograph, 3 $^7/_8$ x 4 $^{11}/_{16}$ in.
Amon Carter Museum, Fort Worth, Texas, P1981.70

radic pines, a strange ribbon of river, and a foreground darkened outcropping that collapses entirely into the background. "Grand View" refers to the name of the specific tourist site at Yellowstone where the photograph was taken, but the actual site she selected is more than a hundred yards west of the tourist platform. At a random location off the main "Grand View," Woodbridge tilted her camera slightly to crop the horizon line and in the abstract arrangement of forms that resulted, she produced, paradoxically, among the most realistic images of Yellowstone at the time. Compared with Moran's painting of Yellowstone of more than thirty years before—a monumental work that Moran achieved by making the canyon landscape fit the aesthetic convention of the time—Woodbridge, in a highly reduced format, manages to convey the perspectival peculiarities of Yellowstone, where depth perception is completely misleading. Whether she created an anomalous vision or, more likely, was prompted by her interest in science, geology, and specifically Yellowstone's dramatic examples of volcanism and erosion, Woodbridge arranges Yellowstone's geological oddities in such a way as to simulate the sense of vertigo that one experienced at the "Grand View."

The selection of expensive platinum papers that yielded a rich and broad scale of grays; the rigorous sense of formalist design, in part derived from Asian aesthetics; and the use of soft-focus lenses firmly link Laura Gilpin (1891–1979) to the Clarence H. White School of Photography and, by extension, to the aesthetic philosophy of Dow (who had hired White to teach at Columbia University in 1907).[93] Unlike other modern artists discussed here, who interacted only briefly with the western landscape, Gilpin produced images of the West over a sixty-year period. These photographs are among the most extensive and coherent accounts of the southwestern landscape and its Pueblo and Navajo cultures. Gilpin was reared in Colorado Springs, which she used as her base between photographic expeditions. Her connections to the western landscape were deep and augured her future. Survey photographer William Henry Jackson was a distant relative, as was William Gilpin, Colorado's first territorial governor. She later recalled that on her father's desk sat Edward S. Curtis's photograph of *Canyon de Chelly*. Like other artists who asserted their western roots while living on the East Coast, Gilpin donned cowboy outfits for parties at her eastern boarding school. But she did not stay away from home for

Fig. 60
Louise Woodbridge visiting western sites, c. 1915
Courtesy, Janet Lehr Inc., New York

long. After attending the Clarence White School in New York, in 1916, she returned to Colorado the following year to set up a commercial studio. The landscape images she produced were used in elegant picture books, either those published for the Colorado Springs Chamber of Commerce (*Winning Health in the Pikes Peak Region*, which promoted the West's arid climate to tuberculosis patients) or those she herself published on the Pikes Peak Region of Colorado and the Ancestral Puebloan site of Mesa Verde National Park.

The Prairie (1917; fig. 61) is among the earliest mature photographs Gilpin produced after returning home. Reflecting her photographic training with White and Dow's aesthetics, Gilpin emphasized careful design in her work: "Acquiring the habit of noting the changes of light and watching for designs, fits and makes us ready for those rare moments when unusual and remarkable things happen, which may last only a fleeting moment. There are the things that photography, and only photography, can catch if we are so well trained that we do our part."[94] Capturing a carefully posed passing moment, *The Prairie* is a remarkably spare but lush photograph that emphasizes the expansiveness of the Colorado prairie (east of Colorado Springs), its big sky filled with wispy clouds that echo

Fig. 61
LAURA GILPIN
The Prairie, 1917
Platinum photograph, 5 7/8 x 7 5/8 in.
Amon Carter Museum, Fort Worth, Texas, Bequest of the artist, P1979.119.8

the windswept skirts of the woman in the left corner of the picture, her hand cupped to her ear as if to appreciate the idea that "silence is best suited to the acoustics of space."[95]

In her photographic exploration of synesthesia, in which one sense is mixed with another, Gilpin makes a windy and silent picture based on the geography of an area in Colorado that artists had not yet rendered in depth. Her appreciation of the aesthetics of the prairie suggests the concurrent work of Georgia O'Keeffe, whose series *Evening Star* similarly enacts the drama of the plains. In engaging the flat spaces of the prairie as a stage for human activity, Gilpin offers an alternative to Remington's masculine heroics performed on the desert prairie; she substitutes a fully sensate woman absorbing the physicality of the landscape. The photograph was made to illustrate a poem about spiritual freedom by Eliza M. Swift, who lived briefly at Colorado Springs' Broadmoor Hotel. Titled "On the Prairie," Swift's poem invokes the time-honored trope of the sea as a metaphor for the prairie before turning to their shared sense of the sublime: "Across the broad spaces/The limited places/Unfettered, unhindered, my spirit goes free.…The song of the exile who's far from the sea." Literally capturing "the blustering swirl of the wind on the lea," Gilpin at the same time evokes the sense of being marooned, of being alone on the prairie, and the sheer exhilaration of this experience.

The connection between Gilpin and O'Keeffe is not a casual one, as both artists call upon landscape to express silence, space, and freedom. Born in Sun Prairie, Wisconsin, O'Keeffe (1887–1986) herself best expressed the foundation of her art. "The outdoors," she wrote from Canyon, Texas, in 1916, "just gets me."[96] Very few major artists of the period deliberately sought out the vast prairies and deserts of the American West, and even fewer interpreted them with the sensitivity to space and color that she did. Intent on becoming an artist at a young age, O'Keeffe attended classes at the Art Institute of Chicago (1905–6), studied with William Merritt Chase at the Art Students League in New York (1907), and with Alon Bement at the University of Virginia in Charlottesville, where she first read Arthur Wesley Dow's *Composition* (1912). After teaching in Amarillo, Texas, from 1912 to 1914, using Dow's *Composition* as her textbook, O'Keeffe became his student at Teachers College at Columbia University (1914). Her teaching career was based on the aesthetic theories of Fenollosa and Dow and also on an aesthetic appetite provoked

by European innovators such as Pablo Picasso and Georges Braque, whose works she saw at Stieglitz's 291 gallery. By the time she was hired to head the art department at West Texas State Normal College in Canyon in 1916 (now called West Texas A&M University), she was pleased to return to Texas, a place she would call her spiritual home. In fact, she had long been prepared for a western encounter. She later wrote that as a child she was reared on romantic stories about western figures such as Billy the Kid: "Texas had always been a faraway dream.…It had always seemed to me that the West must be wonderful."[97]

The heady intellectual and aesthetic environment O'Keeffe had experienced in New York dramatically contrasted with her western experiences of nature. She had a lifelong compulsion for extensive nature walks, during which she would admire and make mental notes of physical geography and spatial dynamics. An ambivalent tone is easily detected in her letters, which in one moment lament the "little people" of Canyon (in part, the faculty whom she found small-minded and who eventually provoked her resignation), and in the next extol the beauties of the "big country."[98] O'Keeffe's letters abound with its sights—the blazing sky, the sheet lightning, the ruggedness of nearby Palo Duro Canyon, the "feeling of bigness"—and its sounds—the wind and, as she would later recall, the sad lowing of cows in the nearby stockyard. "It is absurd," she wrote, "the way I love this country," as if to acknowledge that her unequivocal love of the plains would perhaps be considered eccentric from an aesthetic point of view. O'Keeffe knew how little her convictions had been valued by artists in the past.[99]

Although O'Keeffe's visceral response to the Texas prairie undoubtedly had various roots, the discipline of Dow's teaching and the mantra of "filling space in a beautiful way" may have predisposed her to embrace a physical environment of emptiness—as if the prairie served as a metaphor for the blank sheet or canvas, and she intervened as the creative force that would translate private sensation and feeling to paper through line, space, and color. The watercolor series she titled *Evening Star* (1917; figs. 62–64) expresses her indebtedness to Dow's precepts, combined with her own individual experiences. The watercolors are among the boldest artworks of her career and of American art of the period. Leaving a tiny circle of paper empty to suggest an evening star, O'Keeffe creates radiating bands of striking color—yellow, orange, and

Fig. 62
GEORGIA O'KEEFFE
Evening Star No. V, 1917
Watercolor on moderately thick, cream, smooth wove paper, 8 3/4 x 11 7/8 in.
Collection of the McNay Art Museum, Bequest of Helen Miller Jones

[OPPOSITE, TOP]
Fig. 63
GEORGIA O'KEEFFE
Evening Star No. VI, 1917
Watercolor on moderately thick, cream, smooth wove paper, 8 7/8 x 12 in.
Georgia O'Keeffe Museum, Gift of The Burnett Foundation

[OPPOSITE, BOTTOM]
Fig. 64
GEORGIA O'KEEFFE
Evening Star, No. II, 1917
Watercolor on paper, 8 3/4 x 12 in.
Private collection

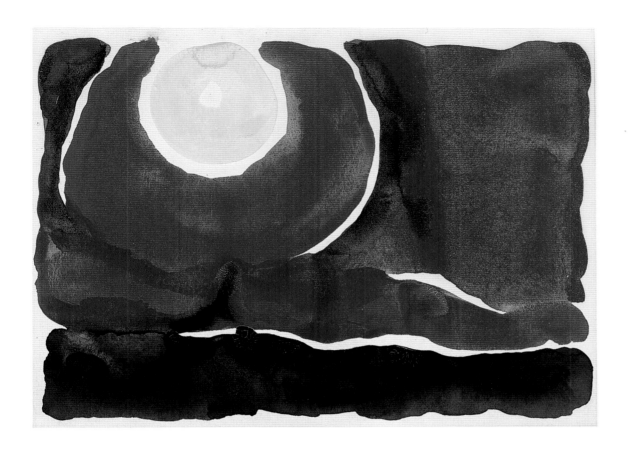

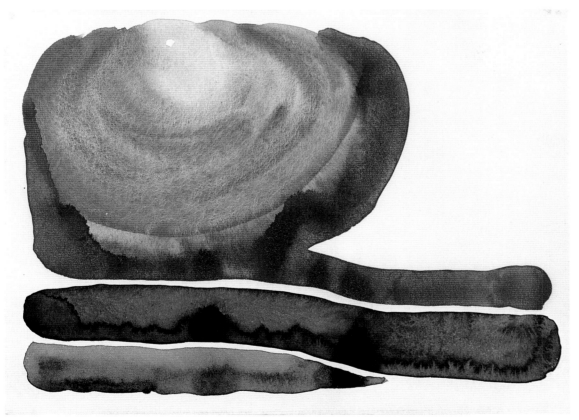

red, some of which bleed into one another, others kept discrete in encircling rings—and the composition at the bottom of the page anchors the scene with a bold wash of blue or green to indicate the darkening sky. Intensity is expressed through color, and expansiveness through massing, to suggest the power, freedom, and sense of infinity O'Keeffe experienced on the Texas prairie. All of these elements emanate from a sparkle in the sky and a mere untouched dot on the paper.

As intuitive and spontaneous as these watercolors may seem, they are also grounded in O'Keeffe's aesthetic discipline and working environment. A close look at the classroom in which she taught at West Texas State Normal College

either represents or at the very least suggests the *kinds* of global aesthetic resources that Dow and O'Keeffe promoted to their art students (fig. 65). Curiously, in this photograph, a Persian textile pattern, hung at lower left, and a similarly patterned textile draped over an Arts and Crafts table are remarkably close to the motif of *Evening Star*, in which the bands of color repeat across the surface.[100] Later, as she recalled the experience of seeing the evening star, she noted that when she and her sister Claudia would take long walks, her sister would shoot bottles in the air with her gun. O'Keeffe "had nothing but to walk into nowhere and the wide sunset space with the star." As if the star were a personal beacon or an

Fig. 65
West Texas State Normal College art classroom,
Canyon, Texas, likely c. 1916–20
Panhandle-Plains Historical Museum, Canyon, Texas

expression of her very self, "the evening star," she wrote, "would be high in the sunset sky when it was still broad daylight. That evening star fascinated me. It was in some way very exciting to me."[101] Certainly no other artist of that period and few since have invested the Texas Panhandle with equal transcendence. As O'Keeffe said of Dow years later, "I had a technique for handling oil and watercolor easily; Dow gave me something to do with it."[102] As will be seen, O'Keeffe drew from many sources as she orchestrated not only her art but her life.

The Texas Panhandle served as O'Keeffe's artistic homeland, the place where she established her aesthetic goals. Ultimately New Mexico would prove to exert a lasting hold on her. There she joined with other artists, writers, and archaeologists, most of whom were searching for a sense of place, manifesting their beliefs and findings in paintings, literature, and scientific journals. From a Euro-American point of view, the making of place in the Southwest derived from a relatively new set of artistic sources and philosophical knowledge: a striking landscape, ancient cultures that left their imprint on the land, and what many artists viewed as a vibrant "living museum" composed of polyglot cultures and the histories they represented. O'Keeffe's *Evening Star* series and the work that she would produce in New Mexico, beginning in 1929, embody the transition in American culture from a monolithic West as a symbolic and psychic space to its division into distinct regions with particular local characteristics.

No more a single region that served as an economic colony of the East—providing raw materials in exchange for manufactured goods—the West gained economic autonomy during the first half of the twentieth century, giving rise to the perception of western regions and the growth of regional cultural movements. The relationship shifted from an exchange between East and West to an exchange among many Wests. These regions were newly articulated by image-makers who shaped identities for places that were in large part settled but still little known on a wider national and international stage.

The Many Wests

Modern Regions

California

CALIFORNIA'S ARCADIA

The highest and lowest points in the nation are located in California. Mount Whitney in south-central California and, to the east of it, Death Valley, near the border of Nevada, represent this broad range in geography. Two mountain ranges, the Coast Range and the Sierra Nevada, several fertile valleys, including the Sacramento and the San Joaquin, twelve hundred miles of coastal terrain facing the Pacific Ocean, and vast arid desert stretches offer the general contours of California's diverse topography. The state's high and low points are echoed in its history of western expansion. On one hand, there is the "final frontier," offering hope and redemption, and, on the other hand, alternate realities: the near decimation of California's original American Indian populations; strained relationships between the Anglo-Americans and Spanish-Mexicans, who claimed the land before Anglo-Europeans; and the rapaciousness of the Gold Rush era, in which redwoods were maimed, forests denuded, and mountains stripped in the name of mining. Dream and nightmare characterize the drama of California's history.

Yet piquant and forceful personalities who at first gasped at California's natural abundance in turn promoted it as the region's ultimate mark of identity. In the mid-nineteenth century John Charles Frémont found in California's climate and topography the hope for a new Mediterranean culture. Later in the century, Scotland-born John Muir forged a conservation ethos so strong it has had a lasting impact on the nation's understanding of nature as sacred place. These perceptions redeemed California and, in the process, attracted visitors, including artists, and encouraged native Californians

aspiring to become painters or photographers to stay and mine the countryside for symbolic meanings.[1]

One visitor was the New York–based Modernist painter Arthur B. Davies (1862–1928), of whom critic James Gibbons Huneker observed: "California is Davies's favorite region. He gives us the living panorama of glorious California. He has discovered the soul of California. Men have been painting there for a lifetime and they have seen her beauties through the eyes of the Barbizon tradition. Not so Davies…those majestic, sweeping landscapes with luminous washes of sun and cloud…are the result of much pondering."[2] By "Barbizon," Huneker referred to Thomas Hill and William Keith, distinguished senior painters of moody, softened California landscapes that often recall the worked, brushy canvases of the French nineteenth-century painters who gathered south of Paris in the village of Barbizon. In his choice of the word "pondering," Huneker suggested Davies's highly intellectual capabilities and thoughtful side, attributes that likely appealed to the artist's most ardent supporters and patrons, the renowned collectors Lizzie Bliss, Joseph Hirshhorn, and Duncan Phillips.[3] And by "sweeping landscapes," Huneker could easily have had in mind Davies's *Pacific Parnassus, Mount Tamalpais* (c. 1905; fig. 66), a view of the San Francisco Bay Area that asserts California's pastoral and panoramic qualities.

Davies is remembered in the history books for his pivotal role in organizing the Armory Show of 1913, the groundbreaking exhibition that introduced Americans to the latest trends in European art, including Fauvism and Cubism, and enduring art figures such as Paul Cézanne, Henri Matisse, and Pablo Picasso.[4] Davies's name also elicits titters in reference

to his paintings of mannered maidens and strange unicorns. In his own day, however, Davies was among the country's most esteemed artists. Even then, it was difficult to associate him with any one group, movement, or style. His elevated artistic stature and adventurous aesthetic tastes made him a valued member of The Eight, a group of moderately rebellious artists, including Robert Henri and John Sloan, who, in 1908, formed their own independent show of paintings that departed from the time-honored tradition of the large public exhibitions held at the National Academy of Design and the Society of Artists in New York. Davies's eclectic canvases were at odds with the general social realism of the group, whose lowbrow subject matter and often aggressive brush-

work described a rougher side of city life. Davies's artistic eccentricity led contemporaneous critics to compare him to the visionary English poet of the early nineteenth century, William Blake, and to the French Symbolist poet Stéphane Mallarmé. A later art historian dubbed Davies an "American Gustave Moreau," referring to the nineteenth-century French artist whose mythological and literary subjects were symbols of his personal feelings, expressed in jewel-like paintings that border on creepy exoticism.[5]

Davies sustained a deep interest in Greco-Roman art. Archaism, particularly an earlier and more "primitive" abstract period in ancient Greek art, appealed to him and linked him with sculptor Paul Manship and dancer Isadora Duncan, both

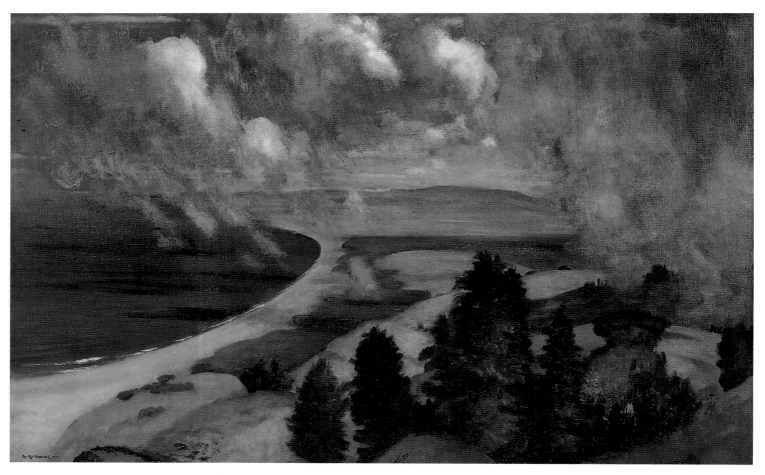

Fig. 66
ARTHUR B. DAVIES
Pacific Parnassus, Mount Tamalpais, c. 1905
Oil on canvas, 26 ¼ x 40 ¼ in.
The Fine Arts Museums of San Francisco, Museum purchase, Gift of The Museum
Society Auxiliary, 1993.19.1

of whom based their art on concepts of classical simplicity and refinement and on graceful rhythms derived from nature. Expressing imaginative freedom and buttressed by an antique tradition, artists could negotiate the modern world by grounding it in the classical past. Nowhere did this concept take hold with more emphasis than in golden California, with its mild climate and fertile soils, so much so that Herman Whitaker, editor of *West Winds: California's Book of Fiction*, declared in 1914: "Though at this hour of our day, it is become trite to draw the familiar parallels between California and Ancient Greece, it yet remains the source from which any utterance concerning western art must proceed."[6] As previously noted, artists such as Remington and Farny located the modern longing for an irretrievable past in the "Old" West. In contrast, Davies and many other artists living and working in California at the same time as Remington and Farny were painting merged the past with the present by using a classical modern idiom; in the process, they provided a utopian vision of modern life. Davies's personal experience navigating the geography of California strengthened his sense of a modern Arcadian pastoral, at the same time helping him to shape a creation myth for California in which the beauties and bounties of nature were made to convey human hopes and dreams.

Davies's 1905 summer trip to the West was not his first. Born in Utica, New York, he went on to study art and design in Chicago. Like so many turn-of-the-twentieth-century artists and writers, he was diagnosed with tuberculosis and at age nineteen was sent to recuperate in the drier climate of the West. A participant in the development and settlement stage of westward expansion, he lived and worked in northeast New Mexico, where he made plat plans for the Atchison, Topeka, and Santa Fe Railroad. Years later, after pursuing additional study at the Art Students League in New York and developing Symbolist sympathies around 1900, Davies returned to the West. He took a trip through the Colorado Rockies and Utah during the summer of 1905, and that July he wrote to his New York art dealer, William Macbeth, "I have seen enough already to satisfy any ordinary man.... The great Pacific calls now."[7]

Davies painted more than sixty panel sketches on this trip, and upon returning to his studio in New York, he used them to produce finished compositions, such as that of *Pacific Parnassus, Mount Tamalpais*, which depicts the artist's "great Pacific." Davies places the viewer atop "Mount Tam," the Bay Area landmark located in Marin County just north of San Francisco's Golden Gate Bridge, looking toward Stinson Beach, a three-and-a-half-mile-long curving sandy beach. *Pacific Parnassus* transforms the California landscape into Arcadia. Employing simple, strong, arcing contours, Davies flattens the hilltop perch so that the precipitous descent is collapsed into compressed hills. These are defined by looping curves framed by feathery pines, at right, and by meandering wetlands, at left, giving way to a great expanse of ocean. The emphasis on simple, graceful lines and broad patterns of color is relieved by clouds moving across the canvas. Using soft brushwork throughout the painting, Davies achieves a lightness of touch, combining it with smoother passages, some of them wiped back in the sky to suggest misty atmosphere. As contemporaneous critic Frank Jewett Mather, Jr., wrote, it is as if in Davies's "spectral grays and blues" his canvases become a "pearly veil into which one had to peer."[8] With its strong sense of design (possibly the composition is arranged in accordance with the classical golden section) and sweeping vistas, *Pacific Parnassus* achieves an evanescent and expansive equilibrium, underscoring an observation by one of Davies's friends that the artist "shared the spirit and observation of the great Chinese tradition and understood the eloquence of empty space."[9]

Though simplified and expansive, *Pacific Parnassus* is not quite empty. Barely discernible in the foreground are tiny frolicking nudes—what Duncan Phillips could have been referring to when he described California's effect on Davies and how its "paradise valleys...call forth apparitions."[10] In the catalogue of Davies's memorial exhibition at the Metropolitan Museum of Art, Bryson Burroughs hastened to add that the artist's "California landscapes show no trace of human habitation. It is a primeval country he depicts in them; those whom one sees there are apparitions in human form—vague personifications of the phenomena of nature or merely improvisations of the artist's fancy."[11] As indicated by the painting's title, Davies converts Mount Tamalpais into a modern Parnassus, the mountain sacred in Greek mythology to Apollo and the Muses, here portrayed with imaginative sprites who inspire the artist and, by implication, the viewer, as if the painting were a paean to the Arcadian beauty of coastal California. Years later the Taos Society artist Walter Ufer would name the Southwest's Sangre de Cristo mountain range the new "American Parnassus," a site where the Muses

would compose "the great American epic, the great American opera."[12] The metaphor was not exactly appropriate; climate and geography were everything in proclaiming California's Arcadian present, and thus the concept of the desert Southwest as a modern classic pastoral never took hold, ceding the classical connotation of an American Parnassus to California.

Pictorialist Anne W. Brigman's (1869–1950) photographs of nudes in the Sierra Nevada mountain range tap into Davies's vision of harmony between man and nature, even when nature may veer from the pastoral conditions of his paintings. In Brigman's works, women serve primarily as models. As in *The Lone Pine* (1909; fig. 67), they are so carefully posed, photographed, and altered by photographic manipulation that they appear inseparable from nature, living in perfect harmony. Born in Nuuanu Valley on the Hawaiian island of Oahu and inspired at an early age by her exposure to

Fig. 67
ANNE W. BRIGMAN
The Lone Pine, 1909
Gelatin silver photograph, 7 3/4 x 9 3/4 in.
Collection of Wallace and Isabel Wilson

Fig. 68
Panorama of Desolation Valley from the lower end, c. 1906
Gelatin silver print, 9 1/2 x 67 in.
Library of Congress, PAN US GEOG–California No. 45

Polynesian mythology, Brigman described her figures, as if to recall Davies's pagan sprites, as "the partially realized forms that flourished in the golden or thunderous days of two months in a wild part of the Sierras where gnomes and elves and spirits of the rocks and trees reveal[ed] themselves under certain mystical incantations."[13] These figures who impersonated spirits were not random models but "slim, hearty, unaffected women of early maturity living a hardy out-of-door life in high boots and jeans, toughened to wind and sun."[14] Further, Brigman wrote, "My friends are brave, and they enter into the spirit of my work.... Many of them have told me that in the very act of posing they have experienced an exaltation of mind and soul," a verbal equivalent of Gilpin's *The Prairie* (see fig. 61) and a sentiment akin to O'Keeffe's experience in the Llano Estacado of Texas.[15]

Brigman's union of nude and nature was not merely a pictorial device but an experiential one, born of the artist's commitment to connect with nature, in her case usually the rugged terrain west of Lake Tahoe in Desolation Valley in the Sierras (fig. 68). This area is vast, still somewhat remote, and dotted with alpine and subalpine lakes, a glacial valley, and weathered granite and volcanic rocks, one of those "clean, high, silent places, up near the sun and the stars," as Brigman phrased it.[16] A poet and a self-described pagan, she nurtured a love of the out-of-doors on frequent camping trips to the Sierras, where her mother took her as a child. Based in Oakland, Brigman would spend her summer months devoted to weeks- or even months-long trips into the wilderness (fig. 69). A guide would help set up camp and then leave her alone with her dog Rory, or with her sister Elizabeth or a friend, as she wrote, to satisfy her "[hunger] for the wilds, the solitude, the 'eating and sleeping with the earth' as Walt Whitman says," and, not least, to make photographic negatives.[17] Promoting an ethic of individual freedom and autonomy, Brigman

Fig. 69
ANNE BRIGMAN
Photograph published in *Camera Craft* 33, no. 4 (April 1926)
Courtesy George Eastman House

extolled the benefits of communing with nature: "Who can experience such days [camping in the Sierras] and not grow into new dimensions of body and thought, selfless and unafraid."[18] Declaring her aesthetics in an article titled "The Glory of the Open," Brigman connects the expansiveness of California geography and its stretches of wilderness with personal freedom and endurance, and her photographs symbolize this equation.[19]

Brigman viewed Desolation Valley as both "sinister" and "radiant and beautiful," where "ghostlike dead trees—and high wild peaks—wind swept and snowmantled, tower above it, but there is a lure like the lure of the desert. Strange junipers and pines have lived in its granite clefts and high spurs for thousands of years and more." Anthropomorphizing trees and seeing in them the "wind-kissed motion of the Victory of Samothrace," their character and strength compared to that of Moses or Abraham Lincoln, she reveals: "Storm and stress well borne made it strong and beautiful."

In *The Lone Pine*, a womanly nude mimics a pine contorted by wind yet thriving among granite boulders that reveal the ravages of time but are still somehow full and voluptuous. Brigman aimed, as she wrote, to make the human body "part of the elements, not apart from them," and, quoting her literary hero Edward Carpenter, to ensure that the body "matches somehow and interprets the whole of nature."[20] In this regard, Brigman turns traditional notions of the sublime on their head, for here humans are not awed in the face of nature because they are not made to be distinct from it. Either enfolded into nature or posed as an extension of it, Brigman's "naturized" nudes symbolize the turn-of-the-twentieth-century desire to achieve psychic wholeness. The figures also express a modern yearning for preindustrial roots that the California landscape itself—at least in the High Sierras—could help sustain. To some degree, Brigman's figures foreshadow the way in which Anglo-American artists integrated American Indians into the landscape, a device with radically different inflections yet equally indicative of this yearning (see, for example, fig. 109).

In a review of Brigman's work published in Stieglitz's influential *Camera Work*, critic J. Nilsen Laurvik writes that, in her prints, "the human is not an alien, not yet divorced by sophistication from the elementary grandeur of nature, rather it serves as a sort of climactic point, where in all that nature holds of sheer beauty, of terror or mystery achieves its fitting crescendo."[21] Laurvik admires the "primitive" spirit of her figures, underscored by an editorial note that "correct[ed] a false impression which has gone abroad....[T]hese negatives are *not* produced in a 'studio fitted up with papier-mache trees and painted backgrounds,' but have been taken in the open, in the heart of the wilds of California." The clarification is key, for not only was Brigman deeply proud of her California roots, often signing her name "Anne Brigman, California," but she reminded Stieglitz that she was, "as yet," his only California delegate to the Photo-Secession.[22] Brigman participated in the insistent rhetoric of American nationalism, linking emotion and art with geography. As fellow Photo-Secessionist Joseph Keily noted in *Camera Work*, Brigman's photographs are filled with a "certain bigness of feeling that the splendor of our Western nature seems to infuse the soul."[23] This same sentiment remained in play in 1918, when Laurvik referred to the immensity of scale in California, "upon which the Californian gazes from birth, giv[ing] him a bigness of vision that visualizes things and events in their entirety."[24]

Brigman's new artistic interpretation of the "naturized" woman, her "bigness of vision" that was equated with California, likely commended her to Stieglitz, whose nationalist concern for defining American cultural identity characterized his career. His strong belief that Brigman struck "a new note" in her work helped him to overlook her technical deficiencies, which he humorously described to her as "rotten."[25] The same year that she separated from her husband, Brigman took her first trip east, arriving in New York in 1910 and spending the summer in Maine, where she studied with Clarence White in order to improve her technique.[26] Of all the photographers in California at the time, the fact that she alone was elected a fellow of the exclusive Photo-Secession, and that her work was promoted by Stieglitz—whose own attention to rigorous technique was well known—underscores the perception of her singularity and the uniqueness of her approach. The symbolic quest of Brigman's nudes in the wilderness of California must have spoken to Stieglitz, fulfilling his quest for what an American art could and should be: a form of spiritual liberation arising from the country's native soil.[27]

When an earthquake and fire shattered San Francisco in 1906 (fig. 70), the city rose up, as is commonly described, phoenix-like from its ashes, its cultural identity carefully rebuilt in part through the efforts of Arthur F. Mathews

(1860–1945) and his wife, Lucia (1870–1955), both of whom helped provide a perfect Golden Age creation myth for California.[28] Born in Wisconsin, Mathews moved to Oakland as a child, and at a young age he learned drafting in his father's architecture studio. He furthered his artistic training at the Académie Julian in Paris—where his close colleague was Arthur Wesley Dow—and served as director of the California School of Design (now the San Francisco Art Institute). After the devastation of 1906, Mathews left teaching and laid the foundation for what would become known as the California Decorative Style. Joining with architects, artists, and developers in efforts to rebuild San Francisco, Mathews founded *Philopolis* (1906–16), a magazine devoted to urban planning and art, and established the Furniture Shop (c. 1908–20), providing elegantly designed Arts and Crafts furnishings with "California" designs derived from the local landscape. Mathews and his cohorts aimed for nothing less than a thoughtfully conceived total environment based on a utopian effort to make California a truly classically modern state, and a state of mind, a "Calitopia," as one *Philopolis* contributor termed it, condensing geography with aspiration.[29] As one contemporaneous art historian noted, "Mathews's influence on the art of the West has been far-reaching in that his thorough knowledge of

the great traditions of the past has served as a guiding and refining influence in a new civilization where unrestrained vigor and enthusiasm are not always balanced by discretion and retrospection."[30]

Mathews's art was informed by the muted palette, flattened surfaces, and Symbolist content of the nineteenth-century French painter Puvis de Chavannes, by the patterned compositions of Japanese prints, by the monotone palette of James McNeill Whistler, and by the muralist tradition. Mathews gave these aesthetic tendencies new life, invigorating them to the point that they took on a utopian dimension when aligned with the broad concept of creating San Francisco afresh. In the period between the earthquake and subsequent fire of 1906 and the Panama-Pacific International Exposition of 1915—a fair that celebrated the completion of the Panama Canal and served as an opportunity for San Francisco to highlight its dramatic recovery—Mathews dominated the art community of northern California. Painted the same year Mathews produced a major mural for the Panama-Pacific International Exposition and exhibited more than fifteen paintings in its Palace of Fine Arts, *View from Skyline Boulevard, San Francisco* (1915; fig. 71) exemplifies his use of soft harmonies and subtle pattern shifts. Here he depicts the scenic and fertile valley of the Coast Range on the central peninsula south of San Francisco, along what is also known as state route 35.

In keeping with the muralist tradition and his preference for a muted palette, Mathews reduces and flattens the landscape into a series of tonal patterns, using the tree-shaded farm as a motif to unify the composition, and a curving road that meanders into the distance to provide the delicate tension between the painted surface and the pastoral scene itself. In this device, his painting recalls a Pictorialist photograph by Alvin Langdon Coburn titled *From a California Hilltop*, dating from around 1911 (fig. 72), when Coburn lived briefly in Southern California before joining Dow at the Grand Canyon in early 1912 (see p. 83). Also a view of California's fertile valleys with farms linked by a curving road, Coburn's photograph likewise recalls Dow's emphasis on pattern, tonal variation, and line. Coburn eliminates the sky entirely, which dramatizes more insistently his flattened composition, whereas Mathews uses the sky to provide another band of color. To achieve a quality of golden serenity, Mathews softens the painting's palette and provides a grayish undertone to the colors he has chosen. He even waited for "Tonalist"

Fig. 70
North Beach from Stockton and Lombard Streets, **May 3, 1906**
[Photograph by Turrill & Miller]:24
The Bancroft Library, University of California, Berkeley, Roy D. Graves Pictorial Collection,
BANC PIC 1905.17500—ALB

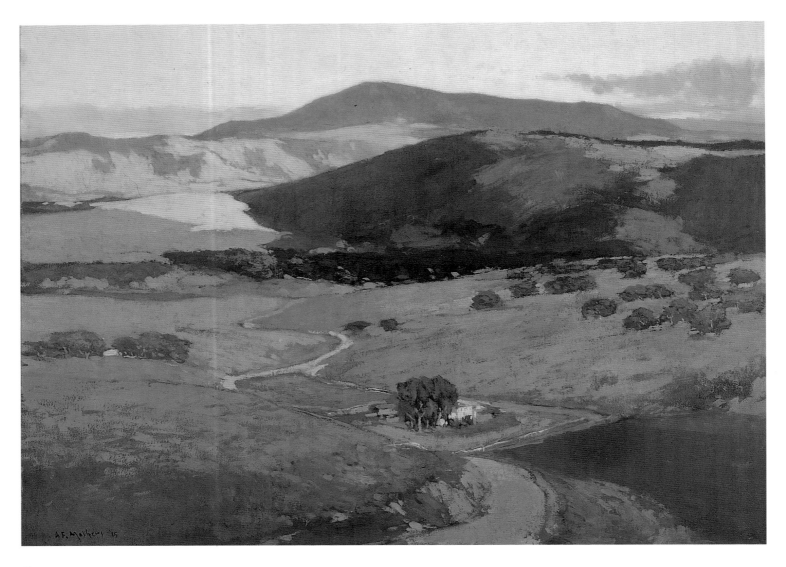

Fig. 71
ARTHUR F. MATHEWS
View from Skyline Boulevard, San Francisco, 1915
Oil on canvas, 30 x 40 in.
Oakland Museum of California, Gift of Concours d'Antiques, the Art Guild

Fig. 72
ALVIN LANGDON COBURN
From a California Hilltop, c. 1911
Platinum print, 12 ⅛ x 15 ¾ in.
George Eastman House

moments to paint, noting that he worked outside after four o'clock because, to him, "the most extraordinary color effects that we find here in the West come only in the diffused afternoon lights."[31] His preference for subdued coloristic light effects connoted delicacy and refinement, underscored in his comment that "[i]t takes a delicate skill to paint a gray picture, and it does not often happen that a full colored one escapes the garish."[32] Mathews was among the first to step forward to provide the quality of restraint, the "discretion and retrospection," that was intended by many artists and critics to define California's cultural identity in the years following 1906.

With its emphasis on flattened space, graceful rhythms, and sinuous curves, and its debt to Japanese compositional aesthetics, Pictorialist photographer William E. Dassonville's (1879–1957) *Mount Tamalpais, Marin County* (c. 1905; fig.

73) resembles the more complex tonal variations found in Coburn's *From a California Hilltop*; the stacked spacing of Mathews's *View from Skyline Boulevard*; and the broad patterns of Davies's *Pacific Parnassus*, which shows a view *from* Mount Tamalpais, as opposed to a view *of* it made from the winding coastal wetlands. A native Californian who was born in Sacramento, Dassonville is best known for his invention of Charcoal Black, a textured paper that perfectly suited soft-focus photographs.[33] Now becoming better known for his photography and the cultural community in which he worked—including painters William Keith and Maynard Dixon, writer and environmentalist John Muir, and the young Ansel Adams, and which was documented by his correspondence with Alvin Langdon Coburn—Dassonville represents the more technically advanced photographers of

Fig. 73
WILLIAM E. DASSONVILLE
Mount Tamalpais, Marin County, c. 1905
Platinum photograph, 8 x 10 1/16 in.
Wilson Centre for Photography, London

the California Camera Club (of which he served as secretary). He was a master craftsman of the platinum printing process. Stating his aesthetic philosophy in the *Overland Monthly* in 1902, the same year that Stieglitz founded the Photo-Secession, Dassonville looked to the work by Steichen and Whistler, among others, as his models; he emphasized that the photographer chooses "those aspects of nature which form a harmony," encouraging him to "learn her [nature's] forms and moods; then, when he has learned this, he re-creates her until he reaches his ideal of an harmonious whole."[34]

As is now clear, Tonalist painting and Pictorialist photography worked hand in hand to produce a quality of discrete refinement, a "harmonious whole" that was not new in Euro-American aesthetics but that took on additional meaning when coupled with the artists' deliberate efforts to nurture northern California's cultural community, particularly after San Francisco's destruction. Scholars previously have described the endurance of both Tonalism and Pictorialism in California as aesthetic indicators of the state's relative isolation or backwardness compared with the heady art-world happenings of New York or Paris occurring at the same time. But we could argue alternately that the endurance of these artistic movements was also a measure of their success: their aesthetics were perfectly aligned with California's developing and distinct ethic of celebrating nature. Put another way, in addition to the extraordinary scenic beauty and variety that inspired artists in California to engage with nature, an aesthetic was also in place that emphasized abstracting the general from the particular, essentializing California's natural glories in a way that was complemented and reinforced by its booster business and civic proactivity. Such gifted people as John Muir, for example, articulated an environmental position in the north, one historian stating that Muir "upgraded the entire California relationship to the mountains. As a public figure he set a standard of what California should be: challenged to beauty and to new passion for life by the magnificent land in which they found themselves."[35] In the south, Charles Lummis and George Wharton James extolled the local landscape through writing and photography. Throughout California, artists and writers celebrated the Golden State's natural grandeur at precisely the time those scenes and vistas were about to change. As the business and artistic communities grew, Pictorialism and Tonalism did their part: artists abstracted and promoted California's distinctive

geography in their dreamy landscapes, perpetuating a vision of Arcadia.

The Swiss-American Gottardo Piazzoni (1872–1945), among the most talented and renowned of Mathews's students, was a painter and muralist whose works distill elements of California's landscapes to their barest elements. At the top of his career in 1918, when *San Francisco News* journalist Max Stern asked Piazzoni to name his religion, he responded, "I think it is California."[36] Although the course of Piazzoni's life and career suggests that it is unlikely he was exaggerating, it should be emphasized that his remark entered into a larger discourse about defining California identity that pervaded the region in the early decades of the twentieth century. The booster rhetoric of the media helped promote the cause. Years earlier, in 1908, a critic for the *San Francisco Call* wrote in reference to Piazzoni's interpretations of California: "[I]t is California with all of her mystery, her wonder, her beauty and undying drawing power that holds you. It is California before the gringo came; with her sunny valleys, unspoiled by the foot of man; her fertile plains where flocks have never grazed; her virginal soil; her rich promise."[37] What had happened *on* this landscape was largely ignored by Piazzoni and others in favor of expressing the intensity of their faith *in* the landscape itself. As another critic observed of Piazzoni, "He is fundamentally a dreamer who cannot move about the country and paint here and there, but must stay quietly in one spot and live in the landscape he paints and absorb it to the point of saturation."[38]

At age fifteen, Piazzoni moved from his native Switzerland to the family dairy farm in upper Carmel Valley on Chupinas Creek, a place that inspired his painting throughout his life. After studying with Mathews, Piazzoni traveled to Paris, where he attended the Académie Julian and also studied with Jean-Léon Gérôme. He returned to San Francisco and established the Piazzoni Atelier d'Art in 1901 and taught at the California School of Fine Arts (now the San Francisco Institute of Art) from 1919 to 1935. Piazzoni became a beloved figure in the art community. In the year of the Panama-Pacific International Exposition, he received a commission from the wealthy California vintner and real estate investor Andrew Mattei, also a Swiss, to paint two works for his Fresno dining room, *The Land* and *The Sea* (1915; figs. 74 and 75). For this commission, Piazzoni exercised his muralist sensibilities; each painting is more than ten feet long and is reduced

Fig. 74
GOTTARDO PIAZZONI
The Land, 1915
Oil on canvas, 48 x 124 in.
University of California, Berkeley Art Museum, Gift of Helen and Ansley Salz

Fig. 75
GOTTARDO PIAZZONI
The Sea, 1915
Oil on canvas, 48 x 124 in.
University of California, Berkeley Art Museum, Gift of Helen and Ansley Salz

Fig. 76
WILLIAM E. DASSONVILLE
Dunes, c. 1925
Gelatin silver photograph, 7 ½ x 9 ⅓ in.
Wilson Centre for Photography, London

to the two features most often used to characterize California: in one, its fertile, sun-drenched rolling hills and in the other, its infinite expanse of ocean.

A study in rhythmic contrasts, *The Sea* is portrayed as a series of tightly interlocked bands layered on top of one another, while *The Land* conveys the sensation of clouds moving over a rolling landscape. Piazzoni achieves the qualities of placid serenity and almost dancing movement through his precise technique. Allowing sections of the canvas in *The Land* to remain exposed, for example, he uses directional brushstrokes to follow the gentle curves of the land, employing a lightness of touch and restraint that contrast with the panoramic scale of the work. The clouds read as massed forms, interlocking pieces of a puzzle shifting from light to dark, as Piazzoni distills the sensation of sunshine and billowing clouds moving over a hillside into delicate patterns. This sensitivity to texture in the landscape, combined with rhythmic movement, can be compared to Dassonville's *Dunes* (c. 1925; fig. 76) of a decade later. In a Pictorialist image of dunes either in the vicinity of Carmel, where Dassonville often photographed, or farther south at the Guadalupe-Nipomo Dunes, the fine beach grasses, smooth hills, and gently rippling sand rills are perfectly captured in the Charcoal Black paper. The parchment-like paper served such scenes of delicacy and restraint well.

Of various hues, the long and short strokes of impasto suggest lapping waves on the shore of *The Sea* before reaching another solid rectilinear band of crisply and evenly painted gray-blue anchored by a smudgelike sail in the far distance. Alternating between movement and stasis, the next band shows massed billowing clouds topped by a band of sky that is thinly painted; the artist used a rag to achieve this mottled effect. He likely layered the entire canvas with blue-gray, then wiped away (as in the sky) or added on top (as in the clouds) in order to render the desired effect of stillness, accentuated by the sensation of gentle lapping waves, or of quietude, discerned in the dense distant fog. Piazzoni's spare approach did not go unnoticed by critics of his day, one of whom wrote, "It is not the outward garb that Nature wears that attracts him, but the underlying spirit or elemental force of Nature that his pictures reveal, its vastness, its silent voice, and above all its perfect peace—one stands silent and prayerful before them."[39] Piazzoni himself embodies this meditative quality in a photograph that his younger colleague Ansel

Fig. 77
ANSEL ADAMS
Portrait of Gottardo Piazzoni in His Studio, c. 1932
Silver print, 15 3/4 x 19 1/2 in.
Collection Center for Creative Photography, University of Arizona

Adams took of him in his studio (fig. 77). We see Piazzoni posed on a scaffold, whose geometric outlines play with the abstracted painting of a hillside landscape propped behind it. Bathed in gentle light and assuming a religious pose, the artist stands with bowed head before his art, as if paying homage to the California landscape that has inspired it.

THE COLOR OF JOY

In contrast to Piazzoni, who painted vastness in a manner that conveys spareness, Selden Connor Gile (1877–1947) fragmented the California landscape into more intimate scenes that rendered them in thick impastos of vivid, exaggerated color. Gile was the leader of the Society of Six, a group of Bay Area painters who had banded together after the Panama-Pacific International Exposition. Because Pictorialist photography and Tonalist and Impressionist painting retained their relevance for an extended period in California, the establishment of the Society of Six was indeed an event when its members came on the scene in the late teens and early twenties. One critic, reviewing an exhibition at the Oakland Art Gallery (now the Oakland Museum, Art Department), warned his readers: "You can see it [color] oozing out the door before you enter the gallery."[40]

The Society of Six, long considered a harbinger of newer artistic trends in the Bay Area, was essentially a group of self-taught painters. Gile, who was born in Maine and moved to California around 1903, did not paint full time until he reached age fifty, when he left his job at a tile and ceramic firm. The group also included William Henry Clapp, August François Gay, Maurice Logan, Louis Siegriest, and Bernard von Eichman. Following daylong excursions to paint in the surrounding countryside, Gile would host spaghetti dinners and "not exactly un-vinous" evenings at his home on Chabot Road in North Oakland, where the group would gather and talk about their work.[41] As scholars often remark, the group's solidarity and camaraderie, their promotion of color, and, above all, an abiding interest in the local landscape united them.

Clapp, who also served as director of the Oakland Art Gallery, was the only formally trained artist in the group and, in an era of artistic manifestos, he wrote one for the Society of Six. Although not formally published as a manifesto until 1926, it articulated the group's position, as stated in comments that Clapp had made in 1923 on the occasion of the group's first exhibition. Putting the group in direct opposition to still-reigning art trends west of the bay in San Francisco, referring presumably to the low-key paintings of Mathews and Piazzoni, Clapp noted, "Across the bay they seem to us to lack joy of vision and color — here vision and color are the very foundation of art."[42] In the official manifesto he states: "[W]e do try to fix upon canvas the joy of vision.…We are not trying to illustrate a thought or write a catalogue, but to produce a joy through the use of the eyes. We have much to express, but nothing to say. We have felt, and desire that others may also feel."[43] In an era of "isms," the group's aesthetic credo was referred to as "joyism."

Likely familiar with European trends in art through magazine illustrations or certainly through direct contact with works shown in Bay Area museum exhibitions, the group engaged with a variety of different artistic sources and ideas. Their works most clearly recall Fauvism and the colorful canvases of Henri Matisse and André Derain. Color, however, was not the only element that the Society of Six held uppermost, in contrast to those "across the bay." If Piazzoni, for example, was meditative, the Society of Six promoted the spontaneity suggested in the oft-repeated phrase "joy of vision." Their plein-air paintings, done in sittings in which they painted wet-into-wet so that colors blend or are layered atop one another, radiate this cultivated intuitiveness.

This painterly approach may be seen in two works by Gile, *The Soil* (1927) and *Untitled (Cows and Pasture)* (c. 1925), the latter a sketch (figs. 78 and 79). The composition of *The Soil* recalls that of Mathews's *Skyline Boulevard*, in which a fertile valley envelops a small farm. Gile's view, however, was captured on the opposite coast of the bay, east of Oakland, in the agriculturally rich orchards and farms of Contra Costa County. Gile zooms in on the scene, leaving narrow passages of yellow and blue to suggest a sliver of sky. And while Mathews layers his scene with stacked passages of relatively small tonal shifts, Gile achieves a quality of flatness in his canvas with a warm blast of orange. Further, he equates the joy of seeing with the joy of touch, visceral sensations conveyed by his choice of vivid hues and his application of rich layered areas of thick paint. This delight in medium is more vivid in *Untitled (Cows and Pasture)*. As the painter Richard Diebenkorn enthused, "Gile's painting is about painting and the act of painting as much as it is about simple, unencumbered subjects."[44] In fact, Gile's friend Jay Hannah commented years later that, while painting, Gile "would not pause—the same stroke that made the hills made the animals. But with people and other sentimental touches, he would have stopped, considered, and held the brush in another way. What you have is a man who is fundamentally a loner and there's a kind of pristine beauty to him being there and everything unsullied. He is relating to nature…and that's why it works better. What he feels about the hills and animals comes naturally."[45] When Hannah used words like "pristine," "unsullied," and "loner," he summoned the theme of the "primitive," the isolated artist uniquely equipped to interpret nature intuitively, so that there is no degree of separation between self and subject.

In conjuring the "primitive," Hannah tapped into the modern search for wholeness and authenticity, a theme that courses through the paintings of Clayton S. Price (1874–1950), whose *Coastline* (c. 1924) is perhaps the most compelling California landscape painting of this period (fig. 80). During his tenure in Monterey, from 1918 until his departure for Portland, Oregon, around 1927, Price never joined the Society of Six, but he became friends with several of these artists, and the public associated his vibrant canvases of the California landscape with their work.

Fig. 78
SELDEN CONNOR GILE
The Soil, 1927
Oil on canvas, 30 ⅛ x 36 in.
Private collection, San Francisco

Born in Iowa, Price moved with his family to Wyoming, where they established a ranch.[46] Working as a cowhand there and in Canada, he kept art supplies in his saddlebag, taking them out to make sketches as he roamed the range. Determined to receive art training, Price studied in 1905–6 at the St. Louis School of Fine Arts, where he met the Montana illustrator and painter Charles M. Russell. Price embarked on a career as an artist, making western illustrations of cowboy themes for monthly magazines. He moved to the Bay Area in 1915; a visit to the Panama-Pacific International Exposition and a meeting with Piazzoni, who would become his mentor, prompted a new direction in his art. Price's ability to dedicate himself to painting full time was made possible by his success as a gambler (early in his artistic career) and by working in Monterey's sardine canneries, making frames, and occasionally selling his paintings. The painter Armin Hansen, who taught outdoor painting classes in Monterey, was Price's only other direct source of artistic training.

Fig. 79
SELDEN CONNOR GILE
Untitled (Cows and Pasture), c. 1925
Oil on canvas, 12 x 16 in.
Collection of Robert Aichele

Price evidently cultivated his outsider status, promoting the idea of an uncultured artist that Gile's friend Hannah had referred to in admiring terms. R. V. Howard, a Canadian artist friend of Price, noted that, in 1923—and this year is important, for it was when the Society of Six directly encountered the art of Derain and Matisse at an exhibition at the San Francisco Civic Auditorium—"Modernism was being talked about. It was in the fall of 1923 I think because he was painting horse pictures in the summer and when I came

back at Christmas he had one or two paintings in a new and quite abstract style. 'How did you come to paint like that?' I asked him." Responding like a seasoned formalist, Price replied, "One day…I was setting up a canvas when I thought a big splotch of red would look nice on it. So I brushed on some red. Then I put some other colors beside it—no particular shape—but some of the shapes would just happen to look like something. One patch of color would be a house—another might look like a cow. I would leave them. People ask

Fig. 80
CLAYTON S. PRICE
Coastline, c. 1924
Oil on canvas, 40⅛ x 50 in.
Hirshhorn Museum and Sculpture Garden, Smithsonian Institution, Washington, D.C.
Gift of Joseph H. Hirshhorn, 1966

me why I paint like that. I don't know. I just like it."[47] Price emerges here as an instinctual, primitive artist who came to modes of abstraction spontaneously, but he was undoubtedly more culturally seasoned than he allowed.

Price, in *Coastline*, produced a complex painting that is sophisticated yet crude, colorful yet austere. Based on a view of Monterey's coast, the work reveals an even slice of sky at the top and a band of still water, which suddenly gives way to a colorful ruptured mass of craggy terrain. A broad stroke of white lead stands in for lapping waves, and cursory brushwork suggests a house by the sea fronted by tall pines. The canvas expands with energy, summing up Price's view that "no matter how small the painting…each stroke should feel as if it was going to be as broad as the room."[48] Throughout, Price sustains constant tension between the scene and the two dimensions of the canvas, working the surface aggressively by adding large areas of impasto, scraping back paint, manipulating the medium with a brush and a palette knife, leaving areas of the canvas exposed, and providing layer upon layer of viscous paint. The artist even joked once that "for every painting he finished, there were five underneath."[49] But there is something more profound at work in this offhand remark.

Price was always looking for something he could not define. As Howard noted, Price "felt that he was working out some problem in paint that he understood none too well himself. He was trying to catch something that kept suggesting itself as he painted. At times he spoke as if he was trying to get at something that was in himself but usually he spoke as if the thing he was trying to get was in the paint on the canvas."[50] As Price struggled to express his intense feelings for the raw sublimity of nature (he was averse, Howard notes, to "the superficial brilliance of technique which offended him"), he delved deeper into the physical act of painting as Jackson Pollock would do in the late 1940s (see p. 271). He found resolution through layering colors on canvas, as if to simulate the ravages of time. Price allowed that he wanted to achieve an effect on canvas similar to that which "was got by nature on an old building covered with layer after layer of paints of different colors, cracked, worn and weathered." Price preferred, Howard wrote, "crude, harsh work that showed signs of primitive strength." Collapsing together time (layered surfaces) and place (surface brushwork that approximates expansive coastline), Price thus achieves a sensuous

harshness perfectly suited to the coastline around Monterey and Carmel. Essentially, through the creative act, he became one with the land, convinced in his belief, as he phrased it, that "the earth and all its creatures exist in one great stream of life which has a single spiritual source…what he called 'the one big thing.'"[51] Price exemplifies the search for psychic wholeness that is first encountered in California in the art of Brigman and that embodies modern yearning.

THE TECHNIQUE OF FORM AND EMOTION

In contrast to the planar muscularity of Price's *Coastline*, Stanton Macdonald-Wright's (1890–1973) *Cañon Synchromy (Orange)* (1919; fig. 81), with its numerous voids and soft prismatic color, appears ephemeral and evanescent. At first glance these two works could not be more different, as were the personalities and the life experiences of the artists. Yet Arthur Millier, a printmaker and longtime art critic for the *Los Angeles Times*, paired these two artists in an article titled "The Pacific Coast: Artists Are Stimulated by Its Diverse Climates." In 1951 he wrote, "While most people were trying to catch up with George Bellows' earthy Americana, a few artists up and down the coast were reacting to other stimuli. S. Macdonald-Wright in Santa Monica and C. S. Price in Monterey…were painting in styles well ahead of the impressionist-conditioned taste of most art buyers."[52]

By describing an "impressionist-conditioned taste," Millier alludes to the persistent hybrid of Impressionism/ Tonalism that prevailed in California art in the early decades of the twentieth century. He referred, for example, to art colonies such as the one at Laguna Beach, farther down the coast south of Los Angeles, where Frank W. Cuprien (1871–1948) reigned supreme. Cuprien's painting *Evening Sun (Poème du Soir)* of 1925 is among the best examples of this genre at the time (fig. 82). Along with William Wendt, who was considered a dominant figure of the "California Impressionist" art colony that developed at Laguna Beach beginning at the turn of the twentieth century, Cuprien, a native of Brooklyn, trained at the Art Students League in New York and taught at Baylor University in Waco, Texas, for several years before permanently settling at Laguna Beach in 1914. Cuprien was joined by other artists, including Wendt, Guy Rose, and Maurice Braun, who shared sentiments about extolling the beauties of California's coastline, the theme that unites their work.

Cuprien comes down to us as a convivial sort, working

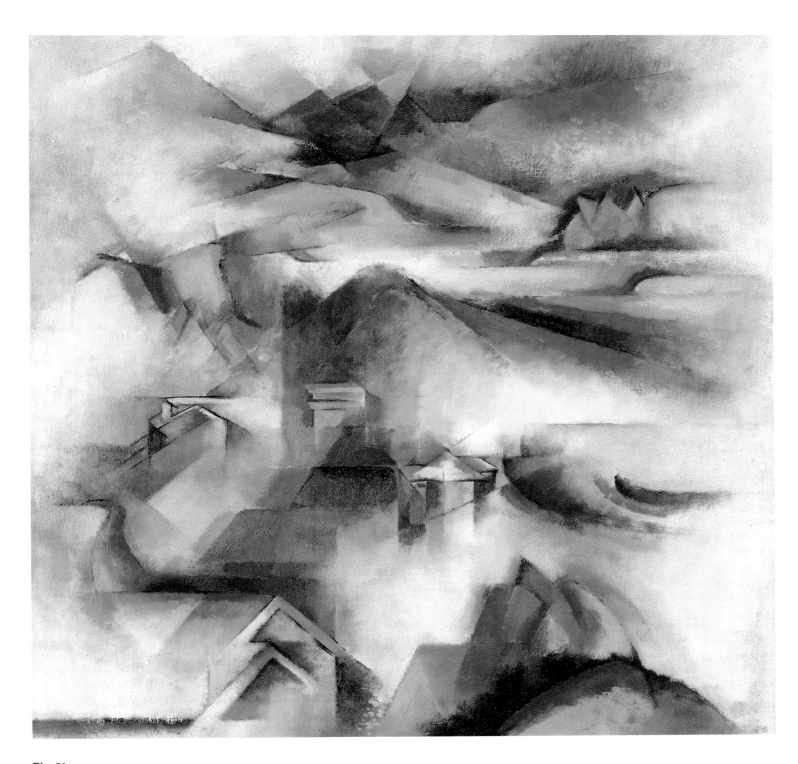

Fig. 81
STANTON MACDONALD-WRIGHT
Cañon Synchromy (Orange), 1919
Oil on canvas, 24 ⅛ x 24 ⅛ in.
Collection of the Frederick R. Weisman Art Museum at the University of Minnesota,
Minneapolis, Gift of Ione and Hudson D. Walker

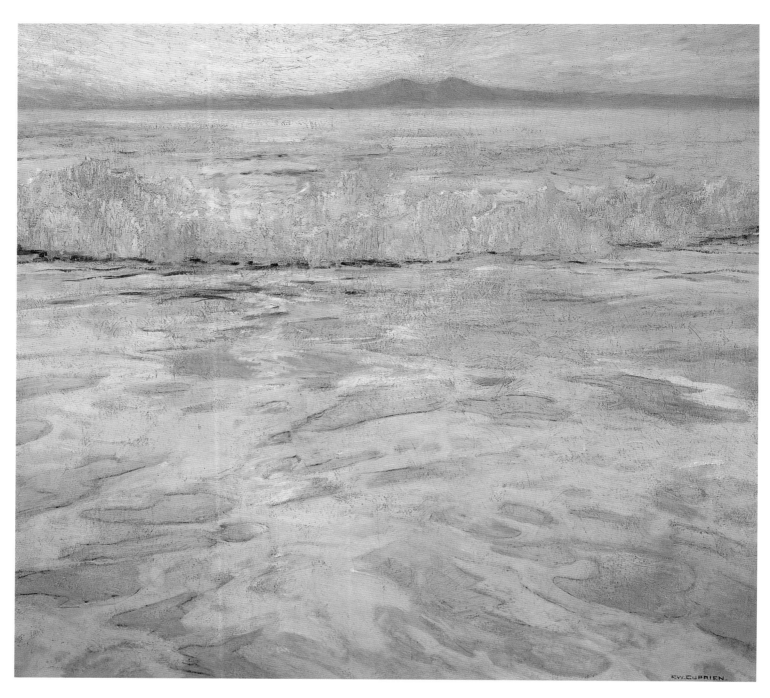

Fig. 82
FRANK CUPRIEN
Evening Sun (Poème du Soir), 1925
Oil on canvas, 32½ x 35⅛ in.
Collection of the Orange County Museum of Art, Newport Beach, California,
Gift of the estate of Frank W. Cuprien

from his home and studio, called the Viking, about a mile south of the city center, and arranging musical and artistic gatherings. He dressed the part, too, wearing a "distinctive costume of knickers, puttees and belted jackets" long after they fell out of fashion.[53] Cuprien, as one contemporaneous critic described him, "loves to paint a slow incoming tide with a subdued illumination of the sun, or the softness of the afterglow on the ocean at dusk."[54] Although the quality of his paintings is inconsistent, Cuprien was prolific. He repeatedly depicted California's light and shadow—varying the titles of his works, such as *Evening Magic* and, translated from the French, *Poem of the Evening*—and usually painted in a vein of quaint romanticism that many might term "coastal kitsch."

Cuprien generally used a lavender and golden palette, a choice that had been parodied as early as 1890 as being a typical feature of the "Monet gang," referring to the American painters who had congregated near Claude Monet's house and gardens at Giverny. Cuprien was also stimulated by his early contact with William Trost Richards, a nineteenth-century Philadelphia artist who specialized in opalescent marine paintings. Lilac and yellow tones, to some local critics, perfectly described the geography of California. In 1913 critic Everett C. Maxwell proclaimed, "From a dozen different writers upon subjects pertaining to the development and trend of art in the west, the word has gone forth to the world that California, that land of golden light and purple shadows, is destined in the course of the next few years to give us a new school of landscape painting."[55]

Geography was used to create destiny, and although the content was new, the "school" or the concepts behind the school were not. Cuprien painted his shimmering *Evening Sun* from the vantage point of a bluff from the garden next door to his house. Like John Henry Twachtman, who had founded the Impressionist artist colony in Cos Cob, Connecticut, Cuprien uses a square canvas format. He provides a tiny sliver of horizon that includes the distant lavender contours of Catalina Island. Near the top of the canvas he paints crashing waves before giving over the rest of the canvas to the illuminated effects of water lapping the shore. He uses thin washes of lavender and gold and curving graphite lines so that most of the canvas is a series of calligraphic swirls. Like a Pictorialist photograph of the period, as seen in an image by Kaye Shimojima, wherein the artist points the camera down to capture the abstract effects of reeds or lily pads on water

(fig. 83), Cuprien's painting revels in the mesmerizing sunlight patterns on water. In its meditative quality, *Evening Sun* is reminiscent of Twachtman's *Emerald Pool* (see fig. 46), even though it dates a full three decades later and is not born of the same rigorous therapeutic intent of that historical moment. A cut above the predictable Laguna Beach art colony Impressionist painting, *Evening Sun* nonetheless represents an enduring trend in California art, both because the painting was created in isolation from art-world centers and because the landscape itself figured prominently in American culture, especially in various regions, particularly in California.

Fig. 83
KAYE SHIMOJIMA
Edge of the Pond, c. 1928
Gelatin silver photograph, 13 7/16 x 10 1/2 in.
Los Angeles County Museum of Art, Gift of Karl Struss, 28.24.2

In Millier's description of California art in the early decades of the twentieth century, we notice another salient characteristic of art criticism of the time. First, in using terms such as "catch up" and "well ahead," he describes artistic endeavor along the Pacific Coast as a historically determined race toward more advanced or avant-garde art. Implicit in his discussion is that this race against time is set against a larger story of art in the northeastern United States and, ultimately, in Europe. This discussion tends to break into two oversimplified categories. Art and artists are labeled either as conservative or traditional, as avant-garde, or as radical in relation to what is happening elsewhere. In California, this East-West dynamic was made more complex by a tension between northern and Southern California.

As the historiography of the art of California demonstrates, the development of art communities in either northern or Southern California (often recounted in competitive terms) was measured by markers related to these other art communities. For example, consider key events such as the founding of what are now the San Francisco Fine Arts Museums (1895) and the Los Angeles County Museum of Art (1913); the opening of the Panama-Pacific International Exposition (1915); the arrival of Walter and Louise Arensberg, major patrons and collectors of European Dada and Surrealist art (in Los Angeles, in 1927); the contributions of Mexican muralists and political activists José Clemente Orozco, Diego Rivera, and David Alfaro Siqueiros in northern and Southern California (in the early 1930s); and, not least, the absorption of artists from other places who taught or interacted with California artists and enlivened and enriched the artistic scene. Indeed, these benchmarks represent significant moments of impact, but because they are tied to a priori notions of an artistic canon, the tendency is to interweave these events into a dominant story line produced largely in New York rather than to understand them in terms of specific places in modern culture. Although imbued with nationalist and booster overtones and pronounced in an era of schools and "isms," this may be what Robert Henri was getting at when, in 1914, he proclaimed, "The new Western school of painting will not be an imitation of all the others that have gone before it, but will be strongly individual, inimitably of the big free West. You have the opportunity here to advance in your own way because you are happily removed from any large center of conservative traditions. Compelled to blaze your own trail, you will grow

fearless and strong."[56] A more cynical art historian might say that California artists grew "fearless and strong" by championing Tonalist/Impressionist modes of painting that, at least in New York at the time, were considered retardataire. But to look at California art in the context of its geography—the state is Janus-headed, facing both east and west (Asia)—we see the creation of a liminal space at continent's end. It is this richer context that provides the basis here for assessing the art of California and California's cultural landscapes as emblematic of the modern West.

Helping to make this point is the work of Stanton Macdonald-Wright, recognized primarily as the founder of the first American abstract movement in art in 1913. Born in Charlottesville, Virginia, Macdonald-Wright was reared in Santa Monica, California. He studied art in New York at the Art Students League and, in 1907, traveled to Paris, where he received academic training. In 1911 he met Morgan Russell, with whom he explored color theory at the time, which led to the development of their theory of color abstraction called Synchromism, which literally means "with color."[57] Exhibiting their works in Munich, Paris, and New York, these young American artists helped catapult color painting to the forefront of critical and public discussion. Distinct from Cubism, which stresses simultaneity of vision, Synchromism is based on the premise that color could be used to suggest the recession or advancement of planes, expressed by Macdonald-Wright in *Cañon Synchromy (Orange)* by chromatic shifts that move throughout the canvas in a series of color rhythms and harmonies. Macdonald-Wright's paintings were only briefly completely nonobjective, around 1914. He generally relied on the human figure, finding special interest in Michelangelo's marble *Dying Slave.* The artist also produced landscapes and still lifes. Representing the insistently nature-based abstraction of American art, Macdonald-Wright wrote in his early Synchromist manifestos that "nature was the source of art and the end of art, as nature was our source and destination as a species."[58] He was adamant about this point. Indeed, Macdonald-Wright became distrustful of abstraction not so very long after he founded the movement in America, finding it vulnerable to, as he later wrote, "little more than surface decoration" and also susceptible to being "routine and facile." Instead, he allowed that he kept searching for a "greater fecundity of unified form and color."[59]

Macdonald-Wright's most distinguished period of artistic renown came in 1913, when he established his color theories, and in 1917, when Alfred Stieglitz mounted a solo exhibition of his work at 291 Gallery. In an exhibition statement, Macdonald-Wright alerted viewers that his present work differed from his earlier work. "My ambition," he wrote, "is to create an art which stands halfway between music and architecture and, in order to ascertain, if I have in some degree succeeded, one should receive what pleasure the works are capable of giving in a state of mental relaxation."[60] Painting, for him, occupies a space between architectonics and music, the tonal forms of which are invisible and should be approached optimally with or stimulated by meditative experience. He did not reveal that his own experience had been stimulated by an opium addiction. This addiction ran in the family: his brother, Willard Huntington Wright, an art historian and critic, had returned to Southern California in 1917 to enter a sanitarium but did not succeed in withdrawing from the drug. As Willard wrote to Stieglitz in December 1919, "Stanton and I are planning a big modern show for Los Angeles and San Francisco this winter and early spring."[61] Echoing his friend Robert Henri's utopian vision of a new American art, Willard wrote, "The West, with its broad tolerance and freedom from precedent and tradition, is the logical place for the development of new ideas, and the time will come when the younger painters will find and project the beauty of modern art."[62] Stanton, who had successfully weaned himself from his addiction, declined to work with his brother on a northern California show. With the help of Stieglitz, he mounted one in Los Angeles shortly after he returned there in 1918, intending to form his own art school. Instead, Macdonald-Wright, a natty and sophisticated intellectual, assumed the roles of director of the Los Angeles Art Students League and of Chouinard Art Institute. He eventually taught art and Asian philosophy at the University of California, Los Angeles.

Cañon Synchromy (Orange) was included in the "Exhibition of Paintings by American Modernists" in February 1920, held at the Los Angeles Museum of History, Science and Art (now the Los Angeles County Museum of Art). The show also included works by Arthur Dove, John Marin, Thomas Hart Benton, and Marsden Hartley. All of these artists had been represented in the Forum Exhibition of 1916, organized by Willard Huntington Wright, Stieglitz, and Henri, among others, to counteract accusations following the 1913 Armory Show that American artists were not sufficiently advanced compared with their European counterparts. Heralding the newness of the art that his California audience would be seeing, and softening what might have been construed as its more radical moments, Macdonald-Wright exclaims in the catalogue, "We modern artists are just what our name implies; we are alive with you today—we are not animated corpses —we speak your language, the language of the hum and stir of moving things, of energy and intensity, of the aspirations of the twentieth century."[63] Perhaps he overestimated his audience. Even three years later when Macdonald-Wright helped organize a show for the Group of Independent Artists of Los Angeles, some critics responded favorably, some antagonistically, and others in ways that betrayed their confusion, one critic describing Macdonald-Wright's submission as "impressionist."[64]

Although *Cañon Synchromy* is not categorically "Impressionist" in art-historical terms, it has an ephemeral quality and displays an evanescent lightness of touch that an untutored critic might well have labeled "Impressionist." Literally hovering between architecture and music, Macdonald-Wright's painting alternates between architectonic forms and the energy of empty space. The artist provides glimpses of rooftops and cornice edges, suggestive of the new buildings erected during the explosive growth of Los Angeles in the 1920s. His painting offers an aerial view, loosely inspired by the many canyons throughout the Los Angeles area. Macdonald-Wright expressed interest in new forms of technology, specifically the rise of aviation in Southern California, which was growing exponentially at this time. He believed that aviation altered perception and "symbolized an expanded consciousness."[65] A mountain forms the central focus of the composition as all perspectival lines radiate outward. Employing his characteristic prismatic color in vibrant blues, oranges, yellows, and greens, Macdonald-Wright uses crisp, angled lines that give way to feathery effects of paint so that form and color ebb and flow throughout the canvas, not unlike the waves lapping the Pacific shore. The tension between opposites, solids and voids, recalls both the idea of *espacement* (what Synchromist artists called "the hollow and the bump") in Synchromist aesthetics and the yin and yang of Asian philosophy. Macdonald-Wright's interest in Asian aesthetics increased dramatically over the years and, toward the end of his life, led him to spend half of each year in

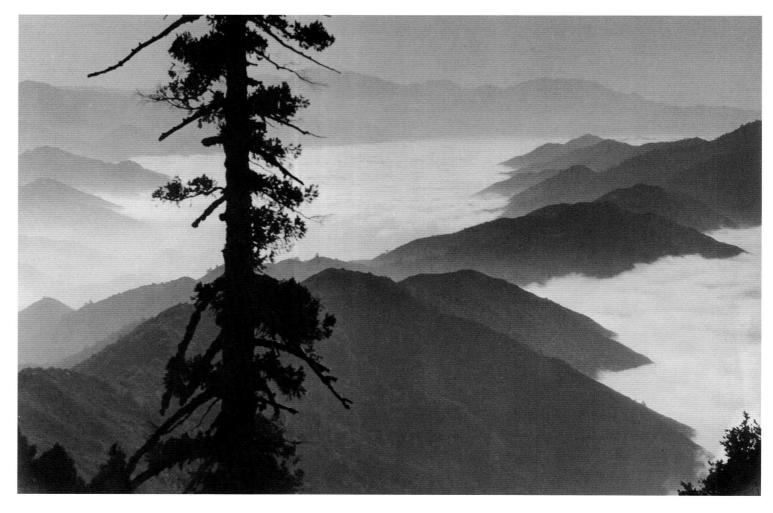

Fig. 84
ASAHACHI KONO
Untitled (Tree and Hills), late 1920s
Gelatin silver photograph, 7³/₈ x 11⁷/₈ in.
Dennis Reed Collection

Los Angeles and the other half at a Zen Buddhist monastery in Kyoto, Japan.[66]

Macdonald-Wright interacted with the Japanese community in Los Angeles and may have come in contact with Asahachi Kono (born in Japan, birth date unknown, died 1943), whose *Untitled (Tree and Hills)*, a Pictorialist photograph of the late 1920s, like *Cañon Synchromy*, exploits empty or fading spaces (mist and fog) and the ephemeral delicacy of mountain forms (fig. 84). Kono's composition, which uses a wind-ravaged pine to slash through the image, also recalls a c. 1911 photograph by Coburn of the San Gabriel Mountains north of Pasadena, *Mount Wilson, California* (fig. 85). It is possible that Kono, who lived in Los Angeles from 1895 to 1932, when he returned permanently to Japan, may have known Coburn's work from his exhibitions in Los Angeles in the 1910s. Whereas Coburn uses a tree to provide a skeletal framework for dividing the image into geometric parts, Kono invokes the art of his native Japan by using a dominant fore-

ground element that abruptly juxtaposes near and far. Here the far looks more like Japan than it does the San Bernadino Mountains east of Los Angeles, where Kono and his contemporaries liked to photograph.[67]

The photographic community in California was enormous at this time. The San Francisco branch of the California Camera Club boasted the largest number of members of any similar group in the country, and Los Angeles was home not only to the Camera Pictorialists of California, founded in 1914, but also to the Japanese Camera Pictorialists, who banded together in 1923 but did not become official until 1926. During the 1920s and 1930s they produced some of the most startling new works in Southern California. Far from isolated, the Japanese-American photographers interacted with other photographers in the community, most notably Edward Weston (1886–1958), whose first solo exhibition occurred in 1921 with Shakudo-Sha, a Japanese organization of artists and intellectuals interested in promoting newer trends in art while preserving their own artistic traditions.[68] They also contributed works to the International Salon of Photography in the 1920s and 1930s. The impact of Asian photographic culture in Los Angeles has been obscured or was destroyed because of the devastating effects of internment of the Japanese-American community following the bombing of Pearl Harbor in 1941. In the past few decades, this history has begun to be reconstructed. Although Kono returned to Japan in 1932 before Japanese-Americans were removed to internment camps, this untitled photograph survived; given to his friend photographer Hiromu Kira, the work was stored during the war in the Nichiren Temple, a Buddhist temple in the Little Tokyo neighborhood of Los Angeles, where the Japanese Camera Pictorialists gathered.

In its presentation of delicate mountain forms, water, and mist to suggest voids and stacked spacing, Ansel Adams's (1902–1984) photograph *Vernal Fall through Tree, Yosemite Valley, California* (1920; fig. 86) also recalls Macdonald-Wright's *Cañon Synchromy*, although Adams was unaware of the senior painter who lived and worked far south of him. Indeed, when the San Francisco–born Adams made this remarkable photograph at age eighteen, he was training to become a concert pianist and had been given a Kodak Brownie only four years earlier. What changed his future course was a summer job, beginning in 1919, as a trail guide and a custodian at the Sierra Club's headquarters at LeConte Memorial in Yosemite.

Adams came to know every inch of Yosemite and took numerous photographs on these hiking expeditions (fig. 87).

Adams's photographic aesthetic at this juncture derived from Pictorialism. As he wrote to his father during the summer of 1920, the same period in which he took *Vernal Fall*, he aimed for something "suggestive and impressionistic" by "represent[ing] material things in the abstract or purely imaginative way."[69] Further, he wrote, "I am more than ever convinced that the only possible way to interpret the scenes hereabout is through an impressionistic vision. A cold material representation gives one no conception whatever of the great size and distances of these mountains.…Form, in a material sense, is not only unnecessary but sometimes useless and undesirable."

Although clearly at this young age Adams was working out in his mind the then-dominant philosophy of fine-art photography, to say in the context of Yosemite that form can be "sometimes useless and undesirable" is a remarkable point because this national park is defined by its hulking, massive forms. Thus, in his insistence on emphasizing the ethereal aspects of nature, Adams captures something new here for Yosemite. To dramatize this point, consider Muybridge's earlier *Cap of the Liberty-Valley of the Yosemite* (see fig. 18), in which Liberty Cap, at left, is the same geological form that Adams includes in the background of his photograph. For

Fig. 85
ALVIN LANGDON COBURN
Mount Wilson, California, c. 1911
Negative, gelatin on nitrocellulose roll film, 9 x 12 cm
George Eastman House, Gift of Alvin Langdon Coburn

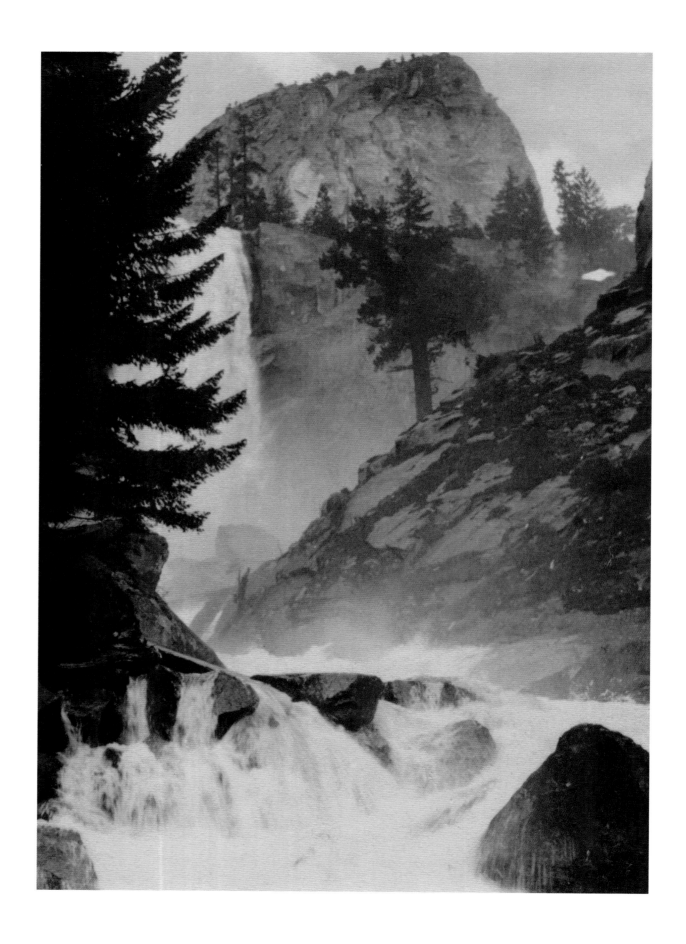

Adams, the form serves more as a backdrop than as "the main event." Rather than photograph Liberty Cap from the easily accessible bridge view of Vernal Fall along the Mist Trail, Adams took his picture from a rocky outcropping about halfway up the trail, which would have taken him toward the middle of the water. There he carefully layered various parts of the scene: the fall itself, which is glimpsed through a lacy pine, at left, and the triangular rock form, at right, balanced by a dead pine set against the virtually obscured monumental landmark of Liberty Cap. Throughout the composition, mist and water emphasize the transience of the scene and impart the "imaginative" qualities of nature that Adams sought at the time. Never had Yosemite been described with such a lightness of touch.

The 1920s proved to be an important decade for Adams's developing aesthetics. At a California Camera Club meeting in the mid-1920s, he sought out and befriended William Dassonville, who mentored Adams in fine craftsmanship and matters of technique. When Adams, now embarked on a professional career as a photographer, worked on his book *Taos Pueblo* in 1929, he secured from Dassonville a supply of Charcoal Black paper on which to produce it. But that same year, at the height of his friendship with Dassonville, Adams went to New Mexico and met Paul Strand (1890–1976), a photographer whose sharp-focus photographs stunned him. Not long after, Adams banded with a group of California photographers, including Edward Weston, Imogen Cunningham, and Sonya Noskowiak, to form f/64, named in reference to the smallest camera aperture that gives the greatest depth of field. As Adams recollected later, his adoption of "straight" photography and thus his departure from Pictorialist principles and, more specifically, his rejection of Charcoal Black paper—because its texture no longer complemented his aesthetic—"broke his [Dassonville's] heart."[70]

Strand is credited with prompting Adams's turn from Pictorialism, and no doubt the encounter was significant. Still, a sharper, more detailed vision was also implicit in the work of other artists at this time. Adams was poised to become a "straight" photographer before he met Strand. In 1928 he encountered Weston's photographs, which he thought were technically excellent but "hard," and he was also well versed in the tradition of mountaineering photography; that same year he was hired as the Sierra Club's photographer at Yosemite.[71] Adams's 1929 photograph *Mount Lyell and Mount*

Fig. 86
ANSEL ADAMS
Vernal Fall through Tree, Yosemite Valley, California, 1920
Gelatin silver photograph, 4 x 3 in.
Private collection

Fig. 87
ARNOLD WILLIAMS
Ansel Adams and view camera, Yosemite National Park, c. 1920
Ansel Adams Archive, Center for Creative Photography, University of Arizona

Fig. 88
ANSEL ADAMS
Mount Lyell and Mount Maclure, Headwaters of Tuolumne River, Yosemite, 1929
Gelatin silver photograph, 5 ⁵/₈ x 7 ⁵/₈ in.
Private collection

Maclure, Headwaters of Tuolumne River, Yosemite (fig. 88)
indicates several principles at work. Here he straddles the
"imaginative" and emotional sensibilities of Pictorialism with
the sharp-focus tradition of mountain photography, which
demanded that a portrait of a mountain emphasize accurate
detail. In 1929 Adams took a "geological and glacial" hiking
trip with the Sierra Club, and he ably captures the effects of
glaciation in this tense, packed photograph.[72] An energetic and
skilled hiker and climber, Adams took this photograph at a
remote site along the eastern boundary of Yosemite, about
twelve miles south of Tuolumne Meadows by the John Muir
Trail. Adams could go where no Pictorialist photographer
had been willing to go before. Texture and pattern play an
important role in this image, as Adams flattens and stacks the
scene, producing an effect, as he phrased it elsewhere, of
"the great rocks…tapestried with snow."[73]

By 1938, when Adams published *The John Muir Trail*,
his philosophies of nature and art were fully developed and
well articulated. Upholding the traditions of mountaineering
as well as of the romantic sublime, Adams described the
Sierras as "one of the wonders of the natural world—a fresh
and complete exposition of the forces of glaciation, of erosion
by wind and waters, and of the deep travail of the earth."[74]
Intent on integrating feeling with landscape, he aimed to por-
tray an "emotional interpretation of the Sierra Nevada—the
revelation of the beauty of wide horizons and the tender
perfection of detail…[as he focused on] relating the qualities
of nature to the mystical and creative elements in man." The
photograph, for Adams, was a liminal space between artist
and nature, and although their balance might change from
photograph to photograph, he was never far from conceptual-
izing the transience of human emotion and nature. As art
historian and photography curator John Szarkowski has
noted, Adams's work in general emphasizes weather and
change as opposed to geology, and his best works "possess a
peculiar tenseness—an edgy, nervous vitality—that is only
barely contained, and that speaks perhaps to the ephemeral
nature even of mountains."[75] As Adams produced an iconic
view of Yosemite, which he envisioned as the heart and soul
of California, he drew from the examples that also fascinated
him, the survey photographs of Timothy O'Sullivan. Adams
focused just as deliberately on the calibration of mood and
the mapping of emotion as O'Sullivan had done in measuring
time at Canyon de Chelly.

The Southwest

THE NEAR AND THE FAR

Although the term "Southwest" was coined about 1803 to designate the states of Alabama, Mississippi, Tennessee, and Louisiana (in much the same way that what we now describe as the Midwest was originally the Northwest), the Southwest did not acquire its present contours until the late nineteenth century. Journalist Charles F. Lummis claims to have introduced the term, but what effectively put it on the map was the railroad, specifically the Atchison, Topeka, and Santa Fe. As historical geographer Richard Francaviglia explains, "The association of the term Southwest with the railroad reminds us that eastern capital and power helped to define the area, which was southwest of the seats of power."[1] Northeastern industry set the stage for the emergence of the Southwest, and artists quickly stepped in to provide various interpretations of this newly defined area.

Few visitors who traveled to the Southwest for the first time in the late nineteenth century, specifically to New Mexico, failed to be astonished or affected by the dramatic landscape and climate of The Land of Enchantment, as the state is now officially known. In the 1880s the railroad was building lines in the area and heavily promoting them, making it easier for visitors to reach and explore the high tableland. By the 1890s, New Mexico began to cast its spell on Anglo-Americans at the same time that new aesthetic ideas were being aligned with the geography and optical sensations of the near and the far associated with the region.

In the Southwest, the rugged, sun-drenched plains, framed by distant snow-capped mountains or angular mesas, offered uncharted material for artists accustomed to the lush wooded landscapes of the eastern United States or to the Pacific coast of California. In the Southwest, vast empty spaces — combined with sharp geological contours, a vivid, boldly colored palette, and an intense sunlight that flattens forms — contributed to the creation of a "modern landscape" in itself. More than its topographical qualities, however, the Native American and Hispanic cultures of the Southwest attracted artists who often idealized, romanticized, and made picturesque the distinctive habits and customs of the region's so-called primitive peoples. The ways in which the Puebloans and the Navajo appeared to relate so harmoniously to the landscape, both philosophically and artistically, fascinated and inspired city-weary artists. These enduring cultures were a vital resource for artists intent on developing a more authentic "American" art.

A wide variety of forces were in play: the primitivist impulse and the fascination with non-Western, particularly African, cultures in turn-of-the-century Europe; the Colonial Revival movement in the United States; the international Arts and Crafts movement; the Southwest landscape itself; and the "discovery" of a "new" type of Indian — not the nomadic Plains Indians depicted by Remington and Farny, but the Pueblo Indians and the Navajo. All of these constructs reinforced one another to prime the Southwest for the international and national attention it would receive from artists and writers. By the 1910s, the Southwest experienced an artistic land rush that would dramatically alter the region and the way people viewed it.

A photograph by Adam Clark Vroman (1856–1916), *"The Desert" on the Way to Hopi Towns, 85 Miles North of*

Holbrook [Arizona] (1902), sets this land rush in motion (fig. 89). Vroman is an odd man out in the history of American photography. He neither participated in the Pictorialist aesthetic nor considered himself a fine-art photographer; rather, he was a man of science and a "*wanting to see* fellow," as he described himself.[2] Most art historians view his photographs as holdovers from survey photography of the post–Civil War era or as prefigurations of the "straight" style that would dominate photography decades later. Better yet, to quote photohistorian Jennifer Watts, his photography is "betwixt and between—not purely art, not purely science, rather a combination of the two…[and this] aesthetic ambiguity is what set Vroman apart from his peers then and what keeps the imagery alive now."

Like so many artists of his era, Vroman journeyed west, lured by the promise of a healthier climate than his native La Salle, Illinois, could provide. And like so many other artists, he made a permanent move to California, living in Pasadena until his death, long after his wife had succumbed to the tuberculosis that had brought them there initially for her health cure. A bookseller and stationer, Vroman developed a reputation for his lucid, unaffected compositions and for the technical proficiency of his platinum photographs. Although he considered himself an amateur and hobbyist, Vroman was hired as a photographer on three scientific expeditions to the Southwest, and he punctuated these journeys with tourist outings. He took eight summer trips to Arizona and New Mexico between 1895 and 1904, focusing primarily on American Indian customs, rituals, and the desert landscape and on the adobe architecture in which Pueblo peoples lived.

Vroman's activities put him at the nexus of two quickly emerging phenomena in the Southwest: the development of regional ethnology/anthropology and tourism. Both were facilitated, in part, by railroad lines and by the effective marketing campaigns of the railroad companies, which trumpeted the glories of a heretofore unappreciated landscape and the novelty of its original inhabitants. Flat, arid spaces had inspired artists such as Remington and Farny to see in them rich potential as metaphors. We recall that, in their artworks, emptiness dramatized the concept of "vanishing" cultures— but desert attractions themselves were not codified until 1901. This was the year that John Van Dyke published *The Desert*, which he wrote in large part from the vantage point of a railroad car passing through Arizona's Sonoran Desert.

Van Dyke provided a vocabulary for articulating the beauty and the terror of the southwestern desert in booster language that exalted its air, color, and light. No sunlight abroad, on the culturally superior continent of Europe, he argued, could compare with that of the desert Southwest. While European air has been "breathed and burned and battle-smoked for ten-thousand years," the air of the Southwest is "pure," "clear and scentless…intangible…[it is] sky-blown sun-shot atmosphere! You breathe it without feeling it, you see through it a hundred miles and the picture is not blurred by it."[3] Van Dyke may have admired the colors of Venice and Cairo, but, he claims, they are "caused by the disintegration of matter—the decay of stone, wood, and iron.…Once more ride over the enchanted mesas of Arizona at sunrise or at sunset, with the ragged mountains of Mexico to the south of you and the broken spurs of the great sierra round about you; and all the glory of the old shall be as nothing to the gold and purple and burning crimson of this new world."[4] Compared with the ancient cultures of Europe and the Mediterranean that appear to be dead or dying (a recurring theme of European artists and the intelligentsia following the devastations of World War I), the desert Southwest is presented in Van Dyke's book as an emblem of freshness and birth, a volcanic, new world order. Published on the heels of the Spanish-American War of 1898, which put the United States on an international stage, Van Dyke's *The Desert* and its phenomenal success suggest that while the United States was in the process of becoming a world power, its home ground was still little understood, if at all, by the larger Anglo population.

The attractions of the desert likewise stimulated Vroman, whose photograph *"The Desert" on the Way to Hopi Towns* captures the new appreciation for arid climes and the relatively unknown yet potentially meaningful desert spaces of the United States. Unabashed in his admiration for the "flat country" and the buttes or "sentinals [*sic*], placed there to see that man did not control the world," Vroman satisfied his interest in what he called "these fleecy rolls of cotton-like vapor" in numerous cloud studies that articulate a dynamic relationship between earth and sky.[5] *"The Desert" on the Way to Hopi Towns* is a remarkable photograph of the period, attentive to the broad spaces of the desert, slightly relieved by a rising mesa, at left, rolling hills, at right, and the two horse-drawn coaches reminiscent of a photograph of the desert taken by Timothy O'Sullivan nearly thirty-five years earlier

Fig. 89
ADAM CLARK VROMAN
"The Desert" on the Way to Hopi Towns, 85 Miles North of Holbrook, 1902
Platinum photograph, 6 ⅛ x 8 in.
Andrew Smith Gallery, Santa Fe, New Mexico

(see fig. 13). The similarity, however, ends there. Vroman's photograph, produced on platinum paper, takes advantage of that printing process, achieving a great range of gray tones that eluded the earlier wet-collodion process. Unlike O'Sullivan, Vroman pictures a world appreciated on its own terms, not a disorienting upside-down world. He articulates a relationship that characterizes the fascination that the Southwest has held for generations and that is evident in photographs and paintings of the early Modernist period. With startling directness, Vroman shows the seemingly static, relentless landscape that stretches endlessly into the distance and serves as

a counterpoint to the dynamic movement of fluffy clouds, which appear flat-bottomed and stacked on top of one another.

Vroman indicates that the line between where the land ends and the theater of the sky begins is indeed a slim to nonexistent one, a precept that Pictorialist photographer Laura Gilpin would dramatize in a different way nearly two decades later. In *The Spirit of the Prairie (Sunlight and Silence)* (1921; fig. 90), which looks somewhat similar to the desert east of Colorado Springs, as previously illuminated in Gilpin's *The Prairie* (minus the figure of a woman) (see fig. 61), she combines Pictorialist soft-focus technique with a new concept of

Fig. 90
LAURA GILPIN
The Spirit of the Prairie (Sunlight and Silence), 1921
Platinum photograph, 7⁵/₁₆ x 9³/₈ in.
Amon Carter Museum, Fort Worth, Texas, Bequest of the artist, P1977.64.2

photography that flourished in the Southwest. For Gilpin, photography will come into its own in the Southwest because "[h]ere the land is 'drawn with light,'" making the equation between geography and atmosphere and the camera's medium of light.[6] Elongated lines of dramatically highlighted plains echo the cloud formations, resulting in a cosmic integration of land and sky. In Gilpin's earlier photograph of the Colorado plains, the woman wearing billowing, windblown skirts holds her hand to her ear to heighten the feeling of isolation and spiritual freedom. In contrast, in this photograph Gilpin removes human intercession, enabling light to become the sole animating force. This concept of light "drawing" the landscape would be taken to an extraordinary extreme, now looking ahead to nearly another two decades, in perhaps the best-known photograph of New Mexico ever taken: *Moonrise over Hernandez, New Mexico* (1941; fig. 91). Ansel Adams, photographing a small town northwest of Santa Fe, captured the village cemetery simultaneously lit by a setting sun and a rising moon. The eerie light effects highlight the shining white crosses in the foreground and are dramatized in the sky, where light appears not drawn but painted with a brush sweeping laterally across a canvas.

Fig. 91
ANSEL ADAMS
Moonrise over Hernandez, New Mexico, 1941
Gelatin silver photograph, 15 ¼ x 19 ½ in.
The Museum of Fine Arts, Houston, Gift of Manfred Heiting,
The Manfred Heiting Collection

Both Gilpin and Adams tie together light and "spirit." Back in 1921, when Gilpin photographed *The Spirit of the Prairie*, the title of her work would have resonated on another, philosophical level. In Gilpin's work, light acts as the land's essential "spirit." Indeed, the title of the photograph emphasizes this notion of "spirit," a term that signaled the literary and artistic rhetoric of place in the early decades of the twentieth century. This specific language is more commonly associated with the artists of the Stieglitz circle. As art historian Wanda Corn notes, in their private and public writings they repeatedly referred to "America," "soil" (and other organic metaphors, such as roots), and "spirit," as in "spirit of place."[7] They sought to encourage the development of a homegrown national art that would transcend what they and many others perceived to be the country's materialistic leanings and spiritual (in a secular sense) poverty. Interestingly, two years after Gilpin produced this photograph, British writer D. H. Lawrence, lured to New Mexico by the indomitable socialite and intellectual salonista Mabel Dodge Luhan (then known as Mabel Sterne), also articulated the "spirit of place." He argued that "different places on the face of the earth have different vital effluence, different vibration, different chemical exhalation, different polarity with different stars: call it what you like. But the spirit of place is a great reality."[8]

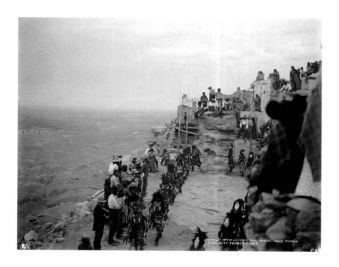

Fig. 92
H. S. POLEY
Circle of Snake Priests: Moki Indians, Wolpi Pueblo [sic], August, 1899
Denver Public Library, Western History Collection, P-85

Concepts of place were discussed and debated in literary and artistic circles of the time, and in 1925 geographer Carl O. Sauer articulated the vital relationship between nature and culture in his pioneering essay "The Morphology of Landscape." He noted that "a cultural landscape is fashioned from a natural landscape by a culture group. Culture is the agent, the natural area the medium. The cultural landscape is the result."[9] Both Lawrence and Sauer, in their own ways, argued for land and landscape as serving as something more than mere topography. To them, land and landscape were inextricably linked to a human imprint, whether derived from a poetic or a scientific discipline. The relationship between land and life stood out in stark relief in the desert Southwest and, again, was essayed in Vroman's photograph.

In his description of *"The Desert" on the Way to Hopi Towns*, Vroman refers to Holbrook, the railroad stop closest to the Hopi (then called Moqui or Moki) towns of First, Second, and Third Mesa in northeastern Arizona. From Holbrook, a coach, two of which are pictured here, was hired to take visitors to the Hopi mesas, where most people came to observe the final and public performance of a days-long religious ceremony called the Snake Dance. This community prayer for rain involved the handling of numerous snakes (fig. 92). For the Hopi, this biennial event held deep religious significance; for Anglo communities, it was, for the most part, a bizarre spectacle generally misunderstood but eagerly sought out for its "exotic" flavor.

Vroman first witnessed the ceremony in 1895 and was surprised to find about forty other tourists at the base of First Mesa, waiting to make the climb to the village of Walpi (see Hillers's photograph of Walpi, fig. 20). In 1897 he estimated attendance at about two hundred people, curiosity seekers like himself who had read Hamlin Garland's account of the ritual in the August 15, 1896, issue of *Harper's Weekly*. Vroman echoed Garland's sensitive response to what Anglos commonly thought was a savage event. Going to the heart of the matter, Vroman observed that at the conclusion of the Snake Dance, "one by one they retired to their homes and [had] now begun to realize that we were still in America.... How I should like it to speak their language and witness the entire 10 days ceremonies and have someone explain it all to me. Join the order if possible and be initiated as it were. How little we know of the Pueblo Indians anyway."[10] Propelled by his scientific interest in the nature of cultures, Vroman embodied the romance of cultural primitivism. Subsequent Anglo-

Fig. 93
JOHN SLOAN
Knees and Aborigines, 1927
Etching: 7 x 6 in. plate size, 11 1/8 x 8 1/2 in. paper size
Denison University Art Gallery, Granville, Ohio

American artists, writers, intellectuals, scholars, archaeologists, and tourists descended, almost locustlike, on the Southwest, wanting to answer Vroman's call of "how little we know"; some of them hoped that what they found there would serve science, and others hoped to discover the secret of a more authentic lived experience. This was the core issue of modernization: the loss of connection to the land.

Vroman's early view of tourism, his journey to witness the Hopi Snake Dance, signals the eventual influx of visitors. We see the consequences of this swarm of tourists in John Sloan's satirical etchings produced decades later. *Knees and Aborigines* and *The Indian Detour* (1927; figs. 93 and 94) refer to the Santa Fe Railroad and Harvey hotel-chain package that promoted tours of historic sites and neighboring pueblos led by couriers bedecked in Indian silver jewelry (fig. 95). Navajo artist Gerald Nailor (Toh Yah) invoked wit and humor to show the way in which Anglo-Americans objectified native culture at the time, caricaturing tourists and textile "connoisseurs" as they examine a blanket to purchase (fig. 96). The Navajo husband (his wife and child stand to the side) holds up the textile for inspection, obscuring his body. The divide between cultures is bridged by the colorful blanket.

Vroman's *"The Desert" on the Way to Hopi Towns* draws attention to a number of concerns that turned the Southwest into a tourist mecca, where the lure of the land and

Fig. 94
JOHN SLOAN
The Indian Detour, 1927
Etching: 6 x 7 1/4 in. plate size, 9 9/16 x 12 5/8 in. paper size
Denison University Art Gallery, Granville, Ohio

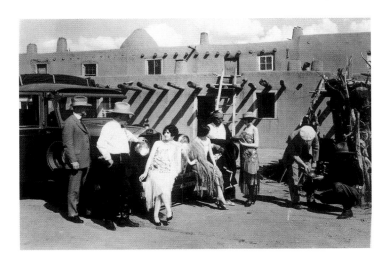

Fig. 95
Indian Detour Bus, Tesuque Pueblo, c. 1926
Courtesy Palace of the Governors (MNM/DCA)

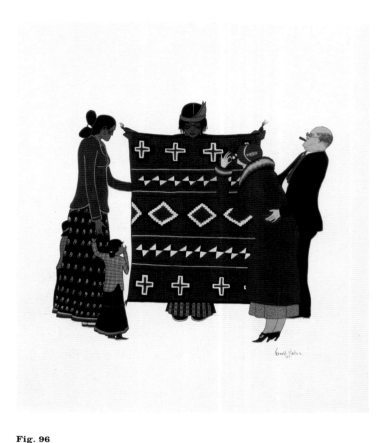

Fig. 96
GERALD NAILOR (TOH YAH)
Untitled, c. 1938
Tempera on board, 12 ¾ x 14 in.
Museum of Indian Arts and Culture / Laboratory of Anthropology,
Department of Cultural Affairs

its indigenous inhabitants worked together as a powerful magnet. As if to echo Honoré Balzac, the nineteenth-century French writer, who claimed that "desert is God without man," many people focused on the landscape's primordial qualities, finding it pristine, untouched, uncorrupted, and still in the process of becoming.[11] Or, as British soldier T. E. Lawrence (Lawrence of Arabia) exclaimed about his passion for the desert: "It's clean."[12] Indeed, as a place that offered a cleansing environment for many people battling tuberculosis and other diseases, the Southwest's high desert served as a decontamination chamber that could rid weary souls of modern ills. D. H. Lawrence, who was tubercular, put it this way: "The moment I saw the brilliant, proud morning shine high up over Santa Fe, something stood still in my soul, and I started to attend....In the magnificent fierce morning of New Mexico one sprang awake, a new part of the soul woke up suddenly, and the old world gave way to a new."[13]

Psychic alertness, induced by high altitudes, fierce sunlight, and desert romance, bleached dry all that was unessential. The desert, according to Balzac, T. E. Lawrence, and D. H. Lawrence, allowed for few shades of gray—physically or metaphorically—because contrast there was so stark. Desert beauty was thus perceived as both elemental and fundamental. Yet the wagon in Vroman's photograph—loaded with tourists, voyeurs and curiosity seekers, artists, photographers, and anthropologists—hints at the price of the desert's newfound allure. In its way, the photograph catalogues the Anglo-American cultural climate that would soon dominate—in both positive and detrimental ways—the cultural, political, and economic life of the Southwest, particularly in New Mexico.

THE TAOS SOCIETY OF ARTISTS AND THE MUSEUM OF NEW MEXICO, SANTA FE: LAYING CLAIM TO THE CULTURAL LANDSCAPE

The Southwest's earliest influential interpreter was Charles F. Lummis, the Harvard-educated journalist who, in an effort to recover from malaria, walked across the country to California and was awakened by the beauties of the land, which he later championed as editor of *The Land of Sunshine*, from 1894 to 1909 (retitled *Out West* in 1902).[14] Lummis and numerous other workers in the field of culture began to promote the Southwest as a place where the materialist strains of the modern age could be counterbalanced by the values of the three cultures in the area: Native American, Anglo, and

Hispanic. The railroads exploited this tricultural attraction by hiring artists to paint the region's distinctive features in exchange for free rail passage. In fact, the dominant Native American, Anglo, and Hispanic communities were already largely hybridized, and boosters ignored any contentiousness among them in favor of promoting a civic image of cross-cultural harmony.

After Lummis, the most effective cultural workers were the people who founded the Museum of New Mexico in Santa Fe (now Museums of New Mexico).[15] This group managed the interpretation of the Southwest, specifically of New Mexico, in the early decades of the twentieth century. This interpretation depended on a two-pronged approach that embraced science as well as art and architecture, symbolized in Santa Fe's Palace of the Governors, which housed the offices of the Museum of New Mexico and the School of American Archaeology (later renamed the School of American Research). The museum's periodical, *El Palacio*, founded in 1913—one year after New Mexico became a state—by Paul Walter, a newspaperman and associate director and secretary of the Museum of New Mexico, helped construct the identity of this community.

Other individuals who united to advance the artistic and cultural assets of the community included Edgar L. Hewett, director of the School of American Research; Frank Springer, a lawyer and patron; Jesse L. Nusbaum, an archaeologist and photographer; and Kenneth M. Chapman, a student of American Indian culture and an artist, who also served as a curator and assistant director of the Museum of New Mexico. As a group, they acted as architectural preservationists, archaeologists, and promoters of artists. Hewett offered free studio space to such nationally known artists as Robert Henri, Marsden Hartley, and Stuart Davis in order to draw attention to the region and its Indian cultures and to place the group's concerns on a larger stage. Archaeology and art were not viewed as separate endeavors but as joint ventures that could achieve the shared objective of helping preserve indigenous American life. *El Palacio* combined news of archaeological activities and discoveries with reports on the thriving artistic community, most prominently the Taos Society of Artists. It is in the context of what amounted to an archaeological cultural salvage project that we come to understand the Taos Society, which existed from 1915 to 1927.

The society first took shape north of Santa Fe, in Taos.[16] In 1898, when the art colony began, artists Bert Phillips and Ernest L. Blumenschein headed west on a sketching tour, encouraged by fellow artist Joseph Henry Sharp, who had visited Taos in 1893 and had shared his experiences with Blumenschein when both were studying art in Paris. Phillips and Blumenschein visited Taos and decided to stay; Phillips lived there permanently, and Blumenschein, who returned to New York and France, began spending his summers in Taos in 1910 and settled there permanently in 1919. "Nature was kind to us," Blumenschein would later say, and indeed it was the beauty of the landscape that attracted him and Phillips. Blumenschein noted the "vast plateau cut by the Rio Grande and by lesser gorges in which were located small villages of flat-roofed adobe houses built around a church and plaza, all fitting into the color scheme of the tawny surroundings. The sky was a clear, clean blue with sharp moving clouds. The color, the effective character of the landscape, the drama of vast spaces, the superb beauty and serenity of the hills, stirred me deeply. I realized I was getting my own impressions from nature, seeing it for the first time with my own eyes, uninfluenced by the art of any man....No artist had ever recorded the New Mexico I was now seeing. No writer had ever written down the smell of this air or the feel of that morning's sky....The morning was sparkling and stimulating."[17] Like Adam exploring Eden for the first time, Blumenschein found everything he saw to be new and ready for his brush.

Soon other artists arrived. Lured by the prospect of living cheaply in "new" surroundings—sponsored to some extent by the Atchison, Topeka, and Santa Fe Railroad in exchange for paintings to be used to advertise the scenic and cultural splendors of its route—Taos artists formed the first artist colony west of the Mississippi River, predating California's coastal colony at Laguna Beach by nearly five years. In 1915, seeking a way to make their paintings better known beyond their borders by organizing traveling exhibitions of their work, the group, which then consisted of Sharp, Phillips, Blumenschein, W. Herbert (Buck) Dunton, Oscar E. Berninghaus, and E. Irving Couse, formed the Taos Society of Artists. The group was later expanded to include Walter Ufer, Victor Higgins, Julius Rolshoven, Catharine C. Critcher, E. Martin Hennings, Kenneth Adams, and associate members Robert Henri, Albert Groll, John Sloan, Randall Davey, B.J.O. Nordfeldt,

[OPPOSITE, TOP]
Fig. 98
E. MARTIN HENNINGS
Passing By, c. 1924
Oil on canvas, 44 x 49 in.
The Museum of Fine Arts, Houston, Gift of the Ranger Fund, National Academy of Design

Fig. 97
Bert Phillips painting an Indian model, undated
Taos Historic Museums

Birger Sandzen, and Gustave Baumann, along with honorary members Edgar L. Hewett and Frank Springer.

The mission statement of the Taos Society of Artists is unusual, if not striking, in the context of artistic manifestos, which had become a crusading trend in early-twentieth-century European art. The second sentence of the statement formalized the group's goals: to preserve American Indian heritage and "to encourage sculpture, architecture, applied arts, music, literature, ethnology and archaeology solely as it pertains to New Mexico and the States adjoining."[18] Thus, when the vivid canvases of Taos artists feature adobe building construction, *hornos* (bread ovens), pottery made at San Ildefonso, Santa Clara, and Zia, Navajo blankets, woven baskets, and squash-blossom silver necklaces, they expose a fetish for Amerindian culture even as the artists sought to bring it alive and celebrate it. Their various approaches to art combined Modernist styles with concepts based not only on cultural preservation but also on wholehearted promotion, fueled by their belief that the Pueblo cultures had not received their due.[19] As Blumenschein explained, "The art of the Indians is not only beautiful, but it is unique. Originality is a priceless donation to all human endeavor and the aboriginal American has actually contributed more to the art than two hundred years of 'civilized' occupation of North America has produced."[20] The Taos Society of Artists drew attention to those traditions, often in a literal way, as exemplified by a photo-

graph of Bert Phillips painting an Indian model out-of-doors in Taos (fig. 97). It is immediately clear that the main distinction between these American artists and turn-of-the-twentieth-century French artists whose work expressed a formalist affinity for African and other "non-Western" masks and sculptures was that the Taos artists interacted with indigenous living cultures within their own country. Their mission statement had political connotations: celebrating Amerindian culture expressed an effort to reclaim that which had been nearly extinguished by earlier assimilationist policies.

The collective belief system of the Taos Society and artists associated with them has not received the consideration it deserves.[21] It is important to keep in mind that, with the exception of Couse and Sharp, the artists were not so much perpetuating nostalgia for a nobler past as they were depicting the living Indian. He had neither vanished (contrary to popular rhetoric about the "vanishing Indian") nor yet attained the cultural presence of Plains Indians as the indigenous "American" stereotype. Thus, Taos artists such as Hennings and Nordfeldt, using a Modernist idiom derived from Jugendstil and Post-Impressionism, set Taos Pueblo Indians against a vibrant tapestry of cottonwoods or posed them as Cézann-esque bathers engaged in religious ceremonies (figs. 98 and 99). All of the Taos artists believed that the lessons of native cultures in the Southwest and how these cultures interacted with the land provided a more integrative model for spiritual

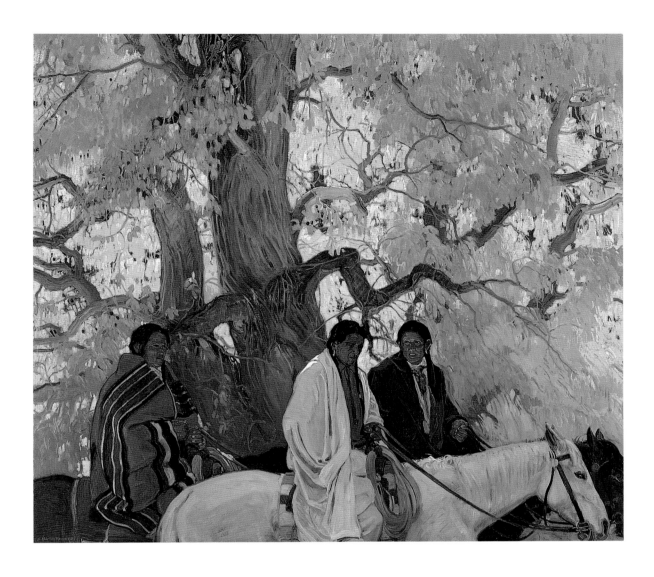

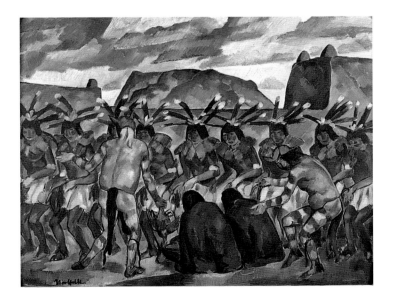

Fig. 99
B.J.O. NORDFELDT
Thunder Dance, 1928
Oil on canvas, 34 x 43 in.
The Fred Jones Jr. Museum of Art, The University of Oklahoma, Gift of Oscar B. Jacobson

Fig. 100
ERNEST L. BLUMENSCHEIN
Superstition, **1921 or earlier**
Oil on canvas, 47¼ x 45 in.
Gilcrease Museum, Tulsa, Oklahoma

Fig. 101
MARSDEN HARTLEY
The Warriors, **1913**
Oil on canvas, 47¾ x 47½ in.
Private collection

living in the modern world, as well as a source of authenticity for a new national art. They differed, however, in their vision of how this new art could be achieved, sometimes among themselves and decidedly among the Stieglitz circle, who would begin to visit the Southwest in the 1910s.

This dynamic of forward momentum—pushing into the future, propelled by integrating the past—is thrown into relief in Blumenschein's *Superstition*, which was painted before 1921, perhaps closer to 1919, when the artist moved permanently to Taos (fig. 100). Pittsburgh-born and reared in Dayton, Ohio, Blumenschein (1874–1960) studied music before pursuing the visual arts at the Art Students League in New York and the Académie Julian in Paris. He returned to New York to work as an illustrator and eventually became a full member of the National Academy of Design in 1927. His art is often characterized as Post-Impressionist, perhaps because of his avowed interest in the work of Cézanne, Vincent van Gogh, and Paul Gauguin. As he wrote, these artists championed "the primitive in art," celebrating decorative qualities, "large masses of harmonious color" and "long harmonious lines, which help to build up a decoration." He considered their work more spiritually inspiring than that of Claude Monet and found in their creations a match for the "exact truth of the color of lights and shadows."[22]

Fig. 102
MARCEL DUCHAMP
Fountain, 1917 (original work lost)
Photograph by Alfred Stieglitz

Blumenschein's artistic allegiances are given full play in *Superstition*, characterized by strong color arranged in massed blocks and vivid "harmonious lines" that build a "decoration." More remarkable is *Superstition*'s similarity, indeed its response, to two artworks, one by Marsden Hartley, the other by Marcel Duchamp. Hartley's *The Warriors* (1913; fig. 101) is an abstract scene of German military pageantry that he painted in Berlin. It was used as the backdrop for an infamous photograph by Alfred Stieglitz documenting what is one of the most influential works of the twentieth century —Marcel Duchamp's *Fountain* (fig. 102), which was refused for exhibition at New York's Society of Independent Artists in 1917 because this "readymade" work was an upside-down, mass-produced urinal. At first glance, no two artists could be a more unlikely pair than Duchamp and Blumenschein. At the time, however, Blumenschein managed his art business from New York, and he would not have been immune to the furor surrounding Duchamp's notorious act of Dadaism, a complex, multilayered piece of conceptual art.

With *Fountain*, the French artist Duchamp was playfully mocking the high seriousness of American art of the period, yet he intended to make his own high-minded statement.[23] Duchamp firmly believed in the idea of a national art of the United States, but like other Europeans of the period,

he essentialized American culture to its urban core: industrial progress; engineering know-how manifested in bridges, elevators, and skyscrapers; and mass-produced machines and products like the urinal. Coming from war-torn Europe, Duchamp and other exiles exalted the "newness" of American culture in the Machine Age.

Offering an alternative view of American culture, Blumenschein substitutes the figure of a Pueblo Indian for the Buddha-like figure that many critics observed in the shape and shadows of Duchamp's urinal; the Indian holds a double-spouted vase and is presented before a dazzling pageant of southwestern landscape and culture. Hispanic Catholicism is symbolized by the vivid Crucifixion, at right, by adobe dwellings melding into mountain forms above the central figure, and, at left, by the suggestion of pagan rituals. This is Blumenschein's America, revitalized through romantic attachment to its ancient cultures. Like the Stieglitz circle, Blumenschein argues for "the soil" as the seedbed for a vigorous American art, this time soil specifically identified with the spirituality (or "superstition," as he calls it) of the polyglot Southwest. Blumenschein's seeming response to Duchamp's *Fountain* is filled with the crusading conviction of a convert discovering the cultural and religious traditions of the Southwest, a convert who boldly replaces a shiny product of

American mass-produced culture with a gleaming earthenware black-on-black wedding vase, likely made at Santa Clara or San Ildefonso Pueblo.[24]

Local spirituality, as expressed in the art of the Taos Society, often took a more sensationalist turn than is seen in *Superstition*, specifically in images that portray Los Penitentes, a Catholic lay order that observed various rituals including self-flagellation during Lent. Blumenschein, among many others, painted these rituals, specifically in a large oil titled *The Penitentes*, which shows a reenactment of the Crucifixion of Christ (c. 1935; fig. 103). The landscape describes the mountains of the Taos Valley with its plateau gorges abstracted into an enormous stage on which the ritual is performed. Rain, sunshine, and cloud effects seem to erupt from the mountaintops, portrayed in organic yet somehow unearthly colors. The apocalyptic scene, magnified by its geologically violent setting, is an analogue of the intensity of the ritual itself. As Alice Corbin Henderson explains in *Brothers of Light*, the Penitente rituals act out "suffering as an atonement for sin; and it is this sincere faith which makes the Penitente ceremonies

so moving."[25] Drama and sensationalism characterize most depictions of Penitente ceremonies, but this one draws on the artist's deeper need to find expressions of "sincere faith" in a modern world in which spirituality was believed to be disintegrating. Anglo artists such as Blumenschein conceived these religious rituals as inseparable from the landscape that dramatizes them. This "uncorrupted" landscape was held up by Blumenschein and other artists as the perfect embodiment of Sauer's "cultural landscape," in which land and human life are inextricably bound, and sincerity and authenticity of feeling are equated with a cosmic landscape.

The landscape, or rather the mountain ranges of the area, was indeed "new," that is, among the youngest of the mountain ranges of North America and still rising.[26] Throughout the Southwest, evidence of geological violence and change abounds. The geological history of the North American continent is long and complex, but a few relatively more recent events are worth noting in order to understand Blumenschein's *Taos Valley, New Mexico* (1933; fig. 104). While the North American tectonic plate has been drifting in a southwest

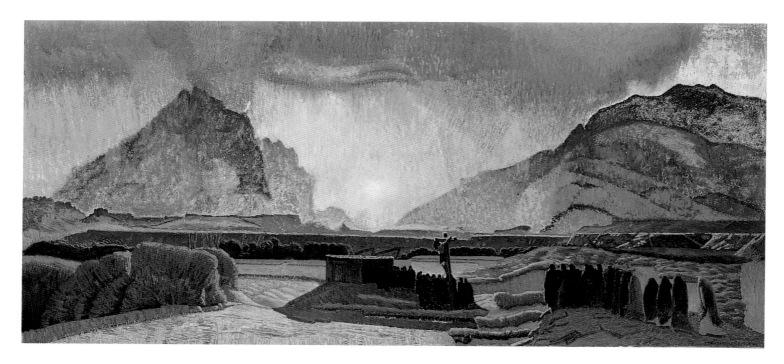

Fig. 103
ERNEST L. BLUMENSCHEIN
The Penitentes, c. 1935
Oil on canvas, 23 x 50 in.
Eiteljorg Museum of American Indians and Western Art, Indianapolis

Fig. 104
ERNEST L. BLUMENSCHEIN
Taos Valley, New Mexico, 1933
Oil on canvas, 25 x 35 in.
The Metropolitan Museum of Art, George A. Hearn Fund, 1934 (34.61)

direction for about a hundred million years, a widening rift has resulted in deep parallel faults (called the Rio Grande Rift) that bisect New Mexico from Colorado to Texas. In the wake of this geological tear, fault-bordering volcanoes erupted and deposited dark basalt from the Earth's mantle. Intermittent volcanism, intermixed with the process of folds, uplift, and erosion, has produced a vibrantly changing and colorful landscape in the Southwest, particularly in New Mexico. This landscape is marked by a pastoral rift valley and violent gorges, including the Rio Grande Gorge in the Taos Valley, which twists and turns across the valley plateau, dramatically descending to depths of seven hundred feet. It is difficult to imagine a landscape in which sun-swept gentle valleys are so suddenly torn by the effects of shift, water, and erosion, and where faults and folds abut abruptly to make skyscraping mountains, but these features are all present in Taos Valley.

Blumenschein's *Taos Valley, New Mexico* describes and compresses these changing geological forces. A sign of the currency of the Taos Society and the novelty of Blumenschein's landscape interpretation, the painting was acquired by the Metropolitan Museum of Art in 1934, directly from the National Academy of Design exhibition in which it first appeared. In the painting, the shape of the foreground hills marked with sage and juniper and surrounded by gorges echoes the forms of the Sangre de Cristo Mountains in the background, where thin, angular strokes of lavender hint at dramatic shadow and connote the atmospheric clarity of the southwestern climate. Even the clouds, heavy with rain, are arranged in blocked masses. In the valley, however, the landscape is bathed in light, thin lines and patches denoting cultured pastureland and creeks and sprinkled throughout with adobe buildings. The "tawny valley," just as Blumenschein described it, is reminiscent of Gilpin's *The Spirit of the Prairie*, in which light serves as a sentient spirit. Indeed, with human agency removed, the landscape comes alive on its own terms, stirred by the power of light, acutely observed by an artist sensitive to its beauties.

In *New Mexico Skies (August Skies)* of c. 1932–35, Victor Higgins (1884–1949) underplays the dramatic gorge of the Rio Grande of the Taos Valley, even as he references it in the sharp lines of the middle ground that describe the alluvial fans (fig. 105). Born in Shelbyville, Indiana, Higgins trained at the Art Institute of Chicago and in Paris and Munich. He represents the Chicago-influenced style of the

second-generation members of the Taos Society, which included Walter Ufer and E. Martin Hennings. United by more than affinity, personality, and friendship from their years of study at the School of the Art Institute, these artists were all sponsored by a powerful Chicago politician, five-time mayor Carter H. Harrison, Jr.

Harrison's zeal for making Chicago a center of artistic activity was manifested in part in a syndicate, in which wealthy midwestern businessmen, including meat-packer Oscar Meyer and sheet-metal tycoon William Klauer, sponsored the travels of Chicago artists to the Southwest in exchange for receiving their paintings. These businessmen helped advance the careers of the artists, simultaneously encouraging the Chicago art community more generally. And, not surprisingly, they recommended specific types of subjects, primarily Pueblo Indians, upholding them as viable source material for a vital American art, as well as for furthering their own Indian-related social causes.[27]

Higgins, perhaps the most gifted artist of the Chicago group, specialized in landscapes and gained exposure in a Museum of Modern Art group exhibition of 1929, nearly fourteen years after he had moved to Taos. Painted at about the same time as Blumenschein's *Taos Valley, New Mexico*, Higgins's *New Mexico Skies (August Skies)* (fig. 105) affects a more cosmic southwestern landscape, in which bright orange and yellow areas of unmixed paint and vigorous directional brushstrokes give a roughened, brittle quality to the work. The angular patches of brushwork suggest the endless expanse of cumulous clouds that march into the distance, as they do in Vroman's earlier photograph (see fig. 89). Clouds loom overhead, too, threatening to surround and overwhelm the viewer and evoking the Earth's disruptive, eventful phenomena; stasis and movement are constantly in play. As Higgins said simply (and profoundly) of his experience living and painting in New Mexico: "It is really something to travel through a day and a night—visually."[28]

As seen in the work of Higgins, the solidity and permanence of southwestern geography, contrasted with its ephemeral skies, encouraged artistic concepts of rhythm. In *Cliff Dwellings, No. 3* (1927; fig. 106), Raymond Jonson (1891–1982), Iowa-born and of Swedish descent, responded to the rhythms of the southwestern landscape with an elegance that recalls Hartley's upward-arching solid black contours combined with Blumenschein's massed decorations (see pp. 140–41).

Fig. 105
VICTOR HIGGINS
New Mexico Skies (August Skies), c. 1932–35
Oil on canvas, 54 x 60 in.
The Snite Museum of Art, University of Notre Dame,
Gift of Mr. and Mrs. John T. Higgins, 65.53.3

Fig. 106
RAYMOND JONSON
Cliff Dwellings, No. 3, 1927
Oil on canvas, 48 x 38 in.
Jonson Gallery Collection, University Art Museum, University of
New Mexico, Albuquerque, Bequest of Raymond Jonson

Jonson trained at the Portland Art Museum School in Oregon. Shortly after moving to Chicago in 1910 with B.J.O. Nordfeldt, Jonson produced stage designs and dramatic lighting for Chicago's Little Theater. He felt an immediate kinship with New Mexico on his first visit to Santa Fe in 1922, finding that the modern landscape provided inspiration for his developing mode of abstraction. In New Mexico, Jonson said, he "sensed a means of arriving at plastic design."[29] He moved to New Mexico two years later, and by the 1930s he had formed the Transcendental Painting Group with Emil Bisttram, including Agnes Pelton and Helen Florence Pierce among its members. Combining abstract and nonobjective art with spiritual content, Jonson, who became part of the University of New Mexico faculty in 1949, was a standard-bearer for the expressive possibilities of abstraction in New Mexico at a time when its validity was still being questioned.

Shortly after Jonson moved to Santa Fe, a Chicago critic chastised him for relocating, questioning why the artist would "[run] away to picturesque Santa Fe or parts even more romantic, and un-American." Jonson replied, "Really, you know, this place is as American as I found in Chicago. In truth, this is the site of the real American—the original one."[30] This exchange bears witness to the constant debate about what constituted an "American" place (and recall that by 1929 Stieglitz had changed the name of his New York gallery from 291 to An American Place), and that something "romantic" was "un-American," perhaps referring to a less humanized Machine Age aesthetic. To go to Santa Fe, according to this Chicago critic (who was likely well aware that the path from Chicago to Santa Fe was a well-worn one), was to go "too deeply into the subjective world to be able to convey to his audience a satisfying reflection." This statement foreshadows comments that Stuart Davis would make about his visit to New Mexico in 1923: the picturesque surroundings were always *there* to distract. But for many artists, including Jonson, the strange geology and the ancient cultures of the first Americans provided a rich vocabulary for addressing the issue of "Americanness," as well as the concept of modernity.

Cliff Dwellings, No. 3 perfectly expresses this dynamic. It is tempting to conclude that the critic who harped on Jonson sparked some response on the artist's part, for the painting transposes the pulsating, energetic aspects of modern city life to southwestern terrain. Emblems of cliff dwellings and pines in higher New Mexico climes thrust upward like a New York or Chicago skyscraper, the eerie background "lights" reminiscent of those of a city night dramatically lit or of the stylized appearance of rain in the desert landscape (fig. 107). Jonson seems to articulate an ancient, indigenous pedigree for the modern skyscraper through his references to what are likely glimpses of his experience at the Pajarito Plateau, just east of the Jemez Mountains. Part of the plateau had become Bandelier National Monument in 1916, little more than a decade before Jonson produced the painting. Archaeological and tourist activities kept it a frequently discussed subject at the time. Jonson references the "pock"-marked

Fig. 107
GEORGIA O'KEEFFE
Radiator Building—Night, New York, 1927
Oil on canvas, 48 x 30 in.
The Carl Van Vechten Gallery of Fine Arts, Fisk University, Nashville, Tennessee,
The Alfred Stieglitz Collection, Gift of Georgia O'Keeffe

Bandelier tuff, the volcanic ash that makes up the sheer walls of the mesas in that region. Such walls, as seen in Frijoles Canyon, remained brittle after being formed by an eruption from the Valles Caldera more than a million years ago, soft enough for the Ancestral Puebloans (Anasazi) to carve cave and cliff dwellings from them. A 1910 photograph by Jesse Nusbaum of the reconstructed kiva at Frijoles Canyon gives a sense of the towering cliff dwellings and the friable tuff that so impressed Jonson (fig. 108). By merging the Machine Age symbol with the Southwest's ancient civilizations, Jonson articulated visually what it meant to be both modern and American.

If Jonson's constructed image looks strangely forced or affected, offering a kind of anthropological bricolage, it nonetheless demonstrates the degree to which the new American urban age was perceived to be a negative phenomenon that required a correction of the imbalance between nature and tradition. For the debate about what constituted a national and a modern art, many artists turned to the Southwest for their answer, and they responded in a variety of ways. Maynard Dixon (1875–1946) was committed to a romantic ideal of the noble Indian, producing works that can be described as carrying a "Deco desert" language.[31] This effort is best exemplified in Dixon's masterwork, *Earth Knower* (dated by the artist "1931–32–35"; fig. 109). With striking clarity, echoed in his rendition of the precise, arid landscape, Dixon brooked no interference with his noble Pueblo Indians and envisioned himself as a prophet who would deliver their message of harmonious living. Like a seer, he proclaimed, "Painting, as I see it, must be human rather than 'arty'…it is a means to an end. It is my way of saying what I want you to comprehend. It is my testimony in regard to life."[32]

Born near Fresno in California's San Joaquin Valley, and often described as a "cowboy artist," Dixon descended from southern aristocracy, and he carefully cultivated his "western" self-image. As he liked to say, from his perspective as an artist in San Francisco, "You have to go East to discover the West."[33] Dixon often traveled and lived in his "western world," as he phrased it, in New Mexico, Nevada, Wyoming, Montana, Idaho, Oregon, and in the backcountry of his native California, summoning his life and landscape experiences for his art.[34] He had very little art training, consisting only of encouragement he received from Frederic Remington, to whom he had sent sketches of his work in 1891, and three months at the California School of Design in 1893. Dixon then became a

Fig. 108
Reconstructed Kiva in Ceremonial Cave, Frijoles Canyon (now Bandelier National Monument), reconstruction and photo by Jesse Nusbaum, 1910
Courtesy Palace of the Governors (MNM / DCA)

western illustrator for various magazines in New York and California, including his friend Lummis's *Land of Sunshine*. Believing that his art lied about the West, he abandoned illustration in the 1920s after marrying the portrait photographer Dorothea Lange; the marriage gave him some financial freedom. As he reminisced with his friend Texas folklorist J. Frank Dobie, "Having slaughtered many people in range wars & bar room brawls on magazine pages over 20 years (I never saw a man shot), I turned away from this evil life in 1921 & since then quieted down & gave my mind to nobler thoughts such as making poetic paintings."[35]

The key words here are "nobler" and "poetic," as both describe the missionary zeal and romanticism of Dixon's artistic project, which he fully realized in *Earth Knower*. As he wrote in a poem, "My Country," in 1922: "I love the grim gaunt edges of the rocks, /the great bare backbone of the Earth, /rough brows and heaved up shoulders, /round ribs and knees of the world's skeleton /protruded in lonely places."[36] Inspired by the topography of New Mexico and Arizona and by his experiences living briefly in Taos beginning in 1930 (where he, Lange, and his children lived in a house he rented from Mabel Dodge Luhan), Dixon produced some of the most powerful paintings of his career. He quickly became a fixture on the Taos artistic scene and explored the landscape and cultural scenery like any other tourist. About the dances he saw at Taos Pueblo, he remarked, "When you see one of

their ceremonies, something fine flashes out clear.... These things are for the archaeologist and the painter to understand. From them the scientist recreates the ancient world; from them the artist creates a new one."[37] Here Dixon perfectly expresses the push-pull dynamic of Edgar Hewett's influential circle and of the Taos Society of Artists, a synergy in which archaeologists uncovered the indigenous past and Anglo artists promoted the Indian present. The same year that Dixon came to Taos, Hewett wrote that artists should strive to paint the relationship between southwestern land and life: "It is the problem of artist and poet, as well as of historian and scientist, to do justice to the race which has given to the world its best example of orderly, integrated racial life....[A Pueblo Indian] never dominates it [the landscape], as does the European his environment, but belongs there like the mesas, skies, sunshine, spaces...seeking no superior place for himself but merely a state of harmony with all created things."[38]

In *Earth Knower*, Dixon conveys visually what he and Hewett had both communicated through language: the Pueblo Indians must be inscribed in the land in which they live. Dixon portrays a Pueblo man in profile, wrapped in his blanket and posed before a background of mesas, with alluvial fans creating patterns of light, shadow, and color, shot through with an almost blinding light. Unusual for Dixon, who is famous for his wide-open blue skies, very little of the canvas is devoted to the sky, and there is no horizon in the distance, only the appearance of a mesa jutting above the foreground landscape, separated by a thin line. Dixon implies the unrelenting aspect of the mesa form that stretches infinitely in both directions, leaving the viewer no means of escape. This imposing emphasis on frontality and, by extension, solidity gives the painting a strongly dimensional feeling, almost like a bas-relief. A working sketch for *Earth Knower* confirms that Dixon carefully calibrated his final composition (fig. 110). In transposing his subject to the canvas, he makes several changes, most notably giving the more chiseled features to his sitter and articulating the background landscape, which assumes greater definition and imposed geometric design. Zigzagging shadows indicate the sculptural qualities of the landforms and simultaneously mimic a stair step, as if the background comprised an ancient Mesoamerican pyramid, permanent and enduring.[39]

Although Dixon proclaims that Pueblo culture is permanent, of and from the earth, here he addresses the broader concept of endurance; his Pueblo man is carved into the land, appearing for all eternity like an Egyptian pharaoh. It could also be said that he offers a contemporaneous alternative to Gutzon Borglum's celebratory sculpture at Mount Rushmore — American presidents carved into the mountain — a heroic act of creative work that trespasses on Lakota sacred land (fig. 111). Yet because Dixon emphasizes flatness in the painting, with the figure seemingly pushed to the surface of the canvas and bathed in warm earth tones, he achieves a palpable presence for this man and, by extension, for Pueblo culture. For all its sculptural solidity and chiseled surface, this painting is no epitaph for the vanishing Indian. Even as Dixon played to native stereotypes of the noble Indian, he firmly believed them, swept up in the current fever of anti-assimilationist government policy that was attempting to retrieve Indianism. Others, too, recognized that his images of Indians were different. As a critic wrote in 1938, "His Indians are never the expressionless 'cigar-store Indians,' nor theatrical, Hollywood Indians, but uncompromising living Indians."[40]

Dixon voiced his constant search for a life lived in the "real" world. "My object has always been to get as close to the real thing as possible — people, animals and country," he wrote. "The melodramatic Wild West idea is not for me the big possibility. The more lasting qualities are in the quiet and more broadly human aspects of Western life. I am to interpret from the most part the poetry and pathos of life of Western people seen amid the grandeur, sternness and loneliness of their country."[41] He did personally experience Amerindian culture and philosophies of life, for example, making and using a sweat lodge to cleanse his body (fig. 112), ravaged by asthma and emphysema, and preferring not to use the name Navajo but rather Diné, which means "the Earth Men — the people who emerged from the rocky depths. The white man says, 'The ground belongs to us'; but the red man says, 'We belong to the ground.' The Earth is truly his mother." Dixon's noble Indian undoubtedly belongs to the earth in *Earth Knower*, a powerful image that was widely celebrated in its own day. As Dixon commented in an interview with *Los Angeles Times* critic Arthur Millier, "Ever since I began to see and think...I have had a feeling that the West is spiritually important to America. As I grow older it becomes a firm conviction. You can't argue with these desert mountains...and if you live among them enough — like the Indian does — you

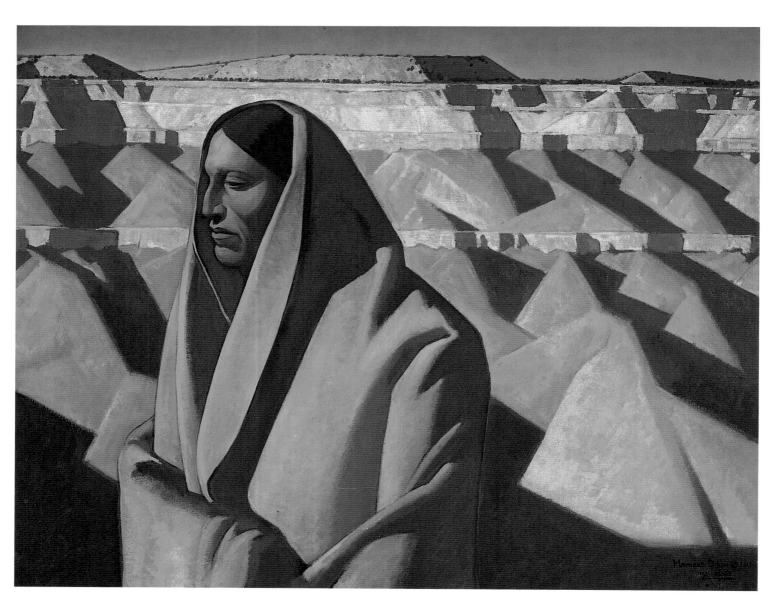

Fig. 109
MAYNARD DIXON
Earth Knower, 1931–35
Oil on canvas, 40 x 50 in.
Oakland Museum of California, Gift of Dr. Abilio Reis

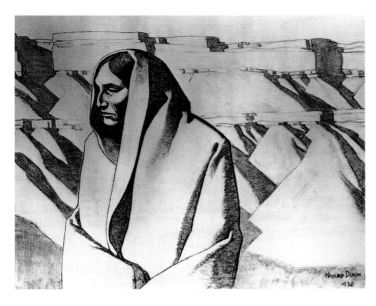

Fig. 110
Study for Earth Knower, 1930
Dixon Family Archives
Image published in *The Thunderbird Remembered: Maynard Dixon, the Man and the Artist* (Los Angeles: Gene Autry Western Heritage Museum, in association with Seattle: University of Washington Press, 1994), 54

Fig. 112
Maynard Dixon's sweat lodge at Fallen Leaf Lake in the Sierra Nevada, 1934
Dixon Family Archives
Image published in *The Thunderbird Remembered: Maynard Dixon, the Man and the Artist* (Los Angeles: Gene Autry Western Heritage Museum, in association with Seattle: University of Washington Press, 1994), 64

Fig. 111
Mount Rushmore, c. 1941
Photograph taken shortly before monument was completed. Carving began at Mount Rushmore in 1927 and the first face carved, that of President Washington, was dedicated in 1934.
Courtesy of the National Park Service, Mount Rushmore National Memorial

don't want to. They have something for us much more real than some imported art style....I tried to express this idea in *The Earth Knower*. He is a sage, calm Indian who stands against his own background of mountains from which he draws his health, wealth, religion, and pattern of living. While we get panic-stricken over 'the market' the Indian puffs his pipe and looks at the sky. The West is big, slow, grand country, with a style all its own. We scurry around it like nervous ants and scarcely take time to let it seep into our souls."[42]

Clearly Dixon expresses the ultimate in cultural primitivism, as if his Pueblo Indians were somehow untouched or unaffected by economic woes or any other kind of communal frictions. In a sense, by embracing the ideal Indian, he denies him his humanity. Yet, in line with his social and political convictions about the importance of Amerindian autonomy and protection from the government's aggressive and, at times, cruel assimilationist policies, Dixon preserves the Indian in perpetuity. As if echoing Walt Whitman, Dixon wrote: "I am the one—/I am the one who brings,/...I hold the black bowl of visions,/Come with answer of thunder-topped mesas,/And revelation of star-traveled plains."[43]

LEARNING THE MODERN SOUTHWESTERN LANDSCAPE

If it can be argued that Maynard Dixon offered his southwestern testimony in terms of a sculptural bas-relief, then Stuart Davis's (1892–1964) declaration in painting appears like a charming postcard, a scallop-edged mounted photograph, or even a framed view from a car window moving through the Rio Arriba, the area of the upper Rio Grande designated during the Spanish conquest (fig. 113). While in Santa Fe, Davis painted some fifteen canvases, many of them lively, energetic, and nearly cartoonlike. These works were created only a decade earlier than Dixon's work but at a time when Davis's art theory crystallized. In fact, Davis's 1923 trip to New Mexico solidified his developing planar abstraction, and his experiences there emphatically pointed out the path that he would pursue for the rest of his career.[44]

An artist entering maturity, Davis traveled by train with his teenage brother, Wyatt, between early June and mid-October 1923. The extensive literature on Davis, considered among the most important twentieth-century American artists, usually describes this New Mexico trip as a transitional moment in his career, if it is mentioned at all. Davis moved from a form of Synthetic Cubism that incorporated American consumer products and smart packaging toward a form of abstraction demonstrated in his celebrated *Eggbeater* series of 1927–28. These innovative, cerebral still lifes rendered a saw, a fan, and an eggbeater in abstract terms. It is worth quoting in full the customary statement about Davis's stay in New Mexico, because the commonly held belief is that he disdained and trivialized his experience there.

As Davis stated in James Johnson Sweeney's catalogue for his 1945 solo exhibition at the Museum of Modern Art in New York, "I spent three or four months there [New Mexico] in 1923—until late fall—but did not do much work because the place itself was so interesting. I don't think you could do much work there except in a literal way, because the place is always there in such a dominating way. You always have to look at it. Then there's the great dead population. You don't see them but you stumble over them. A piece of pottery here and there and everywhere. It's a place for an ethnologist not an artist. Not sufficient intellectual stimulus. Forms made to order, to imitate. Colors—but I never went there again."[45]

Most scholars have used this account retroactively, taking Davis's own record of 1945 as a means of understanding the maturing artist of 1923. Davis's explanation, from the vantage point of 1945, makes sense because, in projecting the persona of the quintessential New York artist (and, by extension, through his art), he was also celebrating the city's jazzy modernity, fractured rhythms, and consciously constructed urbanism. Quoted in *Vogue* magazine at the time of his solo show, Davis observed that "the life of the city dominates modern living and penetrates the culture of the epoch."[46] In this assessment of "modern living," New Mexico had no place.

To account for the Davis of 1923 retroactively is fair game for the artist but unfair by the standards of the scholar, particularly when seen in light of Davis's recollections, as registered in his numerous letters and postcards; these tell a very different story. Because many of Davis's own accounts have not been published before, it is worth recording them more fully here in an effort to know of his activities and beliefs at the exact time he experienced them. As it happened, New Mexico puzzled and confounded him, and he not only experienced many wonders that delighted him (wit, after all, was his strong suit) but also was able to compress, strengthen, and clarify his ambitious artistic goals.

Born in Philadelphia—his mother was a sculptor, and his father was the art director of the *Philadelphia Press*—

Fig. 113
STUART DAVIS
New Mexican Landscape, 1923
Oil on canvas, 32 x 40¼ in.
Amon Carter Museum, Fort Worth, Texas, 1972.49

Davis began his formal art training in 1909 at the Henri School in New York. Robert Henri, John Sloan, William Glackens, Edward Shinn, and George Luks, all newspaper illustrators who were friendly with Davis's father and who would go on to form the art group known as The Eight, influenced the young artist. The Ashcan School of painting that Davis developed under Henri gave way to a variety of European artistic experiments exhibited, infamously, in the Armory Show of 1913, especially Post-Impressionism and Cubism. With an intensity unmatched by any other artist of the time, Davis explored art theory and sought to determine what his personal credo would be. He expressed this credo in a journal, beginning in 1920 and ending in November 1922.

The 1920–22 journal (Pierpont Morgan Library, New York) focuses on Davis's process as he rigorously worked out basic artistic principles, in general, and Cubism in particular.[47] In large part, he focuses on line, form, the two-dimensionality of the picture plane, and so forth, but, more importantly, on subject matter and the making of a relevant American modern art through innovative sources that blend high and low art: "to express everyday American life in vigorous art," as he phrased it, citing Babe Ruth and "sporty automobiles" as examples. His practical, mathematical, analytical, and perceptual approach was highly disciplined, and it involved ridding himself of "romantic ideals—to meet the Facts" and eschewing "imitation" for "endless experimentation." On this front, he reminded himself emphatically: "*Don't emotionalize*. Don't 'feel' sizes. Simply take some things you like and make something out of them. 'Copy Nature' only copy the nature of the present days—photographs and advertisements. Tobacco cans and bags and tomatoe [*sic*] can labels." In short, he wrote, "I conceive of pictures which while having all the Rembrandt-Cézanne structure will at the same time be more sociable. They will be mental as well as optical....Will use literature as well as visualization. Illustrative. Sentimental. Simple. Classic and dealing with popular subjects such as Scott Joplin. ...Indians, Football etc." In his emphasis on the "nowness" of things, Davis played into the rhetoric of defining and creating an American modern art, but this emphasis also stems from a moral, almost existential, position: "he will realize that nothing exists but what is made. There is no static condition and there is no finality. There is nothing to be learnt. There is only 'to live.'"

Davis's journal notes pulsate with formalist issues, concepts of modernity, and his confrontations with "the greats" —artists such as Picasso, Matisse, Braque, Gris, Léger, and Brancusi, whose weaknesses he cites, while simultaneously acknowledging their "enormous achievement." With both the egoism and the uncertainties of a young, emerging artist, Davis declares, "Pure formalism for its own sake is...dead." And then, perhaps surprisingly, he states that these artists "hold up [in Europe] because of their cynicism. But compared with the spontaneous creation of the North American Indian they are a mixed up crew." Davis gives some thought to the Indian, if perhaps initially in terms of "popular" American subject matter, then later, more thoughtfully, as a way to underscore his belief that "it is important to free oneself from their [European Modernists] unquestionable dominance of the world's artistic thought today," and perhaps seeing an alternative in American Indian art (which, to him, represents a "rounded life" in which art functions as one part of a greater whole). Yet, as he admits, in reference to his goal of becoming an artist of note, "The difficulty today is that to take up any profession requires all of one's energies, a lob-sided [*sic*] race. To go back to the land is no answer because there again you have a specialized human out of touch with the rest of the world." Davis tries to reconcile the unrelenting onslaught of modernization with his effort to produce an art that engages contemporary life. In New Mexico, he confronted this dilemma head-on.

Davis's New Mexico trip may have held appeal simply as a grand adventure, or perhaps it fulfilled other personal needs. Nonetheless, his not infrequent references to the Indian (as opposed to other emblems of American culture, including automobiles and ragtime, which receive far less treatment) leave open the possibility that Davis contemplated a more thorough engagement with American Indian culture as he pursued his quest for American subject matter. This possibility accepts that later he may have found the prevalence of American Indian antiquity a nuisance and something to stumble over. In a letter from John Sloan to fellow painter Will Shuster, a friend and a member of the Cinco Pintores group in Santa Fe, we learn that Davis planned a trip to Santa Fe with his mother and brother during the summer of 1922, shortly before he stopped writing in his journal.[48] For reasons as yet unknown, Davis made the trip with only his brother Wyatt one year later.

According to his own account, Davis traveled west at the urging of his family friend, the more senior and well-established New York artist John Sloan, who spent half a year in New Mexico, beginning in 1919. In postcards, letters, and a recorded interview, Davis carefully documented the novelty of his experiences and the warmth with which he received them. He sends red chile peppers to his mother; collects American Indian ceramics from Zia and Cochiti pueblos; learns to ride a horse; camps, picnics, hikes, paints, and takes photographs; buys a sombrero; admires the antiquity of his studio, part of an ancient pueblo reused by conquering Spaniards; observes American Indian dances; and is impressed with Amerindian methods of irrigation in an arid land in which bathwater evaporates, as he wrote to his father, "before you can get in [the tub]."[49]

During this trip Davis traveled southwest to Zuni Pueblo, near the border of Arizona. It is likely that Edgar Hewett, who at Sloan's request provided studio space for Davis at the Palace of the Governors, also assigned Davis a car, enabling him to participate in the archaeological community.[50] Zuni was the farthest point to which he traveled, and his treks outside of Santa Fe included most of the closest pueblos —Tesuque, Nambé, Pojoaque, San Ildefonso, and Santo Domingo (he mentions in a letter that he visited nearly seven). It is clear from Davis's letters that the landscape powerfully affected him. As he said years later, "You can't describe it. You have to experience it to get the sense of space."[51]

In early correspondence Davis recounts the vast distances in the West and the changing topography, admitting in mid-June that "I feel well now and think that the place agrees with me fine."[52] His accounts are marked by enthusiasm and good humor, despite car trouble; in a letter postmarked June 19, Davis records: "Yesterday Sloan and I went in the auto to paint but we got into such interesting scenery that we kept on and on to see what was over the next hill all the time. We went to Nambé Pueblo [and beyond it]....Drove right over the ground no road or nothing. We came to some huge eroded monoliths or *picachos* and climbed around them for a couple of hours. Just like the Grand Canyon on a small scale." He traveled to the Nambé red sandstone badlands several times (fig. 114), "the most marvelous landscape you can imagine. We look right across country into the cañons of Pajarito. Saw 3 thunderstorms going on at once above them."[53] Davis more fully described his experience there in a letter:

Fig. 114
Stuart Davis in the Nambé badlands, 1923

Yesterday and to day [sic], Sloan, Shuster, Wyatt and I went out about eleven miles on the road to Nambe [sic] to paint.…The view from this place is extraordinary especially on a day when there are some clouds around to keep the sun from blistering the paint on the automobile doors and driving the moisture from the brain.…The stuff we were in is light yellowish in color, then there are flater [sic] planes extending ten miles or so to the Rio Grande which are red, beyond and higher is the Pajarito of a light neutral color and which is a long, high plateau cut with deep cañons in some of which are the cliff dwellings of the Frijoles [Creek]. Beyond that are the Jemez mountains which are a bright blue and beyond them is the sky full of cumulous clouds. I painted all this and it is a great sight.[54] The sun is so darn bright in addition to its heat that your eyes are squinted all the time and besides it neutralizes all the colors and conceals the form but the minute it goes under a cloud the stuff all comes out to beat the band. There were thunder and lightening [sic] storms going all around on the horizon.…To day there was a rain bow [sic] around the sun in a big circle, something I never saw before. There was no rain or anything just a clear sky. It was just a bright yellow and orange band. In the distance, between the red plains and the Pajarito described above the Black Mesa [near San Ildefonso Pueblo] sticks up.[55]

By July 3, following continuing trips to the Pajarito Plateau region and a trip to the La Bajada Mesa, Davis admits that, after two weeks of "futile floundering around," he is finally hitting his stride in terms of painting.[56]

Davis's work in New Mexico consists of grisaille still lifes and landscapes.[57] Two of his more monumental, compelling, and resolved paintings are *Still Life with Map* (1923) and *New Mexican Landscape* (1923), both of which summarize his achievements during this roughly five-month trip and signal the artist's preoccupation with planar form and emblematic American subject matter. In *Still Life with Map* (fig. 115), Davis inscribes a saw (one of his favorite still-life objects), possibly the fragment of an Indian blanket, a snow-capped peak, stylized thunderstorms, an opened can of beans (frijoles), and a map of New Mexico that marks Santa Fe and Gallup, perhaps a reference to his extended trip through New Mexico to Zuni Pueblo. Witty, colorful, engaging, and muscular, the painting moves back and forth between flatness and allusions to three-dimensionality, embodied strategically in the map's form. Like a conventional painting of a landscape, a map by its nature reduces three dimensions to a flat surface. The can appears as a "regular" object but also assumes the form of a roadrunner or some sort of figure dashing

across the landscape. This jolly tension gives the painting a startling presence that Davis's bold colors of green, pink, red, and blue make even more vivid, especially as the artist uses them to create a frame, a device that first appears during his New Mexico period and will become a leitmotif in his work. Just as the painted frame of the map within the painting objectifies the landscape, the painted "frame" literally turns the artist's experience of the landscape and also his experience of painting it into a picture. Davis also uses this visually playful device in *New Mexican Landscape.*

New Mexican Landscape (fig. 113) is especially reminiscent of the Nambé badlands, as Davis carefully described their stacked layers in a letter to his mother and as he depicted them on canvas. Certain physical characteristics of the landscape also resonate with the area southwest of Santa Fe, and the area around Pajarito northwest of it, so it is difficult to say with assurance where Davis conceived this painting. The landscape is purposefully generalized and reduced in a series of layered bands that encompass a road, adobe buildings, and cultivated orchards or pastureland; a plateau, distant vivid red mountains, and sharp, towering blue mountains behind them; and a series of cumulous clouds penetrated by a broad band of blue at the very top. Davis alights on the concept of painting a plateau (highlighted in a dash of pink), its characteristic sharp line cutting across space like a knife, and a series of alluvial fans, rounded or angled forms that hint at desert strangeness before giving way to the vibrant red mountains contrasted with blue vibrating colors that radiate energy. Using thick lines in brown, blue, or black to outline his forms, Davis fills in with various colors in such a way that color assumes the role of indicating space. Dots stand in for sage and juniper; horizontal lines indicate roads or are used randomly in the sky to lend taut strength to Davis's view, one that threatens to burst from its edges. Anchoring these edges is a painted "frame," a device that Davis used again to emphasize that the painting is, after all, artifice and consists of a flat surface contained by the curving gray and white borders.

No matter whether the frame anchors the image like a mounted photograph or a picture postcard, or the scene itself is one glimpsed from a car window, the point is the same: Davis makes the experience of the landscape—as acute as it may be—like that of a tourist, brought home through a snapshot, a picture postcard, or a map of a car's journey. Although Davis later complained that the landscape comprised "forms

made to order, to imitate," he admits that the New Mexico landscape is modern and, therefore, to paint it is to imitate literal form in order to make a modern picture. Here he sells himself short because in New Mexico the reality of its landscape — sculptural forms, vivid angles, and geological fault lines — contributed to Davis's developing theory of planar abstraction. The geography of New Mexico and its clearly defined geometries galvanized Davis's artistic process, as he reduced a scene to its component parts of line and color. In terms of content, the Santa Fe region and its very picturesqueness prompted Davis to be receptive to and to concentrate his efforts on "making a picture," and also to distance himself from the region by including devices such as a painted frame in his works. In New Mexico Davis could combine wit, as

well as picturesque and popular subject matter, with his dead-on attention to system and structure. Similar to Dixon's *Earth Knower* in its planar frontality and its friezelike qualities that hint at the landscape stretching beyond its borders, Davis's *New Mexican Landscape* takes the landscape to a different level, emphasizing its "nowness," its modernity.

Davis's correspondence up to late September reveals an artist satisfied with his experiences, but his last-known missive, of October 1923, rather abruptly indicates his desire to go home. It is unclear just when Davis became disenchanted with his experiences, but he never returned to New Mexico. Jazz and its musical heritage ultimately would prove to be a more productive source for his creativity. His brother, Wyatt, on the other hand, settled permanently in New Mexico and

Fig. 115
STUART DAVIS
Still Life with Map, 1923
Oil on canvas, 31 x 39 in.
Collection of Lee and Judy Dirks

Fig. 116
Julian Martinez digs for pottery clay near San Ildefonso Pueblo, c. 1930s.
New Mexico Magazine Archival Photograph by Wyatt Davis, as published in *Forever New Mexico: Heartfelt Images of New Mexico*, edited by Arnold Vigil

photographed the state for various magazines and journals (fig. 116); his descendants live in New Mexico to this day.

Davis's New Mexico story of pleasure, awe, and engagement with the world around him gave way to eventual disdain or disappointment. His experience echoes that of Marsden Hartley (1877–1943), who visited both Taos and Santa Fe in 1918 and 1919, several years before Davis made his journey.[58] When Hartley arrived in Taos in June of 1918, he was a guest of Mabel Dodge Sterne (later Luhan), who had settled there in 1917 determined to attract artists, writers, and intellectuals. Hartley was a sophisticated and worldly artist who had traveled in maverick circles, including those of Gertrude Stein, Alfred Stieglitz, and Wassily Kandinsky. Born in Maine, Hartley went on to study art in Cleveland and New York, then lived and worked in Paris and Berlin. In Germany he painted symbolic abstractions based on his experience of an increasingly militarized state in all its pageantry, as well as on his own sense of personal loss (his friend and likely lover, a Prussian officer, died in battle during World War I). Also an emerging essayist and poet, Hartley was alternately full of self-doubt or refined hauteur, and he fought poverty and frail health. He was a restless spirit who aspired to artistic greatness and innovation and self-consciously pursued the idea of an "American" and "Modern" art.

The time line of Hartley's encounter with New Mexico can be summarized as follows: from June to early October 1918, he lived in Taos, exploring the surrounding area, making pastels and painting still lifes of such objects as *santos* and Indian pottery. In late October 1918 he left Taos (which, by this time, he referred to as "Chaos") and stayed in Santa Fe, exploring the region and continuing to work in pastel, using a studio that Hewett made available at the Palace of the Governors.[59] According to Hartley, Hewett ejected him from his studio, whereupon, yearning for a break during that frigid winter, he traveled to Pasadena. He stayed there from mid-March to mid-June 1919, working on his New Mexico pastels but mostly writing, he said, because "there is no landscape there to speak of [in California], just scenery."[60] There he met, among others, the emerging poet Robert McAlmon (who, along with William Carlos Williams, eventually formed the poetry magazine *Contact*) and artist Arthur Wesley Dow. Returning to Santa Fe in June 1919, he continued working in pastel and oil, then went to New York that November and remained there through the spring of 1920, painting landscapes based on the pastels. In freewheeling postwar Berlin by 1921, and then in April 1923 through 1924, he began to paint a series of moody, turbulent landscapes based on his memories of New Mexico, titled *Recollections*, which he continued to work on in Paris at about the same time Davis was in Santa Fe. Hartley's New Mexico work may thus be categorized as belonging to the three distinct periods of time that he spent there and, in terms of the landscape subject matter, three distinct groupings: intuitive pastel sketches, oils based on those sketches, and the later *Recollections*, all three of which chart the process of his moving away from the earlier symbolic abstractions. In New Mexico Hartley sought to reintegrate form and spirit through an intense investigation of American "soil." The works based on his experiences there show how New Mexico and the Southwest more generally preoccupied him during these years as he struggled "for something to express America," as he wrote, "in terms somehow equivalent to herself."[61]

Like many Anglos then unfamiliar with the western landscape and its indigenous peoples, Hartley had high expectations, and these were initially met. He noted to his friend Stieglitz, "I like it here immensely and the country is very handsome.... It is beautiful, and there never was a more beautiful single mountain than Taos mountain.... They are

beautiful, these people.…It is a perfect place to regain one's body and soul."[62] Yet Hartley was confounded by the differences between what he had envisioned and what he actually encountered, remarking, "It is very handsome country, yet it is taking me a time to get into my system certain peculiarities."[63] In the area of Taos, the colors, for example, were blue and gold, "not red and yellow as I had suspected in imaginative ways." He commented on the "intense sensations" of the region around Santa Fe, Trinidad (Colorado), and Las Vegas, New Mexico—especially "the odd country" near Las Vegas and Santa Fe that he described as "great isolated altar line forms that stand alone on a great mesa with the immensities of blue around and above them and that strange Indian red earth making such almost unearthly foregrounds. The spaces are so huge here and so simple and details are so clear that nothing seems far off, and distance is like a fiction for the eye." In rhapsodizing about the novel, strange landscape, he also revealed his sense of New Mexico as a place to which he could retreat from the "pernicious" East, where he had almost succumbed to "annihilation."

In an effort to find the genius loci of the Southwest and the sculptural solidity of the land that he saw as its salient feature ("a land *in* light," he noted), Hartley turned his attention to the works of Gustave Courbet and Paul Cézanne, known for the muscular strength and vitality of their landscapes.[64] The pulsating energy he found in their work—in Courbet's paintings of Ornans and Cézanne's paintings of Mont Sainte-Victoire, and, as he also noted, the "classical grandeur" of the works of Claude Lorraine, which the canyons around Arroyo Hondo suggested to him—gave him equivalent models for the new landscape he encountered. In three pastels, *Pueblo Mountain* (1918), *Arroyo Hondo, N.M.* (1918), and *New Mexico Landscape* (1919), Hartley reveals the excitement and freshness of his experiences in both vivid and delicate "portraits of places," as he called them (figs. 117–19). Critic Herbert Seligman described these works as "having the quality of joyous impromptus, or intimate revery given letter-fashion to a friend": the hulking, shimmering mass that is Taos Mountain, the complexity of the sculptural geography of nearby Arroyo Hondo, northwest of Taos, and the lightness and ephemeral touch of an empty farmhouse nestled against a grand landscape, likely closer to Santa Fe.[65]

Indeed, Hartley sent the pastels as letters to Stieglitz, to whom he also confided his misery, illness, depression, and frustration with the local community, even as he continued to find in the landscape itself an intensity that inspired his thoughts and deepened his convictions. When he published two articles, "America as Landscape" and "Aesthetic Sincerity," in *El Palacio* in 1918, he threw down the gauntlet, offering his new credo in Whitmanesque style: "I am an American discovering America.…As a painter, I am impressed with the fact that America as landscape is, one might rightly say, untouched."[66] Decrying the local Taos community in "America as Landscape" as proponents of "badly digested impressionism," Hartley argued that the Southwest was ripe for, but had not yet produced, artists whose methods and techniques could match the structure and form of the landscape, something that gets at the "solidity of the landscape itself." The Taos Society of Artists, he said, "merely follow the Indian around, applying Parisian literary poses to him, attaching redman titles.…There will be an art in America only when there are artists big enough and really interested enough to comprehend the American scene." Not mentioning her by name but clearly referring to Santa Fe poet Mary Austin, Hartley admired the geographic sincerity of her poetry, which mined American Indian language to produce a new poetic language —structure, in other words, to inform new structure, a "mature esthetics," he wrote, "to take the place of European echo, something to express America in terms somehow equivalent to herself." For Hartley, the Taos Society was not capable of creating this new aesthetic.

Hartley's other article, "Aesthetic Sincerity," sounded similar notes but framed them in a historical context.[67] After decrying the "rococo" aspects of the local art community, he claimed, "Until painting is ridded of this outward application [rococo], this feeling of something 'put on' a canvas, artists will never arrive at the primal significance of the southwest as a classical subject or of painting as a means of expression. …New Mexico is essentially a major sensation, for my eye, at least. It will not avail to attack it in a minor key. The sense of form in New Mexico is for me one of the profoundest, most original, and most beautiful I have personally experienced. It must be 'learned' in the sense of digesting, as one learns a problem in geometry." And Hartley did, in fact, approach the New Mexico landscape with discipline, getting "on the ground" and "into the subject" (see fig. 120), arguing that a landscape should "look like" the place but be summoned through a structural approach in which form and technique

Fig. 117
MARSDEN HARTLEY
Pueblo Mountain, 1918
Pastel on paper, 17 1/2 x 27 7/8 in.
Collection of Lee and Judy Dirks

Fig. 118
MARSDEN HARTLEY
Arroyo Hondo, N.M., 1918
Pastel on paper, 17 x 28 in.
Collection of Lee and Judy Dirks

Fig. 119
MARSDEN HARTLEY
New Mexico Landscape, 1919
Pastel on paperboard, 18 x 28 in.
Alice C. Simkins

Fig. 120
Marsden Hartley in New Mexico, c. 1918–19
Yale Collection of American Literature, Beinecke Rare Book and Manuscript Library

are parallel. World War I, he argued, changed the terms of American art forever: "The war has accomplished this for the painter, it has demanded originality from him. It has sent him back to his own soil to ponder and readjust himself to a conviction of his own and an esthetics of his own." Hartley answered the call.

But by July 1918 Hartley was peevish, not only about the Taos Society—"impossible, dreadful painters, who are just nasty tongued, and talking all the time about someone. I have never gotten in to such a mean little place"—but about the landscape itself, finding that too much of the Taos area was not sufficiently unique to fulfill his expectations of what the Southwest should be.[68] The Taos Valley was cultivated, Hartley wrote, "just like any valley in New England." He traveled to Twining (now Taos Ski Valley) and must have found in its towering mountains something Alpine, not New Mexican. For Hartley, the area around Santa Fe was more "typical"

Fig. 122
MARSDEN HARTLEY
New Mexico Landscape, 1919
Oil on canvas, 20 x 32 in.
Curtis Galleries, Minneapolis, Minnesota

[OPPOSITE]
Fig. 121
MARSDEN HARTLEY
Landscape, New Mexico, 1919
Oil on canvas, 28 x 36 in.
Whitney Museum of American Art, New York, Purchase, with funds from Frances and Sydney Lewis, 77.23

because of the mesas in its environs, which he had come to identify as quintessentially southwestern. Still, he acknowledged to Stieglitz that he was in the process of reclaiming "a firmness which I did not have before" after years of "speculating in abstractions."

Hartley's "firmness," which translates to his return to figuration, was not a retreat from abstraction, as art historians often describe American art in the years between the two world wars. Rather, it was a way to recover his home ground, soil and all, something that, for him, spoke of permanence and sincerity rather than of theoretical abstractions. New Mexico inspired in Hartley a yearning to "copy nature as faithfully as possible," a transitional process after "six years devotion to abstraction."[69] He was clearly moved by nature (the parts that are "typical," that is), admiring "the beautiful plains, made up entirely of sagebrush which is a silver emerald green shaded through with blue, and looks so like a fine silk tapestry shot through with cloud shadows and long lines of gold and violet light." Further, Hartley claimed he wanted to "give up all worthless intellectual and philosophical deductions, and get into the flow of things again.... I want to get the full harvest out of myself.... I have had three solid years of introspection, esthetic as well as spiritual, and I have felt the need of shuffling all that off from my system and beginning again with a new influx of sensibility.... I want the bigness and the sense of giving of this big country in my system, and it is the only way to recreate myself."

What is interesting about Hartley's pronouncement is his desire to reach some sort of psychic wholeness by merging self with landscape, a prefiguration of Abstract Expressionist Jackson Pollock's affirmation: "I am nature." When Hartley returned to New York and synthesized the pastel "portraits" and his experiences of New Mexico, he created oils such as *Landscape, New Mexico* (1919; fig. 121). His canvases pulsate with sensation, as form, color, and light burst from their confines. He created works derived from earlier compositions, including pastel portraits like *Rio Grande River* (1919, Harwood Museum of Art, Taos) and oils such as *New Mexico Landscape* (1919, Curtis Galleries, Minneapolis; fig. 122), in which he systematically reduced natural forms, removing the specificity of river, arroyo, mountain, and sky, so that although the bands of form are clearly distinct from one another, the lack of a central focus disperses energy evenly throughout the canvas.

This sense of oneness was derived not only from Hartley's encounter with the landscape but also from his experience of the Pueblo Indian, whom he never once painted yet recalled conceptually in paintings such as *Landscape, New Mexico*. Again, the idea of oneness with the universe is expressed in the overall pulsating rhythm of the composition, which vibrates beyond the frame into the viewer's space. In other words, the structural technique of wholeness and integration that Hartley was searching for in his art extended beyond his own experience of landscape sensations to the cultural life he observed on the land. Hartley's yearning for psychic oneness embodied in the landscape paralleled his notions of the noble "redman" living in harmony with nature.

Hartley's conception of Amerindian culture did not begin in New Mexico. In Berlin, where he created his *Amerika* series of 1914, he inserted American Indian symbols into dynamic abstractions that had little, if anything, to do with Indian culture per se and instead were a means of asserting his American identity (fig. 123).[70] In this regard he was not unlike the colonial American painter Benjamin West, who announced to a European audience that the ancient classical sculpture of the *Apollo Belvedere* looked like a "Mohawk warrior." Whereas West had actually seen Indians before, Hartley had not. And when he traveled to New Mexico, he turned his attention to their culture with rapt idealism and sincerity. He entered the political arena with a strongly felt anti-assimilationist policy and a crusade—articulated in several well-received journal articles—that Indian culture should not only be preserved and celebrated but used as a model for living in a modern urban world, a world in which spiritual values were threatened by mechanization.[71] "Every other nation has preserved its inheritances," he wrote. "We need likewise to do the same.…[The redman] will never be able to accept a culture which is inferior to his own.…The redman proves to us what native soil will do. Our soil is as beautiful and as distinguished as any in the world. We must therefore be the discoverers of our own wealth as an esthetic factor, and is it the redman who offers us the way to go."[72]

It is interesting to note that Hartley's encounter with the West began and ended in Europe. In 1923, years after he had departed from New Mexico, he began to paint fiercely tumultuous paintings, using swirling, viscous paint and, at times, acid colors to create almost surreal landscapes based on his memories of New Mexico and on his experiences of returning to Berlin and Paris. The bright, scintillating light and forms, once so carefully integrated, now turn loose in such monumental canvases as *New Mexico Recollection—Storm* (1923; fig. 124) and *Landscape Fantasy* (1923; fig. 125), in which mountain, cloud, thunderstorm, and windswept sagebrush do not so much vibrate as push up, out, and upon one another with a violent geological force, rhythmic in nature, not unlike the swirling, wavelike painterly motions of Thomas Hart Benton and Jackson Pollock, when the latter began as Benton's pupil. Hartley used the movement, sculptural solidity,

Fig. 123
MARSDEN HARTLEY
American Indian Symbols, 1914
Oil on canvas, 39 3/16 x 39 3/16 in.
Amon Carter Museum, Fort Worth, Texas, 1999.8

[OPPOSITE, TOP]
Fig. 124
MARSDEN HARTLEY
New Mexico Recollection—Storm, 1923
Oil on canvas, 29 x 41 1/4 in.
Collection of Mr. Theodore P. Shen

[OPPOSITE, BOTTOM]
Fig. 125
MARSDEN HARTLEY
Landscape Fantasy, 1923
Oil on canvas, 28 1/2 x 41 in.
Grey Art Gallery, New York University Art Collection, Gift of Charles Simon, 1965

rhythm, and stasis of the New Mexico landscape to structure a system based on both nationalism in its effort to produce a "species of purism, native to ourselves in our own concentrated period" and on spiritualism in its rooted, mystical, and sustained contact with the earth.[73] With the exception of the art of O'Keeffe, it is difficult to imagine an earthier New Mexico landscape than that depicted in these two paintings from Hartley's *Recollections* series. Although scholars have attributed these dark landscapes to the artist's personal disappointments and tribulations in Europe, Hartley wrote to Stieglitz that "I think you will like the 'simplicity' of the new work—and a certain coming of repose."[74] Indeed, the art Hartley produced in and about New Mexico does not constitute an interlude or a period of painterly ambivalence, as some argue, so much as it embraces, as Hartley articulated, a thorough process in which the landscape "must be 'learned' in the sense of digesting, as one learns a problem in geometry." The quality of becoming that so many had interpreted in the New Mexico landscape found its corollary in Hartley's extended dialogue. For him, the dialogue ended in "repose." Once the journey was completed, the peripatetic artist moved on.

In an October 1918 letter to Stieglitz, Hartley expressed his wish that "[John] Marin would come here [Taos] because it is 'the paradise of water-color.'"[75] Marin (1870–1953) did come, but not until eleven years later, during the summers of 1929 and 1930. Another member of the Stieglitz circle, but temperamentally miles apart from his great friend Hartley, Marin was more direct and consistent in his unabashed enthusiasm for working out-of-doors and in producing spontaneous impressions of nature, whether in Maine, Austria, or Taos. Not one to dwell on theoretical art debates for very long, Marin considered himself pragmatic, a Yankee to the core. This could be an issue in the high-stakes game of defining American art in the early decades of the twentieth century; when critic Waldo Frank accused Marin of being an "escapist," Marin's good friend, the photographer Paul Strand, defended him by arguing that Marin "related to the American pioneer. But where the latter wanted only to possess the body of a continent, Marin is revealing its spirit."[76] While the Stieglitz artists debated the finer points (yet again eliciting spirit), Marin traveled and worked, enjoying success and prosperity and producing a remarkable body of work that attests to his reputation as the next great American watercolorist after nineteenth-century painter Winslow Homer.[77]

Born in New Jersey, Marin trained at the Pennsylvania Academy of the Fine Arts in Philadelphia before traveling for five years in Europe, where he absorbed its many artistic "isms." He returned in 1911 to New York, his permanent home base between frequent periods of travel. Marin was a quick study, and once he established his basic artistic method, it changed very little. Thus, he took his travel to New Mexico no less seriously than he did to any other place, and he produced watercolor landscapes that are among the most vibrant of his career. But New Mexico, for Marin, was a chance to "go from time to time to the elemental big forms—Sky, Sea, Mountain, Plain,—…to sort of re-true himself up, to recharge the battery."[78]

When Marin, at the age of fifty-nine, arrived in Taos with his wife and son at the invitation of Mabel Dodge Luhan, he borrowed her car and explored the surrounding area. As scholars often note, Marin's work from the summer of 1929 generally differs from his more developed and complex work of the next summer, if only because, as the artist said, he needed to adjust his eyes to "this dogoned [sic] country," likely starting with such iconic landscape features as Taos Mountain, seen in all its hulking, colorful strength in *The Mountain, Taos, New Mexico* (1929; fig. 126). Marin called his watercolors "maps," portraits of places that are, as his friend painter J. Ward Lockwood described them, not very "abstract."[79] As the scholar Van Deren Coke discovered, and as is easily confirmed today, Marin's watercolors, for all their broken, shattered, shimmering surfaces, are quite place-specific.

For *New Mexico, Near Taos* (1929), Marin perched his easel about half a mile outside of Arroyo Seco looking east/southeast with the canyon in between, a view relatively unchanged today (fig. 127). His densely packed *Little Canyon, New Mexico* (1930) is a scene taken from the road heading into Taos Canyon, near the Rio de Fernando (fig. 128). But besides adding a painted frame to the picture—not unlike Davis seven years earlier—Marin sharpens the softer, less angled entrance to the canyon by pulling the scene to the surface and eliminating any middle ground. To contain its consequent and potential disorder, he provides a road in the foreground and frames the view, not wanting his picture to "make one feel that it bursts its boundaries. That would be a delusion, and I would have it that nothing," as if to echo Davis, "must cut my picture off from its finalities."[80] Energy, rhythm, and pattern, "rending tensions, the conflict in forces…thrust and

Fig. 126
JOHN MARIN
The Mountain, Taos, New Mexico, 1929
Watercolor, 14 x 19 ¾ in.
The Museum of Fine Arts, Houston, Gift of Mrs. Efrem Kurtz, 2000.129

Fig. 127
JOHN MARIN
New Mexico, Near Taos, 1929
Watercolor, gouache, and graphite on paper, 14 1/16 x 21 1/16 in.
Los Angeles County Museum of Art, Mira T. Hershey Memorial Collection

Fig. 128
JOHN MARIN
Little Canyon, New Mexico, 1930
Watercolor on paper, 15 ½ x 21 in.
University of New Mexico Art Museum, Albuquerque,
Purchased with Funds from the Julius L. Rolshoven Memorial Fund, 66. 136

counterthrust," as art historian Frederick Wight wrote, define Marin's work.[81] When we see Paul Strand's photograph of a very physically engaged Marin working in Taos in 1930 (fig. 129), we understand how he attacked his paper with a vibrant energy matched by the personality of the artist himself, who said, "I can have things that clash. I can have a jolly good fight going on. There is always a fight going on where there are living things. But I must be able to control this fight at will with a Blessed Equilibrium."[82] In so many watercolors, such as *Taos Canyon, New Mexico* (1930), the equilibrium is barely maintained (fig. 130). Breaking at the sides are jagged frames that mimic the Indian designs Marin had admired in the tourist souvenirs he bought. At left, a mountain form rises up beyond the side, and stair-step designs at bottom left and right pull the motif down to its narrowed bottom.

It is as if watercolor painting out-of-doors is a spirited game for the artist as he chases down the world's ephemeral effects. This notion of the vigorous artist was invoked by Duncan Phillips in describing Marin: "Only his rare genius for significant selection and his unprecedented command of his supposedly fragile medium, justifies and explains the precarious, headlong way in which he fairly hurls his inspiration on paper."[83] The results of his athletic engagement, however, reveal nothing violent or tumultuous; instead, Marin produces a "skeletonizing structure," to quote Phillips, in which light and form resolve themselves in powerful arrangements of movement and pattern. The greatest of these ethereal, rhythmic movements of the earth are felt in Marin's observations of thunderstorms and the strange patterns of light they may create in and around Taos. *Storm over Taos, New Mexico* and *Storm, Taos Mountain, New Mexico*, both from 1930 (figs. 131 and 132), summon these observations.

Unleashing riotous bands of color that march up the paper until reaching the dotted, sunlit adobe buildings of the town, Marin reveals the full range of his expertise in watercolor, creating washes of saturated and thinned-out color to suggest the scrimlike effects of falling showers at various depths in the distance, with Taos Mountain lurking behind (fig. 132). Laura Gilpin also layers landforms, similarly stacking them—the way Marin alternates light and land—in horizontal bands to suggest distance. These bands cling to the surface in a flat, patterned effect like a woven blanket in *Shiprock from the North Rim of Mesa Verde* (1926, printed 1929), in

which the famous landmark and sacred Navajo site of Shiprock is hardly visible in the distance (fig. 133). In *Storm, Taos Mountain, New Mexico*, Marin uses various shades of blue and the white of the paper, providing balance and stability with a thick avocado-colored line and zigzag lines at the bottom of the page. Various washes of blue interlock in a shimmering pattern of mountain form, sheets of rain, and lightning, which, as in *Storm over Taos*, also suggest the Indian design of terraced clouds. These references to Indian symbols firmly anchor the works to place, lest any viewer confuse them (although unlikely) with, say, Maine. Yet on the coast of Maine and in the Southwest, severe geometries enabled the artist to see the movement and rhythms of

Fig. 129
PAUL STRAND
John Marin, New Mexico, 1930
Gelatin silver photograph
Aperture Foundation Inc., Paul Strand Archive

Fig. 130
JOHN MARIN
Taos Canyon, New Mexico, 1930
Watercolor on paper, 15½ x 21 in.
Amon Carter Museum, Fort Worth, Texas, 1965.5

Fig. 131
JOHN MARIN
Storm over Taos, New Mexico, 1930
Watercolor and graphite on paper, 15 1/16 x 20 15/16 in.
National Gallery of Art, Washington, Alfred Stieglitz Collection

Fig. 132
JOHN MARIN
Storm, Taos Mountain, New Mexico, 1930
Watercolor and charcoal on paper, 16 7/8 x 21 3/4 in.
The Metropolitan Museum of Art, Alfred Stieglitz Collection, 1949 (49.70.144)

the earth most clearly and, it may be argued, inspired the greatest watercolors of his career. Even more so than his quasi-Cubist scenes of a frenetic New York City, Marin's landscapes and his body of work from New Mexico reveal the artist's avowed passion and reverence for the Earth itself and his appreciation of its forms. Late in life he wrote to his longtime Taos friend Ward Lockwood with the generosity and esteem that one might expect from this congenial artist: "Go thy way with seeing and reverence—and I would have it, the earth, to give to you—you belonging to it—as it were a mutual respect toward one another—otherwise—what?"[84]

Critic Paul Rosenfeld described the element of time in Marin's art, writing that a watercolor by this artist "represents the world seen by us under conditions of fast motion: the world which looks rhythmic, as though its balance were incessantly displacing itself"; Rosenfeld's phrase aptly describes the energetic motion and vibrating qualities of Marin's art, as well as the pace of modernity and the constant shifts perceived in the modern experience.[85] At the time Marin produced his balanced yet plane-shifting watercolors in New Mexico, the American Indian art of watercolor as it was practiced mostly in and around Santa Fe offered an alternative: still time or timelessness.

Fig. 133
LAURA GILPIN
Shiprock from the North Rim of Mesa Verde, 1926, printed 1929
Platinum photograph, 4 $^{15}/_{16}$ x 6 $^{1}/_{4}$ in.
Collection of Christopher M. Harte and Amon Burton

SYMBOLIC NATURE: AMERICAN INDIAN WATERCOLORS

This part of the story of the Modern West, although far more complicated than generally outlined below, goes something like this: In the early decades of the twentieth century, groups of reformers protested the federal government's policy of assimilation, which had been in place since Capt. Richard Pratt's well-intentioned but ultimately devastating policy of "kill the Indian to save the man." This policy enforced assimilation with white culture, displaced *place* from Indian life (warriors like Bear's Heart, we remember, were exiled to incarceration in Fort Marion, Florida), and attempted to annihilate Indian traditions. By 1934 it was painfully clear that this policy had failed; only then was the policy officially reversed, as the government (and others) worked to save Indian traditions in cultural salvage projects to bring back and preserve what people previously had attempted to erase.

American Indian watercolor painting on paper, as opposed to the American Indian tradition of painting on ceramics, dates back to nineteenth-century ledger drawings. The "modern" development of watercolor painting begins around the turn of the nineteenth century, at Hopi and San Ildefonso.[86] At San Ildefonso Pueblo, watercolor became integrally related to the archaeological digs in Frijoles Canyon on the Pajarito Plateau and to Hewett's broad plan to preserve Indian antiquity and encourage native traditions.[87] Drawing his source of labor from nearby San Ildefonso, Hewett and Chapman employed people such as Julian Martinez (Po-Ca-No, 1885–1943) to excavate and, upon "discovering" their artistic abilities, encouraged them to paint. Hewett and Chapman hired them to produce traditional designs for the School of American Research and, as in the case of Martinez—whose wife, Maria, was a master ceramicist—encouraged their pottery production. A central figure in this group of cultural workers, Martinez appears as the "ancient" Ancestral Puebloan in Jesse Nusbaum's photograph of the ceremonial kiva at the canyon, and he gathers clay for his wife near San Ildefonso in a later photograph by Stuart Davis's brother, Wyatt (figs. 108 and 116).

With the support of white patrons, including a large percentage of activist Anglo-American women, a number of first-generation, self-taught artists like Martinez and Alfonso Roybal (Awa Tsireh, 1895–1955), also from San Ildefonso, produced a body of work widely celebrated for its assertion of Indian lifeways.[88] Composed of abstract designs rendered in flat patterns of bold color, the works were intended for a non-native audience. The white intellectual community of the area encouraged this style of painting (native artists who veered toward Western traditions of perspective were discouraged), and it was celebrated for providing a genuinely "American" pedigree for contemporary forms of abstraction.[89] Supporters, promoters, and enthusiasts included, in addition to people associated with the School of American Research and the Museum of New Mexico, writers Mary Austin and Alice Corbin Henderson, superintendent of the Santa Fe Indian School John DeHuff and his wife, Elizabeth, a teacher, Denver Art Museum curator Frederick Douglas, teachers Olive Rush and Dorothy Dunn, Mabel Dodge Luhan, artist Gustave Baumann, and, notably, artist John Sloan, who helped organize an exhibition of these watercolors as early as 1920 at the Waldorf-Astoria Hotel in New York. The irony of the exhibition venue is not lost on us: in 1905 Edward S. Curtis had announced at the hotel his ambitious project to record the "vanishing" First Americans, and, fifteen years later, Sloan and others helped introduce at the same venue the work of *living* American Indian artists. These watercolors ignited enthusiasm among many influential critics, including Walter Pach, who declared that "this is American" (and considered the examples art as opposed to anthropological artifacts).[90] The construed American-ness of the watercolors would have contrasted dramatically with the baronial grandeur of the hotel, a point that would not have gone unnoticed by either the organizers or attendees, who saw something pure and fundamental in the concise outlines, frontality, and directness of the works. Thus, although indigenous tribes once were regarded as "the Indian problem," they now were part of the solution, their vibrant cultures serving as a source of redress for the rampant materialism and selfish individualism that risked overtaking the modern community. Just as the landscape had been invested with the highest expectations, so, too, was American Indian culture held to the noblest ideal. American Indian watercolors soon became a part of institutional Modernist agendas by means of numerous exhibitions, acquisitions, and publications throughout the country and even the world.[91]

Although an active field of American watercolor existed long before she arrived in Santa Fe, Dorothy Dunn is perhaps the best known of the teachers and promoters of modern American Indian watercolor painting. Dunn founded The

Studio of the Santa Fe Indian School, where young artists were guided carefully to record their native traditions using watercolor. As she wrote in the very first sentence of her groundbreaking book, *American Indian Painting*, published in 1968 and based on more than thirty years of research, "American Indian painting not only is the first painting the continent produced—it is the first American painting in which abstract style and certain other characteristics now commonly associated with contemporary art were developed to an advanced degree."[92] In other words, American Indian

art was "modern by tradition," in the words of a recent book on the topic, and its flat, abstract, and emblematic style could be employed as a pedigree for a "genuine" American art.[93]

Julian Martinez's *Conventionalized Design of Symbols (Sacred Avanyu)* (1930–40) shows a horned water serpent, an ancient design associated with San Ildefonso and a hallmark of his wife's renowned black-on-black pottery, for which he often provided the painted decorations (fig. 134). The serpent or other animal or plant figures beneath a stylized rainbow and the terraced clouds typify San Ildefonso traditions,

Fig. 134
JULIAN MARTINEZ
Conventionalized Design of Symbols (Sacred Avanyu), 1930–40
Tempera on paper, 16 x 19 3/4 in.
The Museum of Fine Arts, Houston, Gift of Miss Ima Hogg

but Martinez includes other features that indicate his familiarity with the then-prevalent Art Deco style. So, too, does Roybal, whose *Mountain Sheep* (1922), stretched and curved under an echoing rainbow, is meticulously handled with fine, precise lines and bold color. The work reflects Roybal's tendency to combine realistic subject matter with emblems, such as, in this example, rain and triangular fertility motifs (fig. 135). Riley Sunrise (Quoyavema, born c. 1900–active until c. 1979/80), an older student, was affiliated with Dunn's studio. He was born a Hopi but was adopted by a Kiowa

family, and his art bears an association with the Kiowa style of Oklahoma: active outlines, an almost stencil-like quality, somewhat frozen and hieratic, as seen in *God of Germination* of the 1930s (fig. 136). Watercolor painting at Zuni was distinct from that of the eastern pueblos, tending toward small blocks of color carefully interlocked in flattened, busy designs, such as Pylen Hanaweaka's (1902–1989) *Zuni Altar with Ceremonial Bowls* (1920–30; fig. 137).

Landscapes do not figure here because landscape painting was not a tradition in American Indian art. But this

Fig. 135
ALFONSO (AWA TSIREH) ROYBAL
Mountain Sheep, 1922
Tempera and ink on wove paper, 11 3/4 x 14 1/4 in.
The Museum of Fine Arts, Houston, Gift of Miss Ima Hogg

Fig. 136
RILEY (QUOYAVEMA) SUNRISE
God of Germination, 1930s
Tempera on tan wove paper, 12 x 8 in.
The Museum of Fine Arts, Houston, Gift of Miss Ima Hogg

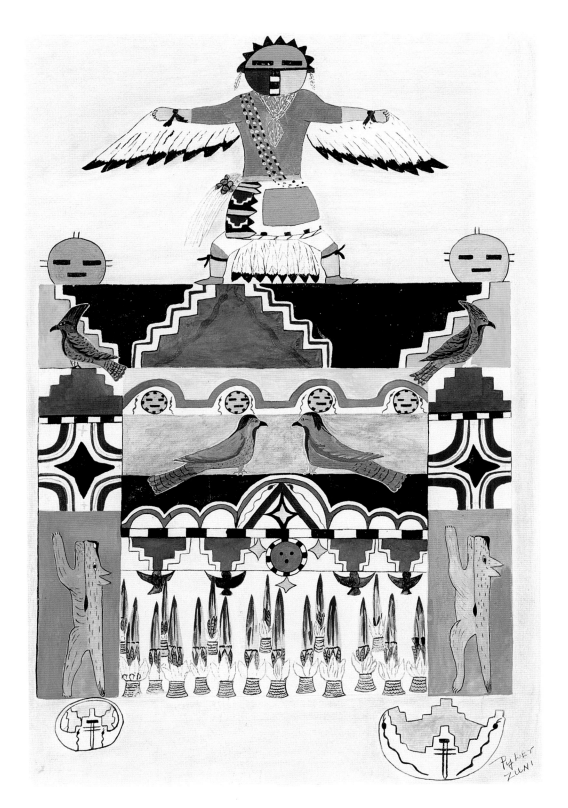

Fig. 137
PYLEN HANAWEAKA
Zuni Altar with Ceremonial Bowls, 1920–30
Tempera over pencil underdrawing on paper, 22 ½ x 15 ¾ in.
The Museum of Fine Arts, Houston, Gift of Miss Ima Hogg

does not mean that land and earth are absent; rather, they are seamlessly present. Land and landscape, in most Indian belief systems, are inseparable from human life. The physical environment is recalled by stylized forms and shapes that suggest symbolic connections to the earth. Water, such as represented by the *avanyu*, or sheets of rain (thin vertical lines) are evoked often in prayerful images that bring forth reciprocity between humankind and the earth and proclaim the importance of maintaining one's balance with the universe. Although these kinds of images appealed to Anglo patrons who saw them as affirmations of a more thoughtful way of life, Geronima Cruz Montoya, one of the artists who made them, had this to say: "[Dorothy Dunn] did a lot for us. She made us realize how important our own Indian ways were, because we had been made to feel ashamed of them. She gave us something we could be proud of."94

The Santa Fe Indian School (and related) watercolors of this period hint at the complexities of cultural primitivism. The Modernism of these watercolors is mostly summarized by the efforts of artists and patrons to keep the subjects as authentic and pure as possible, cloistered from modernity. This goal was not only impossible but also hurt the broader cause of envisioning various Amerindian cultures in all their complex humanity.

SENSE OF PLACES AND SENSES OF PLACE

Paul Strand (1890–1976) was also involved in furthering the romance of Indian authenticity when in 1932 he photographed the famous eighteenth-century church St. Francis, located in the village of Ranchos de Taos (fig. 138). A native New Yorker educated at the Ethical Culture High School, which emphasized humanist teaching, Strand first received training in photography from Lewis Hine, the documentary photographer well known for his pictures of child labor. Strand visited Stieglitz's 291 Gallery, where he absorbed the lessons of Modernism. Throughout his career, Strand was motivated by the social concerns of liberal humanism and the abstract formalism of European modes of art-making, both of which he ultimately aimed to combine in one vital art.95

Strand traveled throughout his life, making sense of places and senses of place as various as the Canadian peninsular coast of Gaspé, Mexico, France, Italy, and New England. He first traveled to the West in 1918, at the request of Stieglitz, to retrieve the ailing Georgia O'Keeffe from Canyon, Texas,

and take her to New York, where she and Stieglitz eventually married. Despite the affection that O'Keeffe and Strand evidently had for each other (as did Strand's soon-to-be wife, Rebecca "Beck" Salsbury, for Stieglitz), Strand married Salsbury, the English-born daughter of Nate Salsbury, manager and co-owner of Buffalo Bill's Wild West Show. The Strands traveled to Colorado in 1926, where Paul photographed Mesa Verde the same year that Laura Gilpin published her photography book on the subject. These activities contributed to the lure of the Southwest popularized in Willa Cather's *The Professor's House* (1925), a fictional account of how the Ancestral Puebloan ruins had come to be "discovered." Several years later, in 1929, O'Keeffe and Beck Strand spent a summer at Mabel Dodge Luhan's Taos home, Los Gallos. Encouraged by Beck, John Marin, O'Keeffe, various other visitors, and Luhan, Strand came to Taos during the summers between 1930 and 1932 and photographed the landscape and architecture of New Mexico. These are among the most potent and gemlike photographs of New Mexico ever taken.

New Mexico was an end and a beginning for Strand. With the benefit of hindsight, we see that in New Mexico he left behind the abstract still lifes that had launched his career in 1916. He began to champion socially urgent causes as he made a foray into Marxism. For him and many others, Marxism offered an answer to the political upheavals and social unrest of World War I and the catastrophic stock market crash of 1929. It was here, too, that his marriage unraveled and his friendship with Stieglitz ended, as Strand began increasingly to turn to left-wing causes that eventually earned him a place on Senator Joseph McCarthy's blacklist.

Strand embraced the Southwest with eyes wide open. As he later revealed, "This fruitful period for me led…to the dramatic vastness of the Southwest—New Mexico. Here a new problem for me presented itself, that of trying to unify the complexity of broad landscape as opposed to the close-up of approachable and relatively small things. There are not only many photographs but also many paintings in which the sky and the land have no relation to each other, and the picture goes to pieces. For the photographer, the solution of this problem lies in the quick seizure of those moments when formal relationships do exist between the moving shapes of sky and the sea or land."96 The handheld 4 x 5 Graflex camera he used helped to capture these fleeting moments, especially in the exhilarating photograph, *Badlands near Santa Fe, New*

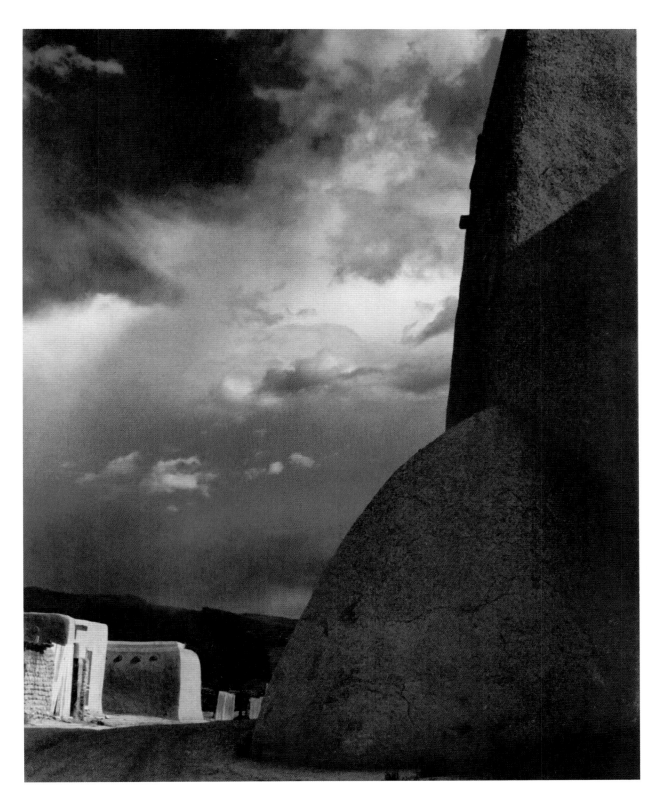

Fig. 138
PAUL STRAND
Church Buttress, Ranchos de Taos, New Mexico, 1932
Platinum photograph, 5 × 4 in.
The J. Paul Getty Museum, Los Angeles

Mexico (1930), taken northwest of Santa Fe about three miles north of Española (fig. 139). Strand suggests both the vast grandeur and detail of the region in this small image in which sky and earth coalesce for one fleeting moment rather than breaking apart as separate entities. The platinum process, which yields a full array of tonal values, helps to portray the clouds dancing across the sky, their flattened bottoms heavy with rain; the dramatic shadows across the badlands, speckled with microscopic juniper and sage; the exquisite highlights that pick up the layers of geological history in the strange, dis-

tant forms; and the road, at left, curving into the distance. Like Hartley's *Landscape, New Mexico* (see fig. 121), the small photograph vibrates with a powerful life force, conveying a "sense of oneness with nature," as Strand's friend critic Elizabeth McCausland described his achievement two years later.[97]

Strand also photographed close-up, in platinum prints such as *The Dark Mountain, New Mexico* (1931; fig. 140), concentrating on the boarded-up adobe structure, the dark mountain peak rising up from behind and spewing, so it seems, a burst of clouds with storm clouds nearby. These

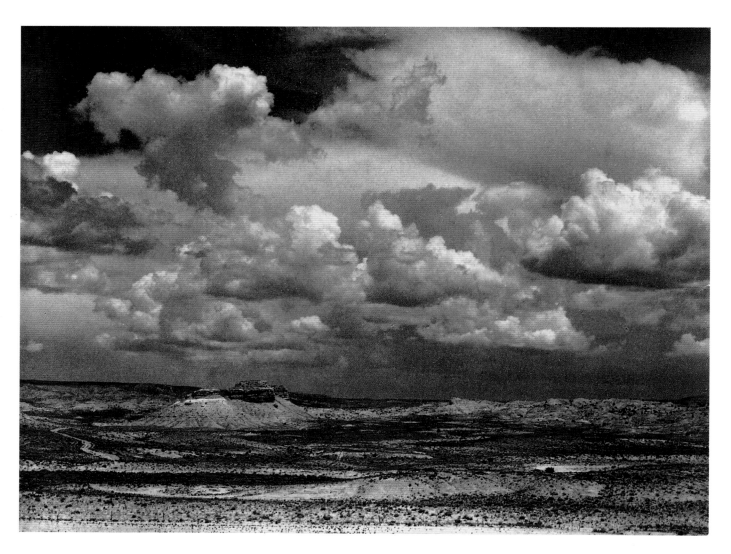

Fig. 139
PAUL STRAND
***Badlands near Santa Fe, New Mexico*, 1930**
Platinum photograph, 3 5/8 x 4 3/4 in.
Museum of Fine Arts, MNM, Department of Cultural Affairs,
Gift of Austin Lamont, 2003

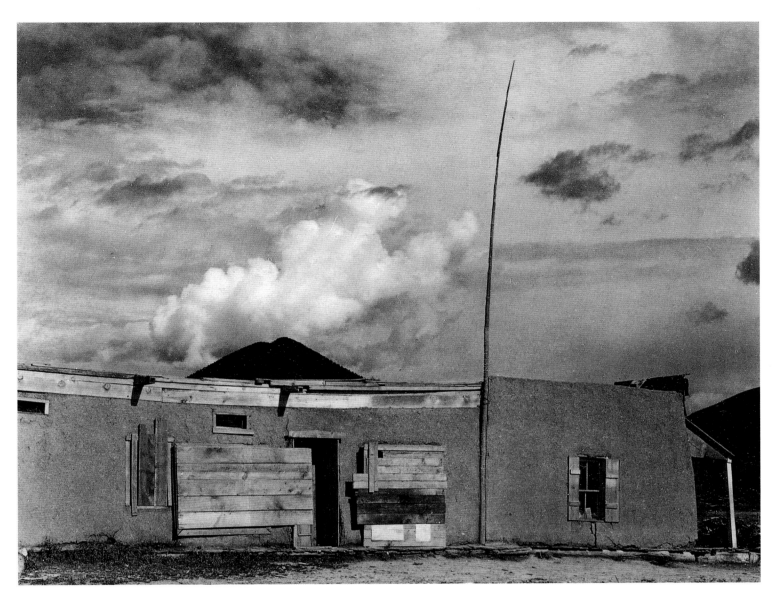

Fig. 140
PAUL STRAND
The Dark Mountain, New Mexico, 1931
Platinum photograph, 4 5/8 x 5 15/16 in.
University of New Mexico Art Museum, Albuquerque,
Gift of the Paul Strand Foundation, Inc., in honor of Beaumont Newhall, 80.290

suggest imminent rain and thus, again, the idea of time. A slender wooden pole holds the composition together, giving it structure and perhaps a bit of whimsy as it tapers and leans to the right. We know from the letters Strand wrote during his summers in New Mexico that notions of time and change concerned him. As he rhapsodized about the landscape and was drawn to the layers of history embedded in the adobe structures, mining-town saloons, and the earth itself, he yearned, as did so many at the time, for a purer, more authentic West that he believed was disappearing. To his friend John Marin he wrote in 1931: "Then I spent a day in Elizabethtown and Red River working with those old deserted houses that are fast being torn down to build tourist cabins—a false front with dignity sounds like a paradox—but they have it…—these last traces of a kind of life that once was lived and lived hard in America.[98]

So romantic and dedicated to notions of a purer West, and therefore a more pristine past, was Strand that two years after he had photographed *Church Buttress, Ranchos de Taos, New Mexico*, he insisted on the removal of a basketball court that had been placed near the church in the interim. He did not want the court to mar the unspoiled view of the swelling buttress that he had previously photographed facing east toward the foothills of the Sangre de Cristo Mountains. In 1929 Ansel Adams and Georgia O'Keeffe began making images of St. Francis Church in the tiny community of Ranchos de Taos just south of Taos itself. This edifice intrigued artists who sought to capture its massive forms and minimal lines, its organic curving shapes that villagers annually molded with mud by hand. The church as a place of community worship meant little to O'Keeffe, Adams, or Strand, but as a place whose adobe contours made a fine modern form, it earned a rightful place in their artistic canon. Just as the landscape aligned with Modernist aesthetics, so, too, did landmarks such as St. Francis, which these artists perceived as embodying a perfect union of nature and culture.

Dorothea Lange, who was also in Taos in the early 1930s, once described Strand as a "sober, serious man driving with a purpose down the road"—a perfect expression of the photographer's ambition and search for meaning in the landscape through disciplined effort and control.[99] By contrast, in his photographic vision, Edward Weston (1886–1958) comes down to us as more relaxed and clear-sighted, both sensitive to epic landscapes and open and witty in his responses to

the unusual and telling detail or even the quirkiness of more prosaic sites. Weston used detail to help make sense of the scene he captured as a whole. His technically brilliant photographs, with their glossy surfaces, appear to have been produced without effort, although he was an indefatigable technician and perfectionist. He avoided, perhaps unconsciously, the highly intellectual, sermonlike rhetoric of the Stieglitz circle, even though he associated with them and, early in his career, had sought Stieglitz's approval.

Weston, the first photographer to receive a Guggenheim Foundation award—an honor that eluded Strand—was an amateur photographer when he moved to California to work as a surveyor following the 1906 San Francisco earthquake. He returned briefly to his native Illinois, studying at Chicago's Illinois College of Photography, before making a permanent move to California in 1908. There he helped establish the Camera Pictorialists of Los Angeles and, in 1932, the group f/64, named for the aperture setting on a camera that allowed foreground and background to remain sharply focused. One year after he founded this loosely organized Bay Area photography group, strongly committed to "straight" (as opposed to Pictorialist photography), Weston traveled to New Mexico with photographers Sonya Noskowiak and Willard Van Dyke. They stayed, of course, with Mabel Dodge Luhan, who had met Weston in Carmel several years earlier and was photographed by him.

Grappling with the disorienting space of the Southwest was one of the challenges that Weston addressed in New Mexico, and to wry effect, in *Church at E-Town, New Mexico* (1933; fig. 141). A lawless nineteenth-century copper-mining boomtown famous for such outlaws as Black Jack Ketchum, Elizabethtown, or E-town, was deserted by the time Weston passed through it in 1933. About five miles north of Eagle Nest in the Moreno Valley, Elizabethtown included a worn-down church and various ruins and outbuildings.[100] This modest church, only about twenty-four-feet long, has a squat integrity that Weston captured by photographing its clear, precise outlines and exquisite textures—dark weathered wood contrasting with the light-colored door. The cross floats in the billowing clouds, but the church is firmly of the earth. Below, a small house or outbuilding is dwarfed so that the scale of the scene seems askew or puzzling. In fact, the building is not far away and is separated by a steep hill, but the seamless line of Weston's photograph minimizes the almost precipitous

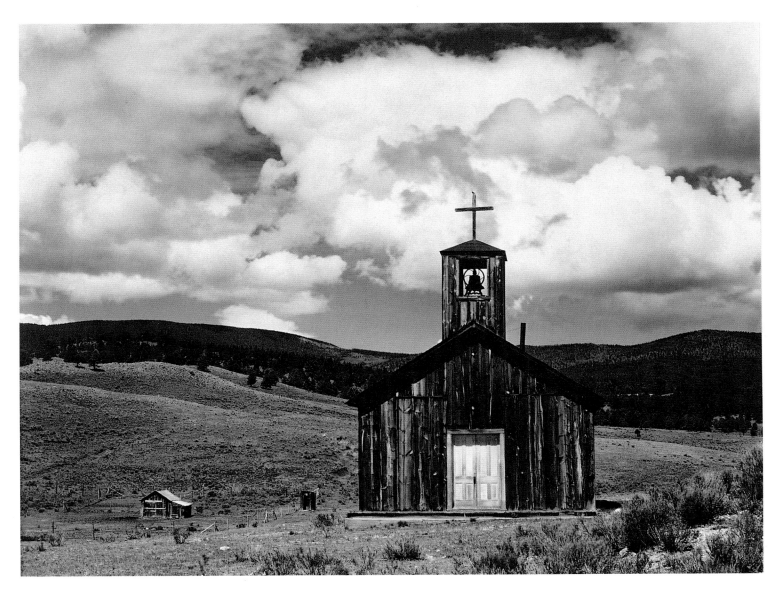

Fig. 141
EDWARD WESTON
Church at E-Town, New Mexico, 1933
Gelatin silver photograph, 7 9/16 x 9 5/8 in.
The Museum of Fine Arts, Houston, Museum purchase

hill between them to practically nothing. Weston plays with the near-far optical issues of New Mexico with wit and humor, and he also addressed these issues in *Santa Fe-Albuquerque Highway* (1937), which shows the highway cutting across the Santa Fe desert and going straight up a steep mesa, with no hint of what lies beyond, just an empty sky or a road to nowhere (fig. 142). Taken during his Guggenheim Foundation trip of 1937 and on a budget designed to maximize his travel throughout the West, the photograph, as noted by his assistant and eventually his wife, the writer Charis Wilson, was a revelation: "Most New Mexico roads look as though they had been laid out with ruler and pencil in a New York office; with apparent disregard for topographical features, they persistently follow the course that was once considered to be the shortest distance between two points. If the road meets a ridge of hills, instead of wandering off to find an easy grade, it shoots straight up this side, drops straight down the other. As we drove south to Albuquerque Edward made a negative of one of these long straight ribbons of highway. (When it was later published in the *New Mexico Magazine*, the editors showed their sense of delicacy by performing a Caesarean section on the print to remove the wrecked car in the foreground.)"[101] The road, in fact, was an improvement on the previous road, a dangerous and infamous switchback on La Bajada Mesa. Still, Weston addressed the oddity of the highway by snaking it into the distance to suggest the sweeping vastness of the landscape, one that he sensitively portrayed through bands of contrasting light in the middle ground, uniform hills in the distance so crisply captured that they look like a stitched and tufted pillow, and the abandoned and decaying car on the side of the road, a common scene that inserts a human presence in the landscape. For all his wit, Weston was serious about his relationship to the landscape, once commenting that "my first great realization came through my camera: at least it brought me into closer contact with nature, taught me to observe more carefully, awakened me to something more than casual noting and romantically enjoying. Even then I was trying to understand, getting closer, becoming identified with nature. She was then as now, the great stimulus."[102]

Weston welcomed the opportunity to come to terms with the western landscape—the subject of his Guggenheim award—making photographs of the West that resulted in *California and the West* (1940). He was voracious, calling himself an "omnivorous seeker."[103] As opposed to nineteenth-century landscape photographers seeking unclaimed subject matter, twentieth-century photographers such as Weston sought nothing less than to mine the already identified landscape for new meaning. For Weston, individual shots were important, but not as important as the breadth of the entire work, which suggests something of the experience of living (or, in his case, camping) on the land in an effort to fully know it. Weston had remarked earlier, "So to one not used to the West, to the scale of things out here,—nature must seem very dramatic. But can nature ever be labeled 'theatrical?' Of course not, or only by those not used to, or not big enough to feel a part of nature on a grand dimension. Only an inability to commune with, be on close terms with a given nature, can account for the label 'theatrical.' It is fear of a thing which makes it strange. Everything in the West is on a grander scale, more intense, vital, dramatic. Forms are here which never occur in the East.... All these forms,—trees, rocks, natural manifestations of western vitality are my neighbors, my friends." Indeed, after a ten-year period, he returned to the East, where he found nature "poetic, tenderly lyrical, almost too sweet."[104] The West, by contrast, had all the muscular strength and power that his camera could barely contain—even as he made the western landscape intimate not so much by emotion as by perception, by concentrating on a detail that was already there and that depended on a fine eye to domesticate it.

When Weston traveled throughout the Southwest, this time in 1941 on a commission to provide photographs for a new edition of Walt Whitman's *Leaves of Grass*, he understood the rhetoric of nationalism and warned the publisher when he accepted the commission: "Of course I will never please everyone with *my* America—wouldn't try to."[105] Still, there is something magisterial about photographs like *White Sands, New Mexico* (1941; fig. 143), a view of the fine undulating gypsum sand dunes of the Tularosa Basin. The dunes appear smooth and still, yet animated by the diagonal patterns of clouds, echoed by a billowy cloud, at upper right. Weston, like Arthur Wesley Dow, was a true believer in the idea of reciprocity, of giving and receiving in art, with an "honest, direct, and reverent approach when granted the flash of revealment."[106] This approach is exposed here in the highly reduced dune form, its contour elegantly lined in black, contrasted with the symphonic movement of the clouds. Weston already had an eye for the uncanny, but in New Mexico and

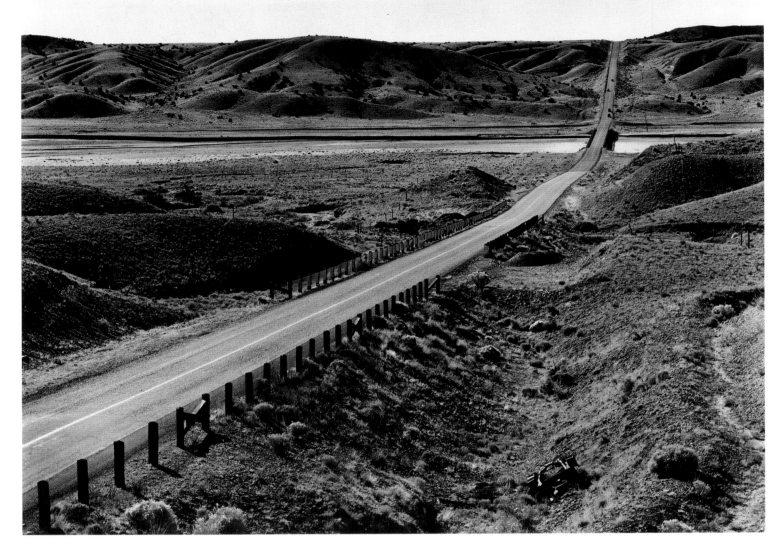

Fig. 142
EDWARD WESTON
Santa Fe-Albuquerque Highway, 1937
Gelatin silver photograph, 8 x 10 in. (printed by Brett Weston under the
artist's supervision, 1953)
Art Institute of Chicago, Gift of Max McGraw, 1959.738

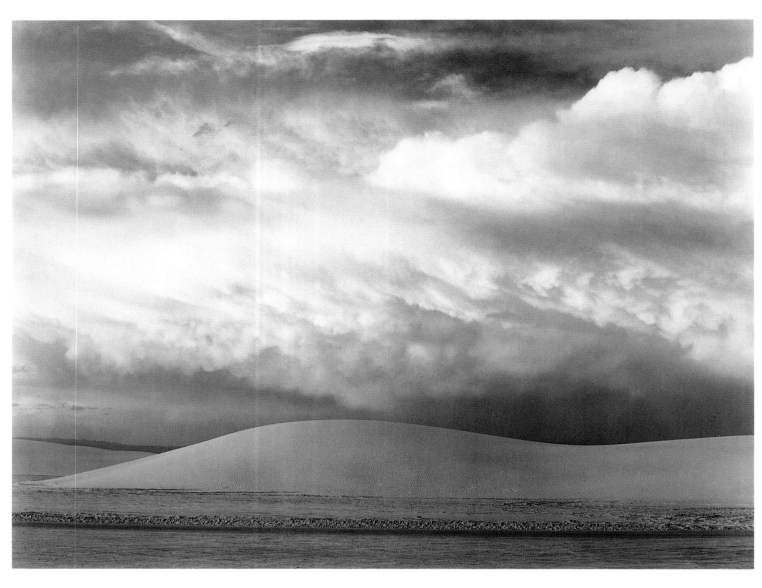

Fig. 143
EDWARD WESTON
White Sands, New Mexico, 1941
Gelatin silver photograph, 7 ½ x 9 ⁹/₁₆ in.
Andrew Smith and Claire Lozier, Santa Fe, New Mexico

in desert regions in general he made the strangeness of the West, especially the Southwest, feel as natural as home.

Georgia O'Keeffe, more than any other artist of this period, was the most highly disciplined in the development of her geographical perceptions of the Southwest. She had visited the region before, but during the summer of 1929, when she traveled to Taos as a guest of Mabel Dodge Luhan, it was as if she had come for the first time. As Luhan recalled, O'Keeffe simply uttered, "Well! Well! Well!…This is wonderful. No one told me it was like *this*!"[107] She instantly attached herself to the landscape and thereafter spent summers in New Mexico every year and moved to Ghost Ranch permanently in 1949, three years after the death of her husband, Stieglitz. She spent half the year in Abiquiu and the other half at Ghost Ranch. In New Mexico, O'Keeffe orchestrated her life and art, which amounted to her life in art. She did so in a manner that hewed to the central concerns of spirit (place, soil, rootedness) and to a constructed sense of an "American" place more so than any other artist of Stieglitz's circle. Stung by criticism that overemphasized the connection between her womanhood and art, and by people who saw her art exclusively in reductive terms of biological nature (particularly in her evocative still lifes of flowers), O'Keeffe played out her life and career in the solitude of New Mexico. She painted what she wished and how she wished with a freedom and an independence she had lacked in New York City or at the Stieglitz family's summer place at Lake George. O'Keeffe created a visual language of painting that allowed her free reign and was so inherently multilayered and conducive to various interpretations that she and her art were overwhelmingly well regarded by the public, for a multitude of reasons. She herself has become something of a cult figure: travel guides in New Mexico even call the area around her home "O'Keeffe country." Such adulation often occurs at the expense of O'Keeffe's art, which has become a victim of her success. It is worth recollecting, then, a few fundamental concepts that the artist held close throughout her life, while recognizing the strong hand the artist played in remaking herself into a desert saint.[108]

When O'Keeffe playfully referred to her mentor Arthur Wesley Dow as "Pa Dow," she signaled a lifelong allegiance to the concept she had learned from him of "filling space in a beautiful way," either in the pages of her sketchbook, on her canvases, or in her various homes; the latter were spartan

yet somehow potent with rich possibilities. Like her friend Hartley, O'Keeffe sought structural, as opposed to "rococo," means of expressing the optical sensations of the land, finding the Asian concept of *enkinho* (which is written as a combination of near and far) perfectly suited to convey the constant contrasts of landscapes: a place where faraway forms seem misleadingly close, and vice versa; where the landscape is defined as constantly moving yet still; where the landscape is weighted with antiquity yet ever present and alert to its arid clime and high altitude; and where, in the confluence of various cultures, as in enkinho, middle ground is eliminated so that there is very little gray area but rather stark areas of black and white. These contrasts also resonated at the time in heated debates about the virtues and values of realism and abstraction, although, as critic Paul Rosenfeld observed, "It may be the most literal representation or the most ethereal abstraction that is rendered; and the artist moves freely from one category to another; for her, the two categories are single —she paints them as one."[109]

In New Mexico, O'Keeffe could be simultaneously a "realistic" and an abstract painter. As she said of the modern geometries of New Mexico, with its startling light and clear forms, "half of your work is done for you"—almost a sly rejoinder to Stuart Davis's comment that the modern landscape is a source for imitation and therefore no longer useful to the artist.[110] O'Keeffe's acute observations of the physical world were painstakingly achieved, and to this day geologists delight in looking at her paintings because she so carefully conveyed geological striations: they resemble charts explaining the history of the earth. That O'Keeffe could unify her being and her art suggests the desire for a psychic wholeness that her generation struggled to achieve, as was the case with Hartley. The difference between the two artists is that O'Keeffe eventually seemed to find harmony, placidly and with a Zen-like appreciation for the reciprocity of self and earth. This relationship lasted until her death in 1986 at the age of ninety-eight. The arc of O'Keeffe's career is strikingly coherent; inspired by the landscape as well as by artistic traditions, she kept the near and the far constantly in play, titling one of her most famous paintings *From the Faraway Nearby* (Metropolitan Museum of Art), a witty allusion to her dual life in "near" New York and "far" New Mexico.

In the summer of 1929 O'Keeffe started work on one of her greatest series of paintings, the subject of which was

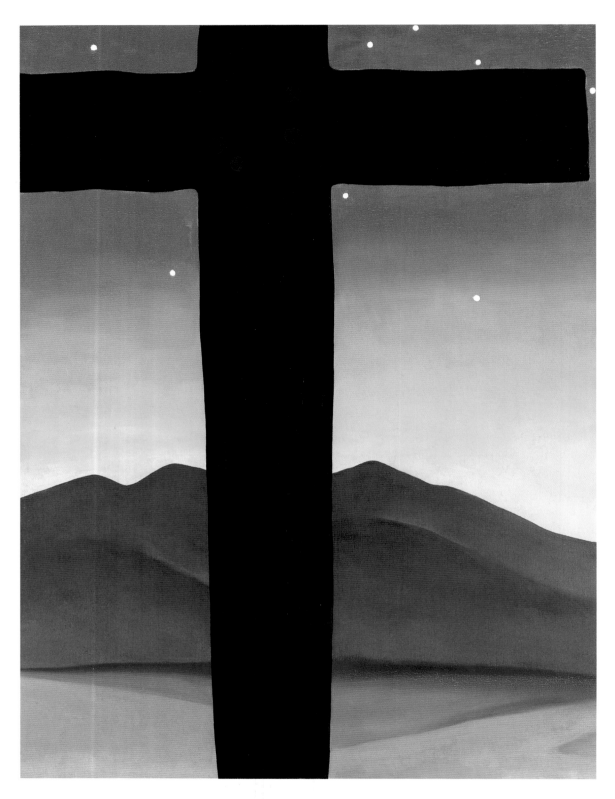

Fig. 144
GEORGIA O'KEEFFE
Black Cross with Stars and Blue, 1929
Oil on canvas, 40 x 30 in.
Mr. and Mrs. Peter Coneway

the crosses she found in the landscape around Taos, particularly in back of Luhan's house bordering Taos Pueblo. O'Keeffe gained admittance to Taos Pueblo lands because of Luhan's marriage to Taos Puebloan Tony Luhan, who often took Mabel's guests to sacred places (or near them) that were off limits to other Anglo visitors. O'Keeffe's sketches show her interest in the geometries of adobe churches and their crosses, especially crosses in doorways that she saw on her travels. *Black Cross with Stars and Blue* (1929; fig. 144) relates to several in a series of crosses, some in back of Mabel's house, some near Alcalde, and one, presumably, near Cameron, Arizona. O'Keeffe described them thus: "I saw the crosses so often—and often in unexpected places—like a thin dark veil of the Catholic Church spread over the New Mexico landscape. One evening when I was living in Taos we walked back of the morada [a small Penitente church] toward a cross in the hills. I was told that it was a Penitente cross but that meant little to me at the time. The cross was large enough to crucify a man, with two small crosses—one on either side. It was in the late light and the cross stood out—dark against the evening sky. If I turned a little to the left, away from the cross, I saw the Taos mountain—a beautiful shape. I painted the cross against the mountain although I never saw it that way. I painted it with a red sky and I painted it with a blue sky and stars."[111]

About an eighth of a mile walking southeast from the rear of Luhan's house, Los Gallos, is a morada with one tall cross similar to the one in *Black Cross* and certainly the one that Paul Strand photographed three years later (fig. 145). The cross, along with several others, also appears in the so-called Schneider Sketchbook, O'Keeffe's book of drawings from this period of her trip.[112] It should be noted, however, that there are several crosses on Taos land, still standing, to which she could have been referring in her description; indeed, the crosses are so ubiquitous that one was used as the symbol of the Santa Fe Railroad and repeated on Indian Detours brochures, which O'Keeffe undoubtedly would have seen repeatedly throughout her visit (fig. 146).

In his photograph, Strand also plays with near/far formalisms, flattening depth by abutting the textured adobe of the morada in the immediate sun-baked foreground with the background landscape. O'Keeffe, however, accentuates the cross so that it hovers over the mountain rather than under it. As she said, she did not see it that way, nor could she; in reality, Taos Mountain appears enormous from any vantage

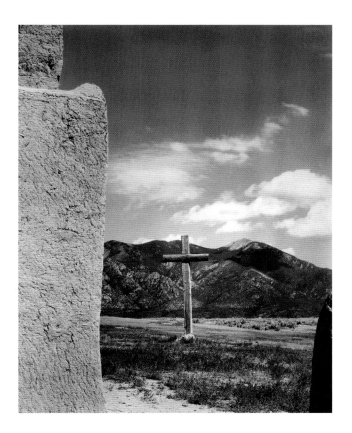

Fig. 145
PAUL STRAND
Landscape with Cross, New Mexico, 1932
Gelatin silver photograph
Aperture Foundation Inc., Paul Strand Archive

Fig. 146
Indian Detours: Roundabout Old Santa Fe, New Mexico
Photograph from Atchison, Topeka, and Santa Fe Railway Company brochure
(Chicago: Rand McNally, 1940 [reprint])
University of Arizona Library, Special Collections, F786 I5 Pam Part 1

point, both protective and overwhelming, appropriately sacred to the Pueblo Indians who have lived there for centuries. In *Black Cross*, O'Keeffe makes Taos Mountain somehow manageable and narrows the sweeping Taos Valley into a shadowy wedge of green.

When reviewing O'Keeffe's 1930 show at Stieglitz's An American Place, which displayed the work from her summer spent in New Mexico the previous year, one critic indirectly noted the similarity between O'Keeffe's skyscraper series and her towering crosses. Unlike Jonson, whose cliff dwelling and skyscraper melded antiquity with the future (see fig. 106), it is doubtful that O'Keeffe intended anything overtly political or literal in the two series. As she noted, "In New Mexico the crosses interest me because they represent what the Spanish felt about Catholicism—dark, somber—and I painted them that way."[113] Yet it is unlikely that O'Keeffe, despite her comment that the crosses cast a "thin dark veil of the Catholic Church" over the landscape, felt that Catholicism overwhelmed the sacred religions of the Pueblo Indians, represented by the visibly reduced Taos Mountain in the background. That said, it should be noted that some visitors to the area at the time were confused by Spanish Catholic churches within pueblos, wanting to see a kind of "pure" ethnicity in the tricultural area rather than the more historically accurate and realistic hybrid. This is unlikely because O'Keeffe rejected reductiveness, having experienced it in the criticism of her own work, even as her crystallized forms and precisionist lines appear to welcome it. She likely entertained more generalized notions of nature and culture, that land and life in New Mexico informed each other unlike any other place she had experienced. And, more fundamentally, that there is something sacred to be learned from the land, especially one so historically fraught as New Mexico's, where to see the land one must see it through the things that have happened there— like a Penitente cross, which suddenly appears in the middle of a valley and, at that moment, reframes the landscape.

It is also possible that in painting a cross on a big scale O'Keeffe restored the picturesqueness of New Mexico to its pretourist days, for it was common in the Stieglitz circle to contrast, as Beck Strand described it, the "hot dog stand of a place" of the souvenir West with the "pure and wonderful —great [mountains]."[114] This quality is undoubtedly what *New York Times* critic Edward Alden Jewell meant when he wrote of O'Keeffe's cross paintings, "How extraordinary is the gift

that can take up 'picturesqueness,' breathe upon it, and release a transformed image absolutely devoid of picturesqueness, thrilling with the vision that pierces through to sheer spiritual experience."[115] O'Keeffe summarized this ability in the catalogue of her retrospective exhibition at the Art Institute of Chicago in 1943: "I can get all that into a picture by suggestion. I mean the life that has been lived in a place."[116] It is characteristic of O'Keeffe that through abstracted design (filling space in a beautiful way), striking color, and strong forms she could suggest so much life through so little.

When O'Keeffe came to New Mexico in 1929, she left behind a faltering career. After her astonishing success in the New York art world in 1916 and her continued achievements for more than a decade, she began to lose favor with some critics who saw her most recent work as banal.[117] Stifled by her summers in Lake George, by marital troubles with Stieglitz, by her painful withdrawal from a mural commission for Radio City Music Hall, and by a period of inactivity, O'Keeffe decided to seek a change. In New Mexico she found the answer to where and how to remake herself and her career. She did not return to Taos after 1930, however, finding, as Hartley had, the people there small and petty. She described Taos as "so beautiful and so poisonous," its cloistered environment not spiritually liberating but confining.[118] This particular sense of place is suggested in the painting by one of Taos's stalwarts, Ernest L. Blumenschein, *Ourselves and Taos Neighbors* (1931–38), a lively portrait of the Taos community crammed into one tiny adobe room (fig. 147). Although there is no evidence to suggest that Blumenschein intended the painting as anything but a celebratory work, the room depicted vibrates with the unease and tension that close proximity can imply: doll-like figures of artists, patrons, and villagers are brought together as a community yet few of them engage with one another, instead posing somewhat stiffly. Rather than join this group, O'Keeffe summered at the H&M Ranch in Alcalde. When Charles Collier, the son of the Indian Affairs commissioner, showed her a high-end dude ranch about twelve miles north of Abiquiu, named Ghost Ranch, she took to the place.[119]

It is not difficult to understand why Ghost Ranch appealed to O'Keeffe. Part of the Chama Basin east of the Continental Divide, Ghost Ranch combines colorful canyons, striking landforms (such as the flat-topped Cerro Pedernal, or Flint Mountain, that O'Keeffe considered her own and painted

Fig. 147
ERNEST L. BLUMENSCHEIN
Ourselves and Taos Neighbors, 1931–38
Oil on canvas, 41 x 50 in.
Stark Museum of Art, Orange, Texas

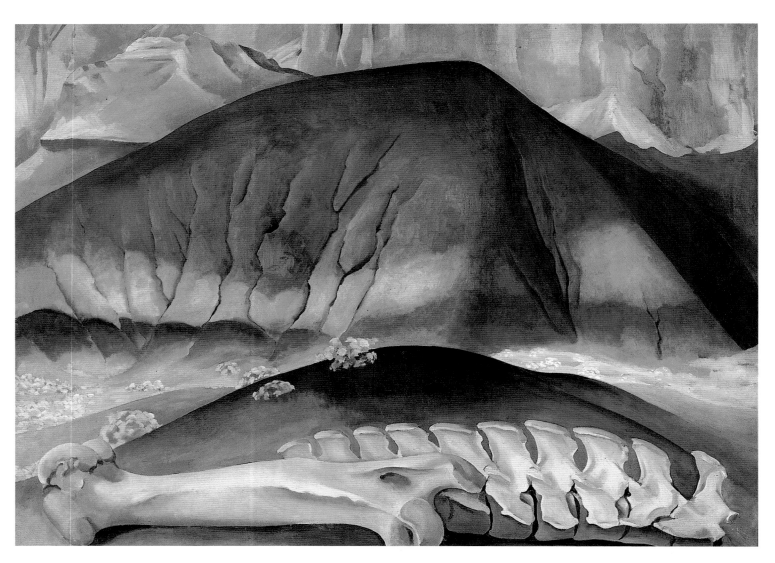

Fig. 148
GEORGIA O'KEEFFE
Red Hills and Bones, 1941
Oil on canvas, 30 x 40 in.
Philadelphia Museum of Art, The Alfred Stieglitz Collection, 1949

repeatedly), and sweeping valleys rimmed with rocks and cliffs and cut through by the meandering Rio Chama that leads south to where it joins the Rio Grande. In addition to its grandeur, the colorful history of Ghost Ranch likely appealed to O'Keeffe, always alert to Wild West stories. A sheep ranch empire during Spanish Colonial times, the property fell into the hands of the Archuleta brothers, who took control of the northeast area of the basin around the turn of the twentieth century, using its high, three-sided cliffs as a protective site in which to conduct their cattle-rustling business.

In the 1930s Ghost Ranch was transformed into a well-known dude ranch by its then-owner, Arthur Pack, the editor of *Nature* magazine. The ranch houses and cottages nestled under the protective arms of the towering cliffs, the fourth side spilling out to the enormous gentle valley beyond it. Near the house O'Keeffe acquired on the property, beneath Chimney Rock, Chinle badlands (what she called "the red hills") rolled in the distance, soft and crackling underfoot, speckled throughout with bands of red, white, and purple. These low hills are part of the Painted Desert

Member of the Petrified Forest Formation, or Chinle Group, about 210 million years old. Here O'Keeffe conceived a number of her greatest paintings, including *Red Hills and Bones* (1941; fig. 148).

She was particular about capturing specific hills; these appear underneath the pronged formation immediately next to Chimney Rock, its bottom portion just left of center. In the immediate foreground, practically shoved into the viewer's gaze, are two bones, the right femur and the vertebral column of a cow; these are enlarged in scale and, in their lines and shapes, mimic the red hills and their alluvial folds. A photograph of O'Keeffe's collection of bones on the patio at Ghost Ranch clearly refers to these two specimens, the femur in the foreground and the vertebrae halfway down the shelf (fig. 149). In her painting, O'Keeffe has made them of a piece, superimposing one atop the other. She also omits a horizon line, compressing the view into a flat surface filled with mysterious folds, shapes, colors, and lines, and sprinkled throughout with tiny buds, life and death in eerie juxtaposition, a strangeness permeating all.

Fig. 149
MYRON WOOD
Backbone (Georgia O'Keeffe's collection of bones displayed on a wooden shelf on the patio at Ghost Ranch), March 1981
Gelatin silver photograph
Pikes Peak Library District Special Collections

If one can say that O'Keeffe reclaimed the desert cross from tourist culture, or a culture that was increasingly trivializing it, and restored its spiritual and historical nature, then the same could be said of her depictions of bone. She took this familiar symbol of the Old West, with all of its resonances of history, death, and the passing of an era—the end of the frontier—and invested it with modern meaning, as art historian Wanda Corn attests.[120] For O'Keeffe, the bones were not dead, but very much alive. As she herself stated, "When I came to New Mexico in the summer of 1929, I was so crazy about the country that I thought, how can I take part of it with me to work on? There was nothing to see in the land in the way of a flower. There were just dry white bones. So I picked them up....They were my symbols of the desert but nothing more....To me, they are as beautiful as anything I know. To me they are strangely more living than the animals walking around—hair, eyes and all, with their tails switching. The bones seem to cut sharply to the center of something that is keenly alive on the desert even though it is empty and untouchable—and knows no kindness with all its beauty."[121]

Even though O'Keeffe had previously collected bones, those she found at Ghost Ranch assumed an added meaning. For all the "empty" desert the artist describes, Ghost Ranch had a colorful Wild West history and buzzed with activity: vacationers, cowboys who worked the property, and archaeologists and paleontologists who, from 1928 to 1934, excavated the ranch under the auspices of the University of California, Berkeley, and discovered dinosaur bones in the Chinle Formation. In 1947 the American Museum of Natural History found the bones of a small meat-eating dinosaur, called *Coelophysis*, at Ghost Ranch. The dinosaur is now a symbol of the state of New Mexico, and the discovery established the area as among the richest dinosaur beds in the world. We know that O'Keeffe took an active interest in the paleontological community, befriending excavators and scientists and learning and talking about fossils and bones.[122] Her interest in what was on top of the earth as well as underneath it played into ideas she held close that emphasized concepts of history and the continuity of time. To her, science and beauty not only coexisted but stood out sharply in the high desert, yielding their own secrets over time. She nurtured this relationship, noting to a critic, "A red hill doesn't touch everyone's heart as it touches mine...and I suppose there is no reason why it should. You have no association with those hills

—our waste land—I think our most beautiful country."[123] By painting the Chinle badlands with such concentrated passion, O'Keeffe reclaimed a barren wasteland deemed unfit for anything except buried dinosaur bones and cow skeletons. With her painter's brush, she imparted the kind of appreciation and reciprocity that would sustain her for almost another half-century. Indeed, she indicated this sense of giving and receiving directly when she noted that "the beauty of those bones justifies the animal for having lived."[124] By this, she did not intend anything unkind about the animal, but rather that desert remains were a gift for her, which she could transform into art: death transfigured.

Whereas the landscape of Ghost Ranch is diverse, with magisterial valleys, strange, towering landforms, and siltstone badlands, the Black Place, about one hundred fifty miles west of Abiquiu and about seven thousand feet high, looks like a lunar landscape, forbidding and somber in its dark black and gray gypsum rolling hills. Yet beginning in 1943, the Black Place, as O'Keeffe called it—to distinguish it from the White Place (not far from Abiquiu, characterized by its columnar forms of white volcanic ash) and the red hills of Ghost Ranch—became a favorite camping spot and the subject of one of her greatest series of paintings, including *Black Place III* (1944; fig. 150). Near Counselor, New Mexico, the Black Place is characterized by soft, uniform, rounded hills of gypsum, a highly soluble soft mineral formed when seawater or salt lakes dry up. The black-gray hills, shot through with white, sometimes a little yellow, and tinted with rust-colored hematite, are porous, and they absorb the sun so that their surfaces appear soft, tactile, and velvety, with a sandlike base. Wind and water erosion sculpt rivulets around them in sinuous patterns, their strange compositions and molded forms captured by O'Keeffe's friend photographer Eliot Porter (1901–1990). His black-and-white *Black Place, New Mexico, September 1945* (fig. 151) offers a more intimate landscape, to use the words ascribed to his photographic method. Close-up, the rivulets' patterns lead the eye away from the dark massive forms (which, in reality, are quite small) that push in on one another. Porter's microscopic view contrasts these misshapen forms, which are so reminiscent of Hartley's abstracted arroyos, with the flat sandlike surface, dotted with granules and highlighted, at far left, by two tufts of hardy plant life springing up from this impossible soil.[125] Porter's photographs demand close viewing; as seen here, the photographer's tight focus still reveals a

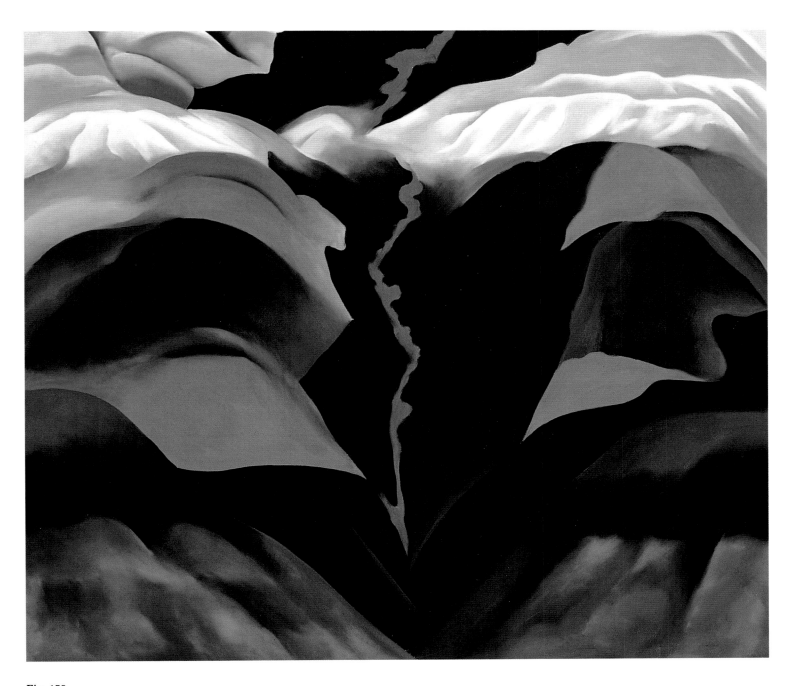

Fig. 150
GEORGIA O'KEEFFE
Black Place III, 1944
Oil on canvas, 36 x 40 in.
Georgia O'Keeffe Museum, Promised gift, The Burnett Foundation

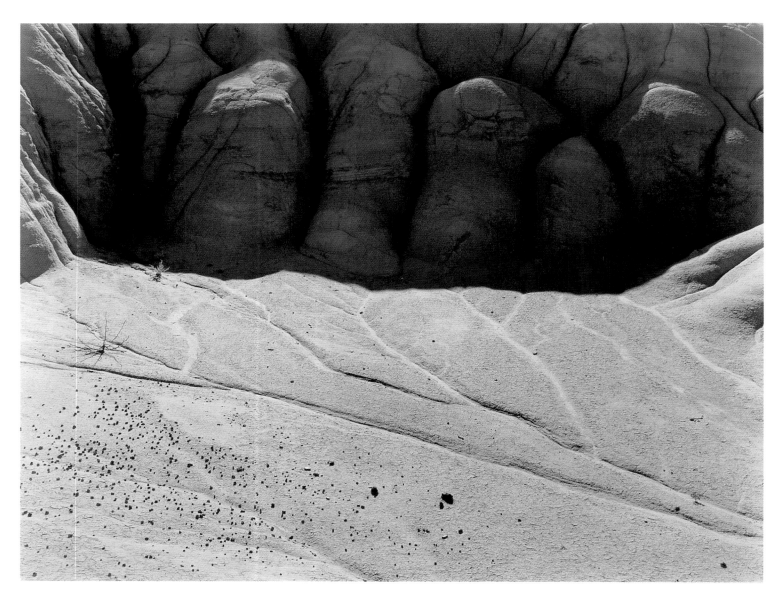

Fig. 151
ELIOT PORTER
Black Place, New Mexico, September 1945, 1945
Gelatin silver photograph, 8 x 10 in.
Amon Carter Museum, Fort Worth, Texas, Bequest of the artist, P1990.54.578

world—strange as it may appear—beyond its borders, a world filled with wonder and awe.

In O'Keeffe's compositions that derive from her experience of the Black Place, the artist adopts a viscous, as opposed to a more "true" matte, paint surface and uses a palette of rust, gray, black, and white. She alternates between precisionist clean lines and filmy passages. Eliminating the sky, she offers little to indicate that it is a landscape except for the brown lightning-like line that passes through the center, articulating landforms out of colored patterns of light and shadow and of striated earth. These shapes and patterns appear in a photograph that O'Keeffe's friend Maria Chabot took on a Black Place camping trip in 1944, in which the artist poses between the folds of the hills, her head pointing to these distinctive zigzag lines (fig. 152). This candid snap is a striking contrast to the carefully composed images of the artist that usually portray her severe beauty, seriousness, and studied artiness. O'Keeffe looks like just another jolly tourist, except that she is virtually alone, inhabiting a remote site that is forlorn and resistant to visitors. Typically in O'Keeffe's works she takes things as ubiquitous as a cross and a set of bones and remakes them into strange, unfamiliar objects, or she takes an unfamiliar and strange locale, the Black Place, and makes of it something lush, voluptuous, elemental, and vital, like rolling waves of the sea.

Unlike other artists who came to the Southwest and left forever, O'Keeffe stayed. As barren and empty as the land was—or as O'Keeffe made it out to be—she found in it an unending source of inspiration and a moral compass for her life. The land was literally a blank slate onto which she could paint her life. What began as a journey with the Stieglitz circle of artists became a solitary exploration for O'Keeffe, the only one of the group who systematically investigated American "soil" and shaped it to fit her way of life. When the Museum of Modern Art approached O'Keeffe about mounting a retrospective exhibition of her work in 1946 (three years after the Art Institute of Chicago's exhibition), she demurred with modesty, peppered with pride and sly self-fashioning: "As I sit out here in my dry lonely country I feel even less need for all those things that go with the city.... When I say that for myself I do not need what showing at the Museum shows mean—I should add that I think that what I have done is something rather unique in my time and that I am one of the few who gives our country any voice of its own."[126] O'Keeffe promoted herself indirectly as the real and authentic "American" artist, highly sought after in the early decades of the twentieth century—an American original springing from the soil of the desert Southwest. O'Keeffe orchestrated a life lived in and on the land, holding up the example of an integrated life that so many feared the modern world would permanently extinguish. She modeled the reverse, staking her artistic claim on concepts such as the near and the far, collapsing middle ground onto one plane with remarkable coherence and willed simplicity: a land, a life, an art.

Fig. 152
Georgia O'Keeffe on a 1944 camping trip
Yale Collection of American Literature, Beinecke Rare Book and Manuscript Library

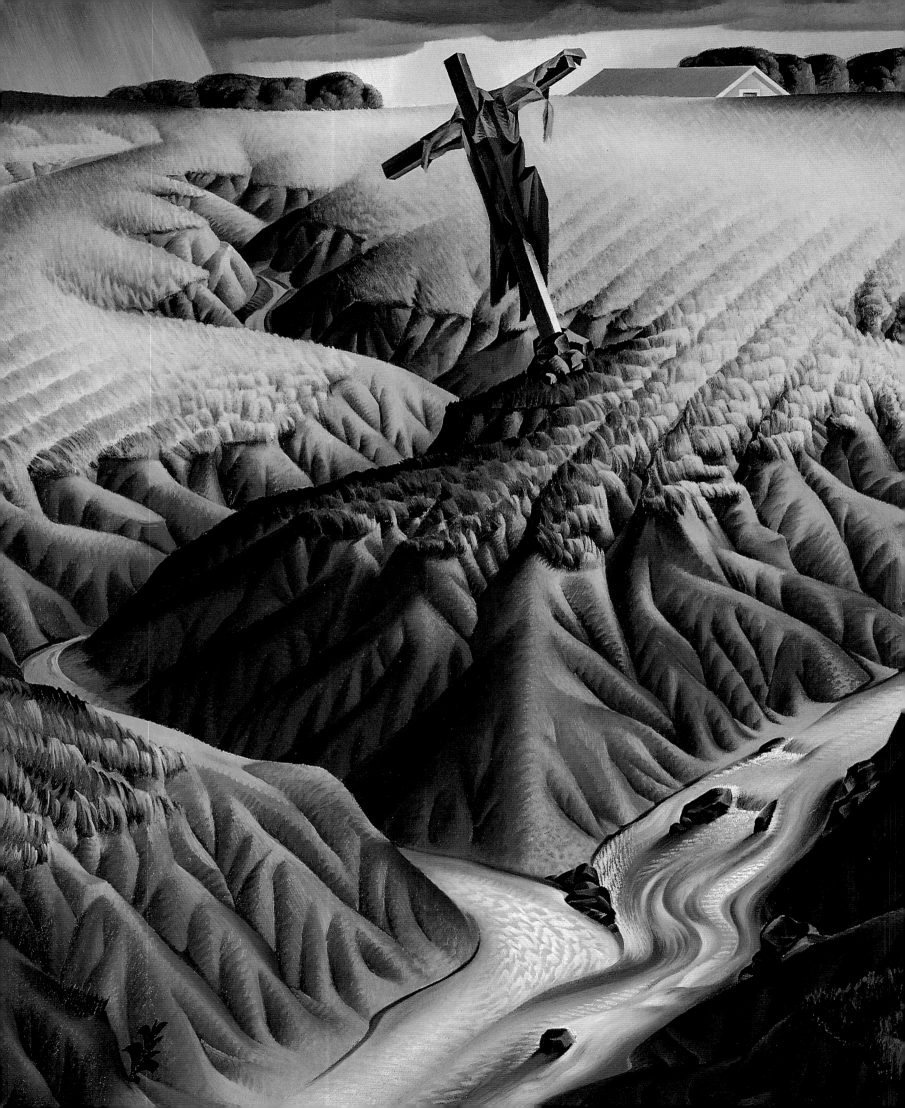

The Dust Bowl Era—Plains and Other Places

In January 1932, after a six-month period spent painting in Taos, Maynard Dixon and his wife, Dorothea Lange, left to return to San Francisco. As they made the long drive back, signs of the Great Depression were everywhere. They saw homeless men walking along the roads, heading for California to look for work, their worldly goods tied together in a bundle on their backs (fig. 153). Dixon called them "forgotten men," and, not long after, he and Lange embarked on their eponymous series of paintings and photographs, in part taking their cues from the "forgotten man" theme of Franklin Delano Roosevelt's New Deal programs proposed during that election year.[1] Dixon's previous works were predominantly western landscapes, and these searing new paintings marked a brief interlude in which he focused on themes of social unrest. He witnessed such strife in Boulder City, where the poor working conditions of the men constructing Hoover Dam distressed him. He also observed the longshoremen's strike along San Francisco's Embarcadero during the summer of 1934. These experiences strengthened his resolve to produce images of the country's political turmoil and social suffering.[2]

Adopting mural-like compositions, Dixon used dark colors and reduced abstracted forms to portray featureless, anonymous men, such as railroad hoboes and agricultural migrants, as well as men struggling for humanity in picket lines and in fights for free speech. Similar in their missionary zeal to his images of Pueblo and Navajo Indians, these paintings suggest his professed interest in anti-artiness as well as his decision to focus on themes of contemporary relevance such as the devastating realities of the Depression.[3] As early as 1927, Dixon had argued that he was not interested in making a "plea for one hundred percent Americanism in art. But let me ask what art is vital that does not grow out of the psychic and material life of the country that produces it? It is not only possible but necessary for us artists to look more frankly at the conditions and country surrounding us, to go directly to them as a source of inspiration and to work out our own interpretation of them."[4]

Dixon, in what must have been a cathartic experience that put him more directly in line with the developing photographic approach of his wife, produced about seven large

Fig. 153
DOROTHEA LANGE
On the Road, near Nipomo, **1935**
Print from original photo negative
The Dorothea Lange Collection, Oakland Museum of California, City of Oakland, Gift of Paul S. Taylor

paintings on social realist themes between 1934 and 1938, making an additional one in 1941. Only *No Place to Go* (1935; fig. 154), in the *Forgotten Man* series, introduces a landscape, the shore of the Pacific Ocean, to convey its message of spatial and social dislocation.

A series of undulating curves—the fertile, grassy knoll in the foreground and the muscular rock forms in the background—sets the scene for a downtrodden man, who leans against a rickety fence and carries a bundle on his back. His head is darkened by shadows, revealing only the sculptural

cut of his face, which bears a certain grimness. The painting's rhythmic curves suggest disorientation rather than pastoral harmony; the dilapidated fence plunges down a hill toward some menacing rocks, and the route to the sea is blocked—the man's only means of escape. The ocean, which in earlier landscapes of California by Arthur B. Davies and Gottardo Piazzoni represents Arcadian freedom and spiritual release, here is carefully constructed to be a dead end, at which all options have expired. This realization is particularly devastating because California, in the national psyche, had always

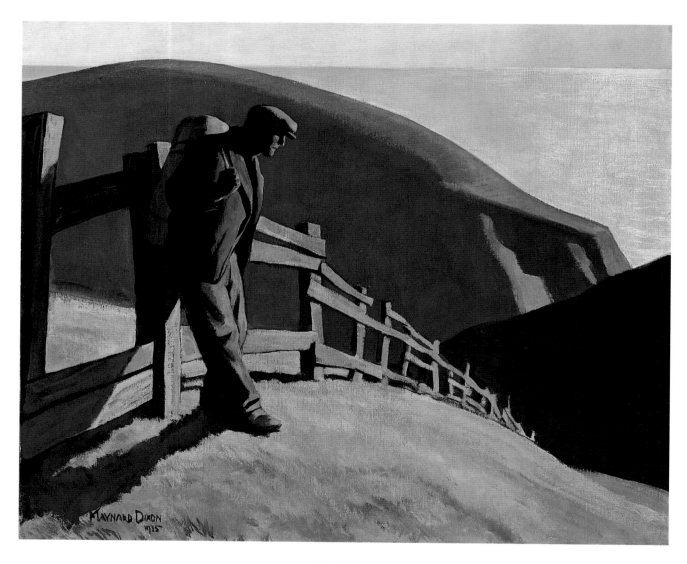

Fig. 154
MAYNARD DIXON
No Place to Go, 1935
Oil on canvas, 25 ⅛ x 30 in.
Brigham Young University Museum of Art

represented the land of milk and honey. As expressed in Dixon's painting and in the novels of his contemporary and friend John Steinbeck, the 1930s exposed the frailty of the American Dream, which no longer could be symbolized by the Golden State. Dixon's image is one of both individual and collective dislocation, where the promise of westward expansion ends with simply "no place to go," or, as Dixon noted next to the work's title in his records, "*Who Cares?*"[5] Dixon, Lange, and a host of other artists *did* care, endeavoring through their work to capture the potential of the common man and the sense of an Eden wasted that would come to characterize so much of 1930s art, politics, and literature in America.

Just one year after Dixon painted *No Place to Go*, Steinbeck arrived on the literary scene, and in the next few years the phrase "no place to go"—with its connotations of homelessness and vagrancy—found its way into Steinbeck's novels, most notably *In Dubious Battle* of 1936.[6] Steinbeck's story is an account of a violent strike among migrant workers, in which no one is safe from a Union machine designed to rouse the rabble with attention-grabbing newspaper headlines, rhetoric, and even martyrdom, or from the anonymous but sinister system of corporate greed. The phrase "No Place to Go," for both Dixon and Steinbeck, symbolized an uprooted citizenry and, ultimately, the irony of an immense country whose people have no place. In contrast to his paintings in the *Forgotten Man* series, Dixon's painting *Earth Knower*, produced after his return to San Francisco, promoted Amerindian notions of kinship with place. The figure of the Pueblo man must have represented the disconnect between what the artist experienced, however romantically, in Taos and along the road to San Francisco, the beginnings of what Lange would call "An American Exodus." Created at the same time, these paintings on seemingly diverse themes—one of romantic heroism in the Southwest and the other of futility at land's end—are two sides of the same coin: an artist's accounting of the unraveling ties between people and place in the modern world.

The journey back to San Francisco initiated a new direction in Lange's career, as she left portrait photography to become a documentary photographer, focusing on Depression-era rural life. *Migrant Mother, Nipomo, California* (1936; fig. 155), a seemingly candid shot of a mother and her children in a migrant camp, remains to this day a ubiquitous symbol of the Great Depression. Born in Montclair, New Jersey,

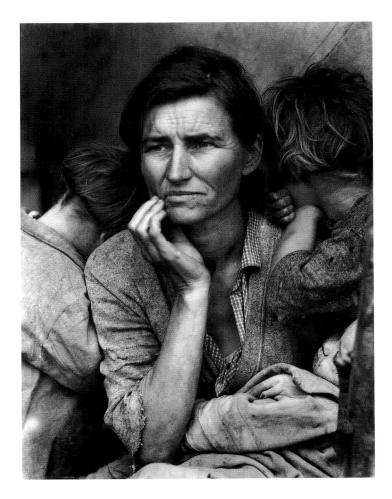

Fig. 155
DOROTHEA LANGE
Migrant Mother, Nipomo, California, 1936
Print from original photo negative
The Dorothea Lange Collection, Oakland Museum of California

to a German immigrant family, Lange received brief training from Clarence White at Columbia University before moving to San Francisco to set up a portrait studio business. Her visual acuity and perception are revealed in her oft-quoted comment: "The camera is an instrument that teaches people how to see without a camera." Lange never lost her sense of moral responsibility when using the camera, which she put to use to document American unrest in the 1930s (fig. 156). She would go on to win a Guggenheim fellowship in 1940, the first awarded to a woman.[7]

Her photographs of striking workers in 1934 brought her to the attention of labor economist Paul Schuster Taylor, a University of California, Berkeley, professor who used photographs as a tool of social research. After her divorce from Dixon, Lange married Taylor, working with him to record, in large part, the problems of agricultural migration in the California State Emergency Relief Administration (SERA). Later that year, in 1935, she transferred to the Resettlement Administration (RA), which in 1937 became the Farm Security Administration (FSA). Until 1942, she worked for the RA

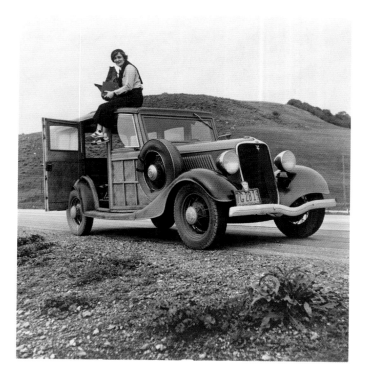

Fig. 156
Dorothea Lange, Resettlement Administration photographer, in California, 1936
Library of Congress, Prints and Photographs Division, FSA / OWI Collection
[LC-USF34-002392-E]

and the FSA under Roy Stryker, the legendary government official who helped conceive and manage the Historical Section (Information Division) of the RA/FSA. It was the Historical Section that launched the documentary photography project, which produced 164,000 developed negatives by a number of photographers, including Lange, Walker Evans, Ben Shahn, Arthur Rothstein, Marion Post Wolcott, Russell Lee, John Vachon, and Gordon Parks. Attentive to the political ends for which these photographs could be used, Stryker shared them with Congress and opened the "file," as it was known, to the press. Journalists used these photographs in newspaper and magazine reports published throughout the country and the world, thereby launching the careers of many of the photojournalists. The Historical Section was unusual. As Rothstein noted, it was run less like a bureaucratic agency and more like a college seminar. Stryker constantly assigned books for the photographers to read, which often led to discussions that lasted until the early hours of the morning.[8] These "seminars" cultivated a sense of mission in the artists, who believed in the importance of their work to effect change.

Although the project covered most, but not all, of the regions of the United States, the RA/FSA devoted its attention to the hard-hit areas of the heartland, particularly the northern and southern plains. The photographers concentrated on agricultural issues at a time when the family farm—one of the country's most sacred symbols—began to disappear in the face of numerous modern problems and advances in technology: mechanization of the farm through tractors and other machinery, the devastating droughts throughout the 1930s, and the dust and sand storms that were a result of widespread overcultivation of the land.[9]

Some of these issues were not exclusive to the West, but this region, particularly Oklahoma, Nebraska, Kansas, South Dakota, the Texas Panhandle, and the prairies of Colorado and New Mexico, was the most affected. Many families had no choice but to uproot themselves and head west to California for seasonal work as fruit and vegetable pickers in order to survive. Lange and Taylor, among others, went to great pains to explain that these were "good" folk who had fallen on hard times and thus were "worthy" of being absorbed by California's economic system.

In Lange's telling of the story, she was at a gas station in California when she noticed a dejected family in an old jalopy with an Oklahoma license plate.[10] She approached them

and learned that they had been "blown out" of their farm. This account was the first she had heard of the dust storms (fig. 157). At that moment she apparently felt acutely aware of her role in history, noting, "That was the beginning of the first day of the landslide that cut this continent." Lange understood that migratory labor in California was an "old story," and the Depression, which brought enormous numbers of displaced people to its valleys, widened the rift. "This shaking off of people from their own roots started with these big storms," she said, "and it was like a movement of the earth." Lange called this phenomenon "human erosion." When she and Taylor published *An American Exodus* (1939), the subtitle was *A Record of Human Erosion*; the full title connects a biblical event, the Exodus, with a landscape metaphor of loss. In the book's conclusion, Lange and Taylor noted that "large-scale, specialized farming dependent upon landless, propertyless, shifting families, are recasting our rural society. They are dissolving its bonds and compelling Americans…'to till the land of a man we don't know.' We cannot escape these forces. We must face them." Lange photographed the migrants

who represented this loss, and her images of displaced mothers and their children tugged at the heartstrings of viewers.

Like nineteenth-century survey photographs, which were also funded by the government, those of the RA/FSA were used for various purposes. One aim was to broadcast the hardships in the heartland as a means of bringing support to New Deal projects that would help, as Franklin D. Roosevelt phrased it, the "one-third of a nation ill-housed, ill-clad, and ill-nourished."[11] Although the politics behind the images were anything but neutral, the photographers aspired to present a "neutral" viewpoint by disguising the hand and the eye of the artist. As a result, documentary photographs of the 1930s often adopted straightforward, often close-in frontal shots. This insistence on the thorough objectivity of the photographer explains the furor that erupted when it was discovered that Arthur Rothstein, in his pictures of the Dakota badlands (see fig. 181), had repositioned a cow skull to maximize its dramatic, shadowy effects.[12] Although, in *Migrant Mother, Nipomo, California*, Lange posed her subjects to maximize the photograph's emotional impact, this does not make it less of

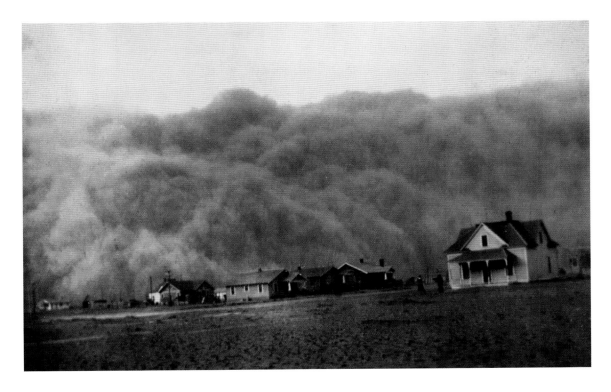

Fig. 157
Dust storm approaching Stratford, Texas, April 18, 1935
National Oceanic and Atmospheric Administration, George E. Marsh Album

a great work of art but more of one, for it reminds us of the *work* of art and the process by which Lange constructed a way to "dare to look at ourselves."[13]

By her account, Lange took five photographs, including *Migrant Mother, Nipomo, California*, in the space of about ten minutes at a migrant camp for destitute pea pickers. If true, it is remarkable how quickly she was able to engage her subjects and earn their trust. Perhaps Lange's instant rapport with the migrants can be attributed to the fact that she, too, bore a visible sign of hardship: a limp caused by lameness in her right leg, the result of polio. In recollecting how she shot this particular photograph, Lange recalled that the migrant mother "seemed to know that my pictures might help her, and so she helped me. There was a sort of equality about it."[14]

These photographs reveal several of Lange's approaches: one shows the mother nursing her baby, and another shows a view from afar of a tattered tent, an open trunk of clothes, and an older child in a rocking chair (fig. 158). In these shots, the ragged clothes and other details of poverty are clear, but the close-up of the thirty-two-year-old mother with three of her children reveals much more (fig. 155). The children's heads are turned away from the camera, bringing the viewer's attention to the pained face of their mother. The baby, with dirt on its cheeks, sleeps in the arms of the mother, whose shirt is still slightly mussed from a recent nursing. The portrait of the mother expressed what Lange wanted her viewers to see: the mixture of fear and fortitude among migrants and the worthiness of the cause to alleviate their suffering. The mother is a Madonna cradling her children, nursing her baby when there is little to give. Malnourished, she remains somehow life-giving, an earth mother, symbolic of the devastated earth that, too, will be reclaimed.

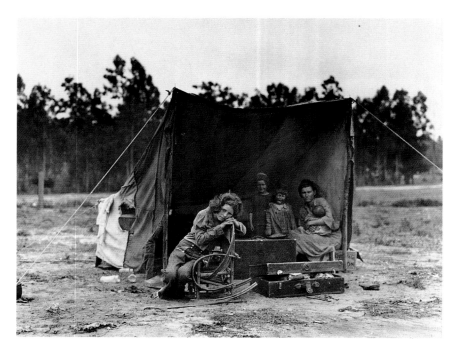

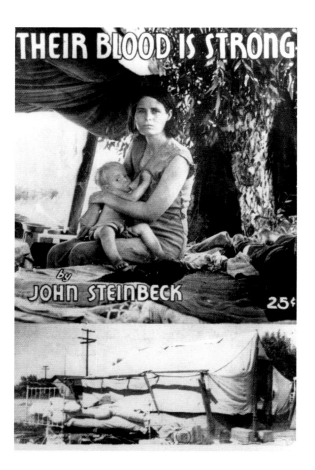

Fig. 158
DOROTHEA LANGE
Migrant Mother, Nipomo, California, **1936**
Print from original photo negative
The Dorothea Lange Collection, Oakland Museum of California

[RIGHT]
Fig. 159
Cover photograph of John Steinbeck's book *Their Blood Is Strong*
(San Francisco: Simon J. Lubin Society of California, 1938)
Martha Heasley Cox Center for Steinbeck Studies, San Jose State University

The cover for Steinbeck's *Their Blood Is Strong* shows one of Lange's pictures of nursing mothers, this one looking almost defiantly at the camera (fig. 159). By showing migrants in tent camps, separated from their roots, and by emphasizing the nursing mother, Lange could illustrate the notion that the umbilical cord had been cut between the land and humans, who had been orphaned and set loose to struggle on their own. Her images drew attention to the need to restore the connection to the land in order to remedy this "human erosion." However, Lange was not nostalgic for a romantic, "better" past, as seen in the idealized role of women in domesticating the West in the mid-nineteenth century, as exemplified in W.H.D. Koerner's *Madonna of the Prairie* (1921; fig. 160). Instead, Lange wished to make the viewer aware of the effects of the modern age on people, using the new language of documentary photography to make images that are never intrusive or judgmental yet utterly revealing, projecting humanity in all its courage, frailty, fear, anger, and confusion. As she wrote years later, "Bad as it is, the world is potentially full of good photographs. But to be good, photographs have to be full of the world."[15]

In making her photographs "full of the world," Lange appropriated art-historical traditions. *Six Lettuce Pickers* (also known as *Filipinos Cutting Lettuce, Salinas Valley, California*) (c. 1935; fig. 161) is clearly influenced by the works of nineteenth-century French painters, such as Jean-François Millet, Gustave Courbet, and Gustave Caillebotte, who first showed the labor force as a worthy subject. Lange took several photographs of Filipinos cutting lettuce, but this one focuses on the relationship between the workers and the land. The zigzag patterning of the earth darts back and forth, leading the eye to the hands of the workers who move rhythmically down the row, their rounded backs echoing the shape of the lettuce they are picking.

By the 1930s, 80 percent of Salinas Valley lettuce workers were Filipino, joining the Chinese, Japanese, Hindustanis, Mexicans, and African-Americans who came before them. Many of the migrant workers, particularly the Filipinos, endured poor wages, racial discrimination, squalid living conditions, and violence.[16] Filipino workers had developed a reputation among ranchers as productive and efficient field hands, which enraged unemployed whites. This fueled efforts to unionize, resulting in the formation of the Filipino Labor Union.[17] As Steinbeck observed, the Filipino group approach to migrant work, with five to eight people sharing expenses and traveling together to look for work, fostered a sense of community that was threatened in contemporary culture.[18] Given this background, *Six Lettuce Pickers* could be seen as representing the hardship of stoop labor and the workers' connection to the land, a nostalgic connection that Lange and Taylor promoted as one way to draw attention to the nation's problems.

Lange's theme of the changing relationship of humans and the land could be conveyed most powerfully when people were not pictured, precisely because their presence—or absence—is always keenly felt. *Tractored Out, Childress County, Texas* (1938; fig. 162) shows Lange's sensitivity to geometry, form, composition, and the divisions of space that the modern landscape imposed.[19] Deeply ridged tractor furrows curve toward an abandoned home, its

Fig. 160
W.H.D. KOERNER
Madonna of the Prairie, 1921
Oil on canvas, 37 x 28 3/4 in.
Buffalo Bill Historical Center, Cody, Wyoming, 25.77

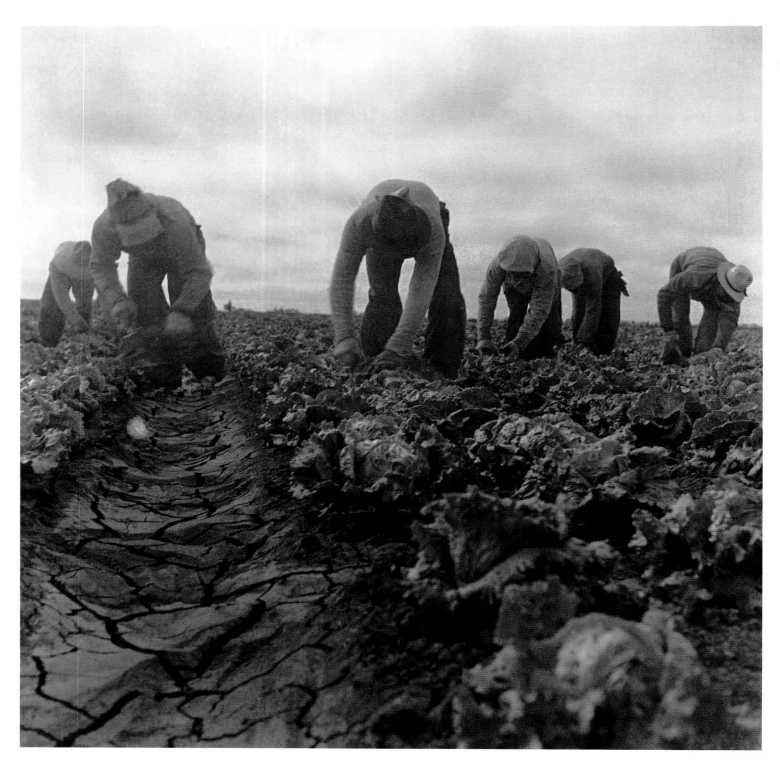

Fig. 161
DOROTHEA LANGE
Six Lettuce Pickers, c. 1935
Gelatin silver photograph, 14 ⅝ x 14 ¹¹/₁₆ in.
Courtesy of Morehouse Gallery, Brookline, Massachusetts

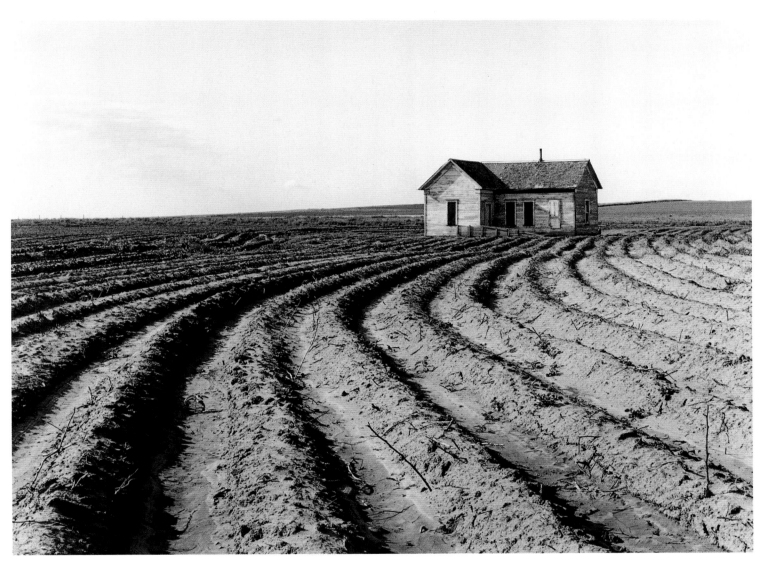

Fig. 162
DOROTHEA LANGE
Tractored Out, Childress County, Texas, 1938
Gelatin silver photograph, 6 x 9 in.
The Dorothea Lange Collection, Oakland Museum of California, City of Oakland,
Gift of Paul S. Taylor

fence partly torn down. It appears as if the tractor had mowed down the inhabitants. In Lange's mind, it just about did. In *An American Exodus*, she juxtaposed this photograph with the following caption: "Tractors Replace Not Only Mules, But People. They Cultivate to the Very Door of the House of Those Whom They Replace."[20] Lange and Taylor refer repeatedly to the human costs of technical innovation and mechanization, displacing sharecroppers and tenant farmers: "The process of displacement from the land started by depression and drought, now is receiving impetus from the machine....[By using tractors] they reduce the labor required and at the same time enlarge the size of their farms by cutting one tenant family from the land where there were two before....The course which tenant displacement is running full tilt on the plains manifests itself clearly on the landscape, now dotted with abandoned tenants' houses, windows boarded, and fields cultivated close." To put it plainly, as the *Dallas Farm News* did in 1939, "Each tractor means from one to three farmers on WPA or other government job at starvation wages."[21]

Lange and Taylor may sound somewhat like Luddites in casting the tractor as an evildoer, but they felt compelled to place the human element at the forefront of the discussion and to draw attention to the cultural effects of social dislocation. Taylor knew that mechanization was inevitable, and Lange, who depended on a machine in her work, could not be opposed to technical innovation; however, the camera was always to be used as a force for good and as a means to effect change.[22]

Change did occur, slowly, as the government stepped in to combat the effects of the Dust Bowl. Soil conservation measures, along with agricultural practices such as crop rotation, strip farming, and terracing, were promoted by Hugh Hammond Bennett, the first chief of the Soil Conservation Service. In Lange's *Tractored Out* the curved, deeply ridged furrows likely show the soil conservation ethos at work. Dead cotton stalks from the previous year's crop have been turned over. A close look at the soil shows that it is sandy, with silt washing down the furrow. Although still vulnerable to the wind, the field is bedded up on the contour, as recommended. Texas did not enact soil conservation legislation until 1939, and a soil recovery ethos designed to reduce topsoil erosion was only in its early stages at the time this photograph was taken. Nevertheless, topsoil erosion was reduced by 65 percent

by 1938, and much of the area that was hardest hit during the dust and sand storms had begun to be restored to grass cover. By then, many had already moved away. Displacement, symbolized by the forlorn yet sturdy house and the aggressive, deep furrows of mechanized plowing, is Lange's larger theme in this photograph.[23]

Stryker wanted to promote the achievement of New Deal reforms through the work of the RA/FSA, especially in the late 1930s, when Roosevelt's administration was at a low ebb and the specter of war threatened to distract Americans from agricultural issues.[24] Unlike Lange, Marion Post Wolcott (1910–1990) and others who later joined the FSA were given shooting scripts and charged specifically with documenting successful agricultural changes. Wolcott, who was lively and intrepid, was born in New Jersey and studied in Vienna, where she was given her first camera. When she returned to live in New York, she studied the work of Paul Strand and met photographer Ralph Steiner at a lecture. Steiner introduced her to Stryker, who, at the time, employed only Arthur Rothstein and Russell Lee. He soon added Wolcott to the list. Not as well known as many of the other RA/FSA photographers, Wolcott was twenty-eight years old when she began working for the project and, during that time, did not produce any iconic photographs, like Lange's *Migrant Mother*, possibly because of the artistic restraints placed on her. She once complained wryly to Stryker that she was photographing "FSA cheesecake," a reference to the boosterish quality of some RA/FSA photographs.[25] Traveling to West Virginia, she demonstrated a special sensitivity in photographing African-Americans. Stryker also sent her to Montana, where she produced some of the most lyrical photographs of land in the project file.

Contour Ploughing and Strip Cropping Wheat Fields Just North of Great Falls, Montana (1941; fig. 163) shows how Wolcott delivers a great deal of information in her photographs, all the while attentive to matters of form. The full caption she gave to the photograph gives an indication of the kinds of information she was expected to impart: *Great Falls, Mont. (vicinity) August 1941 Strip cropping in wheat fields. Strips of vegetation or tall-growing crops, crosswise to the direction of prevailing winds, form barriers against surface winds and protect the strips of fallow soil.*[26] One of the methods advocated by the Soil Conservation Service was strip cropping—planting two complementary crops in alternating strips, one to fertilize and the other to protect the soil from

wind erosion. Wolcott's photograph is virtually a blueprint for the system. Even though following the shooting script, she captures with great delicacy sunlight dappling the severe patterned lines of the crop beds. Horizontal strips, emphasized laterally by the foreground fence, suddenly shift to vertical rows, also concentrated by telephone poles at right that stretch into the distant shadowed mountains. The landscape gently rises and falls, as if breathing, and all is serene, orderly, expansive, and majestic. Wolcott revealed her approach in a letter to Stryker, writing that she "tried to get the feeling of space, and distance, and solitude, etc. in some pix—using various devices—the road, telephone poles and wires, long trains…," much as artists like Farny had done decades before.[27]

In representing the geometry of the plains, *Contour Ploughing and Strip Cropping Wheat Fields* is reminiscent of a small gem of a photograph by Marjorie Content (1895–1984)

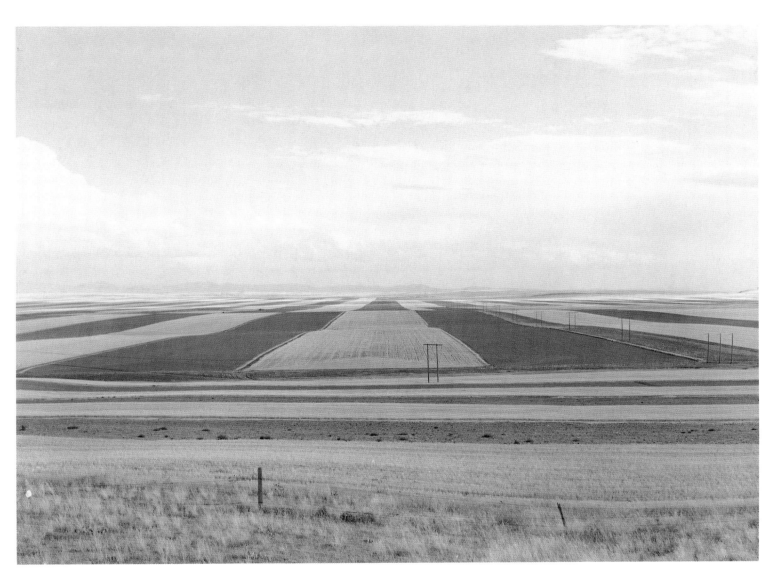

Fig. 163
MARION POST WOLCOTT
Contour Ploughing and Strip Cropping Wheat Fields Just North of Great Falls, Montana, **1941**
Gelatin silver photograph, image 6¹/₈ x 9 in.
Library of Congress, Prints & Photographs Division, FSA/OWI Collection
[LC-USF34-058165-D]

titled *Kansas* (1934; fig. 164). Content was not an RA/FSA photographer, nor was she considered a professional photographer in her lifetime, probably because she was surrounded by such heavyweights as Stieglitz. Born to a wealthy New York family, Content became friends with Stieglitz, O'Keeffe, and other members of the Stieglitz circle. She married four times, and her husbands were all avant-garde artists and writers, including her last husband, Jean Toomer, a famous Harlem Renaissance writer. Content moved about with her camera, quietly taking unaffected photographs with the power to startle. After nursing a depressed O'Keeffe back to health in Bermuda, Content traveled with her by car to New Mexico during the summer of 1934, on their way to the H&M Ranch in Alcalde. As Content wrote to Toomer, whom she would

marry later that summer, "We were going along when we both suddenly espied a field of waving wheat and on its far side black railroad cars and a white silo—We both exclaimed at the wonder of it—when G. said: 'That's a photograph'—I said 'It surely is'—Said she—'Stop and do it!'—With that encouragement I backed up—unloaded all equipment and started work.…I took three different shots of it—and promised if any turned out well—that it should be called 'Portrait of Georgia O'Keeffe'—which amused us both mightily. Fully refreshed with this exciting experience, we again sped over Kansas."[28]

Ever since painter Charles Demuth's 1920s "poster" portraits of his friends (allegorized portraits he created through visual puns, puzzles, and various emblems and props), "por-

Fig. 164
MARJORIE CONTENT
Kansas, **1934**
Gelatin silver photograph, 7 3/4 x 9 5/8 in.
The Museum of Fine Arts, Houston, Museum purchase with funds provided by
Clare and Alfred Glassell and an anonymous donor

traits" of people in the Stieglitz circle were not expected to actually picture the person. Although Content surely intended this particular portrait with humor, the photograph pays tribute to her friend, their shared joy of seeing, and their appreciation for open spaces and the unexpected revelations of beauty. Content takes this stretch of waving grass in Kansas and flattens it with a screen of tightly strung barbed wire that cuts across the surface, anchoring the landscape into place. Above it, a long line of boxcars stretches along the horizon. The photograph's crisp detail captures the soft textures of the grass and the sharp barbs of the wire in between. Like Morse code symbols, the nearly perfect pattern of boxcars suggests the rhythm of a train moving across the plains. The photograph gets its spark from the contrast between these precisely

patterned elements and the boxcars, which move ever so slightly up on the right, so that the composition is slightly off-kilter. Taking familiar symbols of the West—barbed wire, prairies, and trains—Content transforms them from conventional signs of westward settlement into a gentle ode to Kansas, to her friend, and to the thrill of the photographic moment.

Kansas was motivated by personal whim and did not carry the burden of imparting certain kinds of information that photographs taken on behalf of the government did. In comparison, Lange's *Irrigated Field of Cotton Seventy Miles from Phoenix, Arizona* (1937; fig. 165), commissioned by the RA/FSA, offers a straightforward "neutral" perspective. Neat furrows stretch into the distance like orthogonal lines of classical perspective, and the careful rendering of the space of

Fig. 165
DOROTHEA LANGE
Irrigated Field of Cotton Seventy Miles from Phoenix, Arizona, 1937
Gelatin silver photograph, 10 3/8 x 13 3/8 in.
Roy Stryker Papers, Special Collections, Photographic Archives, University of Louisville

pasturelands conveys vastness. The concept of vastness was an integral part of America's national myth, and it appeared in accounts by George Catlin, Francis Parkman, and Frederick Jackson Turner, to name a few. The early-twentieth-century writer Willa Cather, for example, wryly comments in her prairie pioneer stories of 1918, "The only thing very noticeable about Nebraska was that it was still, all day long, Nebraska."[29] With the political and social ruptures of the 1930s, a new accounting of the land was needed. Referring to the migration issues in California, Lange once noted that "there were periods where nobody here in the East was particularly interested. This was a western problem, you know, California problem, California economics."[30] The work of the RA/FSA photographers brought attention to these regional issues as a national problem, binding the nation through photographs designed to show, teach, and promote change or to affirm government initiatives. Although this work may seem uncomfortably nationalistic and propagandistic, the photographs had a higher purpose. Like strip cropping, contour plowing, arbor belts, and terracing, these photographs aimed to heal the land, literally and metaphorically.

Lange's *Irrigated Field of Cotton Seventy Miles from Phoenix, Arizona* shows how the 1911 Roosevelt Dam transformed the Salt River Valley into one of the most fertile agricultural areas in the world. Following the lines of canals built by the Hohokam culture (ancestors of the Pima-Maricopa Indians) thousands of years ago, Arizona emerged as a cotton capital during World War I.[31] At the time, irrigated land rose in value by 800 percent. Although the industry went bust at the end of the war, Lange's photograph draws attention to the importance of water to make the desert bloom. The intense desert heat can even be felt in the harsh reflected light on the moving water.

Among Lange's best-known photographs is *The Catholic, Lutheran and Baptist Churches, Great Plains, Dixon, South Dakota (Freedom of Religion: Three Denominations [Catholic, Lutheran, Baptist Churches] on the Great Plains, Dixon, Near Winner, South Dakota)* (1938; fig. 166). The town of Dixon was founded in 1904 on Rosebud, a Sioux reservation. Through a continuing system of allotment, in 1904 Rosebud lands were required to be ceded to the government to be sold to settlers, with proceeds going to the tribe. Each settler could purchase one hundred sixty acres of Indian land if he would break the sod and use the land for farming

and ranching. For fifteen years, during the time these churches were built, Dixon developed into a community like many others throughout the plains. Claim shanties and sod houses were constructed, later replaced by frame homes and community buildings. As one chronicler of Dixon wrote, "Thus, when this early schoolhouse was built in Dixon, it, along with the establishment of churches, was a testimonial to the world of the homesteaders' firm belief in their town, their land, and themselves."[32] But in the 1930s, tornadoes, grasshopper infestations, drought, crop failure, and sand storms wreaked havoc on the town. By the mid-1930s, when the drought ended, many of Dixon's homesteaders had moved away. When Lange arrived in Dixon in 1938, she witnessed an eroded community whose churches stood as silent sentinels.

In the photograph, St. Stevens Catholic Church appears in the foreground, First Baptist Church in the middle ground, and Trinity Lutheran Church in the distance.[33] Also titled *Freedom of Religion*, the photograph extols American values and the constitutional right to worship as one pleased, evidenced by this cluster of churches on the prairie. A closer look reveals some oddities. Although the churches symbolize religious freedom, to contemporary eyes conditioned by greater architectural and religious diversity, they all look alike, and all three represent Christian religions. Lange's point of view, which emphasizes the soaring height of the foreground church, the expansive plains, and the big sky, makes the churches look slightly off-kilter. St. Stevens veers toward the right and seems to be propped up by a windblown post; the other two churches also lean to the right, as if haphazardly deposited on the plains without firm foundations. None of these churches bears any relationship to the others. If churches are about religious community, there appears to be no community among or within them. Instead, everything seems empty, isolated, and somewhat desolate, in spite of St. Stevens's open door. This door's dark rectangular shadow joins the emphatic visual rhythms of the building's geometrical shapes, which Lange exploits for visual effect.

South Dakota was just one of the many regions covered by the RA/FSA. Its photographers traveled tirelessly as they sought to make connections with the people and places to which they were assigned. In the process, they strengthened notions of regional divisions, further breaking up the monolithic West and concentrating on the concept of American regions and their differences. Regionalism was hardly a new

Fig. 166
DOROTHEA LANGE
The Catholic, Lutheran and Baptist Churches, Great Plains, Dixon, South Dakota
(Freedom of Religion: Three Denominations [Catholic, Lutheran, Baptist Churches]
on the Great Plains, Dixon, Near Winner, South Dakota), 1938
Gelatin silver photograph, 10 1/4 x 10 3/4 in.
The Museum of Fine Arts, Houston, Gift of The Brown Foundation, Inc.,
The Manfred Heiting Collection

idea. In the 1920s the philosopher John Dewey wrote an essay, "Americanism and Localism," for the progressive journal *The Dial*. This essay, a clarion call, argued that the United States was a "spread of localities," and that the "locality is the only universal." "Very provincial?" Dewey asked. "No, not at all," he responded. "Just local, just human, just at home, just where they live....When we explore our neighborhood, its forces and not just its characters and colour, we shall find what we sought."[34]

By the end of the decade, a group of artists called American Scene painters, or Regionalists, rejected what they perceived as a cloistered, out-of-touch art world centered in Manhattan (and more specifically on Stieglitz and his circle) and promoted an "American" art that represented the country's various regions, particularly in the agrarian South, Midwest, and Southwest, joining populism with regional characteristics that they chose and defined. Who had greater claim to an "American art"? This question, part of a national debate in the 1930s, led to one of the most vitriolic battles in the history of American art. The debate was fueled by the emergence of fascism and extreme cultural nationalism in Europe and amplified by the pending specter of war. Both groups argued that they were the authentic voice of Modernism in American art. The concepts of "American" and "modern" were intertwined—Regionalists claimed that *they* were modern; the Stieglitz circle was accused of being "ultra-modern," meaning too effete and reliant on European modes of art-making.[35] Both groups often advocated their views from pulpits located either literally or figuratively in the American West. For the Regionalist artists, as for the artists of the Stieglitz circle, the American landscape loomed large as a symbol, a metaphor, or a source of irony.

Regionalism is not a form of chauvinism about a particular place or geography, but, as Lawrence Alloway points out, "a demand for personal knowledge" in which intimate experiences—memories of a particular place—intertwine with universal knowledge to make an artistic statement.[36] Employing dynamism and motion to express this sense of the American Scene, Thomas Hart Benton (1889–1975), in 1927 and 1928, painted a view of the town of Borger in the Texas Panhandle. This large epic painting, titled *Boomtown* (fig. 167), is one of his greatest Regionalist works.[37] Born in Neosho, Missouri, Benton was the son of a congressman and the great-great-nephew of the senator for whom he was named. He

studied at the Art Institute of Chicago, missing O'Keeffe by just one year, and in Paris, where he absorbed the lessons of European Modernism. When he returned to New York in 1912, he continued to work in a variety of abstract modes, including Cubism, Synchromism, and Futurism—a series of "isms" that he eventually decried, finding them, for the most part, to be merely decorative forms of "personality exhibitionism." He stated that "never before has this growth of successive abstractions, 'one growing out of the other' been so turned in on itself as to completely dehumanize the results."[38] Characterizing the movement years later, Benton argued that, after the 1929 stock market crash, the battle between liberalism and "entrenched money groups" concentrated "new and vigorous discussion of the intended nature of our society."[39] Regionalism, he noted, may have been loosely associated with the "country-wide revival of Americanism," but Benton's intent was much broader. He strove for a populist "art [that] was arguable in the language of the street," the success of which emboldened him and other Regionalists to "make a dent in American esthetic colonialism." Benton's rhetoric was always pungent, and often offensive and rude, but when he stayed on message, he, like the RA/FSA photographers, promoted his art as socially responsible, never aesthetically hermetic. A superb painter, Benton had a solid education, and his short-lived experiments with abstraction prepared him well to produce highly conceptualized, formally rigorous easel paintings and public murals that vibrate with color and intensity.

In 1938 one critic commented that Benton's art represents a "restless world," and, in the rhetoric of the time, that he is "typically American," not because he paints the American Scene but because he is a restless wanderer: "He is indigenous nowhere; not even in his own soul."[40] Benton did try to put down roots, eventually leaving New York to settle permanently in his native Missouri in 1935. When he visited Borger, however, in 1927, he was on a search for America. This visit was part of a larger road trip—what would become an American rite of passage.

Like many American children of the time, Benton grew up reading dime-store western novels. He also attended Buffalo Bill's Wild West Show in 1904 in St. Louis, where he supposedly shook Geronimo's hand. Based on these early experiences, Benton held close certain notions of the West, conditioned by its popular image. He had also read Frederick Jackson Turner's frontier theory and noted in his autobiogra-

Fig. 167
THOMAS HART BENTON
Boomtown, 1927–28
Oil on canvas, 45 x 54 in.
Memorial Art Gallery of the University of Rochester, M.S. Gould Fund

phy, *An Artist in America* (1937), that he wished to eschew "great men" histories and turn to the everyday, to produce a "people's history." "I wanted to show that the peoples' behaviors, their action on the opening land, was the primary reality of American life," he asserted, adding, "This was a form of Turnerism, of course."[41] As Benton traveled through the South and the Southwest, from the Ozarks to the Texas Panhandle, he was prepared to see the sweep and motion of the American landscape according to Turner's terms.

The boomtown of Borger, in the upper Texas Panhandle, fit those terms. Borger occupies land near Adobe Walls, the site of the 1874 battle fought by the Comanche, Kiowa, and other Indians of the southern plains to protect their lands from buffalo hunters. After the famous battle, the area was a virtually unpopulated section of the prairie until 1926, when oil was discovered.[42] In three months the population grew to about forty-five thousand (fig. 168).[43] To aid and benefit from the new commercial interests, the Panhandle and Santa Fe Railway quickly built a spur line, which is depicted in Benton's painting as heading west in the distance.

Like the train and the plow, the oil derrick had its own effect on the land, here serving as a magnet for those looking for new opportunities. The *Amarillo News* in June 1926 reported: "Probably no feature of the oil field is getting such nation-wide publicity as the boom towns. Seven in all, they are being hailed as regular little Sodoms and Gommorahs [*sic*] and the last frontier life of all the movies would have the days of '49 to be."[44] In Borger, Benton believed that he was seeing history in action, a new boom as foul, filthy, and exhilarating as the gold-rush booms he imagined in the Wild West. In 1937 he retrospectively described what he saw: "rough shacks, oil rigs, pungent stinks from gas pockets.…Every imaginable human trickery for skinning money out of people was there."[45] "Borger on the boom," he wrote, "was a big party —an exploitative whoopee party where capital, its guards down in exultant discovery, joined hands with everybody in a great democratic dance." He also described extractive industry itself in ambivalent terms, celebrating and damning it at once: "Out on the open plain beyond town a great thick column of black smoke rose as in a volcanic eruption from the earth to the middle of the sky. There was a carbon mill out there that burnt thousands of cubic feet of gas every minute, a great, wasteful, extravagant burning of resources for momentary profit. All the mighty anarchic carelessness of our country was revealed in Borger. But it was revealed with a breadth, with an expansive grandeur, that was as effective emotionally as are the tremendous spatial reaches of the plains country where the town was set." As art historian Karal Ann Marling has pointed out, these passages are a more accurate description of Benton's painting than of his actual experience.

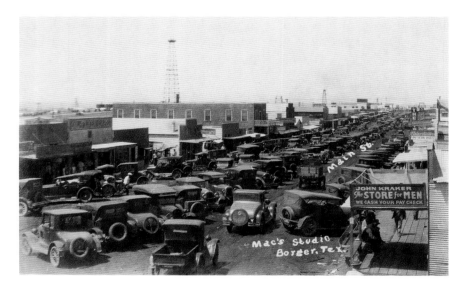

Fig. 168
Street scene, Borger, Texas, 1926
Hutchinson County Museum, Borger, Texas

In fact, Borger was, at the time, much worse than Benton described. There may be a reason he made his reportorial sketches in the privacy of his room on the second story of Dilley's American Beauty Bakery on Main Street. Borger, nicknamed "Booger Town," was among the most dangerous places in the country. Murder, robbery, and moonshine—the products of the organized-crime syndicate run by the mayor's associate—persisted even after the governor of Texas sent the Texas Rangers to Borger, shortly before Benton arrived. Continuing violence caused martial law to be declared for a month. Later, Ace Borger, for whom the town was named, was murdered. Benton did not flinch from painting Borger's potent brew. Instead, he reveled in it; indeed, self-conscious vulgarity would become one of many aesthetic goals of 1930s American art.

Benton's rubbery, boneless figures have a kind of warped stylishness. He represents cowboys, farmers, businessmen, buxom women, toughs, African-Americans, and a menacing figure, at lower right, who crosses the street carrying a knife. These colorful characters inhabit a remarkable landscape, the crossroad at Main, which is localized into a pie-shaped wedge spreading into the distance. By employing a bird's-eye perspective, Benton looks down and across the vast landscape, following the Earth's curve. This effect makes the foreground slip down from the picture plane and fall into the viewer's lap, and the background appears to stretch endlessly, punctuated by telephone poles, enclosed oil wells, and derricks. In this expansive canvas, where the landscape bursts from its borders and the people are full of possibilities, Benton creates a Deweyesque "spread" of a localized place that speaks beyond its geographical boundaries. The painting is a long way from what Fanny Palmer had in mind when she implied the rise of settlement in *Across the Continent: Westward the Course of Empire Takes Its Way* (see fig. 31).

Benton took a perverse delight in this confrontational painting, which finds freedom in Borger's anarchy and shame in the ambivalence that the people in it express toward their surroundings. The city merges with the oil field, and black smoke spews like an apocalyptic cloud, but no one seems to notice, except for the voluptuous woman in white, who raises her umbrella, confusing carbon clouds for a brewing thunderstorm.[46] Here Benton captures one of the defining tensions of the 1920s, as historian Roderick Nash described it, "the confrontation between a symbolic frontier past and a booming industrial present."[47] As if painting a debate, a form of exchange Benton always encouraged, he laid the "symbolic frontier past" and "booming industrial present" on top of each other, with all their potentialities and dangers. That Benton could effect this merger in *Boomtown* is testimony to the ironic subtlety he was capable of unleashing in even his most vibrant work. He combined the quality of expansiveness with his yearning for a "there-ness" that, for him, could be realized only by turning away from abstraction and affirmation of the physical world. To achieve this, he used plastilene to form and arrange the figures in his composition.

Another one of the more subtle ways Benton stretched his borders was through the ubiquitous commercial billboards and placards that dotted the landscape. We see them in *Boomtown*, in which Benton displays flimsy, makeshift signs such as "Red Star Theatre," "Lunch," "Palm Reader Mlle. Flukis," and "Mother Holl's, Bed and Board, Baths 50 Cents," and, beneath it, "Girls Wanted," implying stories and realities beyond what is pictured around these false-front buildings. Benton changed some of the names and locations of actual businesses, an indication of his interest in the expressive possibilities of advertisements.

Words, newspaper lettering, and various kinds of script had appeared in Cubist collages in the 1910s and in the paintings of Stuart Davis in the 1920s. Davis's playfulness was manifested in the presentation of multiple realities, including the fictive space of the painting. The iconography of mass and popular culture, as photographers such as Russell Lee (1903–1986) and Edward Weston found, could be useful in establishing structure, shape, and scale and was rich in implicit meanings. In *Hobbs, New Mexico* (1940; fig. 169), by FSA photographer Lee, commercial signs are the primary subject.

Born in Ottawa, Illinois, Lee trained as a chemical engineer. His first wife, the painter Doris Lee, introduced him to the medium of painting, which he studied at the California School of Fine Arts in San Francisco and the Art Students League, under John Sloan, in New York. Lee attributed his decision to pursue a career in photography to the painter Joe Jones, who told him about the FSA project, and Roy Stryker, for whom he worked from 1936 to 1942.[48] Both Stryker and Lange commented on Lee's greatest strength as a photographer, his skill in highlighting detail, some of which he captured by using flash. As Stryker described him, "Russell was the taxonomist with the camera.... He takes apart and gives you

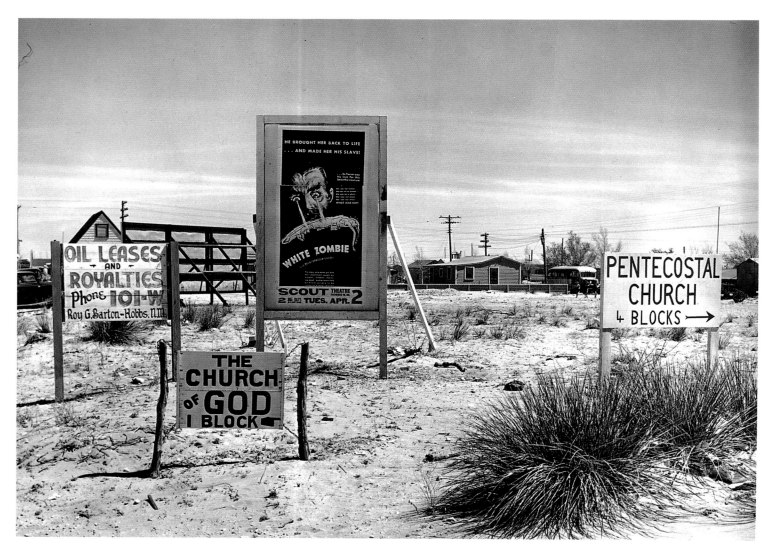

Fig. 169
RUSSELL LEE
Hobbs, New Mexico, 1940
Gelatin silver photograph, 8 x 10 in.
Harry Ransom Humanities Research Center, The University of Texas, Austin

all the details."[49] Because Lee captures infinite details legibly, it is not difficult to extract their larger meanings.

Lee confessed that during the months on the road he tired of taking photographs of people. When he needed a break, he would pick up his view camera and take pictures of "landscapes and buildings and signs."[50] As an example of his wry humor and acute sense of structure, Lee photographed street signs in Hobbs in 1940. New Mexico was not high on Stryker's list of priorities, but he wanted Lee to photograph an oil boomtown, a subject not yet covered in the file. However, by the time Lee arrived in Hobbs, located in the Permian Basin, this boomtown was well on its way to becoming a more established, respectable community. After oil was discovered there in 1928, the town had grown to include schools and twelve churches, and it remains today the oil capital of New Mexico.

In his image of Hobbs, Lee demonstrates how a few signs and billboards can establish the character of a place. His straightforward frontal approach picks up on the geometries of landscapes on the plains: the telephone poles, gates, and, in the foreground, four disparate signs. Homely handmade signs for the Pentecostal Church and the Church of God stand near a sign advertising oil leases. Towering above them all is a slick sign for the newly built Scout movie theater, which publicizes the classic horror film *White Zombie* (1932), starring Bela Lugosi. This second-run movie sign may mark, as Mary Jane Appel has argued, the social and financial status of the community. For this reason, Stryker encouraged his artists to photograph such signs. Lee, however, may simply have liked the way billboards promoting oil, God, and horror shows were juxtaposed. Emphasized by the flatness of the land, these signs suggest an index of the surreal combinations of human interests that could coincide in the West.[51]

Unlike the FSA photographers, Edward Weston determined his own subject matter. Weston received a Guggenheim fellowship in 1937, based on his application "to continue an epic series of photographs of the West, begun about 1929; this will include a range from satires on advertising to ranch life, from beach kelp to mountains." As Weston logged twenty-two thousand miles traveling throughout the West between the spring of 1937 and 1938, he produced twelve hundred 8-by-10-inch negatives. Although he gave ample attention to beach kelp and mountains, few of his images portray ranch life or advertising. (Most scholars agree that *"Hot Coffee,"*

Mojave Desert is an example of irony and amusement rather than of satire.) Weston's prospectus, brief as it is, outlines two important aspects of his vision. He insisted on selecting his own subjects, and he had no interest in making reductive images of western stereotypes. He said he would not be making "a pictorial record of the 'Western Scene,' rather I want to photograph MY Western Scene."[52] This statement takes on added meaning in light of the fact that Weston was tentatively offered a job photographing for the Department of the Interior, but was ultimately turned down, and subsequently found FSA photography too concerned with, as he put it disdainfully, "class struggle."[53] Weston described what *his* scene would be: "the recognition, recording, and presentation of the interdependence, the relativity, of all things,—the universality of basic form." This might consist of a bird, a tree, a smokestack, "each of these being not only a part of the whole, but each —in itself,—becoming a symbol for the whole, of life."

Weston's photographs of things seen and experienced have a leveling effect on "the West," an approach that is quite different from that of the FSA photographers. With no desire to contribute to a national identity, he marginalized accusations of western exceptionalism by pointing out that he could have accomplished his project anywhere. He chose California and the West because, as he noted, it was what he knew well, what he appreciated, and the landscape was rich enough in variety to satisfy the lifetime of any photographer. Seeking to personalize *his* West—as opposed to defining *the* West— Weston made an important distinction that was unusual for American art in the 1930s, one that was supported by the financial freedom of his Guggenheim fellowship and the growing recognition of photography as an art form. Critics have continued to note that "when it came to the California landscape and people, Weston could be superb: the sense of light and atmosphere, of a place lived in and well loved, of people taken for granted yet cherished, is very strong and often very moving."[54] Place, after all, did matter very much. Weston could make photographs that were remarkably beautiful, grand, and acute, but he did so without the cultural nationalism that characterized so much of the work of his American Scene and FSA contemporaries.[55] Instead, his goal was to "identify myself in, and unify with, whatever I am able to recognize as significantly part of me: the 'me' of universal rhythms."

In Weston's art, "the 'me' of universal rhythms" included irony and wit. *"Hot Coffee,"* Mojave Desert (1937; fig. 170)

Fig. 170
EDWARD WESTON
"Hot Coffee," Mojave Desert, 1937
Gelatin silver photograph, 7 7/16 x 9 7/16 in.
The Lane Collection, Museum of Fine Arts, Boston

depicts roadside culture along Route 66 east of Los Angeles in Southern California. The photograph, according to the records of Weston and his wife, Charis Wilson, was taken near the town of Siberia, which no longer exists except on old maps. One of the many water stops erected for desert tourists, Siberia eventually lost its value, and its buildings and stands were disassembled as quickly as they had been built. Taken in December, just two days after Weston and Wilson began their travels, *"Hot Coffee"* shows Weston's delight in incongruities. Like a painting by O'Keeffe, in which the artist magnified a shell or bone and placed it against a distant landscape, collapsing the near and the far, Weston selects, instead of a shell, a flimsy road sign. (In 1931 Weston had experimented with the device of the near/far when he placed a cow skull and a conch shell in a rocky outcropping at Point Lobos, at Carmel.) Unlike O'Keeffe, Weston had no need to magnify his enormous still-life specimen. The photograph is divided into two parts: the distant majestic landscape that stretches on and on and the foreground, littered with rocks, sand, scrub, and the dilapidated sign with its broken "saucer." The two are separated by the crisp line of the Santa Fe Railroad's trestle. Through a formal device, the photograph presents the dualities perceived in the West—its sublime beauty and its prosaic side.

Weston seemed to enjoy the wordplay and the problems of representation that the sign suggests. This juxtaposition of anomalous objects is a fundamental aspect of Surrealism, a style with which he had flirted in the 1920s and 1930s.[56] This playful and complex photograph, however, illustrates an important point with broader implications: ironic images of the once sacred American landscape were byproducts of the 1920s and 1930s, at a time when people felt increasingly disconnected from the land.

The modern disconnect with the landscape had culminated in the rise of the petroleum industry and subsequent urbanization, as seen in Benton's *Boomtown*. By 1940, when Benton painted *The Hailstorm* (fig. 171), after returning to Missouri in 1935, his art had relaxed into softer rhythms of nature that reflect a more unencumbered relationship to the land, even if the artist's rhetoric was more provocative than ever. That year, while he exhibited his work at the American Artists Association in New York, he railed against the directors and curators of Harvard University's Fogg Museum (he called them "museum boys") and announced, "I wouldn't

have any museums. I'd have people buy the paintings and hang 'em anywhere anybody had time to look up at 'em. I'd like to sell mine to saloons, bawdy houses, Kiwanis and Rotary Clubs and chambers of commerce."[57]

Benton had always responded to the romance of the prairie, emphasizing its virile strength and warning that the plains were not designed for the "cozy-minded people for whom life's values reside in little knick-knacks."[58] In his tangy prose, Benton rhapsodized about the wide-open prairie: "For the great plains have a releasing effect....I like their endlessness. I like the way they make human beings appear as the little bugs that they are....To think out on the great plains, under the immense rolling skies and before the equally immense roll of the earth, becomes a presumptuous absurdity. ...The indifference of the physical world to all human effort stands revealed as hard, unescapable fact."

Yet Benton defies this "unescapable fact" in paintings like *The Hailstorm*, which knits together sky, earth, and farmer in lyrical, rhythmic patterns that suggest unity, even in the face of nature at its worst. With its rich tonalities and sensuous surface, achieved by his use of oil mixed with egg tempera and his heavily managed brushwork, Benton celebrates a pastoral harmony and an agrarian ideal. A farmer runs for shelter, while, in the background, another continues to plow as lightning strikes. In his original watercolor (fig. 172), Benton did not include a figure behind the mule. However, being familiar with farm life, he feared the painting's authenticity could be questioned: no farmer would leave his mule unprotected in a storm. To create a narrative of affirmation rather than abandonment, he added the figure in the final version.[59] Benton layered numerous glazes, rubbing them on with his fingers and picking detail out of the wet surface to suggest the eerie light of the sun giving way to the storm with its rich pinks, golds, yellows, greens, and purples. Combining content and form with process, Benton produced a holistic vision of rural life in this whirling ode to Missouri.

Benton was hailed as one of the Regionalist triumvirate, a marketing term coined by the astute dealer Maynard Walker. The other artists were John Steuart Curry (1897–1946) of Kansas and Grant Wood (1891–1942) of Iowa. Art historians have accused Benton and Wood of producing idealistic visions of American farming at precisely the time that agricultural life was in peril, as if they were artistic Neros playing the fiddle while Rome burned. This conclusion comes,

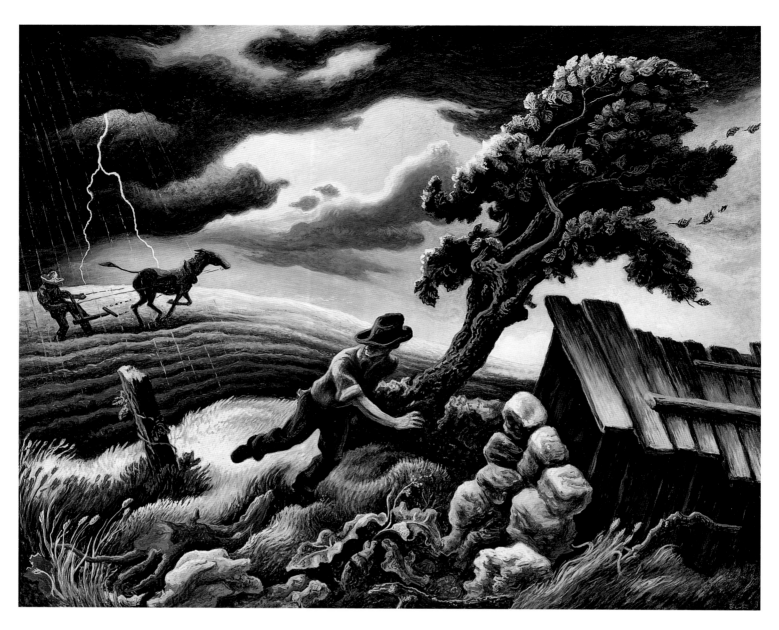

Fig. 171
THOMAS HART BENTON
The Hailstorm, 1940
Oil and egg tempera on linen canvas mounted on cradled plywood, 33 x 40 in.
Joslyn Art Museum, Omaha, Nebraska, Gift of the James A. Douglas
Memorial Foundation

Fig. 172
THOMAS HART BENTON
Running Before the Storm, 1940
Watercolor on paper, 11¼ x 14¾ in.
Private collection

no doubt, from comparisons with the searing work of Wood's contemporary Alexandre Hogue and the many FSA photographs by Lange, Rothstein, Shahn, and others who focused on plight, not plenty. Wood was criticized, even in his own time, for the sweetness of his work.[60] His *Spring Turning* (1936; fig. 173), similar to Wolcott's *Contour Ploughing and Strip Cropping Wheat Fields*, affirms a countryside that is living and breathing in a scene of hushed silence and austere grandeur that also resonates with Wood's wit, as he imposes the cookie-cutter charm of Americana onto the scene. If ever an American painting suggests nostalgia for a different rhythm of life, *Spring Turning* is it. This painting expresses a longing for innocence and revels in a sense of humor, seen in the toylike trees. Wood painted his locality, and although Iowa was hard-hit during the Great Depression, with farm foreclosures and crop and animal reductions, it was not as affected by the Dust Bowl as were areas in the Texas and Oklahoma Panhandles and in eastern New Mexico and Colorado.

Wood was born and reared on a farm in Anamosa, Iowa, until the age of ten, when his father died. His family moved to Cedar Rapids, and eventually he studied art at the Minneapolis School of Design and Handicraft (steeped in the Arts and Crafts movement), the University of Iowa in Iowa City, and the Art Institute of Chicago. He then traveled to France for further study, living the life of an American bohemian in Paris, beard and all, when, as he put it, he "realized that all the really good ideas I'd ever had came to me while I was milking a cow. So I went back to Iowa."[61] A journalist later described Wood's makeover into a homespun Regionalist upon his return: "He shaved his round face smooth, and assumed an exterior as mild as a cup of Ovaltine."[62]

Wood entered into the spirit of American Scene painting, championing a decentralized art and believing that an "authentic" American art would emerge from the soil. He combined his admiration for the work of an Old Master painter such as Hans Memling and other painters of the Netherlandish School with an appreciation of prints by Currier and Ives, old-time furniture catalogues, and Americana in general. In 1932 Wood established the Stone City Colony in Iowa with the idea, as he wrote, that the Midwest was rich with artistic potential, although not as "obvious as Taos, Brown County [once a midwestern art colony in Nashville, Indiana]

Fig. 173
GRANT WOOD
Spring Turning, 1936
Oil on Masonite panel, 18 1/4 x 40 1/4 in.
Reynolda House, Museum of American Art, Winston-Salem, North Carolina

or the coast of Maine (fig. 174)."[63] Wood willed Iowa into midwestern Regionalism, a stroke of good timing given the political and economic crisis in the country, which consistently kept the national limelight focused on its interior. Heartland painting hit a nerve, sifting and filtering the problems of the United States from an interior point of view. Wood and Benton had many heartland patrons, but their appeal extended to New Yorkers, nationally known businessmen, and Hollywood entertainers.[64] To this day, support for Wood and what he represented remains strong in Iowa, where, in 2004, a site identified as the inspiration for one of his major canvases was landmarked for protection, possibly a first in American landscape art.[65]

To drive through the Mississippi River Valley of eastern Iowa today is to inhabit a Grant Wood painting such as *Spring Turning.* The sun sparkles over meticulously manicured rolling prairies of varying shades of green. The land was once the tall grass prairie of the Iowa (Ioway) Indians. After they and other tribes were removed, settlers moved in with their plows to break the plains, turning over the dense sod and making it fertile for corn, wheat, and other crops. Tractors

were invented in the mid-1920s, but they were by no means ubiquitous by the 1930s. Thus the handheld plow depicted in this painting is not necessarily a paean to an older agrarian ideal, nor are the large tilled fields representative of mechanized plowing, as Wood scholar James Dennis asserts.[66] Indeed, as South Dakota writer and poet Larry Woiwode argues, "Wood's landscapes contain the most accurate and clear-edged representations of tillage by horses to be found in American painting." He explains the mathematically precise system of "checking corn," which produces a far more orderly landscape than that achieved through mechanized machinery.[67] For him, "It is this ideal of *order* [emphasis added], at the heart of every conscientious farmer, which Grant Wood represents in his paintings…and [he] excluded machines from his fields for a reason: he sensed their power to abstract the farmer from the land." Wood structures the painting as a series of diagonals set off by squares and softened by gentle curves. The space expands infinitely—a ridge road turns into a tiny bridge at lower right before snaking across the canvas to the glowing fields beyond—and is brought into control by the tiny figures of two farmers with their draft horses, bringing

Fig. 174
Grant Wood "talking it over" with members of the colony, Stone City, c. 1932
Edward Beatty Rowan papers, 1929–1946, Archives of American Art,
Smithsonian Institution

order to the land and making the earth bloom. The sense of "rightness" or contentedness is underscored by the tidy farmhouse, at upper left. Through a reductive streamlining to basic shapes, a minimal palette, and an evenness of detail across the canvas, Wood combines exhilaration with restraint, as he sustains visual interest throughout the work. Wood makes agricultural order—as well as his own artistic discipline—into a midwestern value as well as a source of humor.

Wood and other American artists, particularly in the West, increasingly anthropomorphized the landscape. In the 1920s Alexandre Hogue (1898–1994) began making a series of charcoal sketches in which the flesh and folds of a female form signify plains, hills, and erosion, a subject he would take up with renewed vigor in the mid-1930s. Wood's *Spring Turning*, as scholars have commented, suggests a woman's breasts or pregnant belly, making the connection between the earth and fertile, nurturing mothers, a connection Lange was willing to exploit in her photographic series of migrant mothers. In Wood's example the land rises and falls, as if breathing, and is brought to life through his deft use of paint.

If Paul Sample (1896–1974) intended the tawny, domed hills in *Celebration* (1933; fig. 175) to be humanlike, the vision is not a gentle, life-giving one. Five years after this work was made, art critic Alfred Frankenstein characterized the American Scene painters: "What distinguishes the American scene group…is a highly complex attitude compounded of romantic emotion and realistic delineation, of a desire to expose the plain, unvarnished facts of American life plus a strong, even sentimental love for the facts that finally emerge."[68] This is true of *Celebration*, in which Sample tempers criticism with conviviality. Born in Louisville, Kentucky, he lived in a number of places while growing up but primarily in Winnetka, Illinois. He matriculated at Dartmouth College in New Hampshire, where he would return as an artist in residence in 1938. A star athlete, Sample contracted tuberculosis as a senior in college and recuperated in the Adirondacks for four years, meeting and befriending the Post-Impressionist Jonas Lie, who gave him art lessons. Sample determined to become an artist shortly before he was thirty. He moved to California in 1925 and thereafter divided his time between Los Angeles and New England. Scholars often mention his diverse artistic influences: the sixteenth-century Flemish master Pieter Bruegel and the Mexican muralists Diego Rivera, José Clemente Orozco, and David Alfaro

Siqueiros.[69] Employing these various sources, Sample developed stylized sculptural forms and used strong masses.[70]

Sample often traveled east of Los Angeles to the Central Valley and to the western Mojave Desert, where he toured the area around Bakersfield, in Kern County, and the former mining town of Randsburg, which by then had become a ghost town. Extractive industry had lured settlers and workers to the area since the nineteenth century, when borates (for Borax) and salt flats were mined for commercial uses. The petroleum industry was not far behind.[71] In *Celebration*, Sample includes oil derricks in the foreground, which frame the human and industrial activity, and the smokestacks of a smelting operation, which appear behind the laborers. These elements are repeated on the next rounded dome and, we may infer, in the distance. Boxed in by the crisply delineated pattern of buildings, the workers rest at the end of a shift and likely a pay period, drinking until at least two of them pass out. The title of the work refers to the workers' leisure, but Sample also makes wry reference to the bleakness of the scene, which is hardly celebratory. He keeps stridency in check: in the domelike hills, the eroded surfaces of which form lines running toward the off-the-clock laborers in the foreground, Sample turns the landscape into multicolored tufted pillows. There is certainly life here, unmarred by smoke or dirt. Still, a sun-drenched sterility beats down, and the shadow of the wooden derrick cuts the sleeping African-American worker off at the legs. The artist's ambivalence may be purposeful, for in restraining his social commentary, he encourages viewers to look, see, and ponder what kind of history they are looking at here.

This ambivalence was not shared by Arthur Rothstein or Alexandre Hogue, the latter an artist whose work Sample likely emulated. Hogue stringently denied that his work served as social commentary, although both *Erosions No. 2, Mother Earth Laid Bare* (1938; fig. 176) and *The Crucified Land* (1939; fig. 183) were unprecedented in their ability to shock the public. His work had been introduced to a wider public through the Whitney Museum of Art Biennial of 1936 and the popular magazine *Life* in 1937.[72] As Hogue, a conservationist and keen student of geology, articulated: "I painted what I saw and experienced. I had no thought of castigating anyone. I did not do the Erosion Series (by wind and water) as social comment. I did the dust bowl paintings because I was there before, during and after the holocaust and could see

Fig. 175
PAUL SAMPLE
Celebration, 1933
Oil on canvas, 40 x 48 in.
Private collection

the awesome terrifying beauty of it with my own dust filled eyes….Social comment is negative; my interest in conservation is positive."[73]

Hogue's statement is retroactive. Because he saw his work as a force for good, he probably wanted to ensure that his message would be understood as a warning, not as part of a preachy sermon (he was, after all, the son of a Presbyterian minister). He also situated himself within the two extremes inherent in "terrifying beauty," which he perceptively understood as worthy of his art. Furthermore, Hogue stressed his personal witness and experience on the land and took it as a

point of pride that his work predated the infamous Dust Bowl photographs by Arthur Rothstein that show dusted-out farmers in Cimarron County, Oklahoma. "I've spent years," he once said in an interview, "learning how to use erosion forms as an idiom of expression."[74]

Hogue approached the study of a human figure in the landscape for a number of years, beginning in the 1920s. He produced a double form by using the body of a nude female as a natural outgrowth of the landscape (figs. 177–79). He experimented with developing these studies into a painting but felt he needed a reason to do so. Ultimately he found

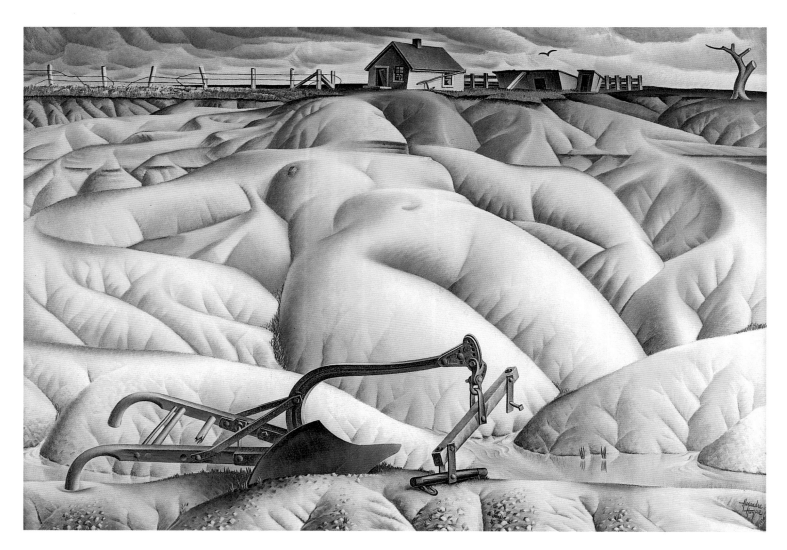

Fig. 176
ALEXANDRE HOGUE
Erosions No. 2, Mother Earth Laid Bare, 1938
Oil on canvas, 40 x 56 in.
The Philbrook Museum of Art, Tulsa, Oklahoma, Museum Purchase

Fig. 177
ALEXANDRE HOGUE
Study no. 1 for Mother Earth Laid Bare, 1926
Graphite on paper, 8 1/4 x 10 3/4 in.
The Philbrook Museum of Art, Tulsa, Oklahoma, Purchase with funds donated
by Geoffrey and Helen Cline

Fig. 178
ALEXANDRE HOGUE
Study no. 2 for Mother Earth Laid Bare, 1928
Charcoal on paper, 10 7/8 x 13 1/2 in.
The Philbrook Museum of Art, Tulsa, Oklahoma, Gift of Friends of Alexandre Hogue in
honor of his 95th birthday

Fig. 179
ALEXANDRE HOGUE
Study no. 3 for Mother Earth Laid Bare, 1932
Charcoal on paper, 8 5/8 x 11 5/8 in.
The Philbrook Museum of Art, Tulsa, Oklahoma, Gift of Robert E. and Cadijah Patterson

that reason in his childhood. Born in Memphis, Missouri, Hogue was a baby when his family moved to Denton, Texas. He received art training at the Denton Normal School, from Dallas artist Frank Reaugh, and at the Minneapolis Art Institute, followed by some time studying and practicing art in New York before returning home. Hogue spent much of his childhood on a ranch, particularly his sister's and brother-in-law's place near Dalhart in the Texas Panhandle. Here he observed "suitcase farmers," as his colleague Jerry Bywaters called them, invade the grassy plains, plow unbroken land, and plant wheat for the boom markets, and he heard ranchers warn these farmers that "if the land were plowed it would blow away."[75] He was aware of the ongoing need for careful stewardship of the land. Shortly before his death in 1994, he remarked that much of the Texas shortgrass is still gone, replowed after the government restored it during the Depression.[76]

Stewardship is something Hogue learned as a child, both on the ranch and in his mother's garden. His mother "poetically referred to the beneficent presence of the mother earth everywhere under ground while we were working in the garden." He also noted his later exposure to Pueblo Indian religious customs, in which a reverence for the earth is enacted. "Until all crops are sprouting all tools are stored," he wrote, "even shoes removed from horses' feet for fear of injury to the Earth Mother. When time for cultivation comes all activity is resumed."[77] After he witnessed the severe erosion of land by wind and water near Dallas, his ideas crystallized. He renewed his earlier efforts to create an anthropomorphized landscape, for he believed that his mother's earth and Mother Earth had been violated. Indeed, Hogue makes literal Lange's and Taylor's concept of "human erosion."

Hogue was precise in his description of the painting: "a shower has just passed leaving the ground glistening wet. …The house and sheds are typical of the run-down condition found on an eroded farm. Some may realize that the plow is a phallic symbol but if they don't it doesn't matter. They still can realize that the plow caused the erosion to begin and so Mother Earth is raped by the plow and laid bare. The little ditches around the bottom edge of the legs symbolize the disintegration that is still going on."[78] Everything is in sharp detail: a broken-down fence, blasted tree, abandoned house, carrion crow in the sky, and the recumbent figure—her ample body billowing like a soft pillow. In the blacklands outside of Dallas, Hogue explained, overplowing revealed limelike thick clay with smooth "pottery-like surfaces" that easily disintegrates in water.[79] In the painting, overplowing reveals a skin-colored subsoil, and the woman's face melts away, her arms eroding into pastureland. The menacing hand plow has cut her off at the knees. It is just a matter of time before she will vanish.

Contemporaneous observers did not know how to describe the painting, except in terms of Surrealism. The work does display the double-form play of Surrealism and the sharply delineated lines and even the surface of a canvas by a Surrealist painter such as Yves Tanguy or Salvador Dalí.[80] Hogue, too, wrote that his style's "nearest kin is sur-realism."[81] However, he called it "psychoreality" because he wanted the painting to play "on the conscious mind not the dream world." Surrealism offered his viewers an escape route he did not intend. He wanted them to experience what *he* had experienced: "I've always been interested in that kind of beauty—things that scare you to death but still you've got to look at them."[82]

His series of erosion paintings joined other similar scenes then being produced, including FSA photographer Arthur Rothstein's iconic *Plow Covered by Sand, Cimarron County, Oklahoma* (1936; fig. 180), which records the worst-hit area of the Dust Bowl in the westernmost tip of the Oklahoma Panhandle.[83] A native New Yorker who attended Columbia University, Rothstein was the youngest—at age twenty-one—of the FSA photographers when he joined in 1935. He learned the finer points of technique on the job. When Pare Lorentz released his classic government-funded film, *The Plow that Broke the Plains* (1936), Stryker had no dust-storm photographs for government or press use. (Lange and others had photographed the effects of the Dust Bowl, not the storms themselves.)[84] Rothstein traveled to Oklahoma and made some of his most famous photographs, which were carefully staged and powerfully portrayed the details of a farming family's hardship on the prairie.[85]

Rothstein took several photographs of the plow, including one titled *The Plow that Broke the Plains; Look at It Now. Oklahoma.* A clear reference to Lorentz's film, this image appeals to viewers' emotions and persuades them to see the plow as a diabolical instrument of torture. The plow, once held up as a classic symbol of agrarian virtue and of the nation's promise, ceased to be an object of reverence.[86] In this image (fig. 180), the plow, pitched over on its side, is abandoned.

Fig. 180
ARTHUR ROTHSTEIN
Plow Covered by Sand, Cimarron County, Oklahoma, 1936
Gelatin silver photograph, image 7 x 7 ⅛ in.
Library of Congress, Prints & Photographs Division, FSA/OWI Collection
[LC-USF-34-004043-E]

Fig. 181
ARTHUR ROTHSTEIN
***The Bleached Skull of a Steer on the Dry Sun-baked Earth of the South Dakota
Badlands***, 1936
Digital file from original negative: nitrate, 2 1/4 x 2 1/4 in. or smaller
Library of Congress, Prints & Photographs Division, FSA/OWI Collection
[LC-USF-34-004507-E]

Fig. 182
ALEXANDRE HOGUE
End of the Trail, 1936
Lithograph, 12 7/8 x 17 7/8 in.
Dallas Museum of Art, Lawrence S. Pollock Purchase Prize, Eighth Annual Dallas Allied
Arts Exhibition, 1937

The setting becomes almost hyperreal in Rothstein's hands: he eliminates the horizon and fence and any other environmental distraction other than dead roots. The ground fills the entire plane of the photograph, and patterns emerge in the wood beam and sand rills. Rothstein aims the point of the plowshare directly at the viewer and focuses on the built-up sand within its contours, where one would expect to see rich loam. Only the plow's swanlike shadow offers a note of relief. In its iconic approach, this image prefigures another photograph by Rothstein, of an animal skull in the South Dakota badlands (fig. 181). Artfully arranged to maximize its effects —and thus causing a public furor—the skull is magnified and, without a horizon line, meets the viewer head on, as in a painting by O'Keeffe. It is surrounded by an aura of cracks and underscored by a shadow.[87] Hogue, in 1936, drew on similar imagery in his print *End of the Trail* (fig. 182), an ironic reference to a settler arriving at the land of promise only to find it upended. The 1930s kept alive the skull symbology of the West, picking up on its earlier association with turn-of-the-century concepts of vanishing. When Hogue painted the Vernon redlands south of Denton, Texas, ravaged by downhill plowing (as opposed to soil-protective measures like contour or terrace plowing), he explained, "The red dirt is no exaggeration....I used the so-called Vernon redlands to symbolize the fact that water is cutting into the very flesh of the earth, draining it of its life-blood, crucifying the land" (fig. 183). Nothing could be more strikingly alive in its vibrant color and energy, and yet this painting is of a desolate and dying Texas landscape—an image that serves as a requiem for the dead.

In his use of erosion and depletion expressed through the aesthetic of psychorealism, Hogue could not avoid sending an urgent social message in this decade of political and economic turbulence, despite his own comments to the contrary. Moreover, Hogue's grim canvases of a raped and exhausted earth suggest not only the evisceration of the land itself but of a landscape tradition in American painting. His vision is so devastating that his work indicates, as in the words of Dixon or Steinbeck, that there is no place for the artist to go. This conclusion would be hasty, however, as familiar forms of landscape painting continued in the work of artists such as Edward Hopper and Georgia O'Keeffe.[88] Yet it is true that increasingly critical, ironic, or paradoxical portrayals of the American land appeared in painting and photography of the

1930s, a time when the blighted landscape served as a new rallying cry for reform. The decade marked a definitive departure from the centuries-old belief in the land as the marker of national identity and promise, a sacred covenant that artists had reverently kept and had transferred to their canvases for generations. Moran's *Mountain of the Holy Cross* (1875) (see fig. 1) and Hogue's *The Crucified Land* demonstrate these two extremes of artistic land use. Hogue and other artists in the 1930s broke the vow and exposed the land, creating new metaphors from its rawness.

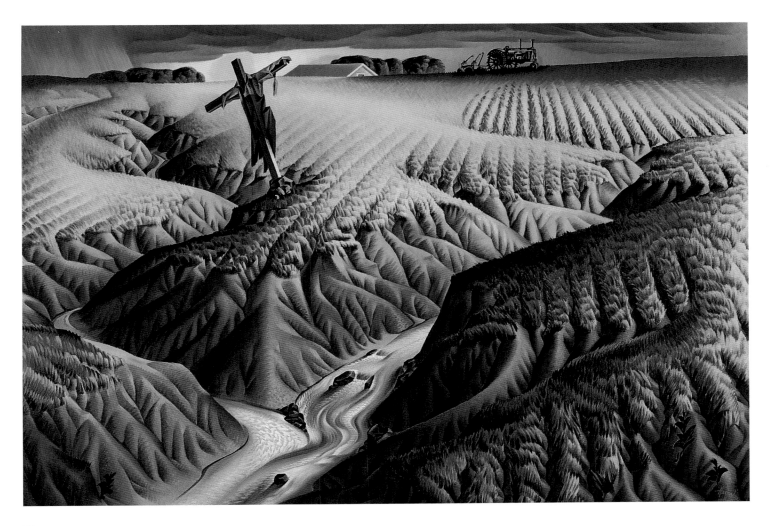

Fig. 183
ALEXANDRE HOGUE
The Crucified Land, 1939
Oil on canvas, 42 x 60 in.
Gilcrease Museum, Tulsa, Oklahoma

Epilogue: The Abstract West

THE NATURE OF MODERN NATURE

The radicalism of Alexandre Hogue's art, which exposed the myth of the American landscape in devastating terms, facilitated a more direct relationship between artist and nature. If, in the 1870s, as embodied in Moran's *Mountain of the Holy Cross*, the painter was anthropocentric in his view of nature (surveying and mapping nature as something separate from him to be controlled), in the 1930s landscape became increasingly anthropomorphized. This transformation is felt keenly in Hogue's *Mother Earth Laid Bare*, in which the land assumes human attributes, and land and life begin to fuse. Hogue expressed, in the most dramatic terms, how land and humankind had failed one another during the Depression, changing the landscape in the eyes of artists coming of age in the late 1930s and 1940s. For artists such as the Wyoming-born Jackson Pollock (1912–1956), any engagement with the land and a landscape tradition had to contend with the grim unveiling that Hogue's paintings represented. Pollock, and other painters in the generation following Hogue, boldly subsumed nature, translating the relationship between life and the land into abstracted, essentialized forms. In Pollock's art, notions and memories of a cultural landscape would merge with other forces and coalesce into a new visual language of great complexity that defies easy categorization or a single interpretation.

Surrealism, and its relationship to the West, aided in changing artists' understanding of nature. As previously discussed, artists in the 1920s and 1930s, such as Stuart Davis and Georgia O'Keeffe, used the western landscape as something to react against or to embrace for its modern characteristics, its stark expanses, its angular and bold forms and col-

ors, and, most important, the near/far optical sensations that elided the middle ground. Wit and irony in the work of photographers during the 1930s, such as Edward Weston and Russell Lee, who perceived those modern qualities in abandoned mining towns and cities hastily built to accommodate the petroleum industry, depended on the juxtaposition of contrasting forces of grandeur and absurdity. These juxtapositions, along with Grant Wood's transformation of Iowa into a homey quilt, or Hogue's portrayal of Texas as a graveyard, helped to open the door to depicting western lands in increasingly fantastic, imaginative ways that the codification of Surrealism in the United States in the late 1930s spurred to new heights.

As an art form, Surrealism focused on creating elements of shock and surprise through the unexpected juxtapositions of objects or ideas arrived at not through conscious thought or deliberation but through unconscious association and automatism. Surrealism thus upset traditional notions of time and space by offering an alternative unstable and limitless universe.[1] And in the endless spaces of the West, where perceptions of time shift dramatically, Surrealism and geography had a mutually reinforcing effect on modern artists.

What Pollock and other artists saw and witnessed in the West blended with the new aesthetic of Surrealism, which they encountered in the work of the Mexican muralists Diego Rivera, David Alfaro Siquieros, and José Clemente Orozco in the late 1920s and 1930s; in exhibitions of European Surrealism at the Museum of Modern Art and New York galleries in the 1930s; and through discussions with Surrealist artists, many of whom immigrated to the United States

Detail of fig. 208
MARK TOBEY
Written Over the Plains, 1950

237

on the eve of World War II. Thus, the effects of the landscape, artists' perceptions of it, and new aesthetics celebrating dreams, irrationality, absurdity, and fantasy released new visions of the West.

This combination of mutually supportive constructs is best embodied in the example of Jackson Pollock. Pollock has become known as the artist who, as his rival and colleague Willem de Kooning phrased it, had "broken the ice," making the breakthrough into what is now called Abstract Expressionism by means of his signature drips, splatters, and overlays of lacy lines and paint puddles merging into an abstract

expression of self.[2] This breakthrough effectively shifted the center of the art world from Europe to the United States, specifically New York at mid-century.[3] This concept was articulated by Pollock's champion, the influential critic Clement Greenberg, whose evolutionary reading of art history seized on Pollock's full exposure of the "flatness" of painting as the signal development of the age and the "next" phase after the innovations of Pablo Picasso. For Greenberg, Modernism was a march toward abstraction: "I do not think it is exaggerated to say that Pollock's 1946–50 manner really took up Analytical Cubism from the point at which Picasso and Braque

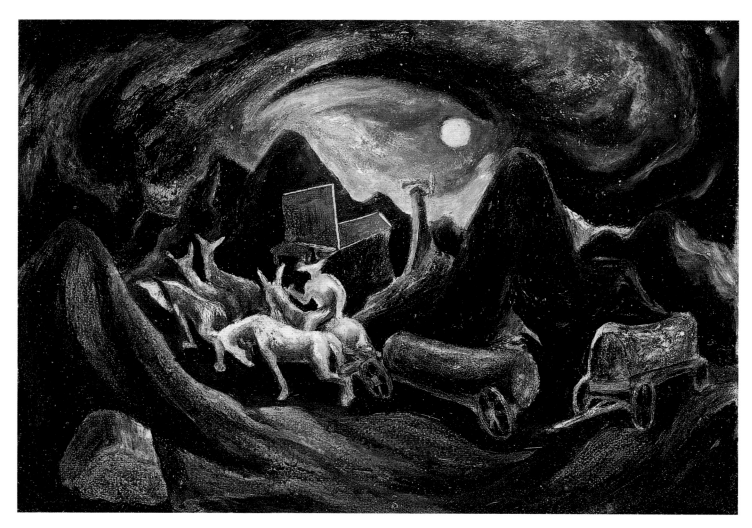

Fig. 184
JACKSON POLLOCK
Going West, 1934–35
Oil on fiberboard, 15 ⅛ x 20 ¾ in.
Smithsonian American Art Museum, Washington, D.C., Gift of Thomas Hart Benton

had left it."[4] In popular culture of the time, Pollock's art was a lightning rod for asking the age-old question of what defines art. This quality was imposed on the artist by the media, which in the August 8, 1949, issue of *Life* magazine bluntly queried, "Jackson Pollock: Is He the Greatest Living Painter in the United States?" Pollock's achievement was presented as so final and complete by critics, curators, and dealers, and so intertwined with a growing celebrity culture and the artist's attention-grabbing, antisocial personal behavior, that it has taken generations to unravel and reevaluate the Pollock myth.[5]

Today Pollock is mainstream, canonized long ago as a foundational figure in modern art, particularly Abstract Expressionism, which gives primacy to individual expression. Nevertheless, Pollock's artistic roots lay in the American landscape. He cultivated a western identity not only in his art but also in his persona. His terse, often crude manner of speech and his cowboy swagger, enhanced by the boots he wore early on after moving to New York in 1930, gave him the outward signs of an authentic and original American. Just as his paintings tapped into the myth of the West, so, too, did Pollock assume the identity of a cowboy; after all, he had grown up, in large part, in Los Angeles, home of the Hollywood western. Pollock's cultivated western qualities have been seized upon more consistently than anything else to describe the artist and his work. Critics and art historians would come to observe the earthbound quality of Pollock's art, which inevitably became associated with the West. In 1943, at Pollock's debut exhibition at Peggy Guggenheim's New York gallery, Art of This Century, James Johnson Sweeney, then-curator at the Museum of Modern Art, invoked a geological metaphor when he likened Pollock's talent to a "mineral prodigality not yet crystallized."[6] Pollock's western identity was something to which people could relate—positively or negatively—when so much else about his radical aesthetics was little understood. His western exceptionalism offered a frame of reference for why the artist felt compelled to pour paint onto the canvas that he laid down on the floor of his studio.

Pollock experimented with painting western subjects early in his career, specifically *Going West* (1934–35; fig. 184), given to the Smithsonian American Art Museum by Pollock's mentor, Thomas Hart Benton. In this work, Pollock announced both his indebtedness to and independence from the Regionalist celebration of the West seen in Benton's canvases of the 1930s. *Going West* is not a great or even a good

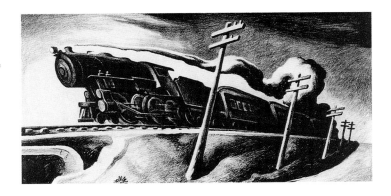

Fig. 185
THOMAS HART BENTON
Going West (also titled *Express Train*), 1934
Lithograph, 11½ x 22½ in.
Craig F. Starr Associates, New York

painting, but it foretells what Pollock would achieve. Like much of his early work of the 1930s, it is awkward, but there was something in it—an energy that hints at the power and intensity that would find such vibrant expression a decade later—that gave influential artists, friends, and family members the confidence to support Pollock's ambitions.

This energy emerges in Pollock's *Going West*, which is closely related to Benton's *Going West* (1930) and perhaps partly conceived as a response to Benton's 1934 lithograph of a speeding train, also titled *Going West* (also *Express Train*) (fig. 185).[7] Pollock's *Going West* differs from his teacher's 1934 image of unimpeded speed and fluidity; his vision of westward expansion appears dark, tortured, and stuck in a never-ending cycle. Ghostly colored mules and a driver are making their way through a mountain pass, with western emblems of town (the false-front building) and country (the windmill) marking its path. The mule driver is pulling either a caisson or water carrier, followed by a Conestoga wagon that has lost its hitch. The narrative is difficult to understand but does not seem to matter. What does matter is the eerie moonlight effects and overall darkness the painting projects in its tumultuous, swirling motion. Pollock's composition enacts a circular sweep of motion, as opposed to the linear thrust of Benton's. Although the subject and the sense of motion are unmistakably derived from Benton, the murky, textured surface suggests the impact of another artist Pollock admired, Albert Pinkham Ryder. The strangeness of the composition and the estrangement of its features, in which nothing

relates clearly to anything else, also demonstrate Pollock's intuitive grasp of Surrealism.

Pollock's well-documented reputation as a misfit, his acute sensitivity and problems with personal demons throughout his life, suggests that *Going West* is a personal expression of hardship and transience more than it is an example of Depression-era Regionalism. The Pollock family, consisting of Jackson's parents and their five sons, the youngest of whom was Jackson, is paradigmatic of the nomadic American family of the 1920s and 1930s. Jackson's parents began married life in 1903 in Cody, Wyoming, a newly established tract development that was more like a modern subdivision than a frontier outpost. Unable to make ends meet in various boom-and-bust agricultural cycles, the Pollocks moved from place to place, including, in 1913, the Salt River Valley in Arizona, where Pollock's father turned the sandy soil into a dairy farm, using irrigation canals modeled on those of the ancient Hohokam culture. A series of moves in California included one prompted by the discovery of a half-mile alkaline strip through Pollock property, rendering it nearly useless. After the breakup of his parents' marriage, Jackson moved with his mother and brothers to Riverside, near Los Angeles, in 1924, and to Los Angeles four years later. During several summers Jackson worked on survey crews, including a memorable summer in 1927, when, at age fifteen, he worked on one crew with his brother Sanford (Sande) on the north rim of the Grand Canyon (figs. 186 and 187).

Despite the constant uprooting of the family and its inner turmoil, Jackson and his brothers had taken pleasure in exploring the Mojave Desert, Utah's Bryce Canyon, and Zion National Park, wandering through the West by car and by foot, sensing its rich variety, conventional beauty, and strangeness. Pollock also discovered American Indian art and culture, which would become a lifelong interest. Apache, Pima, and Maricopa Indians were a part of his daily life in Arizona. In California he witnessed the Bear Dance of the Wadatkut, members of the Northern Paiute, whose burial grounds near Janesville made an impression on him. He encountered cliff dwellings and Ancient Puebloan paintings near Aztec Peak in southeastern Arizona. His friend and fellow artist Reuben Kadish remembered going with Pollock in high school to the Southwest Museum in Los Angeles, which housed Charles Lummis's collection of American Indian art, and to the Los

Angeles County Museum of History, Science and Art (now the Los Angeles County Museum of Art), where they crawled around the basement looking at cases of baskets and ceramics.

Pollock continued to pursue the subject of American Indian art in New York, where he moved in 1930 to study with Benton. Over the next few years, he returned to California during the summer, taking at least four cross-country trips inspired by Benton's of the 1920s (see fig. 167). On one trip Pollock witnessed—about the same time he painted *Going West*—the migration of dusted and tractored-out farmers going to California. Even at this early stage in his career, Pollock recognized that westward expansion may have been

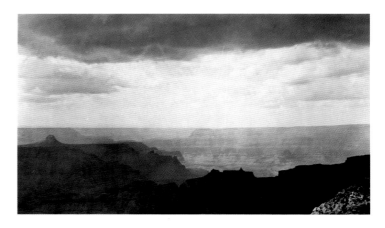

Fig. 186
SANDE or JACKSON POLLOCK
Family photograph of Grand Canyon, 1927
Courtesy, Jason McCoy, Inc., New York

Fig. 187
Jackson Pollock and Sande Pollock at Grand Canyon, summer 1927
Courtesy, Jason McCoy, Inc., New York

heroic for a champion of nation-building like Benton, but it had an entirely different connotation for Pollock, based on personal experience. For him, going west (and back and forth in the West) had been a frustrating experience of failed dreams and rootlessness that becomes, in *Going West*, a surrealistic and menacing fantasy world turned upside down.

A LANDSCAPE IN FLUX

Surrealism did not come to the American West in the luggage of the European artist Max Ernst and his wife, the American painter Dorothea Tanning. When they moved to Sedona, Arizona, in 1946, after several trips to the West, Surrealism had already arrived. As Ernst's biographer, Patrick Waldberg, commented, "It was Max Ernst's desire that led him to this land of violent contrasts and natural frenzy. The petrified forests, kingdoms of agate; the painted deserts with their vibrant hues of copper, chalcedony, jasper, peridot, silver and gold; the mining towns where penniless but stubborn prospectors still elbowed up to horseshoe bars; the Navaho, Apache, Yuma and Hopi reservations, where fertility and rain rites were still performed; and, finally, guarded by its armored sentries, the *sahuaros*, the desert itself—the domain of the blackwidow spider and the poisonous pearl-covered Gila monster—earth swollen and cracked from centuries of burning heat like the face of an old Indian, tattooed with yellow and red ochres and softened here and there by labrets of onyx and turquoise—Max Ernst's craving for splendor could be assuaged by nothing less."[8]

Bob Towers's 1951 photograph of Ernst evokes the drama of the desert and creates an aura of sanctity for it (fig. 188). At a window overlooking the Oak Creek Canyon countryside, Ernst holds up a primitivized sculpture of his own making as if it were the Sacrament, and both artist and sculpture are positioned so carefully that the window frames the scene as a surreal construction. For many people including Ernst, Arizona was inherently surreal, a place of constant opposites, as Tanning described the desert landscape. "Imagine the pure excitement of living," she wrote, "in such a place of ambivalent elements. Overhead a blue so triumphant it penetrated the darkest spaces of your brain. Underneath a ground ancient and cruel with stones, only stones, and cactus spines playing possum. The evilest creatures of nature crawled, crept, scurried, slithered, and observed you with hatred."[9]

Fig. 188
Max Ernst holding original concrete for *Sedona Figure*, Arizona, 1951

It was a diverse group of artists who gathered in the American West, informed by Surrealist ideas, and reshaped local traditions.[10] Vance Kirkland (1904–1981), for example, a native of rural Ohio who trained at the Cleveland School of Art, has become synonymous with Colorado Modernism. The founder of the University of Denver's School of Art, Kirkland made his home in Denver, which served as his base for exploring the Rockies. Daunted by the dominating landscape and dismayed by Colorado's tourist art—tepid landscapes of purple mountains and golden aspens—Kirkland made watercolors in the 1930s that demonstrate his conviction that he "had to change nature" in order to focus on the paint as opposed to the overwhelming subject that surrounded him.[11] This he accomplished by closing in on his subject, highlighting the details of rocks and gnarled tree limbs, often magnified and exaggerated to reflect the mysterious boundary between life and death at timberline.

Kirkland's *Timberline* (1939; fig. 189) and *6 Million Years Ago* (1945; fig. 190) are reminiscent of works by California's Henrietta Shore and Edward Weston, whose paintings and photographs, respectively, feature landscapes torn by time

Fig. 189
VANCE KIRKLAND
Timberline, 1939
Watercolor on paper, 22½ x 30 in.
Kirkland Museum of Fine & Decorative Arts, Denver

Fig. 190
VANCE KIRKLAND
6 Million Years Ago, 1945
Watercolor and gouache on paper, 22 x 30 in.
Kirkland Museum of Fine & Decorative Arts, Denver

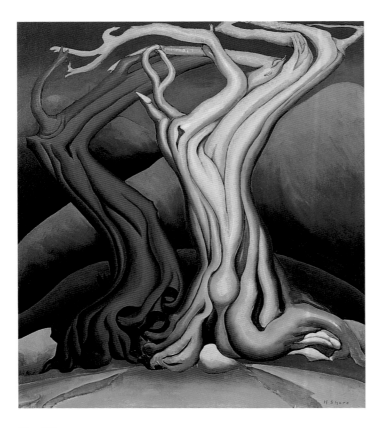

ern subject matter and turn it to new ends through thickly applied paint, swirling motion, and little regard for conventional perspective. In his painting Graves includes a strange, ethereal glass jar that contains a wildflower, a sign of gentle life waving in the wind and articulated with smooth brushstrokes. Through his depiction of the glass and the bright floral note of red, Graves adds a delicate sign of life that contrasts with the thickly painted ominous background.

Born in Fox Valley, Oregon, Graves spent most of his life in the Seattle area and in northern California. Best known for his subtle watercolors of birds and fragments of nature and for his sense of quietude, Graves came to national prominence in 1942 — one year before Pollock — when curator Dorothy Miller included him in the celebrated group exhibition *Eighteen Americans from Nine States* at the Museum of Modern Art. Graves's interest in Surrealism was combined with an interest in Asian art and aesthetics that he knew from

and weather, taking on anthropomorphic traits (figs. 191 and 192). However, Kirkland's compositions reflect Surrealism's fascination with "primitive" religions. In *6 Million Years Ago,* tiny beings enact some sort of ritual among the moss and lichen growing on dead piñon trees, while menacing animal figures appear as spectators. Colorado's timberline — a liminal space in which high altitudes not only alter perceptions but illuminate the struggle for life — perfectly expressed for Kirkland the state of being between reality and the imagination (or the unconscious) so privileged in Surrealism.

The Pacific Northwest visionary Morris Graves (1910–2001) also used Surrealism to recontextualize motifs associated with westward expansion. His paintings of the 1930s, particularly *Memorial Day Wild Flower Bouquet in the Cemetery of an Abandoned Western Mining Town* (1936; fig. 193), are closely aligned with the bleak image of Pollock's *Going West* of the same period. Both artists employ regional or west-

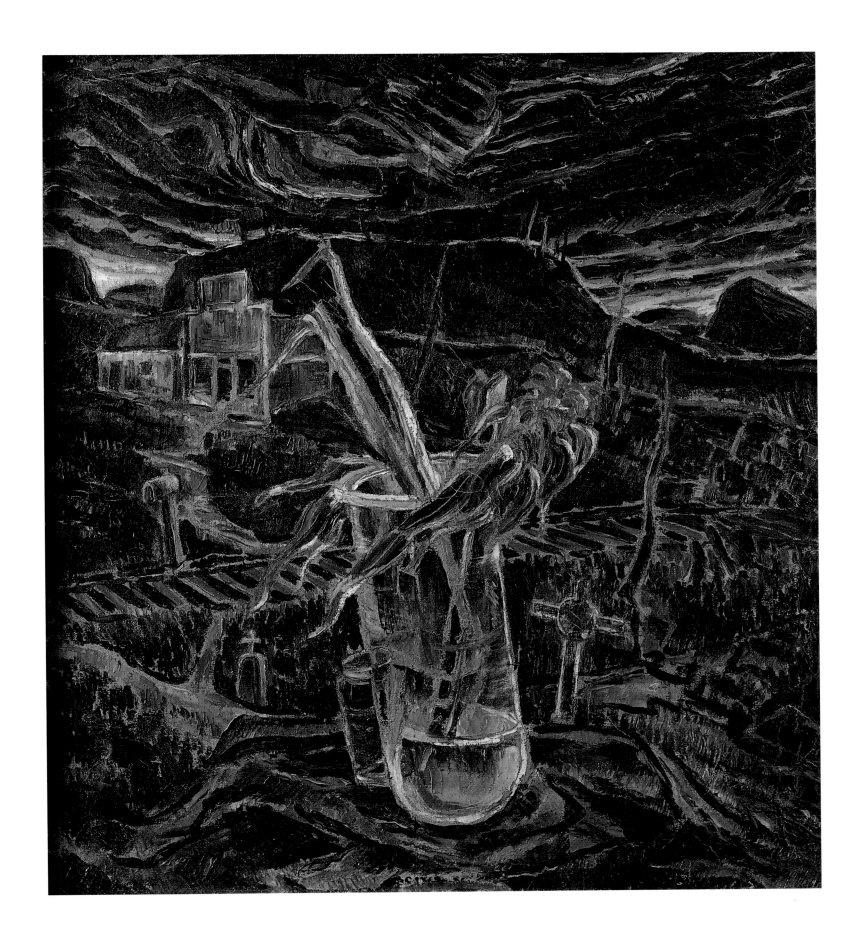

travel, from the Seattle Art Museum's collection, and from curator Ernest Fenollosa, as well as his own study of Asian philosophy. In the Pacific Northwest, Graves staked his claim in a landscape between the Occident and the Orient, engaging the "Janus-faced" notion of the Pacific Coast that earlier artists had created as a way of situating their work.

His father, Graves remarked, "had a Whitmanesque chest-bared-to-the-storm attitude toward the West" that led him to several boom-and-bust enterprises, including prospecting and mining.[12] Graves himself, wracked with pneumonia in his early years, was quite frail, missed high school, and was not particularly interested in it anyway, preferring to explore the flora and fauna of his environment. In his late teens he and his elder brother, Russell, served as cadet seamen and traveled throughout Asia and Hawaii. Graves's Asian tour awakened new attitudes and sparked beliefs that would sustain him throughout his career. Recalling the trip, he said, "It was the acceptance of nature (not the resistance to it)—that impressed me. I had no sense that I was to be a painter but I breathed a different air."[13] Consequently, Graves began to feel confined by geography. As he expressed it, "I had been driven by the uncultivated aspect of the Northwest. The way we think of Alaska was the way I felt about Puget Sound." Then twenty years old, he felt the need to move on and settled on relocating to New Orleans. On the way, he visited relatives in Beaumont, Texas, who convinced him to complete high school, which he did while exploring painting and drawing with supportive teachers in the community. New Orleans, however, sustained him only briefly before he felt compelled to return to the Northwest.[14] "My home environment, the climate, and particularly the weather," he wrote, "pulled me back. Our weather is the most remarkable phenomenon: the thing which brings me back to the Northwest. The way weather occurs here—you get into it like an old coat." Animating nature, even making weather something you wear, Graves consistently and perceptively merged art and life. In Seattle he began informal study with the painter Guy Anderson, with whom he traveled and camped through the West Coast, stopping to make money along the way by picking grapes and harvesting hay. On this 1934 journey, Graves observed the many abandoned buildings in ghost towns made even drearier by the escalating effects of the Great Depression.

Memorial Day Wild Flower Bouquet could represent any number of empty mining towns in California, Washing-

ton, or east of the Cascades. Graves packs every symbol of Whitman's robust West into this image of a dead landscape. He used sacking for canvas, allowing much of its coarseness to come through to the surface, and applied mostly gray and black paint with a palette knife to suggest a stormy sky, a mountainous background, a false-front building, and railroad tracks that divide the painting in half and give structure to its overall pattern and line. A cemetery dotted with gravestones and crosses appears next to the trestle, but the composition is dominated by a delicate still life in the foreground, perched on a precipice overlooking the scene. The composition's near/far tension is derived not from southwestern desert optics but from both Surrealism and Asian aesthetics (*enkinho*). Graves's sense of refinement and restraint is evident even at this early stage of his career. With somber hues he achieves an evanescent quality of glowing light. These formal paradoxes parallel the strangeness of the western scene, so that the viewer is simultaneously attracted to features like the delicate flower and threatened by the gathering storm that caps the painting.

During the same year that Graves painted *Memorial Day Wild Flower Bouquet*, he met the composer John Cage, who had moved to Seattle to take a job as a piano accompanist. It may come as a surprise that Graves, an artist well known for his seclusion and quiet demeanor, indulged in Dada antics with Cage. Yet Graves recognized a connection between Dada and Surrealism's respect for the irrational and "Zen wit, the insight through paradoxes, the jest and humor in the riddle of creation," as he wrote, which would have been reinforced by his interest in Surrealism and his perception of the strange contrasts he saw in the western landscape.

Working in Prescott, Arizona, the photographer Frederick Sommer (1905–1999) heightened reality by focusing on the strange and perception-altering aspects of the western desert. Born in Italy, reared in Rio de Janeiro, and trained as a landscape architect at Cornell University, Sommer frequently credited his architectural training and experience for laying the foundation for his photographic practice. Stricken by tuberculosis, he recovered in Switzerland in 1930 and, while furthering his interest in drawing and painting, took up photography. In 1931 he moved to Tucson and four years later to Prescott, choosing Arizona largely because the climate was beneficial to his recovery. But during an interview in 1976, he claimed that his decision to move had sprung from his expe-

rience driving through Arizona's mountains, hills, and empty stretches of space, where he observed the "cardboard like outlines on the horizon" and felt what he called "a beckoning." "There was a surreal quality to this tonewise, colorwise," he said. "All of this, all of this, really, I think more and more, started to lay the foundations for clarifying my preferences."[15] Sophisticated and ambitious, Sommer sought out Stieglitz in New York, maintained friendships with Weston and Ernst, and thoroughly immersed himself in a photographic vision that embraced an "anti-tourist West" that focused on the "in-between-the-National-Parks-country."[16] Using an 8-x-10 view camera, Sommer portrayed a West few had seen or were prepared to see.

Sommer never learned to drive, but his wife, Frances, a state social worker assigned to Yavapai County, would frequently drop him off for hours in the Arizona desert when she made stops to visit clients. Sommer also explored other landscapes in a triangular area between Wickenberg, Bagdad, and Yarnell. The "Plans for Work" that he drafted about 1945 outlined his intentions to travel to Death Valley and Utah, as well as to desert stretches in Arizona.[17] Without using the term "Surrealism," he nonetheless stated his goals in a language common to it, stressing "chance juxtapositions" and "laws of chance" and the aesthetic potential of his chosen sites: "The beauty and the authentic living record of the West can be obtained only by emphasis in the complete photographing of minute detail in the landscape." He would choose sites that had "intense vitality" and would photograph them so that "no one part or aspect is favored over any other part....Complete use is thus made of chance juxtapositions everywhere widely occurring in nature. Photography should make use of the vast unexplored possibilities of the laws of chance which have played such an important part in the development of contemporary painting." Chance encounters with landscape incidents of "intense vitality," he believed, would unleash a new art of heightened reality and awareness, derived from an approach in which each pictorial element is no more or less emphasized than any other— making an unfamiliar desert even more so. This approach overthrows the conventions of landscape, so that the exacting detail of the image lures viewers while the distorting perspectival effects keep them at bay. Flux in the landscape thus has its corollary in the viewer's experience of looking at the photograph.

In 1945 Sommer made a series of straightforward photographs of dead horses, coyotes, and jackrabbits that he found lying in the desert. In *Horse* (1945; fig. 194), Sommer focused on a decaying carcass. Dramatic cropping and parallel framing of the legs and hooves at top and bottom stabilize the composition and also suggest arrested motion that brings this image of death impossibly alive. At left can be seen an empty patch of finely detailed earth and, at right, a thorough blending of earth and decaying flesh and bone. Dirt and sand appear to take over the corpse, but Sommer's focus is so evenly dispersed throughout the photograph that the body parts seem to be pushing through the earth. Through the image of the decaying horse, Sommer shows the process by which one form of life is exchanged for another, recalling Surrealism's staked claim to states of being between life and death, reality and the unconscious.

Sommer was surprised that photographs such as *Horse* disturbed viewers, particularly as it was taken during World War II, when death and dying were a part of daily life.[18] By using war as his defense—how could a long-dead horse carcass be any more disturbing than the horrors of war?—Sommer leaves open the possibility that these images of dead animals were his way of negotiating war's grim realities. What was disturbing about the photographs at the time was perhaps the fact that Sommer calls attention to the process of decay as opposed to the final state, unlike the work of O'Keeffe, in which the beauty of white bones standing out starkly against the desert "justified," she said, "the animal for having lived." Sommer's photograph is not an overt exchange between artist and found object, but an exchange among the landscape components themselves. "Climatic conditions in the West," he explained, "give things time to decay and come apart slowly. They beautifully exchange characteristics from one to another."[19] This concept of integration is critical to an understanding of Sommer's work, for he frequently talked of the "linkages" and connections to which his art drew attention. "Essentially I am a design specialist," he wrote, "an orientation always taken in the awareness that anything I am able to touch is because it touches something else. That is so natural....Unless we want to become abandoned or estranged we have to come to terms with our environment. From not finding in the desert what I was accustomed to seeing in a landscape, I gradually had to realize that other things make up a landscape. The desert can be a stingy, stark situation, but

by the time you take a few pictures you start to see the inter-relationships."[20] As he once remarked with terse understanding, "Whereness is concerned with linkages. The legato of one squirrel holds a forest together."[21]

Edward Weston's *Mustard Canyon, Death Valley* (1939; fig. 195) shows a similar concern. However, "chance juxtapositions" for Sommer were "subtlety and sudden contrasts" for Weston, whose photographs maintain a feeling of sensu-

ousness and drama as opposed to Sommer's relentless evenness.[22] In this photograph Weston frames a small fragment of a site near the Harmony Borax Works in the shadow of the Mojave Desert's Funeral Mountains. In *Mustard Canyon* (the site is named for its yellow salt deposited there by water evaporating from the porous rock), the push-pull effect of mineral accretion against hard rock signifies flux and trans-figured states. Because the image is taut in its edge-to-edge

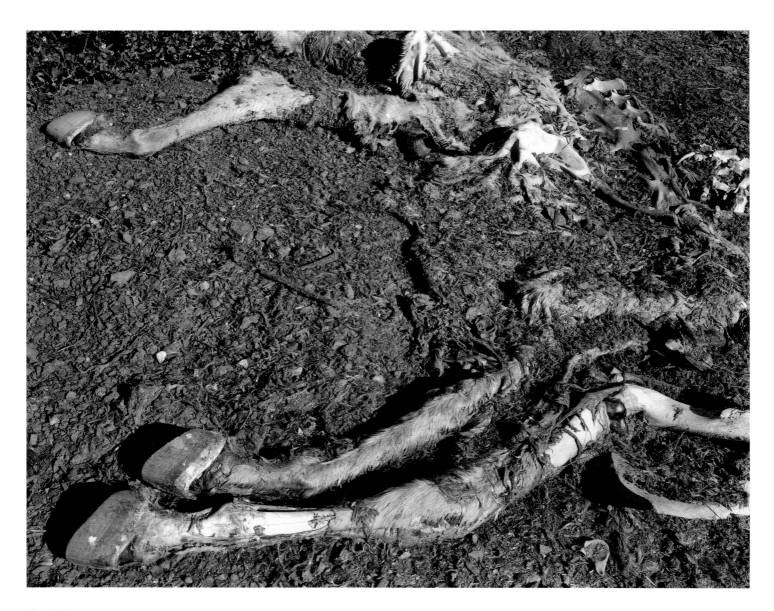

Fig. 194
FREDERICK SOMMER
Horse, 1945
Gelatin silver photograph, 7 ½ x 9 ½ in.
Frederick & Frances Sommer Foundation, Arizona

dispersal of energy, it is difficult to discern whether the light areas are pushing through the dark ones, or vice versa. Without familiar anchors such as a horizon line, point of view and scale are eliminated and the viewer is left disoriented by the lack of reference to space and place and instead is directed toward pattern, design, and texture.

Although Weston did not use the term "surreal" in his writings, eschewing academic formulations, he had earlier described his art in terms that echo the language of the Surrealists. To his friend and colleague Ansel Adams, Weston wrote in 1932 of his still-life compositions: "I have on occasion used the expression, 'to make a pepper more than a pepper.' I now realize that it is a carelessly worded phrase. I did not mean 'different' than a pepper, but a pepper plus,—seeing it more definitely than does the casual observer, presenting it so that the importance of form and texture is intensified....I

Fig. 195
EDWARD WESTON
Mustard Canyon, Death Valley, 1939
Gelatin silver photograph, 7 11/16 x 9 9/16 in.
The Lane Collection, Museum of Fine Arts, Boston

don't want just seeing—but a presentation of the significance of facts, so that they are transformed from things (factually) *seen*, to things *known*: a revelation, so presented—wisdom controlling the means, the camera—that the spectator participates in the revelation."[23] Weston captured this intensity of experience that is Surrealist in its notions of transfigured states. In Weston's art the resolution of contradictory elements among themselves into something that is beyond reality—*sur*-reality—has its echo in André Breton's 1930 manifesto of Surrealism, one of many he wrote beginning in 1924: "Everything suggests that there exists a certain point of the mind at which life and death, the real and the imaginary, the past and the future, the communicable and the incommunicable, the heights and the depths, cease to be perceived contradictorily. Now it is in vain that one would seek any other motive

for surrealist activity than the hope of determining this point."[24] To use Weston's terminology, in *Mustard Canyon* we see a "West plus" that reveals a kind of transfiguration that he locates in the desert, a revelation of flux, motion, and the impossibility of static nature.

Even in classic Weston photographs, such as the earlier *Dunes, Oceano* (1936; fig. 196), this oscillating principle is at work, although here matter is not exchanged or transfigured but altered simply by the unseen force of wind. Weston first encountered California's Oceano and Pismo dunes in 1934, and he returned there with Charis Wilson in 1936. The area was well known as a colony of bohemians, hoboes, writers, artists, and Depression-era end-of-the-liners, collectively called Dunites (Weston and Wilson referred to them as "dune rats"), who lived in shacks and tents along a stretch of land off High-

Fig. 196
EDWARD WESTON
Dunes, Oceano, 1936
Gelatin silver photograph, 8 x 10 in.
Margaret M. Weston and The Weston Gallery, Carmel, California

way One, about halfway between San Francisco and Los Angeles.[25] Although Weston congregated with the locals, he had come to photograph the dunes, which he said were "made-for-photography" because of their sharp black-and-white tones. Wilson was discouraged when she saw that they were, in fact, tan and gray, but Weston moved beyond the low-lying dunes deeper into the landscape, where hills of sand could reach a height of one hundred feet and slip faces plunge precipitously. "We were soon surrounded by trackless wastes," Wilson wrote, "where it was easy to work up…a lost-in-the-Sahara feeling."[26]

Weston chooses a perspective that juxtaposes these vertical banks with dunes of softer contours; a dramatic shadow at upper right creates a dashing flourish. He produces consistent energy and tension throughout the image by means of

his vantage point, which flattens the surface with patterned bands of smooth, rounded, razor-sharp, billowing, and sinuous contours. The vertical banks, in which the constantly sliding sand created what Wilson called a "mysterious fishtail frieze," display tadpole-like curving lines that swim upstream, so that what might normally be a static image of an empty desert is instead alive with movement and flux. Weston must have recognized his achievement; this photograph introduced his 1939 article for *Camera Craft*, "What Is Photographic Beauty?" in which he argued that the beauty of the photograph derived from the "super realism that reveals the vital essence of things."[27]

Laura Gilpin also turned her lens on desert sands to discover a "vital essence." However, her *White Sands* (1945; fig. 197) focuses uniformly on abstract pattern, with little

Fig. 197
LAURA GILPIN
White Sands, 1945
Gelatin silver photograph, 7 1/2 x 9 1/2 in.
The Museum of Fine Arts, Houston, Gift of Clinton T. Willour
in honor of Louisa Stude Sarofim

emphasis on the flux of Weston's compositions. Gilpin achieves a severe, classic beauty here, dividing the vista in half, so that the windblown gypsum sands in the foreground lead toward the cone in the distance, its crescent shape and smooth hollow forming the pinnacle. By making the background dark, through the use of a filter during exposure or in the printing process, Gilpin accentuates the eerie drama of the shadowed surface, so that the cone looks more like a lunar landscape announcing what will become known as the final frontier of outer space. It is, in fact, a tourist site: White Sands National Monument in the Tularosa Basin near Alamogordo in New Mexico, renowned as the largest gypsum-sand dune in the world. At the time Gilpin photographed the site, beginning in the 1940s, the area was becoming a home for military personnel and a stage for war preparations. Fewer than one hundred miles away, on the adjacent White Sands Missile Range, the Atomic Age was born at the Trinity Test Site, where the first nuclear bomb was detonated in the summer of 1945. The combination of beauty and destruction, the latter informed by the subsequent knowledge of what happened there, affects an understanding of the photograph; although Gilpin's photographic vision could not be described as Surrealist, it is difficult to imagine a more disjunctive site than that which inspired this one, where nature and what is known of science collide in cold, stark relief. The Atomic Age and desert geography would become inextricable in the minds of the American public, testimony to the ongoing belief that deserts, like Arctic tundra, are "empty," and thus justifiably expendable in the economy of landscape. By making this desert monument look like it belonged to another world, Gilpin unwittingly announced a terrifying new age.

A NEW PALIMPSEST

Writers and artists had long identified American Indian art as a source for revitalizing Anglo-American art, as previously discussed in this book. By the 1940s, however, in an atmosphere rife with Freudian and Jungian explorations into the unconscious and the subconscious, the symbology of American Indian art assumed a more central role than it had in the past, as it now expressed "primitive" and primordial modes of thinking in terms of abstracted symbols. These ideas resonated with Jackson Pollock, whose appropriation of American Indian art asserted his western sensibilities, invigorated his art, and provided him with a structure for exploring his own psyche.

When Pollock moved to New York in 1930, he may have seen the *Exposition of Indian Tribal Arts* at Grand Central Galleries—a show that John Sloan, who would later serve as his teacher, organized in 1931 to enormous fanfare. During the early 1930s Pollock bought twelve volumes of the illustrated annuals of the Bureau of American Ethnology and, according to his wife, the painter Lee Krasner, he kept them under his bed. Frequent visits to New York's American Museum of Natural History and the Museum of the American Indian further deepened his interest in the art and the rituals of Indian religions. Groundbreaking as it was for many artists and for audiences' perceptions of American Indian art at the time, the exhibition *Indian Art of the United States* in 1941 at the Museum of Modern Art proved a lifeline for Pollock. He visited the show numerous times and discussed it at length with his Jungian analyst. Pollock's friendship in the early 1940s with the Russian émigré artist and critic John D. Graham, who wrote about "primitive" art and the unconscious, also made him especially receptive to the art and ideas expressed in the MoMA exhibition and validated Pollock's personal exploration of archetypes, animism, and shamanism. These experiences, reinforced by memories of his western childhood, provided Pollock with a framework not only for his exploration of the western landscape and his memory of it but also for the inward journey he took through Jungian psychoanalysis.

Unlike his contemporaries and friends who appropriated American Indian art from books and museum exhibitions —Abstract Expressionists such as Adolph Gottlieb and Indian Space painters such as Steve Wheeler and Peter Busa —Pollock used his personal experience in the West as a way of nurturing his understanding of American Indian culture. What was metaphor or simile for his contemporaries took on the added power of personal fact for Pollock. The landscape and memories of his youth, combined with further study and reflection, allowed him to claim a certain authenticity that other observers and advocates noted. Pollock, as his brother Jay phrased it, "felt a kinship with the Indian people."[28]

In his paintings of the 1940s Pollock referred to Indian symbols as he explored what photographers such as Sommer and Weston were achieving in their compositions of the desert landscape. Similar to Sommer's *Horse* and Weston's *Mustard Canyon*, the taut, heavily worked surface of Pollock's *Night Mist* (1945; fig. 198) evokes an exchange in which

fragmented symbols, in part inspired by "primitive" cultures, emerge from below a white-and-gray pattern of aggressive lines and shapes. Areas of blue, yellow, green, and red pulsate from below the surface, making the viewer aware of the layers and the tension between the white web and the fragments of humans, birds, eyes, and faces—a nocturnal haunting. Visible, however, are clear references to shapes and patterns that Pollock explored in the late 1930s and early 1940s, particularly as they relate to American Indian art and mythology. Paintings such as *Night Mist* act as a palimpsest in which the physical fact of the landscape and cultural references placed upon it—as in the petroglyphs and writings at El Morro—inscribe a psychological history of Pollock's experience of western lands.

Night Mist reveals Pollock's principles in practice. The painting contains an altarlike rectangle at lower center, flanked by what appear to be cave painting-like stick figures; a female figure, at left, indicated by a diamond shape and a figure eight on its side to indicate breasts; and a figure, at right, whose "head" appears in other paintings of the period. Art historian W. Jackson Rushing has linked the altarlike rectangle to specific American Indian images and rituals that Pollock would have encountered in his Bureau of American Ethnology annuals and in Indian art more generally, including the formal composition of Zia Pueblo sand paintings.[29] Pollock often interspersed references to American Indian art of the Northwest Coast with the art of other cultures; in general, he was not wedded to meanings related to any specific culture, as he was more broadly interested in ancient symbols and hieroglyphs of a primordial spirit world.

These symbols fascinated Pollock, in part as a source for and a vestige of a modern and collective unconscious

Fig. 198
JACKSON POLLOCK
Night Mist, c. 1945
Oil on canvas, 39 x 72 1/8 in.
Norton Museum of Art, West Palm Beach, Florida, Purchase, the R. H. Norton Trust, 71.14

(ubiquitously discussed in the 1940s), but also for what he saw as their unalloyed formal power and force. While he was undoubtedly familiar with the religious tradition of Navajo sand painting, Pollock's first documented encounter with it was at the 1941 exhibition at MoMA, where he observed Navajo artists making sand paintings on the gallery floors (fig. 199). The ceremony clearly had an effect on Pollock, who eventually moved his canvases to the floor of his studio and released a steady stream of pigment on them, at times even sand. It should be noted that Navajo sand paintings were ephemeral, swept away when the ceremony of bringing back the balance and health of the patient—restoring *hózhó* (roughly translated as harmony, beauty, health, and moral goodness)—was completed.[30] However, the pictographic compositions made from sand, minerals, and pollen were preserved to an extent in deluxe print portfolios, such as *Where*

the Two Came to Their Father: A Navajo War Ceremonial (1943; figs. 200 and 201).

It is unknown whether Pollock owned or had access to this particular portfolio, but, given his interest in Indian art and religion and his Jungian connections, it would be difficult to believe that he was unfamiliar with it. *Where the Two Came to Their Father* is a remarkable collaboration documenting a ceremony led by Jeff King (born c. 1870), a Navajo religious figure, who conducted the ceremony for Navajo men departing for the armed forces; the artist Maud Oakes (1903–2000), who received permission from the Navajo to preserve the sacred ceremony through prints that she made from the original sand paintings; and Joseph Campbell, the writer and professor of comparative mythology who had studied with Carl Jung, wrote the text placing the ceremony in its larger context of symbology. Published as

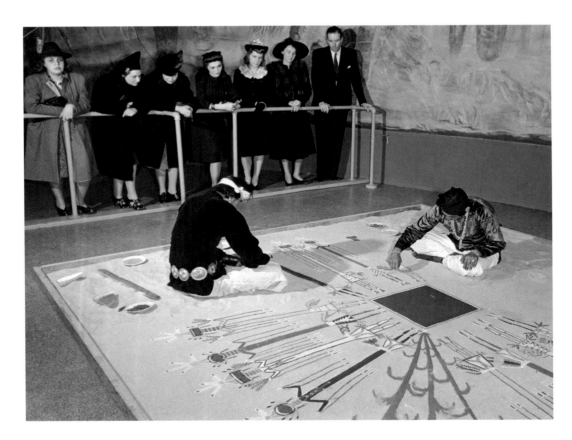

Fig. 199
Navajo Indians executing sand painting, March 26, 1941, during the exhibition
Indian Art of the United States, at the Museum of Modern Art, New York
The Museum of Modern Art, New York

part of the Bollingen Series (funded by Paul and Mary Mellon, who aimed to publish English translations of Jung's writings), *Where the Two Came to Their Father* would have been widely known by those interested in Jung, as well as by those who attended an exhibition at the Mellon-supported National Gallery of Art in Washington, D.C., in 1943, *Navaho Pollen and Sand Painting*, which included Oakes's depictions of the ceremony.[31] The exhibition was covered in both the art press and the *New York Times*.[32] The portfolio and its striking images preserved and documented native rituals learned by the sand painters through years of study and apprenticeship, and it offered aesthetic and spiritual possibilities for a probing artist like Pollock.[33] The emphatic, spare, modern look of the paintings likely appealed to culturally attuned 1940s audiences, who would have made aesthetic connections between native culture and the reductive geometries and pictographic symbols seen in modern art.

Pollock's direct engagement with *Where the Two Came to Their Father* is unclear, but he was certainly embedded in the tripartite culture of *hataali* (healers), comparative mythologists, and artists that it evokes. Throughout his career, and in a self-referential maneuver, he reworked the various kinds of symbols, merging the hieroglyphs and other signs of a "primitive" spirit world with references to his own earlier works. *Night Mist* is a more abstracted and loosely configured version of his earlier *Guardians of the Secret* (1943; fig. 202), which represents two figures flanking an altar and, below it, a she-wolf lying on her back.[34] These memory traces bubble up and sink in Pollock's energized canvases of this period, and they move between two states, call it conscious or unconscious,

Fig. 200
JEFF KING and MAUD OAKES
Where the Two Came to Their Father: A Navajo War Ceremonial
Bollingen Series I, 1943
Plate XVII—Sun's House Guardians "Big Thunder Painting"
14 7/8 x 24 1/2 in.
Hirsch Library, The Museum of Fine Arts, Houston

background or foreground, abstraction or representation, or past or present. Using the device of the white web, Pollock moves back and forth between the surface and what lurks beneath it, figures and symbols with private meanings, as a way to represent the concept of integration and even *hózhó*.

Clyfford Still (1904–1980), another artist from the West, likewise cultivated this push-pull quality in his paintings, in which figure and ground become increasingly undifferentiated. Born near Fargo, North Dakota, he was a child when he moved to Spokane, Washington, with his family, who also had a wheat farm in Alberta, Canada. He studied at Spokane University and at Washington State University, where he later also taught, before moving to California in 1941. By 1946, the same year that Peggy Guggenheim introduced his work at her Art of This Century Gallery in New York (three years after Pollock's debut), Still had become the key figure of what many describe as a West Coast "school" of Abstract Expression-

ism based in the Bay Area and centered in San Francisco's California School of Fine Arts. Although Still either shunned the term "Abstract Expressionist" or claimed that he was the founder of the movement, he developed a path into abstraction along the lines of Pollock, Mark Rothko, and Barnett Newman long before he became familiar with their work.[35] Well educated in the history of art (his master's thesis focused on Paul Cézanne), Still was erudite, steely in his personality, and virtually self-taught when it came to studio practice, a fact that helped him promote his lifelong devotion to artistic freedom. Although this sounds like a bromide in today's cynical world, at the time the celebration of individuality in a conformist culture was liberating, and Still's devotion to these ideals made him an influential teacher. In this engagement with artistic liberation, Still promoted a western mythology associated with Pollock: the lone, isolated, rugged western frontiersman struggling to make art in a hostile world.

Fig. 201
JEFF KING and MAUD OAKES
Where the Two Came to Their Father: A Navajo War Ceremonial
Bollingen Series I, 1943
Plate XIV— "Earth and Sky"
14 7/8 x 24 1/2 in.
Hirsch Library, The Museum of Fine Arts, Houston

In broad terms, Still shared Pollock's childhood experiences of the West. When Still's family moved to Bow Island in southern Alberta, they were following the patterns of agricultural settlement. Bow Island opened to homesteading one year before the Still family moved there to till the land in an extreme climate that led to Dust Bowl conditions during the Depression. Still reflected on the "hardness" of his experiences on the Alberta prairies, where "man and…machines ripped a meager living from the topsoil…yet always and inevitably with the rising forms of the vertical necessity of life dominating the horizon."[36] The contrast between flatlands and what he called "vertical necessities," "aspirational thrusts," or "life lines"—all reminiscent of the insistent verticality of earlier prairie and desert art in telegraph poles, crosses, grain elevators, church steeples, oil derricks, and human activity—found its way into his paintings after 1946, in which lightning-like forces shoot through the canvas from top to bottom, or encrusted, jagged forms in rich earth tones burst from the

ground or retreat into it, often leaving lines and shapes like those on a topographical map. For Still, as David Anfam has argued persuasively, verticality was a subjective metaphor distilled from his experience of the Canadian prairies and the counterthrust to its broad expanse; it was part of "an impeccable native tradition" that relied on landscape and memory as its most potent force.[37]

Still's paintings of the 1930s, like Pollock's, portray Regionalist Depression-era subject matter turned dark by personal experience. In the mid-1930s Still focused intently on figure/ground relationships, painting male and/or female figures loosely based on Picasso's Blue Period protagonists, as well as on tribal sculpture, Northwest Coast masks, totems, and "hoodoos," the strange towerlike forms in Alberta's badlands. In *Brown Study* (1935; fig. 203), a male figure is shown in silhouette; his elongated hand is thrust down and his masklike face with empty eye sockets pulls itself apart. Ten years later this image was reworked in a lithograph Still

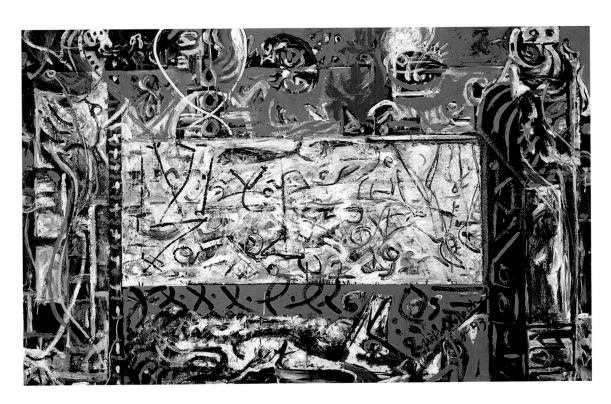

Fig. 202
JACKSON POLLOCK
Guardians of the Secret, 1943
Oil on canvas, 43 3/8 x 75 3/8 in.
San Francisco Museum of Modern Art, Albert M. Bender Collection,
Albert M. Bender Bequest Fund purchase

Fig. 203
CLYFFORD STILL
Brown Study, 1935
Oil on canvas, 31⅝ x 21¾ in.
Munson-Williams-Proctor Arts Institute, Museum of Art, Utica, New York, 75.65

produced during a teaching stint in Richmond, Virginia (fig. 204). Still's memory for past shapes and the contours and textures of his earlier forms reappear and shift in his work, not unlike the great heaving of plate tectonics when form pulls apart and moves over an expanding field. This effect is heightened by his technique of using a variety of palette knives to layer, scumble, and build up his paintings into jagged, rough, earthlike surfaces (one thinks of Gustave Courbet's encrusted canvases) that envelop the viewer. These forms seem to degrade over time and appear on the surface of the canvas like erosional encrustations. They are marked by, as an observer commented, "a violence, a rawness," brilliantly captured in Still's *1954* (fig. 205), in which jagged lines, cadmium red vertical thrusts, and an empty molten black center, form a nonobjective composition that acts as an analog of nature and its effects.[38]

Unlike the literature on Pollock, in which many scholars disagree vehemently on one point or another, Still scholars uniformly identify and embrace landscape references in his art, specifying the sublime, metaphors of geological time, and expansiveness. Critic John Russell dubbed him "wild nature's ambassador."[39] Still encouraged this interpretation, remarking that his art was "of the Earth, the Damned and of the Recreated," a nod to nature's cycles of birth, death, and re-creation, with connotations of spiritual redemption.[40] And he certainly linked himself and his western roots with Pollock's, noting that "it was a grand freedom Pollock and I felt in the West, looking over the mountains being able to move any number of miles."[41] He even quipped, "I paint myself, not nature," resonating with Pollock's infamous remark, "I am nature."[42]

Some painters, like Abstract Expressionist Edward Corbett (1919–1971), clearly grappled with the artist's changing relationship with nature. Corbett, born in Chicago and reared in the Southwest, the Midwest, and abroad, took up residence in New York briefly following his stint as a merchant marine during World War II. There he joined with other artists in their enthusiasm for the possibilities of painting as represented in the work of the Dutch artist Piet Mondrian. What Corbett admired in Mondrian's art was its sense of expansion. Yet he found something chilling in the Neo-Plasticist geometries of Mondrian's canvases and of works by friends such as Ad Reinhardt, who built on Mondrian's lessons. In 1947, tired of New York, where he felt "wedged in by cement, ugly shadows, bad smells and dreary light," Corbett

moved to study and teach at San Francisco's California School of the Fine Arts.[43] In this stimulating environment, associating with art figures such as Clay Spohn, Douglas MacAgy, and Still, Corbett set as his goal the synthesis of the formal rigor he admired in works by Mondrian and others with the warmth of Expressionism. As he phrased it, "The emotion is important in my life as an artist. I believe my first moments of significant awareness of imaginative life, were when I became speculatively involved with the dramatic nature around me."[44] Corbett carefully described the concrete essence of his project: "I am painting a painting, not a landscape....Balance and design concern me, not a possible evocation of landscape. Nor are my paintings landscapes of my mind."[45] However, Corbett's paintings nonetheless bear evidence of his keen appreciation of flux in nature as a metaphor for experience.

In *Untitled* (1949; fig. 206), Corbett sustains tension from edge to edge and leaves "open" a large field of subtle hues that transition from a radiating glow of red/orange at upper left to a creamy white center. A cloudlike form at upper right, cropped forms at far right, and an orange strip at left suggest movement and exactly the expansiveness that

Fig. 204
CLYFFORD STILL
Figure, 1945
Lithograph on cream wove paper, 15 x 10 in.
Oakland Museum of California, Gift of the Art Guild

Corbett sought in his art. The painting is nearly a scrim through which pass fog and clouds. Corbett asserted that his goal was "to give the viewer the emotion of waiting, not the experience of possessing an event, but a mystery in his mind about what might happen," an effect that he claimed was an adjunct of western space, in which empty space becomes a positive value.[46] *Untitled* is about time and expectancy, stopping short of giving the viewer clear grounding; instead, it conjures an effect of nature observed in relation to it and formalized in paint.

Fig. 205
CLYFFORD STILL
***1954*, 1954**
Oil on canvas, 113 ½ x 156 in.
Albright-Knox Art Gallery, Buffalo, New York, Gift of Seymour H. Knox, 1957

Fig. 206
EDWARD CORBETT
Untitled, 1949
Oil on canvas, 61 x 39 1/2 in.
Oakland Museum of California, Gift of Dr. and Mrs. Victor Calef

THE SIMULTANEITY OF SPACE AND PLACE

Maps are diagrams of space that help to find a place. Maps manage chaos by bringing order to space by plotting points on a two-dimensional surface that is implicitly understood to refer to the three-dimensional world. Frederick Sommer's *Arizona Landscape [Large Cactus]* (1943; fig. 207) exposes the rigor behind this idea and brings mapping to a new aesthetic level as it relates to western space and desert place: Sommer holds all of the landscape's constituent parts in dynamic suspension so that space and place are simultaneous. He often used the word "map" to describe his photographs, referring to maps as "plans."[47] This suggests how he perceived the landscape in active terms: "You only know a place if you walk the map. You only know a place if you see it as a map also."[48] Using the terms "occupier" (subject) and "structure" (design), Sommer said that content acts as a place marker that determines structure, and that structure, in turn, determines the map. Subject and ground, and place and space, are layered on top of one another in Sommer's essentially surreal world. He dismissed the near/far optical tensions that had defined the desert West for generations. By stretching the desert across the ground, he designed a new way of looking at and understanding the world around him.

This approach did not come easily to Sommer, who spent several years trying to understand the desert as a landscape. "For years," he wrote, "I looked at the Arizona landscape and it seemed almost a hopeless task.... It was just like a situation where everybody was in trouble. All those plants were dry and dead and dying.... What was the difference between the top of the picture and the bottom of the picture? It was all the same. But there was a difference. The only thing is that it was more subtle.... there's a great deal going on. Maybe this helped me to realize that I was also looking at details.... Finally, there was no foreground, there was no middle distance, there was nothing. And, there was very little distinction between the plants and the rocks. Even the rocks were struggling."[49] Removing the horizon line entirely, as he does in *Arizona Landscape*, Sommer created intensely flattened landscapes in which saguaros look like white matchsticks carefully plotted in the landscape; sagebrush appears to be dark cotton balls; and landscape contours appear simply as surface highlights of light or dark. All is revealed and revealed evenly with a crystalline clarity, and this overall evenness is jarring because Sommer denies the viewer the age-old landscape tradition of atmospheric perspective. Despite and because of Sommer's clarity, it is difficult to understand where we are or even exactly what we see. In order to begin to understand, Sommer forces us to observe the details close up and the patterns from afar, and even so it is nearly impossible to get our bearings. Sommer unmasks the lie that the desert is empty and devoid of interest. More important, the desert and Sommer's "maps" of it are something, he seems to say, that must be understood in time by moving back and forth, even if his images defy any sense of settling into the landscape comfortably.

Mark Tobey (1890–1976) shares Sommer's taut expansion, careful balance, and enormous world of details: organic forms, white dashes, and squiggles hover over his surfaces. Tobey "wrote" his paintings—referred to as "white writing"—recalling the Asian tradition of calligraphy as an aesthetic expression equal to painting. In *Written Over the Plains* (1950; fig. 208), Tobey layers his surfaces, working from dark to light, loose to tight, often rubbing the surface to blend color or burnish it: chalky white background passages, areas of red and terra-cotta, soft blues, active lines of white on the surface, and black and blue lines that "pop" and create a quality of infinite space. Just as his paintings express the tension between surface flatness and space, frenzy and stasis, Tobey thought of himself and his place in the world in similar terms: "Standing as I am here between East and West cultures, I sometimes get dizzy as I find I can't always make a synthesis and also that I admire both paths which should and will, I suppose, merge."[50]

Born in 1890 in Centerville, Wisconsin, Tobey, the son of a carpenter, was reared in the town of Trempealeau on the Mississippi River. In 1923 he moved to Seattle because he liked its "spatial sense."[51] Virtually self-taught as an artist, he learned Chinese brushwork from artist Teng Kuei and familiarized himself with the work of Arthur Wesley Dow and Ernest Fenollosa. To enhance his interests, he traveled throughout Asia in 1934.[52] Tobey admired the elegant balance in Asian religion and art and in his adopted religion, Baha'ism. Based on the teachings of a nineteenth-century Iranian religious figure, the Baha'i faith promotes an evolutionary process by which all religions will become one, and holds that science and religion, the two principal forces of life, must be weighed in careful balance. Tobey confessed that his faith had an impact on his art: "I've tried to decentralize, and interpenetrate

Fig. 207
FREDERICK SOMMER
Arizona Landscape [Large Cactus], 1943
Gelatin silver photograph, 7 ½ x 9 ½ in.
The Museum of Fine Arts, Houston, Gift of The Brown Foundation, Inc.,
The Manfred Heiting Collection

Fig. 208
MARK TOBEY
Written Over the Plains, 1950
Mixed media on paper mounted on Masonite, 30 1/8 x 40 in.
San Francisco Museum of Modern Art, Gift of Mr. and Mrs. Ferdinand C. Smith

so that all parts of a painting are of related value. Perhaps I've hoped even to penetrate perspective and bring the far near."[53] Instead of moving between foreground and background, Tobey penetrated space by bringing bottom to top; bringing the far near counted for more than optical effect in perspective, also representing his sense of place and the importance of geography.

To those who insisted on calling Tobey a "Northwest painter," ever the dean of Northwest painters, he replied, "I'm no more a Northwest painter than a cat."[54] Geography, for him, was not so much a specific place as it was a set of relational values. In Seattle he was acutely aware that he literally faced (as he embraced) the Far East as well as the eastern United States. His sense of internationalism was rooted in geography and reinforced by his faith.

Tobey's "white writing" began in the 1930s with his paintings of New York lit up at night. White lines both defined the contours of city streets and buildings and radiated a nocturnal glow. In time, the relationship between the white lines and specific city scenes became increasingly undifferentiated, resulting in a generalized sense of "the frenetic rhythms of the modern city…the restless pulse of our cities today."[55] As if referring to *Written Over the Plains*, a painting inspired by one of his many cross-country journeys, Tobey exclaimed, "America, my land with its great East-West parallels, with its shooting-up towers and space-eating lights—millions of them in the night sky."[56] Here Tobey conveys breadth and transposes to canvas his experience of having observed the twinkling lights through the window of a railroad car as he crossed his native plains.

Although working in an abstract idiom, Tobey shunned nonobjective art, which he would later consider an academic discipline. He insisted on the content of his art, "time, place and history," all of which would assume an aesthetic and moral balance of constituent parts. Like many artists of this period, Tobey shared a desire for healing and a search for psychic oneness in international terms that he felt he was equipped to articulate from his vantage point along the Pacific slope.[57] "Our ground today," he wrote, "is not so much the national or the regional ground as it is the understanding of this single earth.…Ours is a universal time and the significances of such a time all point to the need for the universalizing of the consciousness and the conscience of man. It is in the awareness of this that our future depends."[58] By care-

fully balancing "the Orient, the Occident, science, religion, cities, space, and writing a picture," as he wrote, Tobey sought to correct the imbalance he perceived in Modernism. "The thing we've got to fight for now is humanism, it's the highest thing we know; we can't mechanize ourselves out of existence."[59] Art historian Joshua Taylor once described Tobey's sense of line as "a path more than a boundary," and, in that regard, Tobey expressed the holistic yearnings and a sense of mission that many American artists felt for an international art before and after World War II.[60]

The moral thrust of Tobey's art may also be seen in the work of Ansel Adams, who was concerned that a rupture with the land would "shrivel the spirit of the people."[61] Unlike Tobey, Adams did not concern himself with issues of internationalism. Instead, he self-consciously took up the mantle of the nineteenth-century survey photographers whom he had helped to rediscover. Photography had come of age in the American West, and, as Adams's friend curator Nancy Newhall phrased it triumphantly, photography was "a new art in a new land," with Adams as a kind of second-generation photographing pioneer.[62] He produced a body of work so refined in its formal beauties, so rich in its relational values, and so unabashedly passionate in its love of the landscape that he set up an ideal marker of pristine wilderness. This marker will, for the foreseeable future, be used as one measure of humankind's relationship to nature. Adams's overwhelming popular reception and the clarity of his vision and superb technical skill also earned him detractors. Many critics saw something retardataire in his reverential treatment of the land, as if it were accompanied by too many trumpeting horns, or that his positivist view was quaint. However, in such masterpieces as *Surf Sequence* (1940; figs. 209–13), Adams carefully balanced formal and spatial concerns with time in a way that more closely approximates, albeit more gently, Sommer's desert views. Adams's time was not the geologic time recorded by the nineteenth-century photographer Timothy O'Sullivan, but rather the ephemeral pleasures of nature's broad rhythms and their sense of expansiveness.

In 1940 Adams visited his good friend and colleague Edward Weston and undoubtedly viewed Weston's *Surf at Orick* (1937; fig. 214), taken along the coastline of California's Humboldt County from a cliff looking straight into the surf. Shortly thereafter, when Adams traveled on Highway One near Pescadero, in San Mateo County, he stopped to take a

Fig. 209

Fig. 211

Fig. 210

Fig. 212

Figs. 209–213
ANSEL ADAMS
Surf Sequence, 1940
Gelatin silver photograph, printed 1941, 8 x 9 ⅝ in. [fig. 212, 8 x 10 ⅛ in.]
Museum of Modern Art, New York, Anonymous Gift

Fig. 213

Fig. 214
EDWARD WESTON
Surf at Orick, 1937
Gelatin silver photograph
Collection Center for Creative Photography, University of Arizona

similar series of photographs.[63] Although the concepts are the same—flattening the field into a series of patterns—the results affirm the artists' differing worldviews. The blinding reflective sun in Weston's photograph renders the foam as a series of opaque patterns that are exquisitely and formally beautiful, binding sky to earth in a one-to-one correspondence. A sense of time, or of the Earth's rhythms, does not concern him here. This quality of super- or hyper-beauty may be what Clement Greenberg famously decried in Weston's art: a sense that Weston had followed painting in his "reserve of the subject" and concentrated too much on its overall focus and clarity of line, as a result of which the "picture becomes nothing more than a pattern."[64]

In Adams's *Surf Sequence*, serial patterns in the surf define time without giving up any of their inherent qualities: foam reads as foam, sand as sand, rock as rock, shadow as shadow, even as Adams clearly separates them into four banded areas. Adams would not let go of the physical world and felt uncomfortable with descriptions of his work as abstract: "It has been termed 'abstract,' but I do not think any photograph can be abstract. I prefer the term *extract* for I cannot change the optical realities, but only manage them in relation to themselves and the format."[65] With refined deli-

cacy, Adams's photograph conveys flux, with great feeling, using light, atmosphere, wind, and the generative force of the tide as his allies. Adams uses the idea of sequence and the serial image as a means to emphasize that no one photograph is or can be an authentic marker of place; there is no key defining moment except for the concept of serial moments themselves. Related to this concept of linkage is Adams's sense of reciprocity, specifically when he defined art as the "taking and giving of beauty, the turning out to the light the inner folds of the awareness of the spirit."[66] Adams's warmly inflected vision lies in these relational values that are seen in the best of his art, a quality that was also present in the way he interacted with friends, journeying with them into the landscape. In 1937 he took Georgia O'Keeffe on a seventeen-day trip through Yosemite, expressing his pleasure to Stieglitz that he began to see it though her eyes. He also traveled often with his friends Nancy and Beaumont Newhall; after climbing a summit in Utah's Bryce Canyon to join Adams, Beaumont uttered, "Oh Gawd, more Nature."[67] The two could laugh about it, Beaumont Newhall preferring, Adams believed, his more familiar landscape of Maine. But the main point for Adams, and among the many reasons his art is inextricably linked with land preservation and conservation, is that the physical

Fig. 215
BEAUMONT NEWHALL
Ansel Adams at Zion National Park, Utah, 1947
Ansel Adams Archive, Center for Creative Photography, University of Arizona

landscape—sharing it with friends, seeing it through their eyes and showing it through his—was a way of fully interacting with the space around him and a way of fully integrating himself with the world, as Newhall's picture of the photographer shows (fig. 215).[68]

In 1946, when Clement Greenberg dismissed Weston's art as mere pattern, he also rejected the rigor, potency, and concentrated eloquence that Weston achieved through sub-tlety and keen perception, most hauntingly expressed in *Oil on Rocks, Point Lobos* (1942, fig. 216). When Weston died sixteen years later, in 1958, his family spread his ashes at Point Lobos, the landscape with which Weston is most closely identified in his art (fig. 217). Point Lobos is three miles south of Carmel, where Weston made his home in 1929 and established his portrait practice. Carmel was a self-consciously created development designed to attract culturally inclined

Fig. 216
EDWARD WESTON
Oil on Rocks, Point Lobos, 1942
Gelatin silver photograph, 7⅝ x 9⅝ in.
The Lane Collection, Museum of Fine Arts, Boston

Fig. 217
WILLARD VAN DYKE
Weston at Lobos, 1930
Posthumous digital reproduction from original negative
Willard Van Dyke Archive, Center for Creative Photography, University of Arizona

residents. Point Lobos, a state park, is better known for its rich social and natural history, including the Ohlone Indians, whose mortars hollowed out of bedrock may still be found, and its two hundred fifty animal species and three hundred forty plant species. It was a place that furnished the photographic material of a lifetime.

When Weston photographed *Oil on Rocks* in 1942, a year after the bombing of Pearl Harbor, this state reserve had been temporarily closed to the public in order to accommodate the military, which was guarding against a second Japanese attack; Weston, in fact, was a civilian guard. Here he explores the theme of time, but unlike the gentle cyclical motions of Adams's *Surf Sequence, Oil on Rocks* portrays a collision between ancient geology, and modern life in a manner that is both disconcerting and stunning. Its edge-to-edge composition reveals a diagonal crevice of rock that cuts across the surface. Carelessly spilled tar splashes across the rocks in random and dramatic patterns that do not obscure the swirls formed by water and weather over millions of years. The tar and rocks work together, as the salt accretions did in *Mustard Canyon*, to produce a beautiful and terrifying force. Knowing that Weston made this photograph during the war near a site that provided daily reminders of it, and that all four of Weston's sons served in the military, it is tempting to see Weston's rock as a body, the stained and creviced surface of which reveals a bloody wound. But Weston does not allow us to take his photographs so literally. Rather, he marshals all evidence of geological rupture, including at upper left a dislodged rock resulting from an erosional process at work for millions of years in the Reserve's Carmelo Foundation. Tar spills from the hole, and the juxtaposition of hole and tar helps to emphasize the larger concept of ravaged time versus the thoughtless human imprint. Thus Weston's photograph engages the device of layered history that Timothy O'Sullivan first essayed in *Historic Spanish Record* (see figs. 23 and 25), using marks and splashes of detritus to tell a concentrated story about land and life in the modern West.

The splashes of tar and erosional imprint of geological forces that Weston reveals as his theme resonate with Pollock's classic so-called drip paintings, which add the element of Native American antiquity to this system of layering. In 1947 and 1948 Pollock found his rhythm and made his mark in his tiny studio on Long Island. In a twenty-one-foot-square barn, he cultivated the liberation of line he had encountered with

Surrealist automatism. Laying out his canvas on the floor of the studio, he could, as he said, "work from the four sides and literally be in the painting. This is akin to the method of the Indian sand painters of the West." Pollock used sticks, knives, brushes, sand, broken glass, aluminum paint, and latex paint to spill, drip, and pour his paintings (fig. 218). "On the floor I am more at ease. I feel nearer, more a part of the painting, since this way I can walk around it," he revealed. "It is only when I lose contact with the painting that the result is a mess. Otherwise there is pure harmony, an easy give and take, and the painting comes out well."[70] In this statement Pollock outlined the relationships that define his mature art: intimacy with the canvas in order to fully interact with, as opposed to command, the space around him, and reciprocity, the gesture of giving and receiving, as he manipulated control and chance to move his media without touching the canvas, making "memories arrested in space."[71] Yet another is the taut expansion of the canvas achieved by the balance

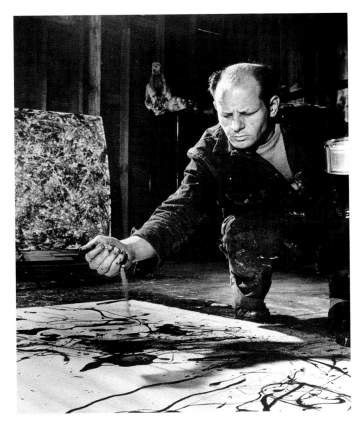

Fig. 218
Jackson Pollock dribbling sand on painting while working in his studio, 1949

between chaos and order, detail and wholeness, depth and surface, movement and pause, dark and light.

Pollock's mature art encouraged critics to equate his monumental canvases with the vastness of the American West. The overall compositions, in which paint spirals around in motion, prohibit viewers from resting their eyes on any centrally focused element, an effect not unlike that experienced in a panorama. Yet many of Pollock's canvases are small, more than a few are vertical, and only the best of them suggest this dizzying expansiveness. If vastness were all, Pollock's canvases could just as well be compared to the ocean. The Atlantic Ocean is less than five miles from his home in The Springs near East Hampton on New York's Long Island, where he lived from 1945 until his fatal automobile accident, at age forty-four, in 1956. It is critical to note, however, that when Pollock left the West, he searched for its equivalent, mapping its quality of vastness onto the Atlantic Ocean. To his friend and first biographer, B. H. Friedman, he recalled, "The ocean's what the expanse of the West was for me."[72] This would be one of the countless times that Pollock associated himself with the West in his artistic self-fashioning, echoing other artists such as O'Keeffe. Ever present in Pollock's art is his important relationship with the land, a relationship that can be likened to connective tissue. Pollock asserted this analogy himself, as did those closest to him.

Inseparable from western space is Pollock's self-imposed connection to American Indian art—his form of cultural primitivism, which became a leitmotif for interpreting his art throughout his career. In response to a question about his western upbringing, Pollock wrote, "I have always been very impressed with the plastic qualities of American Indian art. The Indians have the true painter's approach in their capacity to get hold of appropriate images, and in their understanding of what constitutes painterly subject-matter. Their color is essentially Western, their vision has the basic universality of all real art. Some people find references to American Indian art and calligraphy in parts of my pictures. That wasn't intentional; probably was the result of early memories and enthusiasms."[73] Pollock cast himself as a genuine maverick, as his paintings proved to be on their own merits.

Number 13A: Arabesque (1948; fig. 219), like Pollock's other drip paintings, is intensely personal. Pepe Karmel's reconstruction of Pollock's process in the 1999 MoMA retrospective catalogue reveals that even in his most seemingly

nonobjective paintings, such as *Autumn Rhythm* or *One*, Pollock literally framed them with the American Indian–inspired symbolic forms that sustained his entire career. Pollock worked up the canvases, often on all sides, and buried them in layers of paint, as if brushing away a sand painting, and repeated the process so that his paintings oscillate between two states of being. As his wife, Lee Krasner, commented, Pollock's drip painting "breaks once and for all the concept…that one sits and observes nature that is out there. Rather, it claims a oneness."[74] In a so-called primitive, undifferentiated way, Pollock becomes one integrative whole. In doing so, he retrieves the loss of connection to the land bemoaned in modern culture. As his friend Franz Bultman wrote, "Pollock observed of American Indian cultures that people living close to nature found nature in themselves rather than nature as a motif."[75] Thus Pollock's creative act of making carefully controlled drip paintings should be under-

stood not so much as the apotheosis of the self and an expression of rugged individuality—as his contemporary critics had alleged (and that he himself had encouraged)—but rather as a manifestation of his intense search to visualize American Indian concepts of a closer relationship between humans and nature, one in which they simply fuse.

In his drip paintings Pollock articulates a relationship with time, using the different layers of paint that can only be experienced in time, by moving forward, backward, and sideways before the energized spaces. The artist thus elicits and encourages a reciprocal relationship between artist and viewers, who through their own associations and memories are free to personalize their encounters with the paintings. Pollock, in the end, produced a more democratic art than Benton did. Pollock based his drip method on the promise of surface beauty, on the opportunity for the viewer to make infinite personal connections with it, and on an activated

Fig. 219
JACKSON POLLOCK
Number 13A: Arabesque, **1948**
Oil on canvas, 37 ¼ x 117 in.
Yale University Art Gallery, Gift of Richard Brown Baker, B.A. 1935

space with which the viewer can engage. His form of painting broke with formal convention even as he defined a signature style that indexes him as its only maker — a universal art in which no story is being told and no language is being spoken that would alienate the viewer. Pollock, like other artists of his generation, sought a different, more personal artistic language that acknowledged Modernism. "It seems to me," he commented, "that the modern painter cannot express this age, the airplane, the atom bomb, the radio, in the old forms of the Renaissance or of any other past culture. Each age finds its own technique."[76]

Pollock's technique was inextricable from his New York cultural climate and inseparable from his western experience. At the heart of his drip paintings is a surface in which space and place, and self and art, merge — an echo of his friend Peter Blake's observation that Pollock aims to "formulate unframed space." This is yet another construct that anchors Pollock to the spatial qualities of the West. On one hand, Pollock's paintings have "no beginning or end," and, on the other, they *are* the end. That is to say, the paintings are their own subject. What Pollock's monumental canvases offer collectively is an electrifying blank slate onto which the artist gives viewers license to project themselves, so that his paintings become simultaneously a metaphor of anything and nothing. The profound ambivalence of his art, however, stems not from currents such as the conformist culture of post–World War II America, but from Pollock's lifelong engagement with American Indian art and his appropriation of some aspects of Navajo sand painting. Not to be lost amid this ambivalence is the incontrovertible power of art to heal — not only the self but the modern community. The son of a hardscrabble farmer and a personal witness to the best and the worst of the American West, Pollock affirmed a utopian goal that is unthinkable without, as Willa Cather phrased it, "the great fact" of the West itself.

Notes

Prologue: Landmarking the West

1 Wallace Stegner, *Crossing to Safety* (New York: Random House, 1987). A variant phrased by Stegner, "no place is a place until it has had a poet," appears in his essay "A Sense of Place," included in *Where the Blackbird Sings to the Lemonade Springs: Living and Writing in the West* (New York: Random House, 1992).

2 Tuan 1977, 4.

3 Ibid., 54.

4 Ibid., 3–4.

5 My analysis of Moran's painting draws from and is indebted to the following publications that focus on the place and/or the painting and is amplified by my further research: Szasz 1977, Hults 1991, Kinsey 1992, Anderson 1997, Dippie 1998, Bedell 2001, and Best 2005. Miller 1993 provides a major resource for understanding cultural meaning in nineteenth-century American landscape painting.

6 Bowles traveled to the West in 1868 and published his account in 1869. See Bowles [1869] 1991.

7 James A. Goss, "Traditional Cosmology, Ecology and Language of the Ute Indians," in Wroth 2000, 52.

8 Richard N. Ellis, "The Ute Indians in Southern Colorado since 1850," in Wroth 2000, 74.

9 The four surveys included Lt. Ferdinand V. Hayden (sponsored by the Department of the Interior and commissioned to survey, principally, regions of Yellowstone, the Tetons, and the Rocky Mountains); John Wesley Powell (sponsored by the Department of the Interior to survey the Rocky Mountain region, including the Colorado River and its tributaries); Clarence King (commissioned by the Secretary of War to survey the Fortieth Parallel, principally the Great Basin, the Great Salt Lake, and the Rocky Mountains); and Lt. George M. Wheeler (commissioned by the Army Corps of Engineers to survey the area of Nevada and Arizona). The most comprehensive publications on the Great Surveys remain Bartlett 1962 and Goetzmann [1966] 2000. See also Kelsey 2003; Sandweiss 2002; and Phillips et al. 1996 for further information on the subject of the survey and specific photographers.

10 The subsequent rebuttal to Best 2005, a letter to the editor published in *Forest Magazine* 7, no. 3 (Summer 2005): 6, testifies to the ongoing controversy surrounding the authenticity of the snowy cross and the manipulated photographs Jackson produced to promote its symbolism. For information on Jackson, see Hales 1988.

11 Kinsey 1992, 145.

12 See Novak 1980, 34–44, and Wilton and Barringer 2002, 11–37, for a recent overview.

13 George Sheldon, *American Painters* (New York: D. Appleton and Co., 1881), 123–24, quoted in Kinsey 1992, 15.

14 Hults 1991, 76.

15 Quoted in Trenton and Hassrick 1983, xiii.

16 For example, George Caleb Bingham, an earlier artist of western themes, similarly addressed the issue. See Miller 1992.

17 Bedell 2001, 140–45, and 125.

18 Bedell 2001, 144.

19 Pyne 1998, 54.

20 Novak 1980, 152.

21 See Hults 1991, 81.

22 *New York Times*, April 10, 1875, quoted in Anderson 1997, 107–8.

23 These comments appeared, respectively, in the *Boston Evening Gazette*, November 14, 1875, and *Boston Transcript*, November 16, 1875, and are quoted in Anderson 1997, 109.

24 Remington elicited the concept of the near and far in an unpublished manuscript titled "Taos," written in 1901 (Archives, Frederic Remington Art Museum, Ogdensburg, N.Y.). O'Keeffe used the phrase and variants of it throughout her career and also used it as a title for one of her paintings, *From the Faraway Nearby* (1937, Metropolitan Museum of Art, New York).

25 See Curry 1984, 220–21.

26 Whistler fired the opening salvo in the critical debate about the role of art and the nature of abstraction and paved the way to subsequent battle cries for the increasing subjectivity of the artist, a new emphasis on the materials and technique of the artwork as "text" (as opposed to the exterior world), and painting itself as an arrangement of shapes and forms similar to, say, notes and phrases in a musical arrangement. As nineteenth-century Symbolist artist Maurice Denis famously phrased it in 1890, "It is well to remember that a picture—before being a battle-horse, a nude woman, or some anecdote—is essentially a plane surface covered with colors assembled in a certain order." Originally published in *Art et critique* (Paris), August 23 and 30, 1890, quoted in Chipp 1968, 94.

27 Willa Cather, *O Pioneers!* (1913; reprint, New York: Vintage Classics, 1992), 8.

28 See Franklin Kelly, "The Landscape Tradition: Visions of the West," in Adams, Kelly, and Tyler 1986, 25.

29 Quoted in McGrath 2001, 170–71.

30 Barry Lopez initially suggested the connection between cross and grid (conversation with the author, March 2004).

31 Newhall and Newhall 1966, no pagination.

32 Kelsey 2003. Other photohistorians also avoid the trap of proto-Modernism. Douglas Nickel, for example, in his assessment of the photographer Carleton Watkins, focuses on new means of seeing in the nineteenth century, which involved a greatly expanded array of perceptual options, including panoramas, dioramas, motion studies, and optical entertainments, and the ways in which Watkins distinguished himself in his aesthetic choices (Nickel 1999).

33 In terms of historiographical context, it should be noted that historians stressing contextual issues have been quick to point out the ahistori-

cal gesture of taking photographs, intended, in large part, to be seen in photographic albums or bound government reports, and placing them in frames mounted on a museum wall (Sandweiss 2002, 183–85); they have also questioned using methods of art-historical inquiry intended for "high art" to probe the meanings of survey photographs, which they viewed as occupying a different nexus—one determined by entrepreneurship, consumerism, and science (underrating that both paintings and photographs operated within the same visual culture). This issue is explored in chap. 3 of Trachtenberg 1989, specifically 127–32. See also Rosalind Krauss's essay, "Photography's Discursive Spaces," in Krauss 1985 and Joel Snyder's response to her arguments in "Territorial Photography," in Mitchell 2002, specifically 191–92.

34 Martin Berger marshals evidence of nineteenth-century understanding of photographs in Berger 2003. In another example he cites the nineteenth-century giant of aesthetic theory, John Ruskin, who first championed photography as a truth teller but later decried it for its capacity to lie.

35 It should be noted that not all of the photographs discussed in this chapter were made for U.S. Geological and Geographical Surveys. However, all of the photographers represented here were involved, to one degree or another, with the survey and the survey process itself. This body of work is sometimes referred to as "exploration photography," but I use the term "survey vision," as it connotes the interdisciplinary nature of the survey and its goal of measurement and quantification, which helps characterize American culture in the third quarter of the nineteenth century. The general literature on Timothy O'Sullivan includes Kelsey 2003; William H. Goetzmann, "Desolation Thy Name Is the Great Basin: Clarence King's Fortieth Parallel Survey," in Castleberry 1996; Snyder 1981; Dingus 1982; Horan 1966; and Taft [1938] 1964. In addition, see Naef and Wood 1975 and Wilmerding 1980.

36 Though dubbed a "Great Basin" because of the two inland seas that dried up at the end of the last Ice Age—leaving this region a "basin" rather than an area whose water drains to the sea— the desert stretches along vast spaces but is relieved in the distance by scalloped mountains that appear alternately russet, pale blue, or dark purple.

37 As Mark Twain described it six years earlier, this was "one prodigious graveyard" and a potent image "of the fearful suffering and privation the early emigrants to California endured" (quoted in Bartlett 1962, 157).

38 Notably, the influential English philosopher Joseph Addison wrote in the Spectator 412 (1712) about the physical aspects of nature that promote specific emotional responses from the viewer. Included in his list is a "vast uncultivated desert," which he equates with feelings of magnificence,

amazement, and astonishment—something bigger than ourselves that the mind takes pleasure in trying to grasp, but ultimately cannot. Perhaps the most famous eighteenth-century philosopher subsequently to address similar ideas is Edmund Burke, whose A Philosophical Enquiry into the Origin of Our Ideas of the Sublime and Beautiful (1757) does not mention the desert but rather the vast expanse of the sea.

39 The survey party, in fact, contracted malaria, yet O'Sullivan remained steadfast, remarking, "It was a pretty location to work in and viewing there was as pleasant work as could be desired; the only drawback was the unlimited number of the most voracious and poisonous mosquitoes that we met on our trip" (Horan 1966, 165).

40 The Sand Mountain Recreation Area is located directly across from what was once the Sand Springs pony express station, which was active for only about eighteen months until the arrival of the telegraph in 1861. Sand Mountain is a several-mile stretch of sand dunes about four hundred feet high, the ghostly windblown remains of the sandy beaches of Nevada's prehistoric inland seas. Located about twenty-five miles east of Fallon, Nevada, the dunes, nestled against the Stillwater Mountain Range, are a brief novelty that abruptly crop up in the landscape, despite the framing of O'Sullivan's composition that hints at endless desert sands. Now crawling with campers and dune buggies, the dunes are located within Churchill County in an area that includes the Fallon Paiute-Shoshone Indian reservation, the Stillwater Natural Refuge, and the Fallon Naval Air Station bombing range, the latter two saying much about the extremes in cultural values placed on desert places.

41 See Nickel 2004.

42 In describing the experience of photographing the dunes, O'Sullivan confirms his sustained attention to the mound: "The contour of the mounds was undulating and graceful, it being continually broken into the sharp edges by the falling away of some of the portions of the mound, which has been undermined by the keen winds that spring up during the last hours of daylight and continue through the night" (Horan 1966, 168). Snyder argues that O'Sullivan's emphasis on the disconcerting aspects of the Great Basin suggests the vision and influence of survey leader Clarence King, who stressed its strangeness as a means of carving out sections of the West as the domain not of the military but of scientists (Snyder in Mitchell 2002, 198–200).

43 Francis Parkman, The Oregon Trail (1849; reprint, New York: Penguin Books, 1982), 105.

44 Russ Anderson, "Watkins on the Columbia River: An Ascendancy of Abstraction," in Alinder 1979, 27. The bibliography on Carleton Watkins is extensive; in addition to Alinder, useful sources include Palmquist 1983; Rule 1993; Naef and Christadler 1993; and Nickel 1999.

45 The cultural impact of the railroad and its effect on nineteenth-century vision and perception are discussed in Schivelbusch [1977] 1986; Danly and Marx 1981; and Lyden 2003. Also helpful is Hyde 1990.

46 Coplans 1978, 101. See also Wolf 1983. The subject of American space and vacancy is addressed in the second section of this essay.

47 See Palmquist 1983, 33–34.

48 See "Oregon Steam Navigation" in Lewty 1987, 17–27, for information on the history of the company. Susan Seyl, public services librarian, and Richard H. Engeman, public historian, at the Oregon Historical Society, graciously supplied information about the history of the Oregon Steam Navigation Company and the site itself (correspondence with the author, December 2004). It should be noted that Cape Horn is a name no longer in use and that this particular Cape Horn is not to be confused with another Cape Horn located on the Pacific coast of Washington.

49 In the photograph facing west is a "4–2–4" tank engine named for D. F. Bradford, the vice president of the Oregon Steam Navigation Company. This new engine further suggests the relationship between the Oregon Steam Navigation, Watkins, and the effort to demonstrate the company's modern advances.

50 One of the company's directors even promoted the idea of encouraging the Northern Pacific Railroad to construct its line to the eastern banks of the Columbia so that the Oregon Steam Navigation Company could maintain control by providing portage connections to Portland. This did not occur.

51 The Columbia River, with its reflective surface shimmering in the photograph and delivering its quality of expansive space, is now a series of dam-created lakes. The Union Pacific Railroad tracks are now flanked by the Columbia River highway. Inundated by The Dalles Dam, built in 1957, Celilo Falls is defunct.

52 The bibliography on Muybridge generally focuses on his motion photography. Helpful sources that address his landscape work include Hood and Haas 1963 and Solnit 2003. Another helpful source is Coke [1964] 1972. A standard reference for Yosemite includes John Muir's seminal The Yosemite (1912). See also Sears [1989] 1998, 122–55.

53 These commercial establishments include Nahl's, Houseworth's, and Bradley and Rulofson.

54 Intertwined with any understanding of Yosemite, John Muir, the intrepid Scotsman who would forever change the way in which Americans thought about wilderness, arrived one year later, in 1868.

55 Home to the Southern Miwok (Miwuk) and Paiute Indians for thousands of years, Yosemite is derived from the Miwok words Yohhe'mete, or Yos s e'meti, and means "those who kill," in reference to Yosemite Indians who inhabited

the valley proper. Those who lived within the valley called it Ahwahnee, or Place of a Gaping Mouth.

56 Hood and Haas 1963, 5.

57 Ibid., 16.

58 Phillips et al. 1996, 19.

59 To be sure, the wet-plate process required too long an exposure to lure many sitters, many of whom might have been unwilling to pose anyway. Still, while survey photography includes a great number of images of American Indians, few of them show American Indians interacting with landmarks.

60 See Sandweiss 2002, 257, for a discussion of antiquity and heritage in nineteenth-century western photography.

61 The standard references for John K. Hillers include Fowler 1989 and Hooper 1988; for information about Hillers and his photographs of the Hopi mesas, see Southall 1996. See also Childs 1996.

62 "Distant View of an Aztec City," in *Frank Leslie's Illustrated Newspaper* 38, July 18, 1874, 300, 302, quoted in Southall 1996, 72. This observer might also have mentioned, for example, William James Stillman's views of the Athenian Acropolis, taken from below, which emphasized the crumbling ancient Greek civilization on a hill, cutting across the landscape like a ship of state.

63 In northeastern Arizona, three Hopi mesas tower over the arid, expansive landscape below, about fifteen miles west of Keams Canyon. Atop First Mesa are three villages: Hano, a Tewa village of refugees from the Rio Grande pueblos after the 1680 revolt against the Spanish; Sichomovi, a Hopi town founded in the 1700s and occupying the center of the mesa; and Walpi, which, since the 1600s, has perched on the far end of the mesa, six hundred feet above the desert floor—a compact Hopi village with ceremonial kivas that hug the edge of the precipice. When Hillers photographed this view of Walpi, from the south side of the mesa, he stood on the farthest edge of a ledge next to a house that serves as a gate to the village. The village appears empty, "just one step," as photohistorian Thomas Southall describes it, "beyond archeological ruins." See Southall 1996, 74.

64 Helpful references for the history and geology of Canyon de Chelly include Noble 1986; Grant 1978; and Kiver and Harris 1999, 413–18. The cliff dwellings were built not so much for protection from possible enemies (the term "White House" refers to their shiny color, clearly visible to any approaching foe) but to avoid the floodplain and to provide additional space on the limited but fertile canyon floor below. In addition, rock shelters provided protection from the elements and moderated extremes in temperatures, making them an excellent site for food storage. O'Sullivan's photograph, in fact, shows a storage container at upper right of the shelter.

65 One of the surveyors, J. W. Conway, could not resist marking his own presence in time's continuum and wrote the date "Sept 1873" on one of the structures, obscured in the photograph but visible at the site.

66 The expressive phrase comes from Pyne 1998, 2, describing the approach to the Grand Canyon.

67 Historians have interpreted Wheeler's statement as a way of completely dismissing, even "erasing," its aboriginal inhabitants, based on culturally biased confusion about the origins of the dwellings' original builders. This confusion is, in turn, founded on culturally superior attitudes toward Navajo culture. The alleged 1873 Navajo response of ignorance about the dwellings may be more accurately attributed to a clash of cultures, based on either Navajo distrust of the U.S. government, which the surveyors represented, or a reluctance to discuss the ancient dwellings they encountered (and left alone) at Canyon de Chelly when they arrived there in the 1700s, believing them to be a sacred space full of ancient spirits better left undisturbed. It is taboo in Navajo culture to enter a house in which people have died. *Anasazi* is a Navajo word meaning "someone's ancestors."

68 Recorded by Spaniards as early as 1583, the area was likely known to Oñate when he passed by in 1598, but he did not leave his imprint until 1605. Perhaps his recent exploits explain his compulsion to leave his name (Adelanto Don Juan de Oñate ["Adelanto," an honorary title bestowed on conquerors]), date (April 16, 1605), and record of his proud discovery of the South Sea (a reference to the Gulf of California).

69 Dingus 1982, 97.

70 Letter from Wheeler to James W. Simpson, February 26, 1874, quoted in Kelsey 2003, 64n, 722. I am indebted to Robin Kelsey for his assistance in understanding the sequence of events in a telephone conversation, July 2004, and in follow-up correspondence in February 2005.

71 Ibid.

72 The now classic volume on Plains Indian drawings is Berlo 1996. See also Petersen 1971.

73 Basso 1996, 34.

74 Berlo 1996, 66. Berlo suggests that the drawing may, in fact, refer to a specific event, the Sand Creek Massacre, which took place November 29, 1864 (Berlo 1996, 115). Bear's Heart left the Oklahoma Territory for Fort Marion, Florida, where he stayed for three years until he left to study at Hampton Institute in Virginia. He returned to the Cheyenne-Arapaho Agency in 1881 and died of tuberculosis the following year.

75 See Berlo 1996, 132. Berlo makes the suggestion that Little Chief and Bear's Heart collaborated on this large sheet, in which several days of religious activities and events are combined in one sacred circle.

The End of the Frontier: Making the West Artistic

1 Wood and Fels 1992, 10.

2 This discussion of maps draws from White and Limerick 1994, specifically 17–19. I thank historian Dr. Kathleen A. Brosnan, University of Houston, for clarifying the issue of nineteenth-century American maps.

3 Frederick Jackson Turner, "The Significance of the Frontier in American History," in Taylor 1972, 3–28. See also William Cronon, "Turner's First Stand: The Significance of Significance in American History," in Etulain 1991, 73–101. As Cronon elaborates, Turner's construct of the frontier depended on the concept of "free" land, a term from political economics that refers to a land free of rents in contrast to the European model of feudal land management. The concept was, however, historically loaded to suggest vacant, uninhabited, empty, and unclaimed space. See also Smith 1959 [2005].

4 Faragher [1994] 1998, 1.

5 See William Cronon, "Turner's First Stand" in Etulain 1991, in which he summarizes how several of the various threads in Turner's thesis have been subsequently unraveled by historians. To name just a few: in his construction of the West, Turner ignored the role of the federal government and urbanism; he made the subject of conquest unproblematic, virtually obliterating the American Indian; he ignored the role of women and minorities in his narrative; his conception of settlement as a linear east-west movement is inaccurate; and he made an essentialist argument for American character.

6 Turner once wrote that "each age writes the history of the past anew with reference to the conditions uppermost in its own time" (quoted in William Cronon, "Turner's First Stand" in Etulain 1991). In writing a history that addressed his own time, Turner's perceptions, as scholars have shown, were shaped by his interest in social science, maps, and data, and his childhood in Portage, Wisconsin, a frontier town that expanded dramatically during his youth. See section two, "Expansion," in Milner, O'Connor, and Sandweiss 1994, for helpful essays that describe the changes wrought by nineteenth-century expansion.

7 Boym 2001, xvi. In carving out a new study of the historical emotion of nostalgia (the root of the word is from *nostros* [return home] and *algia* [longing]), Boym asserts that nostalgia "goes beyond individual psychology. At first glance, nostalgia is a longing for a place, but actually it is a yearning for a different time—the time of our childhood, the slower rhythms of our dreams. In a broader sense, nostalgia is rebellion against the modern idea of time, the time of history and progress." Boym describes how nostalgia entered the lexicon in the sixteenth century as a curable disease (xv). According to Boym,

nostalgia was symptomatic of a new understanding of space and time, and its rise can be located with the concurrent growth of mass industrial culture.

8 Quoted in Perriton Maxwell, "Frederic Remington: Most Typical of American Artists," *Pearson's Magazine* (October 1907): 394–407.

9 Frederic Remington, "A Few Words from Mr. Remington," *Collier's Weekly*, March 19, 1905, 16. Helpful resources in the Remington literature include Hassrick and Shapiro 1988; Ballinger 1989; Nemerov 1995; Hassrick and Webster 1996; Neff 2000; and Anderson 2003.

10 Theodore Roosevelt to Arthur W. Little, "An Appreciation of the Art of Frederic Remington by Theodore Roosevelt," *Pearson's Magazine*, October 1907, 392–93, 395.

11 Wilson 1971, 153–56. For the relevance of this idea in terms of the patronage of Remington artworks, see Neff 2000, 26–32.

12 Neff 2000, 80–85; Remington likely saw Twachtman's *Emerald Pool* (The Phillips Collection).

13 Albany Institute and Albany Historical and Art Society, *Catalog of Paintings, Spring Exhibition*, no. 105 (March 1–14, 1905), quoted in Anderson 2003, 108.

14 Remington, quoted in Edwin Wildman, "Frederic Remington: The Man," in *Outing* 41 (March 1903): 715–16.

15 This quality is a device Remington often used. See, for example, a discussion of Remington's *The Herd Boy* (c. 1905) and *The Call for Help* (c. 1908) in Neff 2000, 98–104.

16 The statistic comes from the 2000 U.S. Bureau of the Census report. If one includes American Indians/Alaska natives in combination with one or more other races (i.e., multiracial), the statistic jumps to 4.1 million. Greatly renewed attention to American Indian history, traditions, and lifeways is best exemplified by the new National Museum of the American Indian (Smithsonian Institution) that opened in 2004 on the nation's Mall in Washington, D.C. For a review of the reviews that appeared in the national press at the time of the opening, see Janet Berlo and Aldona Jonaitis, "'Indian Country' on Washington's Mall—The National Museum of the American Indian: A Review Essay," in *Museum Anthropology* 28, no. 2 (Fall 2005): 17–30. While farming and ranching practices continue to change, the 2002 Census of Agriculture notes that 719,903 farms throughout the United States were dedicated to beef cattle ranching and farming, including cattle feedlots. The definition of a cowboy may be elastic, with plenty of city folk and politicians assuming the piquant persona, but as witnessed on ranches and farms throughout the country and at countless county rodeos, cowboy lifeways endure.

17 See William N. Goetzmann, "The Arcadian Landscapes of Edward Sheriff Curtis," in Castleberry 1996. Useful resources on Curtis include

Graybill and Boesen 1976; Davis 1985; Gidley 1998; Cardozo 2000; and Worswick 2001.

18 In the context of varying interpretations of Curtis's work, see Anna Blume, "Ways through Amnesia: Photographs and Native American History," *The Print Collector's Newsletter* 26, no. 3 (July–August 1995): 113–15. The quote here is by novelist N. Scott Momaday in Cardozo 2000, 9.

19 Curtis was broke and exhausted in 1930 when he completed *The North American Indian*. The project no longer seemed pertinent, and its Pictorialist photographs no longer were fashionable. Curtis worked for filmmaker Cecil B. DeMille in Hollywood before dying in obscurity in Los Angeles in 1972, just as his North American Indian photography was rediscovered and celebrated in the context of a renewed nostalgia and appreciation of indigenous culture that coincided with the rise of the counterculture in the 1960s and 1970s. I thank Janet Berlo for clarifying this history.

20 See Richard White, "Animals and Enterprise" in Milner, O'Connor, and Sandweiss [1994] 1996, 237–73.

21 The authoritative work on Erwin E. Smith remains Price 1998. This quote appears in Price 1998, 72.

22 For example, photographers Laton A. Huffman and Evelyn Cameron of Montana and W. G. Walker and Charles Kirkland of Wyoming.

23 Harry Peton Steger, quoted in Price 1998, 72.

24 His method of operation is one that filmmaker John Ford would employ in his Hollywood westerns half a century later.

25 For an overview, see Neff 2000, 56–58. See Splete and Splete 1988, 255.

26 *Cincinnati Enquirer*, December 24, 1916, typescript of obituary located in Taft Museum object files for Farny. Helpful resources on Farny include Robert Taft, "Artists of Indian Life—Henry F. Farny," *Kansas Historical Quarterly* 18, no. 1 (February 1950): 1–19; Carter 1978; and Nannette V. Maciejeunes and M. Melissa Wolfe, "Like Going Home: Henry Farny's American West," *Timeline* 12, no. 1 (1995): 2–25; and J. Gray Sweeney, "Racism, Nationalism, and Nostalgia in Cowboy Art," *Oxford Art Journal* 15, no. 1 (1992): 67–80.

27 *Cincinnati Commercial*, December 1, 1881, 4.

28 "Mr. Farny among the Sioux," *Cincinnati Daily Gazette*, November 8, 1881, 8.

29 *Cincinnati Enquirer*, December 24, 1916 (see n. 26).

30 On this issue, see especially Julie Schimmel's "Inventing 'the Indian'" in Truettner 1991, 149–89.

31 *Cincinnati Times-Star*, "Studio Impressions of Farny," April 2, 1910.

32 Carter 1978, 33.

33 Although the U.S. government outlawed the ceremony in 1904, the ritual was practiced surreptitiously until its legitimacy was recognized by the Jimmy Carter administration.

34 Duff et al. 1987, 13; this quote appears in an

unpublished letter of August 11 or 16, 1908, written by Wyeth, in which he refers to the painting as "Indians Going to the Dance." I thank Christine B. Podmaniczky, Brandywine River Museum, for sharing her N. C. Wyeth file information.

35 Remington was further insulted by the knowledge that President Roosevelt invited Schreyvogel to the White House. It should be noted that Roosevelt, in another example of celebrating western nostalgia, spontaneously invited Wyeth, who was attending the 1905 inaugural proceedings dressed in western garb, to join the parade.

36 Duff et al. 1987, 11–12.

37 The literature on primitivism, "otherness," and Modernism is vast. For a helpful overview, see Lemke 1998, 3–9. Among the art exhibitions that set the dialogue on primitivism in relatively recent motion is William Rubin, ed., *Primitivism in Twentieth-Century Art: Affinity of the Tribal and the Modern*, 2 vols., exh. cat. (New York: Museum of Modern Art, 1984). In the context of primitivism as it applies to American Indian culture, see Dilworth 1996.

38 Dilworth 1996, 4–7.

39 Duff et al. 1987, 17.

40 In a letter written to his mother on September 5, 1908, Wyeth describes the positive reaction among *McClure's* editors to his series of Sun-Dance paintings (in Wyeth 1971, 269). Wyeth relates *McClure's* financial issues in a letter dated October 2, 1908 (in Wyeth 1971, 260). The two paintings published in Bronson are *Calling the Sun Dance* and *The Mystery Tree*.

41 See "The Last Great Sun Dance" in Edgar Beecher Bronson, *Cowboy Life on the Western Plains: The Reminiscences of a Ranchman* (New York: George H. Doran Company, 1910), 221–51, this quote on 226–27).

42 Wyeth's studio was filled with numerous books, pictorial references, and magazine tearsheets, and he often borrowed material from his fellow illustrators. According to Christine Podmaniczky, Brandywine River Museum, Wyeth does not appear to have had a personal copy of Curtis's photograph (telephone conversation with author December 9, 2004).

43 Mabie 1896, 51.

44 On the subject of cultural weightlessness, see Lears 1981, 32–58.

45 Thomas Wilmer Dewing in "John H. Twachtman: An Estimation," *North American Review* 176, no. 1 (April 1903): 554–62 (this quote on 554); and Charles Curran in "The Art of John H. Twachtman," *The Literary Miscellany* 3, no. 4 (Winter 1910): 72–78 (this quote on 72). Scholarly resources on the art of Twachtman include Hale 1957; Boyle 1979; Chotner, Peters, and Pyne 1989; Peters 1995 and 1999; Larkin 2001; and, in the context of his Yellowstone series, Eldredge 1996 and Hassrick 2002, 127–34.

46 I thank art historian Susan Larkin, who clarified the source of the anecdote in a letter to the

author, June 12, 2005. The sources are a short article titled "Artists Give Dinner to J. Alden Weir," *New York Times*, November 26, 1913, and Duncan Phillips's essay on Weir in *Julian Alden Weir: An Appreciation of His Life and Works*, ed. J. B. Millet (New York: The Century Association, 1921).

47 J. Alden Weir in *North American Review*, 561, and Curran, ibid., 77 (see n. 45).

48 Eliot Clark, "The Art of John Twachtman," *International Studio* 72 (January 1921): lxxvii–lxxxvi, this quote on lxxxi.

49 "The Art Exhibition," *Philadelphia Press*, November 22, 1896, 11.

50 Eliot Clark, *John Twachtman* (New York: privately printed, 1924), 28.

51 Thomas Eakins was sent to the B-T Ranch in the Dakota Territory in 1887 to regain his grounding, composure, and perspective. It was hoped that this return to a rougher state of nature would counterbalance the effects of living in the urban East. See Berger 2000, 107, for a summary of Eakins and neurasthenia.

52 Also called New Thought, mind cure was a form of meditation that drew on Buddhism, transcendentalism, and various other religious ideas and psychotherapeutic devices to produce spiritual renewal through a Zen-like merging of the self with the universe. This subject is thoroughly examined in Kathleen Pyne, "John Twachtman and the Therapeutic Landscape," in Chotner, Peters, and Pyne 1989 and Pyne 1996.

53 Pyne in Chotner, Peters, and Pyne 1989, 59.

54 Maj. William A. Wadsworth (called "Austin") of Geneseo, New York, had admired Twachtman's paintings of Niagara Falls, which he had seen at the home of his Buffalo friend Dr. Charles Cary. In 1895 Wadsworth provided Twachtman with a commission to paint Yellowstone. Why Wadsworth chose Yellowstone as a subject, if he did, is difficult to assess, other than the obvious point that, like Niagara, it meant paintings of scenes from a national park that had some relevance or interest for the family. Although Wadsworth himself seems to have preferred fox hunting and polo, his cousin "Boss" (James Wolcott Wadsworth), a Stetson-wearing congressman in Washington, D.C., had years earlier joined the cavalry as an Indian fighter and attached himself to Buffalo Bill Cody, whose eponymous Cody, Wyoming, home was a gateway to the national park. Wadsworth family connections to the West, both personal and financial, may have prompted the choice of Yellowstone. See Hatch 1959.

55 Evelyn Rumsey Cary (Mrs. Charles Cary) to William A. Wadsworth, 6 September 1895, Wadsworth Family Papers, State University of New York, Geneseo, New York. I am grateful to Liz Argentieri, SUNY, Geneseo.

56 I am grateful to Susan Larkin for providing details of Twachtman's family life. See Larkin 2001 for information on Twachtman's finances.

57 See "Yellowstone and 'The Wild West'" in Sears

[1989] 1998, 156–81. The quotes that appear here are from 163–67.

58 The letter is quoted in Peters 1995, vol. 1, 368.

59 Tourist Margaret Cruikshank, 1883, quoted in Sears [1989] 1998, 167; visitor J. Salford Saltus, 1894, quoted in Whittlesey 1988, 53. See also Haines 1996, 186, which notes that F. J. Haynes, Yellowstone Park photographer, officially named Emerald Pool in the Upper Geyser Basin.

60 Another, less likely, candidate is the lesser-known "Emerald Spring" at Norris Geyser Basin.

61 Pyne in Chotner, Peters, and Pyne 1989 and Pyne 1996.

62 Duncan Phillips, "Twachtman—An Appreciation," *International Studio* 66 (February 1919): 106–7.

63 Each exhibition installation was punctuated by a large brass bowl that Steichen used to anchor the gallery's tiny rooms. As Steichen's wife, Clara, noted about 291, it was "so large a spirit in so small a space" (quoted in Niven 1997, 208).

64 Steichen voiced this in a 1955 interview with Wayne Miller (Wisdom Series Interview, National Broadcasting Company), quoted in Niven 1997, 209.

65 Undated letter from Edward Steichen to Alfred Stieglitz, 1906, quoted in Longwell 1978, 90.

66 Useful resources on Dow include Dow [1899] 1998; Johnson 1934; Moffatt 1977; Green 1990; and Green and Poesch 2000. See also Spanierman 2000. On Dow and photography, see Enyeart 2001.

67 Dow [1899] 1998, 177.

68 Archives of American Art, Papers of Arthur Wesley Dow, Notes on Dow Letters (by Frederick C. Moffatt), February 27, 1891.

69 Dow [1899] 1998, 5 and 18.

70 Quoted in Green and Poesch 2000, 58.

71 Archives of American Art, Papers of Arthur Wesley Dow, Notes on Dow Letters (by Frederick C. Moffatt), June 19, 1891.

72 Green and Poesch 2000, 61. The moral thrust of Dow's philosophy is summed up by his following statement: "Teach the child to know beauty when he sees it, to create it, to love it, and when he grows up he will not tolerate the ugly. In the relations of lines to each other he may learn the relation of lives to each other; as he perceives color harmonies, he may also perceive the fitness of things."

73 As his student Georgia O'Keeffe expressed it years later, "This man had one dominating idea: to fill a space in a beautiful way—and that interested me. After all, everyone has to do just this—make choices—in his daily life, even when only buying a cup and saucer" (quoted in Moffat 1977, 129).

74 Smith 1997, 180, refers to Cushing as Dow's inspiration to travel west.

75 Archives of American Art, Papers of Arthur Wesley Dow, catalogue notes handwritten by Arthur Wesley Dow (omitted in final version), Montross Gallery, New York, "The Color of the Grand Canyon of Arizona: Exhibition of Pictures

by Arthur Wesley Dow," April 7–19, 1913.

76 Quoted in Pyne 1998, 38.

77 After this western trip, Dow's work would be characterized by larger-scale canvases, a brighter palette, and a more rigorous underlying structure inspired, in part, by his experience of western nature.

78 See the published catalogue for the 1913 exhibition at Montross (n. 75).

79 See the handwritten notes for the catalogue cited in n. 75.

80 See the published catalogue cited in n. 75. All Dow scholars cite Dow's Grand Canyon paintings as a turning point in his art, which assumes a more vibrant palette and structural muscularity.

81 "The Color of the Grand Canyon," *New York Times*, April 13, 1913.

82 See Van Dyke [1901] 1999, 87, regarding atmospheric color at the Grand Canyon, which compares favorably to Dow's interest in the canyon's "cosmic dust."

83 Coburn to Karl Struss in Roberts n.d., 11–12n, in which Coburn also writes about his trip to Dassonville, stating that "my work has changed some." Useful sources on Coburn include Gernsheim and Gernsheim 1966; Bogardus 1984; Weaver 1986; and Roberts n.d. Coburn exhibited fifty prints of Yosemite and the Grand Canyon at Blanchard Gallery in Los Angeles in February 1912.

84 Gernsheim and Gernsheim 1966, 44.

85 Weaver 1986, 16.

86 Gernsheim and Gernsheim 1966, 82–84.

87 Alma May Cook, *Los Angeles Express*, February 1, 1912, in ALC Papers, George Eastman House, ALC Scrapbook, 1911–15, regarding his exhibition at Blanchard Gallery, January 29–February 10, 1912.

88 Alvin Langdon Coburn Scrapbook, 1911–15, catalogue of October 1913 exhibition at Goupil's in London, Alvin Langdon Coburn papers, Richard and Ronay Menschel Library, George Eastman House.

89 Charles H. Caffin in *Camera Work*, quoted in Bogardus 1984, 160.

90 Quoted in Furth 1993, 46.

91 Ibid., 48.

92 See Panzer 1980–81 and Panzer 1982. The bibliography on Woodbridge is scant. I thank Janet Lehr, New York, for her additional assistance regarding Woodbridge's photographs.

93 Helpful resources for Gilpin include Sandweiss 1986 and Sandweiss 1987; Garner 1987; Gilpin 1989; Pitts 1981; and Rosenblum 1994. See also Robert Adams, "An Enduring Grace: The Photographs of Laura Gilpin," exh. review, *Aperture* 110 (Spring 1988): 70–77; and James C. Faris, "Laura Gilpin and the 'Endearing' Navajo," *History of Photography* (April 1997): 60–66.

94 Gilpin 1989, 238.

95 Henry David Thoreau, quoted in Novak 1980, 150.

96 O'Keeffe to Stieglitz, September 4, 1916, in Cowart, Hamilton, and Greenough 1987, 155. The

literature on O'Keeffe is voluminous. In addition to those cited below, helpful sources used here include Lynes 1989; Lisle 1980; Robinson 1989; Peters 1991; Udall 1998; Lynes 1999; and Lynes 2005.

97 Georgia O'Keeffe, *Georgia O'Keeffe* (New York: Penguin Books, 1976), opposite pl. 2.

98 O'Keeffe to Stieglitz, September 4, 1916, in Cowart, Hamilton, and Greenough 1987, 155.

99 O'Keeffe to Anita Pollitzer, September 11, 1916, in Cowart, Hamilton, and Greenough 1987, 157. In this O'Keeffe was new; only Dallas artist Frank Reaugh and his circle of students had earlier felt the lure of the Llano Estacado (High Plains). Reaugh produced tiny gemlike pastels of the western region of the Panhandle at the turn of the century. See Flores 1990 for artists who responded to the geography of the Texas canyonlands.

100 Scholars agree that figure 65, an undated photograph in a scrapbook titled *College Days* from "World War I to World War II," represents an art classroom in a building at West Texas State Normal College in Canyon and that was completed in April 1916. Thus the photograph dates no earlier than the spring of 1916 and is unlikely to date past 1920. This estimate is based on the Arts and Crafts furniture and ceramics and on the hairstyles and clothing worn by students in another photograph in the scrapbook; the latter image was taken at the same time as the one labeled figure 65. O'Keeffe taught in this classroom from the fall of 1916 to early 1918, and so it is possible, if not likely, that some or perhaps all of the images on the walls and the objects in the classroom were present during her tenure at the college. O'Keeffe was given funds to furnish the then-new classroom, but it is not known whether she selected and arranged the photographs of ornamental designs, Asian prints (on the far wall), and Arts and Crafts furniture and ceramics. In the correspondence between O'Keeffe and Anita Pollitzer, O'Keeffe charges her friend to go to the Metropolitan Museum of Art, the American Museum of Natural History, and other places to buy books on "rugs and furniture," "photographs of textiles—greek pottery and Persian plates," "Alaskan stuff," and "textiles." O'Keeffe acknowledges receipt of Pollitzer's photographs but does not specifically describe them. However, the images displayed on the classroom wall are evocative of those described in O'Keeffe's and Pollitzer's correspondence and affirm Dow's and O'Keeffe's philosophy of teaching fine design based on pancultural artistic examples. The *Evening Star* series brilliantly displays O'Keeffe's distillation of pattern and emotion, based on her visceral response to the geography and climate of the Texas panhandle. For correspondence between O'Keeffe and Pollitzer, see O'Keeffe 1990, 186–229.

101 Georgia O'Keeffe, *Georgia O'Keeffe*, opposite pl. 6.

102 Kuh [1962] 2000, 190.

California

1 Helpful background sources for the cultural history of California include Starr 1973 and Starr 1986.

2 Perlman 1998, 147. See also James Gibbons Huneker, "Arthur B. Davies," *New York Sun*, June 4, 1908, 6.

3 The Bliss, Hirshhorn, and Phillips art collections are held, respectively, by the Museum of Modern Art, the Smithsonian Institution, and the Phillips Collection.

4 See Milton W. Brown, *The Story of the Armory Show* (Greenwich, Conn.: Joseph H. Hirshhorn Foundation, distributed by New York Graphic Society, 1963).

5 Reich 1970b, 366.

6 Herman Whitaker, *West Winds: California's Book of Fiction, Written by California Authors and Illustrated by California Artists* (San Francisco: Paul Elder and Company, 1914), vii, quoted in Wallace 2000, 16–18.

7 Arthur Davies to William Macbeth, July 18, 1905, Salt Lake City, Utah, NMc37, frame 1100, Macbeth Gallery Papers, Archives of American Art.

8 Frank Jewett Mather, Jr., "The Art of Arthur B. Davies," in Phillips 1924, 48. Mather suggests that in about 1903, when Davies changed his palette to "spectral grays and blues," Mather became more interested in his work, and his canvases became "a pearly veil into which one had to peer …[with] enigmatic figures related to each other only in pattern and rhythm, a tenser and less easy contour with a new tendency to posture and proportions askew, but always expressively" (Phillips 1924, 48).

9 A. W. Bahr, *Exhibition of Early and Middle Periods of the Work of Arthur B. Davies*, exh. cat. (New York: Gallery of Mrs. Cornelius J. Sullivan, 1939), no pagination.

10 Phillips 1924, 13.

11 Burroughs, Wehle, and Winlock 1930, xiv. Davies created "a world apart, appropriate and consistent, which sensitive people are lured to and where they find sanctuary from commonplace affairs.…He traveled to California and the mighty landscape of the West fulfilled his new craving for solemnity and grandeur. It was still his own world he painted, but his own world made grandiose with lofty mountains and gigantic redwood forests" (Burroughs, Wehle, and Winlock 1930, xi–xiv).

12 Paul A. Walter, "The Santa Fe-Taos Art Movement," *Art and Archaeology* 4 (1916): 337.

13 Quoted in Heyman 1974, 6. Brigman made this comment in the margins of her own copy of *Camera Work* 25 (1909). Other useful Brigman sources include Stern 1992, Ehrens 1995, and Wallace 2000.

14 Anne Brigman, unpublished foreword to *Songs of a Pagan*, 1939, I, Alfred Stieglitz/Georgia O'Keeffe Archive, Yale Collection of American Literature, Beinecke Rare Book and Manuscript Library, Yale University, quoted in Ehrens 1995,

26. Brigman sent her unpublished foreword to Alfred Stieglitz on July 30, 1939.

15 "Fear Retards Woman, Avers Mrs. Brigman," *San Francisco Call*, June 8, 1913. Quoted in Ehrens 1995, 26. Brigman often used her sister and friends as models.

16 Anne Brigman, "The Glory of the Open," *Camera Craft* 33, no. 4 (April 1926): 158, quoted in Ehrens 1995, 24.

17 Anne Brigman to Alfred Stieglitz, July 24, 1912, Alfred Stieglitz/Georgia O'Keeffe Archive, Yale Collection of American Literature, Beinecke Rare Book and Manuscript Library, Yale University.

18 Anne Brigman, "Awareness," *Design for Arts in Education* 38 (June 1936): 18, quoted in Ehrens 1995.

19 Anne Brigman, "The Glory of the Open," *Camera Craft* 33, no. 4 (April 1926): 155–63.

20 Ibid., 161.

21 J. Nilsen Laurvik, "Mrs. Annie W. Brigman—A Comment," *Camera Work* 25 (1909): 47–48, quoted in Heyman 1974, 6.

22 Anne Brigman to Alfred Stieglitz, October 14, 1905, Alfred Stieglitz/Georgia O'Keeffe Archive, Yale Collection of American Literature, Beinecke Rare Book and Manuscript Collection, Yale University. In this letter Brigman also wrote: "I am, so far as I know the only Secessionist in California." In another letter she wrote, "As I'm your only Californian, please right [*sic*] me," and then inserted "just now" after "Californian" (Anne Brigman to Alfred Stieglitz, March 20, 1904).

23 Joseph Keily, *Camera Work* 33 (1911): 23–29, quoted in Heyman 1974, 8.

24 J. Nilson Laurvik, foreword to *Catalogue of the 1918 San Francisco Art Association Annual Exhibition*, exh. cat. (San Francisco: Palace of Fine Arts, 1918), 11–12.

25 Anne Brigman, "What 291 Means to Me," *Camera Work* 47 (January 1915): 19. Everyone agreed that her technique was wanting, but there was something in her photographs that moved Stieglitz: "The *way* you did them *was rotten*, but they were a new note—they were worthwhile" (*Camera Work* 47 (July 1914): 17–20).

26 Brigman's *Infinitude* had previously been assigned to her California scenes, but it actually represents her work in Maine working with Clarence White. See Anne Brigman to Alfred Stieglitz, July 8, 1918, Alfred Stieglitz/Georgia O'Keeffe Archive, Yale Collection of American Literature, Beinecke Rare Book and Manuscript Library, Yale University.

27 For a nuanced discussion of the rhetoric and beliefs of Alfred Stieglitz and the exclusive group of artists and writers in his circle, see Corn 1999, 3–40.

28 See Hailey 1936–37a and Jones [1972] 1985 for a biographical overview of Arthur Mathews. Thanks to Harvey Jones, in particular, whose essay in Nash 1995, 35–39, discusses Mathews.

29 Frederick J. Teggart, "The Education of the Adult," *Philopolis* 1, no. 9 (June 25, 1907): 3–4, quoted

in Nancy Boas and Marc Simpson, "Pastoral Visions at Continent's End: Painting of the Bay Area 1890–1930," in Nash 1995, 53.

30 Hailey 1936–37a, 24. Hailey quotes Eugene Neuhaus, *The History and Ideals of American Art* (Palo Alto: Stanford University Press; London: H. Milford, Oxford University Press, 1931).

31 Quoted in Jones [1972] 1985, 46.

32 *Philopolis* 1, no. 8 (May 25, 1907): 30. Quoted in Nancy Boas and Marc Simpson, "Pastoral Visions at Continent's End: Painting of the Bay Area 1890–1930," in Nash 1995, 57, 21n. See also Jones [1972] 1985, 34, which recounts how Mathews, like Whistler before him, was dubbed by a local critic an "apostle of grey," in reference to the gray tones that unified his palette.

33 Palmquist 1999, 21. The First World War caused a shortage in platinum printing papers, so Dassonville began experimenting with coating photographic papers. As a result of much experimentation, he invented Charcoal Black, whose textured, thin, and translucent-roughed surface made it perfect for soft-focused photographs.

34 William E. Dassonville, "Individuality in Photography," *Overland Monthly* 40, no. 4 (October 1902): 339–45. Reproduced in Palmquist 1999, 91–93.

35 Starr 1973, 186.

36 Max Stern, "Twenty-five Great Californians, No. 21, Gottardo Piazzoni: His Religion Is California," Archives of American Art, reel 1902, frame 329. Interviewing Piazzoni in 1918 in the *San Francisco News*, Stern asked him: "And what is your religion?" He hesitated: "I think it is California"; quoted in Hailey 1936–37b, 64, and in Shields 2001, 106.

37 Miss Jerome, *San Francisco Call*, September 13, 1908. Reproduced in Hailey 1936–37b, 48.

38 Ray Boynton, art critic and artist, quoted in Hailey 1936–37b, 63.

39 Josephine Mildred Blanch, "A Western Painter: The Art of Gittardo [sic] Piazzoni," *Overland Monthly* 54, no. 5 (November 1909): 462.

40 H. L. Dungan, "Artists and Their Work," *Oakland Tribune*, August 29, 1926, quoted in Boas 1988, 101.

41 Laura Bride Powers, exhibition review, *Oakland Tribune*, March 11, 1923, quoted in Boas 1988, 112–13.

42 Mary McPhail, "Oakland Is Now on the Map as an Art Center: 'Society of Six' Blazes Trail as New School," *San Francisco Examiner*, March 25, 1923, Oakland edition, quoted in Baird 1981, 25.

43 Terry St. John, *Society of Six*, exh. cat. (Oakland: Oakland Museum, 1972), 15, quoted in Baird 1981, 25.

44 Quoted in Boas 1988, 77.

45 Jay Hannah, taped interview, New London, Connecticut, December 2, 1983, quoted in Boas 1988, 86.

46 Portland Art Association, *C. S. Price, 1874–1950:*

A Memorial Exhibition, exh. cat. (Portland, Oreg.: Portland Art Association, 1951), 10.

47 Robert V. Howard, "Remarks on Price," unpublished manuscript, December 11, 1950, photocopy in the American Art Study Center, Fine Arts Museums of San Francisco, 1–2. Howard also suggests Price's enthusiasm for primitive art, John Constable's landscapes, Odilon Redon's flowers, and his "catholic" taste.

48 Roger Saydack, "C. S. Price: Landscape, Image & Spirit," review of *C. S. Price: Landscape, Image & Spirit*, University of Oregon Museum of Art, Eugene, 1998–99, *American Art Review* 10, no. 6 (November–December 1998): 181.

49 Ibid., 182.

50 Robert V. Howard, "Remarks on Price," unpublished manuscript, December 11, 1950, photocopy in the American Art Study Center, Fine Arts Museums of San Francisco, 3.

51 Rachel Griffin, "C. S. Price, Maverick of Western Art," undated, unidentified article in the American Art Study Center, Fine Arts Museums of San Francisco, quoted in Nash 1995, 51, 87n. Griffin's article also discusses Price's abstractions.

52 Arthur Millier, "The Pacific Coast: Artists Are Stimulated by Its Diverse Climates," *Art Digest* 26 (November 1, 1951): 30.

53 Moure 1998, 1991. See also untitled press clipping of Cuprien's obituary, Library files, Laguna Art Museum, undated, unpaginated. Several sources mention that he received criticism from William Trost Richards. Regarding *Poème du Soir*, Will South wrote, "In the hesitant fragility of this image, Cuprien captured what so many California Impressionists sought in their work: the dreamlike reverie that could be induced by the ocean, and a hint of its impenetrable infinitude and mystery" (Solon 1999, 39).

54 Margaret R. Burlingame, "The Laguna Beach Group," *The American Magazine of Art* 24 (April 1932): 265, quoted in Dominik 1986, 24.

55 Everett C. Maxwell, "Exhibition of California Art Club," *Fine Arts Journal* 28 (January–June 1913): 189, quoted in Gerdts and South 1998, 145.

56 Quoted in Jones, Caldwell, and St. John 1981, 20, and in Moure 1980, 27.

57 See South 2001 and Scott 1967 for detailed biographical information on Macdonald-Wright.

58 South 2001, 70. For more information on his emphasis on nature, see his manifestos in Stanton Macdonald-Wright, "Influence of Aviation on Art: The Accentuation of Individuality," *Ace: The Aviation Magazine of the West* 1, no. 2 (September 1919): 11–12.

59 Stanton Macdonald-Wright statement to the Carnegie Institute of Art, 1961, reel LA5, p. 14, Stanton Macdonald-Wright Papers, Archives of American Art.

60 Stanton Macdonald-Wright, statement for 291 exhibition, 1917, reel LA5, Stanton Macdonald-Wright Papers, Archives of American Art.

61 Willard Huntington Wright to Alfred Stieglitz,

December 3, 1919, reel 52, YCAL MSS 85, Box 52, Folder 1275, Alfred Stieglitz/Georgia O'Keeffe Archive, Yale Collection of American Literature, Beinecke Rare Book and Manuscript Library.

62 Willard Huntington Wright, "Innovators Will Find West Good Field for All Sound Modernism," *San Francisco Bulletin*, February 22, 1919, clipping, Willard Huntington Wright Scrapbooks, Seeley G. Mudd Manuscript Library, Princeton University Archive, quoted in South 2001, 69.

63 Stanton Macdonald-Wright, preface to *American Modernists*, exh. cat. (Los Angeles: Los Angeles Museum of History, Science, and Art, 1920), quoted in Dailey et al. 2003, 37.

64 George Rodier Hyde, "Color Riots at L.A. Exhibit of 'Modernists,'" reproduced in John Alan Walker, *Accounts of Early California Art: A Reprint Anthology* (Big Pine, Calif.: Privately printed, 1988), quoted in Vure 2000, 87, 56n.

65 South 2001, 72.

66 Stanton Macdonald-Wright remained an authoritative figure in Southern California as head of the Works Progress Administration's Federal Art Project (1935–37) and as an innovator in the art of public murals. See "Invention and Imagination" murals for the Santa Monica Public Library, 1934–35, Smithsonian American Art Museum.

67 See Reed 1985, Wilson and Reed 1995, and McCarroll 2004. Mount Lowe, in the San Gabriel Mountains north of Pasadena, was served, at the time, by a railway to its summit, and was a popular site for photographing. It is more likely, however, that Kono's subject was taken in the San Bernardino Mountains.

68 Reed 1985, 35.

69 Alinder and Stillman 1988, 7. Adams wrote a letter to his father on June 8, 1920, while in Yosemite National Park.

70 Quoted in Palmquist 1999, 26.

71 Quinn and Stebbins 1991, 9. See also Hammond 1999 for more on Adams and mountaineering. Anne Hammond's article attests to Adams's knowledge of mountaineering and mountain writing from the point of view of science, romance, and adventure: "Outside the ranks of the Sierra Club, mountain photography was not a genre to which many photographers in the 1920s, particularly pictorialists, were willing to commit themselves, as articles in the photographic press testified" (Hammond 1999, 92). Although the mountain portrait was a great subject, it was difficult to accomplish because the photographer had to have sophisticated climbing skills. Adams effectively combined the tradition of mountain photography and mountaineering with Pictorialist aesthetics, the latter having become far less important to him by the late 1920s and 30s.

72 Hammond 1999, 94.

73 Ansel Adams, notes for a proposed book never published, "Here Is Yosemite," undated, AG31:2:14:1, The Ansel Adams Archive, Center

for Creative Photography, The University of Arizona. Used with permission of the Trustees of The Ansel Adams Publishing Rights Trust. All Rights Reserved.

74 Ansel Adams, foreword to *The John Muir Trail* (Berkeley, Calif.: The Archetype Press, 1938), no pagination.

75 The Museum of Modern Art, exhibition brochure for *Ansel Adams at 100* (New York: The Museum of Modern Art, 2003). See also Szarkowski 2001. For a helpful review of the exhibition, see Vicki Goldberg, "Visions of Majesty," *Vanity Fair* (August 2001).

The Southwest

1 Richard Francaviglia, "Elusive Land: Changing Geographic Images of the Southwest," in Francaviglia and Narrett 1994, 24. See, in particular, Francaviglia's discussion of the shifting nature and complexity of regional terminology, 8–13.

2 A. C. Vroman, Journal, Huntington Library, San Marino, California, quoted in Jennifer A. Watts, "Adam Clark Vroman: The Inquisitive Eye," in Watts and Smith 2005, 5; the quote by Watts on 9.

3 Van Dyke [1901] 1999, xix.

4 Ibid., xx.

5 Vroman, quoted in Andrew Smith, "Adam Clark Vroman: A Modern Photographer," in Watts and Smith 2005, 11; Vroman, 1901, quoted in Watts, "Adam Clark Vroman: The Inquisitive Eye," in Watts and Smith 2005, 6. See also Mahood 1961; Webb and Weinstein 1973; and Van Keuren 1997.

6 Quoted in "Laura Gilpin's Rio Grande Country," *U.S. Camera* 13, no. 2 (February 1950): 45.

7 Corn 1999, 32–33, 249–50. See also Eldredge, Schimmel, and Truettner 1986, 12–13.

8 D. H. Lawrence, "The Spirit of Place," in *Studies in Classic American Literature* (1923; reprint, New York, Viking, 1964), 5–6.

9 Carl Sauer, "The Morphology of Landscape," in Leighly 1963, 315–50, this quote on 343.

10 Vroman, Journal, August 18, 1895, in Watts and Smith 2005, 23.

11 The well-known quote derives from Balzac's short story "A Passion in the Desert" (1830).

12 Attributed to T. E. Lawrence and used in the screenplay *Lawrence of Arabia*, produced by Sam Spiegel and directed by David Lean (RCA/Columbia Pictures, 1962).

13 D. H. Lawrence, "New Mexico," *Survey Graphic* (May 1931): 152–55.

14 Starr 1973, 397–401, and Wilson 1997, 72–75.

15 This group created and promoted an architectural idiom that could be described as "ancient picturesque," bringing together City Beautiful planning with pueblo and Spanish Colonial (Territorial) architectural revivals, and naming the new look Santa Fe style. See "Romantic Regional Architecture, 1905–1930" in Wilson 1997, 110–45.

16 Helpful sources on this subject include Bickerstaff [1955] 1983; Coke 1963; White 1983; Gibson 1983; Eldredge, Schimmel, and Truettner 1986; and Porter, Ebie, and Campbell 1999. See also Weigle and Fiore 1994.

17 Blumenschein's account appears in Bickerstaff [1955] 1983, 31 and also 27.

18 The aim of the group appears in Article III of its constitution and bylaws and may be found in White 1983, 17.

19 Some examples of Modernist styles include the Art Deco qualities of Dunton's paintings, Hennings's ongoing interest in the sinuous lines and patterning of Jugendstil, and the Post-Impressionist color blocking of Blumenschein.

20 Blumenschein, in "Appreciation of American Indian Art," *El Palacio* 6, no. 12 (May 24, 1919): 178–79.

21 Soon after being made, a number of Taos Society paintings entered important institutional collections, including the Metropolitan Museum of Art and the Art Institute of Chicago. The society united artists and archaeologists in its mission to preserve what had once been thought to have vanished. However, many art historians and critics restrict Taos Society art to a tourist context, not recognizing the importance of the field of science in this cultural salvage project. As one example of institutional inattention to these artists, the 2000 exhibition at the Whitney Museum of Art, *The American Century*, did not include any works by Taos Society artists or even mention them in the text or index.

22 Bickerstaff [1955] 1983, 37.

23 The bibliography on Duchamp's *Fountain* is voluminous. Helpful sources used here include Camfield 1988 and Corn 1999, "Américanisme," 43–89.

24 Santa Clara and San Ildefonso Pueblos are famous for their traditions of black-on-black earthenware, particularly those by Maria Martinez at San Ildefonso. It is tempting to speculate (and would be entirely in keeping with Taos Society promotional measures regarding native art) that at least one of the ceramics that Blumenschein depicts in *Superstition* is the newly invented black-on-black pottery, whose matte surfaces are contrasted with polished ones. Maria Martinez and her husband, Julian, both artists of the Hewett "circle," invented this technique around 1918, not long before Blumenschein produced this painting. For a discussion regarding the contemporaneous issue of Indians as cultural model, particularly the 1924 arguments of sociologist Edward Sapir, see Michaels 1990, 220–41.

25 Henderson 1937, 13.

26 See Chronic 1987, 1–35 and 137–140.

27 Porter, Ebie, and Campbell 1999, 87–121; and Barter 2003, 61–75.

28 Higgins to Paul Grafe, May 31, 1946, *Victor Higgins: Letter to Mr. Paul Grafe*, published by Owings-Dewey Fine Art, Santa Fe, and Rosenstock Arts, Denver (March 2004): 20. For more information on Higgins, see Art Gallery of the University of Notre Dame 1975; Art Museum of South Texas 1984; and Porter 1991.

29 Ed Garman, *The Art of Raymond Jonson, Painter*, quoted in Eldredge, Schimmel, and Truettner 1986, 159.

30 Samuel Putnam, "Lost: One America; Provincetown to Santa Fe," *Chicago Evening Post Magazine of the Art World*, 1926, quoted in Udall 1984, 101–2. The archives and work of Jonson are housed in the Jonson Gallery of the University of New Mexico.

31 Charles Eldredge coined the phrase "Deco desert."

32 Dixon, quoted in Hagerty [1993] 1998, 206.

33 Lange, Hamlin, Dixon, and Dixon 1994, 33. Useful sources on the art of Dixon include Burnside 1974; Hamlin 1975; Hagerty [1993] 1998; Gibbs 2000; and, more recently, Erika Doss, "Between Modernity and 'the Real Thing': Maynard Dixon's Mural for the Bureau of Indian Affairs," *American Art* 18, no. 3 (Fall 2004): 8–31. See also Hailey 1936–37c, 1–89; and the extensive curatorial files at the Museum of Art, Brigham Young University, Provo, Utah.

34 Dixon, quoted in Gibbs 2000, 8.

35 Dixon, quoted in Gibbs 2000, 58.

36 This poem by Dixon is quoted in full and juxtaposed with a reproduction of *Earth Knower* in Ansel Adams, "Free Man in a Free Country: The West of Maynard Dixon, with a selection of his paintings and poems, and an essay on understanding by Ansel Adams," in *The American West* 6, no. 6 (November 1969): 43.

37 Hailey 1936–37c, 55.

38 Hewett, quoted in Gibbs 2000, 112.

39 In its firm geometries and geography, *Earth Knower* is quite reminiscent of Dixon's painting *Remembrance of Tusayan No. 2* (1924, Museum of Art, Brigham Young University), which derives from a landscape in Arizona, not New Mexico.

40 Press clipping, "Artist Dixon Protests," ed. Max Miller, San Diego, 1983 (unpaginated and not dated), in Archives of American Art, Papers of Maynard Dixon, reel 823, frame 920.

41 Quoted in Hamlin 1975, unpaginated.

42 Dixon's comments regarding *Earth Knower* were published in Arthur Millier, "Indian Mode of Life Proved Superior in Time of Panics," *Los Angeles Times*, April 9, 1933, 8. Reviews of Dixon's work were uniformly good, except for Joseph A. Danysh's dissenting opinion in *The Argonaut*, November 24, 1933 (Archives of American Art, Papers of Maynard Dixon, reel 823, frame 915). Dixon's biographer Wesley Burnside termed Dixon's style "cubist-realism," but Dixon deplored "hot house modernisms" and likely would have shunned the term to describe his work (Burnside 1974, 74).

43 Dixon, quoted in Ruth Pielkovo, "Dixon, Painter of the West," *International Studio* (March 1924): 469.

44 I thank Ani Boyajian, of the Stuart Davis

catalogue raisonné project, who provided pre-publication information, comments, and an overview of Davis's paintings in New Mexico in a letter dated April 27, 2005 (see Boyajian and Rutkoski, forthcoming). Boyajian also generously shared unpublished letters that Davis wrote during his stay. I also thank Earl Davis, the artist's son, who provided encouragement, assistance, and generous help with identifying photographs of Stuart Davis in New Mexico. The ample literature on Davis that proved especially helpful here includes Sweeney 1945; Kelder 1971; Lane 1978; Wilkin 1987; Sims 1991; and Kelder 2002.

45 Sweeney 1945, 15.

46 Cecelia Ager, "Stuart Davis," *Vogue* 107, January 15, 1946, 126.

47 I consulted the Journal of Stuart Davis (Stuart Davis, Autograph manuscript diary, 1920 May–1922 November. Purchase; Young Associates Fund, MA 5062, The Pierpont Morgan Library, New York) on microfilm at the Archives of American Art, Papers of Stuart Davis, reel 3842. See also Kelder 2002.

48 John Sloan to Will Shuster, May 7, 1922, Museum of Fine Arts, Museums of New Mexico, Santa Fe, Archives of American Art, reel 3437.

49 All letters and postcards cited below, copyrighted Estate of Stuart Davis, are courtesy of Ani Boyajian, Stuart Davis catalogue raisonné project, all dated as postmarked: June 7, 1923, Davis to his father; June 8, 1923, Davis to his mother; June 18, 1923, Davis to his mother; June 19, 1923, Davis to his mother; July 3, 1923, Davis to his cousin Hazel Foulke; July 10, 1923, Davis to his mother (postcard and letter); September 27, 1923, Davis to his mother; September 2[7?], 1923, Davis to his mother; October 12, 1923, Davis to his mother.

50 Davis later recounted that he was assigned to deliver a Ford automobile from "Santa Fe to the Museum of the American Indian Excavation of the original Zuni Pueblo" (Typescript, 139, interview with Stuart Davis, n.d., courtesy of Earl Davis).

51 Ibid., 143.

52 Davis to his mother, June 18, 1923.

53 Davis to his mother, July 10, 1923.

54 This is likely a direct reference to Davis's painting *Pajarito* (private collection).

55 Davis to his mother, July 23, 1923.

56 Davis to his cousin Hazel Foulke, July 3, 1923.

57 Sanford Schwartz describes Davis's New Mexico landscapes thus: "The richness of the material, combined with his feeling that none of it mattered a great deal to him—that he wasn't face to face with a Stuart Davis landscape but, rather, peeking in on somebody else's—resulted in the most relaxed pictures of his career. Relaxed without being limp. The pressure in them comes from the way the 'literal' landscape pushes up against everything Davis knows about how to artificialize the motif. If, in his effort, he came close to making cartoons, they're taut, witty, mus-

cular ones," in "When New York Went to New Mexico," *Art in America* 64, no. 4 (July–August 1976): 92–96, this quote on 96. Apart from his 1920–22 journal, Davis's direct comments about "nature" are infrequent. In an unidentified questionnaire, dated September 3, 1957, in the Whitney Museum artists' files, Davis wrote: "I am more interested in what Man does to Nature than what Nature does to Man."

58 Of the extensive literature on Hartley, the following publications were most useful: Moore 1966; Haskell 1980; Scott 1988; Ludington 1992; Hokin 1993; Robertson 1995; McDonnell 1997; Hartley and Ryan 1997; Brennan 2001, 156–98; Kornhauser 2003; Scott 2003; and Hole 2005.

59 Hartley to Rebecca Strand, October 1918, Archives of American Art.

60 Hartley to Harriet Monroe, July 3, 1919, Archives of American Art.

61 Hartley, "America as Landscape," *El Palacio* 5, no. 21 (December 21, 1918): 340–42.

62 Hartley to Stieglitz, June 20, 1918 (Alfred Stieglitz/Georgia O'Keeffe Archive, Yale Collection of American Literature, Beinecke Rare Book and Manuscript Library, New Haven (hereafter cited as YCAL).

63 Hartley to Stieglitz, June 24, 1918 (YCAL).

64 Ibid. The art of Claude Lorraine is mentioned in Hartley's August 1, 1918, letter to Stieglitz (YCAL).

65 See *El Palacio* 11, no. 9 (November 1, 1921), which includes an excerpted review by Herbert Seligman from the October edition of *International Studio*, 117–18. Hartley's quote is taken from a letter he wrote to Stieglitz, September 19, 1918 (YCAL), in which he elaborates on the pastel medium: "It is the only way I can get a line on the qualities, and it is a very important and typical medium for this country which has such wonderful dry quality of colour, and such hardness and brilliancy." In another letter from Hartley to Stieglitz, November 20, 1918 (YCAL), he notes that he worked further on a "large one [pastel] I began in Taos, of the Hondo Canyon, which has some real merits, I think.... You will see a little Courbet, and a little Renoir, and a little Cezanne, and you will also see myself which is inevitable....It is a magnificently sculptural country....It is strong, sober, starkly simple, and the light is hard and clear, not at all an impressionistic country as the small men are trying to show. It is essentially of the type of Courbet's d'Orleans [sic] landscapes." Interestingly, in the same letter, he notes, "The western landscape holds me more than I thought it would in the summer, and I can see things enough down here in the southwest to keep one going for years, but I could not do it unless I could come to it frequently....There is noone doing the southwest outside of [Paul] Burlin and myself, that is among the more serious ones." One wonders if, in the new relationship developing between O'Keeffe and Stieglitz, O'Keeffe was learning about Hartley's rapturous

response to the New Mexico landscape.

66 Hartley, "American as Landscape," *El Palacio* 5, no. 21 (December 21, 1918): 340–42.

67 Hartley, "Aesthetic Sincerity," *El Palacio* 5, no. 20 (December 9, 1918): 332–33.

68 Hartley to Stieglitz, July 20, 1918 (YCAL).

69 Hartley to Stieglitz, August 1, 1918 (YCAL).

70 See Wanda M. Corn, "Marsden Hartley's Native Amerika," in Kornhauser 2003, 69–93.

71 Hartley, "Red Man Ceremonials: An American Plea for American Esthetics," *Art and Archeology* 9, no. 1 (January 1920): 7–14; "The Scientific Esthetic of the Redman: Part I: The Great Corn Ceremony at Santo Domingo," *Art and Archaeology* 13, no. 3 (March 1922): 113–19; and "The Scientific Aesthetic of the Red Man: Part II: The Fiesta of San Geronimo at Taos," *Art and Archaeology* 14, no. 3 (September 1922): 137–39.

72 Marsden Hartley, "A Proposed Indian Theater in Santa Fe," *El Palacio* 18, no. 6 (March 16, 1925): 127–28.

73 In Hartley's "Dissertation on Modern Painting" (1921), quoted in Ludington 1992, xi–xii. Here Hartley further articulates his definition of Modern painting: "to produce the newness or the 'nowness' of individual experience."

74 Hartley to Stieglitz, April 28, 1923 (YCAL).

75 Hartley to Stieglitz, October 16, 1918 (YCAL).

76 Strand (1928), quoted in Udall 1984, 125.

77 The three most helpful sources about Marin in New Mexico are Landis and Udall 1999; Coke 1968; and Stevens 1968. Other helpful resources, amid a voluminous literature, include Marin and Norman 1949; Reich 1970a; and Fine 1990.

78 Marin (1929), quoted in Marin and Norman 1949, 127.

79 Marin (1929), quoted in Marin and Norman 1949, 128; Lockwood, quoted in Stevens 1968, 12.

80 Paul Rosenfeld, "Art: An Essay on John Marin," *The Nation* 134, no. 3473 (January 27, 1932): 122–24; this quote on 123.

81 Wight 1956, unpaginated.

82 Rosenfeld, see 80n.

83 Duncan Phillips, "Original American Painting of Today," *Formes*, no. 21 (January 1932): 197–204; this quote on 198.

84 Ward Lockwood, "The Marin I Knew: A Personal Remembrance," *Texas Quarterly*, reprint (Spring 1967): 107–12; this quote on 111–12.

85 Rosenfeld (1932), 80n, 123.

86 Modern American Indian watercolor painting also developed slightly later, about 1914, at the Kiowa branch of this style in Anadarko, Oklahoma.

87 Fundamental sources for the history of modern American Indian watercolor painting are Dunn 1968; Brody 1971; Brody 1997; and Bernstein and Rushing 1995.

88 On the subject of the relationship between activist white women and the promotion of Native American arts, see Jacobs 1999.

89 In this regard, see especially Bernstein, "Art for the Sake of Life," 17–25, and Rushing, "Modern

by Tradition," 32–37, in Bernstein and Rushing 1995. Also, see an account of the search for artistic purity and sincerity among white patrons, as reflected in an anecdote concerning Awa Tsireh and teacher Elizabeth DeHuff. DeHuff discouraged the artist from painting Hopi subjects, urging him to concentrate on his own traditions at San Ildefonso. After Awa Tsireh absorbed the lessons of the art of Japanese and other cultures, she noted, "I have often wondered just what he might have accomplished in a distinctive style of his own had he not been subjected to these alien influences." Her comment, representative of a dominant viewpoint at the time, ignored the fact that Pueblo cultures had interacted with non-Indians for over four hundred years. See Ina Sizer Cassidy, "Art and Artists of New Mexico," *New Mexico Magazine* 11 (October 1933): 28, 48–49.

90 Pach, "Notes on Pueblo Water-Colours," *The Dial* 68 (March 1920): 343–45.

91 These exhibitions occurred throughout the United States and the world, for example, in Houston, Cincinnati, Paris, and Prague. For example, philanthropist and collector Miss Ima Hogg of Houston collected, in a context that embraced her passion for modern works on paper by European artists as well as the Colonial Revival, some ninety Pueblo watercolors in the 1920s and 1930s, eventually donating them to the Museum of Fine Arts, Houston, in 1944. These works were exhibited along with pottery, textiles, and sand paintings made by Navajo artists in the gallery spaces in the manner of the 1941 exhibition at the Museum of Modern Art. I thank Janet C. Berlo for sharing her pre-publication article, "The Szwedzicki Portfolios: Native American Fine Art and American Visual Culture, 1917–1952," introduction to *The Szwedzicki Portfolios of American Indian Art* (Cincinnati: University of Cincinnati Digital Press, forthcoming, spring 2006).

92 Dunn 1968, xxvi.

93 Bernstein and Rushing 1995.

94 Quoted in Bruce Bernstein, "Art for the Sake of Life," in Bernstein and Rushing 1995, 25. Rushing, in particular, points out that although some scholars may see only the "paternalism" in this cultural salvage project, Dunn and others were committed to notions of preservation by the recently dissolved acculturation policies that exposed their devastating effects. At a time when many believed American Indians *ought* to vanish, he says, Dunn and others, with their unwavering certainty about the contributions of American Indian art, offered a strong statement about valuing cultural difference (37).

95 Useful resources used here include Rosenblum 1978; Stange 1990; Busselle and Stack 2004; and Lyden 2005. Especially helpful is Steve Yates, "The Transition Years: New Mexico" in Stange 1990, 87–99. *The Transition Years* is also the name of an exhibition, cited here as

Yates 1989. I also thank Anthony Montoya, archivist at the Paul Strand Archive, for his willingness to assist with numerous requests.

96 Beaumont Newhall, "Paul Strand, Traveling Photographer," *Art in America* 50, no. 4 (1962): 1, as quoted from *Minicam Photography* (May 1945).

97 Quoted in Yates 1989, 27.

98 Strand (1931), quoted in Busselle and Stack 2004, 94.

99 Lange (1968), quoted in Busselle and Stack 2004, 97.

100 The church at E-town, subsequently a school, was removed long ago, but a replica, a church for working cowboys, has recently been erected in its place.

101 Wilson and Weston 1940, 105. Helpful resources for Weston include Newhall 1946; Newhall 1973; Maddow 1973; Newhall 1975; Conger 1992; Mora 1995; Wilson and Madar 1998; Stebbins, Quinn, and Furth 1999.

102 Entry for January 29, 1931, in Newhall 1973, vol. 2, 239.

103 Newhall 1946, 10.

104 Entry for March 19, 1932, in Newhall 1973, vol. 2, 250–51.

105 Entry for April 28, 1941, in Newhall 1975, 70.

106 Entry for February 23, 1931, in Newhall 1973, vol. 2, 206.

107 Luhan 1931, 407.

108 On the subject of O'Keeffe's self-fashioning and her career painting western subjects, see "The Great American Thing," in Corn 1999, 239–91.

109 Rosenfeld [1924] 1966, 206.

110 Quoted in Sanford Schwartz, "When New York Went to New Mexico," *Art in America* 64, no. 4 (July–August 1976): 92–96, this quote on 96. Schwartz attributes O'Keeffe's observations to her interview with Calvin Tomkins in the *New Yorker*, March 4, 1974.

111 O'Keeffe 1976, unpaginated, text accompanying entry 64. See also Moore 1986, 32–39.

112 Schneider Sketchbook, The Georgia O'Keeffe Foundation. See Lynes 1999, vol. 2, 1053–61, specifically nos. 1842, 1844, 1846, 1847–48.

113 O'Keeffe, quoted in Robinson 1989, 376.

114 Rebecca Strand to Alfred Stieglitz, quoted in Busselle and Stack 2004, 75.

115 Edward Alden Jewell, "New O'Keeffe Pictures," *New York Times*, February 9, 1930, 12. See exhibition reviews also in Moore 1986. Critic Samuel M. Koetz, for example, admired how "[s]ometimes, as in her latest religious pictures, she attains a fuller human quality. Life is in them, strong and pulsating. Vibrant black crosses beat at one from the canvasses, assertive, boldly crying their new faith. Well, let it be religion that O'Keeffe has, but though it may become sentimental it as present is also a new intellectual experience in that she has found the ability to clothe her ideas and experiences in thoughtful language."

116 Rich 1943, 29.

117 For example, see Murdock Pemberton, *Creative*

Art 4 (March 1929): i–lii. A review in *Parnassus* 1, no. 8 (December 1929): 13–16, found her work "banal" and "superficial."

118 O'Keeffe, quoted in Robinson 1989, 357.

119 Initially she rented a cottage in the summer of 1934 before eventually buying a house and property there, Ranchos de Los Burros, from its owner, Arthur Pack, in 1940.

120 Corn 1999, specifically 276.

121 "Georgia O'Keeffe in New Mexico: Stark Visions of a Pioneer Painter/Horizons of a Pioneer," *Life* 64, March 1, 1968, 40–49.

122 Colbert 1995, 7, 28, 50–51.

123 O'Keeffe to Henry McBride, "Sees Mountains Red," *New York Sun*, January 28, 1939, 9.

124 Henry McBride, "Georgia O'Keeffe's Bones," *New York Sun*, February 6, 1942, 32. As O'Keeffe further elaborates: "'How can one possibly cheapen disaster by regarding it as the end of the story,' Miss O'Keeffe asks. 'To the artist, she says, disaster is just the beginning and often it's merely the prelude to creation.'"

125 A Harvard-trained medical student, Porter left school to concentrate on his lifelong interests, birds and photography. Supported by his family's personal resources, this native of Winnetka, Illinois, was introduced by his brother, the painter Fairfield Porter, to Ansel Adams and Alfred Stieglitz, who gave him his first show, in 1938, at An American Place. Thereafter, Porter pursued photography, earning renown for his innovative work in color, reinforced by his passion for natural history and environmental issues. I thank John Rohrbach, Amon Carter Museum, Fort Worth, for sharing his expertise on Eliot Porter. The Amon Carter Museum contains the Eliot Porter Photographic Archive.

126 O'Keeffe to James Johnson Sweeney, June 11, 1945, in Cowart, Hamilton, and Greenough 1987, 241.

The Dust Bowl Era—Plains and Other Places

1 Deborah Brown Rasiel, "Dixon and Lange: The Give and Take in a Marriage of Aesthetics," in Gibbs 2000, 141.

2 Dixon had firsthand knowledge of the working conditions at Boulder City; Dorothea Lange's brother, Martin Lange, worked there. In 1934, hired by the U.S. government, Dixon painted laborers building the Hoover Dam.

3 Nonetheless, he devised an artful image for himself, marking his paintings with a thunderbird logo.

4 Dixon, "Toward an American Art," *Argus* (April 1927): 6–7.

5 From Maynard Dixon Papers, Archives of American Art, reel 823, frame 333; typescript of the interview suggests that Dixon may have titled the painting *Who Cares? No Place to Go.*

6 Steinbeck [1936] 1994, 612. *In Dubious Battle* takes place in the fertile land of fictional Torgas Valley, perhaps an allusion to Steinbeck's native

Salinas Valley, about fifteen miles inland from Monterey Bay. In this novella a jobless and desperate young man joins the union and is assigned the task of helping its leaders organize a strike among migrant fruit-pickers. The workers need a place to stay, and a union leader informs a local landowner, "We're goin' to have a thousand or two men with no place to go. They'll kick 'em off the ranches and won't let 'em on the road. Now if they can camp on that five acres, they'd be safe." Both Dixon and Steinbeck appropriated a commonly used phrase, "no place to go," to give their art a sense of urgency and contemporaneity.

7 Helpful resources for Lange used here include Heyman 1978; Meltzer 1978; Levin and Northrup 1981; Coles 1982; and Partridge 1994.

8 Rothstein 1979, 6–10, this information on 7.

9 As journalist J. Russell Smith wrote in 1934, "We have, in effect, grabbed this continent almost without restrictions. We have done with it as we pleased, and now the consequences of this grab-and-kill policy are beginning to show up.…We have plowed and plowed—plowed land that should never have been plowed—and recently the skies of Chicago, New York and Washington were clouded with dust because the tractor has destroyed the prairie-sod and the winds blew the top-soil away," in "The Drought—Act of God and Freedom," *Survey Graphic* 23, no. 9 (September 1934): 412–13.

10 Richard Doud interview with Lange, in Levin and Northrup 1981, vol. 2, 69–70.

11 Roosevelt used this phrase in his 1937 inaugural address and variants of it throughout the period.

12 See Rothstein's account of the notorious skull picture in Rothstein 1979, 8–9.

13 Richard Doud interview with Lange, in Levin and Northrup 1981, vol. 2, 87.

14 Coles 1982, 76. We now know that the "migrant mother" is Florence Owens Thompson, an Oklahoma native and a Native American woman who was a labor organizer and leader. She had lived in California for ten years at the time Lange took the photograph.

15 Lange and Dixon 1952, 9.

16 The Filipino writer Carlos Bulosan, who spent his first year in the United States as a migrant worker, described his experience in *America Is in the Heart* (1946): "All roads go to California. …It is hard to be a Filipino in California.…The lives of Filipinos were cheaper than those of dogs. They were forcibly shoved off the streets when they showed resistance," in Bulosan [1946] 1976, 112–43.

17 Howard Dewitt, "The Filipino Labor Union: The Salinas Lettuce Strike of 1934," *Amerasia* 5, no. 2 (1978): 1–21.

18 As Steinbeck characterized the situation, "They [Filipinos] were good workers, but like the earlier immigrants they committed the unforgivable in trying to organize for their own protection. Their organization brought on them the usual

terrorism. A fine example of this was the vigilante raid in the Salinas valley last year when a bunk house was burned down and all the possessions of the Filipinos destroyed" (Steinbeck [1936] 1938, 27).

19 The photograph's alternate title is *Tractored Out: Power Farming Displaces Tenants from the Land in the Western Dry Cotton Area, Childress Co., Texas Panhandle, June 1938.*

20 Caption in Lange and Taylor 1939.

21 February 7, 1939, quoted in Lange and Taylor 1939.

22 Lange and Dixon 1952, 6.

23 As if to recall Lange's image, Taylor noted in his speech at the Commonwealth Club of California on April 15, 1938, "Where the tractors are appearing, the rural landscape is strewn with abandoned houses. Residents in western Texas explain as they point, 'There used to be two families out there. The tractor got both of them. …The tractors are keeping our families from making a living'" (Speech titled "What Shall We Do with Them?" quoted in Levin and Northrup 1981, vol. 2, 9).

24 See Murray 1980, 86.

25 Stein 1983, 9. Other helpful publications on Wolcott include Murray 1980, Hurley 1989, and Hendrickson 1992.

26 Traveling to the northern hills of Great Falls in the Missouri River Basin in north-central Montana, Wolcott may have been photographing property on the Schnitzler Corporation Ranch, according to brief notes included in the file. This presumably refers to John H. Schnitzler, an aviator who died in 1932, leaving behind thousands of acres of wheat fields.

27 Exhausted by the effort, Wolcott confessed that she had "gotten an eyefull, camerafull and carfull of wheat, flatlands, and sun" and had decided to "recuperate" in Glacier Park (Stein 1983, 47; quoted in Hurley 1989, 110; and Hendrickson 1992, 195).

28 Content to Toomer, June 11, 1934, James Weldon Johnson Collection, YCAL, Toomer Papers (Box 8, folder 251). A helpful resource for Content, about whom little has been written, is Quasha 1994; see also the short review in "Photography: Modest Accomplishments," *New Yorker*, April 24, 1995.

29 Willa Cather, *My Ántonia* (Boston: Houghton Mifflin Company, 1918), 1.

30 Richard Doud interview with Lange, in Levin and Northrup 1981, vol. 2, 70.

31 See Weisiger 1995.

32 This information is gleaned from the Gregory County Historical Society 1974, 24. Interestingly, Lange's photograph is reproduced in the pamphlet, although her name is not included (29).

33 Ibid., 29–31. Trinity Lutheran, in the distance, was eventually moved to Main Street, and First Baptist was struck by lightning and burned down in 1946.

34 Dewey 1920, 684–85, 687.

35 For a helpful discussion of this issue, see Corn 1999, 288–90.

36 Lawrence Alloway, "The Recovery of Regionalism: John Steuart Curry," *Art in America* 64, no. 4 (July–August 1976): 71.

37 See Marling 1981, which offers the most comprehensive discussion of the painting to date. Helpful resources for Benton include *Time* 1934; Benton 1951; Benton 1968; Benton and Baigell 1971; Baigell 1974; Adams 1989; and Doss 1991.

38 Spiva Art Center 1973, 46 and 75–76.

39 Benton 1951, 9. Benton also said, "We symbolized esthetically what the majority of Americans had in mind—America itself." Once Americans' problems became more exterior, he wrote, "our interior images lost public significance."

40 Ruth Pickering, "The Restless World of Thomas Benton," *London Studio* 15, no. 115 (June 1938): 324–29; these quotes on 324–25.

41 Benton 1968, 148–49.

42 One of the survivors, Billy Dixon, whom Remington knew and made indirect reference to in at least two of his paintings (*Fight for the Water Hole*, 1903, and *Episode of a Buffalo Gun*, 1909), had ranched and farmed in this formerly sparsely populated area, virtually alone on this section of the prairie. See Neff 2000, 80–85, 105–7).

43 Statistics are derived from the *Handbook of Texas Online*, s.v. "BORGER, TX," http://www.tsha.utexas.edu/handbook/online/articles/BB/heb10.html (accessed February 26, 2006).

44 "And Then Came Black Gold," *Amarillo News*, June 6, 1926, quoted in Plains Printing Company 1976.

45 Benton 1968, 201–2.

46 When the dust storms of the 1930s made their way across the Texas Panhandle, carbon-burning residue merged with dust and dropped a kind of slime over the town.

47 Marling 1981, 101, includes references to the work of historian Richard Etulain and, specifically, to Roderick Nash, *The Nervous Generation: American Thought, 1917–1930* (1970).

48 Lee and Davis 1965, unpaginated. Also see Hurley 1973; Hurley 1978; Appel 2003; and references in Wood 1989.

49 Hurley 1972, 148. According to Dorothea Lange, "Russ Lee is a great cataloguer of facts, great.… [He got] things in the greatest detail and loved the detail. And the detail is valuable." In Richard Doud interview with Lange, Levin and Northrup 1981, vol. 2, 74.

50 Hurley 1978, 18.

51 Appel 2003, 26.

52 Quoted in Bunnell 1983, 79.

53 Quoted in Conger 1992, s.v. fig. 805, *Lettuce Ranch, Salinas Valley* (1934). Weston's version of a lettuce ranch makes an interesting comparison with Lange's (fig. 161). Weston's is filled with exquisite detail, and a subtle beauty and serenity permeate the scene. By contrast, Lange's is visceral and earthbound.

54 Unnamed reviewer, "Exhibitions," s.v. Hayward

Gallery, *Burlington Magazine* 119 (April 1979): 299.

55 Entry for February 23, 1932, in Newhall 1975, vol. 2, 206.

56 Perhaps the oversized coffee cup reminded Weston of the painting *Ceçi n'est pas une pipe* (This is not a pipe) of 1929 by the Belgian Surrealist painter René Magritte. Weston, uninterested in theory and semantics, probably did not envision his photograph as a response to Magritte's painting, even if he subconsciously thought of it. However, this work demonstrates how Weston's refined perception could lead to such resonant meanings.

57 Quoted in Adams 1989, 303.

58 Benton 1968, 200.

59 See Benton's letter dated July 25, 1966, in curatorial files of the Joslyn Art Museum, Omaha. (The original watercolor study, *Running Before the Storm*, is in a private collection.)

60 For example, Wood's dealer, Maynard Walker, in a letter to Wood, praised his darker vision, as revealed in *Death on the Ridge Road* (1935), which, he believed, persuaded audiences of Wood's seriousness (correspondence, April 22, 1935, curatorial file, Williams College Museum of Art, Williamstown, Massachusetts). The critical reception of Wood's work is complex. Some critics valued his work because it held up an image of American self-reliance at a time it was needed; others found it dismissive of painful realities. Critical controversy erupted during the Wood memorial exhibition at the Art Institute of Chicago in 1942. In a review of the exhibition published in 1943, art historian H. W. Janson equated Wood's neat craftlike style with art forms that accompanied the rise of nationalism in Europe. See H. W. Janson, *Art Journal* 2 (May 1943): 110–15. Helpful resources on Wood include Baigell 1966–67; Dennis 1975; Guedon 1982; Corn 1983; Kuspit 1984; Woiwode 1989; and Roberts et al. 1995. Resources for art of the midwestern plains, more generally, include Kinsey 1996 and Stearnes et al. 2000.

61 Baigell 1966–67, 2. Baigell finds the earliest source for this anecdote in an article in *Art Digest* (February 1, 1936): 18.

62 "As They Saw It: Three from the 30s," *Time* 63, March 1, 1954, 72.

63 Archives of American Art, Edward B. Rowan Papers, Reports to American Federation of the Arts re: Cedar Rapids Art Community Project, reel D142.

64 For example, Ernst Lubitsch, the famous director of 1920s madcap movies, owned Benton's *Hailstorm*. Grant Wood's *Spring Turning* was purchased by the prominent New York theater critic Alexander Woollcott, a member of the famed Algonquin Roundtable, whose members included Dorothy Parker, Ring Lardner, and Edna Ferber.

65 In 2004, in the vicinity of Viola, Iowa (Linn County), a Rural Historic Landscape District was designated one-half mile north of the junction of Matsell Lane and Stone City Road. The site, including its buildings, has been identified as Wood's "outdoor studio," where he first sketched the scene that appears in *Fall Plowing* (1931, Deere Collection, Moline, Illinois). See State Historical Society of Iowa, "Properties Listed on National Register of Historic Places Earn Recognition," State Historical Society of Iowa, http://www.iowahistory.org/contacts/news_release/2004/nrhp_properties.htm (accessed March 12, 2005).

66 Dennis 1975, 216, argues that Wood integrates "a modernized pastoralism with a traditional agrarianism."

67 Woiwode 1989, 80, 100, 102. Woiwode interprets the gentle mounds of Wood's *Spring Turning* as "coffinlike." Thus he argues, the artist transforms the painting into a memorial to his mother, who died in 1935.

68 Frankenstein, *Magazine of Art* 31 (July 1938): 387–91; this quote on 387.

69 The year before painting *Celebration*, Sample had assisted Siqueiros in Los Angeles, where he was working on a mural.

70 Helpful sources for Sample include Sample 1984 and McGrath 1988. I thank Paula and Irving Glick for their additional assistance.

71 This locality included Elk Hills in Kern County, infamous as one of the areas related to the Teapot Dome scandal in the early 1920s during President Warren Harding's administration.

72 "The U.S. Dust Bowl: Its Artist Is a Texan Portraying 'Man's Mistakes,'" *Life* 2, no. 25, June 21, 1937, 61–65.

73 "Hogue Statement," obtained by Donne D. Good while preparing material for a Gilcrease Museum publication, February 1971, Gilcrease Museum curatorial files. Helpful resources on Hogue include Rosson DeLong 1983; Rosson DeLong 1984; Kalil 1986, 35–37; Stewart 1985; and Kalil 1995.

74 Kalil 1995, 11.

75 Jerry Bywaters, "Contemporary American Artists," *Southwest Review* 23, no. 3 (April 1938): 305.

76 Kalil 1995, 11.

77 I consulted the artist's original statement, dated August 31, 1938, in the Philbrook Museum of Art curatorial files. The statement is reprinted in Rosson DeLong 1983, 119.

78 Ibid., 121.

79 In Kalil 1995, 10–11, Hogue describes in greater detail the "viscous limey clay" that melts when wet.

80 Dalí was especially emulated by American artists beginning around 1935. See Dervaux 2005, 14.

81 See Rosson DeLong 1983, 114.

82 Ibid., 98.

83 See http://www.geog.okstate.edu/users/cordova/Dustbowl.pdf for "georeferences" and photographs of the site taken in 2004.

84 Paul Strand was the cinematographer for Lorentz's film.

85 See "Flight from Reality: Arthur Rothstein and The Dust Bowl," in Curtis 1989, 71–89. Worster 1979 and Egan 2005 provide further historical accounts of the Dust Bowl.

86 For example, in chap. 4 of *My Ántonia* (1918), Willa Cather expressed the heroic quality of the plow set against a Nebraska sunset: "The sun was sinking just behind it [the plow]. Magnified across the distance by the horizontal light, it stood out against the sun, was exactly contained within the circle of the disk; the handles, the tongue, the share—black against the molten red. There it was, heroic in size, a picture writing on the sun."

87 Rothstein encountered a cow skeleton in the Dakota badlands and then moved it to various sites to increase its dramatic qualities. The photograph was subsequently misused to illustrate overgrazing, despite the fact that alkali flats are a common occurrence not only in the Dakotas but elsewhere. The controversy undermined Stryker's project. See Curtis 1989, 71–75, and Rothstein 1979, 8–9.

88 In addition, beginning in the late 1960s, new forms emerged that have sparked the landscape tradition, notably the land art, vast in scale, of Robert Smithson, James Turrell, and Michael Heizer. Writing about Turrell's Roden Crater in New Mexico, *New York Times* critic Michael Kimmelman states, "Roden will almost certainly turn out to be the first great, enduring work of the new century" ("Inside a Lifelong Dream of Desert Light," *New York Times*, April 8, 2001).

Epilogue: The Abstract West

1 Helpful sources on the subject of Surrealism and American Art include Wechsler 1977; Tashjian 1995; and Dervaux 2005. On Surrealism in art more generally, see Ades 1978.

2 De Kooning, as reported by artist Milton Resnick, in Naifeh and Smith 1989, 598. See note on 883, which clarifies that de Kooning was making a comment on Pollock's "commercial" breakthrough and the fact that the 1949 exhibition at Betty Parsons's gallery was more broadly attended by wealthy collectors. The comment is often used to refer to the aesthetic impact Pollock had on artists of his generation. The voluminous literature on Pollock includes many helpful sources included here, in addition to Naifeh and Smith 1989: O'Connor and Thaw 1978; Polcari 1979; Cox 1982; Guilbaut 1983; Frascina 1985; W. Jackson Rushing, "Ritual and Myth: Native American Culture and Abstract Expressionism" in Tuchman 1986, 273–95; Landau 1989; Doss 1991; Cernuschi 1992; Leja 1993; Rushing 1995; Varnedoe and Karmel 1998; and Karmel 1999.

3 It should be noted that de Kooning's remark was in part a form of self-congratulatory hyperbole among this macho cohort. Without taking away from the signal achievements of the Abstract Expressionists, the first "American" artists to break the international barrier were the eighteenth-century history painters Benjamin

West, John Singleton Copley, and John Trumbull, whose achievements prompted the French history painter Jacques-Louis David to ask Rembrandt Peale in the early 1800s why all the great painters were Americans.

4 Clement Greenberg, "'American-Type Painting,'" in Greenberg [1961] 1989, 218.

5 A sampling of key contributions to the Pollock literature would include the work of Stephen Polcari, who in 1979 retrieved from the margins the importance of Thomas Hart Benton as Pollock's mentor; the politicized reading offered by Serge Guilbaut in 1983, which positioned Abstract Expressionism in general, and the reception of Pollock's work in particular, in the context of America's Cold War aspirations; Steven Naifeh and Gregory White Smith's richly detailed and psychologically inflected biographies published in 1989; Michael Leja's 1993 analysis of how Pollock's work may be interpreted in terms of a culturally widespread understanding of the condition, nature, and behavior of "modern man" in the war-torn 1940s and 1950s; W. Jackson Rushing's 1995 comprehensive study of American Indian art, cultural primitivism, and the New York School, particularly rich in its discussion of Pollock; and Kirk Varnedoe and Pepe Karmel's magisterial retrospective of Pollock's art at the Museum of Modern Art in 1998–99, which with great care revealed so much more about Pollock's methods and techniques while at the same time reiterating the formalist criticism that earlier generations of MoMA curators had essentially invented and developed into dogma (cited herein as n. 3).

6 Sweeney 1943.

7 Henry Adams, in Adams 1989, 118, cites a more direct reference to what would have inspired Pollock, Benton's *Going West* (1930).

8 Patrick Waldberg, quoted in Spalding 1979, 36.

9 Tanning 2001, 142 and 145. On Tanning, see Bailly 1995; on Max Ernst and Surrealism, see Camfield 1993.

10 For example, an active community in Los Angeles, led by artists Lorser Feitelson and Helen Lundeberg, explored Surrealism. However, the artists associated with this group rarely engaged the landscape in their work.

11 Helpful sources regarding Kirkland include Grant, Stuckey, and Kríž 1998; Weiermair and Vanderlip 1998; and Andreeva and Grant 2000; this quote in Grant, Stuckey, and Kríž, unpaginated.

12 For helpful sources for Graves, see Wight, Baur, and Phillips 1956; Kass 1983; and Wolff 1998, this quote in Wight, Baur and Phillips 1956, 4.

13 Ibid., 7. Throughout the text, Graves's quotes derive from Wight, Baur, and Phillips 1956.

14 In one of those interesting coincidences of art history, Graves stayed in New Orleans with the Bultman family, whose son Fritz would become

an artist and friend of Pollock's, accompanying him on his many visits to museums of American Indian art in New York.

15 James McQuaid interview with Frederick Sommer, George Eastman House Oral History Project transcript (December 2–6, 1976), lines 3862–93. © Frederick & Frances Sommer Foundation. Other sources for Sommer include Sommer 1972; Kelly 1973; Von Glahn 1975; Weiss 1980; Haworth-Booth 1981; Sommer 1984; Conkelton 1995; Horowitz 1999; and Davis and Torosian 2005.

16 Quoted in *Minicam Photography* 8, no. 4 (January 1945): 30–31.

17 The "Frederick Sommer: Plans for Work" is included in the Museum of Modern Art Artists Files and is undated but was likely written c. 1945. Naomi Lyons and Jeremy Cox, co-trustees of the Frederick and Frances Sommer Foundation, graciously helped on numerous matters, including the identification of places in Arizona where Sommer photographed the landscape. Correspondence dated July 12 and 18, 2005.

18 Glenn and Bledsoe 1980, 9.

19 Quoted in "The Photographs of Frederick Sommer: A Centennial Tribute," http://www.getty.edu/art/exhibitions/sommer/ (accessed July 1, 2005).

20 Quoted in Davis and Torosian 2005, 207 and 211.

21 Quoted in Von Glahn, 162.

22 Weston, "Of the West" (1939), quoted in Bunnell 1983, 114.

23 Weston to Adams, January 28, 1932, in Alinder and Stillman, 1988, 48–49.

24 André Breton, *Deuxième Manifeste du Surréalisme* (1930), quoted in Dawn Ades, "Dada and Surrealism," in Stangos 1981, 134.

25 One of the Dunites, Gavin Arthur, the grandson of U.S. President Chester Arthur, owned a home in the area, where Weston would stay during his dune photographic expeditions.

26 Wilson and Madar 1998, 108.

27 Weston 1939, 254.

28 Jay Pollock to James Valliere (1965), Archives of American Art, quoted in Rushing 1995, 169. The most comprehensive discussion to date on Pollock's relationship to the New York School and American Indian art remains Rushing 1995 (see, especially, "Jackson Pollock and Native American Art," 169–94).

29 Rushing 1995, 180–83.

30 On Navajo aesthetics, see Witherspoon 1977.

31 I am grateful to Janet Catherine Berlo, professor of art history and visual and cultural studies and codirector, Visual and Cultural Studies Graduate Program, University of Rochester, for sharing her expertise and research regarding *Where the Two Came to Their Father*, which we uncovered together, in the best spirit of collegiality, while serving as summer fellows at the Clark Art Institute, Williamstown, Mass., in 2004.

32 Ibid. Contemporaneous reviews and reports

about the project include *College Art Journal* 4, no. 3 (March 1945): 172–74; *New York Times*, November 6, 1943; *New York Times*, February 27, 1944, in which the reviewer, Hal Borland, describes its importance as the "Navaho Book of Genesis"; and *Art Digest* 18 (May 15, 1944): 20.

33 See Janet Berlo's article, "Toward an Ecology of Native American Visual Culture: Eco-Aesthetics in Navajo Pictorial Arts and Eco-Crisis in Dinétah," forthcoming.

34 The she-wolf is yet another reference to another of Pollock's paintings: *She-Wolf* (1943, Museum of Modern Art).

35 Helpful sources used here include Kuh 1966; O'Neill 1979; Kellein 1992; Landauer 1996, 52–59 and 87–91; and Demetrion 2001 (see, especially, David Anfam, "Clyfford Still's Art: Between the Quick and the Dead," therein, 17–46).

36 Anfam 1983, 260–69.

37 David Anfam in Demetrion 2001, 24.

38 Kenneth Sawyer (1947), quoted in Landauer 1996, 56. For specific information on *Brown Study*, see Stephen Polcari's catalogue entry, no. 69, s.v., in Schweizer 1989, 151.

39 Critic John Russell, for example, dubbed Still "wild nature's ambassador" (Russell, *New York Times*, August 28, 2001).

40 Still, quoted in Mark Rothko, *Clyfford Still*, exh. cat., *Art of This Century Gallery*, New York (1946), quoted in Anfam 1983, 264.

41 Still, quoted in David L. Shirey, "Men of the Arts," *Newsweek*, December 22, 1969, 15, quoted in Michael Auping, "Clyfford Still and New York: The Buffalo Project" in Kellein 1992, 39.

42 Still, quoted in Anfam in Demetrion 2001, 24; Naifeh and Smith 1989, 486, on Pollock. The art-historical literature mostly interprets Pollock's comments as an indicator of hubris and an index to the era's apotheosis of the inner self; the remarks do, indeed, sound self-important. Yet Pollock's rejoinder was in response to Hans Hofmann's criticism that Pollock did not work directly from nature. Hofmann had the last word, chastising him by saying that working too much from the interior as opposed to the exterior risks repetition. But Hofmann's logic is flawed; if nature is subsumed and internalized, as it was for these artists, and reemerges during the act of painting in a model of integration between self and nature, than self/nature has the same infinite possibilities as the object (nature) that was subsumed.

43 Quoted in Nordland 1969, unpaginated. For helpful sources on Corbett, see Nordland 1969; Nordland and Niese 1979; and Landauer 1996, 48–51 and 94–96.

44 Quoted in Nordland 1969, unpaginated.

45 Ibid.

46 Corbett (1965) in ibid.

47 James McQuaid interview with Frederick Sommer, George Eastman House Oral History Project transcript (December 2–6, 1976), lines 2156–

57. © Frederick & Frances Sommer Foundation.

48 Ibid., 2177–88.

49 Sommer (1971), cited by Leland Rice, "Introduction" in Glenn and Bledsoe 1980, 9–13.

50 Tobey to Marian Willard, August 1957, in Mathey 1961, unpaginated.

51 Krasne 1951, 26.

52 For helpful sources on Tobey's art, see Seitz 1962; Kuh 1962; Dahl 1984; Rathbone 1984; Wilkin 1990; on Tobey's technique, see the essay by Judith S. Kays in Cummings and Kays 1990, 12–16.

53 Alice B. Toklas, writer Gertrude Stein's partner, apparently first told Tobey that he had "penetrated perspective," a phrase he used when mentioning his effort to "bring the far near." According to Eliza Rathbone, Tobey was taken to visit Toklas in 1945. See Rathbone 1984, 104.

54 Krasne 1951, 5.

55 See Kuh 1965, 98.

56 Tobey, quoted in Rathbone 1984, 53.

57 Compare, for example, Weston, who, in 1932, saw photography as a means to rediscover the self "in a civilization severed from its roots in the soil,—cluttered with nonessentials, blinded by abortive desires" (Bunnell 1983, 70).

58 Tobey, quoted in Rathbone 1984, 55.

59 Tobey, quoted in Rathbone 1984, 21.

60 Joshua Taylor, "Looking at Tobey's Pictures," in Dahl 1984, 27–29; this quote on 28.

61 Adams, quoted in Adams and Alinder 1985, 290.

62 From an unpublished manuscript by Nancy Newhall (1985), quoted in Adams and Alinder 1985, 198.

63 For accounts of Adams's photographing of the *Surf Sequence*, see Adams 1983, 23–27; Adams and Alinder 1985, 199–200; and Hammond 2002, 98–101. See also his letter to Stieglitz (1941) in Alinder and Stillman 1988, 130.

64 Greenberg 1946, 294–98. Greenberg states his belief that "photography should be less about technique and more about seizing the anecdote." This may come as a surprise to those who are familiar with Greenberg's "arch" formalism and his reverence for material and medium, but Greenberg saw painting and photography as different modes of art that dictated different means and ends.

65 Adams and Alinder 1985, 145.

66 Adams to Cedric Wright, June 10, 1937, in Alinder and Stillman 1988, 95. Also in Adams and Alinder 1985, 37.

67 Quoted in Adams and Alinder 1985, 213.

68 Compare, for example, Hudson River School painter Asher B. Durand's *Kindred Spirits* (1847, Walton Family Foundation), a commemorative painting that depicts the recently deceased painter Thomas Cole and poet William Cullen Bryant communing with nature in the Catskills.

69 For information on the Ohlone in the area of Point Lobos, see Margolin 1981 and Bean 1994. On Weston's later work in Carmel, see Travis 2001. Also helpful is Karen E. Quinn, "'Universal Rhythms': Edward Weston and Modernism after 1927," in Stebbins, Quinn, and Furth 1999, 81–103. See Conger 1992, s.v. Figure 1704/1942. Weston had essayed this subject in 1939.

70 Jackson Pollock, "My Painting," *Possibilities* (1947–48), quoted in Karmel 1999, 17–18.

71 Pollock (c. 1950), quoted in O'Connor and Thaw 1978, vol. 4, 253.

72 Pollock to B. H. Friedman, quoted in Landau 1989, 159. See also "Jackson Pollock: A Questionnaire" (1944), quoted in Karmel 1999, 15.

73 Ibid., 15–16. As late as 1950, Lee Krasner proclaimed that "Jackson's work is full of the West. …That's what gives it that feeling of spaciousness. That's what makes it so American." Pollock apparently scowled at her remark (related in [Berton Roueché], "Unframed Space," *New Yorker,* August 5, 1950, 16).

74 Bruce Glaser, "Jackson Pollock: An Interview with Lee Krasner" (1967), quoted in Karmel 1999, 28.

75 Bultman to Rushing (1984), in Rushing 1995, 189.

76 Pollock, interview with William Wight (1950), quoted in Karmel 1999, 20.

Checklist of the Exhibition

Prologue: Landmarking the West

THOMAS MORAN
American, born England, 1837–1926
Mountain of the Holy Cross, 1875
Oil on canvas, 82⅛ x 64¼ in.
Museum of the American West Collection, Autry
National Center, Los Angeles, Donated by Mr. and
Mrs. Gene Autry

PHOTOGRAPHS
WILLIAM HENRY JACKSON
American, 1843–1942
Mountain of the Holy Cross, Colorado, 1873
Albumen photograph, 8 x 10 in.
Collection of Neil S. Goldblatt

WILLIAM HENRY JACKSON
American, 1843–1942
Roches Moutonnées, Near the Mountain of the Holy Cross, 1873
Albumen silver photograph, 16 x 20 in.
Denver Public Library, Western History Department,
Z-2602

EADWEARD MUYBRIDGE
American, born England, 1830–1904
Cap of the Liberty-Valley of the Yosemite, 1872
Albumen silver photograph, 16⁹⁄₁₆ x 21 in.
The Museum of Fine Arts, Houston, Museum
purchase with funds provided by the Brown
Foundation Accessions Endowment Fund, The
Manfred Heiting Collection

TIMOTHY O'SULLIVAN
American, probably born Ireland, 1840–1882
Sand Dunes, Carson Desert, Nevada, 1867
Albumen photograph, 10¾ x 7¾ in.
Cleveland Museum of Art, John L. Severance Fund,
2002.45

CARLETON E. WATKINS (1st venue only)
American, 1829–1916
Cape Horn, near Celilo, 1867
Albumen photograph, 15¾ x 20⅝ in.
The Metropolitan Museum of Art, Gilman Collection,
Purchase, The Horace W. Goldsmith Foundation Gift,
2005 (2005.100.109)

CARLETON E. WATKINS (2nd venue only)
American, 1829–1916
Cape Horn, near Celilo, 1867
Albumen photograph, 20½ x 15¾ in.
Wilson Centre for Photography, London

JOHN K. HILLERS
American, born Germany, 1843–1925
Hopi Pueblo of Walpi, First Mesa, Arizona, 1876
Albumen photograph, 9¾ x 12¹³⁄₁₆ in.
Collection Centre Canadien d'Architecture / Canadian
Centre for Architecture, Montréal

TIMOTHY O'SULLIVAN
American, probably born Ireland, 1840–1882
Ancient Ruins in the Cañon de Chelle, N.M., 1873
Albumen photograph, 8 x 10 in.
The Museum of Fine Arts, Houston, Gift of Mr. and
Mrs. Robert L. Clarke

TIMOTHY O'SULLIVAN
American, probably born Ireland, 1840–1882
*Historic Spanish Record of the Conquest, South Side
of Inscription Rock, New Mexico*, 1873
Albumen silver photograph, 8 x 10 in.
Robert G. Lewis Collection

Attributed to KOWEONARRE (Little Chief)
Cheyenne, 1854–1923
Cheyenne Medicine Lodge, c. 1870
Ink, pencil, and watercolor on paper, 23½ x 26 in.
National Museum of the American Indian,
Smithsonian Institution (11.1706)

BEAR'S HEART
Cheyenne, 1851–1882
Troops Amassed against a Cheyenne Village, 1876–77
Pencil and ink on paper, 8 x 12⅞ in.
Massachusetts Historical Society Manuscript
Collection

The End of the Frontier: Making the West Artistic

JOHN HENRY TWACHTMAN
American, 1853–1902
Emerald Pool, Yellowstone, c. 1895
Oil on canvas, 24¼ x 30¼ in.
Wadsworth Atheneum Museum of Art, Hartford,
Connecticut, Bequest of George A. Gay, by exchange,
and the Ellen Gallup Sumner and Mary Catlin
Sumner Fund

JOHN HENRY TWACHTMAN
American, 1853–1902
Edge of the Emerald Pool, Yellowstone, c. 1895
Oil on canvas, 25 x 30 in.
Courtesy of Spanierman Gallery LLC, New York

FREDERIC REMINGTON
American, 1861–1909
*Fight for the Water Hole
(An Arizona Water Hole)
(A Water-Hole in the Arizona Desert)*, 1903
Oil on canvas, 27⅛ x 40⅛ in.
The Museum of Fine Arts, Houston, the Hogg
Brothers Collection, gift of Miss Ima Hogg

FREDERIC REMINGTON (1st venue only)
American, 1861 – 1909
The Scout: Friends or Foes?
(The Scout: Friends or Enemies?), 1902–5
Oil on canvas, 27 x 40 in.
Sterling and Francine Clark Art Institute,
Williamstown, Massachusetts

FREDERIC REMINGTON (2nd venue only)
American, 1861 – 1909
The Herd Boy, c. 1905
Oil on canvas, 27 ⅛ x 45 ¼ in.
The Museum of Fine Arts, Houston, the Hogg
Brothers Collection, gift of Miss Ima Hogg

HENRY F. FARNY (2nd venue only)
American, born France, 1847 – 1916
The Song of the Talking Wire, 1904
Oil on canvas, 22 ⅛ x 40 in.
The Taft Museum of Art, Cincinnati, Ohio, Bequest
of Charles Phelps and Anna Sinton Taft

HENRY F. FARNY (1st venue only)
American, born France, 1847 – 1916
Morning of a New Day, 1906
Oil on canvas, 18 ⅝ x 28 ⅝ in.
Private collection, Wyoming

N. C. (NEWELL CONVERS) WYETH
American, 1882 – 1945
Moving Camp, 1908
Oil on canvas, 36 ¼ x 26 ⅛ in.
The Museum of Fine Arts, Houston, Gift of
Mr. and Mrs. Ralph Mullin

ARTHUR WESLEY DOW
American, 1857 – 1922
The Grand Canyon, c. 1911–12
Oil on canvas, 26 x 36 in.
Courtesy of Spanierman Gallery LLC, New York

GEORGIA O'KEEFFE (1st venue only)
American, 1887 – 1986
Evening Star No. V, 1917
Watercolor on moderately thick, cream, smooth
wove paper, 8 ¾ x 11 ⅞ in.
Collection of the McNay Art Museum, Bequest of
Helen Miller Jones

GEORGIA O'KEEFFE
American, 1887 – 1986
Evening Star, No. II, 1917
Watercolor on paper, 8 ¾ x 12 in.
Private collection

GEORGIA O'KEEFFE
American, 1887 – 1986
Evening Star No. VI, 1917
Watercolor on moderately thick, cream,
smooth wove paper, 8 ⅞ x 12 in.
Georgia O'Keeffe Museum, Gift of The
Burnett Foundation

AUGUSTUS VINCENT TACK
American, 1870 – 1949
Storm, c. 1922–23
Oil on canvas mounted on wallboard, 36 ⅞ x 48 ¹⁄₁₆ in.
The Phillips Collection, Washington, D.C.

PHOTOGRAPHS
EDWARD S. CURTIS
American, 1868 – 1952
Canyon de Chelly, 1904
Toned gelatin silver print, 7 ⅞ x 9 ⅞ in.
Amon Carter Museum, Fort Worth, Texas, P1979.54.3

EDWARD S. CURTIS
American, 1868 – 1952
Canyon de Chelly, c. 1920
Orotone photograph, 24 ¼ x 30 ½ in.
Collection of Alan G. Burch

ERWIN E. SMITH
American, 1884 – 1947
The Dust of the Drags, Three Block Range, near
Richardson, New Mexico, 1908–9
Gelatin silver photograph, 10 x 14 in.
The Center for American History, The University of
Texas at Austin

LAURA GILPIN
American, 1891 – 1979
The Prairie, 1917
Platinum photograph, 5 ⅞ x 7 ⅝ in.
Amon Carter Museum, Fort Worth, Texas, Bequest of
the artist, P1979.119.8

EDWARD STEICHEN
American, born Luxembourg, 1879 – 1973
The Black Canyon, c. 1906
Gum-bichromate photograph, 19 x 15 ¹⁄₁₆ in.
Andrew Smith, Claire Lozier, and John Boland,
Santa Fe

ALVIN LANGDON COBURN
British, born United States, 1882 – 1966
The Temple of Ohm, Grand Canyon, 1911
Gelatin silver photograph, 16 x 12 ¾ in.
George Eastman House, Gift of Alvin Langdon Coburn

LOUISE DESHONG WOODBRIDGE
American, 1848 – 1925
Yellowstone "Grand View," c. 1912
Platinum photograph, 3 ⅞ x 4 ¹¹⁄₁₆ in.
Amon Carter Museum, Fort Worth, Texas, P1981.70

California

ARTHUR B. DAVIES
American, 1862 – 1928
Pacific Parnassus, Mount Tamalpais, c. 1905
Oil on canvas, 26 ¼ x 40 ¼ in.
The Fine Arts Museums of San Francisco, Museum
purchase, Gift of The Museum Society Auxiliary,
1993.19.1

ARTHUR F. MATHEWS
American, 1860 – 1945
View from Skyline Boulevard, San Francisco, 1915
Oil on canvas, 30 x 40 in.
Oakland Museum of California, Gift of Concours
d'Antiques, the Art Guild

GOTTARDO PIAZZONI
Active United States, 1872 – 1945, born Switzerland
The Land, 1915
Oil on canvas, 48 x 124 in.
University of California, Berkeley Art Museum,
Gift of Helen and Ansley Salz

GOTTARDO PIAZZONI
Active United States, 1872 – 1945, born Switzerland
The Sea, 1915
Oil on canvas, 48 x 124 in.
University of California, Berkeley Art Museum,
Gift of Helen and Ansley Salz

FRANK CUPRIEN
American, 1871 – 1948
Evening Sun (Poème du Soir), 1925
Oil on canvas, 32 ½ x 35 ⅛ in.
Collection of the Orange County Museum of Art,
Newport Beach, California, Gift of the estate of
Frank W. Cuprien

SELDEN CONNOR GILE
American, 1877 – 1947
The Soil, 1927
Oil on canvas, 30 ⅛ x 36 in.
Private collection, San Francisco

SELDEN CONNOR GILE
American, 1877 – 1947
Untitled (Cows and Pasture), c. 1925
Oil on canvas, 12 x 16 in.
Collection of Robert Aichele

CLAYTON S. PRICE
American, 1874 – 1950
Coastline, c. 1924
Oil on canvas, 40 ⅛ x 50 in.
Hirshhorn Museum and Sculpture Garden, Smith-
sonian Institution, Gift of Joseph H. Hirshhorn, 1966

STANTON MACDONALD-WRIGHT
American, 1890 – 1973
Cañon Synchromy (Orange), 1919
Oil on canvas, 24 1/8 x 24 1/8 in.
Collection of the Frederick R. Weisman Art Museum
at the University of Minnesota, Minneapolis, Gift of
Ione and Hudson D. Walker

PHOTOGRAPHS
WILLIAM E. DASSONVILLE
American, 1879 – 1957
Mount Tamalpais, Marin County, c. 1905
Platinum photograph, 8 x 10 1/16 in.
Wilson Centre for Photography, London

ANNE W. BRIGMAN
American, 1869 – 1950
The Lone Pine, 1909
Gelatin silver photograph, 7 3/4 x 9 3/4 in.
Collection of Wallace and Isabel Wilson

WILLIAM E. DASSONVILLE
American, 1879 – 1957
Dunes, c. 1925
Gelatin silver photograph, 7 1/2 x 9 1/3 in.
Wilson Centre for Photography, London

ASAHACHI KONO
American, born Japan, birth date unknown, died 1943
Untitled (Tree and Hills), late 1920s
Gelatin silver photograph, 7 3/8 x 11 7/8 in.
Dennis Reed Collection

ANSEL ADAMS
American, 1902 – 1984
*Vernal Fall through Tree, Yosemite Valley,
California*, 1920
Gelatin silver photograph, 4 x 3 in.
Private collection

ANSEL ADAMS
American, 1902 – 1984
*Mount Lyell and Mount Maclure, Headwaters of
Tuolumne River, Yosemite*, 1929
Gelatin silver photograph, 5 5/8 x 7 5/8 in.
Private collection

The Southwest

ERNEST L. BLUMENSCHEIN
American, 1874 – 1960
Taos Valley, New Mexico, 1933
Oil on canvas, 25 x 35 in.
The Metropolitan Museum of Art, George A. Hearn
Fund, 1934 (34.61)

VICTOR HIGGINS
American, 1884 – 1949
New Mexico Skies (August Skies), c. 1932–35
Oil on canvas, 54 x 60 in.
The Snite Museum of Art, University of Notre Dame,
Gift of Mr. and Mrs. John T. Higgins, 65.53.3

MAYNARD DIXON
American, 1875 – 1946
Earth Knower, 1931–35
Oil on canvas, 40 x 50 in.
Oakland Museum of California, Gift of Dr. Abilio Reis

RAYMOND JONSON
American, 1891 – 1982
Cliff Dwellings, No. 3, 1927
Oil on canvas, 48 x 38 in.
Jonson Gallery Collection, University Art Museum,
University of New Mexico, Albuquerque, Bequest of
Raymond Jonson

STUART DAVIS
American, 1892 – 1964
New Mexican Landscape, 1923
Oil on canvas, 32 x 40 1/4 in.
Amon Carter Museum, Fort Worth, Texas, 1972.49

GEORGIA O'KEEFFE
American, 1887 – 1986
Black Cross with Stars and Blue, 1929
Oil on canvas, 40 x 30 in.
Mr. and Mrs. Peter Coneway

GEORGIA O'KEEFFE
American, 1887 – 1986
Red Hills and Bones, 1941
Oil on canvas, 30 x 40 in.
Philadelphia Museum of Art, The Alfred Stieglitz
Collection, 1949

GEORGIA O'KEEFFE
American, 1887 – 1986
Black Place III, 1944
Oil on canvas, 36 x 40 in.
Georgia O'Keeffe Museum, Promised gift,
The Burnett Foundation

MARSDEN HARTLEY
American, 1877 – 1943
Landscape, New Mexico, 1919
Oil on canvas, 28 x 36 in.
Whitney Museum of American Art, New York,
Purchase, with funds from Frances and Sydney
Lewis, 77.23

MARSDEN HARTLEY (1st venue only)
American, 1877 – 1943
New Mexico Recollection–Storm, 1923
Oil on canvas, 29 x 41 1/4 in.
Collection of Mr. Theodore P. Shen

MARSDEN HARTLEY (2nd venue only)
American, 1877 – 1943
Landscape Fantasy, 1923
Oil on canvas, 28 1/2 x 41 in.
Grey Art Gallery, New York University Art Collection,
Gift of Charles Simon, 1965

MARSDEN HARTLEY
American, 1877 – 1943
Pueblo Mountain, 1918
Pastel on paper, 17 1/2 x 27 7/8 in.
Collection of Lee and Judy Dirks

MARSDEN HARTLEY
American, 1877 – 1943
Arroyo Hondo, N.M., 1918
Pastel on paper, 17 x 28 in.
Collection of Lee and Judy Dirks

MARSDEN HARTLEY
American, 1877 – 1943
New Mexico Landscape, 1919
Pastel on paperboard, 18 x 28 in.
Alice C. Simkins

JOHN MARIN
American, 1870 – 1953
The Mountain, Taos, New Mexico, 1929
Watercolor on paper, 14 x 19 3/4 in.
The Museum of Fine Arts, Houston, Gift of
Mrs. Efrem Kurtz, 2000.129

JOHN MARIN
American, 1870 – 1953
Taos Canyon, New Mexico, 1930
Watercolor on paper, 15 1/2 x 21 in.
Amon Carter Museum, Fort Worth, Texas, 1965.5

JOHN MARIN
American, 1870 – 1953
Storm over Taos, New Mexico, 1930
Watercolor and graphite on paper, 15 1/16 x 20 15/16 in.
National Gallery of Art, Washington, Alfred Stieglitz
Collection

JOHN MARIN
American, 1870 – 1953
New Mexico, Near Taos, 1929
Watercolor, gouache, and graphite on paper,
14 1/16 x 21 1/16 in.
Los Angeles County Museum of Art, Mira T. Hershey
Memorial Collection

JOHN MARIN
American, 1870 – 1953
Little Canyon, New Mexico, 1930
Watercolor on paper, 15 1/2 x 21 in.
University of New Mexico Art Museum, Albuquerque,
Purchased with Funds from the Julius L. Rolshoven
Memorial Fund, 66. 136

JOHN MARIN
American, 1870–1953
Storm, Taos Mountain, New Mexico, 1930
Watercolor and charcoal on paper, 16 7/8 x 21 3/4 in.
The Metropolitan Museum of Art, Alfred Stieglitz
Collection, 1949 (49.70.144)

PHOTOGRAPHS
ADAM CLARK VROMAN
American, 1856–1916
*"The Desert" on the Way to Hopi Towns, 85 Miles
North of Holbrook*, 1902
Platinum photograph, 6 1/8 x 8 in.
Andrew Smith Gallery, Santa Fe, New Mexico

LAURA GILPIN
American, 1891–1979
Shiprock from the North Rim of Mesa Verde, 1926,
printed 1929
Platinum photograph, 4 15/16 x 6 1/4 in.
Collection of Christopher M. Harte and
Amon Burton

LAURA GILPIN
American, 1891–1979
The Spirit of the Prairie (Sunlight and Silence), 1921
Platinum photograph, 7 5/16 x 9 3/8 in.
Amon Carter Museum, Fort Worth, Texas, Bequest of
the artist, P1977.64.2

ANSEL ADAMS
American, 1902–1984
Moonrise over Hernandez, New Mexico, 1941
Gelatin silver photograph, 15 1/4 x 19 1/2 in.
The Museum of Fine Arts, Houston, Gift of Manfred
Heiting, The Manfred Heiting Collection

PAUL STRAND
American, 1890–1976
Badlands near Santa Fe, New Mexico, 1930
Platinum photograph, 3 5/8 x 4 3/4 in.
Museum of Fine Arts, MNM, Department of Cultural
Affairs, Gift of Austin Lamont, 2003

PAUL STRAND
American, 1890–1976
The Dark Mountain, New Mexico, 1931
Platinum photograph, 4 5/8 x 5 15/16 in.
University of New Mexico Art Museum, Albuquerque,
Gift of the Paul Strand Foundation, Inc., in honor of
Beaumont Newhall, 80.290

PAUL STRAND
American, 1890–1976
Church Buttress, Ranchos de Taos, New Mexico, 1932
Platinum photograph, 5 x 4 in.
The J. Paul Getty Museum, Los Angeles

EDWARD WESTON
American, 1886–1958
Church at E-Town, New Mexico, 1933
Gelatin silver photograph, 7 9/16 x 9 5/8 in.
The Museum of Fine Arts, Houston,
Museum purchase

EDWARD WESTON
American, 1886–1958
White Sands, New Mexico, 1941
Gelatin silver photograph, 7 1/2 x 9 9/16 in.
Andrew Smith and Claire Lozier, Santa Fe,
New Mexico

ELIOT PORTER
American, 1901–1990
Black Place, New Mexico, September 1945, 1945
Gelatin silver photograph, 8 x 10 in.
Amon Carter Museum, Fort Worth, Texas, Bequest of
the artist, P1990.54.578

EDWARD WESTON
American, 1886–1958
Santa Fe-Albuquerque Highway, 1937
Gelatin silver photograph, 8 x 10 in. (printed by
Brett Weston under the artist's supervision, 1953)
Art Institute of Chicago, Gift of Max McGraw,
1959.738

AMERICAN INDIAN WATERCOLORS
ALFONSO (AWA TSIREH) ROYBAL
North American Indian, Pueblo (San Ildefonso Pueblo,
N.M.), c. 1895–1955
Mountain Sheep, 1922
Tempera and ink on wove paper, 11 3/4 x 14 1/4 in.
The Museum of Fine Arts, Houston, Gift of
Miss Ima Hogg

JULIAN MARTINEZ
North American Indian, Pueblo (San Ildefonso Pueblo,
N.M.), 1885–1943
*Conventionalized Design of Symbols (Sacred
Avanyu)*, 1930–40
Tempera on paper, 16 x 19 3/4 in.
The Museum of Fine Arts, Houston, Gift of
Miss Ima Hogg

RILEY (QUOYAVEMA) SUNRISE
North American Indian, Kiowa Tribe, trained Hopi Pueblo,
born c. 1900–active until c. 1979/80
God of Germination, 1930s
Tempera on tan wove paper, 12 x 8 in.
The Museum of Fine Arts, Houston, Gift of
Miss Ima Hogg

PYLEN HANAWEAKA
North American Indian, Zuni Pueblo, 1902–1989
Zuni Altar with Ceremonial Bowls, 1920–30
Tempera over pencil underdrawing on paper,
22 1/2 x 15 3/4 in.
The Museum of Fine Arts, Houston, Gift of
Miss Ima Hogg

The Dust Bowl Era—Plains and Other Places

GRANT WOOD
American, 1891–1942
Spring Turning, 1936
Oil on Masonite panel, 18 1/4 x 40 1/4 in.
Reynolda House, Museum of American Art, Winston-
Salem, North Carolina

THOMAS HART BENTON
American, 1889–1975
The Hailstorm, 1940
Oil and egg tempera on linen canvas mounted on
cradled plywood, 33 x 40 in.
Joslyn Art Museum, Omaha, Nebraska, Gift of the
James A. Douglas Memorial Foundation

THOMAS HART BENTON
American, 1889–1975
Boomtown, 1927–28
Oil on canvas, 45 x 54 in.
Memorial Art Gallery of the University of Rochester,
M.S. Gould Fund

ALEXANDRE HOGUE
American, 1898–1994
The Crucified Land, 1939
Oil on canvas, 42 x 60 in.
Gilcrease Museum, Tulsa, Oklahoma

ALEXANDRE HOGUE
American, 1898–1994
Erosions No. 2, Mother Earth Laid Bare, 1938
Oil on canvas, 40 x 56 in.
The Philbrook Museum of Art, Tulsa, Oklahoma,
Museum Purchase

PAUL SAMPLE
American, 1896–1974
Celebration, 1933
Oil on canvas, 40 x 48 in.
Private collection

MAYNARD DIXON
American, 1875–1946
No Place to Go, 1935
Oil on canvas, 25 1/8 x 30 in.
Brigham Young University Museum of Art

DOROTHEA LANGE
American, 1895–1965
The Catholic, Lutheran and Baptist Churches, Great Plains, Dixon, South Dakota (Freedom of Religion: Three Denominations [Catholic, Lutheran, Baptist Churches] on the Great Plains, Dixon, Near Winner, South Dakota), 1938
Gelatin silver photograph, 10 1/4 x 10 3/4 in.
The Museum of Fine Arts, Houston, Gift of
The Brown Foundation, Inc., The Manfred
Heiting Collection

MARION POST WOLCOTT
American, 1910–1990
Contour Ploughing and Strip Cropping Wheat Fields Just North of Great Falls, Montana, 1941
Gelatin silver photograph, image 6 1/8 x 9 in.
Library of Congress, Prints & Photographs Division,
FSA/OWI Collection [LC-USF34-058165-D]

MARJORIE CONTENT
American, 1895–1984
Kansas, 1934
Gelatin silver photograph, 7 3/4 x 9 5/8 in.
The Museum of Fine Arts, Houston, Museum
purchase with funds provided by Clare and Alfred
Glassell and an anonymous donor

DOROTHEA LANGE
American, 1895–1965
Irrigated Field of Cotton Seventy Miles from Phoenix, Arizona, 1937
Gelatin silver photograph, 10 3/8 x 13 3/8 in.
Roy Stryker Papers, Special Collections, Photographic
Archives, University of Louisville

ARTHUR ROTHSTEIN
American, born 1915
Plow Covered by Sand, Cimarron County, Oklahoma, 1936
Gelatin silver photograph, 7 x 7 1/8 in.
Library of Congress, Prints & Photographs Division,
FSA/OWI Collection [LC-USF-34-004043-E]

DOROTHEA LANGE
American, 1895–1965
Six Lettuce Pickers, c. 1935
Gelatin silver photograph, 14 5/8 x 14 11/16 in.
Courtesy of Morehouse Gallery,
Brookline, Massachusetts

DOROTHEA LANGE
American, 1895–1965
Tractored Out, Childress County, Texas, 1938
Gelatin silver photograph, 6 x 9 in.
The Dorothea Lange Collection, Oakland Museum of
California, City of Oakland, Gift of Paul S. Taylor

RUSSELL LEE
American, 1903–1986
Hobbs, New Mexico, 1940
Gelatin silver photograph, 8 x 10 in.
Harry Ransom Humanities Research Center,
The University of Texas, Austin

EDWARD WESTON
American, 1886–1958
"Hot Coffee," Mojave Desert, 1937
Gelatin silver photograph, 7 7/16 x 9 7/16 in.
The Lane Collection, Museum of Fine Arts, Boston

Epilogue: The Abstract West

JACKSON POLLOCK
American, 1912–1956
Going West, 1934–35
Oil on fiberboard, 15 1/8 x 20 3/4 in.
Smithsonian American Art Museum, Washington,
D.C., Gift of Thomas Hart Benton

VANCE KIRKLAND
American, 1904–1981
6 Million Years Ago, 1945
Watercolor and gouache on paper, 22 x 30 in.
Kirkland Museum of Fine & Decorative Arts, Denver

VANCE KIRKLAND
American, 1904–1981
Timberline, 1939
Watercolor on paper, 22 1/2 x 30 in.
Kirkland Museum of Fine & Decorative Arts, Denver

MORRIS GRAVES
American, 1910–2001
Memorial Day Wild Flower Bouquet in the Cemetery of an Abandoned Western Mining Town, 1936
Oil on canvas, 39 x 35 in.
Portland Art Museum, Purchased with a donation by
Harold and Arlene Schnitzer

CLYFFORD STILL
American, 1904–1980
Brown Study, 1935
Oil on canvas, 31 5/8 x 21 3/4 in.
Munson-Williams-Proctor Arts Institute, Museum of
Art, Utica, New York, 75.65

CLYFFORD STILL
American, 1904–1980
1954, 1954
Oil on canvas, 113 1/2 x 156 in.
Albright-Knox Art Gallery, Buffalo, New York, Gift of
Seymour H. Knox, 1957

JACKSON POLLOCK
American, 1912–1956
Night Mist, 1945
Oil on canvas, 39 x 72 1/8 in.
Norton Museum of Art, West Palm Beach, Florida,
Purchase, the R. H. Norton Trust, 71.14

JACKSON POLLOCK
American, 1912–1956
Number 13A: Arabesque, 1948
Oil on canvas, 37 1/4 x 117 in.
Yale University Art Gallery, Gift of Richard Brown
Baker, B.A. 1935

EDWARD CORBETT
American, 1919–1971
Untitled, 1949
Oil on canvas, 61 x 39 1/2 in.
Oakland Museum of California, Gift of Dr. and Mrs.
Victor Calef

MARK TOBEY
American, 1890–1976
Written Over the Plains, 1950
Mixed media on paper mounted on Masonite,
30 1/8 x 40 in.
San Francisco Museum of Modern Art, Gift of
Mr. and Mrs. Ferdinand C. Smith

JEFF KING and MAUD OAKES
Where the Two Came to Their Father: A Navajo War Ceremonial (selected plates)
Bollingen Series I, 1943
14 7/8 x 24 1/2 in.
Williams College Library, Williamstown,
Massachusetts

FREDERICK SOMMER
American, born Italy, 1905–1999
Horse, 1945
Gelatin silver photograph, 7 1/2 x 9 1/2 in.
Frederick and Frances Sommer Foundation, Arizona

FREDERICK SOMMER
American, born Italy, 1905–1999
Arizona Landscape [Large Cactus], 1943
Gelatin silver photograph, 7 1/2 x 9 1/2 in.
The Museum of Fine Arts, Houston, Gift of
The Brown Foundation, Inc., The Manfred
Heiting Collection

LAURA GILPIN
American, 1891–1979
White Sands, 1945
Gelatin silver photograph, 7 1/2 x 9 1/2 in.
The Museum of Fine Arts, Houston, Gift of Clinton T.
Willour in honor of Louisa Stude Sarofim

EDWARD WESTON
American, 1886–1958
Dunes, Oceano, 1936
Gelatin silver photograph, 8 x 10 in.
Margaret M. Weston and The Weston Gallery,
Carmel, California

ANSEL ADAMS
American, 1902–1984
Surf Sequence, 1940, printed 1941
Gelatin silver photographs, 8 x 9 ⅝ in. (nos. 1, 2, 3, 5),
8 x 10 ⅛ in. (no. 4)
Museum of Modern Art, New York, Anonymous Gift

EDWARD WESTON
American, 1886–1958
Mustard Canyon, Death Valley, 1939
Gelatin silver photograph, 7 ¹¹/₁₆ x 9 ⁹/₁₆ in.
The Lane Collection, Museum of Fine Arts, Boston

EDWARD WESTON
American, 1886–1958
Oil on Rocks, Point Lobos, 1942
Gelatin silver photograph, 7 ⅝ x 9 ⅝ in.
The Lane Collection, Museum of Fine Arts, Boston

Select Bibliography

Sources with full publication data cited in notes are not listed in the bibliography.

ADAMS 1934
Adams, Ansel. "An Exposition of My Photographic Technique—Landscape." *Camera Craft* 41, no. 2 (February 1934): 72–78.

ADAMS 1938
Adams, Ansel. *The John Muir Trail.* Berkeley: Archetype Press, 1938.

ADAMS 1983
Adams, Ansel. *Examples: The Making of 40 Photographs.* Boston: Little, Brown and Company, 1983.

ADAMS AND ALINDER 1985
Adams, Ansel, with Mary Street Alinder. *Ansel Adams: An Autobiography.* Boston: Little, Brown and Company, A New York Graphic Society Book, 1985.

ADAMS, KELLY, AND TYLER 1986
Adams, Celeste, Franklin Kelly, and Ron C. Tyler. *America: Art and the West.* Exh. cat. New York: American-Australian Foundation for the Arts, 1986. Art Gallery of Western Australia, Perth, and Art Gallery of New South Wales, Sydney.

ADAMS 1989
Adams, Henry. *Thomas Hart Benton: An American Original.* New York: Alfred A. Knopf, 1989.

ADES 1978
Ades, Dawn. *Dada and Surrealism Reviewed.* Exh. cat. London: Arts Council of Great Britain, 1978. Hayward Gallery, London.

ALINDER 1979
Watkins, Carleton E. *Photographs of the Columbia River and Oregon.* Edited by James Alinder, with essays by David Featherstone and Russ Anderson. Carmel, Calif.: The Friends of Photography, Inc., 1979.

ALINDER AND STILLMAN 1988
Alinder, Mary Street, and Andrea Gray Stillman, eds. *Ansel Adams: Letters and Images 1916–1984.* With a foreword by Wallace Stegner. Boston: Little, Brown and Company, 1988.

ALLEN AND ALLEN 1972
Allen, Douglas, and Douglas Allen, Jr. *N. C. Wyeth: The Collected Paintings, Illustrations, and Murals.* New York: Crown Publishers, 1972.

ANDERSON 1997
Anderson, Nancy. *Thomas Moran.* Exh. cat. Washington, D.C.: National Gallery of Art in association with Yale University Press, 1997. Gilcrease Museum of Art, Tulsa, and Seattle Art Museum.

ANDERSON 2003
Anderson, Nancy. *Frederic Remington: The Color of Night.* Exh. cat. Washington, D.C.: National Gallery of Art; Princeton, N.J.: Princeton University Press, 2003. Gilcrease Museum, Tulsa, and Denver Art Museum.

ANDREEVA AND GRANT 2000
Andreeva, Ekaterina, and Hugh A. Grant. *Vance Kirkland: Retrospective.* Exh. cat. St. Petersburg: State Russian Museum; Denver: Vance Kirkland Museum and Foundation, 2000.

ANFAM 1983
Anfam, David. "'Of the Earth, the Damned, and of the Recreated': Aspects of Clyfford Still's Earlier Work." *Burlington Magazine* 135, no. 1081 (April 1983): 260–69.

APPEL 2003
Appel, Mary Jane. *Russell Lee: A Centenary Exhibition.* With Connie Todd. Exh. cat. San Marcos: Witliff Gallery of Southwestern and Mexican Photography, Alkek Library, Texas State University, 2003.

ART GALLERY OF THE UNIVERSITY OF NOTRE DAME 1975
Art Gallery of the University of Notre Dame and Indianapolis Museum of Art. *Victor Higgins, 1884–1949.* Exh. cat. Notre Dame, Ind.: Art Gallery of the University of Notre Dame, 1975.

ART MUSEUM OF SOUTH TEXAS 1984
Art Museum of South Texas. *Victor Higgins in New Mexico.* Corpus Christi: Art Museum of South Texas, 1984.

BAIGELL 1966–67
Baigell, Matthew. "Grant Wood Revisited." *Art Journal* 26, no. 2 (Winter 1966–67): 116–22.

BAIGELL 1974
Baigell, Matthew. *Thomas Hart Benton.* New York: Harry N. Abrams, Inc., 1974.

BAILLY 1995
Bailly, Jean Christophe. *Dorothea Tanning.* Translated by Richard Howard and Robert C. Morgan. New York: George Braziller, 1995.

BAIRD 1981
Baird, Joseph Armstrong, Jr., ed. *The Development of Modern Art in Northern California, Part Two: From Exposition to Exposition: Progressive and Conservative Northern California Painting, 1915–1939.* Sacramento: Crocker Art Museum, 1981.

BALKEN 2003

Balken, Debra Briker. *Debating American Modernism: Stieglitz, Duchamp, and the New York Avant-Garde.* With an essay by Jay Bochner. Exh. cat. New York: American Federation of Arts in association with D.A.P./Distributed Art Publishers, Inc., 2003. Georgia O'Keeffe Museum, Santa Fe; Des Moines Art Center; Terra Museum of American Art, Chicago.

BALLINGER 1989

Ballinger, James K. *Frederic Remington.* New York: Harry N. Abrams, Inc., in association with the National Museum of American Art, Smithsonian Institution, Washington, D.C., 1989.

BARTER 2003

Barter, Judith A. *Window on the West: Chicago and the Art of the New Frontier, 1890–1940.* With contributions by Andrew J. Walker. Exh. cat. Chicago: Art Institute of Chicago in association with Hudson Hills Press, 2003.

BARTLETT 1962

Bartlett, Richard A. *Great Surveys of the American West.* Norman: University of Oklahoma Press, 1962.

BASSO 1996

Basso, Keith H. *Wisdom Sits in Places: Landscape and Language Among the Western Apache.* Albuquerque: University of New Mexico Press, 1996.

BEAN 1994

Bean, Lowell John. *The Ohlone Past and Present: Native Americans of the San Francisco Bay Region.* Menlo Park, Calif.: Ballena Press, 1994.

BEDELL 2001

Bedell, Rebecca. *The Anatomy of Nature: Geology and American Landscape Painting, 1825–1875.* Princeton, N.J.: Princeton University Press, 2001.

BENTON 1951

Benton, Thomas Hart. "What's Holding Back American Art?" *Saturday Review of Literature* 34, no. 50 (December 15, 1951): 9–11.

BENTON 1968

Benton, Thomas Hart. *An Artist in America.* Columbia: University of Missouri Press, 1968.

BENTON AND BAIGELL 1971

Benton, Thomas Hart, and Matthew Baigell, eds. *A Thomas Hart Benton Miscellany: Selections from His Published Opinions, 1916–1960.* Lawrence: University Press of Kansas, 1971.

BERGER 2000

Berger, Martin A. *Man Made: Thomas Eakins and the Construction of Gilded Age Manhood.* Berkeley and Los Angeles: University of California Press, 2000.

BERGER 2003

Berger, Martin A. "Overexposed: Whiteness and Landscape Photography of Carleton Watkins." *Oxford Art Journal* 26, no. 1 (2003): 3–23.

BERLO 1996

Berlo, Janet Catherine, ed. *Plains Indian Drawings, 1865–1935: Pages from a Visual History.* Exh. cat. New York: Harry N. Abrams, Inc., in association with the American Federation of Arts and The Drawing Center, 1996. Milwaukee Art Museum; Joslyn Art Museum, Omaha; and Frick Art Museum, Pittsburgh.

BERNSTEIN AND RUSHING 1995

Bernstein, Bruce, and W. Jackson Rushing. *Modern by Tradition: American Indian Painting in the Studio Style.* Albuquerque: University of New Mexico Press, 1995. Related to exhibition of the permanent collection at the Museum of Indian Arts and Culture/Laboratory of Anthropology, Museum of New Mexico.

BEST 2005

Best, Allen. "A Divine Sanction." *Forest Magazine* 7, no. 2 (Spring 2005): 38–43. A rebuttal to this article appears in 7, no. 3 (Summer 2005): 6.

BICKERSTAFF [1955] 1983

Bickerstaff, Laura M. *Pioneer Artists of Taos.* 1955. Rev. and expanded ed., Denver: Old West Publishing Co., 1983.

BOAS 1988

Boas, Nancy. *The Society of Six: California Colorists.* San Francisco: Bedford Arts, Publishers, 1988.

BOEHM 1990

Boehm, Gottfried. *Mark Tobey: A Centennial Exhibition.* Exh. cat. Basel, Switzerland: Galerie Beyeler, 1990.

BOGARDUS 1984

Bogardus, Ralph F. *Pictures and Texts: Henry James, A. L. Coburn, and New Ways of Seeing in Literary Culture.* Ann Arbor, Mich.: UMI Research Press, 1984.

BONNIFIELD 1979

Bonnifield, Paul. *The Dust Bowl: Men, Dirt, and Depression.* Albuquerque: University of New Mexico Press, 1979.

BOWLES [1869] 1991

Bowles, Samuel. *Parks and Mountains of Colorado: A Summer Vacation in the Switzerland of America, 1868.* 1869. First edited edition by James Pickering. Reprint, Norman: University of Oklahoma Press, 1991.

BOYAJIAN AND RUTKOSKI, FORTHCOMING

Boyajian, Ani, and Mark Rutkoski. *Stuart Davis: A Catalogue Raisonné.* New Haven: Yale University Press, forthcoming.

BOYLE 1979

Boyle, Richard J. *John Twachtman.* New York: Watson-Guptill Publications, 1979.

BOYLE 1999

Boyle, Richard J. *Arthur Wesley Dow (1857–1922): His Art and His Influence.* Exh. cat. New York: Spanierman Gallery, 1999.

BOYM 2001

Boym, Svetlana. *The Future of Nostalgia.* New York: Basic Books, 2001.

BRENNAN 2001

Brennan, Marcia. *Painting Gender, Constructing Theory: The Alfred Stieglitz Circle and American Formalist Aesthetics.* Cambridge: MIT Press, 2001.

BRODER 1984

Broder, Patricia Janis. *The American West: The Modern Vision.* With a foreword by Charles C. Eldredge. Boston: Little, Brown and Company, 1984.

BRODY 1971

Brody, J. J. *Indian Painters and White Patrons.* Albuquerque: University of New Mexico Press, 1971.

BRODY 1997

Brody, J. J. *Pueblo Indian Painting: Tradition and Modernism in New Mexico, 1900–1930.* Santa Fe: School of American Research Press, 1997. Collection of Indian Arts Research Center of the School of American Research.

BULOSAN [1946] 1976

Bulosan, Carlos. *America Is in the Heart: A Personal History.* 1946. Reprint, Seattle: University of Washington Press, 1976.

BUNNELL 1983
Bunnell, Peter C., ed. *Edward Weston on Photography*. Salt Lake City: Gibbs M. Smith, Inc./ Peregrine Smith Books, 1983.

BUNNELL 1992
Bunnell, Peter C. "The Art of Pictorial Photography, 1890–1925." *Record of The Art Museum, Princeton University* 51, no. 2 (1992): 11–15.

BURNSIDE 1974
Burnside, Wesley M. *Maynard Dixon: Artist of the West*. Provo, Utah: Brigham Young University Press, 1974.

BURROUGHS, WEHLE, AND WINLOCK 1930
Burroughs, Bryson, Harry B. Wehle, and H. E. Winlock. *Catalogue of a Memorial Exhibition of the Works of Arthur B. Davies*. Exh. cat. New York: Metropolitan Museum of Art, 1930.

BUSSELLE AND STACK 2004
Busselle, Rebecca, and Trudy Wilner Stack. *Paul Strand Southwest*. New York: Aperture Foundation, Inc., 2004.

CAMFIELD 1988
Camfield, William A. *Marcel Duchamp, Fountain*. Houston: Houston Fine Art Press, 1989.

CAMFIELD 1993
Camfield, William A. *Max Ernst: Dada and the Dawn of Surrealism*. Exh. cat. Houston: Menil Collection; Munich: Prestel, 1993. Museum of Modern Art, New York, and Art Institute of Chicago.

CARDOZO 2000
Cardozo, Christopher, ed. *Sacred Legacy: Edward S. Curtis and the North American Indian*. Foreword by F. Scott Momaday and essays by Christopher Cardozo and Joseph D. Horse Capture. New York: Simon & Schuster, 2000.

CARTER 1978
Carter, Denny. *Henry Farny*. New York: Watson-Guptill Publications in association with the Cincinnati Art Museum, 1978.

CASTLEBERRY 1996
Castleberry, May. *Perpetual Mirage: The Arid West in Photographic Books and Prints*. Exh. cat. New York: Whitney Museum of American Art, 1996.

CERNUSCHI 1992
Cernuschi, Claude. *Jackson Pollock: Meaning and Significance*. New York: Icon Editions, 1992.

CHILDS 1996
Childs, Elizabeth. "Time's Profile: John Wesley Powell, Art, and Geology at the Grand Canyon." *American Art* 10, no. 1 (Spring 1996): 7–35.

CHIPP 1968
Chipp, Herschel B. *Theories of Modern Art: A Source Book by Artists and Critics*. Berkeley and Los Angeles: University of California Press, 1968.

CHISOLM 1963
Chisolm, Lawrence W. *Fenollosa: The Far East and American Culture*. New Haven: Yale University Press, 1963.

CHITTENDEN 1895
Chittenden, Hiram Martin. *The Yellowstone National Park*. Cincinnati: The Robert Clarke Company, 1895.

CHOTNER, PETERS, AND PYNE 1989
Chotner, Deborah, Lisa N. Peters, and Kathleen A. Pyne. *John Twachtman: Connecticut Landscapes*. Exh. cat. Washington, D.C.: National Gallery of Art, 1989, distributed by Harry N. Abrams, Inc.

CHRONIC 1987
Chronic, Halka. *Roadside Geology of New Mexico*. Missoula, Mont.: Mountain Press Publishing Company, 1987.

CLARK 1924
Clark, Eliot. *John Twachtman*. New York: privately printed [Frederick Fairfield Sherman], 1924.

COKE 1963
Coke, Van Deren. *Taos and Santa Fe: The Artist's Environment, 1882–1942*. Exh. cat. Albuquerque: University of New Mexico Press for the Amon Carter Museum of Western Art, Fort Worth, and the Art Gallery of the University of New Mexico, 1963.

COKE [1964] 1972
Coke, Van Deren, ed. *The Painter and the Photograph: From Delacroix to Warhol*. Exh. cat. 1964. Rev. and enlarged ed., Albuquerque: University of New Mexico Press, 1972.

COKE 1968
Coke, Van Deren. *Marin in New Mexico, 1929 & 1930*. Exh. cat. Albuquerque: University Art Museum, University of New Mexico, 1968.

COLBERT 1995
Colbert, Edwin H. *The Little Dinosaurs of Ghost Ranch*. New York: Columbia University Press, 1995.

COLES 1982
Coles, Robert. *Dorothea Lange: Photographs of a Lifetime*. New York: Aperture, 1982.

CONGER 1992
Conger, Amy. *Edward Weston: Photographs from the Collection of the Center for Creative Photography*. Tucson: Center for Creative Photography, University of Arizona, 1992.

CONKELTON 1995
Conkelton, Sheryl, ed. *Frederick Sommer: Selected Texts and Bibliography*. Oxford, U.K.: Clio Press, 1995.

CONRADS 1990
Conrads, Margaret C. *American Paintings and Sculpture at the Sterling and Francine Clark Art Institute*. New York: Hudson Hills Press, 1990.

COPLANS 1978
Coplans, John. "Carleton Watkins at Yosemite." *Art in America* (November–December 1978): 100–108.

CORN 1972
Corn, Wanda M. *Color of Mood: American Tonalism, 1880–1910*. San Francisco: M. H. De Young Memorial Museum, 1972.

CORN 1983
Corn, Wanda M. *Grant Wood: The Regionalist Vision*. Exh. cat. New Haven: Yale University Press, 1983. Minneapolis Institute of Arts and Whitney Museum of American Art.

CORN 1999
Corn, Wanda M. *The Great American Thing: Modern Art and National Identity, 1915–1935*. Berkeley and Los Angeles: University of California Press, 1999.

COWART, HAMILTON, AND GREENOUGH 1987
Cowart, Jack, Juan Hamilton, and Susan Greenough. *Georgia O'Keeffe: Art and Letters*. Exh. cat. Washington, D.C.: National Gallery of Art; Boston: New York Graphic Society Books, 1987.

COX 1982
Cox, Annette. *Art-as-Politics: The Abstract Expressionist Avant-Garde and Society*. Ann Arbor, Mich.: UMI Research Press, 1982.

CUMMINGS AND KAYS 1990
Cummings, Paul, and Judith S. Kays. *Mark Tobey: Works on Paper.* Exh. cat. Stanford, Calif.: Stanford University Museum of Art, 1990. Stanford Art Gallery.

CURRY 1984
Curry, David Park. *James McNeill Whistler at the Freer Gallery of Art.* Exh. cat. Washington, D.C.: Freer Gallery of Art, Smithsonian Institution, Washington, D.C., in association with W. W. Norton & Company, 1984.

CURTIS [1907–30] 1970
Curtis, Edward S. *The North American Indian.* Foreword by Theodore Roosevelt. 20 vols. 1907–30. Reprint, New York and London: Johnson Reprint Corporation, 1970.

CURTIS 1989
Curtis, James. *Mind's Eye, Mind's Truth: FSA Photography Reconsidered.* Philadelphia: Temple University Press, 1989.

DAHL 1984
Dahl, Arthur L. *Mark Toby: Art and Belief.* Oxford, U.K.: George Ronald, 1984.

DAILEY ET AL. 2003
Dailey, Victoria, et al. *LA's Early Moderns: Art/ Architecture/Photography.* Los Angeles: Balcony Press, 2003.

DANLY AND MARX 1981
Danly, Susan, and Leo Marx, eds. *The Railroad in the American Landscape, 1850–1950.* Exh. cat. Wellesley, Mass.: Wellesley College Museum, 1981.

DAVIS 1985
Davis, Barbara A. *Edward S. Curtis: The Life and Times of a Shadow Catcher.* San Francisco: Chronicle Books, 1985.

DAVIS 1990
Davis, Gene. *N. C. Wyeth's Wild West.* Chadds Ford, Pa.: Brandywine River Museum, 1990.

DAVIS 1996
Davis, John. *The Landscape of Belief: Encountering the Holy Land in Nineteenth-Century American Art and Culture.* Princeton, N.J.: Princeton University Press, 1996.

DAVIS AND TOROSIAN 2005
Davis, Keith F., and Michael Torosian. *The Art of Frederick Sommer: Photography, Drawing, Collage.* Prescott, Ariz.: Frederick and Frances Sommer Foundation, distributed by Yale University Press, 2005.

DEMETRION 2001
Demetrion, James, ed. *Clyfford Still: Paintings, 1944–1960.* Exh. cat. Washington, D.C.: Hirshhorn Museum and Sculpture Garden, Smithsonian Institution, Washington, D.C., in association with Yale University Press, 2001.

DENNIS 1975
Dennis, James M. *Grant Wood: A Study in American Art and Culture.* New York: Viking Press, 1975.

DERVAUX 2005
Dervaux, Isabelle. *Surrealism USA.* Exh. cat. Ostfildern-Ruit, Germany: Hatje Cantz, 2005. National Academy Museum, New York, and the Phoenix Art Museum.

DEWEY 1920
Dewey, John. "Americanism and Localism." *The Dial* 68 (June 1920): 684–88.

DILWORTH 1996
Dilworth, Leah. *Imagining the Indians in the Southwest: Persistent Visions of a Primitive Past.* Washington, D.C.: Smithsonian Institution Press, 1996.

DINGUS 1982
Dingus, Rick. *The Photographic Artifacts of Timothy O'Sullivan.* Albuquerque: University of New Mexico Press, 1982.

DIPPIE 1998
Dippie, Brian W. *West-Fever.* Los Angeles: Autry Museum of Western Heritage in association with University of Washington Press, 1998.

DIPPIE 2001
Dippie, Brian W. *Frederic Remington Art Museum Collection.* New York: Harry N. Abrams, Inc., 2001.

DOMINIK 1986
Dominik, Janet Blake. *Early Artists in Laguna Beach: The Impressionists.* Exh. cat. Laguna Beach, Calif.: Laguna Art Museum, 1986.

DOSS 1991
Doss, Erika Lee. *Benton, Pollock, and the Politics of Modernism: From Regionalism to Abstract Expressionism.* Chicago: University of Chicago Press, 1991.

DOW [1899] 1998
Dow, Arthur Wesley. *Composition: A Series of Exercises in Art Structure for the Use of Students and Teachers.* 1899. Reprint, with a new introduction by Joseph Mashek. Berkeley and Los Angeles: University of California Press, 1998.

DUFF ET AL. 1987
Duff, James H., Andrew Wyeth, Thomas Hoving, and Lincoln Kirstein. *An American Vision: Three Generations of Wyeth Art.* Exh. cat. Boston: Little, Brown and Company in association with the Brandywine River Museum, 1987.

DUNN 1968
Dunn, Dorothy. *American Indian Painting of the Southwest and Plains Areas.* Albuquerque: University of New Mexico Press, 1968.

EGAN 2005
Egan, Timothy. *The Worst Hard Time: The Untold Story of Those Who Survived the Dust Bowl.* Boston: Houghton Mifflin, 2005.

EHRENS 1995
Ehrens, Susan. *A Poetic Vision: The Photographs of Anne Brigman.* Exh. cat. Santa Barbara, Calif.: Santa Barbara Museum of Art, 1995.

ELDREDGE 1996
Eldredge, Charles C. "American Impressionism Goes West." In *Crosscurrents in American Impressionism at the Turn of the Century,* edited by William U. Eiland, Donald D. Keyes, and Janice Simon. Athens: Georgia Museum of Art, University of Georgia, 1996.

ELDREDGE, SCHIMMEL, AND TRUETTNER 1986
Eldredge, Charles C., Julie Schimmel, and William H. Truettner. *Art in New Mexico 1900– 1945: Paths to Taos and Santa Fe.* Exh. cat. New York: Abbeville Press and National Museum of American Art, Smithsonian Institution, Washington, D.C., 1986.

ENYEART 2001
Enyeart, James. *Harmony of Reflected Light: The Photographs of Arthur Wesley Dow.* Santa Fe: Museum of New Mexico Press, 2001.

ETULAIN 1991
Etulain, Richard W., ed. *Writing Western History: Essays on Major Western Historians.* Albuquerque: University of New Mexico Press, 1991.

FARAGHER [1994] 1998
Faragher, John Mack. *Rereading Frederick Jackson Turner: "The Significance of the Frontier in American History" and Other Essays.* New York: Henry Holt and Company, 1994. Reprint, New Haven: Yale University Press, 1998.

FINE 1990
Fine, Ruth. *Selections and Transformations: The Art of John Marin.* Exh. cat. Washington, D.C.: National Gallery of Art; New York: Abbeville Press, 1990.

FLORES 1990
Flores, Dan. *Caprock Canyonlands.* Austin: University of Texas Press, 1990.

FOWLER 1989
Fowler, Don D. *The Western Photographs of John K. Hillers: Myself in the Waters.* Washington, D.C.: Smithsonian Institution Press, 1989.

FRANCAVIGLIA AND NARRETT 1994
Francaviglia, Richard, and David Narrett, eds. *Elusive Land: Changing Geographic Images of the Southwest.* With an introduction by David J. Weber. College Station: Texas A&M University Press for the University of Texas at Arlington, 1994.

FRASCINA 1985
Frascina, Francis. *Pollock and After: The Critical Debate.* New York: Harper & Row, 1985.

FURTH 1993
Furth, Leslie. *Augustus Vincent Tack: Landscape of the Spirit.* With essays by Elizabeth V. Chew and David W. Scott. Exh. cat. Washington, D.C.: Phillips Collection, 1993.

GARNER 1987
Garner, Gretchen. *Reclaiming Paradise: American Women Photograph the Land.* Exh. cat. Duluth: Tweed Museum of Art, University of Minnesota, 1987.

GERDTS AND SOUTH 1998
Gerdts, William H., and Will South. *California Impressionism.* New York: Abbeville Press, 1998.

GERNSHEIM AND GERNSHEIM 1966
Gernsheim, Helmut, and Alison Gernsheim, eds. *Alvin Langdon Coburn, Photographer: An Autobiography.* London: Faber, 1966.

GIBBS 2000
Gibbs, Linda Jones. *Escape to Reality: The Western World of Maynard Dixon.* With an essay by Deborah Brown Raisel. Exh. cat. Provo, Utah: Museum of Art, Brigham Young University, 2000.

GIBSON 1983
Gibson, Arrell Morgan. *The Santa Fe and Taos Colonies.* Norman: University of Oklahoma Press, 1983.

GIDLEY 1998
Gidley, Mick. *Edward S. Curtis and the North American Indian, Incorporated.* Cambridge: Cambridge University Press, 1998.

GILPIN 1989
Gilpin, Laura. "The Need for Design in Photography, 1926." In *Camera Fiends and Kodak Girls: 50 Selections by and about Women in Photography, 1840–1930,* edited by Peter E. Palmquist, 237–38. New York: Midmarch Arts Press, 1989.

GLENN AND BLEDSOE 1980
Glenn, Constance W., and Jane K. Bledsoe, eds. *Frederick Sommer at Seventy-Five: A Retrospective.* Exh. cat. Long Beach: California State University Press for the Art Museum and Galleries, 1980.

GOETZMANN [1966] 2000
Goetzmann, William H. *Exploration and Empire: The Explorer and the Scientist in the Winning of the American West.* 1966. Reprint, Austin: Texas State Historical Association, 2000.

GRANT 1978
Grant, Campbell. *Canyon de Chelly: Its People and Rock Art.* Tucson: University of Arizona Press, 1978.

GRANT, STUCKEY, AND KRÍŽ 1998
Grant, Hugh, Charles F. Stuckey, and Jan Kríž. *Vance Kirkland 1904–1981.* Exh. cat. Prague: Czech Museum of Fine Arts, 1998. Museum Kiscelli, Budapest; Denver Art Museum; State Gallery of Art, Sopot, Poland; National Museum of Art, Lithuania, in the M. Žilinskas Art Gallery; Latvian Foreign Art Museum, Riga; Frankfurter Kunstverein, Germany; and Sala Parpalló, Valencia, Spain.

GRAYBILL AND BOESEN 1976
Graybill, Florence Curtis, and Victor Boesen. *Edward Sheriff Curtis: Visions of a Vanishing Race.* New York: Thomas Y. Crowell Company, 1976.

GREEN 1990
Green, Nancy E. *Arthur Wesley Dow and His Influence.* Exh. cat. Ithaca, N.Y.: Herbert F. Johnson Museum of Art, Cornell University, 1990. Amon Carter Museum of Art, Fort Worth.

GREEN AND POESCH 2000
Green, Nancy E., and Jessie Poesch. *Arthur Wesley Dow and American Arts and Crafts.* New York: Harry N. Abrams, Inc., in association with the American Federation of the Arts, 2000.

GREENBERG 1946
Greenberg, Clement. "The Camera's Glass Eye." *The Nation* 162 (March 9, 1946): 294–98.

GREENBERG [1961] 1989
Greenberg, Clement. *Art and Culture: Critical Essays.* 1961. Reprint, Boston: Beacon Press, 1989.

GREGORY COUNTY HISTORICAL SOCIETY 1974
Gregory County Historical Society. *History of Dixon, South Dakota.* Gregory, S.Dak.: Gregory Times Advocate, 1974.

GUEDON 1982
Guedon, Mary Scholz. *Regionalist Art: Thomas Hart Benton, John Steuart Curry, and Grant Wood; A Guide to the Literature.* Metuchen, N.J.: Scarecrow Press, 1982.

GUILBAUT 1983
Guilbaut, Serge. *How New York Stole the Idea of Modern Art: Abstract Expressionism, Freedom, and the Cold War.* Chicago: University of Chicago Press, 1983.

HAGERTY [1993] 1998
Hagerty, Donald J. *Desert Dreams: The Art and Life of Maynard Dixon.* 1993. Rev. ed., Layton, Utah: Gibbs Smith, Publisher, 1998.

HAILEY 1936–37A
Hailey, Gene, ed. "Arthur Mathews: Biography and Works." *California Art Research* 7 (1936–37): 1–29. WPA Project 2874: Archives of American Art, Smithsonian Institution, Washington, D.C.

HAILEY 1936–37B
Hailey, Gene, ed. "Gottardo Piazzoni." *California Art Research* 7 (1936–37): 31–87. WPA Project 2874: Archives of American Art, Smithsonian Institution, Washington, D.C.

HAILEY 1936–37C
Hailey, Gene, ed. "Maynard Dixon." *California Art Research* 7 (1936–37): 1–87. WPA Project 2874: Archives of American Art, Smithsonian Institution, Washington, D.C.

HAINES 1996
Haines, Aubrey. *Yellowstone Place Names: Mirrors of History.* Niwot: University Press of Colorado, 1996.

HALE 1957
Hale, John Douglass. "The Life and Creative Development of John H. Twachtman." 2 vols. Ph.D. diss., Ohio State University, 1957.

HALES 1988
Hales, Peter B. *William Henry Jackson and the Transformation of the American Landscape.* Philadelphia: Temple University Press, 1988.

HAMBOURG ET AL. 1993
Hambourg, Maria Morris, Pierre Apraxine, Malcolm Daniel, et al. *The Waking Dream: Photography's First Century: Selections from the Gilman Paper Company Collection.* Exh. cat. New York: Metropolitan Museum of Art, distributed by Harry N. Abrams, Inc., 1993.

HAMLIN 1975
Hamlin [Dixon], Edith. *Maynard Dixon: A Bicentennial Retrospective.* Exh. cat. Fresno, Calif.: Fresno Arts Center, 1975.

HAMMOND 1999
Hammond, Anne. "Ansel Adams and the High Mountain Experience." *History of Photography* 23, no. 1 (Spring 1999): 88–100.

HAMMOND 2002
Hammond, Anne. *Ansel Adams: Divine Performance.* New Haven: Yale University Press, 2002.

HARTLEY AND RYAN 1997
Hartley, Marsden, and Susan Elizabeth Ryan, eds. *Somehow a Past: The Autobiography of Marsden Hartley.* Cambridge: MIT Press, 1997.

HASKELL 1980
Haskell, Barbara. *Marsden Hartley.* Exh. cat. New York: Whitney Museum of American Art in association with New York University Press, 1980.

HASSRICK 2002
Hassrick, Peter H. *Drawn to Yellowstone: Artists in America's First National Park.* Los Angeles: Autry Museum of Western Heritage; Seattle: University of Washington Press, 2002.

HASSRICK AND SHAPIRO 1988
Hassrick, Peter H., and Michael Edward Shapiro. *Frederic Remington: The Masterworks.* Exh. cat. New York: Harry N. Abrams, Inc., 1988. Saint Louis Art Museum; Buffalo Bill Historical Center, Cody, Wyo.; Museum of Fine Arts, Houston; and Metropolitan Museum of Art, New York.

HASSRICK AND WEBSTER 1996
Hassrick, Peter H., and Melissa J. Webster. *Frederic Remington: A Catalogue Raisonné of Paintings, Watercolors, and Drawings.* 2 vols. Seattle: Buffalo Bill Historical Center, Cody, Wyo., in association with University of Washington Press, 1996.

HATCH 1959
Hatch, Alden. *The Wadsworths of the Genesee.* New York: Coward-McCann, 1959.

HAWORTH-BOOTH 1981
Haworth-Booth, Mark. "Frederick Sommer: A Goldmine in Arizona." *Creative Camera* (December 1981): 328–35.

HENDERSON 1937
Henderson, Alice Corbin. *Brothers of Light: The Penitentes of the Southwest.* New York: Harcourt, Brace and Company, 1937.

HENDRICKSON 1992
Hendrickson, Paul. *Looking for the Light: The Hidden Life and Art of Marion Post Wolcott.* New York: Alfred A. Knopf, 1992.

HEYMAN 1974
Heyman, Therese Thau. *Anne Brigman: Pictorial Photographer/Pagan/Member of the Photo-Secession.* Exh. cat. Oakland: Oakland Museum of California, 1974.

HEYMAN 1978
Heyman, Therese Thau. *Celebrating a Collection: The Work of Dorothea Lange.* Exh. cat. Oakland: Oakland Museum of California, 1978.

HEYMAN 1992
Heyman, Therese Thau, ed. *Seeing Straight: The f.64 Revolution in Photography.* Exh. cat. Oakland: Oakland Museum of California, 1992.

HOKIN 1993
Hokin, Jeanne. *Pinnacles & Pyramids: The Art of Marsden Hartley.* Albuquerque: University of New Mexico Press, 1993.

HOLE 2005
Hole, Heather. "America as Landscape: Marsden Hartley and New Mexico, 1918–1919." Ph.D. diss., Princeton University, 2005.

HOMER 1983
Homer, William Innes. *Alfred Stieglitz and the Photo-Secession.* Boston: Little, Brown and Company, A New York Graphic Society Book, 1983.

HOOD AND HAAS 1963
Hood, Mary V. Jessup, and Robert Bartlett Haas. "Eadweard Muybridge's Yosemite Valley Photographs, 1867–1872." *California Historical Quarterly* (March 1963): 5–26.

HOOPER 1988
Hooper, Bruce. "Windows on the Nineteenth Century World: John K. Hillers's Glass Window Transparencies." *History of Photography* 12, no. 3 (July/August 1988): 185–92.

HORAN 1966
Horan, James D. *Timothy O'Sullivan: America's Forgotten Photographer.* New York: Bonanza Books, 1966.

HOROWITZ 1999
Horowitz, Roth. *Books on Photography, III.* New York: Roth Horowitz, 1999.

HULTS 1991
Hults, Linda C. "Pilgrim's Progress in the West: Moran's *The Mountain of the Holy Cross.*" *American Art* 5, nos. 1–2 (Winter–Spring 1991): 69–85.

HURLEY 1972
Hurley, F. Jack. *Portrait of a Decade: Roy Stryker and the Development of Documentary Photography in the 1930s.* With photographic editing by Robert J. Doherty. Baton Rouge: Louisiana State University Press, 1972.

HURLEY 1973
Hurley, F. Jack. "Russell Lee." *Image* (September 1973): 1–32.

HURLEY 1978
Hurley, F. Jack. *Russell Lee: Photographer.* Dobbs Ferry, N.Y.: Morgan and Morgan, 1978.

HURLEY 1989
Hurley, F. Jack. *Marion Post Wolcott: A Photographic Journey.* Albuquerque: University of New Mexico Press, 1989.

HYDE 1990
Hyde, Anne. *An American Vision: Far Western Landscape and National Culture, 1820–1920.* New York: New York University Press, 1990.

JACKSON 1947
Jackson, C. S. *Picture Maker of the Old West: William Henry Jackson.* New York: Charles Scribner's Sons, 1947.

JACKSON 1997
Jackson, John Brinckerhoff. *Landscape in Sight: Looking at America.* Edited by Helen Lefkowitz Horowitz. New Haven: Yale University Press, 1997.

JACOBS 1999
Jacobs, Margaret D. *Engendered Encounters: Feminism & Pueblo Culture, 1879–1934.* Lincoln: University of Nebraska Press, 1999.

JOHNSON 1934
Johnson, Arthur Warren. *Arthur Wesley Dow, Historian–Artist–Teacher.* Ipswich, Mass.: Ipswich Historical Society Publications, 1934.

JOHNSON 2001
Johnson, Drew Heath. *Capturing Light: Masterpieces of California Photography 1850 to the Present.* With a foreword by Therese Thau Heyman. New York: Oakland Museum of California in association with W. W. Norton and Company, 2001.

JONES [1972] 1985
Jones, Harvey L. *Mathews: Masterpieces of the California Decorative Style.* Exh. cat. 1972. Reprint, Layton, Utah: Gibbs Smith/Peregrine Smith Books in association with the Oakland Museum of California, 1985.

JONES, CALDWELL, AND ST. JOHN 1981
Jones, Harvey L., John Caldwell, and Terry St. John. *Impressionism, The CA View.* Exh. cat. Oakland: Oakland Museum of California Art Department, 1981.

JUNKER 1998
Junker, Patricia. *John Steuart Curry: Inventing the Middle West.* Exh. cat. New York: Hudson Hills Press in association with the Elvehjem Museum of Art, University of Wisconsin-Madison, 1998. Fine Arts Museums of San Francisco and Nelson-Atkins Museum of Art, Kansas City, Mo.

KALIL 1986
Kalil, Susie. *The Texas Landscape, 1900–1986.* Exh. cat. Houston: The Museum of Fine Arts, Houston, 1986.

KALIL 1995
Kalil, Susie. "Interview with Alexandre Hogue." *Circa* 1, no. 1 (Winter 1995): 9–13.

KARMEL 1999
Karmel, Pepe, ed. *Jackson Pollock: Interviews, Articles, and Reviews.* New York: Museum of Modern Art, distributed by Harry N. Abrams, Inc., 1999.

KASS 1983
Kass, Ray. *Morris Graves, Vision of the Inner Eye.* Exh. cat. New York: George Braziller in association with the Phillips Collection, Washington, D.C., 1983.

KAUFMAN 2004
Kaufman, Thomas DaCosta. *Toward a Geography of Art.* Chicago: University of Chicago Press, 2004.

KELDER 1971
Kelder, Diane, ed. *Stuart Davis.* New York: Praeger, 1971.

KELDER 2002
Kelder, Diane. *Stuart Davis: Art and Theory, 1920–1931.* Exh. cat. New York: Pierpont Morgan Library, 2002.

KELLEIN 1992
Kellein, Thomas, ed. *Clyfford Still 1904–1980: The Buffalo and San Francisco Collections.* Exh. cat. Munich: Prestel, 1992. Kunsthalle Basel, Switzerland.

KELLY 1973
Kelly, Jain. "Frederick Sommer." *Art in America* (January–February 1973): 92–94.

KELSEY 2003
Kelsey, Robin. "Viewing the Archive: Timothy O'Sullivan's Photographs for the Wheeler Survey, 1871–74." *Art Bulletin* 85, no. 4 (December 2003): 702–23.

KINSEY 1992
Kinsey, Joni Louise. *Thomas Moran and the Surveying of the American West.* Washington, D.C.: Smithsonian Institution Press, 1992.

KINSEY 1996
Kinsey, Joni Louise. *Plain Pictures: Images of the American Prairie.* Exh. cat. Washington, D.C.: Smithsonian Institution Press for the University of Iowa Museum of Art, 1996. Amon Carter Museum of Art, Fort Worth, and Joslyn Art Museum, Omaha.

KIVER AND HARRIS 1999
Kiver, E. P., and D. V. Harris. *Geology of U.S. Parklands,* 5th ed. Hoboken, N.J.: John Wiley and Sons, 1999.

KOLODNY [1975] 1984
Kolodny, Annette. *The Lay of the Land: Metaphor as Experience and History in American Life and Letters.* 1975. Reprint, Chapel Hill: University of North Carolina Press, 1984.

KORNHAUSER 2003
Kornhauser, Elizabeth Mankin, ed. *Marsden Hartley.* Exh. cat. Hartford, Conn.: Wadsworth Atheneum Museum of Art; New Haven: Yale University Press, 2003.

KRASNE 1951
Krasne, Belle. "A Tobey Profile." *Art Digest* 26, no. 2 (October 15, 1951): 5, 26, and 34.

KRAUSS 1985
Krauss, Rosalind. *The Originality of the Avant-Garde and Other Modernist Myths.* Cambridge: MIT Press, 1985.

KUH [1962] 2000
Kuh, Katharine. *The Artist's Voice: Talks with Seventeen Modern Artists.* New York: Harper & Row, 1962. Reprint, Cambridge, Mass.: Da Capo Press, 2000.

KUH 1965
Kuh, Katharine. *Break-Up: The Core of Modern Art.* Greenwich, Conn.: New York Graphic Society, 1965.

KUH 1966
Kuh, Katharine. *Clyfford Still: Thirty-Three Paintings in the Albright-Knox Art Gallery.* Buffalo, N.Y.: Buffalo Fine Arts Academy, 1966.

KUSPIT 1984
Kuspit, Donald B. "Grant Wood: Pathos of the Plain." *Art in America* 72 (March 1984): 138–43.

LANDAU 1989
Landau, Ellen G. *Jackson Pollock.* New York: Harry N. Abrams, Inc., 1989.

LANDAUER 1996
Landauer, Susan. *The San Francisco School of Abstract Expressionism.* Exh. cat. Berkeley and Los Angeles: University of California Press, 1996. Laguna Art Museum, Calif., and San Francisco Museum of Modern Art.

LANDIS AND UDALL 1999
Landis, Ellen J., and Sharyn Rohlfsen Udall. *John Marin in New Mexico.* Exh. cat. Albuquerque: Albuquerque Museum, 1999.

LANE 1978
Lane, John, ed. *Stuart Davis: Art and Art Theory.* Exh. cat. Brooklyn: Brooklyn Museum of Art, 1978.

LANGE AND DIXON 1952
Lange, Dorothea, and Daniel Dixon. "Photographing the Familiar." *Aperture* 2 (1952): 5–15.

LANGE AND TAYLOR 1939

Lange, Dorothea, and Paul Schuster Taylor. *An American Exodus: A Record of Human Erosion.* New York: Reynal & Hitchcock, 1939.

LANGE, HAMLIN, DIXON, AND DIXON 1994

Lange, Dorothea, Edith Hamlin, Daniel Dixon, and John Dixon. *The Thunderbird Remembered: Maynard Dixon, The Man and The Artist.* Los Angeles: Gene Autry Western Heritage Museum, 1994.

LARKIN 2001

Larkin, Susan. *The Cos Cob Art Colony: Impressionists on the Connecticut Shore.* New York: National Academy of Design; New Haven: Yale University Press, 2001.

LEARS 1981

Lears, T. J. Jackson. *No Place of Grace: Antimodernism and the Transformation of American Culture, 1880–1920.* New York: Pantheon Books, 1981.

LEE AND DAVIS 1965

Lee, Russell, and Marian Davis. *Russell Lee: Retrospective Exhibition, 1934–64.* Exh. cat. Austin: University Art Museum of the University of Texas, 1965.

LEIGHLY 1963

Leighly, John, ed. *Land and Life: A Selection from the Writings of Carl Ortwin Sauer.* Berkeley and Los Angeles: University of California Press, 1963.

LEJA 1993

Leja, Michael. *Reframing Abstract Expressionism: Subjectivity and Painting in the 1940s.* New Haven: Yale University Press, 1993.

LEMKE 1998

Lemke, Sieglinde. *Primitivist Modernism: Black Culture and the Origins of Transatlantic Modernism.* New York: Oxford University Press, 1998.

LEVIN AND NORTHRUP 1981

Levin, Howard M., and Katherine Northrup, eds. *Dorothea Lange: Farm Security Administration Photographs: 1935–1939.* 2 vols. Glencoe, Ill.: Text-Fiche Press, 1981.

LEWTY 1987

Lewty, Peter J. *To the Columbia Gateway: The Oregon Railway and the Northern Pacific, 1879–1884.* Pullman: Washington State University Press, 1987.

LIEBERSOHN 1998

Liebersohn, Harry. *Aristocratic Encounters: European Travelers and North American Indians.* Cambridge: Cambridge University Press, 1998.

LISLE 1980

Lisle, Laurie. *Portrait of an Artist: A Biography of Georgia O'Keeffe.* New York: Seaview Books, 1980.

LONGWELL 1978

Longwell, Dennis. *Steichen, The Master Prints 1895–1914: The Symbolist Period.* New York: Museum of Modern Art, 1978, distributed by New York Graphic Society, Boston.

LUDINGTON 1992

Ludington, Townsend. *Marsden Hartley: The Biography of an American Artist.* Boston: Little, Brown and Company, 1992.

LUHAN 1931

Luhan, Mabel Dodge. "Georgia O'Keeffe in Taos." *Creative Art* 8 (June 1931): 407–10.

LYDEN 2003

Lyden, Anne M. *Railroad Vision: Photography Travel and Perception.* Los Angeles: Getty Trust Publications for the J. Paul Getty Museum, 2003.

LYDEN 2005

Lyden, Anne M. *Paul Strand: Photographs from the J. Paul Getty Museum.* Los Angeles: Getty Publications, 2005.

LYNES 1989

Lynes, Barbara Buhler. *O'Keeffe, Stieglitz and the Critics, 1916–1929.* Ann Arbor, Mich.: UMI Research Press, 1989.

LYNES 1999

Lynes, Barbara Buhler. *Georgia O'Keeffe: Catalogue Raisonné.* Vol. 2. New Haven: Yale University Press in association with the National Gallery of Art, Washington, D.C., and the Georgia O'Keeffe Foundation, Abiquiu, N.Mex., 1999.

LYNES 2004

Lynes, Barbara Buhler. *Georgia O'Keeffe and New Mexico: A Sense of Place.* Exh. cat. Princeton, N.J.: Princeton University Press in association with the Georgia O'Keeffe Museum, Santa Fe, 2004. Columbus Museum of Art, Ohio, and Delaware Art Museum, Wilmington.

MABIE 1896

Mabie, Hamilton Wright. *Nature and Culture.* New York: Dodd, Mead and Co., 1896.

MADDOW 1973

Maddow, Ben. *Edward Weston: Fifty Years.* Millerton, N.Y.: Aperture, 1973.

MAHOOD 1961

Mahood, Ruth I., ed. *Photographer of the Southwest, Adam Clark Vroman, 1856–1916.* Los Angeles: Ward Ritchie Press, 1961.

MARGOLIN 1981

Margolin, Malcolm. *Ohlone Way.* Berkeley, Calif.: Heyday Books, 1981.

MARIN AND NORMAN 1949

Marin, John. *Selected Writings of John Marin.* Edited with an introduction by Dorothy Norman. New York: Pellegrini and Cudahy, 1949.

MARLING 1981

Marling, Karal Ann. "Thomas Hart Benton's Regionalism Redefined." *Prospects* 6 (1981): 73–137.

MATHEY 1961

Mathey, F. *Mark Tobey.* Exh. cat. Paris: Musée des arts décoratifs, 1961. Musée du Louvre.

MCCARROLL 2004

McCarroll, Stacey. *California Dreamin': Camera Clubs and the Pictorial Photography Tradition.* With an introduction by Kim Sichel. Exh. cat. Boston: Boston University Art Gallery, 2004.

MCCRACKEN 1947

McCracken, Harold. *Frederic Remington: Artist of the Old West.* Philadelphia: J. B. Lippincott, 1947.

MCDONNELL 1997

McDonnell, Patricia. *Marsden Hartley: American Modern; The Ione and Hudson D. Walker Collection.* Exh. cat. Minneapolis: Frederick R. Weisman Art Museum, University of Minnesota, distributed by the University of Washington Press, 1997.

MCGRATH 1988

McGrath, Robert L. *Paul Sample, Painter of the American Scene.* With an extended chronology by Paula F. Glick. Exh. cat. Hanover, N.H.: Hood Museum of Art, 1988.

MCGRATH 2001

McGrath, Robert. *Gods in Granite: The Art of the White Mountains of New Hampshire.* Syracuse, N.Y.: Syracuse University Press, 2001.

MELTZER 1978
Meltzer, Milton. *Dorothea Lange: A Photographer's Life.* New York: Farrar, Straus and Giroux, 1978.

MICHAELIS 1998
Michaelis, David. *N. C. Wyeth: A Biography.* New York: Alfred A. Knopf, 1998.

MICHAELS 1990
Michaels, Walter Benn. "The Vanishing American." *American Literary History* 2, no. 2 (Summer 1990): 220–41.

MILLER 1992
Miller, Angela. "The Mechanisms of the Market and the Invention of Western Regionalism: The Example of George Caleb Bingham." *Oxford Art Journal* 15, no. 1 (1992): 3–20.

MILLER 1993
Miller, Angela. *The Empire of the Eye: Landscape Representations and American Cultural Politics.* Ithaca, N.Y.: Cornell University Press, 1993.

MILNER, O'CONNOR, AND SANDWEISS [1994] 1996
Milner, Clyde A., II, Carol A. O'Connor, and Martha A. Sandweiss. *The Oxford History of the American West.* 1994. Reprint, New York: Oxford University Press, 1996.

MITCHELL 2002
Mitchell, W. J. T., ed. *Landscape and Power.* 2nd ed. Chicago: University of Chicago Press, 2002.

MOFFATT 1977
Moffatt, Frederick C. *Arthur Wesley Dow: 1857–1922.* Exh. cat. Washington, D.C.: Smithsonian Institution Press for the National Collection of Fine Arts, 1977.

MOORE 1966
Moore, James Collins. *Marsden Hartley: The New Mexico Period, 1918–1919.* Albuquerque: University of New Mexico, 1966.

MOORE 1986
Moore, James. "So Clear Cut Where the Sun Will Come…Georgia O'Keeffe's Gray Cross with Blue." *Artspace* 10, no. 3 (Summer 1986): 32–39.

MORA 1995
Mora, Gilles, ed. *Edward Weston: Forms of Passion.* New York: Harry N. Abrams, Inc., 1995.

MOURE 1980
Moure, Nancy Dustin Wall. *Painting and Sculpture in Los Angeles, 1900–1945.* Los Angeles: Los Angeles County Museum of Art, 1980.

MOURE 1998
Moure, Nancy Dustin Wall. *California Art.* Los Angeles: Dustin Publications, 1998.

MURRAY 1980
Murray, Joan. "Q and A: Marion Post Wolcott." *American Photographer* 4, no. 3 (March 1980): 86–93.

NAEF AND CHRISTADLER 1993
Naef, Weston J., and Martin Christadler. *Pioneers of Landscape Photography: Gustave Le Gray, Carleton E. Watkins, Photographs from the Collection of the J. Paul Getty Museum.* Exh. cat. Malibu: J. Paul Getty Museum; Frankfurt am Main: Städtische Galerie im Städelschen Kunstinstitut, 1993.

NAEF AND WOOD 1975
Naef, Weston J., and James N. Wood. *Era of Exploration: The Rise of Landscape Photography in the American West, 1860–1885.* Exh. cat. Buffalo, N.Y.: Albright-Knox Gallery, 1975, distributed by New York Graphic Society. Metropolitan Museum of Art, New York.

NAIFEH AND SMITH 1989
Naifeh, Steven W., and Gregory White Smith. *Jackson Pollock, an American Saga.* New York: C. N. Potter, 1989.

NASH 1995
Nash, Steven A. *Facing Eden: 100 Years of Landscape Art in the Bay Area.* Exh. cat. Berkeley and Los Angeles: University of California Press, 1995. Fine Arts Museums of San Francisco.

NEFF 2000
Neff, Emily Ballew. *Frederic Remington: The Hogg Brothers Collection of the Museum of Fine Arts, Houston.* Princeton, N.J.: Princeton University Press in association with the Museum of Fine Arts, Houston, 2000.

NEMEROV 1995
Nemerov, Alexander. *Frederic Remington and Turn-of-the-Century America.* New Haven: Yale University Press, 1995.

NEWHALL AND NEWHALL 1966
Newhall, Beaumont, and Nancy Newhall. *Timothy O'Sullivan: Photographer.* With an appreciation by Ansel Adams. Rochester, N.Y.: George Eastman House, Inc., 1966.

NEWHALL 1946
Newhall, Nancy. *Edward Weston.* Exh. cat. New York: Museum of Modern Art, 1946.

NEWHALL 1973
Newhall, Nancy, ed. *The Daybooks of Edward Weston.* Millerton, N.Y.: Aperture, 1973.

NEWHALL 1975
Newhall, Nancy, ed. *Edward Weston: The Flame of Recognition; His Photographs Accompanied by Excerpts from the Daybooks & Letters.* Millerton, N.Y.: Aperture, 1975.

NEWHALL 1990
Newhall, Nancy. *From Adams to Stieglitz: Pioneers of Modern Photography.* With a foreword by Michael E. Hoffman and an introduction by Beaumont Newhall. New York: Aperture Foundation, 1990.

NICKEL 1999
Nickel, Douglas R. *Carleton Watkins: The Art of Perception.* Exh. cat. San Francisco: San Francisco Museum of Modern Art, 1999. Metropolitan Museum of Art, New York, and National Gallery of Art, Washington, D.C.

NICKEL 2004
Nickel, Douglas R. *Francis Frith in Egypt and Palestine: A Victorian Photographer Abroad.* Princeton, N.J.: Princeton University Press, 2004.

NIVEN 1997
Niven, Penelope. *Steichen: A Biography.* New York: Clarkson Potter, 1997.

NOBLE 1986
Noble, David Grant, ed. *Exploration: Annual Bulletin of the School of American Research.* Santa Fe: School of American Research, 1986.

NORDLAND 1969
Nordland, Gerald. *Edward Corbett.* Exh. cat. San Francisco: San Francisco Museum of Modern Art, 1969.

NORDLAND AND NIESE 1979
Nordland, Gerald, and Henry Niese. *Edward Corbett.* Exh. cat. College Park: University of Maryland Art Gallery, 1979.

NOVAK 1980
Novak, Barbara. *Nature and Culture: American Landscape and Painting, 1825–1875.* New York: Oxford University Press, 1980.

O'CONNOR AND THAW 1978
O'Connor, Francis V., and Eugene Victor Thaw. *Jackson Pollock: A Catalogue Raisonné of Paintings, Drawings, and Other Works.* New Haven: Yale University Press, 1978.

O'KEEFFE 1976
O'Keeffe, Georgia. *Georgia O'Keeffe*. New York: Viking Press, 1976.

O'KEEFFE 1990
O'Keeffe, Georgia. *Lovingly, Georgia: The Complete Correspondence of Georgia O'Keeffe and Anita Pollitzer*, edited by Clive Giboire. New York: Simon & Schuster/Touchstone, 1990.

O'NEILL 1979
O'Neill, John Philip, ed. *Clyfford Still*. Exh. cat. New York: Metropolitan Museum of Art, distributed by Harry N. Abrams, Inc., 1979.

PALMQUIST 1983
Palmquist, Peter E. *Carleton E. Watkins: Photographer of the American West*. Exh. cat. Albuquerque: University of New Mexico Press, 1983. Amon Carter Museum of Art, Fort Worth; Museum of Fine Arts, Boston; St. Louis Art Museum; and Oakland Museum of California.

PALMQUIST 1999
Palmquist, Peter E. *William E. Dassonville, California Photographer, 1879–1957*. Nevada City, Calif.: Carl Mautz Publishing, 1999.

PANZER 1980–81
Panzer, Mary. L. D. W. Collection at the Delaware County Historical Society, Media, Pa. Unpublished typescript.

PANZER 1982
Panzer, Mary. *Philadelphia Naturalistic Photography, 1865–1906*. Exh. cat. New Haven: Yale University Art Gallery, 1982.

PARTRIDGE 1994
Partridge, Elizabeth, ed. *Dorothea Lange: A Visual Life*. Washington, D.C.: Smithsonian Institution Press, 1994.

PENNINGTON AND GRUBER 1994
Pennington, Estill Curtis, and J. Richard Gruber. *Victorian Visionary: The Art of Elliott Daingerfield*. With a foreword by William S. Morris III. Exh. cat. Augusta, Ga.: Morris Museum of Art, 1994.

PERLMAN 1998
Perlman, Bennard B. *The Lives, Loves, and Art of Arthur B. Davies*. Albany: State University of New York Press, 1998.

PETERS 1995
Peters, Lisa N. "John Twachtman (1853–1902) and the American Scene in the Late Nineteenth Century: The Frontier within the Terrain of the Familiar." 2 vols. Ph.D. diss., City University of New York, 1995.

PETERS 1999
Peters, Lisa N. *John Twachtman: American Impressionist*. Exh. cat. Atlanta: High Museum of Art, 1999.

PETERS 1991
Peters, Sarah Whitaker. *Becoming O'Keeffe: The Early Years*. New York: Abbeville Press, 1991.

PETERSEN 1971
Petersen, Karen Daniels. *Plains Indian Art from Fort Marion*. Norman: University of Oklahoma Press, 1971.

PHILLIPS 1924
Phillips, Duncan, et al. *Arthur B. Davies: Essays on the Man and His Art*. The Phillips Publications, no. 3. Cambridge, Mass.: Riverside Press, 1924.

PHILLIPS ET AL. 1996
Phillips, Sandra S., Richard Rodriguez, Aaron Betsky, and Eldridge M. Moores. *Crossing the Frontier: Photographs of the Developing Frontier, 1849 to the Present*. Exh. cat. San Francisco: Chronicle Books in association with San Francisco Museum of Modern Art, 1996.

PITTS 1981
Pitts, Terence R. "The Early Work of Laura Gilpin, 1917–1932." *Center for Creative Photography, University of Arizona, Research Series*, no. 13 (April 1981): 3–9.

PLAINS PRINTING COMPANY 1976
Plains Printing Company. *Borger Centennial Memorial: Borger's Fiftieth Birthday, 1926–1976*. Borger, Tex.: Plains Printing Company, 1976.

POLCARI 1979
Polcari, Stephen. "Jackson Pollock and Thomas Hart Benton." *Arts Magazine* 53 (March 1979): 120–24.

PORTER 1991
Porter, Dean. *Victor Higgins: An American Master*. Exh. cat. Salt Lake City: Gibbs Smith, Publisher, 1991.

PORTER, EBIE, AND CAMPBELL 1999
Porter, Dean A., Theresa Hayes Ebie, and Suzan Campbell. *Taos Artists and Their Patrons, 1898–1950*. Exh. cat. Notre Dame, Ind.: Snite Museum of Art, University of Notre Dame, 1999.

PORTER 1985
Porter, Eliot. *Eliot Porter's Southwest*. New York: Holt, Rinehart and Winston, 1985.

PORTLAND ART ASSOCIATION 1951
Portland Art Association. *C. S. Price, 1874–1950: A Memorial Exhibition*. Exh. cat. Portland, Oreg.: Portland Art Association, 1951. Initiated by the Portland Art Museum and Walker Art Center and also exhibited at the Seattle Art Museum; Los Angeles County Museum of Art; Baltimore Museum of Art; Munson-Williams-Proctor Institute, Utica, N.Y.; Detroit Institute of Arts; California Palace of the Legion of Honor, San Francisco; and Santa Barbara Museum of Art.

PRICE 1998
Price, B. Byron. *Imagining the Open Range: Erwin E. Smith, Cowboy Photographer*. Exh. cat. Fort Worth: Amon Carter Museum, 1998. National Cowboy Hall of Fame, Oklahoma City, and Buffalo Bill Historical Center, Cody, Wyo.

PYNE 1996
Pyne, Kathleen A. *Art and the Higher Life: Painting and Evolutionary Thought in Late Nineteenth-Century America*. Austin: University of Texas Press, 1996.

PYNE 1998
Pyne, Stephen J. *How the Canyon Became Grand: A Short History*. New York: Penguin Books, 1998.

QUASHA 1994
Quasha, Jill. *Marjorie Content: Photographs*. New York: W. W. Norton and Company, 1994.

QUINN AND STEBBINS 1991
Quinn, Karen E., and Theodore E. Stebbins, Jr. *Ansel Adams: The Early Years*. Exh. cat. Boston: Museum of Fine Arts, Boston, 1991.

QUINN, STEBBINS, AND WILSON 1994
Quinn, Karen E., Theodore E. Stebbins, Jr., and Charis Wilson. *Weston's Westons: California and the West*. Exh. cat. Boston: Museum of Fine Arts, Boston, in association with Bulfinch Press, 1994.

RATHBONE 1984
Rathbone, Eliza E. *Mark Tobey: City Paintings*. Exh. cat. Washington, D.C.: National Gallery of Art, 1984.

REED 1985
Reed, Dennis. *Japanese Photography in America, 1920–1940.* Exh. cat. Los Angeles: George J. Doizaki Gallery, 1985.

REICH 1970A
Reich, Sheldon. *John Marin: A Stylistic Analysis and Catalogue Raisonné.* 2 vols. Tucson: University of Arizona Press, 1970.

REICH 1970B
Reich, Sheldon. "The Paradoxes of Arthur B. Davies." *Apollo* (November 1970): 366–71.

RICH 1943
Rich, Daniel Catton. *Georgia O'Keeffe.* Exh. cat. Chicago: Art Institute of Chicago, 1943.

ROBERTS ET AL. 1995
Roberts, Brady M., James M. Dennis, James S. Horns, and Helen Par Parkin. *Grant Wood: An American Master Revealed.* San Francisco: Pomegranate Artbooks, 1995.

ROBERTS N.D.
Roberts, Pam. *Alvin Langdon Coburn, 1882–1966.* With a foreword by Therese Mulligan. Rochester, N.Y.: George Eastman House, n.d.

ROBERTSON 1995
Robertson, Bruce. *Marsden Hartley.* New York: Harry N. Abrams, Inc., in association with the National Museum of American Art, Smithsonian Institution, 1995.

ROBERTSON 1984
Robertson, David. *West of Eden: A History of the Art and Literature of Yosemite.* El Portal and Berkeley, Calif.: Yosemite Natural History Association and Wilderness Press, 1984.

ROBINSON 1989
Robinson, Roxana. *Georgia O'Keeffe: A Life.* New York: Harper & Row, 1989.

ROSENBLUM 1978
Rosenblum, Naomi. "Paul Strand: The Early Years, 1910–1932." Ph.D. diss., City University of New York, 1978.

ROSENBLUM 1994
Rosenblum, Naomi. *A History of Women Photographers.* New York: Abbeville Press, 1994.

ROSENFELD [1924] 1966
Rosenfeld, Paul. *Port of New York: Essays on Fourteen American Moderns.* 1924. Reprint, Urbana: University of Illinois Press, 1966.

ROSSON DELONG 1983
Rosson DeLong, Lea. "The Career of Alexandre Hogue." Ph.D. diss., University of Kansas, 1983.

ROSSON DELONG 1984
Rosson DeLong, Lea. *Nature's Forms/Nature's Forces: The Art of Alexandre Hogue.* Exh. cat. Tulsa: University of Oklahoma Press in association with the Philbrook Museum of Art, 1984.

ROTHSTEIN 1979
Rothstein, Arthur. *Words and Pictures.* Rev. ed. New York: Amphoto, 1979.

RUDNICK 1996
Rudnick, Lois Palken. *Utopian: The Mabel Dodge Luhan House and the American Counterculture.* Albuquerque: University of New Mexico Press, 1996.

RULE 1993
Rule, Amy, ed. *World Photographers Reference Series.* Vol. 4, *Carleton Watkins: Selected Texts and Bibliography.* With an essay by Mary Warner Marien. Boston: G. K. Hall and Co., 1993.

RUSHING 1995
Rushing, W. Jackson. *Native American Art and the New York Avant-Garde: A History of Cultural Primitivism.* Austin: University of Texas Press, 1995.

SAMPLE 1984
Sample, Paul. *Paul Sample, Ivy League Regionalist.* Exh. cat. Miami: Lowe Art Museum, University of Miami, 1984.

SAN FRANCISCO MUSEUM OF ART 1975
San Francisco Museum of Art. *Women of Photography: An Historical Survey.* Exh. cat. San Francisco: San Francisco Museum of Art, 1975. Museum of New Mexico, Santa Fe; Art History Galleries, University of Wisconsin, Milwaukee; Wellesley College Museum, Wellesley, Mass.

SANDLER 2002
Sandler, Martin W. *Against the Odds: Women Pioneers in the First Hundred Years of Photography.* New York: Rizzoli International Publications, 2002.

SANDWEISS 1986
Sandweiss, Martha A. *Laura Gilpin: An Enduring Grace.* Exh. cat. Fort Worth: Amon Carter Museum, 1986.

SANDWEISS 1987
Sandweiss, Martha A. "Laura Gilpin and the Tradition of American Landscape Photography." In *The Desert Is No Lady: Southwestern Landscapes in Women's Writing and Art,* edited by Vera Norwood and Janice Monk. New Haven: Yale University Press, 1987.

SANDWEISS 2002
Sandweiss, Martha A. *Print the Legend: Photography and the American West.* New Haven: Yale University Press, 2002.

SCHAMA 1995
Schama, Simon. *Landscape and Memory.* New York: Alfred A. Knopf, 1995.

SCHARFF 1966
Scharff, Robert, ed. *Yellowstone and Grand Teton National Parks.* New York: David McKay Company, Inc., with the cooperation of the National Park Service, 1966.

SCHIVELBUSCH [1977] 1986
Schivelbusch, Wolfgang. *The Railway Journey: The Industrialization of Time and Space in the 19th Century.* 1977. Reprint, Berkeley and Los Angeles: University of California Press, 1986.

SCHWEIZER 1989
Schweizer, Paul D., ed. *Masterworks of American Art from the Munson-Williams-Proctor Institute.* New York: Harry N. Abrams, Inc., 1989.

SCOTT 1967
Scott, D. W. *The Art of Stanton Macdonald-Wright.* Exh. cat. Washington, D.C.: National Collection of Fine Arts, 1967.

SCOTT 1988
Scott, Gail R. *Marsden Hartley.* New York: Abbeville Press, 1988.

SCOTT 2003
Scott, Gail R. *Marsden Hartley: New Mexico 1918–20: An American Discovering America.* Exh. cat. New York: Mark Borghi Fine Art and Alexandre Gallery, 2003.

SEARS [1989] 1998
Sears, John F. *Sacred Places: American Tourist Attractions in the Nineteenth Century.* New York: Oxford University Press, 1989. Reprint, Amherst: University of Massachusetts Press, 1998.

SEITZ 1962
Seitz, William Chapin. *Mark Tobey.* Exh. cat. New York: Museum of Modern Art, distributed by Doubleday, 1962. Cleveland Museum of Art and Art Institute of Chicago.

SHIELDS 2001
Shields, Scott A. "Eternal Light: Visions of Gottardo Piazzoni." *California History* 80 (Summer/Fall 2001): 106–57.

SIMS 1991
Sims, Lowery Stokes. *Stuart Davis: American Painter*. With contributions by William C. Agee et al. Exh. cat. New York: Metropolitan Museum of Art and San Francisco Museum of Modern Art, distributed by Harry N. Abrams, Inc., 1991.

SIMS 1980
Sims, Patterson. *Stuart Davis: A Concentration of Works from the Permanent Collection of the Whitney Museum of American Art: A 50th Anniversary Exhibition*. Exh. cat. New York: Whitney Museum of American Art, 1980.

SLATER 1961
Slater, John M. *El Morro: Inscription Rock, New Mexico*. Los Angeles: Plantin Press, 1961.

SMITH [1959] 2005
Smith, Henry Nash. *Virgin Land: The American West as Symbol and Myth*. 1959. Reprint, Cambridge: Harvard University Press, 2005.

SMITH 1999
Smith, Joel. *Edward Steichen: The Early Years*. Princeton, N.J.: Princeton University Press in association with the Metropolitan Museum of Art, 1999.

SMITH 1976
Smith, Roberta. "Stuart Davis: Picture Builder," *Art in America* 64 (1976): 80–87.

SMITH 1997
Smith, T. D., ed. *American Art from the Dicke Collection*. Exh. cat. Dayton, Ohio: Dayton Art Institute, 1997.

SNYDER 1981
Snyder, Joel. *American Frontiers: The Photographs of Timothy O'Sullivan, 1862–1874*. Millerton, N.Y.: Aperture, 1981.

SOLNIT 2003
Solnit, Rebecca. *River of Shadows: Eadweard Muybridge and the Technological Wild West*. New York: Viking Press, 2003.

SOLON 1999
Solon, Deborah Epstein. *Colonies of American Impressionism*. With an essay by Will South. Exh. cat. Laguna Beach, Calif.: Laguna Art Museum, 1999.

SOMMER 1972
Sommer, Frederick. *The Poetic Logic of Art and Aesthetics*. Stockton, N.J.: Carolingian Press, 1972.

SOMMER 1984
Sommer, Frederick. *Sommer*. Tucson: Center for Creative Photography, University of Arizona, 1984.

SOUTH 2001
South, Will. *Color, Myth, and Music: Stanton Macdonald-Wright and Synchromism*. Exh. cat. Raleigh: North Carolina Museum of Art, 2001. Los Angeles County Museum of Art and Museum of Fine Arts, Houston.

SOUTHALL 1996
Southall, Thomas W. "Personal Selection: Hopi Mesa." *American Art* 10, no. 3 (Fall 1996): 70–75.

SPALDING 1979
Spalding, Jeffrey J. *Max Ernst from the Collection of Mr. and Mrs. Jimmy Ernst*. Exh. cat. Calgary, Alberta: Glenbow-Alberta Institute, 1979.

SPANIERMAN 2000
Spanierman, Ira. *Arthur Wesley Dow: His Art and His Influence*. Exh. cat. New York: Spanierman Gallery, 2000.

SPIVA ART CENTER 1973
Spiva Art Center. *Thomas Hart Benton, A Personal Commemorative: A Retrospective Exhibition of His Works, 1907–1972*. Exh. cat. Kansas City, Mo.: Burd & Fletcher, 1973. Spiva Art Center, Missouri Southern State College, Joplin, Mo.

SPLETE AND SPLETE 1988
Splete, A. P., and M. D. Splete, eds. *Frederic Remington: Selected Letters*. New York: Abbeville Press, 1988.

STANGE 1990
Stange, Maren, ed. *Paul Strand—Essays on His Life and Work*. New York: Aperture, 1990.

STANGOS 1981
Stangos, Nikos. *Concepts of Modern Art*. Rev. ed. New York: Harper & Row, 1981.

STARR 1973
Starr, Kevin. *Americans and the California Dream, 1850–1915*. New York: Oxford University Press, 1973.

STARR 1985
Starr, Kevin. *Inventing the Dream: California Through the Progressive Era*. New York: Oxford University Press, 1985.

STEARNES ET AL. 2000
Stearnes, Robert, Karal Ann Marling, Catherine Evans, et al. *Illusions of Eden: Visions of the American Heartland*. Exh. cat. Columbus, Ohio: Columbus Museum of Art, 2000.

STEBBINS, QUINN, AND FURTH 1999
Stebbins, Theodore E., Karen Quinn, and Leslie Furth. *Edward Weston: Photography and Modernism*. Exh. cat. Boston: Museum of Fine Arts, Boston, in association with Bulfinch Press, 1999.

STEIN 1983
Stein, Sally. *Marion Post Wolcott: FSA Photographs [(Untitled 34)]*. Carmel, Calif.: The Friends of Photography Bookstore, 1983.

STEINBECK [1936] 1938
Steinbeck, John. "Their Blood Is Strong." *San Francisco News*, October 1936. Republished as a pamphlet. San Francisco: Simon J. Lubin Society of California, 1938.

STEINBECK [1936] 1994
Steinbeck, John. "In Dubious Battle." In *John Steinbeck, Novels and Stories 1932–1937*. New York: Library of America, 1994.

STERN 1992
Stern, Jenny. "Unleashing the Spirit: The Photography of Anne Brigman." *Art of California* 5, no. 4 (September 1992): 58–61.

STEVENS 1968
Stevens, Walter E. "John Marin in New Mexico." *Southwestern Art* 2, no. 2 (March 1968): 6–17.

STEWART 1985
Stewart, Rick. *Lone Star Regionalism: The Dallas Nine and Their Circle*. Dallas: Dallas Museum of Art and Texas Monthly Press, 1985.

STEWART 1998
Stewart, Rick. *A Century of Western Art: Selections from the Amon Carter Museum*. Fort Worth: Amon Carter Museum, 1998.

SWEENEY 1943
Sweeney, James Johnson. *Jackson Pollock, Paintings and Drawings: First Exhibition*. Exh. cat. New York: Art of This Century, 1943.

SWEENEY 1945
Sweeney, James Johnson. *Stuart Davis*. Exh. cat. New York: Museum of Modern Art, 1945.

SZARKOWSKI 2001
Szarkowski, John. *Ansel Adams at 100*. Boston: Little, Brown and Company in association with the San Francisco Museum of Modern Art, 2001. Art Institute of Chicago and Museum of Modern Art, New York.

SZASZ 1977
Szasz, Ferenc M. "Wheeler and Holy Cross: Colorado's 'Lost' National Monuments." *Journal of Forest History* 21 (July 1977): 133–44.

TAFT [1938] 1964
Taft, Robert. *Photography and the American Scene: A Social History, 1839–1889.* 1938. Reprint, New York: Dover Publications, Inc., 1964.

TANNING 2001
Tanning, Dorothea. *Between Lives: An Artist and Her World.* New York: W. W. Norton and Company, 2001.

TASHJIAN 1995
Tashjian, Dickran. *A Boatload of Madmen: Surrealism and the American Avant-Garde, 1920–1950.* New York: Thames and Hudson, 1995.

TAYLOR 1972
Taylor, George Rogers, ed. *The Turner Thesis: Concerning the Role of the Frontier in American History (Problems in American Civilization).* 3rd ed. Boston: Heath and Co., 1972.

TIME 1934
"U.S. Scene." *Time* 24, no. 26 (1934): 24–27.

TRACHTENBERG 1989
Trachtenberg, Alan. *Reading American Photographs: Images as History, Mathew Brady to Walker Evans.* New York: Hill and Wang, 1989.

TRAVIS 2001
Travis, David. *Edward Weston: The Last Years in Carmel.* Chicago: Art Institute of Chicago, 2001.

TRENTON AND HASSRICK 1983
Trenton, Patricia, and Peter H. Hassrick. *The Rocky Mountains: A Vision for Artists in the Nineteenth Century.* Norman: University of Oklahoma Press, in association with Buffalo Bill Historical Center, Cody, Wyo., 1983.

TRUETTNER 1991
Truettner, William H., ed. *The West as America: Reinterpreting Images of the Frontier.* With contributions by Nancy K. Anderson et al. Exh. cat. Washington, D.C.: Smithsonian Institution Press for the National Museum of American Art, 1991.

TRUETTNER 2003
Truettner, William H. "Plains Geometry: Surveying the Path from Savagery to Civilization." *Winterthur Portfolio* 38, no. 4 (Winter 2003): 199–219.

TUAN 1977
Tuan, Yi-Fu. *Space and Place: The Perspective of Experience.* Minneapolis: University of Minnesota Press, 1977.

TUCHMAN 1986
Tuchman, Maurice. *The Spiritual in Art: Abstract Painting 1890–1985.* Exh. cat. New York: Abbeville Press, 1986. Los Angeles County Museum of Art; Museum of Contemporary Art, Chicago; and Haags Gemeentemuseum, The Hague.

UDALL 1984
Udall, Sharyn Rohlfsen. *Modernist Painting in New Mexico 1913–1935.* Albuquerque: University of New Mexico Press, 1984.

UDALL 1998
Udall, Sharyn Rohlfsen. *O'Keeffe and Texas.* Exh. cat. San Antonio: Marion Koogler McNay Art Museum in association with Harry N. Abrams, Inc., 1998.

UNRUH 1993
Unruh, John D., Jr. *The Plains Across: The Overland Emigrants and the Trans-Mississippi West, 1840–60.* Urbana: University of Illinois Press, 1993.

VAN DYKE [1901] 1999
Van Dyke, John C. *The Desert: Further Studies in Natural Appearances.* New York: Charles Scribner's Sons, 1901. Reprint, Baltimore: Johns Hopkins University Press, 1999.

VAN KEUREN 1997
Van Keuren, Philip. *Shimmering Skies: Clouds in Adam Clark Vroman's Photographs of the American Southwest.* Exh. cat. Dallas: Pollock Gallery, Meadows School of the Art and William P. Clements Center for Southwest Studies, 1997.

VARNEDOE AND KARMEL 1998
Varnedoe, Kirk, and Pepe Karmel. *Jackson Pollock.* Exh. cat. New York: Museum of Modern Art, distributed by Harry N. Abrams, Inc., 1998. Tate Gallery, London.

VON GLAHN 1985
Von Glahn, Susan. "Death Imagery in the Work of Four Twentieth-Century Artists: Käthe Kollwitz, Mauricio Lasansky, Frederick Sommer and Jerome Liebling." Master's thesis, University of New Mexico, 1985.

VURE 2000
Vure, Sarah. *Circles of Influence: Impressionism to Modernism in Southern California Art, 1910–1930.* Newport Beach, Calif.: Orange County Museum of Art, 2000.

WALLACE 2000
Wallace, Robin Lynn. "The Glory of the Open: Spirituality and Nature in the Photography and Poetry of Anne Brigman." Master's thesis, University of Kentucky, 2000.

WATTS AND SMITH 2005
Watts, Jennifer A., and Andrew Smith. *Adam Clark Vroman: Platinum Prints, 1895–1904.* Exh. cat. Santa Fe and Los Angeles: Andrew Smith Gallery, Santa Fe, and Michael Dawson Gallery, Los Angeles, 2005.

WEAVER 1986
Weaver, Mike. *Alvin Langdon Coburn: Symbolist Photographer, 1882–1966.* New York: Aperture Foundation, 1986.

WECHSLER 1977
Wechsler, Jeffrey. *Surrealism and American Art, 1931–1947.* Exh. cat. New Brunswick, N.J.: Rutgers University, 1977. Rutgers University Art Gallery.

WEIERMAIR AND VANDERLIP 1998
Weiermair, Peter, and Dianne Perry Vanderlip. *Vance Kirkland 1904–1981.* Exh. cat. Zurich and New York: Stemmle, 1998. Frankfurter Kunstverein, Germany.

WEIGLE AND FIORE 1994
Weigle, Marta, and Kyle Fiore. *Santa Fe and Taos: The Writer's Era, 1916–1941.* Santa Fe: Ancient City Press, 1994.

WEISIGER 1995
Weisiger, Marsha L. *Land of Plenty: Oklahomans in the Cotton Fields of Arizona, 1933–1942.* Norman: University of Oklahoma Press, 1995.

WEISS 1980
Weiss, John, ed. *Venus, Jupiter & Mars: The Photographs of Frederick Sommer.* Exh. cat. Wilmington: Delaware Art Museum, 1980.

WESTON 1939
Weston, Edward. "What Is Photographic Beauty?" *Camera Craft* 46 (June 1939): 247–55.

WHITE 1983
White, Robert R., ed. *The Taos Society of Artists.* Albuquerque: University of New Mexico Press, 1983.

WHITE AND LIMERICK 1994
White, Richard, and Patricia Nelson Limerick. *The Frontier in American Culture: An Exhibition at the Newberry Library.* Edited by James R. Grossman. Exh. cat. Berkeley and Los Angeles: University of California Press, 1994. Newberry Library, Chicago.

WHITTLESEY 1988
Whittlesey, Lee H. *Yellowstone Place Names.* Helena: Montana Historical Press, 1988.

WIGHT 1956
Wight, Frederic S. *Contemporary Calligraphers: John Marin, Mark Tobey, Morris Graves*. Exh. cat. Houston: Contemporary Arts Museum, 1956.

WIGHT, BAUR, AND PHILLIPS 1956
Wight, Frederick S., John I. H. Baur, and Duncan Phillips. *Morris Graves*. Berkeley and Los Angeles: University of California Press, 1956.

WILKIN 1987
Wilkin, Karen. *Stuart Davis*. New York: Abbeville Press, 1987.

WILKIN 1990
Wilkin, Karen. *Mark Tobey*. New York: Edizioni Philippe Daverio, 1990.

WILMERDING 1980
Wilmerding, John. *American Light: The Luminist Movement, 1850–1875*. Exh. cat. Washington, D.C.: National Gallery of Art, 1980.

WILSON 1997
Wilson, Chris. *The Myth of Santa Fe: Creating a Modern Regional Tradition*. Albuquerque: University of New Mexico Press, 1997.

WILSON 1971
Wilson, Robert L. *Theodore Roosevelt, Outdoorsman*. New York: Winchester Press, 1971.

WILSON AND MADAR 1998
Wilson, Charis, and Wendy Madar. *Through Another Lens: My Years with Edward Weston*. New York: North Point Press and Farrar, Straus and Giroux, 1998.

WILSON AND REED 1995
Wilson, Michael G., and Dennis Reed. *Pictorialism in California, Photographs 1900–1940*. Exh. cat. Santa Monica, Calif.: J. Paul Getty Museum and Henry E. Huntington Library and Art Gallery, 1995.

WILSON AND WESTON 1940
Wilson, Charis, and Edward Weston. *California and the West*. New York: Duell, Sloan and Pearce, 1940.

WILTON AND BARRINGER 2002
Wilton, Andrew, and Tim Barringer. *American Sublime: Landscape Painting in the United States 1820–1880*. Exh. cat. Princeton, N.J.: Princeton University Press, 2002. Tate Britain, London; Pennsylvania Academy of the Fine Arts, Philadelphia; and Minneapolis Institute of Arts.

WITHERSPOON 1977
Witherspoon, Gary. *Language and Art in the Navajo Universe*. Ann Arbor: University of Michigan Press, 1977.

WOIWODE 1989
Woiwode, Larry. "Against the Grain." *Art and Antiques* 6 (January 1989): 74–80, 100–104.

WOLF 1983
Wolf, Daniel, ed. *The American Space: Meaning in Nineteenth-Century Landscape Photography*. With an introduction by Robert Adams. Middletown, Conn.: Wesleyan University Press, 1983.

WOLFF 1998
Wolff, Theodore F. *Morris Graves, the Early Works*. Exh. cat. La Conner, Wash.: Museum of Northwest Art, 1998. Whitney Museum of American Art, New York.

WOOD 1989
Wood, Nancy. *Heartland New Mexico: Photographs from the Farm Security Administration, 1935–1943*. Albuquerque: University of New Mexico Press, 1989.

WOOD AND FELS 1992
Wood, Denis, with John Fels. *The Power of Maps*. New York: Guilford Press, 1992.

WORSTER 1979
Worster, Donald. *The Dust Bowl*. New York: Oxford University Press, 1979.

WORSWICK 2001
Worswick, Clark. *Edward Sheriff Curtis: The Master Prints*. Santa Fe: Arena Editions, 2001.

WRIGHT 1978
Wright, Brooks. *The Artist and the Unicorn: The Lives of Arthur B. Davies (1862–1928)*. New City, N.Y.: Historical Society of Rockland County, 1978.

WROTH 2000
Wroth, William, ed. *Ute Indian Arts and Culture: From Prehistory to the New Millennium*. Exh. cat. Colorado Springs: Taylor Museum of the Colorado Springs Fine Arts Center, 2000. Anasazi Heritage Center, Dolores, Colo.; Autry Museum of Western Heritage, Los Angeles; and Buffalo Bill Historical Center, Cody, Wyo.

WYETH 1971
Wyeth, Betsy James, ed. *The Wyeths: The Letters of N.C. Wyeth, 1901–1945*. Boston: Gambit, 1971.

YATES 1989
Yates, Steve. *The Transition Years: Paul Strand in New Mexico*. Exh. cat. Albuquerque: Museum of New Mexico Press, 1989.

Index